Travel Photography

Steve Davey

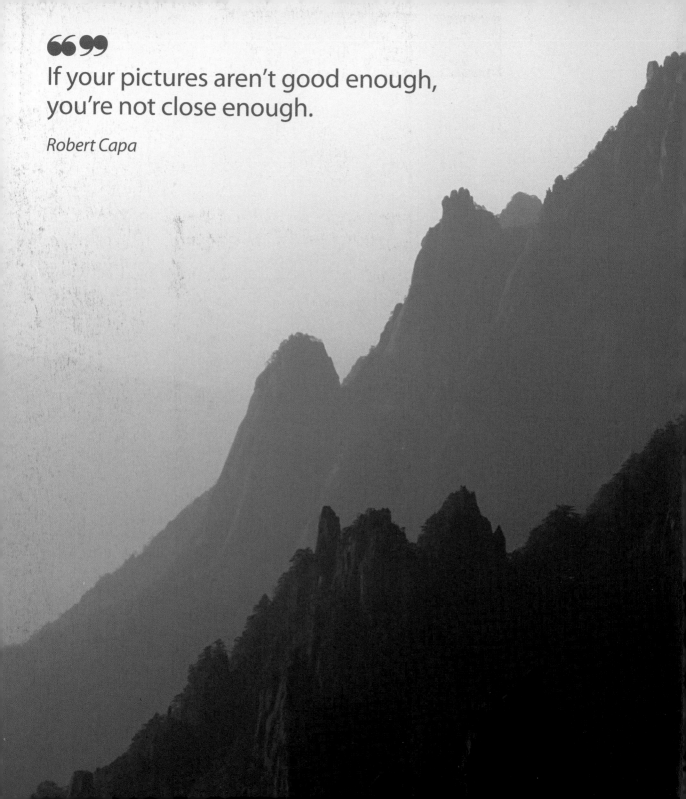

> **❝❞**
> If your pictures aren't good enough,
> you're not close enough.
>
> *Robert Capa*

It is very easy with travel photography to be so blown away by what you are seeing that all creativity goes out of the window. You raise your camera and 'snap': you end up with a purely representational photograph that is identical to so many others. I will try to inspire you to create pictures that you are proud of, not just records of the fantastic places that you travel to.

I am a jobbing travel photographer and writer, accepting commissions to go all over the world, almost always with insufficient time. I sometimes have just a few days to capture a place's essence and produce pictures to fill multiple pages of a book. I have to battle against time constraints, jetlag, bad weather, crowds, equipment issues and a lack of familiarity with the place itself. In this way my professional life often mirrors the experience of the amateur photographer who is limited by time and budget.

If you have tremendous luck, or unlimited time, then all the elements may come together for a picture: the light will be perfect, the subject laid out before you, without a tourist coach in sight. All you will have to do is take your camera, snap and get a masterpiece. Unfortunately, that seldom happens.

Once, when shooting Hong Kong Island, I spent five days struggling against the smog, travelling to the top of Victoria Peak on four occasions to try to get the perfect shot. On my last night I was relaxing in a bar, when the owner told me about a sunrise at the beginning of the week. In his five years in Hong Kong, it was the clearest and most beautiful he had seen. The pictures he had taken out of the window of his apartment on the Peak were fantastic. He wanted to know what I, as a photographer, had thought of it. To my dismay, I had to tell him that this amazing sunrise had occurred the day before I arrived!

On another occasion, I was shooting in Rio. The weather was cloudy and difficult but I kept working and tried a shot from the summit of Corcovado in the early morning. Shooting into the light, with all of the islands of the bay draped in backlit shadow produced a spectacular image which ended up on the cover of my first book. It would have been easy to give up and stay in bed that day but my persistence paid off.

What both these experiences show is that, as a photographer, you can't have perfect luck all of the time and you certainly never have unlimited time. You have to make your own luck with skill and hard work. This book aims to help you by offering tips, advice and encouragement. I believe that you can always take a great photo – no matter what the conditions. It might not be the photo that you set out to take or a photo that you would see on a postcard rack but that unique picture is out there. All you have to do is create it.

I often come back from a long trip exhausted, somewhat lighter and leaner, but ultimately more fulfilled and relaxed than if I had just been on holiday. Travel photography is really a way of life: a way of travelling. I have seen more sunrises and sunsets, looked more people from all walks of life in the eye and shaken more hands than I ever would have done as a traveller or holidaymaker. I have climbed more hills and mountains, and then often climbed them again the next day when the weather is better. I often find myself in the middle of the action – running from bulls, bathing with elephants or pilgrims, swimming with sharks – in a way that would not be possible without photography. Photography has been my motivation and I have experienced a greater level of enjoyment and involvement because of it. I hope to convey some of the magic of travel photography in this book and inspire you to get out there to see and embrace the world yourself.

Contents

Preparation

Exploration

Execution

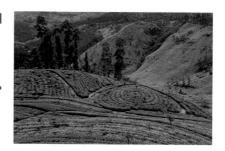

Inspiration

Correction

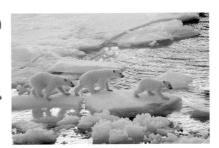

W On the web

Footprint Travel Photography is not just a book; it also comes with a unique companion website (**www.footprinttravelphotography.info**) that will help you to improve your travel photography and get more out of your travels. The site includes:

- up-to-date weblinks for all the websites, publications and products mentioned in the book
- a photoclinic where you can submit pictures for comment and help by the author
- an ask-the-author service which allows you to ask questions directly to the author
- image galleries where you can view the many images that didn't make it into the final book.

To complement the first edition of *Footprint Travel Photography*, Steve Davey launched a comprehensive series of London-based courses and exclusive travel photography tours to the most exotic and photogenic parts of the world. Destinations include India, Morocco and South East Asia. Land arrangements are provided by some of the biggest names in adventure travel. The tours website (**www.bettertravelphotography.com**) also features image galleries of some of Steve's recent work, travel photography features and extensive illustrated travel photography tips.

Profession

Front cover: Pilgrim at the Golden Temple, Amritsar, Punjab, India
Nikon D2x, ISO 100, RAW. 38 mm (57 mm equivalent). 1/200 second, f6.3

Inside front cover:
Polar bears in Svalbard, Norway
Nikon D2x, ISO 160, RAW. 420 mm (630 mm equivalent). 1/1000 second, f 5.6

Inside back cover:
Overlooking Jemaâ el-Fna square, Marrakech, Morocco
Nikon D2x, ISO 160, RAW. 70 mm (105 mm equivalent). 1/13 second, f 3.5. Tripod

Page 1: Sadhu at the Gangar Sagar Mela, West Bengal, India
Nikon D2x, ISO 200 RAW. 31 mm (46 mm equivalent). 1/125 sec, f4

Page 2: Huangshan Mountains, Anhui Province, China
Nikon F4, Provia 100 ASA film. 80-200 mm lens. Exposure not noted

Back cover:
Morning alms round, Luang Prabang, Laos
Nikon D3x, ISO 800, RAW. 98 mm. 1/100 second, f4.5

The Siq, Petra, Jordan
Nikon F5, Provia 100 ASA film. Lens and exposure not noted

Doge's Palace, Venice, Italy
Nikon F5, Provia 100 ASA film. 17 mm. Exposure not noted

From Steve Davey

About the author

Steve Davey is a photographer and writer, based in London. Blessed and cursed in equal measure with a low boredom threshold, he has turned travel photography into a way of life, as well as a career.

Steve first got hooked on photography at school. The mix of creativity and technicality seemed to suit his personality, and he realised that photography could make a good lifestyle: leaving school during the day was forbidden but, if he was stopped with a camera, he could just say that he was off to take some photos. He has used this excuse ever since and, remarkably, some people still believe it.

Steve is the author and principal photographer of *Unforgettable Places to See Before You Die* and *Unforgettable Islands to Escape To Before You Die*, both published by BBC Books. Between them, these titles have been published in over 40 language editions. Steve has also recently authored *Around the World in 500 Festivals* (Kuperard)

Steve's work has taken him all over the world, from the snowy wastes of the Arctic to the lush islands of Vanuatu. Highlights have included photographing the Maha Kumbh Mela festival at Allahabad for *Geographical Magazine*, and flying in a light aircraft around five countries in southern Africa. More recently he has danced with Kalash villagers in the remote border regions of Pakistan and got utterly drenched in the chaos of Lao New Year. Pictures from all of these trips appear in this book.

Represented by a number of agencies, Steve also sells his work through his own professional website: *www.stevedavey.com*. He markets his own unique range of travel photography tours and courses through *www.bettertravelphotography.com*.

Acknowledgements

This book is dedicated to my children, Amber Sashi and Alexander Rishi, and to my partner, Katharine, all of whom give me a reason to come home.

Those close to me know how hard travel photography can be as a career. One year I travelled the equivalent of seven and a half times around the world on some 99 flights. Although it is what I do and a large part of who I am, I always miss family and friends when I'm away. I thank them for still talking to me when I get home and for curbing their envy, at least to my face.

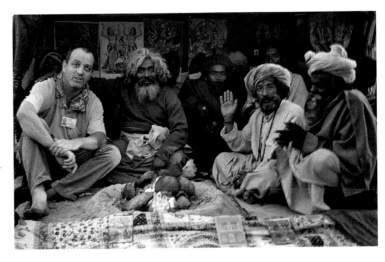

The author

Just another day at work: Steve Davey relaxing with sadhus (Indian Holy Men) at the Ganga Sagar Mela, Sagar Island, West Bengal, India. © Findlay Kember

I would also like to thank all of the people I have met on the road over the years. I am proud to say that I have friends across the world that I have met through my work. Some are other travellers or photographers; some are locals. Sometimes the friendships are fleeting; other times they survive decades and continents. Thoughts go out to the family of 'Mr Desert' in Jaisalmer, a larger-than-life character who featured in the first edition of this book but has since passed away.

No one exists in isolation. Thanks go to some of my fellow photographers, who I turn to for information – Marc Schlossman, Gary Ombler, Rob Hackman, Jamie Marshall and Findlay Kember. We don't always agree, but the debates are usually entertaining. Special thanks to Simon Joinson who acted as a virtual (and unpaid) technical consultant on the first edition. Simon is the Editor-in-Chief of the *DP Review* website and has written a number of books.

Thanks go to all at Footprint for having the vision to see the worth in the proposal I sent them for this book and putting in all of the hard work to make it a reality. Those who worked on the first edition: Alan Murphy, Zöe Jackson, Catherine Phillips and Liz Harper; and Sophie Jones and Angus Dawson who worked on both editions. Particular thanks to Patrick Dawson for the go ahead to produce this second edition.

Finally, this book must also be dedicated to Mr S. The place still seems empty without you.

About the book

This book really is a labour of love. I have wanted to write it for some time. In part, it is a retrospective of my work over the past twenty or more years of travelling and photography. In part, it is an expansion of all the travel photography articles I have written, especially the regular features for *Wanderlust* magazine in the UK and *Get Lost* magazine in Australia. Freed from the constraints of a short magazine article, I have, finally, been able to go into the depth I feel the subject needs. I hope you agree.

Since the first edition of this book was published in 2008, I have juggled a number of professional trips with a growing family and launched my own series of travel photography tours. Technology has developed, and the way that I shoot has evolved and moved on too. In part, the need to explain the way I work to people on photography tours has helped me refine my ideas, but I am always learning and refining my photographic skills. As well as incorporating many new images, this second edition also reflects what I have learned in the last five years.

I learnt my trade shooting transparency film, where everything had to be spot on in the camera. Although in later years I used to scan my transparencies on to a computer so that I could make certain changes and edits, the exposure and colour balance had to be right. What wasn't recorded on the slide, just wasn't there. I used colour correction filters to sort out the white balance and graduated filters to balance shadows and highlights; I calculated exposure manually with a spot meter, and there were times when the conditions were such that I simply couldn't shoot.

On a long trip I used to carry vast amounts of film and fuss over it like a mother hen, protecting it from heat, X-rays and loss. When I got home I paced nervously waiting for it to be processed and then pored over it, hunched over a lightbox, before embarking on the long process of editing, mounting and captioning. I used to get a thrill from the fact that the picture was created by light falling on this very piece of celluloid and causing a chemical reaction, just a few millimetres from my cheek!

Now, I exclusively shoot digital. I love digital photography. I love the immediacy, the cost, the speed of the process and the sheer quality. I love the fact that I can create back-up copies instantly and work on my images when I am away. With a digital camera, a laptop and a halfway decent internet connection, everywhere can be my office, and I can distribute my pictures from anywhere in the world.

The vast majority of photographers now shoot digital, and you will struggle to buy a new film camera. Yet, there is a significant minority that still shoots film, and there is a good second-hand market for film cameras. Although this book is primarily aimed at the digital travel photographer, I have not ignored those still shooting film. Many of the photographic principles behind photography are the same whatever camera you are using; where there are differences in approach, I have identified them.

Where possible, I have included the lens and exposure details for each picture, but, in many cases, this is simply not possible. Digital cameras record this information with each frame; film cameras don't. Some people claim to have written down exposure and lens details for every frame they shot on film, but I certainly didn't: I was too busy taking pictures.

Although I have covered different types of cameras, this book is not a replacement for your camera manual. I can tell you what the various functions of your camera might do and when you might use them, but you will need to consult your manual to ascertain just where these functions are located and how to use them in your individual case. Although I have included some information about choosing and buying different styles of camera, I have tried to avoid countless pages of technical specifications. There are websites – notably the incomparable *Digital Photography Review* – that are able to do this in more depth and can keep pace with the almost daily advances in technology. I wanted to write a book teaching people how to take pictures, not how to buy cameras.

I have also taken the decision not to include 'bad' pictures, illustrating poor exposure, focus and composition and a host of other mistakes. This is partly due to personal vanity and partly because I would like people to take pleasure from just flicking through this book, enjoying the pictures.

I hope this book is about more than taking pictures. Photography is a fantastic motivator and should encourage you to get more out of your travels. It has done that for me, and if this book conveys just a part of the excitement and wonder that I have experienced during my explorations over the years, then it will have succeeded.

Using the book

This book is divided into the following sections, representing the different areas of knowledge that you will need:

Preparation This section looks at all of the equipment issues that you will need to consider before you leave, as well as the information you will require to plan your trip and take the best pictures.

Exploration This section explains how to travel with your camera, including keeping your equipment safe and how to survive on the road.

Execution The compendium of technical know-how that you will need to understand the craft of photography and to get the most out of your camera: **exposure**, **focus** and some of the scary modes, buttons and menu items that might confuse and bemuse you.

Inspiration Photography is not just about the technical stuff: there are different approaches for different types of photography and for different environments. This section should make you want to dig out your passport and hit the road. As a further incentive, there are inspirational images throughout the book, which illustrate certain key aspects of travel photography.

Correction There are so many things that can be done on a computer to enhance your digital images and, if you decide to shoot in **RAW** format, all of your images will have to be post-processed in some way. Most of these enhancements will also be relevant to film photographers who scan their work.

Profession There are a number of ways of making money out of your photography, from competitions and print sales through to being a fully fledged professional. This section gives you a few tips of the trade.

For the purposes of this book, I am covering three types of camera: film **SLR**, digital SLR (including mirrorless) and digital **compact**. Although primarily geared towards those shooting with a **DSLR**, this book, does not ignore other cameras. I explain technical aspects of photography and how you can address them, depending on which style of camera you are using. You should think about how you want to use your camera, as well as what sort of camera it is.

Digital SLR Accepts interchangeable lenses and can shoot RAW. The DSLR user will be serious about their photography and want to learn more about photographic techniques. They may even want to master **manual exposure**. This category includes those shooting with sophisticated mirrorless cameras who want to progress past the automatic modes and gain more control of their camera.

Digital compact This category is for users of digital compacts who want to improve their photography but not to wade into all of the technical aspects. They will typically shoot on automatic but will want to know some tips on how to make this more effective and also get some inspiration about different picture-taking scenarios. This category also applies to those with DSLR and mirrorless cameras who only use automatic and **picture scene modes**.

Film SLR There are still a number of purists using film SLRs to shoot transparency (slide) film. The last significant 35 mm film SLR to be released was the Nikon F6 in 2004; this camera is still listed as a current model on the Nikon website. Where appropriate this book highlights the issues you need to consider when shooting film and assumes that film photographers want to have as much control over their photography as possible.

Throughout the book you will find these boxes, representing the following more advanced techniques you can employ.

Shooting RAW Most digital cameras save their pictures in a compressed format called **JPEG** but DSLRs and some **bridge cameras** can save images in a more sophisticated format called RAW. This is like a digital negative and needs post-processing on a computer. The advantages of this format will be covered in the appropriate sections throughout this guide and, specifically, on pages 14-15.

Pro tips There are certain professional techniques that can help improve your photography. Some of these are quite technical and may require additional reading, but a brief description of the most useful skills and the associated equipment is given where appropriate.

Certain words in this book are shown in **bold**. These are for technical terms which are defined in the glossary on pages 310-313.

The names of any *websites*, *products and publications* mentioned in the book are shown in *italics*. All of the URLs and publication details for these can be found on our companion website *www.footprinttravelphotography.info*. This allows us to keep all of the details up to date and avoids the need to include long and complicated addresses.

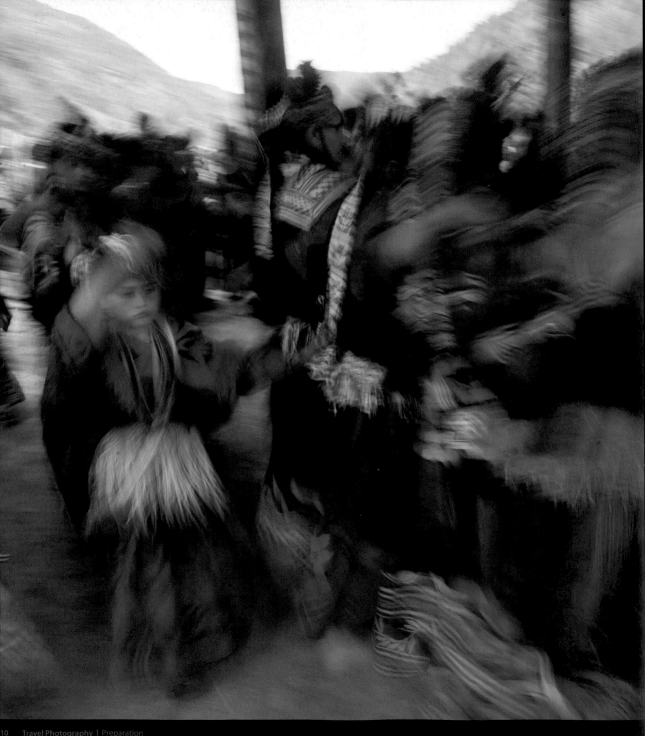

Preparation

Many of the foundations of successful travel photography are laid before you even leave home. Not only do you have to choose what equipment to take, but you need to be familiar with it and make sure that it is all working. Good research is the key to a successful trip: you have to be at the right place at the right time, whether it be to photograph a festival or just to avoid (or even catch) the monsoon. This section will take you through some of the equipment issues you need to consider and some of the groundwork you will have to do before you set off.

Kalash Joshi (Spring Festival), Chitral, Pakistan ❮

Nikon D3x, ISO 100, RAW. 24 mm. 1/4 second, f20

The Kalash people live in three remote valleys near Chitral in Khyber-Pakht▮▮▮wa, near the Afghanistan border in Pakistan. Non-Muslim animists, they hold three lively festivals in a year to appease their Gods and the local spirits. Women wear bright clothes, and men and women dance together, often after drinking quantities of the local mulberry wine. The *Joshi* (Spring Festival) is noisy, chaotic and dusty. People spin in long lines around the *Charso* (dancing ground). I wanted to take some shots showing the movement and chaos, and so opted for a slow shutter speed and a touch of panning to create blur.

Digital photography

A film camera uses a lens to focus light from a subject onto light-sensitive film. As each piece of film is exposed, it is wound on, so that an unexposed piece moves into position ready for the next shot. Colour film has three light-sensitive layers, red, green and blue, which record the various colours of the image. To make the latent image visible, the film needs to be chemically processed.

A digital camera uses a **sensor** instead of film. The sensor comprises a grid of **pixels** that are sensitive to either red, green or blue wavelengths. When combined, these can reproduce all of the colours of the spectrum. Once the image has been recorded, it is saved to a memory card that can then be read by a computer.

Since the first edition of this book, it seems that the whole world has gone digital. The proliferation of cameras on smartphones means there are now more people regularly shooting digitally than were ever shooting film. Whole social networks – such as *Instagram* – have sprung up around digital imaging, and incredible volumes of pictures are being taken and shared. The world has gone photo-crazy: you can't sit down in a restaurant without seeing someone at the next table photographing their meal, and at concerts, performances and even riots, your view is likely to be obstructed by a sea of smartphone screens, as their owners compulsively photograph or, more usually, film everything that is going on. Much of this material is uploaded to the internet with little or no moderation.

Ⓦ The URLs of all the sites and products mentioned in this chapter are given on the website: footprinttravelphotography.info

This democratization of photography has been a incredible thing, bringing the joy of photography to people all over the world: I have seen Ladakhi monks and hilltribe minorities in Laos all pull out phone cameras and snap away with wild abandon. Yet the mushrooming of digital images has led to a perception that images are disposable, even worthless. In many cases, all notion of quality and craft has gone out of the window. Nevertheless, people are still drawn to images of quality. You only have to read the comments on photo-sharing sites to see how many people aspire to take great pictures, rather than just taking pictures of great things. This book is unashamedly aimed towards those people who aim to take the best picture they can in any given situation.

You don't have to own a computer to shoot with a digital camera. You can snap away, drop your memory card off at a photo-processing shop, wait a few hours and then collect your prints. All of your pictures can be written to a CD, which can be chucked in to the same old shoebox into which you used to file your negatives. You can even connect a printer straight to some cameras and print directly.

But, if you want to take your photography seriously, the digital process does call for some degree of post-processing and time in front of a computer. Although it also allows you to correct some mistakes that you might have made in camera, you should try to

Film SLR

There are three main types of film that you can choose from: colour negative, colour transparency and black-and-white negative. Colour transparency gives a transparent positive image, which can be mounted individually to make a slide. This can be projected, scanned or printed on photographic paper. Many film photographers still shoot transparency because of the quality, although this is surpassed by the quality available from professional digital equipment. There are also photographers who still appreciate the craft of shooting transparency film and the discipline of getting everything right in camera.

With sales of film drastically reduced, both the range of films available and the number of processing laboratories has dropped considerably. It is important to buy a good-quality film and to make sure that it has been stored correctly. If it is out of date or has been stored in the heat of a shop window, it can be seriously degraded. It is possible to buy professional film, but this has been optimized to be stored in refrigerated conditions. As a travel photographer, you are probably better off sticking to a good-quality, non-professional film.

Each film from different manufacturers will have its own characteristics. I would advocate sticking to a manufacturer and even a film type, so that the colour rendition is fairly standard across all of your pictures. I used to always use Fuji Provia, which comes in 100 ASA and 400 ASA speeds.

Unprocessed film needs to be protected from heat, humidity and excessive x-rays, though normal sensitivity films (400 ASA and lower) should be OK when passed through hand-baggage machines a few times on a trip (see page 47). Film needs to be processed fairly soon after it has been exposed, which can be hard on a long trip. You can either risk shipping it home or get it processed locally. I always used to get transparency film processed on the road if I could find a good professional lab.

think of this as a positive aspect of digital photography, as it gives you the control and creative freedom previously only exercised in a photographic darkroom.

There is a world of difference between digital correction and digital manipulation, however. This book does not cover how to drop those unbelievably large full moons into a night shot or how to create a perfect sky in a dull picture: those examples lie at the thin end of the wedge that is 'digital art'. Instead, I will be concentrating on digital correction as a way of making your photography more real. Digital correction allows you to overcome the shortcomings of the photographic process and bring your image closer to your perception of the scene when you took the picture.

If you are seriously shooting film at the moment, then far be it from me to try to persuade you to change, but digital photography enjoys a number of benefits over shooting with film. Practically, you are able to assess a photograph instantly, so you can learn from your mistakes while there is still time to do something about it. You are also able to back up your work far more safely, and you can have a higher degree of interactivity with the people you are photographing by showing them the pictures on the LCD preview screen. Pictures can instantly be shared, distributed or even sold, and the technical advances mean that a **Digital SLR (DSLR)** gives a greater quality than the equivalent film camera, especially if you are shooting in low light levels. There are also the particular technical advantages of having built-in **colour temperature** correction and the ability to change the **sensitivity**; these will be dealt with in the Execution section (starting on page 56).

Lagoon, Moorea, French Polynesia ⋀

Nikon D2x, ISO 100, RAW. 135 mm (200 mm equivalent). 1/320 sec, f4.5. Polarizing filter.

In order to make the colour of the lagoon more saturated, I used a polarizing filter to cut down the reflections, and slightly warmed up the colour temperature of the image in RAW processing. Cropping out everything from the background except for the lagoon makes the image more immediate.

Shooting JPEG or RAW

Generally, digital cameras can save pictures in two formats: JPEG and RAW. JPEG is a compressed format, meaning that you can save more files on a memory card, but there is an inherent loss of quality. RAW is a far higher quality format that gives you all of the information that the sensor can record but you need to process it on a computer to produce the final image. Each format has its own advantages and disadvantages, and it is worth considering them at this point as it will affect which camera you buy and how you use it. Currently, very few compact cameras shoot RAW.

Before making a decision about which format you are going to use, you should understand how your camera creates **RAWs** and **JPEGs**. A RAW file is a complete record of everything that the sensor can pick up, with the camera settings tagged to it as suggestions for the RAW-processing software. You can make many edits to the RAW file without degrading the image quality. The edits are made in controlled conditions on a computer screen rather than on the LCD preview screen of your camera in strong sunlight. Also, these edits are non-destructive: they are remembered in software and don't affect the original RAW file.

A JPEG, on the other hand, comes pre-processed. The camera applies settings for **saturation**, **contrast**, **white balance**, **exposure**, noise reduction and **sharpening**, and then applies a **tone curve** and cuts down the number of tones, before saving the picture in a compressed format. The camera makes a lot of decisions on your behalf, including what picture information to keep, and the rest of the information in the file is simply discarded to make the file size smaller. If you're shooting JPEGs you should aim to get the exposure and white balance spot-on in the camera since, although you can edit the file later, it will further degrade the image quality if you do. Any process, such as editing or compression, which degrades the image is known as '**lossy**'. Changes to a JPEG are destructive: they are written to the file. This means that the only way to review the saved changes you have made is to keep copies of each version.

When you save a file as a JPEG you usually get the choice of low, medium and high quality. This corresponds to the degree of compression: in other words, how much information the camera seeks to identify as superfluous and throws away. The lower

the quality of the JPEG, the greater the degree of compression. This results in a smaller file, which allows you to fit more pictures on a disk. High levels of compression can lead to compression **artefacts**, where fine details and gradations can be pixellated and lose their smoothness.

You also have the chance to record your picture as a smaller image that takes up less space on the memory card, but, with memory cards getting bigger and cheaper all the time, I can see no reason to do this. If you want a smaller image, you can always reduce the size on a computer later.

A JPEG from a camera is typically adjusted to look brighter and punchier, which causes it to lose detail in the highlights and the shadows. A RAW file tends to look flatter but will hold more information, which can be brought out in post-production. RAW files are also generally able to hold at least a **stop** more detail in the highlights, allowing a pale sky to render light blue instead of white and highlights to maintain their detail.

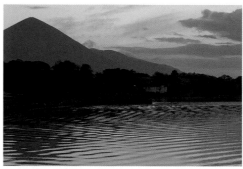

Croagh Patrick, Westport, Ireland ◄

Nikon D2x, ISO 400, RAW. 70 mm (105 mm equivalent). 1/80 second, f11

The extra dynamic range given by shooting in RAW has helped manage the high contrast. I opted for a slightly higher sensitivity rather than a longer shutter speed to minimize subject blur. Focusing a third of the way into the picture maximized the depth of field.

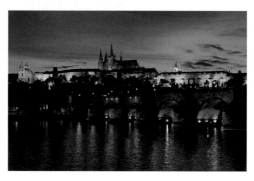

Charles Bridge at night, Prague, Czech Republic ◄

Nikon D3, ISO 200, RAW. 70 mm lens. 0.6 second, f5.6

Shooting RAW allows far greater control over the colour temperature of your image and also allows you to handle contrast and dynamic range better. You can even process a RAW file with different colour temperature settings and combine them in post-production (see page 277).

	Advantages	Disadvantages
RAW	✅ Higher quality: at least 4096 levels for editing and no lossy compression ✅ Ability retrospectively to change white balance and other attributes without loss of quality ✅ Better highlight detail and ability to rescue poor exposures ✅ Edits made non-destructively, without over-writing the original file	❌ Time and software needed for processing ❌ Slower to record ❌ Larger file, so more storage capacity (memory cards and hard disk space) needed
TIFF	✅ No compression, so no loss of quality due to artefacts ✅ Files are ready instantly (if you need that) ✅ No post-processing (if you get everything right)	❌ Large files, so more storage capacity needed ❌ Slower to record ❌ Lower quality: only 256 levels per channel make editing lossy
JPEG	✅ Smaller files; easier to store ✅ Files are ready instantly (if you need that) ✅ No post-processing (if you get everything right)	❌ Lower quality: only 256 levels per channel make editing lossy ❌ Compression can introduce artefacts into the image ❌ Contrast, saturation, sharpening, noise reduction and white balance all have to be set on the camera for all images, as editing in post-production degrades the image

Some cameras can also save in a high-quality format called a **TIFF**. This is slightly better quality than a high-quality JPEG but will not hold as much information as a RAW file. TIFF files from a camera are uncompressed, so they don't suffer from compression artefacts, but they are saved in 8 bit, so they only have the same colour range as a JPEG (see below).

8 bit or 12 bit?

The greatest difference between the two formats is the way that the colour information is translated to computer information. A JPEG is saved with 8 bits of information per **pixel**. This means each of the red, green and blue channels has up to 256 shades to display the picture. Most DSLRs shoot in 12 bit when shooting RAW, which gives a whopping 4096 shades per channel. Some cameras shoot in 14 bit which gives even more shades per channel.

A JPEG is probably sufficient, if the tones in your picture are spread out from highlights to shadow and use all of the 256 shades per channel. However, a low-contrast image saved as a JPEG may be recorded in camera across just 100 shades. If you increase the contrast of this image in post-production you are, in fact, stretching those 100 shades across the 256 range. This will give a lack of subtlety and make the tones appear banded, not continuous. With a RAW file, there are more shades of colour than you will need, so, within reason, you can adjust the image quite considerably without seeing any banding or loss of tonal gradation.

My recommendation is to always shoot RAW, as long as you have access to a computer. It gives the experienced photographer far more creative options and provides a useful safety net for the beginner. If you can't make up your mind, most DSLRs will let you save the file in both JPEG and RAW simultaneously.

Styles of camera

There has never been so much choice when considering which camera to buy. Mirrorless cameras have taken over the middle ground between the DSLR and the compact camera, or you could simply use your smartphone or tablet.

Compact cameras

As the name suggests, the main characteristic of a compact camera is that it is small and easy to carry. There is no excuse not to carry a compact camera with you at all times, allowing you to shoot discreetly in most situations. Yet, despite its diminutive size, a compact camera is often packed with features – some that are missing on larger, more expensive cameras.

✅ Advantages

- The compact size makes carrying them a breeze.
- The LCD screen is useful for unobtrusive photography. Some also tilt, allowing for high and low **viewpoints**.
- Some compacts can shoot in a panoramic 16:9 format.
- They can be mounted on a mini table-top tripod.
- The fixed lens (usually a zoom lens) prevents dust and dirt getting on the **sensor.**
- Relatively cheap housings are available for underwater photography or wet and dusty conditions.
- The simple and automatic modes are often very user friendly.
- They often have comprehensive **picture scene modes** and intuitive features, such as video, WiFi, GPS and **focus modes** that recognize and bias towards faces.

❌ Disadvantages

- Many compacts don't have **optical viewfinders**. The LCD screen is hard to use in bright light and drains batteries.

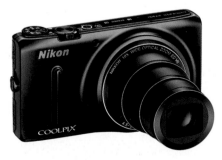

- **Focal lengths** are more limited with a built-in lens.
- Lenses tend to be small, which doesn't allow for all of the corrective glass required to combat lens faults.
- They have a weak **flash** and, usually, won't take a separate flash unit.
- The small **sensor** gives more high **ISO noise**, limited **dynamic range** and less control over **depth of field**.
- There is often an appreciable delay between pressing the shutter-release button and the picture being taken.

Although often outperformed by a **DSLR** with an equivalent resolution sensor, compact cameras have experienced great advances in both technology and picture quality. If you want a camera that sorts out the technical stuff, while you concentrate on what you are shooting, then a compact could be perfect for you.

Phone and tablet cameras

With at least one camera built into almost every smartphone and tablet, more people are carrying a camera than ever before. There is a lot to recommend a smartphone camera, and it is often a better option than a simple compact.

✅ Advantages

- It is compact in size and always carried with you.
- The LCD screen is useful for unobtrusive photography.
- The fixed lens avoids possibility of dust on the sensor.
- Simple and automatic modes are often very user friendly.
- A range of processing and panorama software is built in.
- You can upload images to **cloud** and social media sites virtually instantly.
- They have comprehensive digital video ability.

❌ Disadvantages

- There is no optical viewfinder and the LCD preview screen can be difficult to see in bright light.
- They have very limited optical zoom; usually digital zoom only.
- Lenses tend to be small and of limited quality.
- They either have no flash, or very weak built-in flash.
- The small sensor gives greater depth of field, higher noise, especially at higher **sensitivities**, and more limited dynamic range.
- There is often an appreciable delay between pressing the shutter-release button and the picture being taken.

Compact camera ◄

If you just want a simple compact camera, you may well be better off with a phone camera. The Nikon Coolpix S9400 fills the higher end of the market with an 18.1MP resolution and an 18x zoom, giving you the equivalent of an 25-450 mm zoom. It is even available in red – classy!

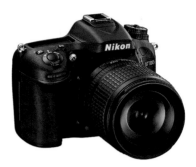

If you just want a simple point-and-shoot camera, then often a smartphone will give you the same functionality as a simple compact camera, as well as the ability to make phone calls and access the internet.

Digital SLR (DSLRs) and SLRs

A DSLR stands for Digital Single Lens Reflex camera, a name and style of camera derived from the film-based **SLR**. The basic premise of an SLR camera is that you actually view the scene through the same lens that takes the picture. The light from the scene is reflected on an internal mirror (reflex) and diverted through a pentaprism on the top of the camera to the eyepiece. The prism corrects the mirroring effect that transposes right and left when things are reflected. When you actually take a picture, the mirror flips up out of the way, the lens aperture closes down to the selected aperture, the shutter opens and closes, exposing the film or sensor, before the mirror returns and the **aperture** is reopened to the maximum value, so the picture you are looking at is as bright as possible for viewing and focusing.

✔ Advantages

- Because you are looking through the lens, you can accurately judge the effect of zooming, cropping and focus (although viewfinders of most entry-level cameras will only show about 95% of the frame).
- They take a range of interchangeable lenses, from extremely wide **'fish-eye' lenses** through to super **telephoto lenses** that can magnify distant objects.
- There are a greater range of accessories available, from flashguns to filters and remote releases, enabling you to build a comprehensive system.
- They tend to focus more quickly than other styles and don't suffer from a shutter release delay.

Digital SLR camera (DLSR) ‹

Nikon D7100: this has a 16.2 MP crop sensor, a built-in spot meter and a 6-frames-per-second motordrive. Boasting improved high ISO performance, the recommended ISO range is 100-6400; expandable to ISO 25,600. The D7100 can also shoot full HD video.

View over the Yasawa Islands, Fiji ⌄

Nikon D2x, ISO 100, RAW. 60 mm (90 mm equivalent). 1/800 second, f5.0

This image was taken from an old seaplane, as it bounced around just after take-off. There are some situations where you have more things to think about than your camera, and familiarity and simplicity of operation are more important than sophisticated technology.

- They have more accessible **manual exposure modes**, allowing direct control of aperture and **shutter speed**.
- All DSLRs will have the ability to shoot the more versatile **RAW** format.
- The large sensor produces images with a greater dynamic range, less noise at higher sensitivities and the ability to achieve shallow depth of field.

✖ Disadvantages

- Dust and dirt can get into the camera body when changing lenses. Dust on the sensor causes black marks on images and can scratch film.
- They tend to be more expensive, bulkier and heavier than other styles of cameras, especially if you are also carrying a range of lenses.
- To get the most out of your camera, you have to achieve a relatively high level of knowledge.

One thing to consider when deciding whether a DSLR is right for you is whether you will actually use the extra functionality. If you are only going to use the limited-range kit lens that comes with your camera, shoot everything as a JPEG in auto and not blow your pictures up very large, then you might be better off with a cheaper and more portable mirrorless camera or even a sophisticated compact.

Mirrorless (Compact System) cameras

A few years ago, the middle ground between compact cameras and DSLRs was occupied by **bridge cameras**,

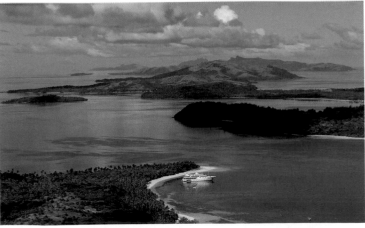

Mirrorless (Compact System) camera **>**

Mirrorless or Compact System Cameras borrow the best from both compact and DSLR cameras. Small and light, they also have DSLR sized crop sensors and interchangeable lenses. The one drawback is the electronic viewfinder, but this allows for the more compact size. The Nikon 1 v2 boasts a 14.2MP sensor and a range of high quality lenses.

which seemed to take the worst from each format. Now you can choose a **Mirrorless (Compact System) camera**, which seems to take the best from each format. Small and compact, they boast the larger sensors and interchangeable lenses of a **DSLR**. Instead of an optical viewfinder, mirrorless cameras have an electronic viewfinder, showing a live view of the subject. As there is very little to recommend a bridge camera (except for the powerful, yet low-quality telephoto zoom setting) when compared to compact, mirrorless or DSLR cameras, I have largely disregarded them here. Bridge cameras share many of the characteristics of a larger compact camera, and many of the things to consider are covered in the compact camera buying guide.

✔ Advantages
- Although they are larger than compact cameras, they are still very light and portable.
- A wide range of interchangeable lenses are available.
- The LCD screen is useful for unobtrusive photography.
- They can be used as simple point-and-shoot cameras, but by delving just a little deeper you can uncover some sophisticated functionality.
- They often have comprehensive **picture scene modes**, which will automatically customize camera settings.
- Many models have **spot meters**, which allow for more accurate metering, especially with **manual exposure**.
- The same sized **sensor** as an amateur DSLR gives good **dynamic range**, lower **ISO noise** and the ability to achieve a shallow **depth of field**.
- They are cheaper than a DSLR with a kit lens.

✖ Disadvantages
- The electronic viewfinder can be difficult to use, especially over long periods of time.

- The interchangeable lens can allow dust to reach the sensor.
- With a range of lenses, they can be almost as bulky as a DSLR kit.
- They can feel unbalanced if fitted with a larger lens.
- Their smaller bodies mean most functions are menu driven.

Although the size and weight of a mirrorless camera with a few lenses can add up, it will be far smaller than the equivalent DSLR kit, making it a very good option for those who want more functionality, but still want good-quality images and the ability to wrest control from their camera.

Sensor resolution

The **resolution** of a camera is only part of what governs quality, yet it seems to dominate much of the advertizing and most people's perception of what constitutes a good or poor camera.

The resolution of a digital camera chip is determined by the number of **pixels** or photo-receptive cells in the camera. Each of these produces a coloured pixel on the finished image. For instance, a sensor of 3264 x 2448 pixels will produces an image of 3264 x 2448 pixels, which equates to approximately 8 million pixels. A camera with this sensor will be referred to as an 8 megapixel (8 MP) camera.

Yet there is far more to the quality of a digital camera than the number of pixels. The characteristics of each pixel will also have an effect. To start with, the capacity of each pixel determines the dynamic range of the camera – the amount of light that each pixel can record between the darkest black and brightest white. The lower the dynamic range, the less able a camera is to photograph high-contrast subjects. Another characteristic that affects quality is the level of **digital noise** produced by the sensor. This appears on images as random speckling and is especially marked at higher **sensitivities** (see page 111). Many cameras boast higher sensitivities than they are capable of using to produce acceptable pictures.

There are no hard and fast rules as to sensor quality but, in general, the more pixels that are crammed into a sensor (the **pixel density**) the more likely they are to suffer from dynamic range and noise issues. There is a great deal of variation, depending on the manufacturer and even the type of sensor, but, in general, the larger the pixels and the lower the pixel density then the

Focus on

Morning exercises, Hoan Kiem Lake, Hanoi, Vietnam

Waking up to photograph the sunrise over the Hoan Kiem Lake in the centre of old Hanoi, I was greeted by a cold, wet, drizzly morning. On days like this it is easy to give up and just stay in bed, but I headed out to see what there was to photograph.

Usually the lake shore is packed with people doing Tai Chi, dancing and even playing badminton. On this day it was deserted. After a while, I noticed this man walking along, doing his morning exercises. I caught his eye, and he stopped and started to play up for the camera.

After taking a few shots, I started a conversation. He told me that he has carried out his morning exercises for over thirty years, and credits that for his excellent health. He also mentioned that his son is a dentist in Luton, just outside of London, in the UK!

Photographically this picture shows that you should never give up and that there are always photographs to be taken: whatever the weather. The light was so bad that I had to use a high ISO and a relatively slow shutter speed, but the vibration reduction on the lens meant that there is no camera shake. It also shows that it is a small world, and you should always get permission to take pictures!

 Find out more

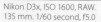

Nikon D3x, ISO 1600, RAW. 135 mm. 1/60 second, f5.0

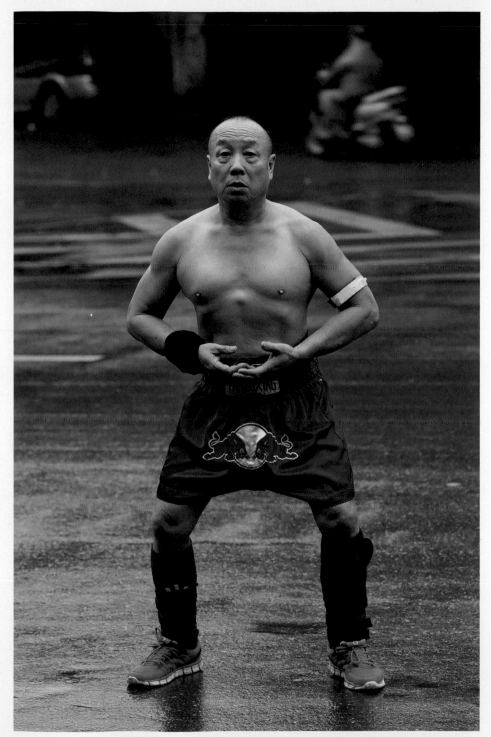

Travel Photography | Preparation 19

better the pixel quality. This means that you should expect a better quality image from a 12 MP DSLR with a larger sensor and a high-quality lens, than a picture taken on a budget compact camera that boasts the same or even higher resolution. Note that the quality of the lens is vital here; it doesn't matter how good the sensor is if you are projecting a flawed image on to it.

Don't try to assess a camera by how the images look on the LCD preview screen, as these are often boosted to give punchy, over-sharpened images: shoot some test images using each of the models at a camera shop and then view them on a computer to check the quality. If this isn't possible, or you are buying from an online retailer, then check out an authoritative camera review site such as *DP Review*. This carries out exhaustive tests on many cameras, including the performance of the sensor.

Film and digital formats

The majority of film **SLR**s used the 35 mm roll film format, which has an image size of 36 x 24 mm, giving an **aspect ratio** of 3:2 (see page 21). This is the aspect ratio also adopted by most **DSLR**s, even those with a **sensor** that is smaller than the 35 mm frame. This results in a **crop factor**, which effectively multiplies the focal length of the lens (see page 25).

Some professional DSLRs have sensors that are equal in size to the 35 mm frame. These are known as **full-frame** or, in the case of Nikon, Fx format. There are only a few models available, and they are expensive. The advantage of using a full-frame camera is that it doesn't have a crop factor, so **wide-angle lenses** behave just as they would on a 35 mm film camera. As the sensor is bigger, a full-frame camera tends to offer higher **resolution**, less **noise** and better **dynamic range** than a DSLR with a smaller **crop sensor**. However, a crop sensor DSLR has the effect of making **telephoto lenses** more powerful, which is a bonus for sports and wildlife photographers.

Some DSLRs use the 4/3 system that was developed by Olympus. These cameras have an aspect ratio of 4:3, a format conceived for digital imaging. This is an open system that will allow you to use any 4/3 lens with any 4/3 camera body from any manufacturer. Cameras and lenses based on the 4/3 system are more compact than other DSLRs, although the sensor is smaller and the crop factor gives an effective **focal length multiplier** of 2x. Unfortunately, the smaller sensor also

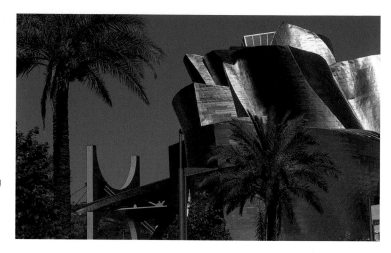

makes it more difficult to obtain a shallow **depth of field** and means that the 4/3 system has a propensity for noise at higher **ISO**s. Personally, I find the 4:3 ratio, which is also used in many compact cameras, far too square.

Some compact cameras will shoot a wider, panoramic 16:9 format picture, though this is often just a cropped version of the native sensor, accentuating many of the drawbacks of the limited sensor size.

There are also a number of film and digital cameras with frame sizes larger than the standard 35 mm frame. In the film world, these cameras are known as **medium-format** and use a film that is 6 cm wide. The resulting picture sizes vary from 6 x 4.5 cm through to 6 x 9 cm. There are even some cameras that shoot panoramic images that are even wider.

Many medium-format film cameras are SLRs, employing a lens and prism so that the photographer can compose and focus through the lens. They are often modular, meaning that the camera body can be fitted with a range of lenses and different format film backs. Some even take a digital back, which allows pictures to be taken at far higher resolutions than standard DSLRs based upon the 35 mm frame, as more pixels can be fitted onto the larger sensor area. However, as well as giving phenomenally high resolution, they are also phenomenally expensive and are suited to professional studio and location work, rather than travel photography. Although this book does not cover medium-format cameras in any detail, many of the general tips will be relevant to them as well as to standard DSLRs.

Guggenheim Museum, Bilbao, Spain ⌃

Nikon D2x, ISO 100, RAW. 70 mm (105 mm equivalent). 1/800 second, f8

The Guggenheim is a fantastic subject for photography, although you have to be careful of reflections. These form specular highlights which are impossible to bring into range, and will always burn out. A digital camera shooting RAW will have a much greater dynamic range than a compact camera shooting JPEG, but even this will struggle with reflected highlights on a subject like this.

Buying guide

Digital camera technology is changing all the time. Models seem to be developed, released, superseded and then discontinued far faster than in the days of film.

On a positive note, this means that the functionality of digital cameras is constantly improving and developing – especially in terms of high **ISO noise**, **resolution** and **dynamic range**. A new digital camera is likely to be cheaper than a similar model bought a couple of years ago; it will out perform the old camera and have a number of features that you always wanted and, no doubt, some that you never knew you wanted! On the negative side, this rapid change means that whatever camera you buy, it will probably be discontinued and replaced by a better and cheaper model within a year or so. Although this sounds depressing, bear in mind that your camera won't stop working when it is no longer a current model. You will still be able to use it to take great pictures. You should probably worry more about investing in lenses than buying the latest camera as soon as it comes out. That being said, there will sometimes be quantum leaps in technology, which will add something to your photography; it is up to you to whether you can afford or justify the upgrade.

The constant upgrading of camera technology means that the second-hand value of digital cameras drops rapidly, far quicker than film cameras used to. Although it might appear that you are losing money by buying a digital camera, this depreciation is more than outweighed by the savings in film and processing costs that you will make. When I was shooting transparency film I calculated that buying a good quality film and then getting it properly developed and mounted cost around £10. Based on this calculation, if you shoot the equivalent of 100 rolls of film, you will have balanced out the cost of a £1000 digital camera!

The rapid development of cameras means that it is all but impossible to make specific recommendations about which model you should buy. What I will try to do here is to look at some of the features you should consider when purchasing a camera. Even these are subject to change, and I am resigned to the fact that the new killer feature is probably just around the corner. You might not be able to work out the answers to all of these questions yourself, in which case consult an independent review site, such as *DP Review*.

Compact cameras (and bridge cameras)

For further explanation of these terms, consult the Glossary, page 310.

Auto-bracketing Can the camera take a range of pictures at different exposures to ensure a correct exposure?
Battery life What is the claimed battery life?
Exposure compensation Does it have an easily accessible and usable exposure compensation facility?
Exposure modes Does it have easily accessible and usable manual, aperture priority and shutter speed priority exposure modes?
Exposure range What are the fastest and longest shutter speeds available? This will affect your ability to freeze action or shoot long-exposure at night.
Flash How powerful is the built-in flash? Is there a hotshoe for a separate flash?
Focus How quick is the focus; how many focus points are there, and can you manually change them? Are there any special focus modes, such as face recognition?
Format Does the camera use the 4:3 aspect ratio or can it also shoot in 3:2 and the panoramic 16:9 ratios?
High ISO What is the highest usable ISO before digital noise becomes too great?
Histograms Are there usable histograms in playback mode?
Image stabilization Does the camera have electronic/mechanical image stabilization, which properly compensates for movement without selecting a higher sensitivity?
LCD screen pivot Does the LCD screen pivot, making it easier to shoot from high and low angles?
Lens focal length range How wide is the wide-angle setting and how powerful is the telephoto setting, without using a digital zoom? Also, is the zoom range stepless or does it jump as you zoom.

Aspect ratios >

The aspect ratio of your camera is the ratio between the length and the height of the pictures. This affects the shape, not the size of your images. The most popular ratios are shown here: square (1:1), 4:3, 3:2 and 16:9

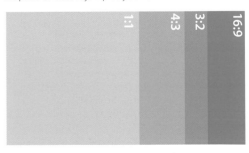

Lens maximum aperture What is the maximum aperture of the lens, especially at the telephoto setting? A narrow aperture makes lower-light photography difficult without using a higher sensitivity.

Motor drive How fast is the motor drive and how many shots can it take in succession?

Optical viewfinder Does the camera have an optical viewfinder? An LCD screen can be impossible to see in strong light.

Picture scene modes How many useful modes does it have and how easy are they to set? These modes enable you to select the type of picture you are taking, such as snow, sunset, action or even party, in order to optimize the camera settings.

RAW Does the camera have the ability to save files using the versatile and high-quality RAW format?

Sensor size and quality What is the resolution and quality of the camera sensor and the noise performance at higher ISOs (see Sensor resolution, page 18)?

Shutter delay What is the delay between pressing the shutter-release button and taking a picture?

Special features Some cameras have printing docks, Wi-Fi capability, GPS tagging and other special features. These aren't really vital but can tip the balance if it is a feature you want.

Spot meter Does the camera have a spot meter for more accurate metering in manual exposure mode?

Video If video is important to you, how advanced is the video functionality; can it shoot HD video, and what video formats can be used?

White balance setting How easy is it manually to set the white balance?

DSLRs and mirrorless cameras

When you buy a DSLR you are, in effect, buying into a whole camera system. Once you have a few lenses and a flash, then you are unlikely to sell up and completely change to another manufacturer's system. This inertia is magnified if you have more than one camera body and a large range of lenses. You might upgrade or replace a lost or damaged camera body but to sell off everything and replace it from scratch is a large expense. Even professional photographers tend to show quite remarkable brand loyalty: once you get used to a system, then there is a steep learning curve if you shift to another one. So, the camera manufacturer you choose may be more important than the actual model.

Some smaller manufacturers have their own bespoke lens mounts, while others use the mounts of the bigger manufacturers: Nikon, Canon and Pentax. Fuji, for instance, use the Nikon F mount. Some DSLRs use the 4/3 system which is not tied to any one manufacturer. Models from each manufacturer have a different feel and style. It is worth handling SLRs from different manufacturers to see which you prefer in terms of ergonomics and menu layouts.

In suggesting possible features to look out for when buying a DSLR, I am avoiding those that will generally only be found in top-of-the-range, professional cameras, although many of these will eventually trickle down to lower models.

Battery life What is the claimed battery life?

Depth of field preview Can you stop down the lens before exposure to predict the depth of field?

Exposure compensation How usable is the exposure compensation facility?

Exposure range What are the fastest and longest shutter speeds available? This will affect your ability to freeze action or take long-exposure photographs at night.

Flash How powerful is the built-in flash?

Focus How quick is the focus, how many focus points are there, and can you manually change them? Are there active focus modes with movement prediction?

Focus/Exposure lock Are there separate exposure and focus lock buttons?

Format What format is the sensor (crop or full-frame; see page 20)?

High ISO What is the highest usable ISO before digital noise becomes too great?

Histograms How usable are the histograms in playback mode?

Live view Is there a live view facility which uses the LCD preview screen to compose instead of the viewfinder?

Long exposure noise reduction Is there a specific mode to reduce noise during very long exposures?

Manual exposure Does it have a workable manual exposure mode that is easy to access and use?

Mirror lock-up Does it have a mirror lock-up to avoid shake on long exposures?

Motor drive How fast is the motor drive and how many shots can it take in succession?

Picture scene modes How many useful modes, such as sunset or action, does it have and are they easy to set?

Sensor cleaning Is there a sensor-cleaning mode to vibrate dust off the sensor?

Sensor size and quality What is the resolution and quality of the camera sensor and the noise performance at higher ISOs (see Sensor resolution, page 18)?

Special features What special features are there. These might include a voice note facility to record captions for pictures, dual memory slots (allows two memory cards to be used simultaneously for instant back-ups), artificial horizons and Wi-Fi capability.

Spot meter Does the camera have a spot meter for more accurate metering in manual exposure mode?

Stop increments Are the aperture and shutter speeds incremented in thirds of a stop, which allow for more accuracy and control than half stops?

Video If video is important to you, how advanced is the video functionality; can it shoot HD video, and what video formats can be used?

White balance setting How easy is it manually to set the white balance?

Buying a film SLR

If you are just starting out in photography, then it is probably not worth bothering with film. Digital has so many advantages for the beginner, notably a relatively low cost per photograph and the chance instantly to review your pictures to discover and rectify any mistakes that you might have made. But, if you are already shooting film, there has never been a better time to invest in equipment. Although there are no current 35 mm SLR cameras in production, the almost universal take-up of digital can work in your favour. The second-hand market for film SLRs is flooded with top-quality camera bodies, so, if you shop around, it is possible to buy a professional camera for just a few hundred pounds that would have retailed for over a thousand a few years ago.

Many of these pro cameras are very sophisticated, with complex and accurate metering systems, built-in motor drives and even removable prisms that allow you to look directly down on the focusing screen of the camera, instead of having to lift the camera up to your eye. This makes candid portrait photography much more discreet and allows you to shoot at low angles without having to grovel around on the ground.

One of the drawbacks of shooting film is that the range of film available and the number of processing labs is dwindling all the time.

Buying options

Grey imports Most digital camera manufacturers limit their guarantees to the region or even the country where the camera was officially sold. This is because cameras are sold for different prices in different territories and manufacturers want to deter people from buying unofficial or 'grey' imports. These are items that have been bought wholesale at a cheap price in one country in order to be shipped to another country to be sold. Many of the cheap internet deals that you see will be these so-called grey imports. You may also not be covered by a guarantee if you buy equipment duty-free in the USA or Asia and then bring it back to the UK yourself. If nothing goes wrong, then this won't concern you but, if you need a warranty repair, you will have to ship the camera back to its official country of sale at your own expense.

If you bring expensive equipment back from overseas, you are legally supposed to declare it for duty and tax at Customs. This can considerably add to the cost. If you don't declare it, you risk being caught every time you leave and then return to the country. Just because you smuggled it in successfully doesn't make it legal: in effect you will have to re-smuggle it home each time you leave the country!

Second-hand digital equipment The fast depreciation inherent in digital cameras means that there are some very good deals on second-hand equipment. If you can resist the temptation to have the latest model, then you can often find cameras that were top-of-the-range a couple of years' ago selling for a fraction of the original price. One thing to be aware of, though, is that most second-hand cameras have a very limited warranty or none at all and, if anything goes wrong, then you will be burdened with expensive and time-consuming repairs. Second-hand lenses hold their value really well and are often very sought after.

Ⓦ The URLs of the sites and products mentioned in this chapter, as well as other tips, are given on the website footprinttravelphotography.info

Lenses

The lens is the eye of your camera and affects how it sees and, therefore, records the scene in front of you.

The power of a lens is measured by its **focal length**, designated in millimetres. There is a complicated optical definition for focal length, but you will never need to know what it is. Suffice it to say that a lens with a focal length of around 50 mm is defined as a **standard lens**, as it approximates the perspective and magnification of the human eye. A lens with a focal length of less than 50 mm is defined as a **wide-angle lens**, and higher than 50 mm is defined as a **telephoto lens**.

Each type of lens has its own characteristics of distortion, magnification and **depth of field**, which makes it suitable for certain photographic applications and gives it certain creative properties. The creative selection of lenses to exploit these characteristics is discussed in the Execution section on page 72. This section explains the power of different lenses and suggests which ones you should take with you on your travels.

A lens with a single focal length is called a **prime lens**; a lens with a variable focal length is a **zoom lens**. For simplicity, throughout this book I often refer to the focal length of a prime lens, although you can get exactly the same effect by selecting the appropriate focal length with a zoom lens. A 200 mm setting on a zoom is equivalent to using a 200 mm prime lens.

Angle of view ▾

Understanding the angle of view is vital when thinking about how your lenses allow you to see the world. These diagrams show you what is going on inside your lens and camera.

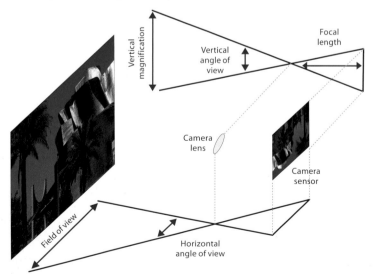

Vertical magnification

Vertical angle of view

Focal length

Camera lens

Camera sensor

Field of view

Horizontal angle of view

Angle of view

A better way to think of the power of a lens is in terms of the angle of view. In the horizontal plane, the angle of view indicates the width of the scene that can be fitted into the shot. In the vertical plane the angle of view is an indication of the magnification.

As the lens focal length doubles, the angle of view is halved and vice versa. The horizontal angle of view of a 50 mm lens is 40° on a 35 mm frame (27° on a **DSLR** with a 1.5x **crop factor**). The angle of view of a 100 mm lens is 20° on a 35 mm frame (18° on a DSLR with a 1.5x crop factor). This means that if you switch from a 50 mm to a 100 mm lens, you will only be able to take in half of the scene in front of you.

Vertically, the angle of view of a 50 mm lens is 27° on a 35 mm frame (18° on a DSLR with a 1.5x crop factor), which drops to 14° for a 100 mm lens on a 35 mm frame (8.9° on a DSLR with a 1.5x crop factor). This has the effect of doubling the magnification of the image.

Obviously, you also double the horizontal magnification and halve the vertical angle of view of the image when you double the focal length but, I think, it helps to think of the horizontal angle of view as the width and the vertical angle of view as the magnification.

A term which is often used interchangeably with angle of view is 'field of view' but, strictly speaking, field of view is a linear dimension and is dependent on the subject distance, whereas angle of view is independent of subject distance and measured in degrees. The crop factor has the same effect on the field of view as the angle of view, even though the definition is different.

Maximum aperture

When you look through an **SLR** or a DSLR, you are seeing the picture with the lens opened to its maximum aperture. When the picture is taken, the lens stops down to the selected aperture to ensure the correct **exposure**. The wider the aperture, the brighter the viewfinder when you are looking through the camera. This benefits both manual and auto focusing and also makes it more possible to shoot in lower light levels without a tripod. A wider aperture also gives you more control over depth of field (see page 106). The speed of a lens is relative to its size and focal length but, as a rule of thumb, a lens with a maximum aperture of 2.8 or wider is considered fast because it allows more light into the camera (and, presumably, because this will permit the use of a faster

Digital SLR

All but a few professional DSLRs have a **sensor** that is smaller than a frame of 35 mm film (36 x 24 mm). The image that the lens projects onto the sensor will be the same size as it would be on a film camera but the sensor will crop into it by some degree. This amount is known as the crop factor and typically ranges between 1.3x and 1.6x depending on the size of the sensor (a 1.5x crop factor is a good average).

The crop factor has the effect of reducing the angle of view, making the subject appear bigger in the frame. To calculate the equivalent lens that would give the same effect on a 35 mm frame, multiply by the crop factor. For instance, using a 200 mm lens on a 1.5x crop DSLR will give the same angle of view and magnification as shooting with a 300 mm lens on a 35 mm film camera or a **full-frame** DSLR. To maintain the same angle of view with a 1.5x crop camera as you would have when shooting on a full-frame DSLR or 35 mm film camera, you need to divide the focal length by the crop factor; in other words, instead of a 200 mm lens, you would need to use a 133 mm lens.

As the crop factor appears to multiply the focal length (200 x 1.5 crop factor is 300 mm), it is often referred to as the **focal length multiplier**, even though, strictly speaking, the focal length is unchanged. It is useful, though, to think in terms of an equivalent focal length and this has become an industry standard comparison. A 50 mm lens on a 1.5x crop camera can be said to be equivalent to a 75 mm lens on a 35 mm camera in terms of angle of view and magnification. A DSLR with a 4/3 sensor has a crop factor of 2x, so a 14 mm lens on a 4/3 camera is equivalent to a 28 mm lens on a full-frame or 35 mm film camera. In the technical captions in this book I have given the actual and equivalent focal lengths when the pictures have been shot on a camera with a crop sensor.

Some lenses are designed only to fit a DSLR with a **crop sensor**. If these are used on a full-frame or 35 mm film camera, they will degrade in quality at the edges and, sometimes, vignette completely, producing a circular image with a black masked edge.

Digital compact

Compact cameras have very small sensors, with crop factors of 4x or even 5x. To achieve the same crop as a 28 mm lens on a 35 mm camera, a compact might need a lens with a focal length of just 7 mm. Consequently, many manufacturers don't state the actual focal length and crop factor of their compact cameras, providing instead the equivalent focal length on a 35 mm camera. The short focal length of a compact camera means it is likely to have a very large depth of field, making it hard to throw a background out of focus.

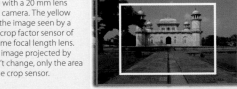

The red keyline shows the scene photographed with a 20 mm lens on a full-frame camera. The yellow keyline shows the image seen by a camera with a crop factor sensor of 1.5x and the same focal length lens. The size of the image projected by the lens doesn't change, only the area recorded by the crop sensor.

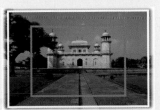

The red keyline shows the scene photographed with a 30 mm lens on a full-frame camera. The yellow keyline shows the scene projected by a 20 mm lens.

The image from a 20 mm lens on a full-frame camera

To get the same image size on a camera with a full-frame sensor as a camera with a 1.5x crop factor sensor and a 20 mm lens, you would need to use a 30 mm lens (20 multiplied by 1.5).

The image from a 20 mm lens on a 1.5x crop sensor. This would take a smaller crop of the scene as viewed by the lens. The image is effectively magnified 1.5x and the angle of view reduced by 1.5x

To get the same image size as a full-frame camera with a 30 mm lens on a camera with a 1.5x crop sensor, you would have to shoot the scene with a 20 mm lens (30 divided 1.5).

shutter speed); an aperture of f4 is about medium; any aperture smaller than this can be considered slow because it delivers less light intensity into the camera, resulting in a slower shutter speed.

The **maximum aperture** of a lens is quoted in its title. So a 17-35 mm, f2.8 lens is a wide-angle zoom with focal lengths that vary from 17 mm to 35 mm and has a maximum aperture of 2.8 throughout the zoom range. An 18-200 mm, f3.5-5.6 lens has a variable aperture depending on the focal length. It will be f3.5 at the wider end, reducing to f5.6 at the telephoto end. If you set an aperture of f5.6 or smaller, you can zoom throughout the range without it changing.

In terms of **resolution**, most lenses perform better around apertures of f8 or f11. At wider apertures they can be slightly softer, especially at the edges. While smaller apertures will give more **depth of field**, they can suffer from an overall reduction in sharpness due to the light being diffracted by the small hole of the aperture. This can be countered by increasing overall **sharpening** in post-processing.

Standard lens (usually 50 mm but sometimes 40 mm or 60 mm)
A standard lens gives roughly the same magnification as the human eye. Some people mistakenly claim that it also has the same **field of view** but, in fact, the human eye has a much wider field of view than a standard lens, closer to that given by a 28 mm lens.

The standard lens is much undervalued: its similarity to the human eye encourages the viewer to concentrate on the subject of the picture, rather than on any optical characteristics given by more extreme lenses, and it tends to have a wide maximum aperture, making it useful in low light. In fact, the maximum aperture can be as wide as f1.4, two **stops** faster than most professional **zoom lenses** and around three stops faster than an average amateur zoom lens. Standard lenses are also compact and lightweight, making them useful lenses to have in the corner of a camera bag.

Wide
Wide-angle lenses have a lower magnification than a standard lens and a much wider field of view. A lens with a focal length of 35 mm to 24 mm is considered a mild wide-angle lens; anything 20 mm and wider is an extreme wide-angle lens. Typically, it is the field of view that governs the selection of a wide lens. A 28 mm lens will have almost double the field of view of a standard lens, and a 14 mm lens will have twice the field of view of a 28 mm. It is worth having both a mild and a super-wide lens in your camera bag, especially if you are shooting with a **crop sensor DSLR** that, effectively, reduces the field of view of your lenses (see chart below).

Telephoto
Telephoto lenses have a greater magnification than a standard lens and a narrower field of view. Usually, photographers select them for the magnification

Focal length and zoom range ⌄

These examples show how focal length changes throughout the zoom range and how angle of view is affected by focal length. Examples are shown for full frame and crop sensors.

Crop sensor 1.5x

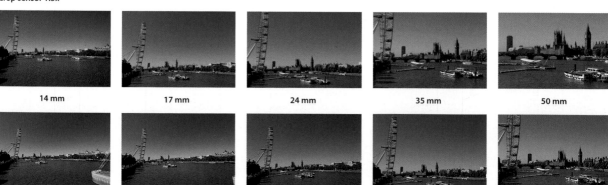

| 14 mm | 17 mm | 24 mm | 35 mm | 50 mm |

Full frame/35 mm

effect, which makes subjects appear closer than if you had photographed them with a standard lens. Lenses with a focal length from 70 mm to around 105 mm are considered fairly mild telephoto lenses; anything from 110 mm to 200 mm is a strong telephoto, and a lens with a focal length above 200 mm is a super-telephoto lens. As the focal length doubles, the magnification doubles and the field of view halves. So, a 100 mm lens has twice the magnification of a 50 mm lens, and a 200 mm lens has twice the magnification of a 100 mm lens or four times that of a 50 mm lens.

It is useful to have a lens in the mild and strong telephoto categories in your camera bag, as they have a lot of uses, from magnifying details to taking close-up portraits without having to intrude on the subject. Super-telephoto lenses are a little more specialized and are typically used for sport and wildlife shots but you can also use a 400 mm lens for landscapes.

Speciality lenses

Macro A macro lens is specifically designed for close-up work. The definition of a macro lens is one that allows you to photograph at a ratio of 1:1 (actual size) or greater – much closer than non-macro lenses of the same focal length. Choose a 60 mm lens as a good general lens for a camera with a crop sensor or a 100 mm lens for a 35 mm film or a **full-frame** DSLR.

Fish-eye A fish-eye lens has a very wide **angle of view** and imparts a characteristic circular distortion

to the frame. This distortion can either be used as a creative effect or moderated with software in post-processing to give a very wide view.

Taj Mahal, Agra, India ◄

Nikon F4, Velvia 50 ASA film. 35 mm shift lens. Exposure not noted

The minarets of the Taj Mahal actually lean out so they will fall away from the main building in case of earthquake. Most pictures introduce distortion due to tilting the camera, creating converging parallels so they appear straight or leaning in. Shooting with a 35 mm shift lens corrects this perspective, showing them leaning outwards slightly.

Arctic flowers, Spitzbergen, Norway ◄

Nikon D2x, ISO 100, RAW. 60 mm macro lens (90 mm equivalent). 1/320 second, f5.6

A number of small plants cling on to life in the harsh climate of the Svalbard Archipelago. Using a 60 mm macro lens allowed me to get in close and show the tiny fragile petals. A macro lens allows you to focus very close and is also a useful back-up 'prime' lens.

70 mm **105 mm** **135 mm** **200 mm** **300 mm**

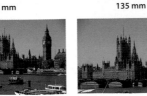
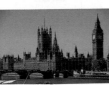
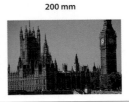
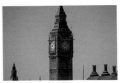
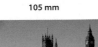

Shift lens A shift lens is designed for architectural photography, since it prevents the distortion that happens when a **wide-angle lens** is tilted upwards to fit a building into the frame. A shift lens avoids this by 'shifting' the front of the lens upwards instead.

Zoom lenses

Zoom lenses allow you to change the **focal length** of the lens between two values, either by using a focus ring on the lens or buttons on a compact camera. Moving towards a **telephoto** setting makes the magnification larger and is often referred to as 'zooming in'. Moving towards a wider setting makes the image appear smaller and is often referred to as 'zooming out'.

A lot of photographers get sniffy about zoom lenses, regarding them as low quality and used only by amateurs. However, while there are certainly some average quality zoom lenses around, there are a lot of very good ones as well. This is partly because much of the recent development in optical technology and design has concentrated on zoom lenses. If you are shooting with a modern zoom lens on a **DSLR**, then you can assume that it has been optimized for digital photography and should produce sharper results, especially at the edges of the frame. You should also consider whether you really need the best quality lenses: if you have an entry-level camera and are only going to view pictures on a computer or make moderate-sized prints, then the range of focal lengths provided by a good zoom is probably the most important consideration for your photography.

There are practical advantages to shooting with a zoom lens. Since you have a range of focal lengths built into one lens, you have more chance of having the right lens on the camera at the right time, allowing you to achieve the composition and crop you require without having to swap lenses. Cutting down the number of times that you have to change the lens will drastically reduce the amount of dust and dirt that can get on to the camera **sensor**.

A zoom where all the focal lengths are in the wide range (such as 17-35 mm) is known as a wide-angle zoom; those in the telephoto range (such as 80-200 mm) are known as a telephoto zoom, and those that run from wide to telephoto (such as 18-70 mm) are know as mid-range zooms. Many entry level DSLRs come bundled with a cheap mid-range zoom (typically 18-55 mm) that is often referred to as a kit lens.

It is possible to buy so-called super-zooms that run from super-wide to telephoto with a zoom ratio of at least 6x. (A 20 mm to 200 mm lens, for example, has a zoom ratio of 10x.) A popular focal length range for a zoom on a digital camera is 18 to 200 mm (equivalent to approximately 24 to 300 mm on a **full-frame** camera). With a lens like this on the camera, you might never need to change your lens, although,

Asakusa Kannon Temple, Tokyo, Japan ‹

Nikon D2x, ISO 200, RAW.
10.5 mm fish-eye lens.
1/160 second, f4.0

From the high viewpoint where I shot the previous image of this incense burner, I knew that I wanted to shoot closer, using a wide lens. I decided to use this fish-eye lens as I wanted the widest view possible and thought that the distortion could give an interesting effect. This lens has such a wide view that I had to virtually hold the camera over the burner which was rather hot!

if you were only to take a lens like this away with you, then you really are putting all of your eggs in one basket in terms of mechanical breakdown or damage. There are also some downsides to the super-zoom. The **maximum aperture** will be relatively small and will get smaller as you zoom towards the telephoto end. There will also be some quality issues inherent in any lens that covers such a wide range, although, depending on the **resolution** of your camera and the size you intend to reproduce your images, these might never become apparent. That being said, with the improvements in high **ISO** performance outweighing the smaller aperture, a super-zoom is worth careful consideration by the travel photographer. You could buy one merely to serve as a one-piece back-up to existing **prime lenses**.

All of the main camera manufacturers and also some of the third-party lens manufacturers produce a range of professional zoom lenses. These will be much better quality than their amateur counterparts and have a wider maximum aperture, giving a brighter viewfinder and better functionality in lower light

levels. A professional lens is also more likely to have a constant aperture, so that your **exposure** won't change as you zoom – vital if you are shooting with **manual exposure**. Professional lenses tend to have both a built-in focusing motor, which makes focusing quicker, and internal focusing, which prevents the lens element from rotating when the lens is focused; this is a massive advantage when using **polarizing** and **graduated filters**. The downside to professional zoom lenses is that they tend to be larger, heavier and considerably more expensive than the equivalent amateur lens. They also tend to cover a smaller focal length range.

Added extras

Teleconverter A teleconverter fits between a telephoto lens and the camera to magnify the focal length. The most powerful is a 2x teleconverter which will make a 200 mm lens behave like a 400 mm lens. Unfortunately, if the lens starts off with a maximum aperture of f4, it will, in effect, end up with an aperture of f8, losing two **stops** of light. To limit the loss of light to just one stop, use a 1.4x or 1.5x teleconverter, which will make a 200 mm lens behave like a 280 mm or 300 mm lens respectively.

Using a teleconverter will result in a slight loss in quality but this is easily outweighed by their compactness and portability. Before you buy, check that the teleconverter will fit the lens you want to use it with and that the autofocus will still work. Some teleconverters are optimized for use with particular lenses.

Vibration reduction Some lenses have a vibration reduction or image stabilization gyroscope built in to avoid **camera shake**. This may enable you to use a **shutter speed** up to three stops slower than normal, which can be very useful in low light levels.

Ben Youssef Madrasa, Marrakech, Morocco ›

Nikon D3x, ISO 100, RAW.
15 mm. 1/640 second, f6.3

Extreme wide-angle lenses have a very wide angle of view, seeing more in the frame than the human eye. They also tend to give a dynamic distortion, where objects are literally bent inwards, especially if you tilt the camera upwards. Some photographers dislike this effect but I like to exaggerate it.

Suggested kits

When you are travelling with photographic equipment there is always a trade-off: you have to balance an item's usefulness with its weight, bulk and cost. This is a key issue when you're getting gear onto planes and while you're on the road, as you don't want to be so loaded down that you don't enjoy your trip.

The amount that you carry will depend as much on your style of travel as your style of photography. You can take more if you are picking up a hire car at the airport than if you are backpacking around on local buses. You should also consider how important photography is for you. If not being able to take pictures wouldn't spoil your holiday too much, then you won't have to take as much spare kit: one **DSLR** and lens, with a **compact** as back-up, might be sufficient. But if you travel to photograph, then you want to cover yourself for as many eventualities as you can. If you take just one camera with one lens, one memory card, one battery and one charger, then there will be nothing you can do if something goes wrong, or if you have an equipment failure.

The key characteristics of a successful travel photography kit are inter-changeability and compatibility. You obviously want to make sure that lenses and accessories can be used on any camera you take. I always carry two identical camera bodies, but, if you choose to take different bodies, try to make sure that they at least take the same batteries and charger. It might sound paranoid but, if one camera gets stolen, you don't want to be left with a camera body and charger that are incompatible. It is not just cameras that you need to think about; you should anticipate other things going wrong and work out how you would cope. If my laptop breaks, I have a back-up drive with a card reader, so I can still back up my pictures.

You also have to asses what level of quality you need for your pictures. Although you can take creative photographs with any camera, you will need a better quality **sensor** and lenses if you want to blow up your pictures to very large print sizes, publish some of your work or enter a reputable photography competition. What equipment you choose depends on your budget but also on what you want from your photographic trip. If you don't need the attendant weight and hassles of looking after larger and heavier equipment, then leave the better quality kit at home and take something smaller.

Below are some suggestions as to the sort of kits that you could take away with you and how you might think of upgrading them.

Minimal kit
Compact camera with nothing else.

Advantages This kit will be cheap and easy to carry around. There is no excuse for not having your camera with you at all times. You will be able to concentrate on taking pictures rather than worrying about technicalities.
Disadvantages Your photographic options will be limited: you won't be able to shoot very wide-angle pictures or have a particularly strong telephoto. Also, you will struggle to have control over the **shutter speed** and **aperture** that your camera selects and will probably have to rely on **picture scene** and automatic modes. With just one camera at your disposal, you will have no back-up should you have any technical failures.
Consider adding An underwater camera housing, not only to allow you to shoot underwater but also to protect your camera from dust and rainfall; a back-up device and a few more memory cards, so that you can back up your own pictures and not have to rely on internet cafés on the road, and a table-top tripod for night photography.

Minimal DSLR or mirrorless camera kit
Entry-level DSLR or mirrorless camera with bundled kit lens: usually a fairly cheap mid-range **zoom**.

Advantages Any of the current crop of DSLRs/mirrorless cameras will give good-quality results, if they are used correctly. This kit will be fairly portable and will give you a larger sensor and lens than you would get with a compact, with the inherent increase in quality. Cameras will probably have a number of picture scene modes but also easily accessible auto and **manual exposure** modes, giving you complete control over the technical aspects of your photography. These systems are also modular, allowing you to add compatible lenses, flashes and even spare camera bodies as your experience and budget grows.
Disadvantages You will have no spare kit in case of equipment failure and no way of backing-up your pictures without using internet cafés on the road. Kit lenses are good value but aren't always the best quality and will suffer from a limited zoom range.

Consider adding A wider-range zoom or even a super-zoom that might typically run from 18 mm to 200 mm. If possible, buy this instead of a kit lens when you purchase the camera. A number of retailers have special deals for kits that they put together with better lenses. You should also consider adding a compact camera as a spare and, maybe, a back-up device, so that you don't have to rely on internet cafés.

Extended DSLR kit

DSLR or mirrorless camera with two or three lenses, plus a compact camera and a back-up drive.

Advantages Two or three lenses will give you a good choice of **focal lengths** from wide to telephoto, and some overlap for security. Having a compact camera means that you can still take pictures if you have equipment failure and at times when you don't want to carry the DSLR kit.

Disadvantages This kit is starting to get quite expensive and heavy; make sure that you have good insurance for your equipment.

Consider adding A second compatible DSLR or mirrorless body and a back-up lens, perhaps an 18-200 mm super zoom that will back up all of your lenses in one hit. You could also add a speciality lens, such as an extreme wide or **fish-eye**, or a powerful **telephoto lens** for wildlife photography. Other useful items would include a portable flash, a back-up device and a tripod.

Comprehensive DSLR kit

Two compatible DSLR bodies with overlapping zoom lenses (wide-angle, mid-range and telephoto), 18-200 mm super-zoom lens, back-up device, tripod, portable flash. This is the sort of kit for a serious amateur or aspiring semi-professional photographer.

Advantages A wide range of lenses gives you a lot of creative options in terms of lens choice. Use the good-quality, wider aperture zoom lenses for most of your pictures, backed up by the 18-200 mm super-zoom. Two compatible camera bodies gives you good security in terms of equipment failure and loss. You don't have to spend a fortune on the second camera body, a cheaper body would do the trick. You could use this kit to photograph just about everything and even start to sell your images.

Disadvantages This kit is a large investment and weighs a lot. You would need to be quite committed to your photography to carry this around with you.

Consider adding Photographers always covet a wider or more powerful telephoto lens. A small laptop is a good investment, so that you can work on your pictures as you go.

Professional kit

This sort of kit encompasses most eventualities and includes a vast range of lens types. My standard photographic gear is:

- Two identical Nikon professional DSLR bodies
- Spare charger
- A range of overlapping pro zoom lenses:
 14-24 mm f2.8 super-wide-angle zoom
 17-35 mm f2.8 wide-angle zoom
 28-70 mm f2.8 mid-range zoom
 70-210 mm f2.8 telephoto zoom
- Back-up **prime lenses**:
 20 mm
 50 mm f1.8 for low light levels
 180 mm f2.8
- Speciality lenses:
 300 mm f4 super-telephoto lens
 60 mm f2.8 macro lens for close-ups
 10.5 mm fish-eye
- 1.4x and 2x **teleconverters**
- A range of filters and accessories
- Flashgun, softbox and **ringflash adapter**
- Sirui carbon-fibre tripod
- Laptop, portable drive, Colorspace back-up device as well as a lot of 16 GB and 32 GB memory cards.

Advantages By having at least two lenses in each of the wide, mid and telephoto ranges, as well as two camera bodies, I am covered in case disaster strikes. I also have access to whatever lens I need for every creative and practical situation.

Disadvantages This level of equipment costs a lot; it is also very heavy. Most professional photographers resign themselves to backache and the hassle of trying to get their gear onto planes. Even if you can afford it, carrying this amount of gear with you will dramatically change your travelling experience.

Consider adding There is always a new lens or accessory to be bought…

Other equipment

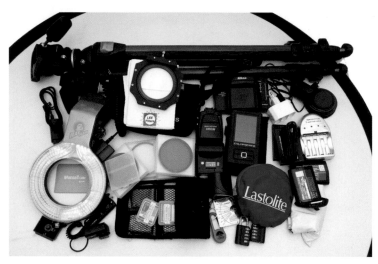

As well as your cameras and lenses, there are a number of other things that you should consider taking with you on your trip. What you actually take will depend on your style of travel and how important photography is to you on your travels.

Tripod A good tripod is essential. A flimsy tripod can cause **camera shake** if there is more than a whisper of wind and may even tip over. Tripod heads are either ball head or pan-and-tilt. When loosened, ball heads allow the camera to move in any direction. Pan-and-tilt heads have three controls, each allowing the camera to be moved in only one axis, without affecting the others. Carbon fibre tripods are expensive, but very light. Check the tripod extends both as high as you want and also as low as possible for close-up and low viewpoint images. If you are planning on shooting panoramas, get a tripod with a spirit level built into the body, as well as the tripod head. Alternatives to tripods include bean bags and clamps, which will steady the camera in some instances but are of limited use. A **monopod** (one-legged tripod) can provide support if you are shooting with a telephoto lens.

Spare tripod quick-release plates Always have at least one spare tripod quick release plate with you, as these tend to get lost. They fit to the camera and allow it to be mounted and released from the tripod instantly; without one your tripod is useless.

A photographer's kit ∧

Some of the many accessories and other equipment that I carry with me. Most of this is shipped in my check-in luggage. I tend to carry smaller accessories in three zippered bags: for electrical, laptop and photographic accessories. This helps to keep things organised, making it less easy to loose anything, or leave something behind.

Cable release A cable release will minimize camera shake when shooting long **exposures** on a tripod. You will need one with a lock to hold the shutter open on a B setting. It is possible to buy wireless releases that will trip the camera from a distance.

Spirit level Fits into the camera **hotshoe** and shows when the camera is straight – vital for panoramas.

Flash and ringflash adapter or softbox Although an on-camera flash can be useful at times, for greater flexibility you should consider a separate flash. I also carry a ringflash adapter, which fits around the lens and gives very flat lighting. This is useful for **macro** and close-up work and also for **fill-in flash**. You can also fit a collapsible soft box to soften the light from the flash.

Off-camera flash lead This allows you to fire the flash off the camera, which gives a better lighting effect.

Reflectors Many photographers use reflectors instead of a fill-in flash. A small reflector (even some crumpled up aluminium foil) doesn't take up much space and can drastically improve lighting for portraits, close-up and macro photography.

Filters Now that I shoot digital I only take **polarizing** neutral density filters (to reduce overall light levels) and occasionally **graduated neutral-density filters**. If you are shooting film, you should also consider warm-up and colour-correction filters (see page 123). Every lens should have a **UV filter** for protection.

Colorchecker Passport Photograph this colour target, and then run a calibration in **Lightroom** to profile your camera and make **RAW** conversions faster and more accurate.

Lens hoods Every lens should have a lens hood fitted to protect the lens and reduce flare.

Lens caps and end caps Every lens should have lens and end caps for protection. It is also worth packing a couple of spares as they often get lost.

Weatherproofing If you don't have a bespoke weatherproof rain cover, such as those made by *Kata*, then a shower cap or a piece of cling-film can protect the camera in dusty conditions and light showers.

Silca-gel bags A desiccant will absorb moisture and can help to stop mould forming on lenses in very humid conditions. Make sure the bags are well marked for when you take them through Customs!

Cleaning stuff A blower brush and washable lint-free camera cloths are vital for cleaning lenses and filters. A small paint brush (with handle cut off for space) is perfect to remove dust from cameras and lenses.

Gaffa tape Good for running repairs, organization and even light waterproofing.

Alarm clock and stopwatch Vital for early starts and for timing super-long exposures.

Head torch Very useful if you are up before sunrise or taking night photographs.

GPS tagger This will imprint the GPS co-ordinates into the metadata of an image allowing you to locate where you shot it for captioning.

Padlocks Good quality combination padlocks are vital. Get four-wheel ones for security and make sure they are TSA-approved, if you aim to ever pass through the USA.

Caffeine drinks and energy bars If you are making early starts before breakfast, in remote locations or doing a lot of trekking, these can make all the difference to how you feel and how you photograph.

Electrical things

A digital camera will take a special battery that will need a bespoke charger. Take at least one spare battery and even a spare charger, depending on size and weight. If either fail, you will not be able to take any pictures and probably won't be able to replace them, especially in remote places. I take up to five batteries if I am going to be away from electricity for long periods.

I typically carry a charger for my laptop, camera batteries, four AA batteries for my flash, mobile phone, back-up drive and a compact camera. These take up bulk and weight, so shop around for the smallest ones available. I get all of my gear with EU rather than UK plugs as they are smaller, lighter and they also fit directly into shaver points in hotel bathrooms. I also carry a multi travel adapter with built-in surge protection (with spare fuses) and a mini Euro multiple adapter to allow a number of devices to be plugged into one socket. If I am away from power but in a vehicle, I carry a small inverter, which turns the DC output for a car cigarette lighter to usable AC. If you are away from vehicles and power, then it is possible to use a lightweight fold-out solar charger. I also have a couple of dodgy adapters, which allow me to charge devices from bulb sockets, although these are not recommended! Take spare fuses and batteries for all devices, especially any bespoke ones on Wifi releases; these can be all but impossible to replace when you are on the road.

Digital things

Although the digital photographer saves the weight of all those rolls of film, there are a number of uniquely digital things that you will need to carry instead.

Memory cards You can never have too many memory cards, and they have never been so cheap. If you only have one back-up device, then carry enough cards that you never have to reuse them on a trip. This means you will still have two copies for security. Keep your memory cards organized and protected in a good case, with some sort of indicator to show if a card is empty. I have a label on each with my name, email and mobile number, offering a reward if they are returned to me, in case of loss.

Laptop I always take a laptop with me. It helps to be able to review and process images on the road. It also allows me to check email as I go. Many people won't want to take a laptop on holiday, but there are a number of really small models that are perfect for the digital travel photographer. I use a 14" *Macbook Pro*, which I back up to a portable hard-drive when on the road. Being able properly to review images and check for photographer and equipment errors is vital for a serious photographer. I have fitted a solid state SSD drive in the laptop, which has no moving parts, so it uses less power, is faster and more tolerant of altitude.

Back-up drive Even if you have a laptop, you should take a small back-up drive, which allows an extra back-up, independent of the laptop. If you don't have a laptop, then one is absolutely vital. I use the *Hyperdrive Colorspace*, which has a colour screen and a built-in card reader (in case the laptop breaks).

Card reader If you have a laptop, make sure you take along a card reader and a spare USB cable to connect the camera to the laptop directly.

Recovery software There are a number of software products that will repair crashed or formatted cards, and recover images thrown away by mistake. If you have a laptop, make sure that you have one of these installed just in case. I have found *Photorescue* from *DataRescue* to be one of the best.

Sensor cleaner Cleaning dirt off the sensor will save hours of retouching. I use an Arctic Butterfly brush from a company called *Visible Dust*, which is electrostatically charged to lift dust and dirt. I would be careful of any cleaning that involves wetting the sensor and never spray compressed air directly into the camera.

Choosing a camera bag

Getting your gear safely to the point where you are ready to take pictures is one of the greatest challenges of being a travel photographer.

When choosing a bag for your equipment, you need to balance protection with accessibility. You also have to consider the size and weight of different options, especially when getting on a plane, as you will need to make sure that the bag is within the maximum dimensions stipulated by the airline. Sometimes this can be as little as 20 cm depth, which effectively rules out many shoulder bags. You should check that your gear comfortably fits into the bag that you choose and that there is room for any additional kit you might buy. Don't forget to allow space for your laptop, if you carry one. Some bespoke camera/laptop backpacks store the laptop next to your back, which is uncomfortable and can crush the screen. Some bags have more comfortable straps; others have better organizational pockets. Some are fully waterproof, while others may have rain covers and attachments for supplementary lens cases and tripods. I use a backpack camera bag to get stuff on to a plane but also pack a smaller shoulder bag in my hold luggage to use as a day bag when I arrive. In the end, the ideal bag will depend on your personal requirements but the main options are detailed below.

Hard cases The best protection is a hard, waterproof case but these are heavy, not particularly transportable and are not suitable as a 'shooting' bag. Unless you are in a studio or a single location, it is inconvenient to keep stopping to open them to change lenses. If you are on an expedition with a vehicle, however, then this style of case can be useful: they can be used to store and access equipment in the boot of a car, are lockable and can be secured to the body of the car or the spare wheel with a chain and a padlock. The inside is organized with cut foam or padded dividers that are adjusted with velcro. Makes to look out for are *Peli-Case* and *Storm Case*.

Over-the-shoulder and waist bags These offer the best accessibility for your equipment when shooting, although carrying a heavy bag on one shoulder can cause back problems. Smaller versions have hip belts that can take a lot of the weight. Some of these bags are designed to take a single camera and lens, which

is perfect if this is the only equipment you have with you. Be aware that some of these bags are officially too wide to count as hand luggage on many planes. Names to look out for are *Lowe-Pro, Billingham, Crumpler* and *Domke*.

Backpacks These are a good compromise between the convenience of an over-the-shoulder bag and the durability of a hard case. They are almost the perfect

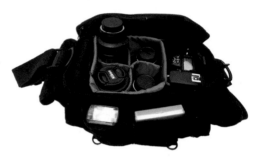

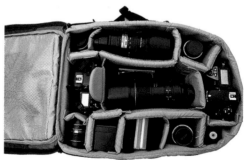

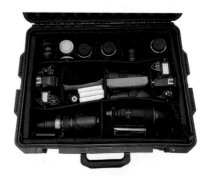

Domke over-the-shoulder camera bag ◄

I use this bag as a day shooting bag when I am on the road. It can hold one body and four or five lenses, a flash and filters: perfect for walking around a city without wearing a backpack. Accessing equipment is easy, and it is light and collapsible for storage. Some photographers use a bigger version to transport all of their equipment.

Lowe-pro Photo Trekker II backpack ◄

This bag has just the right dimensions for carry-on luggage. I use it to transport all of my equipment and also as a shooting bag if I need to take more equipment. It fits a large amount of gear, including large telephoto lenses, but I have to take it off my back to access things. The backpack harness makes this the best solution for carrying heavy equipment. It even has a rain-proof cover.

Storm hard case ◄

A good solution for shipping fragile equipment. The inserts are padded and adjustable and the case can be secured with a couple of padlocks. This style of case is not particularly transportable but will give your equipment the greatest level of protection. Most of these cases are totally waterproof, making them ideal for expeditions.

shape to count as hand luggage for a plane and, if you have to do any walking, the harness and waist strap make them the most comfortable option. A drawback is that you have to take them off your back to get anything out, though they could be combined with a photographer's vest or a lens pouch system for items that are needed most often. The interiors are adjustable with padded velcro dividers. Often they will have space for a laptop, various interior pockets for organizing accessories and the ability to strap a tripod to the outside. Names to look out for are *Lowe-Pro* and *Tamrac*.

ⓘ Getting on to a plane

It is imperative to carry as much of your gear as possible on to the plane as hand luggage, as it is more likely to suffer damage or theft in the baggage hold. Unfortunately, most airports and all airlines have restrictions regarding the amount, size or weight of hand luggage.

Find out the rules for each airline that you are using, including any internal flights, which often have tighter restrictions. Some airlines have weight limits as low as 3 kg, while others allow any weight of carry-on luggage as long as it is within certain dimensions. I think it is worth paying more to fly on one of these airlines.

Although being friendly and polite to check-in staff can help your cause, don't assume that you can just wing it and charm your way on to a plane with too much hand luggage. You might get away with it once or twice but travel enough and your bag will doubtless be weighed somewhere along the line. Check in is the most risky time, as it is easy for the staff to make you put the bag into the hold. The further through the process you go, the more likely you are to get your over-sized luggage on board, although I have seen bags weighed at boarding on certain airlines. If it happens on a return journey, you may have to choose between letting your camera bag travel home in the hold or missing your flight and being stranded.

As a final resort, wear a photographer's vest and secrete some of the heavier equipment in the pockets. If you plan to do this, transfer the gear before you reach the airport to avoid drawing attention to yourself.

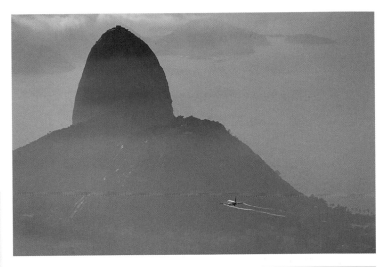

Photographer's vests and street systems

Photographer's vests and so-called street systems (harnesses or belts with clip-on lens and camera pouches) keep your gear very accessible but don't necessarily protect it from damage or theft as well as a bag or case. They distribute weight and allow for free and unencumbered movement, so they are useful for carrying your equipment around on a day-to-day basis but are not so practical for shipping and transportation. A vest can also be useful for getting extra gear on to a plane if your camera bag is too heavy! Makes to lookout for are *Domke* and *Lowe-pro*. The *Think Tank* lens pouch system is particularly good.

Other luggage

Many travellers will automatically think of travelling with a backpack but this can be impossible if you already have a heavy backpack-style camera bag. Backpacks are also difficult to lock, which is an issue if you want to use them to carry extra equipment. I have now settled on the *Berghaus Mule*, a large wheeled holdall-style bag. This is large enough to hold both my tripod and a smaller day camera bag, packed with all the accessories I can't fit into my carry-on luggage. Empty, it hardly weighs anything, the wheels are almost silent and, best of all, it can be securely locked with just two padlocks. You can even lock a camera-bag inside it in a hotel room, to deter any tampering and make sneak theft impossible.

Plane flying past Sugar Loaf Mountain, Rio de Janeiro, Brazil ⌃

Nikon F5, Provia 100 ASA film. 80-200 mm lens. Exposure not noted

This plane is actually on a flight path to a domestic airport. It appeared to head directly towards the iconic shape of Sugar Loaf Mountain but suddenly banked to the left on the approach to the runway. The mountain dwarfs the plane, giving a real sense of scale. Shooting into the light has given a soft and misty feeling to the image.

Focus on

Taj Mahal from the far bank of the Yamuna River
Agra, India

I have always been fascinated by the way that the Taj Mahal blends into the landscape along the River Yamuna, so, in the quest to find a new and interesting shot of this iconic building, I headed for the far bank. There were vast swathes of farmland here, and I was able to take pictures of day-to-day life that had changed little for generations, with the Taj as a resplendent backdrop.

During the day, it is sometimes possible to get a boat across the Yamuna, but I wanted to shoot at sunrise so I caught a cycle-rickshaw. At the time, there wasn't a decent road, so we had to ride through a small village. It was a hot morning and people were sleeping on low charpoys outside their houses. They didn't stir as I passed. Unfortunately, the small village has now been cleared, and the authorities have put up razor-wire which prevents people getting down to the river to shoot reflections. Your only option now (short of climbing though the fence) is to pay to get into the archaeological park that has been set up on the bank.

I actually had food poisoning when I took this picture. I shot three frames and vomited between each one. I still love the final shot, though. When I was a child I used to go to the Bristol Museum & Art Gallery, where they had a stuffed Indian tiger mounted amid rushes, similar to those in the picture. As a result, I always associate these sort of rushes with India.

The picture was shot with a telephoto lens in order to make the Taj fill the frame. I had to stand some way back from the rushes to make sure that they were in focus. Shooting with a telephoto lens compressed the perspective, making the rushes and the Taj appear much closer together. I was using 50 ASA film and so had to use a relatively long exposure. In the days before lenses came with Vibration Reduction, this was difficult to hand-hold without a tripod, but by controlling my breathing, I managed to keep the camera still.

 Find out more >

Nikon F4, Velvia 50 ASA film.
80-200 mm lens at 200 mm.
Exposure not noted

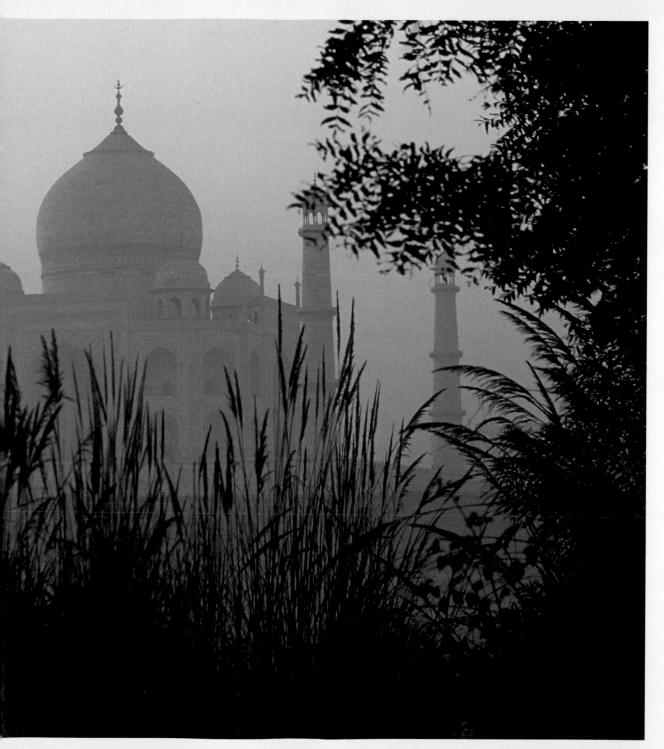

Familiarization and servicing

If you are going to get the most out of your camera, make sure that you have enough time to familiarize yourself with it. This means that you should really practise with a new camera before you leave on a two-week trip. On a longer trip, you could pick up a duty-free camera at the airport and spend a bit of time getting used to it when you are away. If you are going to do this, I would definitely advise taking a laptop so you can assess images properly. Don't trust the LCD preview screen on your camera or back-up drive for this.

Unless you know every function on your camera and flash, take the manuals with you. If you are taking a laptop, download the pdf version of the manual from the manufacturer on to it; if you don't have a laptop, then email yourself the link and download it at an internet café as required. You should also check reviews of the cameras and, especially, lenses that you own. Some reviews include tests that can give you an idea how lenses behave in various zoom and **aperture** settings.

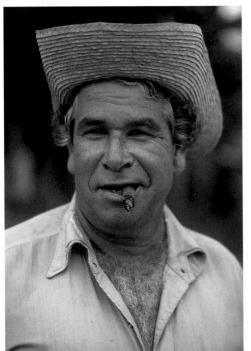

Man at country rodeo, Rodas, Cuba ◄

Nikon F4, Provia 100 ASA film.
28-70 mm lens.
Exposure not noted

If you are shooting a portrait, then it is vital to be familiar with your equipment and working practices. If you keep looking away to fiddle with your camera, then you will break eye contact with your subject and may struggle to re-establish the connection with them. Sometimes sorting the lens choice and exposure before approaching someone to take their picture can help with this. You must ensure that all of your attention is focused on the subject of a portrait, not on your camera.

ⓘ **Checking your gear**
Set your tripod up in front of a brick wall and adjust it so that the camera is square on to the wall. Shoot with each lens and with each end of the zoom range. (You might have to move the camera to fill the frame on a wide setting.) Don't tilt the camera at all, as this will skew the results. Shoot at the widest, middle and smallest aperture. If you are shooting with film, you will have to keep notes as to which shot is which. It is easier to isolate problems if you have more than one camera and more than one lens. Review the images either on a lightbox or with a loupe or at 100% on a computer. Check the focus in the centre, at the edges and the corners. Things to look out for are:

Consistently wrong exposure, using…
- one lens on two cameras – lens needs servicing; aperture could be sticking.
- only one camera with all lenses – camera needs servicing, or the light meter needs fine tuning.
- one camera with one lens (other lenses work fine) – lens may need servicing; aperture could be sticking.

Blurred at edges, using…
- one lens on two cameras – problem with lens, or lens mount may need adjusting.
- only one camera with all lenses (worse on telephoto lenses) – problem with camera; lens mount on camera needs adjusting.
- one camera with one lens (other lenses work fine) – possible problem with lens, or lens mount may need adjusting.

Blurred in centre, using…
- one lens on two cameras – lens needs servicing.
- only one camera with all lenses – problem with camera; focus may need adjusting.
- one camera with one lens (other lenses work fine) – lens may need servicing.

If you experience any of these issues, try gently cleaning the contacts between the lens and camera and repeat the test. These tests are quite subjective; you will get a better idea if you repeat them regularly. You can also repeat this test on the road. If you travel with a laptop, then take previous lens test pictures with you so you can make a comparative assessment.

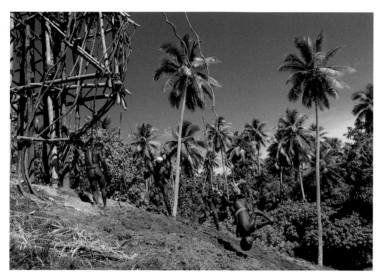

Familiarizing yourself with your equipment includes saving any custom presets. This could be as simple as establishing how the autofocus will behave or what certain function buttons will do. Some people argue that you don't need to know every function on your camera but I completely disagree. Until you know what something does, how do you know whether you need it or not? Most **DSLR**s have a number of custom functions tucked away that can drastically improve the handling and performance of your camera. For instance, my camera has a shutter delay function and a **mirror lock-up** that minimizes **camera shake** when shooting long **exposures**. Some of these variations are discussed in the 'Execution' section of this book.

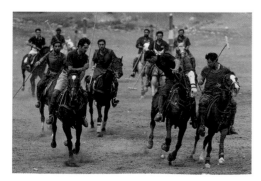

**Land diver,
Pentecost Island, Vanuatu** ⌃

Nikon D2x, 125 ISO, RAW.
12 mm (18 mm equivalent).
1/640 second, f5.0

This original bungee jumper on the remote island nation of Vanuatu is caught just before he hits the ground, after jumping from a high tower, secured only by vines. He was unhurt but a little dazed. Familiarization with your equipment and camera setting is vital if you are to catch moments such as these. Pause to look at your camera and you will miss the moment.

**Playing polo,
Chitral, Pakistan** ⌃

Nikon D3x, 800 ISO, RAW.
200 mm. 1/1250 second, f5.0

If you are familiar with your equipment then you are free to think about composition and focus, rather than just snapping off pictures and hoping for the best. I set my camera to use all of the focus sensors and focus on the closest object. This is usually the best option when shooting action.

If you have two camera bodies you should set the same custom functions on each body. You should also change the prefix on each camera, so the file names will be different, and also synchronize the clocks. This is vital if you are going to shoot with two bodies, throw all the pictures in a folder and sort by capture time. They will be in time order when you copy them to a computer, and you can edit them as if they were all taken on one camera.

The last thing that you want to be doing when photographing wild animals on safari or dancers at a festival is fiddling with your camera. Find out exactly where the buttons are and what they do. With practice, you should be able to make a lot of changes to camera settings without taking your eye away from the viewfinder. This is a useful skill to develop.

Over the years, I have worked out the optimum settings for my cameras for my preferred method of working. The key for me is to make things as simple as possible, so whenever I pick up a camera, I pretty much know what each function will be set to. If I deviate from these settings for any reason, I will re-set them as soon as practicable.

Servicing

If it is going to be reliable, equipment should be serviced regularly. Unfortunately, this is relatively expensive and is also time-consuming, unless you have access to professional services. You need to balance this cost against the overall cost of your trip and to what extent dodgy equipment would ruin it. I budget about 10% of my equipment costs a year for servicing and repairs. You can also run tests yourself to see which equipment might be experiencing problems, (see box left).

One of the advantages of professional gear is that it will often qualify you for preferential servicing which is carried out much faster than for amateur equipment. The latter will often have to be posted off for a few weeks. Always check your equipment in good time before a trip to allow time for repairs or servicing, and leave adequate time after any repairs, in case you need to have the repairs repaired! It can happen that equipment might need a second visit. Make sure to ask for a quote before okaying any work, as repair or servicing costs can soon mount up, especially if you are using a professional service centre, as they tend to assume that money is no option!

Insurance and customs

As well as personal travel insurance, it is essential to have good insurance to cover your camera. The chances are that you will never have any problems but, if something does happen to you or your gear and you are not insured, then it can cost you a fortune. Travelling around the world with expensive equipment need not be a cause for concern, as long as you are properly insured. You shouldn't take stupid risks but neither should you be so worried that you don't take your camera out in public.

If you have a relatively cheap camera, check whether it is covered on your general travel insurance and whether you have to declare it on the policy first. If you have more equipment, then you will have to take out a separate policy. I would recommend a bespoke photography policy that offers new-for-old cover. Insure for the replacement cost of your equipment, being sure to declare the correct replacement value.

Whatever policy you choose, read the small print and make sure you know what precautions you do and don't have to take. My gear, for instance, is covered if it is locked in a hotel room but only a part of it is covered in the boot of a car and not if I leave it overnight. There will always be restrictions to the policy, such as dangerous sports, underwater photography or press work, so make sure you choose a policy that offers cover for all the activities and situations in which you might find yourself. You should also know what the excess is on any claims, how to make a claim and when you need to notify local police about any loss or theft.

Before you leave, find out exactly how to make a claim. For general travel insurance, make sure that you take the number of the overseas assistance line, which will be able to offer advice if you become stranded without your luggage and passport. Make sure you keep the original receipts for equipment (and even clothes) as some insurance companies will demand to see them before making a payment. If you don't have receipts, request that the company lists the insured items on the policy when you buy the insurance.

If you are likely to be making any money from your photography, then you should investigate whether you need a professional policy. It is never worth trying to mislead an insurance company. Declare your intentions to the company in writing when you take out the policy and make sure you keep copies of every letter.

Customs

If you take more than a personal amount of photographic equipment into a country then you are supposed to declare it and pay tax and duty. What constitutes a 'personal amount' is often relatively low and will vary from country to country. You might have to declare a second camera body, for example.

Some countries require you to have a carnet: an official list of your equipment that comes with a guarantee that it will be re-exported. These are expensive and somewhat restrictive as you have to take exactly what is listed on the carnet, nothing more, nothing less. If you don't have a lot of gear, then you can sometimes get away with a list of your equipment and the serial numbers instead. In theory, this should be declared on entry and stamped and then checked on the way out, but this can take a lot of time and effort and most people don't bother. In practice, if you are travelling as a tourist, and you don't have a lot of professional equipment, then you should be alright just walking through the green channel. Whether you go down the official route or just try to wing it is up to you and really depends on how much equipment you have. The situation gets a little more complicated if you also have expensive video equipment, as a lot of countries are particularly hot on this.

When you buy equipment in your own country you pay tax and duty, so you are usually allowed to take it out of the country and bring it back without paying again. However, you might be requested to prove that you haven't bought your equipment overseas. Some countries have lower rates of tax, and most camera manufacturers have different prices for different regions, so customs officials may be on the look out for equipment that has been bought cheaply overseas and then smuggled into the county without paying any duty. Most camera manufacturers limit the warranty to stop cheaper equipment being bought in one place and imported in somewhere else. Having copies of all of the purchase receipts will help if you get stopped at customs on the way home but, officially, many countries require you to have a list of equipment stamped on the way out and, again, when you return home. Bear in mind that if you buy equipment overseas and bring it home without declaring it for duty, it is officially smuggling. You will also be smuggling each time you leave and come home again: far better to pay duty or buy in your home country.

Research

One of the most important things for successful travel photography is research before you go. Even if you had unlimited time in one place, it would be a shame to turn up the day after a festival that only happens once every 12 years! The first step is to buy a good guidebook. Footprint guides are written by experts in their field and have built up a reputation for being authoritative. They will help you to plan your route and work out what you might want to see and how long you should allow to do it. They will also give you pointers as to the mechanics of travelling in the country or region, local customs and suggestions for places to stay. You can also use the internet to carry out unique research for your trip.

The internet is both the best and the worst research tool available. The key to good internet research is checking the quality of the source and looking for corroboration with other sources. You should, however, beware of similar phrases appearing on a number of sites: a lot of information is just copied directly from *Wikipedia* without being checked. Instead, start with sites run by national and regional tourist offices, which are often gold mines of information. Avoid booking sites with similar-looking interfaces, as these are often affiliated commercial sites that get a percentage on bookings and will lead you round in circles, wasting your time and effort. Sites run by domestic travel operators are useful for local knowledge and often offer short bespoke tours.

Destination research
Finding out what there is to see and do at a destination is a key part of your advance research. As well as the obvious sights, try to find new, off-beat or bizarre places or events. See if there are any customs or special foods that you should try to photograph. Maybe there are certain sights that are open at night for the full moon, such as the Taj Mahal or the Iguaçu Falls. There might be a particular train ride or a classic bar that you really want to photograph. Finding all of this out in advance can save you time when you arrive and make it less likely that you will miss anything that you are interested in photographing.

Checking the calendar
Many festival dates changes from year to year, so always double-check the date with a reliable source.

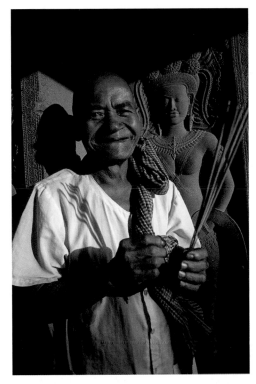

Apsaras and temple guardian, Angkor Wat, Cambodia ‹

Nikon F5, Provia 100 ASA film. 28-70 mm lens. Exposure not noted.

The light only falls on these *apsaras* for a short while every day. For the rest of the time they are in partial, or full, shadow. I only discovered this on the last day of my previous visit – when it was too late. This time, whilst the crowds were photographing the sunset, I was scuttling up to the main sanctuary to catch the moment. I also managed to photograph a very happy temple guardian in front of the carvings and in perfect light.

Korzok Gustor festival, Tsomoriri, Ladakh, India ⌄

Nikon D3x, ISO 400, RAW. 24 mm. 1/1250 second, f8

Establishing the correct time for festivals can be tough, especially remote ones that follow the lunar calendar. Proper research alerted me to the tapestry hanging in the background, so I chose my angle to make sure that this was in the picture.

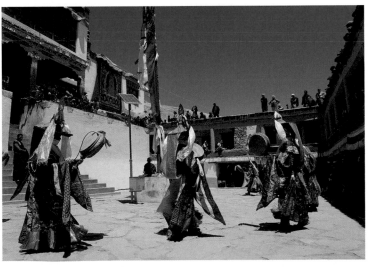

My own book *Around the World in 500 Festivals* (Kuperard) is a great place to start! Try to establish what actually goes on and sort out a place to stay. You may also want to work out seasonal changes at your destination to coordinate your trip with blooming flowers, wildlife migrations and other natural phenomena, such as the Northern Lights. Consider looking at the moon phases, if you want to shoot long exposures by moonlight.

Once you have worked out what you want to see and do at your destination and when you want to go, then you will be able to start making the travel arrangements.

Travel and transport

Getting up-to-date information about who flies where and when can be difficult, especially for more out-of-the-way places. Coordinating international and internal flights can also be tricky but is well worth doing before you book, as it's very frustrating to miss out on a whole leg of your journey just because an internal flight doesn't dovetail with a pre-booked international flight. A guidebook should give you the web addresses of domestic airlines so you can check schedules and book flights direct.

Note that some of the best websites for booking flights won't always show every option. *Amadeus* and *Skyscanner* both scrape fares from many other sites, saving both time and money. *Expedia* also has a lot of good options for internal and regional flights. It is worth seeing whether charter airlines fly to your destination; they can often work out cheaper than a scheduled flight, although the times can be less flexible.

It is often tempting to wing it with travel arrangements and sort things out when you get to a destination. This can be fine if you have a lot of time and are just travelling around but, if you are prioritizing travel photography, then you won't want to waste your time looking for a hotel or queuing for a railway ticket. Some rail companies have extensive websites that allow you to plan and book in advance but, if your time is short, consider contacting a local travel agent. Accommodation can also be booked through a central booking site or direct with a hotel: your guidebook should provide phone, website or email details. Alternatively, go on an organized tour, as long as you make sure that the tour gives you enough free time at key destinations to enable you

to take pictures in the best light. Tours that involve long stretches of time on a coach, or that stay at hotels in the middle of nowhere won't be the best for photography. Consider a photography tour that will combine tuition with photo opportunities and the company of like-minded souls; maybe even join me on one of my *Better Travel Photography* tours!

Weather

The weather can make or break a photographic trip and so you should consider it carefully. Unfortunately, the sort of information that a photographer needs is often not very easy to find in guidebooks or on websites. There are a number of weather sites, but most of them struggle to predict two weeks in advance, which is not very useful unless you can leave at a couple of days'

Noon day gun, Hong Kong, China ⌄

Nikon D2x, ISO 100, RAW. 48 mm (72 mm equivalent). 1/640 second, f4

The noon-day gun is fired every day in Hong Kong. Finding out about rituals like this in advance can be vital when you are planning a trip. I used a fast speed and a motordrive to ensure that I captured the moment.

Rainy day in Hoi An, Vietnam ‹

Nikon F4, Provia 100 ASA film. Lens and exposure not noted

Proper research can help you avoid the most likely times of bad weather – although there are some countries, such as Vietnam, where rain seems somehow more appropriate and atmospheric. Use a rain-cover to protect your equipment and try to capture the wet atmosphere.

Erher Beach, Socotra, Yemen ∧

Nikon D2x, ISO 100, RAW.
60 mm (90 mm equivalent).
1/160 second, f9

Looking for remote and
exotic islands to include in
Unforgettable Islands, I simply
scoured an atlas, to see places
that looked interestingly
located, then researched
them on the internet to see if
any were suitable. In this way
I 'discovered' Socotra off the
Yemen. I even used the internet
to locate a local travel agent to
organize some of the ground
arrangements.

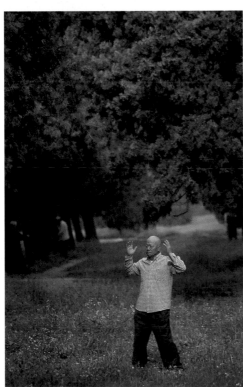

**Man performing Tai Chi,
Temple of Heaven, Beijing,
China** ❯

Nikon F4, Provia 100 ASA film.
80-200 mm lens.
Exposure not noted

In the early morning many older
people come to this park in
the middle of Beijing to do Tai
Chi exercises. Visit at any other
time and it's still a nice park, but
visit in the early morning and it
manages to be both traditional
and bizarre.

notice. Instead, look at historical average figures to
work out the likelihood of good or bad weather.

I tend to use *Accuweather*, as I have found it
consistently accurate, even on a 15-day forecast. It
also gives precise sunrise and sunset times, which can
be vital on your first day in a new location. I also use a
book called *Weather to Travel*, by Maria Harding, which
has a lot of information, although some of it is rather
buried. With both of these options, you can work out
a lot about the expected weather by comparing the
daylight hours with the average hours of sunlight for
a given month. Rainfall figures can also be useful, but
bear in mind that, if you get 30 mm of rain in one hour
followed by seven hours of sunshine, you can still get
some great shots.

Photographic research

As a photographer, you will need to know what sights
are interesting to you, which are worth photographing
and when. There are a host of image and photolibrary
sites, such as *Alamy*, where you can see the sort of
pictures that other photographers have managed to
take. This can give you a good idea of the angles and,
depending on the detail of the captions, the time
of day that might be best to take pictures. There are
also online photographic discussion forums where
you can ask destination-specific questions, although
the answers may well reflect personal experiences
rather than concrete facts: someone might have been
lucky photographing Angkor Wat in the middle of the
monsoon; you might not be so fortunate!

Do your own research

Research doesn't stop when you arrive at your
destination. Look at postcard stands and ask around,
especially at tourist offices and hotel receptions to
see if there are any events happening or sights you
shouldn't miss. Don't just rely on other people for
your research: make notes while you are travelling, in
case you ever return to a place. It is especially helpful
to note down things that you don't get round to
photographing, either because you ran out of time
or because the weather wasn't good enough.

Ⓦ The URLs of all the sites and products
mentioned here, as well as other research ideas,
are given on footprinttravelphotography.info

Exploration

Before you can start the creative process, you have to get yourself and all of your gear to the right place. This is likely to involve getting on to a plane and possibly a good few local buses. In this section I will give you a few pointers on how to get you and your equipment to your destination and back again, and how to travel with your camera in some of the poorer and more remote parts of the world.

Bushman trackers walking towards Kubu Island, Botswana ◄

Nikon D2x, ISO 100, RAW. 400 mm (600 mm equivalent). 1/640 second, f9. Tripod

I had pre-visualized this shot before I even got to Botswana as a way to try to add some interest to what is essentially a large rock in the middle of the white expanse of the Makgadikgadi Pan! Kubu Island (Lekhubu) is sacred to some bushmen, and so I wanted something that showed their link with this site. It was formerly a rock island, surrounded by an inland sea and is still stained by ancient bird guano.

The trackers worked for a tour company and found it strange walking next to each other: when hunting they would usually be single file to avoid spooking the animals. This would have looked more cluttered photographically, but I think they were still concerned that people looking at the picture would doubt their hunting prowess!

Photography on the road

All of the travel planning and research, all of the buying, practising, packing, protecting and lugging of your gear culminates in the moment when you actually get out your camera and start shooting. This is what it is really all about. This is the moment that drives travel photographers and what makes all of the other stuff worthwhile. The world is alive with possibilities and your next shot could be your best ever.

Travelling companions

When things are going badly – sometimes due to the light, circumstances or just because I am not performing – then, frankly, I am not a pleasant person to be around. When things are going well, and I am capturing pictures seemingly without effort, interacting with locals and shooting great portraits, then I am euphoric! This is why it is often better not to travel with a non-photographer. They will not be able to understand the interminable waits for the light to be perfect, the moments of frantic action following long bouts of torpor and just why you have to climb that hill three times to see the sunset because the light might be different each time, not to mention the crushing lows and soaring highs of being a photographer on the road.

Travelling with another photographer, however, can throw up its own challenges. You need to avoid being in competition with each other and copying each other's shots. It's usually best to keep some distance between you while you are both shooting but, if you are working closely together, then support each other. Distract bystanders to allow a colleague to take a portrait without onlookers; then, a few minutes later, they can do the crowd control thing for you. And never boast: you might have just taken the best picture of the day while they have failed to get a single decent shot but, rest assured, the situation will be reversed at some point and then you won't want them to add to your misery by crowing.

Most serious travel photographers end up travelling solo. This is the best way to guarantee that you can devote all of the time you want to your pictures, but it can be lonely. It is difficult to meet other travellers, if you get up for sunrise and go to bed early to recover. I used to wonder what sort of person would order a club sandwich from room service in Rio, rather than heading out to a bar or restaurant, but I have done it myself on more than one occasion. If you

choose to travel on your own, it is worth scheduling a few days off every so often, so that you can take it easy, relax and meet up with other travellers.

Establish a routine

You can add to your chances of success by following a routine when you are away. I will admit here to very occasionally heading out for the day without spare memory cards, batteries and, in one really embarrassing case, without a camera in my bag, but I don't recommend it! In general, my routine is always to pack the next day's bag before I go to bed. I might check or change something in the morning, but I need to know that, if I just run out of the room in a pre-coffee haze, I will have a full kit that can last me for the whole day.

Every night I copy off the day's pictures to the laptop and back them up. Then I fit a new card and recharge the batteries for the camera and **flash**. At this point I check that the camera **sensor** is free of dust and dirt, and clean all of my lenses and filters.

Zebu cart on the Avenue de Baobab, Morondova, Madagascar ◄

Nikon D2x, ISO 100, RAW. 200 mm (300 mm equivalent). 1/200 second, f5.6

The Avenue de Baobab in Madagascar is a famous landmark, where a series of the ancient trees line a small country road. I managed to time my visit for a few hours before sunset, but wanted to shoot more than just the trees on their own. As I was travelling on my own with a guide, I was able to wait for the light and for something photogenic to happen along. Having this freedom can be vital for good travel photography.

I use a blower brush first and then wipe them using a microfibre cloth, if necessary. Remember to check the elements at both ends of the lens. It is also worth checking the day's images on a laptop to look for problems with equipment or technique.

Packing the day bag is vital. In mine, I can fit a camera body and four lenses, as well as a flash, converter, **polarizing filters**, graduated filters, spare batteries and memory cards. I also pack a small backpack for myself containing a hat, sunscreen, snacks and water, and maybe an overspill of camera stuff, such as a flash diffuser and, possibly, a couple of speciality lenses, like a **macro** and a **fish-eye**. This way, I can just grab the bags and a small travel tripod and head out.

I always have spare equipment with me on my travels but, generally, I leave this at my hotel. This means that I am not carrying too much with me and I have a complete spare kit if I lose my day bag. If I don't have a safe place to leave things or think I might need more of my kit, including both camera bodies, then I take everything with me in a backpack camera bag. Sometimes I also wear a photographer's jacket or lens pouches so that I don't have to keep taking the backpack on and off.

Get ready for action

It also helps to have a routine when you are out and about, so, if you suddenly see a picture, you won't be fumbling around with your camera:

- Return your camera to your usual day settings whenever you can. If you have been shooting at night, the camera might still be on a slow **shutter speed** with a high **ISO sensitivity**, which will take time to change if you need to take a picture quickly.
- If you are shooting manual, set an average daytime **exposure** before you head out, and update it as you walk around, especially if conditions change.
- Fit a good general **zoom**, which will give you the best chance of having the right lens.
- Unless you are in rain or very dusty conditions, take off the lens cap, so that you are ready to shoot.

Looking after your memory cards or film

As you are taking pictures, keep an eye on the frame count. I can take many times more pictures on a memory card than I used to get on a 36-exposure film, but this means it is even easier to run out

unexpectedly. Don't let a memory card or a film, for that matter, run out before you change it. Instead, if you have a pause in shooting and the film is at 34 or there are just 10 or 15 shots left on the card, then change it. Something amazing might be round the corner and you don't want to have to change film or cards at that vital moment.

You should also work out a routine for your used film or memory cards. With film, I always used to wind the end in completely, so there was no chance of accidental reuse. It would then be numbered and dropped into a sealable bag in an inner pocket of a camera bag. Used memory cards can be slipped into the plastic case of the new card and then put into a card case, with the 'used' flag on the case pulled out. This avoids the chance of getting out the wrong card and allows me to see at a glance how much I am shooting. The used cards are all copied and backed up every night, so I can reuse them the next day. For added security, I label both the cards and plastic cases with a sticker that details my name, email address and mobile number and offers a reward if they are found.

Memory cards are not affected by security x-rays at airports but camera film can be – especially sensitive film of 800 **ASA** or higher. X-ray damage is accumulative: the more exposures, the more chance of fogging. I regularly had standard film x-rayed a number of times without any problems but, apparently, since then, some machines have become more powerful. A few passes though hand baggage machines shouldn't hurt, but never allow film to go through checked luggage machines in the USA: one pass will ruin your film. You can usually ask for your bag to be searched by hand instead, but carry the film in a clear plastic bag and get to the airport early.

Hazards and attitudes on the road

Although you have to be aware of the possibility of your equipment being stolen or damaged, it is important not to dwell on it, or it could ruin your trip and stop you taking pictures. Follow a few simple rules, and you can mitigate the risk without becoming paranoid.

Avoiding damage

- Always carry your camera in a decent camera bag or around your neck with a sturdy strap. It is very easy for the lens mounts of **SLR** and **DSLR** cameras to be misaligned if they are knocked against something, so if your gear is in transit, store it without a lens mounted and with the plastic protection cap in place.
- **Compact** and **mirrorless** cameras are easier to protect in a small backpack or daypack, but be careful that they don't fall out when you open it.
- Don't leave cameras on seats next to you in cars, boats or planes. They can, and do, roll off. Loop the strap around the headrest for more security.
- If you can, change lenses on a hard surface, even the ground. Trying to juggle two lenses and a camera can be a recipe for dropping one or more expensive pieces of kit. Develop a safe routine: take one lens off and put it in your camera bag before taking out the replacement. All the time keep your hand over the open camera to prevent dust getting in. Drop an expensive lens and the repair can cost hundreds; drop a cheap lens and it is often damaged beyond repair.
- Be careful of rain. If your camera bag doesn't have a shower-proof cover, take a plastic bag with you to cover it. Also take plastic bags and elastic bands to seal up lenses and cameras in really humid or wet conditions and silca gel to absorb moisture.

Avoiding theft

Theft is a potential threat when travelling with expensive gear. Most guidebooks recommend keeping valuables out of sight but that is not possible if you are a photographer. Instead, buy decent insurance, read the conditions so you know what is and isn't covered, and try to be unobtrusive.

- In potentially dangerous areas, keep your camera hidden as much as possible, only taking it out of the bag just as you are about to take a picture. If you have a compact as well as a larger camera, consider taking this with you and leaving the expensive gear in your hotel.
- In any risky situations, make sure that you back up your memory card, so that if you lose your camera, you won't lose your pictures as well.
- Avoid leaving valuable gear on tables and chairs in public places, where it could be easily snatched. If you put your camera bag on the floor, put your seat leg through the strap so it can't be easily grabbed. Stopping someone from getting your gear in the first place is far better than having to chase them down the street.
- Be extra careful shooting early in the morning or late at night, or in remote places at any time of day. Consider taking a trusted person with you – even a verified local guide or taxi driver – and make sure that they are made aware that a third party knows where you have gone and with whom.
- If you leave things for safety in your room, lock them in the safety deposit box or, failing this, in your main bag. This won't stop a determined thief from cutting open or stealing the whole bag but it will deter an opportunist. You will also know if something has been stolen and can call the police.
- If you take a laptop, make sure that you have it securely password protected and even encrypted, in order to protect the personal information on it. Back up all information before you leave home.

Children playing on a cluster bomb casing near Phonsavanh, Xieng Khuang Province, Laos ▼

Nikon F4, Velvia 50 ASA film. Lens and exposure not noted

There are other potential hazards on the road apart from theft. Laos was the most bombed country in history and there are still swathes of land that have unexploded ordnance. This village in the northeast used cluster bomb cases as fences and troughs to feed animals. In areas such as this, it is worth seeking local advice as to where is safe to walk. Travelling in poorer parts of the world can be difficult if you are carrying a large amount of expensive equipment. The key is to use the openness of your personality to break down barriers.

Water fight during Lao New Year, Luang Prabang, Laos ◂

Nikon D2x, ISO 400, RAW. 24 mm (36 mm equivalent). 1/1250 second, f5.0

You will encounter all sorts of potential hazards on the road, but you can mitigate most of them with a bit of thought and some advanced planning. Lao New Year is marked by massive waterfights, so I made sure to have a really good raincover and even an underwater housing with me. This meant that I was able to throw myself into the middle of the action, and keep shooting without being worried about my equipment. Even though I got soaked, my gear didn't.

Attitudes on the road

Many travellers feel uncomfortable when confronted with poverty in the developing world, and this feeling may be compounded when you have a few thousand pounds' worth of equipment around your neck. Similarly, it may be difficult for local people to relate to you because of your wealth or your appearance.

The best way to overcome any social barriers is to look people in the eye and treat them with respect and openness. Your positive attitude will shine through, no matter how wealthy you might appear to them. Smile and, if it is culturally acceptable, shake hands. Take an interest in them and what they do. Most people will be happy to answer questions about their family, work and culture.

You may be asked how much your camera costs, which is always a difficult question. Say too much and you will have set up an instant barrier between you and the person asking; say too little and someone might offer to buy it from you. (This has happened to me.) These days, despite the fact that I'm freelance and own all of my gear, I usually say that my camera belongs to my 'boss' and I don't know how much it's worth. This deals with issues of cost as well as ownership in one stroke.

Now I have a son and a daughter I can at least respond positively when I get asked the standard question about children; showing people pictures of family members is a great ice-breaker. However, despite often repeated advice, I would always avoid showing people in developing countries pictures of your house, as even the most modest dwelling is likely to be far more luxurious than the local homes.

Travel is about meeting and learning about other people. You shouldn't leave your common sense behind at the airport but don't be so paranoid about the risks of getting ripped off that you don't trust anyone. Opening your mind and your heart will give you a better travelling experience and better photographs.

ⓘ For detailed information concerning digital photography on the road, see page 150.

General travel tips

Over the years I have travelled hundreds of thousands of miles on a variety of modes of transport. In one frenetic year, I took 99 different flights and landed on every continent apart from Antarctica. I have been lucky in my travels, coming away largely unscathed over the years, and I have built up some knowledge on safe and efficient travel.

Getting from A to B (or usually A to Z) is a crucial part of travel photography. Travel mishaps can make good dinner party anecdotes, but losing all of your gear is more than a little counter-productive when it comes to photography. You also wouldn't want to miss a train and turn up a day late for a festival or, in the case of some friends of mine, head to the wrong town: who

would have thought that there were two places called Saintes Maries in France?

Below are some of the pearls of wisdom I have picked up during my years on the road.

People that you meet

- Never take any answer at face value, especially when it concerns travel arrangements. Always corroborate what people say.
- Avoid posing yes/no questions, such as 'Is this the right way to …?' In many parts of the world, people do not want to give a negative answer and so will just say 'yes', or nod regardless.
- Don't trust everyone on your travels, just because they are foreign. There are dishonest people everywhere.

Moulay Idriss, Morocco ∧

Nikon D3x, ISO 100, RAW.
48 mm. 1/320 second, f7.1

Being a travel photographer means that you have to try to find angles that give you a unique view of the places that you visit. For the Moroccan pilgrimage town of Moulay Idriss, some of the best views are from the surrounding countryside. This represents a whole new way of approaching travel: you end up spending a lot of time trudging through fields and even climbing hills surrounding towns rather than simply exploring their mains sights.

- Don't distrust everyone on your travels, just because they are foreign. You will miss out on a number of amazing experiences and might just as well stay at home.
- Open yourself up to meeting new people, but don't leave your common sense behind and get into situations that you would avoid at home.
- You are probably more likely to get ripped off by other travellers than by locals.

Money matters

- See how much cash is covered by your insurance and carry that amount with you. Most destinations now have AIMs at least in the main cities and airports, but check in advance. Getting local currency in this way is usually better value than cashing traveller's cheques; some banks no longer charge for overseas cash withdrawals. Notify your bank where you intend to use your card, so that they don't put a stop on it as soon as you try to use it. Take the emergency service number with you, as most of them will put a stop on them regardless.
- Take debit and credit cards from a number of different banks in case of account problems, and don't carry them all with you at all times.
- Don't be too hung up on your budget: the occasional taxi or treat is usually well worth the extra expense.
- Never skimp on the first night after a long-haul flight. Avoid the local airport bus and catch a reputable taxi to a half-decent hotel where you can recover from the journey. At most airports you can hail a city taxi at 'Departures', just after it has dropped off a passenger, and ride into the city on the meter, avoiding the overpriced airport taxis.

Practicalities

- Get good travel insurance, know the terms and conditions and follow them. If you don't have a motorbike licence, but crash one whilst drunk and not wearing a helmet, the chances are your insurance company isn't going to pay out! Make sure you know what you have to do to make a claim. Any thefts usually have to be reported to the local police within 48 hours.
- Keep a scan of your passport and other vital documents attached to an email on a web-based email account in case the originals go missing.

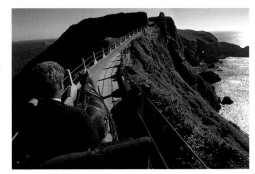

Carriage ride on Sark, Channel Islands ◄

Nikon D2x, ISO 100, RAW. 12 mm (18 mm equivalent). 1/250 second, f9.0

The narrow causeway of La Coupé is one of the most famous landmarks on the island of Sark in the Channel Islands. Except for a few tractors, there are no motorized vehicles on Sark, so I wanted an image that combined the causeway with one of the carriages that ply the island.

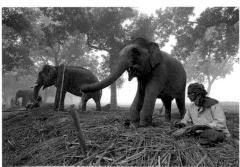

Elephants for sale at the Sonepur Mela, Bihar, India ◄

Nikon D2x, ISO 400, RAW. 12 mm (18 mm equivalent). 1/50 second, f5.0

One of the delights of travel is getting off the beaten track to areas where tourists seldom go. The Sonepur Mela in Bihar is one of those places: the largest livestock fair in the world. Travelling in places like this can be harder, as there are fewer facilities, but is ultimately more rewarding. As locals are less familiar with tourists, they tend to be more inquisitive and more welcoming.

- A holdall with wheels is probably the most convenient travel bag, especially if you already have a backpack-style camera bag on your back.
- Be aware of the affects of jetlag and altitude, and don't try to do too much until you have acclimatized.
- Unless you are in a dormitory at a hostel, unpack your bag if you are staying more than a couple of days. It will take less time to repack than if you just rummage.
- Always pack the night before if you have an early start the next morning, just in case you oversleep.
- Avoid using air-conditioning so that you get used to the heat and also to protect your equipment from condensation when you take it outside into humid conditions. If you can't do without it, at least switch it down to a reasonable level – you are not storing meat in your room!
- Travelling isn't a military conquest – leave some stuff to chance.
- Remember, it is supposed to be fun! Today's disaster will be tomorrow's bar anecdote.

Styles of travel

Your style of travel will affect the amount of equipment that you can carry and the sort of pictures that you can expect to achieve. It is worth being realistic about this fact when planning both your trip and your photography. If you take too much gear and try to see or do too much you will miss a great deal and risk coming back with fewer good pictures.

If you are backpacking, travelling on local buses and staying in communal hostels, then you will be able to take far less equipment and you will probably need to keep everything with you at all times. If you are staying at better, more secure hotels, then you can leave spare equipment locked away in a hotel room and only take out what you need each time. And, if you are flying to Europe or North America, picking up a hire car at the airport and heading out on your own, then you can take almost as much gear as the airline will let you carry.

Travelling on a really tight budget may leave little time or energy to take pictures, so you will come back with far fewer shots, and travelling with minimal equipment will be an issue if you have any problems with theft or damage. On a photography-orientated trip, spending a bit more money will buy you time and flexibility, which can often lead to better results.

Try to stay at better quality, more centrally located hotels. These are usually safer for your equipment and often have great views. Certain key hotels – such as the Machu Picchu Lodge or the parador in the grounds of the Alhambra in Granada – can offer special access to a particular site, outside of normal hours. Although expensive, these hotels could give you an edge in getting that unique shot. You don't always have to spend big money to get a special view: the rooftop restaurant of the budget Shanti Guest House in Agra has fantastic views across to the Taj Mahal, while the Diavolezza Mountain Lodge in Switzerland allows you to stay at 10,000 feet surrounded by mountain peaks relatively cheaply.

You should also budget for the occasional local guide and private vehicle for short journeys where public transport is inadequate. Private vehicles often cost far less than you might think and can drop you precisely where you want to go. You can also stop off at any sights en route; it can be soul destroying to see that perfect photograph disappearing in a cloud of diesel fumes through the dirty back window of a bus.

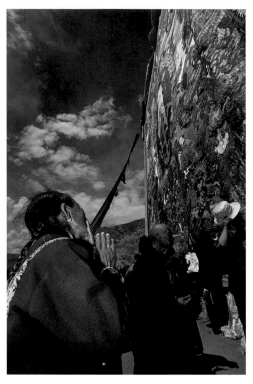

What's more, you will have the flexibility to travel at optimum times of day to ensure that you are passing a particular view at the best time for shooting.

Solo travel can be fun but sometimes a good local guide can serve as an interpreter and as a vital link between you and the people you want to photograph. A bad one can be worse than useless, however: droning on endlessly, alienating local residents and dragging you into countless shops where they hope to make a commission. The only real way to ensure you have a positive experience is to get a personal recommendation. Discuss your wants and needs with the potential guide before you book their services and make sure they spell out what is included, in terms of transport, entrance fees and food.

There is nothing to say that you have to travel in one particular way for your whole trip. You could backpack for some of the time, and then spend some cash or even take a tour at the times when it will really help you to take better pictures.

Festival, Sera Monastery, Lhasa, Tibet ◄

Nikon F5, Provia 100 ASA film. 17-35 mm lens. Exposure not noted

I had just arrived in Lhasa to photograph the Jokhang Temple on a gruelling round-the-world trip for *Unforgettable Places*. I was going to update my coverage of Jokhang Temple and the Barkhor Square and was only going to be in Tibet for a few days. The altitude is crippling, so I was planning on resting for the first morning to try to acclimatize. Then I heard that there was a festival at the Sera monastery where a vast Buddhist tapestry called a *Thangka* was going to be unveiled. This only happens once a year, so I threw down a cup of coffee and headed there in a taxi. The festival was hot and crowded but I managed to get some nice shots, including this image of a pilgrim lit with fill-in flash looking up to the tapestry. After a few hours of photography I was invited to join some locals for a picnic and a good few local *chang* beers. After a short while, I regretfully had to tear myself away to get on with the job I was being paid for! If I had been on a fixed schedule I wouldn't have been able to change plans and photograph this festival. Reacting to events is a large part of the joy of travelling.

Organized tours

Organized group tours can be a good way of maximizing your time. They take over the hassle of travel arrangements, giving you more time to think about your photography. Tours also often stop at notable sights en route, which you would miss if you were sitting on a local bus. However, you should avoid tours that whisk you between sites and then stay at hotels far from anywhere. Try to find a tour that incorporates a great deal of free time and spends at least two days at each major destination. This will allow you to strike out on your own, make early starts and even take the odd day for yourself. Confirm the free time and itinerary of the tour before you book. It is also worth speaking to the tour leader at the start and letting them know that you will want to do certain things on your own.

Some tours are specifically designed for photography. These will factor in early starts and photo opportunities, and will include varying degrees of tuition, usually by a professional travel photographer. Travelling with a professional will give you access to a lot of tips of the trade and can greatly improve your own work. You should check the itinerary, though, and also research the photographer who will be leading the tour. If you can't find their work in magazines or on the internet, if they specialize in wedding and not travel photography, or simply if their pictures just aren't very good, then the chances are that they will have little to teach you.

Since the first edition of this book was published I have set up my own *Better Travel Photography* range of photography tours, to locations as diverse as Morocco, Laos and the Himalayan region of Ladakh in India. Land arrangements are provided by some of the best names in adventure travel, and I accompany each trip supplying tuition and encouragement.

The one drawback with being on a tour is the lack of flexibility. If you have two days of rain at a particular place but the sun comes out just as you are due to leave, you have no choice but to leave with the others, whereas, if you are travelling on your own, you can change your plans. Similarly, if you discover a local festival or are invited to a wedding (this happens in Spain or India far more than you might imagine), then you can alter your schedule and go along. Impromptu events can give you some of the most evocative and unusual pictures of your trip.

Benirras beach, Ibiza, Spain ‹

Nikon F5, Velvia 50 ASA film.
28-70 mm lens.
Exposure not noted

Even on non-photographic trips there are opportunities for photography. I was on Ibiza with a few friends, but still managed to shoot some sunsets at the beach. Including silhouetted people and yachts gives a real sense of place. As long as you curb your expectations, you can mix a holiday and travel photography.

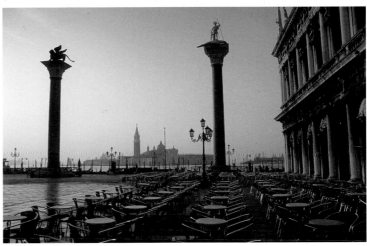

Taking your time

A photographic trip will need a lot more time at each place than a standard trip. This is partly to cushion you from bad weather and partly to allow you to photograph more places at the best times of the day. More time at a destination will also give you the chance to be creative: an imaginative photographer may well want five days at a sprawling site, such as Angkor Wat, whereas a holidaymaker might be satisfied with three and a tour group might allocate just two. The flipside to this is that by spending too much time photographing the major sites, you may miss out on taking pictures of everyday life and culture. Try to achieve a good balance that gives you adequate time to do justice to the best known places, but still leaves you time to explore.

St Mark's Square at dawn, Venice, Italy ⌃

Nikon F5, Provia 100 ASA film.
17-35 mm lens.
Exposure not noted

City breaks can be perfect for photography, especially if you are staying in the centre of town. Even if you are travelling with a partner, you can often slip out to catch the early morning light. I was staying just around the corner from the square and was able to get there in time for dawn, shoot for two hours and still be back at the hotel for breakfast.

Focus on

Self-portrait bungee jumping from Kawarau Bridge
Queenstown, New Zealand

Taken some time ago (when I had considerably more hair than I have now), this shot illustrates a number of issues about travel photography.

First, it demonstrates the travel photographer's constant desire to get a different and unique shot. A lot of people take pictures from the bridge; very few shoot all of the way down!

Second, there is the planning required to take this shot. I experimented with the lens to get the right balance between the field of view and the subject size, and decided on a 24 mm lens as the best option. Not wanting to trust autofocus, I prefocused the manual lens and taped it up so the focus couldn't get knocked. Next, the camera strap was double gaffa-taped to my wrists and then my hands were taped to the camera so I wouldn't miss the shutter release button. As the light was likely to change, I shot with the camera on aperture priority with multi-zone metering. I chose to specify the aperture because I wanted to ensure that I came within the depth of field. As I was shooting with a wide lens, I kept the aperture to around f8. I was not so worried about the shutter speed, as I wasn't moving very fast relative to the camera.

On the way down (and back up and down again), I shot a whole roll of film in three long batches using the slowest motor drive speed. This shot was about the third on the roll and manages to get the bridge in as well. Essentially, this was a lucky shot but I have always believed that if you prepare and try hard enough, then you make your own luck.

This picture shows that travel photography is all about getting involved and having fun. Sometimes you need to get so close to the action that you become a part of it. Because of photography, I have hung from planes, swum with sharks and run with bulls. I am so scared of heights that I probably would never have done this bungee jump without a camera.

Lastly, this picture illustrates how travel photographs can make you money. It has been sold a number of times, appearing in a magazine advertizement for alcopops and on a billboard advertizing a German internet company.

⊕ **Find out more** ❯

Nikon F4, Provia 400 ASA film.
24 mm manual lens, taped.
Automatic, aperture priority.

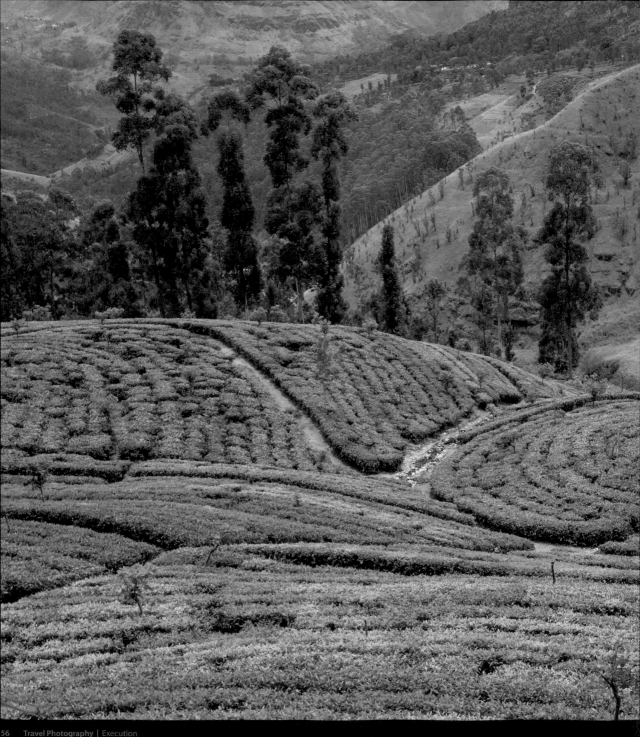

If you master the basic photographic skills then you can turn your hand to any style of photography. Back up your exposure and compositional expertise with a range of techniques, and it doesn't matter what the world throws at you, you will be able to come away with great pictures.

Tea plantation, Nuwara Eliya, Sri Lanka

Nikon D2x, ISO 160, RAW, 25 mm (37 mm equivalent), 1/125 second, f7.1, Polarizing filter.

What makes a good picture?

We are all constantly bombarded by pictures. In the years since the first edition of this book, the number of people shooting with camera phones and then uploading their pictures to image-sharing sites has multiplied exponentially. Pictures are seen everywhere, and everyone seems driven to document and share every facet of their day-to-day lives. Our consumption of pictures has changed: many of us have got used to ignoring pictures, spending less time looking at individual images before swiping our way on to the next quick visual fix.

With such a proliferation of images, it can be difficult for the keen photographer to make their images stand out. In a sea of mediocrity, it can be hard to even work out what constitutes a good photograph in the first place.

Arguably, the most important interaction that you need to consider when taking pictures is the dialogue with the viewer of your pictures. The whole point of photography is to communicate with them. It doesn't necessarily have to be a deep idea of political significance, but the picture should convey an idea, even if it is just *look at that - isn't it big*! If you don't know the idea or the emotion that you are trying to communicate to them, then how are they supposed to know what they are looking at? If you have an idea when you take a picture and use your photographic skills to convey that idea, then you will have more chance of attracting someone's attention and interest when they look at the picture. The use of composition to convey meaning is described on page 61.

My view is that a good picture is essentially one that provokes an active response in the viewer. I would argue that even a strongly negative reaction is better than no reaction at all. Boredom and disinterest should be avoided at all costs.

An original view of the world
Some level of originality is vital for a good travel photograph. There are countless similar and dull images out there, and you should work hard not to produce yet another one. Most of the iconic places in the world have been photographed countless times and are familiar to the point of monotony. If you can take a shot that looks significantly different, then your picture will stand out. This can be achieved by luck – a spectacular light effect, say, or extreme weather

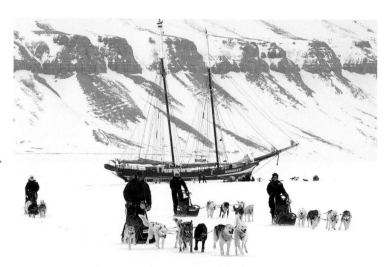

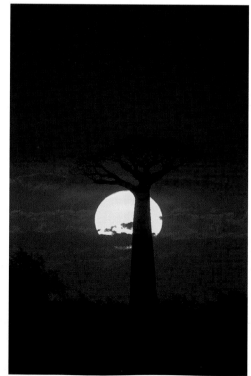

Dog sleds and the *Ship in the Ice*, Svalbard, Norway ∧

Nikon D2x, ISO 200, RAW. 140 mm (210 mm equivalent). 1/800 second, f8

I was staying at the *Ship in the Ice*, an old Dutch schooner that is frozen in the ice of a fjord as a unique hotel. I wanted a picture showing the dog sled teams that were also staying. I positioned myself on the ice and shot as they came towards me, with the ship in the background. Predictably the dogs ran right towards me, forcing me to jump out of the way at the last moment!

Baobab at sunset, near Morondava, Madagascar ＜

Nikon D2x, ISO 100, RAW. 280 mm (420 mm equivalent). 1/1250 second, f4.5

In order to crop in as close as possible to this sunset, I used a 70-200 mm lens with a 1.4x convertor. The result is a memorable and iconic sunset that holds a lot of detail in the sun. The sky is dark, but this just adds to the atmosphere. Silhouetting the tree gives the sunset a sense of place.

conditions – or by exploiting and exaggerating the inherent qualities of photography to produce something out of the ordinary.

Photography has certain qualities that distinguish it from what we see with the naked eye; exploiting them can elevate your pictures from the level of mere snapshots. This may be the wider **field of view** and distorted perspective created by using a **wide-angle lens**, or the compressed perspective and magnification achieved when using a **telephoto lens**. It might be the way that the camera records movement: freezing a fraction of a second or allowing it to blur into an impressionistic interpretation of a moment in time.

Working in the extremes will help to make your pictures stand out: use a very fast or very slow speed, have a large **depth of field** or virtually none at all, and compose your pictures boldly. Many of the characteristics of creative photography – blur, shallow depth of field, distortion and imaginative camera angles – can also look like mistakes if they are used marginally. Working in the extremes lets people know that these are intentional creative effects.

Sometimes, taking a photograph from a different place to most people will be enough to make the viewer look twice at your image. You might choose a different **angle** or a different **viewpoint** or use an unfamiliar composition to add some visual interest. A shot with the subject right in the middle of the frame is seldom interesting.

Flat overhead lighting at midday tends to produce boring pictures. Light and shadow are important in a picture as they can highlight form and texture. Introducing **contrast**, whether through light and colour or by combining conflicting objects or people, can make a picture visually and mentally striking.

If you are an accomplished photographer of people, then you will always be able to take original pictures. Combine people with iconic sights and you can breathe life into even the most hackneyed subject.

The quality of your image is important. The **exposure** should be correct and the key parts of your image should be in focus. Be critical of your own work and learn from your mistakes. However, unless you are trying to make it as a professional, don't set the bar so unreasonably high that you are continually disappointed. It is never worth throwing away your photographs of a trip just because they aren't technically perfect.

Although you should always strive to take original photographs, this won't always be possible. Even professionals take illustrative filler shots to provide context for their more creative images. After all, alongside the reverse shots of the Taj Mahal thorough reeds at sunrise, everyone should have a picture of the iconic frontage.

A photographer for all seasons
As a travel photographer you will always be battling a number of things beyond your control: weather, building work or even other travellers getting in to your picture. Two things that you can control, however, are your level of skill and the amount of effort that you put into taking pictures. A travel photographer needs to use a variety of technical skills. As you may be working in difficult and unfamiliar conditions, these will have to be second nature. There will be no time to read your camera manual in the middle of the Tomatina tomato fight or to swot up on the white-balance facility when a

Loading a truck, Bodh Gaya, Bihar, India

Nikon D2x, ISO 100, RAW. 16 5mm (247 mm equivalent). 1/2000 second, f7.1

I had just photographed some labourers loading a truck . I noticed this man stamping down the sacks and realised that there would be a good silhouette from the opposite side of the truck, so stopped the driver and took a few shots with a telephoto lens.

Morning exercises by Hoan Kiem Lake, Hanoi, Vietnam

Nikon D3x, ISO 500, Raw. 112 mm. 1/160, f5.6

This man was performing Tai Chi routines in the morning by Hoan Kiem lake in the centre of Hanoi. I simply sat nearby and shot a few pictures as he adopted more striking poses. It was a drizzly morning and the light levels were low; increasing the ISO helped, as did the fact that he held the poses.

flock of flamingos flies over your head at sunset! If you learn and practise the skills detailed in this chapter, then you will be equipped to take on almost any style of travel photography with confidence: you might have to worry about being charged by an angry elephant in Africa, but you won't have to worry about getting your **exposure** or composition wrong.

Learn to exploit all of the unique characteristics of photography, such as the camera's rendition of movement, perspective, distortion and **field of view**. These are unique to the medium and unlike anything that you can see with the naked eye. Learning how to achieve these characteristics and what their effect will be on your picture is vital if you are to be able to assess the subject in front of you and, then, pre-visualize the photographic choices you can make.

As you get more familiar with some of the technical aspects of photography, you should be able to look at a subject, assess how you want a photograph of it to look and pre-visualize the effect that your creative choices will have. You can even practise pre-visualizing a subject when you don't have a camera with you. Look at different subjects and imagine how you would photograph them. After a while this will become second nature and the whole process will take less time and concentration.

Don't limit yourself to a single image or effect: assess a number of photographic choices for a given subject and pre-visualize the results. Photography is seldom a one-shot process and developing your ideas through a combination of assessment and experiment will help produce striking, memorable photographs.

**Kasbahs of
Ait Benhaddou, Morocco** ⌄

Nikon D2x, ISO 250, RAW.
150 mm (225 mm equivalent).
1/1250 second, f4.5

Most things have been photographed countless times, but by exploiting lighting effects (like the sunset light picking out the edges of these old kasbahs) and composition, it is still possible to take a shot that stands out and looks both atmospheric and visually pleasing.

Composition for meaning

Mention composition, and many people will think of the rule of thirds and other compositional conventions. Yet, whilst these rules can make your pictures more balanced and visually pleasing, composition is a powerful tool that can also be used to introduce meaning into your pictures.

The most important thing that you can do when you are about to take a picture is to stop and think. Too many people march up to their subject, whip out their camera and snap off a shot with little or no thought and then move on. The result is likely to be a unmemorable record shot, with little or no creativity. Obviously, if you are in a fast-moving situation and only have a split second to take a picture, then you just have to get on with it, but, if not, spend a little time thinking about what you are trying to achieve and how you should approach your subject.

Many photographers are familiar with the idea that they should interact with people that they are photographing, but this overlooks the most crucial relationship in your photography: that with the person who is looking at your finished picture. We are all bombarded by countless images everyday, and something has to stand out for us to spend more than a split second before moving on to the next one.

A good photograph will elicit some sort of response from the person looking at it. You might be amazed finally to be seeing Angkor Wat, for example, but the person looking at your pictures won't have that emotion. Your picture will need to have some greater depth or visual interest in order to stand out. If you don't consider this in advance, then their most likely response will be one of boredom or simple disinterest.

The crucial question to ask yourself is what is it about the subject that makes you want to take a picture? Try to drill your thoughts down to what you find remarkable about the subject, in the true sense of the word. If someone were to be standing next to you, what would you point out and remark upon.

You obviously can't work some deep political or social significance into every photograph, but you should try to ensure that it at least has a point! The meaning that you are trying to convey can sometimes be very simple: 'this is big', 'this is incongruous' or even 'this person has an interesting face'. Even simple ideas like these, can be the first step to creating a considered and effective image.

Chicken in a basket, on the streets of Kolkata, India ∧

Nikon D2x, ISO 100, RAW.
12 mm lens (18 mm equivalent).
1/200 second, f4.5

Although, for those of a certain age, the phrase chicken in a basket is mildly amusing on its own, I wanted to take a shot that showed the close proximity of the basket of chickens to day-to-day life on the streets of Kolkata. As I travel I am constantly looking to illustrate themes that might one day sell: I have to confess that this picture is a part of my 'bird-flu' collection. Rather than have to caption the closeness between the people and the birds, I chose an angle and a viewpoint that meant that the crowded street was in the background. This gave a sense of place, as well as an idea of people living close to poultry. If I had just shot from the obvious place, I would have had a fairly featureless wall as the background, which would not have been so effective.

Pre-visualize and assess

Once you have decided on your reason for taking a photograph, you have to work out how to convey this to the person viewing it. Don't rely on being there to tell them something or having to explain your intentions with a caption: a successful photograph will include the explanation in the picture. If something is funny or incongruous, then you need to include the reason why this is so in the frame. If someone is doing something interesting or has a characterful face, then make sure to show this.

Try to get into the habit of pre-visualizing how you want your picture to turn out, before you start shooting. Assess how the different creative decisions you make – from lens choice to **viewpoint** – will affect the picture.

This can be a difficult skill to master, but it is worth persevering. You can even use it to practise your photography when you can't take pictures, such as when commuting or even driving a car. Look at a subject and imagine how you would photograph it. Once you have developed the skill of pre-visualizing then you will be able to take pictures faster, and come away with more considered and successful images that you are proud to show to your friends and that they will be happy to see!

On the next few pages I have set out my own creative workflow, which contains things that I consider when pre-visualizing and composing pictures.

Creative workflow

It is all very well advocating pre-visualization and encouraging creativity, but how should you approach the practical steps of creating your photograph? With such a range of technical and creative choices, many people don't know where to start and so give in to the temptation to just point and shoot.

To make the creative process seem less daunting, I have broken it down into a seven-point plan, covering some of the technical and creative decisions that you should consider when approaching a new subject. They won't necessarily be addressed in this order and neither will the progression be linear – subsequent decisions might cause you to backtrack and rethink the viewpoint or lens choice – but this is a good place to start.

All of these steps are expanded upon in subsequent pages. You don't have to follow them every time you take a picture but, once you understand the various decisions that go into creative picture-taking, you can decide when and how to apply them.

1 Consider the combination of objects in the frame
'Mise en scène' describes the objects that you put into the frame, either for purely visual reasons or to create an extra level of meaning. Combining your subject with a more attractive foreground can make a picture look more visually pleasing; choosing a recognizable background can give a sense of place. Combining two objects in the frame may set up meaning and dialogue within your picture through contrast, humour, explanation or subversion.

2 Consider your angle
Don't just take a picture as soon as you see your subject; think whether there is a better angle a few feet away, or even from a completely different side. You might want to change the background, find a new way of looking at a subject, to combine objects or to make the most of light coming from a particular direction.

3 Consider your viewpoint
Once you have worked out the angle, then look for different viewpoints. Rather than just shooting everything from the same height, look for higher and lower points of view. Not only will this change the nature of the shot but it can set up distortions and different power relations in your picture. High

viewpoints are perfect for getting a view over a city or a crowd of people. Low angles can cut out a confusing background and also work better for pictures of children.

4 Consider a vertical orientation
Believe it or not, your camera works just as well vertically as it does in the more usual horizontal orientation. Consider whether your picture will be more effective if you shoot with the camera vertical.

1 Mise en scène
Autumn in St James's Park, London, England ◄

Nikon D3x, ISO 250, RAW
175 mm. 1/400 second, f8

I wanted a shot that showed people sitting in the park in the Autumn sunshine. The mass of leaves fills half the frame, and all but shouts 'Autumn'. Combining this with the people on the bench and the backlit deckchairs conveys this meaning.

2 Change your angle
Elephant temple festival, Kochi, Kerala, India ◄

Nikon D3x, ISO 200, RAW
26 mm. 1/200 second, f6.3

If I had shot these elephants from the front, I could have included a couple of them in the frame. Shooting from the side creates a strong diagonal and allowed me to include the whole line of them, as well as the acolytes and pilgrims that were standing in front.

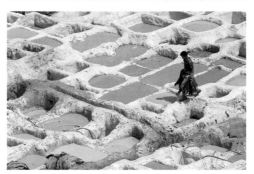

3 Change your viewpoint
Looking down onto the tanneries, Fes, Morocco ◄

Nikon D2x, ISO 250, RAW
200 mm (300 mm equivalent). 1/500 second, f13

A high viewpoint has controlled the background of this picture, limiting it to the fairly uniform coloured curing pits, which provide an intriguing contrast to the worker. Choosing a high viewpoint can also be a good way to crop out an overcast sky, as well as providing a more memorable way of looking at the subject.

5 Shoot vertical
Fishing boats,
Essaouira, Morocco ‹

Nikon D2x, ISO 100, RAW
98 mm (147 mm equivalent).
1/400 second, f8

I wanted to show the way that the prows of these traditional blue fishing boats were intertwined. The best way to show this was to use the vertical orientation to isolate this particular detail and fill the frame with colour and repetition.

5 Select which lens to use

The choice of lens can affect a number of elements in the picture. On the most simple level the power of the lens will dictate the level of magnification and the crop of the picture. Creatively, each lens will give a different effective perspective and impart its own characteristic feel to your picture. A **wide-angle lens** will tend to give more distortion and a greater **depth of field** and, as they tend to be used closer to your subject, they have the effect of exaggerating perspective and making objects seem further apart. A **telephoto lens**, on the other hand, will appear to compress perspective, making objects appear closer together. It also has a shallower depth of field.

6 Calculate the exposure, prioritizing aperture or shutter speed

Exposure is about more than just letting the right amount of light into the camera. The choice of shutter speed and aperture will have a significant creative effect on your picture. Rather than allowing your camera to set them, take control yourself and work in the extremes. This will make your pictures stand out. If there is movement in the subject, then you should give precedence to the shutter speed. This will control how the movement is reproduced: either frozen or blurred. If there is no movement, then give primacy to the depth of field, which is controlled by the aperture.

The choice between shutter speed and aperture is consider in greater depth on page 96.

7 Work out your composition

The rules of composition are a series of conventions intended to make your image look balanced.

6 Lens choice
Hong Kong skyline,
Hong Kong, China ›

Nikon D2x, ISO 320, RAW
130 mm (195 mm equivalent).
1/13 second, f2.8. Tripod

Shooting from across the harbour with a telephoto lens has filled the frame with the buildings and had the effect of compressing the apparent perspective, making them look denser and closer together than they are in reality.

6 Aperture or shutter speed
Arabic script,
Marrakech, Morocco ›

Nikon D2x, ISO 320, RAW
42 mm (63 mm equivalent).
1/80 second, f3.5

A wide aperture has given a shallow depth of field and a side angle has given a strong receding diagonal, where the depth of field falls off markedly. The viewer's attention is drawn to the sharp part of the script by the focus and the diagonal.

7 Composition
Circling a religious cairn,
Ulaan Batur, Mongolia ›

Nikon F4, Provia 100 ASA film.
200 mm lens. Exposure not noted

This religious cairn of stones was on a small hill on the outskirts of Ulaan Batur. The picture has been composed with the subject at the very edge of the frame with a strong diagonal leading the viewer's eye to the subject.

However, rather than slavishly following these rules, break them and exaggerate them, if that is what will give you a better picture. Try to fill the frame with your subject, but don't place the subject in the centre of the frame, and leave space for any movement.

There are also a series of compositional devices that you can choose to consider in your picture to make it more effective, such as strong diagonals, frames and even focus.

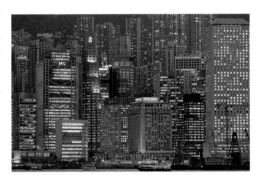

Mise en scène

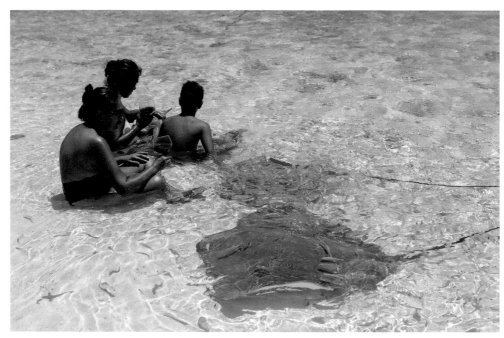

**Rays and picnickers,
Moorea, French Polynesia** ‹

Nikon D2x, ISO 100, RAW.
28 mm (42 mm equivalent).
1/320 second, f5.3

I was trying to photograph the rays on this beach from a wildlife point of view, and trying to crop out the holidaymakers from the shot. Looking around I noticed these people sitting in the shallow water eating and drinking, and being hassled for scraps by the rays. What attracted me to the shot were the large red wine glasses that they were drinking from. To me this is just so typically French: not just drinking red wine in the tropics, but drinking it from such extravagant glasses! The red wine glasses seem to shout 'French', and the rays 'Polynesia'. By changing my angle so I could photograph the two together, I created a shot that says French Polynesia far more effectively than either of the elements on their own.

If you photograph an object on its own, then you will merely have recorded what it looks like, but if you photograph it combined with something else, then you set up a relationship within your picture. This can introduce levels of meaning or can be used to simply create a more complex and visually stimulating picture.

In theatre and film, the combination and placement of objects on the stage or the screen is known as *mise en scène*, quite literally the things that are put in the scene. In these media, everything that appears does so for a considered reason. By applying the theory of mise en scène to stills photography and thinking carefully about the objects in the frame and how they combine, you will produce images that are more meaningful and individual.

Controlling the background

The simplest element to control is the background to your picture. Shoot your subject in front of an appropriate background to set up a simple dialogue.

This will give your picture a sense of place and give the viewer more information about the subject than a portrait with a plain background. Sometimes you will have to change your angle to make an element combine with the background; on other occasions it will happen automatically and all you will have to do is see it. The background can be thrown out of focus

Aeng Man, Kengtung, Burma ‹

Nikon F4, Velvia 50 ASA film.
Exposure and lens not noted

I came across this man and his son in traditional dress while trekking. They were happy to be photographed. The half-length portrait of the man didn't really work. I was using a mid-range zoom, so zoomed out slightly to show the man with his son, which gives a more interesting image and changes the whole emphasis of the portrait. The subject ceases to be 'a man' and is now 'a father' with his son.

**Naga Sadhu from
Juna Akhara, Kumbh Mela,
Ujjain, India** >

Nikon F5, Provia 100 ASA film.
Lens and exposure not noted

The naga sadhus walk round
completely naked and sport
long dreadlocks. They are
regarded as living saints by
some devout Hindus but also
have a reputation for fiercely
defending themselves and
their religion with swords
and tridents. They don't take
perceived insults lightly. I had
got to know this sadhu and his
brother at an earlier festival,
so tracked them down with
copies of pictures I had shot.
I was sitting in their ashram
at the festival when this man
got up for a scratch and to
see what was happening. The
pilgrims filing through the
camp look somewhat shocked
at his nakedness and I was able
to snap a couple of images
from this privileged position.
The combination of the two
elements in the picture is
what makes it so effective.

**Masked characters, Lao New
Year, Luang Prabang, Laos** >

Nikon D2x, ISO 200, RAW.
24 mm (36 mm equivalent).
1/640 second, f6.0

These mythical masked char-
acters are emblematic of the
town of Luang Prabang. They
are part of the Lao New Year
procession and then dance in a
monastery courtyard. At the end
of the procession I saw these
characters moving towards a
group of seated dignitaries.
Assuming they were about to
dance for them, I positioned
myself so that if they did, I would
have this famous monastery
building as a backdrop. Luckily
I judged things just right, and
I was able to photograph the
dancing from the front, and with
an atmospheric background
that gives a real sense of place
to the shot.

with a shallow depth of field so that it doesn't conflict
with the subject, or photographed with a broader
depth of field so that it is more prominent.

Shooting a portrait with a significant background
is a good way to show more about them than a
simple picture of what their face looks like. This style
of picture is known as an environmental portrait
as it includes information about your subject's
environment, to show something about them.

Combining objects in the frame

You can also create meaning by combining individual
objects in the frame. This gives you a great deal of
creative freedom, depending on the objects
themselves and how you combine them.
Combinations can be made to convey the following:

- Show scale by photographing a recognizable
 person or object next to a much larger object,
 such as a small boat passing a towering glacier.
- Undermine an object by introducing a contrast,
 for instance by photographing someone begging
 outside an expensive restaurant.
- Create humour, possibly by contrasting strange
 objects or showing someone's reaction or surprise
 to something.
- Show incongruity by photographing your subject
 next to something where it really doesn't fit.
- Explain or qualify the meaning or purpose of an
 object by illustrating its nature or function.
- Impart a sense of place by photographing an
 object or person with something that is associated
 with a particular location.

Superfluous sign, top of the Jungfraujoch, Switzerland ‹

Nikon D2x, ISO 100, RAW.
32 mm (48 mm equivalent).
1/800 second, f10

A lot of people like to photograph amusing signs on their travels, but make sure that you include why a sign is amusing in the picture. This picture was taken by the highest railway station in Europe. This railway burrows through the Eiger mountain and emerges on the top of the Jungfraujoch! Looking down onto clouds from the top of a snow-capped mountain, this has to be the most superfluous sign in the world!

Mise en scène for visual reasons

You don't just have to use the idea of mise en scène to produce meaningful pictures; you can also combine objects in the frame solely for compositional and visual reasons. For instance, if you are photographing a building in a city and there is a dead space at the front of your image, you might choose to select an **angle** that includes a flower bed or even a road sign in the foreground. Similarly, you can mask a dull sky by shooting from underneath a tree and having a few out-of-focus leaves forming an arch. You can always produce a virtually unique photograph by including a person in the frame. This might be a local or even a group of tourists, whose reactions to the sight you are photographing may be the key element of the picture.

 If you are photographing one of the great travel icons, such as the Pyramids of Giza or the Grand Canyon, try to include an interesting object in the foreground, such as a local trader or a unique vehicle. In these instances, you might prefer to shoot with a greater **depth of field** to make sure that foreground and background are both sharp.

Buddhist monk in an orange doorway Keng Tung, Burma ‹

Nikon F4, Provia 100 ASA film. Lens and exposure not noted

Mise en scène doesn't just have to be used to convey a deep meaning; sometimes it can be used to create a visually intriguing and interesting photograph. Walking through the town of Keng Tung in the Eastern Shan State of Burma I noticed this monk standing in an orange doorway. I was struck by the similarity of colours and so composed the picture to enhance the link between the monk and his surroundings.

Angle and viewpoint

Thinking about the angle and viewpoint of your picture is a simple photographic technique that can be exploited no matter what type of camera you have. It utilizes the most accessible yet powerful of photographic tools – your creativity.

Angle

Most subjects have an obvious angle from which they are usually photographed and, for the great iconic travel sites around the world, these are instantly familiar. But they are seldom the only possibilities: by selecting a different angle, you can produce a shot that is less familiar and more interesting. Sometimes the angle will be dictated by access or by the available light but a creative photographer usually has some level of choice.

The classic example is the Taj Mahal in India. The vast majority of the pictures that you see will be taken from the gardens in front: either from the entrance gate or the raised dais about halfway down, where Princess Diana famously posed morosely for the cameras. There is nothing wrong with these shots but there are a number of more creative angles that you could choose. Only a fraction of the people who visit the Taj Mahal ever view the back of the building from across the river, for example, yet this is a far more atmospheric angle and you can often have it all to yourself. It would be a shame completely to reject the more obvious angles out of hand but make sure you take other, less familiar ones as well. (See pages 36-37 and page 68).

You don't have to move far to get a significantly different angle. By avoiding the face-on view of a building; moving to one side to shoot through an arch or including a flower bed in the foreground, you can create a more unusual shot. If you are taking a portrait, shooting from the side might create an interesting profile, or enable you to show someone looking out across a sweeping landscape by placing them in front of a completely different background.

Even changing the angle by a few metres can give a completely different shot, moving obstructions from the frame, altering the foreground or changing the way your subject interacts with the background.

Viewpoint

It is often all to easy to guess the height of a photographer from his or her pictures: too many photographs are taken from eye level because it

is easy and few people stop to think of doing something different. A good photographer, however, will be forever scrabbling around on the floor or climbing up walls and furniture in order to find a more unique viewpoint. As with most things in photography, the most striking results come from

Man holding bird cages, Bird market, Hong Kong, China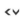

Nikon F4, Provia 100 ASA film. Lens and exposure not noted

Moving just a few feet can completely change an image and give you a wildly different picture. When I shot the face-on portrait (see below) it just felt too staged and posed, even though it probably shows the man's face far better. By walking to his side and shooting through the birdcage I was able to get a more engaging image. This angle has also improved the light on his face and, as he was intrigued by what I was doing, his expression is more interesting. The bird was hopping all over the cage, so I had to take a few shots to get it in the frame as well.

Taj Mahal in a misty sunrise from across the Yamuna River, Rajasthan, India ◄

Nikon F5, 100 ASA Provia film. Lens and exposure not noted.

Everyone is familiar with the front view of the Taj Mahal but if you shoot across the Yamuna River you can get a much more evocative angle, especially in the misty light at sunrise. When this view is combined with a ferry boat and a fisherman, then it makes a unique and timeless image; a world away from the more familiar angles that seem to grace every Indian takeaway food menu!

Ghost Crab on Cousine Island, Seychelles ►

Nikon D2x, ISO 100, RAW. 17 mm (25 mm equivalent). 1/640 second, f7.1

Photograph a small creature like this Ghost Crab from above and you will just get the sand as a background, but lie on the ground and photograph a crab's-eye view and you can have the beach, sea and sky as an atmospheric backdrop that gives a sense of place to the picture. I used a medium aperture to give enough depth of field to compensate for any focusing errors on the small crab, but still have an out of focus background. I simply had to wait for this inquisitive little fellow to approach close enough to photographed.

wildly exaggerating visual effects. Standing on tip-toe or slightly bending your knees won't make much difference to your pictures; to really change the viewpoint, get up high or right down low.

Shooting high

On a practical level, shooting from a higher angle is a great way of clearing clutter from a shot. You can look over the heads of a crowd and cut a disappointing sky from the shot completely. Traffic or electric wires can be removed by getting up high and shooting downwards. More importantly, a high viewpoint will give you an entirely different outlook. You can use it to exaggerate the vertiginous effect of looking down from a tall building or to get a classic bird's eye view of a city. Try to find an unfamiliar view of familiar things. Looking down on a town square, for instance, will give a different interpretation to a picture taken at ground level. If the high view is not a regular

> ⬚ **Digital compact**
> If you have a compact or a bridge camera with a tilting LCD screen, then it is much easier to take pictures from a higher or lower viewpoint. You can shoot from below without having to lie on the ground to look through the optical viewfinder, and you can easily compose with the camera held above your head and the screen pointing downwards.

vantage point open to the public, then you are on the way to creating a unique picture.

With a bit of practice you can easily locate high viewpoints. It might be the terrace of a bar or café, a car-park or even just a fire escape leading to some flats. At times, you might have to ask for permission to access private property for the best view. You will need a thick skin to get to some of these vantage points but usually all you have to do is ask. I once had to climb through a dining room window and on to the roof of the Peace Hotel to get a shot of the Shanghai Bund. I had permission from the Media Relations Officer but he asked me not to tell anyone in case he got in to trouble. Knowing that this might be my only chance

Mannequin, Marrakech, Morocco ◄

Nikon D2x, ISO 250, RAW. 19 mm (28 mm equivalent). 1/250 second, f3.2

Changing the angle gave a different background to the picture, showing why this Western mannequin is so incongruous in the souks of Marrakech. On its own, it could have been in a trendy Western market, in the souks of Marrakech it looks decidedly out of place. The angle showed this in a single shot.

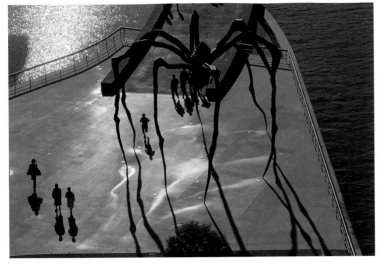

Nikon D2x, ISO 100, RAW. 22 mm (33 mm equivalent). 1/1250 sec. f8

This high viewpoint, shot from a pedestrian walkway over the River Nervión gives a unique view of the statue, cutting out the sky and accentuating the long shadows thrown by the setting sun. I simply had to wait until the right combination of passers-by occurred.

more dominant. This can work well for some portraits, especially of children and people in the developing world who aren't always given a fair representation in photographs. By shooting from below you can place your subject against a blue sky and avoid potential distracting backgrounds. It can also be a useful way of cropping onlookers out of a picture.

Shooting upwards often gives a level of distortion, especially if you are shooting with a **wide-angle lens**. Some people dislike this effect but I think it can add dynamism to pictures. For objects that tower above you, it is possible to take low viewpoint shots with a wide-angle lens just by walking closer and tilting up the camera. This creates the effect of **converging parallels**, whereby parallel lines appear to narrow to a point; it often happens when photographing tall buildings.

Some film **SLRs** have a removable prism, which allows you to look straight down in to the camera for low viewpoint shots rather than crawling around on the floor. If you shoot with a **DSLR** or an SLR without a removable prism, it is sometimes possible to buy a right angle finder that makes composing low viewpoint shots much easier.

> ① **Pro tip**
> Sometimes it is possible to create a higher viewpoint simply by holding the camera above your head: a technique that is often used by news photographers. With a bit of practice you can aim the camera quite accurately to shoot over people's heads or look down on your subject. (See below).

to shoot at this vantage point, I stayed up on the roof for hours until it got dark and I could take some night shots. I had to make my escape through a kitchen window, much to the consternation of the staff.

Shooting low

Shooting from a low angle is nearly always possible, although it usually means having to grovel around on the ground, so you are likely to get some funny looks and end up with dirty clothes.

Taking pictures from a low viewpoint looking up can create a completely different power relation with your subject, making them look bigger and

Street vendor, Delhi, India ►

Nikon D2x, ISO 100, RAW 12 mm (18 mm equivalent). 1/200 second, f6.3

Walking through the back streets of Old Delhi, I saw this vendor carrying a tray of food. I wanted to get a shot looking down on the tray, but with no suitable vantage point I simple ran behind him and held my camera over his head to create a looking down viewpoint. A difficult technique to master, but worth the effort.

Shoot vertical

Your camera is a versatile tool: contrary to popular belief, it will work vertically just as well as it does horizontally! Yet most people take all of their pictures with the camera in a horizontal orientation, whether the subject suits it or not. The result can be images with poor composition, large areas of dead space and not much impact.

The vertical orientation is often referred to as 'portrait' and the horizontal orientation as 'landscape' in the erroneous belief that you should always shoot portraits vertically and landscape shots horizontally. I don't hold to this and so prefer to use the terms 'horizontal' and 'vertical'.

Just about any subject can lend itself to a vertical treatment. A good way to train yourself is to try to shoot a vertical and horizontal shot of the same subject. If you shoot creatively and think about the composition, there is no reason why you can't take a great shot of the same subject in both horizontal and vertical orientations.

Sometimes shooting vertical is a necessity: if you are photographing a tall building or a tree, it might be the only way that you can fit everything in. Certainly, just moving back and using a wider lens could give you a very poor composition. Shooting vertical can also be used to allow a tighter, more immediate crop that will remove conflicting people and objects from the frame.

Shooting vertically with a **wide-angle lens** is a great way to include a lot of the foreground in a picture. You can look down on an object in the foreground and still be photographing whatever is in the background. In these instances the inherent **depth of field** given by a wide-angle lens should mean that all of the picture is in focus.

Hoodoos in Bryce Canyon, Utah, USA ⌃

Nikon D2x, 100 ISO, RAW. 190 mm (285 mm equivalent). 1/250 second, f7.1

The remarkable thing about these rock formations is that they are so big. There is a wide sweep of them, but I wanted to show their size, not their proliferation. Shooting vertically and filling the frame with a few of the hoodoos shows their size; which is accentuated by waiting for a couple of people to walk into the shot to give a scale.

ⓘ **Pro tip**
Shooting verticals is vital if you are trying to sell some of your pictures to publications, since many magazines use more vertical than horizontal shots. It also gives you a chance of getting a prestigious (and lucrative) cover shot.

Focus on

Pilgrim with a prayer wheel at Jokhang Temple
Lhasa, Tibet

I was sitting among the pilgrims outside the Jokhang Temple, quietly and discreetly taking pictures. I had been there for at least an hour and people had got used to my presence and were pretty much ignoring me. I had shot a number of portraits and was looking for something a little different.

Although it doesn't show a face, to me this image is still a portrait as it conveys a lot of information about the subject. It was taken in a shady courtyard, so the light levels were low. The shallow depth of field and the relatively slow shutter speed have given a pleasing level of blur to the prayer wheel. I had to take a number of shots to get the bead of the prayer wheel in the right position. If I had been shooting digital, I would probably have increased the sensitivity to increase the depth of field by an extra stop and thus have a little more of the prayer book in focus.

The corner of the yellow towelling was too light in the finished picture and was slightly distracting, so I used the burn tool in Photoshop to darken it slightly, making the picture more balanced.

⊕ Find out more **>**

Nikon F5, Fuji Provia 100 film. 200 mm lens.

Lens choice

In the Preparation section, I covered the types of lenses that you should consider taking with you on your travels, based upon the field of view and the magnification required (see page 24). However, there is a lot more to lenses than their power and a lot more to selecting them than just achieving the crop you want.

Essentially, there are only two types of lens: the **wide-angle** and the **telephoto**. The **standard lens**, however useful and undervalued, is merely the midpoint between the two.

Although you can achieve a similar subject magnification and effective **field of view** while shooting with lenses of different **focal lengths** simply by varying the subject distance, the resulting pictures will look significantly different from each other in a number of ways. This is because each focal length has inherent visual characteristics of distortion, **depth of field** and apparent perspective. The greater the difference between the focal length of a lens and that of a standard lens (40-50 mm), the more profound the effect of these visual characteristics will be. In other words, a super-wide lens will demonstrate more extreme effects than a normal wide-angle lens, and a strong telephoto lens will be more extreme than a mild one.

Some photographers prefer the more 'normal' perspective and distortion of standard, mild telephoto and weak wide-angle lenses, but I like to work in the extremes. I love the unique photographic quality that super wide-angle and strong telephoto lenses give; they allow you to create an image that is as far removed as possible from that seen by the human eye. I also prefer images where the depth of field covers most of the picture or virtually nothing at all.

Apparent perspective

When I talk in this book about the perspective given by a lens, I am referring to the 'apparent' or 'effective' perspective. Although people often talk about a lens having a given perspective, in fact, perspective is solely a property of the subject distance. If you shoot something from the same subject distance with a 20 mm lens and a 100 mm lens and then enlarge the 20 mm shot so that the subject in each shot is the same size, the perspective of each picture will be the same. The reason that lenses *appear* to have an

inherent perspective is that we tend to use them for particular subject distances. Shooting a subject from far away (which you would normally do with a telephoto lens) gives a more flattened, compressed perspective. Shooting a subject up close (which you would normally do with a wide-angle lens) gives a more exaggerated perspective.

A standard lens gives a similar apparent perspective to the human eye because it has a similar

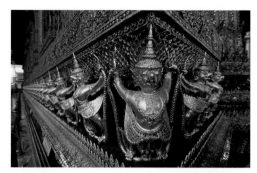

Grand Palace, Bangkok, Thailand ◀

Nikon F5, Provia 100 ASA film. 17 mm lens. Exposure not noted

There is no 'correct' lens for any subject; any focal length can be used for creative effect. Shooting close with a wide-angle lens has caused the right angle of this building to distort to a more extreme angle. The figures recede and appear some distance away from each other as the perspective recedes.

Grand Palace, Bangkok, Thailand ◀

Nikon F5, Provia 100 ASA film. 200 mm lens. Exposure not noted

The same subject taken with a powerful telephoto lens: figures appear to be a similar size and closer together than when shot with a wide-angle lens. Using a wide aperture has resulted in a shallow depth of field so only the first figure is in focus. With the wide-angle shot, everything is in focus.

Camel drover, Pushkar Mela, Rajasthan, India ◀

Nikon D2x, ISO 250, RAW. 145 mm (217 mm equivalent). 1/250 second, f5.0

Shooting with this telephoto lens has made the subject appear much closer to the background than a wide-angle lens would have done, giving a sense of place, but allowing the background to be rendered out of focus due to the inherently shallow depth of field.

As this image was shot with a crop-sensor camera, it was not possible to throw the background completely out of focus, so this image was post-processed to effectively reduce the depth of field. See page 272-273.

You can see other examples showing the visual characteristics of a powerful telephoto lens on pages 36-37; 44-45 and 118-119.

Statue on Charles Bridge, Prague, Czech Republic ◄

Nikon D3, 200 ISO, RAW.
1/1000 second, f 7.1
Left: 70 mm
Right: 300 mm

This simple illustration shows how changing a lens and subject distance can keep the magnification of the subject almost the same size, but can completely change the relationship with the background.

In the shot taken with a 70 mm lens, the cathedral is hardly visible. By walking backwards to increase the distance between me and the statue and using a 300 mm lens, I am able to compensate for the increased power of the lens, and photograph the statue at approximately the same size while magnifying the cathedral in the background. A 300 mm lens is 4 times more powerful than a 70 mm lens, and so the background is 4 times bigger in the frame. The distance to the background is so great that walking back slightly has virtually no effect on this magnification of the background. Changing the subject distance has also changed the position of the cathedral in the frame.

magnification. A telephoto lens has the effect of apparently compressing the perspective of an image because we tend to use it to photograph things at a distance. This makes objects seem closer together in the final picture and makes both close and more distant objects appear of a similar size. Conversely, a wide-angle lens has an apparent exaggerated perspective because we tend to use it to photograph things that are close to us. This makes objects appear further apart and causes objects that are close to us to look larger than more distant objects. Thanks to these apparent or effective characteristics, you can use the lens selection to alter the relationship between elements within your picture.

For instance, if you were photographing the ostriches on page 190 with a wide-angle lens instead of a powerful telephoto, you would have to get up close to the ostriches to make them appear the same size in the final picture, and the sun would just be a small dot in the distance. By moving a long way back and shooting with an extreme telephoto lens, the ostriches can be reproduced the same size but the sun is greatly magnified. Shooting the sun with a 600 mm lens radically alters its magnification, making it almost five times bigger than it would be if the picture were shot with a 35 mm wide-angle lens. The size of the subject (in this case the ostriches) can be maintained by increasing the subject distance. Walking a hundred or so metres backwards has not significantly altered the distance to the sun but does have a substantial effect on the size of the ostriches. The overall effect is to make the background of a picture appear bigger and closer.

Conversely, if you want a subject to stand out from the background, then get in close and shoot with a very wide-angle lens. The exaggeration of perspective from the closer subject distance will

make the subject appear to loom large in the frame and the background will appear further away and much less significant.

A **telephoto lens**'s apparent compression of perspective can also be used to make a series of far-away objects appear closer together, whether it be a crowd of people or a jumbled collection of buildings. The gaps between them are minimized and so a crowd can look far more densely packed than it really is. A wide-angle lens will have the perceived effect of making the gaps look bigger than they are, making people in a crowd appear more individual and spread out.

Convention says that the most pleasing effective perspective for a portrait of the human face is achieved by shooting with a mild telephoto lens: between 70 and 100 mm. Strictly speaking this might be true, but you can create some interesting effects by shooting portraits with a wide-angle or an extreme telephoto lens. A **wide-angle lens** used up close can make the subject seem to lean towards the viewer and appear more engaging, whereas the apparent flatness of an extreme telephoto lens can accentuate symmetry and even the wrinkles of a face.

Subject distance
Changing the focal length will allow you to vary the subject distance and maintain the same crop. I will often use a wider zoom setting just to allow me to stand closer to the action, especially if I am photographing

something like a festival. This allows me to get closer to the action, which often produces a more engaged shot. The slight distortion from shooting close with a wide lens can give a more dynamic picture, and if there are people in the shot then they are more likely to interact with the photographer, and by extension the viewer of the picture. Shooting close also has the advantage that random people won't be able to walk between you and your subject ruining the picture.

Distortion
If you are shooting with a wide-angle lens, the effective exaggeration of perspective that causes near objects to appear bigger and far objects to appear smaller will stretch the relationship between them, resulting in distortion.

This is particularly pronounced when you are shooting buildings and architectural subjects with a wide-angle lens. If the camera is tilted upwards, then the tops of the buildings will appear to converge. The geometric nature of most buildings makes this effect, known as **converging parallels**, more easily distinguishable but it will occur whenever you shoot with a wide-angle lens and tilt the camera. Some photographers dislike this effect – you can buy special (and very expensive) **'shift' lenses** to correct it – but, as with most inherently photographic qualities, I like to exaggerate it. If you tilt a really wide-angle lens upwards, then you can, in effect, drag objects into the frame, distort them and alter the relationship between them. The distortion is most pronounced at the corners of the frame.

Shooting with a wide-angle lens can distort things so much that right-angles are stretched and completely bent out of shape, especially if you shoot from a very close subject distance and use a super-wide lens. The ultimate wide-angle lens, the **fish-eye**, distorts subjects so much that they are actually curved.

Depth of field
A telephoto lens has a much shallower depth of field than a wide-angle lens at a given **aperture**. This means that it can be used to isolate a subject from its surroundings by throwing the background out of focus. The extremely shallow depth of field produced by super-telephoto lenses is sometimes regarded as a problem but it is also a quality that you can exploit to render backgrounds completely out of focus.

Golden Temple complex, Amritsar, Punjab, India ⌄

Nikon D2x, ISO 100, RAW. 12 mm (18 mm equivalent). 1/640 second, f7.1

This image of some of the buildings of the Golden Temple complex shows the inherent characteristics of shooting with an extreme wide-angle lens. Closer objects render much bigger than far away objects, the perspective appears to be distorted, and the buildings all converge. There is a much greater inherent depth of field and all of the scene is sharp.

You can see other examples of pictures that show the visual characteristics of a wide-angle lens on pages 154 (top) and 175.

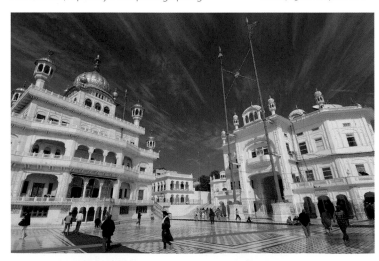

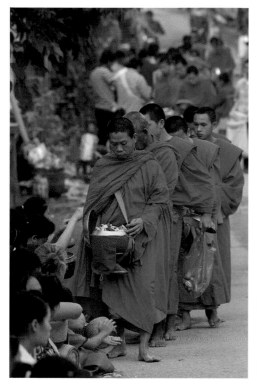

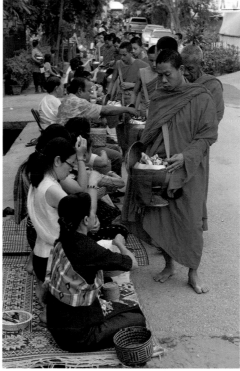

Monks of their morning alms round, Luang Prabang, Laos ‹

Nikon D2x, 640 ISO, RAW.
1/160 second, f 5.0
Left: 180 mm (270 mm equiv.)
Right: 36 mm (54 mm equiv.)

These images show the effect of lens choice and subject distance. The shot on the left was shot from a distance using a telephoto lens. As the line of monks moved closer, I changed lenses and shot the same subject with a wider focal length of 36 mm. On the telephoto shot, the perspective appears compressed: the monks look close together, and of a similar size. There is a shallow depth of field and the line does not appear to recede significantly. Although the wider shot does not use an extreme focal length, it looks significantly different. The size of the monks and the distance between them appears to recede, exaggerating the perspective. The depth of field is greater for the same aperture.

⌾ Digital compact

The built-in zoom on a compact will generally run from a wide-angle to a telephoto setting. This will give you the chance to create some degree of exaggeration of perspective and distortion at the wide-angle end, and some degree of compression of perspective at the telephoto end, but the effect will not be extreme. It is possible to buy adapters for some models to widen or lengthen the existing lens options, in order to make the effect more pronounced.

An extreme wide-angle lens, in contrast, gives a very large depth of field. Again, this can be used to good effect. You can place the subject of your picture close to the camera and off to one side, focus on it and still have the rest of the image sharp.

Zoom lenses

It is worth remembering here that a zoom lens has essentially the same characteristics as the equivalent **prime lens**. So when I refer to a 24 mm wide-angle lens, you can achieve the same effect from a zoom lens on the 24 mm **focal length** setting. The kit lenses that come with many **DSLR**s are usually mid-range zooms that run from a mild wide-angle to a mild telephoto. These are useful for many general picture-taking scenarios but will lack the extremes at either end that really allow you to distort and manage perspective. To get these you will have to invest in a wider-angle or a stronger telephoto lens.

The digital effect

The crop effect produced by most DSLRs that have **sensors** smaller than a 35 mm frame (see page 25) does not affect the perspective, distortion or depth of field of the lens, it merely crops into the image, giving the same result as you would get if you made a print from a film camera and then cut an inch or so off either side. Any change in perspective occurs only if you increase the subject distance in order to fit the subject in to the frame. If you zoom out, using a less powerful focal length to change the crop, then the perspective is completely unaltered. The apparent extra depth of field given by a DSLR with a **crop sensor** arises because you have to use a lens with a lower focal length on a crop sensor to get the same object size as on a 35 mm film camera. If the camera has a crop factor of 1.5x, then to get approximately the same object size as a 35 mm camera with a 50 mm lens, you would have to use a 35 mm lens, which inherently gives you more depth of field.

Composition for balance

Although the composition of your picture can be a powerful way to convey meaning, it is most usually associated with the series of visual conventions that make your pictures more pleasing to look at by creating balance. Once you have learnt what they are, you will be able to appreciate how they work in images that you see every day. Look at images that you like and those that you don't like; analyze their composition to see what makes them look balanced or not, and get ideas to enhance your own photography.

Rule of thirds

We are all familiar with pictures that show a person with their head in the dead centre of the frame, cut off at the waist, with vast amounts of sky above them and wasted space on either side; or a famous landmark slap bang in the middle of the picture, dwarfed by a featureless sky and with an interesting foreground completely cropped out.

These pictures break the most familiar compositional rule: the rule of thirds, which states that if you divide the frame up into thirds, your picture will look more balanced if the focal point of the picture lies on the dividing line between those thirds, not stuck in the middle. Apparently, one of the reasons that this format is pleasing to us is because it mirrors the composition of the human face, where the eyes lie close to the upper third line and the

Alpacas, Machu Picchu, Peru ❯

Nikon D2x, ISO 160, RAW.
13 mm (19 mm equivalent).
1/125 second, f8. Fill-in flash.

Composing the picture so that the main alpaca is facing into the frame makes this picture more balanced – a simple matter of leaving more space in front of a subject than behind. I have cropped the picture to preserve the shadow, and exaggerated the rule of thirds by placing the horizon at the very top of the frame, making the mountains appear bigger.

You can see some examples of leaving space for motion in the frame on pages 104 and 105.

Fisherman, Havana, Cuba ❮

Nikon F4, 100 ISO Film.
80-200 mm lens
Exposure not noted.

This fisherman was floating in a car inner tube off the Malecon, the Havana waterfront. The image conforms to the rule of thirds, with the picture composed so that the fisherman lies on one of the anchor points which are formed when two of the third lines cross.

mouth falls on the lower third. Thus, in a landscape shot the horizon should lie on one of the third lines, not across the centre.

The rule of thirds doesn't just work in one plane. A picture can be divided up into both horizontal and vertical thirds, with the horizon on a horizontal third line and the subject on a vertical third line. You can also use the rule of thirds to place people in a portrait, or when composing a wildlife shot.

The points where the horizontal and vertical lines intersect are sometimes called anchor points. Composing your picture so that important objects fall at or near an anchor point can help to achieve a strong composition.

Rule of not centred

A good photographer should always break the rules to create an image that is visually different and exciting, and the rule of thirds is no exception. I prefer to refer to it as the 'rule of not centred'. Slavishly placing your subject on one of the lines of thirds can be as dull and prescriptive as having it in the centre of the frame. Be bold and adventurous. If there is a boring foreground and a striking sky, then place the horizon at the very bottom of the picture. Conversely, if the sky is bland but the ground is breathtaking, have the horizon as a narrow strip along the top of the frame. If you are photographing an object or a person, make a daring crop with them at the very edge of the frame. You could even accentuate this by partially cropping them out of the frame.

Direct motion into the frame

Pictures tend to look more balanced if the subject of the image is looking or moving towards the centre of

**Glacier, Svalbard
Archipelago, Norway** ⌃

Nikon D2x, ISO 160, RAW.
155 mm (230 mm equivalent).
1/640 second, f5

This picture exaggerates the
rule of thirds, to great effect. By
composing with the top of the
glacier at the top of the frame
it makes it seem much larger
than if it were placed a third of
the way up the frame. Similarly,
placing the Zodiac boat at the
very bottom of the frame also
accentuates the height of the
glacier compared to the boat.
Without the boat there would
be no real indication of the size
of this glacier. By composing the
shot with a small boat of brightly
coloured people the viewer gets
a real sense of scale. As I was in
a similar boat in choppy water,
I increased the sensitivity slightly
to avoid camera shake.

the frame. If someone is at the edge of a frame
looking outwards, then the viewer of the picture is
likely to wonder what they are looking at and what
they are doing. Unless you want your image to inspire
these questions in the viewer, you should compose
your picture so that the subject is facing inwards.

Leave space for movement
If there is a moving object in your picture, such as an
animal or a vehicle, then the picture will look better if
you leave space for that movement: for instance, if the
movement is from left to right, then leave more space
on the right-hand side of the picture. Even a small
amount of extra space will improve the composition.

Point of interest
It might sound obvious but make sure that your picture
has a point of interest in it. A shot of a long and empty
road stretching into the desert can look good but a
single vehicle will add interest and emphasize the
isolation. If that single vehicle is a Harley, then suddenly

you have an iconic image of the all-American road trip.
Use diagonals and anchor points to draw the viewer's
attention to the point of interest.

Filling the frame
You can give a picture greater impact if you fill the
frame by cropping out any unwanted space around
your subject. This can be done by using a more
powerful lens or by walking a few paces closer to your
subject. A large amount of featureless sky, without any
clouds to add interest, can look boring and dominate
an image. To remove excessive sky at the top of a
picture without zooming in, try tilting the camera
down to include more of an interesting foreground.

Simplicity and avoiding clashes
If a picture has too many competing elements it can
look busy and confusing. Choose an **angle** with a
simpler background; sometimes just taking a few
steps to one side can work wonders. You can further
minimize a confusing background and limit competing

elements in a picture by using **depth of field**. Make sure that the focus point is on the subject of the picture to keep it sharp and that any confusing elements are outside the depth of field, so they are blurred.

You should also avoid clashes in the frame, such as the classic error of having a tree growing out of someone's head! Spend a bit of time scanning around the picture before you take it and you can avoid this happening. Sometimes, just moving a few feet to one side can change the angle enough to stop any clashes.

Cropping

Every picture is cropped in some way; after all, it is the photographer who decides what is kept inside and what is excluded from the frame. If you are deciding to crop out part of the subject, then crop boldly. It should be clear to anyone looking at the picture that you have intended the crop. Instead of having the edge of the frame falling midway across someone's shoe, either have the whole shoe in the frame or crop out on the shin. Note that cropping on or just below a joint (such as a knee or an elbow) looks ugly. Also, try to avoid breaking the line of the frame with strong shapes, such as windows or even clouds wherever possible. It is worth getting into the habit of scanning around the edges of the frame to see where the crop will lie.

What you crop out of a picture can be almost as important as what you decide to include. Excluding a

Hmong woman, near Sapa Vietnam ❯

Nikon D3x, ISO 1000, RAW
62 mm. 1/320 second, f5.0

Cropping in close on a picture can exclude distracting backgrounds and create a more emphatic image. This woman from the Hmong minority in Vietnam has a wonderfully expressive face and I wanted to concentrate all attention on her. by creating a tight crop that excluded all other details.

Climbing Big Daddy, Sossusvlei, Namibia ❮

Nikon D2x, ISO 100, RAW.
185 mm (277 mm equivalent).
1/640 second, f5.0

At 480 m, Big Daddy is reputed to be the tallest sand dune in the world but there was no idea of its scale until these climbers appeared on the ridge. With them in the picture, the true scale of the dunes can be appreciated. Exaggerating the rule of thirds and placing the people close to the edge of the frame accentuates the distance they still have to walk. Placing them a third of the way into the frame would not be so effective.

modern satellite dish from a picture of a remote tribal village will give the impression that the place is far less technologically advanced than it really is. Cropping another tourist from your shot may suggest that you are the only one there, when, in reality, you might be part of a tour group. Try to crop out any extraneous details, such as parked vehicles, telegraph poles or unwanted people near the edges of the frame.

It is best to compose correctly in camera, if you can, but it is inevitable that you will sometimes take a picture with a poor composition. In these instances, all is not lost. You can change the composition in post-production by cropping the image. Essentially, this is the same as zooming and cropping in camera, although if you do it on a computer you will lose quality, as you will be throwing away some of the image information. There is more about cropping in post-production on page 252.

It is worth remembering that the viewfinder on all but the top professional models typically shows only 95% of the finished picture. Experiment with your camera on a tripod to work out just what your viewfinder does and doesn't show.

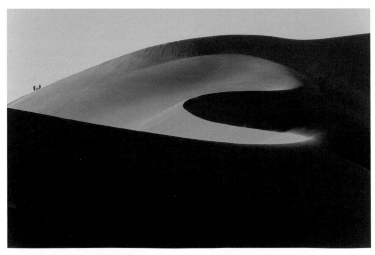

① **Pro tip**
If you are hoping to sell your pictures, then you should be careful of cropping too tightly as this can make an image less useful to a designer who might want to change its shape or even bleed it off the edge of the page. See Taking pictures for sale, page 300

Autofocus

Autofocus is the biggest enemy of good composition. Many **compact cameras** and even the default setting on most **SLR** and **DSLR**s has the **focus point** in the centre of the frame. This subconsciously entices you into pointing the autofocus **sensor** directly at the subject, leading to it ending up in the middle of the picture.

Fortunately, most DSLRs and many compacts and modern SLRs allow you to move the focus point between a choice of a number of different positions. This will range from seven to over fifty focus points, depending on your camera. Some of these are typically on or near the vertical and horizontal third lines. By simply switching the focus to one of the peripheral points, you will bias the composition towards that point. For instance, if you are photographing a vertical portrait, use a focus point closest to the eyes; your composition will instantly improve. Conversely, if you are shooting a landscape and want the land to take up the bottom third of the picture and the sky the top two thirds, then use a sensor near the bottom third line. By

doing this you will naturally compose the picture with these dimensions.

Changing the focus point for each set-up might seem like a lot of trouble, but most cameras allow you to do it very quickly, often using a multifunction button on the back of the camera. When you are familiar with your camera, you will be able to do this without even taking your eye from the viewfinder.

If your camera doesn't allow you to move the focus sensor or you are using an extreme composition where the subject is at the edges of the frame and not covered by a focus sensor, then you will have to focus and then recompose to get an in-focus picture that is also well composed. This can either be done using manual focus or by using some sort of **focus lock**, either a focus-lock button or a single autofocus mode: half press and hold the shutter release button to focus the camera, then recompose. If you or your subject moves slightly, then the focus may not be correct. This will spoil a very close-up portrait in which you want the eyes to be pin sharp, but, in most other instances, the depth of field of the lens will deal with any slight inaccuracies.

Greeting the dawn with conch shells, Shey Gompa, Ladakh, India ➤

Nikon D3x, ISO 200, RAW
44 mm. 1/640 second, f7.1

Every morning, monks blow conch shells from the roof of Shey Gompa to announce the dawn and to signal the morning chanting. Although it meant that I had to lean precariously over the parapet, I wanted to compose the picture showing surrounding scenery and the spectacular cloud formations. To ensure correct focus, even with the subject on the right of the frame, I moved the focus sensor so that it fell over the subject. Combined with a continuous focus mode, this kept the subject sharp, even if the subject distance changed. The picture has space in front of the subject for balance.

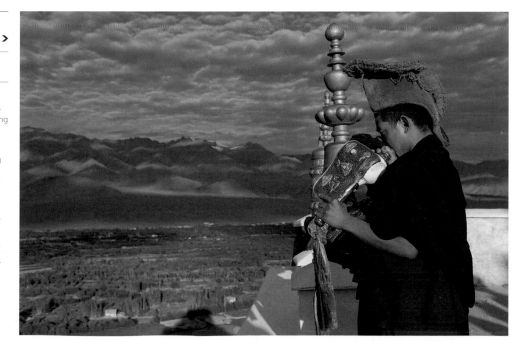

Compositional devices

As well as being aware of composing your pictures to make them appear more balanced, you can utilize a series of compositional devices to make your pictures more effective and visually pleasing.

The thing about compositional devices is that they will often occur naturally; the trick is to notice them and alter your composition to make the most of them. This can be done by changing **angle**, or **view-point** and deciding on lens choice, subject distance and crop. Compositional devices to look out for and incorporate into your pictures are as follows:

Diagonals

Diagonals can add dynamism to your image and lead the viewer's eye into the picture. A diagonal might be a long road stretching into an image or a sweep of buildings. Diagonals are easy to incorporate into the picture; once you start looking for them you might be surprised how often they naturally appear. Also look out for curves and 'S' shapes. These can have a similar effect of leading the eye and are even more dynamic.

It can be easy to create a strong diagonal. Instead of photographing something like a line of people or the facade of a building straight on, move to the side, and shoot from an angle. The closer you are, the tighter the angle and the wider the lens, the more pronounced the diagonal. If you shoot in this way with a **telephoto lens**, then you can focus on the nearest part of the subject and use a wide **aperture** to give a shallow **depth of field**, so the focus falls off and the

El Capitolio, Havana, Cuba ◄

Nikon F4, Provia 100 ASA film. 17-35 mm lens. Exposure not noted

This picture employs a rather sophisticated composition. The Capitolio is the Cuban national assembly, and a building that is kept in good condition. By placing it at the very edge of the frame, with a strong diagonal created by the run-down street, it sets up a relationship between the two components, effectively making a comment on life in Cuba. Diagonals can be created with many subjects, simply by shooting from the side at an angle.

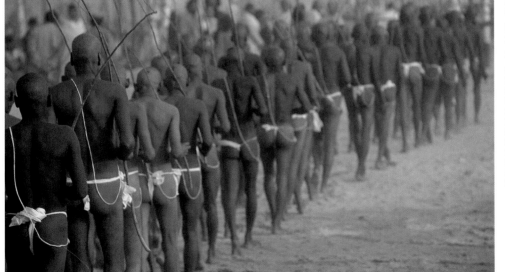

Sadhus undergoing initiation, Maha Kumbh Mela, Allahabad, India ◄

Nikon F5, Provia 100 ASA film. 200 mm. Exposure not noted.

These Indian holy men were in procession and I only had a few seconds to take a picture, as they were walking away from me. Zooming in with a telephoto lens, I was able to fill the frame with this strong diagonal. To cope with the shallow depth of field inherent in telephoto lenses, I focused on the closest person and let the focus fall off as the line stretches into the distance.

rest of the subject renders out of focus. A **wide-angle lens** will create a more dynamic, distorted effect, but the inherently broad depth of field will mean that the majority of the diagonal will be in focus.

A strong diagonal can work particularly well if you have the main subject of the picture at the very edge of frame with a strong diagonal leading towards it. If you are shooting with a telephoto lens, then you will need to be careful to accurately place the point of focus to ensure the desired part of the picture is sharp.

Frames and arches

Having your picture framed by an arch or a window is a great way to add some visual interest to it. It is also a good technique for cropping out a dull sky or any other objects that you don't want in the final picture. Experiment with the depth of field to get the frame both in and out of focus.

Frames can be found or created. The more obvious examples involve shooting through a window or a doorway, but you can also create an apparent frame by shooting under overhanging foliage (see example on page 292-293), or even from a low angle through someone's legs.

If the frame is dark, then it might affect the overall exposure, by fooling the camera meter into taking its darkness into consideration when metering the scene. This can result in the normally lit parts of the scene being overexposed. To avoid this, you should meter through the frame using a **spot meter**.

Focus

It seems odd thinking of focus as a compositional device, but remember that, if you have a picture with a shallow depth of field (see page 106), then anyone viewing the picture will have their eye drawn to the part of the picture that is most sharp. If you ensure that the camera is focused on the part of the subject that you consider to be the most significant, then the person looking at the picture will look at this first and register that it is the most important thing. The rest of the picture, which if you shoot with a shallow depth of field should be pleasantly out of focus, will give a context to the main subject. This technique can be particularly useful if you have a relatively crowded subject, which might make a busy and confusing picture if photographed with a broad depth of field that would render everything in focus.

Priest with Ethiopian cross, Lalibela, Ethiopia ∧

Nikon F5, Provia 400 ASA film. 28-70 mm lens. Exposure not noted

Focus can be used as a compositional device to let the viewer of the picture know what is important and where they should look first. In this instance I wanted to draw attention to the Ethiopian cross and so focused on it, keeping the priest as an out-of-focus background to add a context without distracting.

Berber irrigation system, Sahara Desert, Morocco ‹

Nikon D3x, ISO 100, RAW. 60 mm. 1/125 second, f16

When you look out for them, you can find a number of ways to include a frame in your pictures. In this case this man was framed by the ancient Berber irrigation that he was demonstrating. Once I noticed the frame, I simply changed the angle and the focal length of the lens to include it in the picture.

Exposure

One of the main areas of difficulty for many amateur photographers is getting the correct exposure. People assume that because they have an expensive or sophisticated camera, their pictures should be perfect all the time. Yet this is often not the case, especially in difficult lighting conditions. Pictures sometimes seem too light, with washed-out colours, or so dark that you can hardly see any detail in parts. Sometimes the effect will be subtle; at other times, it will be quite extreme and the picture will be useless.

Under- or **overexposed** photographs don't mean that there is anything wrong with your camera; even the most sophisticated cameras are essentially making an educated guess when it comes to the correct exposure. All sorts of things can affect exposure: the colour of your subject, areas of shadow, light sources in the pictures, high **contrast**, and even the intention of the photographer. Your camera can't read your mind, but by knowing a bit more about exposure and the decisions the camera makes on your behalf, you can work out when to trust it and when you should intervene.

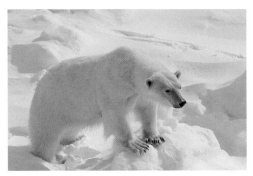

Many photographers maintain that as long as a picture can be corrected in post-processing then exposure doesn't matter. But this takes time, and if you are over-exposing in low light, such as when shooting mountain gorillas, you might end up using a slower **shutter speed** than necessary, introducing **camera shake** to the picture. If you significantly overexpose, then you can lose detail in the highlights.

Before reading on, there are a few definitions opposite that you should understand.

Female polar bear, Svalbard, Norway ◄

Nikon D2x, ISO 160, RAW . 300 mm (450 mm equivalent). 1/1000 second, f9.0

Photographing a polar bear in bright white snow poses a problem at the opposite end of the scale to the gorilla. Most cameras, when pointed at a subject like this, will assume that it is a midtone subject being lit by very bright light. Consequently, the camera would underexpose the picture, giving a very dark, grey result. To get the correct exposure for a subject like this, you might have to override the suggested reading by as much as +2 stops. The light bouncing off the snow gave this picture a pronounced blue cast that I corrected during post-processing. If I had been shooting JPEGs, I would have had to set the white balance to the cloudy or shade setting to warm the image up.

Baby mountain gorilla, Virungas, Democratic Republic of Congo ◄

Nikon F4, Provia 400 ASA film. 35-70 mm lens. Exposure not noted

Metering on this baby mountain gorilla is likely to confuse most camera meters. The subject is very dark, almost black, and was set in some fairly dark foliage. Most cameras would see this as a midtone subject in low light and, consequently, decide to give more exposure, resulting in an overexposed and washed-out image. To get the correct exposure for a subject like this, you might have to override the suggested reading by as much as –2 stops. This gorilla was far more awake than its older relatives and was fascinated by the human visitors.

Exposure

Put quite simply, exposure is the amount of light which hits the **sensor** or film. Although some degree of variance comes into play, due to subjectivity and creativity, there is a *correct exposure* for each shot at which your subject is rendered accurately.

The amount of light needed to make the correct exposure varies depending on the **sensitivity** of the sensor/film. The camera uses the **aperture** (the size of the hole that lets in the light) and the **shutter speed** (the duration of time that light is let in) to control the exposure and let in the correct amount of light needed by the sensor/film. If too much light hits the film/sensor, the picture will be too bright or overexposed. If too little light hits the film/sensor, the picture will be too dark or underexposed.

The amount of light needed for the correct exposure is calculated by using the **light meter** in your camera to measure the brightness or luminance of the subject. This is what photographers mean when they refer to "working out the exposure".

Stop

A stop is a relative unit for measuring exposure. Each stop represents a doubling or a halving of the exposure. In other words, increasing the exposure by a stop means allowing double the light to reach the sensor/film; decreasing the exposure by a stop means you are reducing the light by half. If your picture is overexposed by a stop, it has received twice as much light as the sensor/film actually needed; if it is overexposed by two stops, it has received four times more light. If it is underexposed by a stop it only got half the light it needed, and two stops of underexposure means it has only received a quarter of the light required. Most cameras are incremented in half stops but more sophisticated ones work in third stops, which gives greater control of the exposure.

Sensitivity

The sensitivity of the sensor/film is a measure of how much light it needs to make a correct exposure. On the majority of digital cameras, sensitivity is incremented in thirds of a stop on a scale referred to as **ISO** (from the International Organization for Standardization). Each doubling or halving of a number (which takes three increments) represents a whole stop (shown in **bold** below). Some simple cameras only increment in whole stops. If you change from 100 to 200 ISO, then you double the sensitivity. Similarly, if you reduce the ISO from 640 to 320, then you halve the sensitivity. The lower the number, the lower the sensitivity and the more light is required for a correct exposure.

50	64	80	**100**	125	160	**200**	250	320	**400**	500	640	**800**	1000	1250	**1600**

Sensitivity is a constant. For instance, if a slide film, a **compact camera** and a **DSLR** all have a sensitivity of 100 ISO, they will all need the same amount of light to make the correct exposure and, if you point them at the same thing, you can use the same aperture and shutter-speed settings to achieve it. For film, the scale is sometimes called **ASA** (after the American Standards Association) but the values are essentially the same.

Aperture

Aperture is a measure of the size of the hole that lets light into the lens. Expressed in a unit called an **f-stop** and often shown prefixed by an 'f', it is either controlled by a ring on the lens or through a control on the camera. The smaller the number, the bigger the hole and the more light that is let into the camera. A doubling or halving of an f-stop number changes the exposure by two stops. Thus, if you change the aperture from f4 to f5.6, you reduce the exposure by a stop, and, if you open the aperture from f16 to f8, you increase the exposure by two stops. The aperture is not the actual diameter of the hole but a measure of the light it lets in based upon the **focal length** of the lens. So an aperture of f8 will let in the same amount of light on any lens, even though the physical hole may be a different size. Most lenses are incremented in half stops, with every two increments – or clicks – representing a whole stop of exposure (shown in **bold** below).

f2.8	f3.3	**f4**	f4.8	**f5.6**	f6.7	**f8**	f9.5	**f11**	f13	**f16**	f19	**f22**

If your lens is incremented in third stops, it will be on the following scale, with three increments representing a whole stop (shown in **bold**):

f2.8	f3.2	f3.5	**f4**	f4.5	f5	**f5.6**	f6.3	f7.1	**f8**	f9	f10	**f11**	f13	f14	**f16**	f18	f20	**f22**

Shutter speed

The shutter speed is the length of the exposure. Measured in seconds or fractions of a second, it runs on the following scale:

1	1.5	**2**	3	4	6	**8**	10	**15**	20	**30**	45	**60**	90	**125**	180	**250**	350	**500**	750	**1000**

Apart from 1, the other numbers represent fractions, so 125 is actually 1/125 second; the higher the number, the faster the shutter speed and the shorter the amount of time that the sensor/film is exposed to the light. On this scale, each step is half a stop and each doubling or halving of a number is a whole stop. Most cameras will also be capable of shutter speeds longer than one second and faster than 1/1000 second.

If your camera is incremented in third stops, it will have the following range of shutter speeds, with whole stops shown in **bold**:

1	1.3	1.6	**2**	2.5	3	**4**	5	6	**8**	10	13	**15**	20	25	**30**	40	50	**60**	80	100	**125**	160	200	**250**	320	400	**500**	640	800	**1000**

Exposure metering

In the majority of cases, your camera will calculate the correct exposure without you having to do anything more than tweaking an image slightly in post-processing. However, if you are shooting subjects with very dark or very light colours, or if you get creative by moving the subject from the centre of the frame, or shooting into the light, then your camera might struggle. Understanding how your camera meters, and what can go wrong is the vital first step to achieving better exposures.

Your camera **light meter** continually suggests different exposures when you point the camera at different subjects because the camera is actually measuring the light that is reflected from the subject, not the light that is falling upon it. This reading is affected by the colour and tone of an object: a dark colour will reflect less light than a lighter colour. Unfortunately, only a couple of the most sophisticated cameras on the market can actually distinguish the colour of the object you are photographing.

Most camera light meters assume that you are photographing a subject with an average range of colours and tones and work out the exposure accordingly. Usually, these colours and tones will aggregate to this average exposure: the highlights and the shadows, the darks and the lights will balance each other out and the exposure will be pretty much correct. The photographic midtone that most cameras choose to represent their average is lighter than you might expect: around 18% grey. This is a measure of reflectance though and equates to a 50% tint of black on a computer (see opposite).

There are a number of non-standard cases, however, when your camera meter will be fooled, and this will lead to **over-** or **underexposure**. For example, if your subject is averagely darker than a midtone – such as an almost-black mountain gorilla – then the camera will be fooled into assuming that it is a midtone in dull light and will decide that it needs more exposure. Consequently, the picture will be overexposed and appear too light. Conversely, if your subject is lighter than a midtone – such as a white polar bear in the snow – then the camera will be fooled into thinking that it is actually a midtone in very bright light, and will decide that it needs much less exposure: the picture will be underexposed and come out far too dark.

The degree of under- or overexposure will depend on the colour of the subject or, rather, the aggregate colour and tone of the scene in front of you compared to a photographic midtone.

It is not just the colour of your subject which can cause over- or underexposure. If your scene includes deep shadows, these can fool the meter into thinking there is less light falling on the subject, leading to overexposure. If there are bright light sources, such as reflections or even the sun, in your frame, then the camera will be fooled into thinking that the subject is brightly lit and will underexpose the picture.

Aim to achieve the correct exposure wherever possible, especially if shooting **JPEG**s, which have less latitude than **RAW**s. If you significantly over or underexpose, then detail will be lost in the highlights or shadows that can't be recovered. Each **stop** of underexposure that you subsequently correct on a computer is analogous to increasing the **sensitivity** by a stop, so significant underexposure will give similar 'noise' to shooting with a high **ISO**, especially in shadow areas.

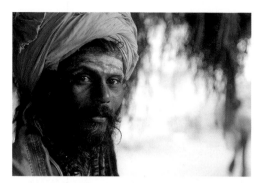

Sadhu at the Pushkar Mela, Rajasthan, India ‹

Nikon D2x, ISO 500, RAW. 50 mm (75 mm equivalent). 1/60 second, f2.8

This sadhu was sitting under the shade of a tree. The large area of highlight combined with the dark skin on his face would have confused most meters into underexposing, but with a spot meter I could choose which parts of the scene to base the exposure on. In this instance I was able to meter on the lightest part of the turban and on the sadhu's face. I ignored the area of highlight, knowing it would bleach out atmospherically – the dynamic range of the scene being too great for any camera.

Victoria Falls at sunset, Livingstone, Zambia ‹

Nikon D2x, ISO 100, RAW. 155 mm (233 mm equivalent). 1/160 second, f2.8

The areas of deep shadow and the setting sun make this a hard picture to meter. A multi-zone meter should be able to ignore the sun but might struggle with the shadow areas on the water, leading to overexposure. The only way to get the exposure right would be to use a spot meter in manual or to use the histogram to make a retrospective adjustment.

Photographic midtone ∧

There is some debate as to what constitutes a photographic midtone. Traditionally photographers have used an 18% grey card, although this is a measure of reflectance and equates to a 50% grey tone on a computer. Some people claim that meters are set to a 12% grey (approx 2/3 stop darker and equating to a 67% tint of black). From my experience I consider this far too dark, especially when using the spot meter on my camera. If I meter and photograph an 18% grey card I get a histogram with a bar in the middle indicating a perfect midtone. You should experiment with your own equipment to establish what it considers a midtone and bear in mind that each meter might see a midtone as slightly different.

The Treasury seen through the Siq, Petra, Jordan ❯

Nikon F5, Velvia 50 ASA film.
80-200 mm lens.
Exposure not noted

Metering a shot like this is a nightmare for most light meters. There is a large amount of shadow area surrounding the image and only a portion of the picture is lit. This could fool the camera into overexposing the image, making the lit areas far too light, with little detail. I used a spot meter to meter through the crack of the siq, which leads to the ruined city. This allowed me to meter the lit facade of the Treasury and ignore the surrounding dark areas.

Metering modes

There are essentially three metering modes that you can use on your camera. Most of the time, any of these should achieve a correct exposure reading, but in difficult lighting conditions each mode is likely to give a different exposure reading. Understanding which mode to use in which circumstances could be the difference between correctly exposed pictures and disappointing results.

Multi-zone, matrix or evaluative meter

This metering mode uses a number of zones that can each take an individual light reading. The readings are then compared to a vast database of picture-taking scenarios and, with a bit of luck, the correct exposure is calculated. A few more sophisticated meters can also 'see' the colour of the subject and even take into account the point of focus from the lens and the orientation of the camera to try to ensure that the picture is correctly exposed.

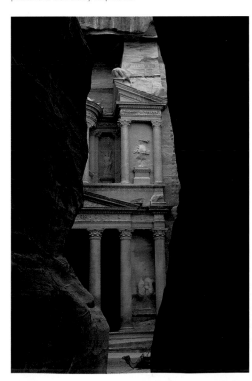

Multi-zone meters are phenomenally accurate for many scenarios but they are not perfect. For instance, if you have a subject that is half in shadow and half in bright sunlight, the meter will not know which bit of the picture you want to be correctly exposed.

Multi-zone meters are best used with automatic exposure modes, including when shooting with **flash**, as their sophistication means that they are more likely to get an accurate result, especially in difficult lighting conditions. One of the drawbacks of multi-zone meters is their unpredictability. It is difficult to pre-judge the level of **exposure compensation** required, as you can never be sure how close they will get to the correct exposure. Having said that, it is possible to assess the amount of exposure compensation that is needed from the preview of the picture and the **histogram**, if you are shooting digital.

Centre-weighted meter

The centre-weighted meter takes a reading across the whole frame but pays more attention to the centre. It is essentially a legacy mode, left-over from old film **SLRs**. It has the advantage of being predictable for metering a midtone, but generally a spot meter is likely to be more accurate for manual and a multi-zone meter more accurate when shooting on auto.

Spot (partial) meter

The spot meter gives you the most control. It takes all of the meter readings from a small area in the centre of the frame – as little as 2% of the picture area. A partial meter does the same thing but over a larger area. More sophisticated cameras will move the spot meter depending on the active focus point, so focus and exposure are biased towards the subject of the picture.

Spot metering is perfect for **manual exposure**. Not only can you meter a small part of the picture to calculate your exposure but you can take a number of readings to check that the highlights are in range, the shadows won't be too dark, and even to check the tone of the sky when using a **polarizing filter**. At its simplest level, spot metering can allow you to meter from a midtone in your picture. Although you can use a spot meter with **exposure lock**, it is not well suited to automatic exposure modes.

ⓘ For further information about using a spot meter, refer to Manual exposure, page 92.

Exposure and dynamic range

In addition to metering, the other main issue affecting exposure is contrast. Without getting too technical, this is a problem of dynamic range. The dynamic range of a camera is the number of stops of exposure that a camera can render between the lightest white and the darkest black. A digital SLR shooting in JPEG mode typically has a dynamic range of around eight or nine stops. If you shoot in RAW then you will probably get at least an extra stop of dynamic range at the highlight end. A compact camera will typically only have six stops of dynamic range, about the same as colour transparency film.

The dynamic range of a digital image is affected by the capacity of each **pixel** in the **sensor**. To understand this, you could think of each pixel in the sensor as a glass: if it is empty, the pixel is recorded as absolute black; each **stop** of exposure lightens the pixel until it is full, when it renders absolute white. Anything beyond this point is, in effect, lost: brighter areas of the image render as pure white with no detail,

and the highlights are **clipped** (see page 88). If the pixel has a capacity of eight stops then the camera will have a dynamic range of eight stops.

For most subjects lit by even lighting, a **DSLR** with a dynamic range of eight stops will be more than adequate to record the full range of tones in your subject. A **compact camera** with a dynamic range of six stops may lose detail in either the highlights or the shadows, depending on the contrast of the subject and the exposure used.

If you have a scene that is part in sunlight and part in shadow, or even a foreground **backlit** by a bright sky, then the dynamic range from shadows to highlights could be as much as 20 stops. This is well outside the range of any camera and, consequently, much of the scene won't register. Sometimes the camera will choose to expose for the shadows and the highlights will be **blown**. Other times it will bias towards the highlights, and the shadows will render too dark to show detail. Often the camera will attempt to achieve a balance between the two and some detail will be lost in both highlights and shadows.

Santorini, Greece ➤

Nikon F5, Provia 100 ASA film
28-70 mm lens.
Exposure not noted

This shot was strongly backlit and it was difficult to balance the buildings with the strong light reflected on the surface of the water. In most of the shots I took, the foreground was far too dark, almost silhouetted. Then, I discovered this tiny church; a nearby white-walled building was acting like a giant reflector, bouncing enough light back at the church to lighten it.

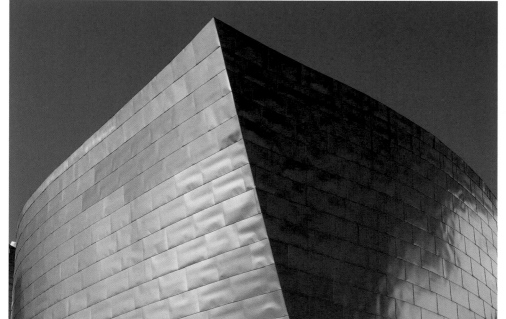

Guggenheim Museum, Bilbao, Spain ◄

Nikon D2x, ISO 100, RAW.
70 mm (105 mm equivalent).
1/800 second, f8

Some highly reflective subjects, such as the Guggenheim in Bilbao, will have specular highlights on them that will be far too bright to register, virtually whatever the exposure. To bring them into the range of the camera, the rest of the picture would be far too dark. In this instance, the only way to cope with the wide dynamic range is to change your angle to keep the highlights out of the shot or to shoot at a time when the reflections aren't so extreme.

Shooting RAW

A RAW file has about an extra stop of dynamic range in the highlights and shadows, which helps to resolve subjects with a greater dynamic range than a JPEG can handle. For subjects with a wide dynamic range you take multiple images at different exposures with the camera on a tripod and combine them into one picture with a technique called HDR (High Dynamic Range). Although popular, I find that this can often give results that look over-processed and too artificial. A more natural result can be achieved by manually combining different areas of highlight and shadow that have been produced from the same shot during RAW processing. This technique is explained further on pages 147.

Solutions for limited dynamic range

In most cases, the easiest option is to avoid excessive contrast in the first place, especially if you're using a film or compact camera, which will have a more limited dynamic range. Recompose the picture so that it predominantly includes either only the bright or only the dark elements, or move your subject into the light or into the shadow for a more even exposure. You don't have to cut out all of the opposing tone; just compose so that it doesn't dominate the picture, or for that matter the meter reading.

There are also a couple of techniques that you can employ to reduce the contrast of certain scenes. If the sky is too light, use a **graduated neutral density filter** (see page 126), which fades from dark to light by up to three stops, darkening the sky enough for it to register. If the foreground is in shadow, use **fill-in flash** (see page 131) to lighten it and bring it back within the dynamic range. This technique won't work for large areas that are some distance from the camera and, if you're using a compact, the fill-in flash will probably only be sufficient for a subject that is up to a couple of metres away.

Some DSLRs have modes designed to increase dynamic range in a single shot, although these will need post-processing in the manufacturer's own software for the effect to work. Nikon's function to increase dynamic range is called Active D-Lighting and Canon's is called Highlight Tone Priority.

**Fishing boat,
Halong Bay, Vietnam** ❯

Nikon F4, Provia 100 ASA film.
80–200 mm lens.
Exposure not noted

The dynamic range in this picture is too great for both the fishing boat and the highlight on the water to register detail. The best way to tackle this subject is to expose to silhouette the boat; even then, some of the highlights don't register details and the sky is rather dark.

Gondalas, Venice, Italy ❯

Nikon F5, Provia 100 ASA film.
80–200 mm lens.
Exposure not noted

The strong backlighting and bright reflections on the water present too great a dynamic range for transparency film. The best solution is to expose for the shadows and let the highlights overexpose and clip completely.

Reading histograms

One of the main advantages of shooting digital is that you get instantly to review your exposures on the LCD screen on the back of the camera. However, it can be difficult to assess the on-screen images properly, especially if you're outdoors and in bright sunlight. Even in perfect conditions, most camera screens are designed for viewing, not for assessing. They are often set to be far too bright, meaning that a picture that looks correctly exposed on the screen can look underexposed and murky on the computer. You can get around this by resetting the brightness of the LCD preview screen: view the same image on your camera screen and on a calibrated computer screen in a darkened room; then adjust the brightness of the camera screen until the image looks the same as on the computer.

A much more accurate way to assess your images is to use the analytic tools that are built in to most digital cameras. Some have an indicator for **blown highlights** which will superimpose a flashing mask on the areas where the highlights are '**clipped**' or too **overexposed** to show detail. This is easy to see, even outdoors in the sun. In general, you should always avoid blown highlights, although if you have a light source in the picture you may not be able to. Some cameras also have a shadow **underexposure** indicator, to indicate areas of clipped shadow.

The most precise way of assessing an image is to use the histogram, which is found on most digital cameras. This is a chart of brightness levels, with the highlights on the right and the shadows on the left. For the purposes of the histogram, each image is broken down into 256 shades, with 0 being black and 255 being white. The histogram is simply a graph of

how many **pixels** fall into each shade. Learning to read a histogram takes some practice, yet it is a vital skill for the digital photographer. Not only can you assess your exposures accurately in the field, but it can tell you how much you have to compensate the exposure.

Reading a histogram can instantly tell you if the highlights are overexposed or the shadows underexposed. If the graph is cut off at either end, it is referred to as 'clipped'. If the highlights have clipped, then everything above the clipping point will render as white, with no detail or gradation. If the shadows are clipped, then everything below the clipping point will render as black, with no detail in the shadows at all. Try to avoid a histogram that is clipped, although there will be some high contrast subjects that will always clip at one or both ends.

A histogram can't be read in isolation: it needs to be assessed in conjunction with the image. If the subject is a dark colour then the histogram will be biased towards the left. If you just base the exposure on the histogram then you would reshoot, allow extra exposure and overexpose the picture. Essentially this is what your camera does when you shoot in automatic, attempting to create a 'perfect' histogram from a non-standard subject!

The actual style of the histogram will vary depending on your camera (and indeed your software). They are all read in the same way, though, with the left side representing blacks, then dark tones, midtones, light tones and, finally, whites on the right. Some cameras show four histograms representing the red, green, blue channels and a composite. If this is the case, base your corrections on the composite histogram, as it is easier to assess.

The height of the graph is largely irrelevant, even if this appears to clip at the top: this just means that there are a lot of similar tones in the picture. If the histogram is 'pinched' and very narrow then this just indicates a low contrast picture. The tonal range, and therefore the histogram, can be stretched in post-processing but, bear in mind that not every image has a black and white point. This is why Auto Levels functions, which force these points on each image, often give an unnatural result.

Histograms are also used in **RAW**-processing software and image manipulation software, such as Adobe **Photoshop**, so they will follow you through your entire workflow.

⬤ Shooting RAW

Although histograms and overexposure indicators are useful, you should bear in mind that they are calculated from the JPEG preview version of the image, even if you are shooting in RAW. The RAW file has about a stop more dynamic range at the highlight end, so often, when your histogram or exposure indicator shows clipping, the RAW file won't. With a bit of practice, you will be able to work out the difference between what is shown on the histogram and the RAW file.

Histogram examples ▶

A histogram is a powerful tool that helps you to assess the exposure even in bright sunlight when the LCD screen is difficult to see. The histogram has to be interpreted though. Not every subject will give a 'perfect' histogram, with a good spread of tones between black and white. If your subject is very dark or very light coloured then the histogram will be biased to one side, even though the picture is correctly exposed.

ⓘ Pro tip

When you correct exposures in post production you will get more digital noise in your pictures if you make dark pictures lighter, than if you make light pictures darker. Many people recommend erring on the side of over not underexposure. Some photographers take this to an extreme in a technique called ETTR (expose to the right), deliberately overexposing as much as possible to reduce noise in the corrected image. Make sure that the highlights aren't clipped though: if they are you will lose detail in them even when you correct the exposure.

Normal histogram

An image with a good range of tones, from highlights to shadows. Most of the graph is in the middle, representing a good range of midtones, and it gently slopes down to black and white representing a good contrast. The ends of the graph almost touch the edges showing that the shadows and highlights are present but not clipped.

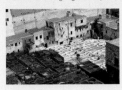

Underexposure with clipped shadows

The whole graph is biased towards the left and appears to fall off the side. This shows that the shadows have been clipped and detail is lost. This picture needs up to two extra stops of exposure. In cases of slight clipping one stop more exposure might be sufficient to lighten the picture and bring detail back to the shadows.

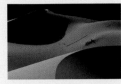

Overexposure with clipped highlights

The whole graph is biased to the right and appears to fall off the edge; the highlights have been clipped and lost detail. This picture should be re-shot with between one and two stops less exposure. If the overexposure indicator was switched on, then the white area would be flashing to indicate the clipped highlights.

Slight underexposure

The graph is biased towards the left and comprises mainly dark tones and shadows; there are no real highlights, even though there are light clouds present. Foliage has rendered too dark, and the shadows have clipped slightly so this picture needs about an extra stop of exposure.

Correct exposure for reference

The image largely consists of midtones but these are slightly biased towards the darker midtone area because of the dark green. There are both highlights and shadows present. The fact that the image is the same shape as the histogram is just a coincidence!

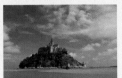

Slight overexposure

The graph is biased towards the right, with virtually the whole picture showing midtones or lighter. Considering the dark foliage in the scene, there should be more mid and darker tones. Even though the highlights haven't clipped, this picture needs about a stop less exposure.

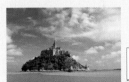

High-contrast subject

This subject has a wide dynamic range, and the histogram has clipped at both ends, indicting high contrast. The clipped shadows show that part of the image is silhouetted and the sun is obviously so bright that no detail is recorded and the highlights have clipped. The contrast of this subject is too great for the camera to render both the shadows and the highlights and this exposure is the best balance for a tricky subject.

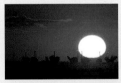

Dark-toned subject

This image consists mainly of blacks and dark green foliage, so the histogram is biased towards the shadow area. As the graph doesn't clip on the left, no detail is lost in the shadows and the image is correctly exposed. When metering a subject like this, your camera would assume an average subject and try to create a 'perfect' histogram by increasing the exposure: giving a more perfect shaped histogram but an overexposed picture..

Light-toned subject

Most of the scene is light toned and even white. This has caused the histogram to bias strongly to the right of the graph. However, the highlights haven't clipped, so this image is correctly exposed. If you were to shoot a white subject like this using an uncorrected meter reading your camera would try to create a 'perfect' histogram by underexposing the picture. This would give a murky grey result with a histogram showing more midtones.

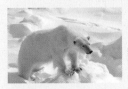

Low-contrast subject...

The histogram 'pinched' in the centre, indicating a low contrast subject. Most of the image is a midtone, with no real highlights or shadows. This image could be given more contrast in post-processing although the result will depend on whether it was originally shot as a RAW or JPEG.

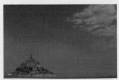

...corrected in RAW processing

A 12-bit RAW has 4096 tones. Contrast was increased in RAW processing by setting a black and a white point, effectively stretching out the histogram. With so many 'spare' tones, there are more than enough to fill the gaps ensuring an even gradation of tones in areas like the sky.

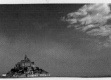

...corrected from 8-bit JPEG

An 8-bit JPEG of a low-contrast subject might only use 60 of a possible maximum 256 tones in each channel. If the histogram is stretched in Photoshop to increase contrast there are no 'spare' tones to fill the gaps, giving a broken graph and banding in areas of gradation like skies.

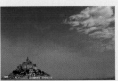

Exposure solutions in automatic

Most people shoot with their cameras set to one of the automatic exposure modes, where the camera calculates the exposure and automatically sets the relevant shutter speed, aperture or both to achieve it. All of the automatic modes (AUTO, shutter-priority, aperture-priority and program) will give pictures with exactly the same exposure, as they are all based on the same meter reading. On the face of it, this gives the photographer very little control over the exposure, but there are two basic strategies for improving your exposures in automatic mode: one is to make your metering more accurate; the other is simply to override it.

More accurate metering
Metering an average subject with exposure lock
If your subject is not an average colour and tone, you can get a more accurate meter reading by taking the reading off something that is. To avoid the exposure changing as soon as you recompose your shot, you need to use the **exposure lock** button. This will hold the exposure setting until you release the lock button, even if you take a number of exposures. This method works better with **spot** or centre-weighted metering. **Multi-zoned metering** is less predictable: you might think that you are metering from an average subject, but your camera meter might not see it the same way!

Sometimes the exposure lock button will lock focus as well as the exposure, so you might find that the camera is focused at the wrong distance. If this is the case with your camera, then make sure that the object you are using for a meter reading is approximately the same distance from you as your subject.

◉ Shooting RAW
A RAW file records more information than will ever find its way onto a JPEG. This means that you can rescue an over- or underexposed picture to a much greater degree than if you are shooting JPEG. The wide latitude of a RAW file also means that you can deal with a picture that has too much contrast; most RAW-processing software will actually have sliders to recover blown highlights and rescue lost shadows. An image which is too flat can have its contrast boosted during the RAW-processing stage. More information about these techniques can be found in the Correction section, pages 240-291.

Golden Temple of Amritsar, Punjab, India ⌃

Nikon D2x, ISO 100, RAW. 200 mm (300 mm equivalent). 1/400 second, f5.0

Bright and shiny subjects, such as the Golden Temple of Amritsar, can easily fool camera meters, leading to underexposure. You can either meter off a midtone subject and use the exposure lock button or use exposure compensation to override the reading.

Zoom to cut out confusing areas If you have a **zoom lens**, you can zoom in to make your light reading, apply the exposure lock, then zoom out to compose and take the picture. This can be used to cut out confusing highlights or shadows from the metering. It is also useful when metering on **backlit** subjects or for compositions where there is a bright light in the frame.

Note that this technique will only work if you have a zoom lens with a constant **aperture**, or if the aperture you are using is small enough not to change when zooming. If the aperture changes when you are zooming, then all of your exposures will be wrong.

Overriding the metering
Exposure compensation Most cameras have an exposure compensation facility, where you can dial in a correction figure that the camera will apply to all subsequent automatic exposures. Once you begin to build a knowledge of photographic subjects and how they might fool your camera meter, you can quickly input the appropriate correction before you take a picture. For instance, based on the examples on page 82, you might choose to decrease exposure by −2 **stops** when shooting a gorilla in the forest and increase it by as much as +2 stops if you were shooting polar bears in the snow. You don't even have to guess the compensation amount. You can shoot an image, assess the **histogram** (see page 88), apply exposure compensation and then retake the shot. Obviously, this

won't work with a fast-moving subject, as the moment will pass before you have a chance to re-shoot, but, with a bit of trial and error, you should be able to estimate the correct amount for a given subject. You can also shoot a test image, assess any compensation and be ready for action when it happens.

The main advantage of this approach is that you get corrected exposures but can still take advantage of auto exposure if the lighting conditions

Film SLR

All of the DSLR techniques that you can use to improve your exposures will also work with a film SLR, with the important difference that there is no histogram or instant preview to check your exposures. Instead, you will have to make an educated guess as to the compensation factor. This is why many film photographers tend to use bracketing to ensure that their exposures are correct, although this has a big cost implication.

Metering for midtones and using the exposure lock is another good option for film, although probably the best method is to use your camera in manual mode and take meter readings with a spot meter (see Manual exposure, page 92)

Digital compact

All but the very simplest compacts will have an exposure compensation mode which you can use to override the automatic exposure. Many compact cameras will work out both the exposure and the focus when you half press the shutter release button. This effectively acts as an exposure lock button, as long as you don't release it before actually taking the picture. Note that the camera is not only taking a light reading but also focusing at this point, so if you are metering from a midtone, try to choose one that is a similar distance from you as your subject. The large depth of field inherent in compact cameras means that this shouldn't be too great a problem.

The Picture Scene modes that are present on many compact cameras will also go some way to balancing the exposure. For instance, selecting the 'snow' mode should automatically apply one or more stops of extra exposure to compensate for the underexposure that results from metering from the white of the snow.

change. The downside is that if you photograph a different subject, the compensation value may well be different and, if you don't change it on your camera, your exposures will be wrong. Most exposure compensation facilities are very user-friendly and can be adjusted very quickly, sometimes without even taking your eye from the viewfinder.

Typical values for exposure compensation

Snow scenes/white walled towns	+2 stops
Light-coloured subjects	+1 to +2 stops
Backlit portrait (avoiding silhouette)	+1 to +2 stop
Grass and light foliage	−1 stop
Dark-coloured subjects	−1 to −2 stops
Scenes with dark foliage	−2 stop

Bracketing This is a technique that involves taking two or more pictures at slightly different exposures in the hope that one of them will be correct. Many cameras offer automatic bracketing, where the camera will take the pictures for you, most commonly at metered exposure, then plus and minus a stop. This gives you three shots over a range of exposures.

The advantage of bracketing is that you have more chance of getting a correctly exposed picture. Make some notes and review the results, so that you can learn for the future. The disadvantages are that the correctly exposed shot might not be the best one. If you are shooting with film it will triple your costs and, even shooting digital, you are making more editing work for yourself, choosing the correct image from three. You will also fill up memory cards and run down batteries more quickly than if you take one shot and get it right first time.

Elephant on the Zambezi, Zambia ◄

Nikon D2X, ISO 100, RAW. 112 mm (168 mm equivalent). 1/500 second, f5.0

Sometimes, in fast-moving situations, it is worth shooting on automatic. You don't want to be checking manual exposures when confronted with an angry elephant! This elephant was on a small island in the Zambezi River, and I was floating past on a raft.

Manual exposure

Manual exposure is a vital tool for the serious photographer. It allows ultimate control over your images, as you interpret the meter reading and manually set both the aperture and shutter speed to achieve the desired exposure. In many cases, manual exposure can also be faster than shooting in automatic and having to set an exposure compensation every few shots.

Exposure is governed by the light falling on your subject, but the meter attempts to assess this by measuring the light that is reflected by that subject. Reflected light is affected by the colour of the subject, which is what can fool the meter into incorrectly exposing. You can achieve a correct auto exposure by setting **exposure compensation**, but this is only correct for a given subject. If you allow for the same exposure compensation in manual, then you will have to set the correct exposure for the lighting conditions, and can shoot away without changing the settings at all, as long as the light doesn't change. The meter reading might change, as you point the camera at a different subject, but this will only indicate the compensation you would have had to use to achieve a correct auto exposure for that subject.

Imagine this scenario. You are photographing a polar bear on an ice-flow. Shoot on automatic and your pictures will come out too dark, as all of the white will fool your meter into **underexposing**. If you set the exposure compensation at +2 **stops** then your exposures will be correct. As you keep shooting, the polar bear walks to the edge of the ice, jumps in the very dark water and swims away. If you don't change the exposure compensation, your pictures will now be far too light: instead of being set to –2 stops for the almost black water, it will still be on +2 stops, giving an exposure that will be four stops out.

Now, if you were shooting on manual, you would have adjusted the **aperture** and **shutter speed** so the exposure graph read +2 stops when the polar bear was on the ice. This would have given you the correct

settings for the lighting conditions. When the animal was in the water, the meter would show a reading of –2 stops, but as you haven't changed the settings and the light hasn't changed your exposure will be correct.

This is why in many circumstances, shooting in manual can be quicker than shooting on auto: if the light doesn't change, you might be able to shoot with the same exposure for some time. The only time that I use auto-exposure is when light levels are changing rapidly, such as moving from light to shade or on days of broken cloud. Manual exposure is more effective if you are continually making small adjustments: if you only take pictures every few hours, then auto will probably work better for you. Either way always use the mode which gives you the best exposures.

The manual exposure graph

The key to manual exposure is the manual exposure graph (see below), which appears in the viewfinder and is activated when you switch on the **metering mode**. This typically shows the suggested exposure, and two or three stops of under- and overexposure. This will further be broken down into third or half stops depending on your camera. If you are more than two stops from the suggested exposure, you will see arrows indicating that you are off the scale. The meter shows you how far you are from what the meter considers is the correct exposure.

If you slavishly follow the exact exposure suggested by your camera, setting the graph to read zero, then you are not really shooting in manual and would be better off using one of the automatic exposure modes, which will be able to set the suggested shutter speed and aperture quicker than you can. The point with manual is to interpret the result based upon the scene. In effect, you set the manual exposure graph to reflect the exposure compensation you would use if were shooting auto.

For instance, if you are photographing snow, you might set the desired aperture and shutter speed so that the graph reads +2 stops, not zero.

Manual exposure graphs ▼

Typical manual exposure graphs showing plus and minus two stops, incremented in third stops. Unfortunately there is no standardization between manufacturers, with Canon having minus on the left and Nikon having minus values on the right.

Correct

Minus 1 stop

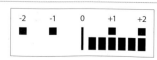
Plus 2 stops

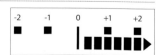
Plus more than 2 stops

Which meter to use

There are two approaches to manual exposure, which I term reactive and predictive. Reactive exposure involves taking a picture and then assessing the exposure based upon the preview image and the **histogram**. As you will want the camera meter to be as accurate as possible you should use the **multi-zone meter** so the camera will try to interpret the scene in front of you. Once you have made any adjustments you will have set the camera for the lighting conditions.

Predictive exposure takes more skill. You have to assess the scene in front of you and adjust the exposure based upon the meter reading and where you think that the tones will lie on the exposure scale. With a bit of practice, this can be done very quickly. In this instance you want your meter reading to be as predictable as possible and so should use the **spot meter**, which measures the exposure on specific and small areas of the image. This is usually shown as a marked area in the centre of your frame but, sometimes, is within the active **focus point**, depending on your camera. See also page 85.

With experience you will probably adopt a technique that borrows from both elements. With reactive metering you might prejudge what compensation to use; for instance setting the graph to –1 stop if photographing foliage, before checking the histogram and adjusting. With predictive manual you should always quickly glance at the histogram to check that you have achieved a correct exposure, before fine-tuning as necessary.

You can calculate a manual exposure in advance, safe in the knowledge that, as long as the lighting conditions don't change your exposure will be correct. This means you can avoid missing a moment as you fumble with settings, or ruining portraits by paying more attention to the histogram than to your subject.

Spot metering in manual exposure

Most meters are set to read off the equivalent of an photographic **midtone** (see page 85). The dynamic range of a **DSLR** typically allows you to record three stops lighter than the metered midtone and around five stops darker. This is shown in the diagram opposite where the whitest white that still shows a touch of detail is at +3 stops from the midtone. Above this will be absolute white, with no tone and clipped highlights.

The blackest black that can still show detail is around –5 stops. Outside of this will be absolute black, with no detail at all. If you shoot **RAW** you should get about one stop more at the highlight end of the scale.

If you take an exposure reading from a midtone in your picture, as the camera is programmed to do, then the picture should be correctly exposed when the exposure graph is at zero. Tanned caucasian skin or medium pavements are often a good source for a midtone, although you need to experiment with your particular camera. If I can't identify a good midtone, I often meter from the brightest tone in the picture that I want to register, such as a freshly painted white wall, and use that to set the exposure. This is called metering for the highlights. Don't use this reading as the correct exposure or your pictures will be very underexposed; rather, use it as the area of maximum **overexposure**.

From the diagram below you can see that you don't have to identify a midtone and set your meter to zero. You could identify the brightest area in your scene and then set the aperture and shutter speed to achieve an exposure of +2 stops to ensure that this part of the picture will hold a good amount of detail. You could push it to +3 stops, if it is an area of brightness that you want to have definition rather than detail, but beware of overexposure.

Typical tonal chart ⌄

This is a representation of a typical tonal range which can record as detail or tone with a digital camera – approximately nine stops of dynamic range. On either side are absolute black and absolute white that record no tone or detail at all. From the midtone, there are three stops of highlight information and five stops of shadow information.

You can emulate this with a sheet of white paper. Spotmeter and add +3 stops, and you should get a white that just shows tone. Reduce the exposure by three stops and reshoot, and your histogram should show a midtone. You should be able to stop down another five stops and still show tone, without the shadow end of the histogram being clipped.

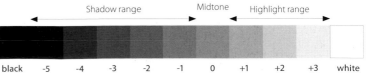

Shadow range — Midtone — Highlight range

| black | -5 | -4 | -3 | -2 | -1 | 0 | +1 | +2 | +3 | white |

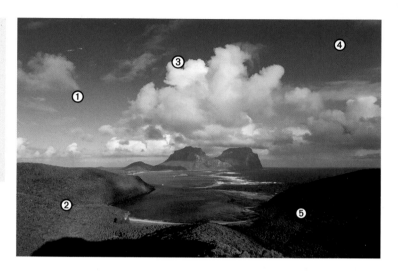

Lord Howe Island, Australia ∧

Nikon D2x, ISO 100, RAW.
14 mm (21 mm equivalent).
1/250 second, f5.6

Using a spot meter doesn't just allow you to set the exposure, it allows you to measure the various parts of the scene and assess how they will reproduce in the final image:

1 Mid blue sky:
 approximately 0 stops.
2 Foliage:
 approximately –1 to –2 stops.
3 Brightest part of cloud:
 approximately +2 stops.
4 Dark blue sky:
 approximately –1 stops.
5 Foliage in shadow: should still
 hold detail at –3 stops .

Similarly, you could **meter** from a darker tone than a **midtone** and set the **aperture** and **shutter speed** to achieve an **exposure** of –1 **stop** or more, depending on the tone. This, too, will give a good exposure, without the need to identify a midtone.

If you are photographing something in shadow, then experiment with shooting at a stop less than indicated on the chart. So if you are shooting someone with tanned skin in shadow, set the meter to –1 stop for a more realistic effect than using the suggested exposure. Shadows, after all, should look like shadows, but without being too dark.

Sample values for spot metering

Very white clouds	+2.5 stops
Bright snow	+2 stops
Light blue sky or pale Caucasian skin	+1 stops
Mid pavement, mid blue sky	0 stops
Tanned Caucasian skin	0 stops
Dark pavement or dark blue sky	–1 to –2 stops
Dark green foliage	–1 to –2 stops
Black objects	–3 or –4 stops

These amounts are conservative and should be the starting point for your exposures. Check the picture after shooting it and review the **histogram**s to make sure there is no **clipping** at either end. If you are shooting **RAW** or post-processing **JPEG**s, you can always introduce more **contrast** on the computer and stretch the tones to achieve a true black and white.

Checking your levels

The real advantage of manual spot metering is that once you have set the exposure, you can quickly build up a picture of the different levels in your scene. For instance, you might be metering a snow scene and take a +3 reading from textured snow. You could then meter the sky and find it will be reproduced as a midtone (zero). Then a quick check on a dark tree trunk might come up as –1.5 stops. Checking some dark foliage or in some shadows might give you a reading of –2.5 stops. Very quickly, you will be able to work out that your scene is well within the **dynamic range** of your camera and that you will register good detail in all of these tones. However, if you metered the shadows and found them to be at –4.5 or even –5.5 stops, you would know that little detail would survive, and you should think about recomposing your picture, or even using a bit of flash to lighten shadows.

The actual dynamic range of your camera will vary with the model. Although I have given approximate values, you should experiment with, andget to know, your own equipment.

Manual bracketing

If you are unsure about your exposures, or just want to make sure, then try **bracketing**. Take a couple of exposures at slightly different settings to make sure one of them is correct. With manual rather than automatic bracketing, you can do this intelligently. For instance, if you are placing a set of highlights at +2.5 stops, consider bracketing at +2 and, possibly, +1.5 to give you a range of exposures. When you are editing your pictures, try to learn from the bracketed shots.

Creative exposure

So far, I have constantly referred to 'correct' exposure. In fact there is no such thing. Any exposure can be correct if it is what the photographer intended. By intentionally over- or underexposing you can create some unique pictures and show familiar parts of the world in an unfamiliar way – the whole point of travel photography.

Overexposure

Creative overexposure will produce very light, often mystical pictures, where many of the highlights are **blown**. These **high-key** images have simplicity and energy. Through overexposure, the shadow areas will be moved into the **midtone** range and the midtones into the highlight range. The highlights will be lost. This will change both colours and tone, giving a washed-out and muted effect. In extreme cases the blown highlights will appear to merge into the midtones, producing an even more ethereal effect. With high-key images, there is a greater risk of **flare** on your pictures, due to reflection on the inner surfaces of the lens. This is usually considered a problem but in deliberately overexposed images it can add dynamism to the picture. High-key pictures often work better when there is some degree of movement; totally static pictures and portraits don't always lend themselves to creative overexposure.

You should overexpose dramatically: anyone looking at the picture shouldn't be wondering if you have just got the exposure wrong; they should know that the effect is intentional!

Underexposure

There are probably fewer cases where you can use dramatic underexposure. In general it will only work if there is a dominant highlight that is quite a few **stops** lighter than the surrounding scene. Two things that work well are light sources or **specular highlights**, such as reflections on water or shiny surfaces. If the exposure is adjusted so that these blown highlights are brought back into range, then the rest of the picture will become atmospherically dark.

This technique can be used to good effect if you have a subject that is lit with bright side lighting. Under normal circumstances you would choose an exposure that would render the lit sections as highlights. However, if you select an exposure that reproduces them as midtones, then the rest of the

picture will be reproduced in the shadow range, giving the picture an atmospheric **low-key** effect.

Creative underexposure can also be used to create artificial silhouettes, by placing a light source or a specular highlight behind a subject and underexposing by two or even three stops. By doing this, the highlights will reproduce as midtone, and much of the shadow information will be lost. It can even be used to simulate a night shot with the moon in the frame.

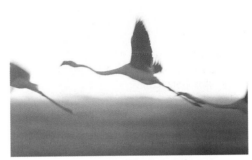

Flamingos in the Camargue, France ‹

Nikon F5, Provia 100 ASA film. 300 mm lens. Exposure not noted

If you have a subject which would normally be silhouetted, such as these flying flamingos, but expose for the shadows, allowing the backlighting to bleach out, you can create an atmospherically overexposed, high-key image.

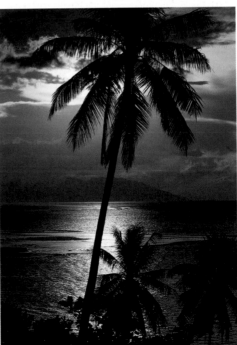

Island of Moorea, seen from Tahiti, French Polynesia ‹

Nikon D2x, ISO 100, RAW. 50 mm (75 mm equivalent). 1/2000 second, f8

This image was taken in daylight but I underexposed to produce a low-key image which emulates a night-time shot photographed with a full moon. Deliberately underexposed images generally need a highlight of sorts or else they can look too dark. This image has the sun in it but, to moderate its effect, I composed the image with the sun and the bright reflection partially obscured by the palm tree.

Combining aperture and shutter speed

In order to get the desired exposure, either you or your camera will set the aperture and shutter speed. However, there is more than one combination that will work. If each whole increment of aperture and each whole increment of shutter speed is a stop, then a range of different combinations will all result in the same exposure value.

Shutter speed:	1/500	1/250	1/125	1/60	1/30	1/15	1/8
Aperture:	f2.8	f4	f5.6	f8	f11	f16	f22

All of the shutter speed and aperture combinations shown in this chart would give the same **exposure value (EV)**. As the shutter speed decreases by a **stop** (slowing from 1/60 to 1/30, say), the exposure increases by a stop; this is balanced by closing down the aperture by a stop (from f8 to f11). Equally, if your camera **light meter** suggests an aperture of f8 and a shutter speed of 1/60 second, then you could increase the shutter speed by two stops to 1/250 second, so long as you open the aperture by two stops to f4. Both of these settings will give an identical exposure value.

This range of different aperture and shutter speed combinations for each given exposure is one of the most creative aspects of photography. Shutter speed controls how movement is rendered in the image (see pages 98-105). Aperture controls the **depth of field** of an image: in other words, the amount of the scene which is in or out of focus (see pages 106-109). These are two of the main attributes that gives photography its unique qualities.

There is a third variable, the **sensitivity** or **ISO**, which is a measure of how much light your camera needs to achieve a correct exposure (see page 110).

When you alter either the aperture or shutter speed, always remember to set the corresponding value to maintain the exposure. For instance, if you use a faster shutter speed to freeze movement without increasing the aperture, then your pictures will come out too dark.

You don't have to shoot manual to exploit these characteristics; even the simplest camera will have a range of **exposure modes** that will give you control over what aperture and shutter speed the camera chooses.

Khon Phapheng Falls, Si Phan Don, Laos ◀

Nikon D2x, ISO 100, RAW. 135 mm (202 mm equivalent) 3 second, f22. Tripod & ND filter

In the far south of Laos on the border with Cambodia is a mass of islands in the Mekong River.

Photographing a waterfall with a long exposure allows the water to move during the exposure, forming a blur where the water loses all of its form. The key is to use a solid tripod so that the non-moving bits of the picture – in this instance the rocks – are pin sharp. I was on a wooden platform overlooking the waterfall and whenever anyone walked by, it vibrated badly, ruining the exposure. It took me about 20 attempts to get an exposure without camera shake. The opposite approach to photographing a waterfall – using a fast shutter speed to freeze the movement – is shown on page 98.

Exposure modes

Somewhat confusingly, the exposure mode doesn't affect the exposure. Instead, it takes the exposure value measured by the meter and decides which aperture and shutter speed combination will be used to achieve it. Most modern cameras have a number of different available modes and, as they only affect the combination of the aperture and shutter speed, they should all give identically exposed pictures.

In general, the basic four exposure modes that you will find on most cameras are **manual**, plus three automatic modes: **aperture priority**, **shutter speed priority** and **program**. Essentially all of the auto modes do the same thing and are a legacy from older film **SLR**s. With these you changed the aperture using a ring on the lens and the shutter speed using a knob on top of the camera. Your choice of exposure mode was governed by which of these methods you preferred. On a modern **DSLR** you can change both quickly with finger dials, and so the differences between modes become less relevant.

Some cameras also have an all encompassing AUTO mode, sometimes designated by a green rectangle. This doesn't just engage auto exposure but often customizes other functions to simplify your camera, for instance setting it to **JPEG** and not **RAW**. If you are trying to achieve more creative control, my advice is to ignore this mode.

Aperture priority
This is usually designated as 'A' or 'Av' on cameras, which some people wrongly assume stands for automatic. In aperture priority mode, you set the aperture that you want the camera to use and the camera sets the corresponding shutter speed.

Shutter speed priority
This is usually designated as 'S' or 'Tv' on your camera. In shutter speed priority mode you set the required shutter speed and the camera sets the corresponding aperture to maintain the correct exposure.

Program
Designated as 'P' on most cameras, program mode will set both the aperture and shutter speed based upon a series of preset values. Some cameras have a range of different program modes, including ones for depth of field or speed, which prioritize aperture and shutter speed respectively. Some will even alter the program mode based upon any picture mode that you select. With program mode, you can vary the combination of aperture and shutter speed away from that selected by the camera by just using a dial, setting any combination without changing the exposure.

With this flexibility, you can see that actually there isn't a great deal of difference between these modes: in aperture priority you can select a faster shutter speed simply by selecting a wider aperture. Conversely, in shutter speed priority you can select a smaller aperture, by dialling in a slower shutter speed. In program you can use the override to change whatever you like. All of these changes can use the same dial on your camera.

Manual
This mode – usually designated with an 'M' – gives you the most control over your exposures and the most options for creativity, yet its function is often misunderstood. I have met people who laboriously set the aperture and shutter speed based upon what the meter reading suggests, without any alteration, and think they are shooting manually: a waste of time as any of the automatic modes can set the suggested exposure faster than you can. To use manual properly you should interpret the meter reading, incorporating any **exposure compensation**. Although faster in many ways, manual is less convenient when setting different aperture and shutter speed combinations as you have to adjust both yourself.

Manual is such a vital mode that it is covered on its own in a separate section (see page 92).

Picture scene modes
Although they are not strictly speaking exposure modes, the picture scene modes on most **compact** digital cameras and some DSLRs will also affect the aperture and shutter speed selected to make the exposure. For instance, an action mode will bias towards a faster shutter speed, and a landscape mode will prioritize a narrower aperture. They will also adjust the exposure, depending on the mode selected, and even affect the white balance used. By selecting the correct picture scene mode on a compact camera, you can customize many of the settings, even if you are not sure what those settings are.

ⓘ **Pro tip**
Changing from a wide to a narrow aperture for greater depth of field is more tricky in manual as you have to commensurately change the shutter speed to avoid underexposure. A quick way to do this is simply to count the 'clicks': twelve clicks of aperture will equate to 4 stops (if your camera increments in third stops). You don't have to work out the required shutter speed, simply count twelve 'clicks' of shutter speed the other way to compensate. The overall exposure will stay the same and you can even practise so you can do this as you are walking along without looking.

Shutter speed

Many photographers who have mastered exposure struggle to decide whether to prioitise shutter speed or aperture when setting their exposures. I have a simple rule of thumb for this: if your subject has any significant movement, then the most creative thing that you can do is to interpret that movement, and so you should bias your choice towards the shutter speed. As with most things in photography, you should work in the extremes by exaggerating the movement. The best way to do this is to wrest control of the shutter speed back from your camera, which has a tendency to go for a more middle-of-the-road approach!

Photography produces still pictures. This means that your camera can only produce an abstraction of any movement that is in the scene. The abstraction arises when the camera attempts to record movement that happens in the real world in the amount of time that the camera shutter is open. This produces an image that is uniquely photographic and unlike anything that you might see with your own eyes, including on a movie or on television. When we look at something we have our own awareness of its movement. The camera allows us to step outside this awareness, by creating an image that is blurred or which freezes motion in a way that is not visible to the human eye.

The **exposure mode** that you choose to do this is somewhat irrelevant. Although you will get direct control over the shutter speed if you use the **shutter speed priority** mode, you can also alter it indirectly by setting the aperture in **aperture priority** mode. You will have direct control of shutter speed in the **manual** mode, but remember to change the aperture correspondingly when you alter the shutter speed in order to maintain the correct **overall exposure**. If you are using one of the automatic modes then the camera will do this for you.

Camera shake
One thing to be aware of when selecting a shutter speed is unintentional camera shake – when the camera moves or even vibrates slightly during the exposure. This can ruin your picture. There will be a shutter speed below which you will not be able to hold the camera by hand and will have to use a tripod. This speed will depend on the lens you are using and how still you can hold the camera.

Khon Phapheng Falls, Si Phan Don, Laos ◄

Nikon D2x, ISO 100, RAW. 135 mm (203 mm equivalent). 1/800 second, f4.5

The same falls as on page 96, but photographed using a different treatment. Here I used a wider aperture and a fast shutter speed of 1/800 second. This had the effect of freezing the movement in the water, turning it into a bubbling, frothing cauldron.

A **telephoto lens** magnifies any camera shake, so you won't be able to hand-hold a telephoto lens as efficiently as a standard or wide-angle lens. A good rule of thumb is that the average person needs to use the shutter speed closest to the **focal length** of the lens they are using. So, for a 50 mm lens, you would need to use a shutter speed of 1/60 second to avoid camera shake and, for a 200 mm lens, you should use a 1/200 second speed. The **crop factor** of the smaller **sensor** found in most **DSLR**s doesn't just magnify the lens's effective focal length, it magnifies the camera shake as well, so you should be using the shutter speed closest to the effective focal length. For instance, use a shutter speed of 1/80 second for a 50 mm lens, and 1/300 second for a 200 mm lens.

Vibration reduction
Some telephoto lenses have **vibration reduction** or **image stabilization** built in. This uses a gyroscope and often allows you to hold a camera by hand at speeds up to three **stops** lower. When using vibration reduction, get into the habit of taking a few pictures in quick succession. The image jumps around slightly as the gyroscope kicks in, which can play havoc with your composition, and the stabilization effect seems to work better in some frames than others. Taking a few shots is, effectively, **bracketing** for camera shake. There are usually two modes: normal to reduce vertical and horizontal movements, and active, which ignores horizontal movement if you are panning or in a moving vehicle. Never use image stabilization if your camera is on a tripod. Some **compact** cameras have active vibration reduction built in, but others have vibration reduction modes that just select a higher **sensitivity** to allow a faster shutter speed.

Tightrope artist, Udaipur, India ►

Nikon F801, Provia 100 ASA film. Lens and exposure not noted

This man was bouncing on a tightrope, performing acrobatic tricks for a few rupees. I positioned myself so that the man was a silhouette, blocking out the strong sun, and took the picture when he reached the apex of the jump. This is the ideal moment to take a photograph as you are able to freeze the action with even a relatively slow shutter speed.

Freezing movement

The classic way to show movement is to use a fast shutter speed and to freeze the action completely, often leaving subjects in bizarre and seemingly unnatural poses. Photography is so good at revealing movement that, until it first showed how horses gallop, artists always used to paint them with their legs outstretched front and back, all off the ground at the same time.

The **shutter speed** that you will need successfully to freeze any movement will depend on the speed and direction of the movement and even the lens that you are using. Obviously, the faster the subject, the faster speed you will need to completely freeze it. The movement will also be accentuated if it is perpendicular to the camera and shot with a **telephoto lens**. You should aim for at least 1/1000 second if your subject is someone

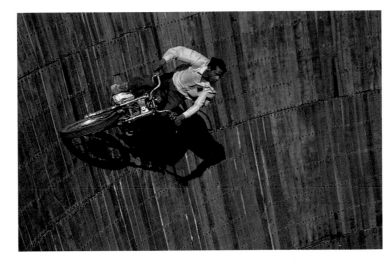

jumping or diving; faster if it is a plane or bird in flight. Go for the fastest speed that you can, in order to freeze all of the movement in the picture.

Sometimes there will not be enough light around to select the speed you want. In these instances you can increase the **sensitivity** of a digital camera so that it needs less light to make a correct **exposure**. In this way you can get one or even two **stops** more shutter speed, which is the difference between a lacklustre 1/500 second and a motion-freezing 1/2000 second.

The bubbling water of a waterfall is a classic subject to freeze with a fast shutter speed, as it reveals all sorts of unnatural and convoluted shapes. People and animals in motion are also good subjects, although you need to anticipate when the action will reach its zenith, especially if your subject is frozen in mid air.

Other subjects, such as trains or vehicles, don't suit this freezing technique, since, when they are frozen, they just look stationary. If you do use this technique to photograph a moving object like a bicycle or a motorbike, take the picture at a corner when the bike and rider are leaning over, so the picture will look dynamic.

⬚ **Digital compact**
Even if you don't set the shutter speed yourself using a manual or shutter priority exposure mode, most compact cameras will have an action picture mode that will bias towards a faster shutter speed.

Wall of Death, Maha Kumbh Mela, Allahabad, India ⌃

Nikon F5, Provia 100 ASA film.
28-70 mm lens.
Exposure not noted

Even though the Maha Kumbh Mela was a religious festival, there was a vast and sprawling funfair and bazaar on the outskirts. This was a wall of death, where motorbikes were driven round to the delight of the crowd. The wall was very shaky and the planks rattled alarmingly.

Compositionally, the motorbike is probably too far to the left and doesn't have the impression of having much space to move into, but this is counterbalanced by the strong line of sight of the man looking back into the rest of the picture.

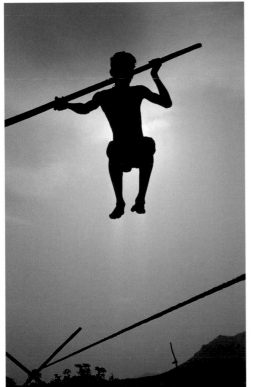

Shooting action

If you photograph movement by panning or allowing a subject to blur with a long exposure, then you have a surprising amount of leeway over the point of focus and when you need to trip the shutter. A delay of a fraction of a second won't significantly affect the result, since the slow shutter speed demands a correspondingly narrow aperture and the resultant depth of field should be large enough to keep even a moving subject in focus. However, if you are attempting to freeze a fast piece of action, then the correspondingly wide aperture will mean you need to be precise both with the focus and with the moment at which you actually trip the shutter.

With most types of action there is a moment that sums up the entire train of movement, such as a skier appearing to hover in mid air before landing a jump. It is this moment that you should try to capture in your photograph. There are two different techniques for this: one is to anticipate the action and trip the shutter at the right moment; the other is to fire a number of exposures in quick succession using a **motor drive**. Which you choose depends on your own preference and the speed of your reactions: some photographers maintain you have more control with a single anticipated moment; others prefer to rely on the scatter-gun approach.

A motor drive is built into all **DSLR**s and many **SLR**s and **compacts** and enables the camera to take between two and eight frames in a second, depending on the model. If you are relying on autofocus, be careful not to set the motor drive at a frame rate that is faster than your autofocus will allow.

Accurate focus is a real issue when photographing movement, especially as the fast **shutter speed** needed to freeze the action usually results in a shallow **depth of field**. If the action is coming towards you, then shooting on autofocus and setting your camera to lock on to any movement (if you have this as an option) will usually focus accurately. However, if the angle of movement is across the frame, then it can often be too quick for your camera's autofocus to pick up. You can help by tracking the camera to follow the movement. This gives the camera more time to focus on the subject and the movement of the camera will be frozen, along with the movement of the subject. Sometimes, motion appears to pause for a second at the key

moment, such as when an athlete reaches the apex of a jump, before gravity kicks in. If you take the picture at this time, you should be able to freeze the movement without using a ridiculously fast shutter speed, which can be useful in lower light levels.

Another way to photograph action is to pre-focus on a point in the frame and wait until the subject gets to that point before taking a picture. If you have a camera that can manually focus, this is relatively simple. If not, you will have partially to depress and hold the shutter release button to focus and then finish pressing it when your subject is in the right position. Pre-focusing is a useful way to counteract the slight delay on some digital cameras, especially simple compacts.

Even if your camera doesn't have a significant delay, you will still have to anticipate the action and trip the shutter before the action reaches the point that you want to photograph to compensate for your own slightly delayed reactions. If the action is repeated, take a few shots as practice and try to note the ideal point to take your photograph. Sometimes this can be done more easily if you put the camera on a tripod, pre-focus and trip the shutter when the action reaches your pre-selected mark.

It is important to work out everything in advance, especially if the action only happens a limited number of times. If you only have one chance, you want to make sure that everything is ready. Take a few preparatory shots to check exposure and focus and, then, when it comes to the actual moment to take the picture, don't hesitate! Shoot and keep shooting! Don't keep running around, following the action: it will always be ahead of you. Instead, find a good location, set up the camera and wait for the action to come to you.

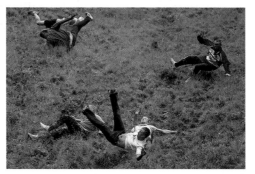

Cooper's Hill Cheese-rolling, Gloucester, England ◄

Nikon D3, ISO 1250, RAW. 300 mm. 1/1250 second, f5.6

Cheese-rolling is an old English tradition, where people race down an impossibly steep hill chasing a roll of cheese. People fall, bounce and are often hurt all of the way to the bottom. I wanted to use a fast shutter speed to freeze the action as contestants fell down the slope, and so I increased the ISO considerably to allow for a very fast shutter-speed.

⊡ **Digital compact**
Most compact cameras have an appreciable delay after the shutter release button is pressed, before the actual picture is taken. This is often caused by the slowness of the camera's focusing. You can speed up the process by half pressing the shutter to focus the camera and then finishing pressing the release button when you are ready to take the picture. Most compact cameras, mirrorless cameras and entry level DLSRs will have a sport picture scene mode that will customize settings for capturing action.

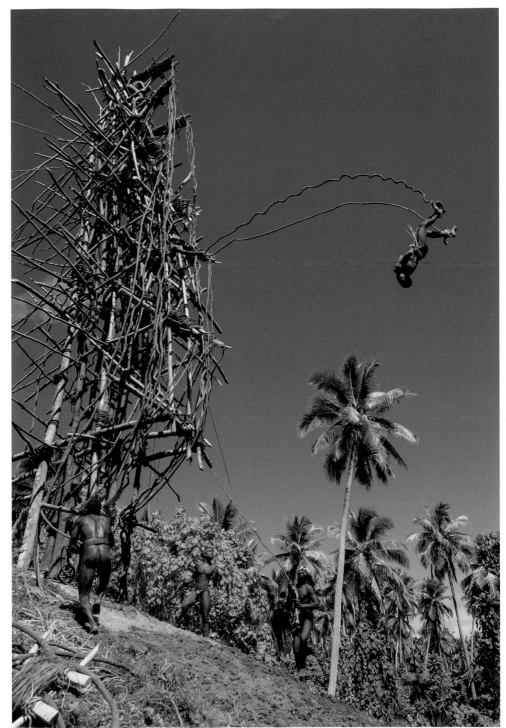

Naghol (land diving)
Pentecost Island, Vanuatu ❯

Nikon D2x, ISO 160, RAW.
14 mm (21 mm equivalent).
1/640 second, f5.0

I had wanted to go to Pentecost
Island in Vanuatu to see the
land diving, or naghol, for as
long as I could remember, and
shooting *Unforgettable Islands*
gave me my chance. It is an
ancient fertility ritual to try to
increase the Yam harvest. For a
couple of months a year, when
the vines are supple enough,
jumpers construct great towers
and then throw themselves
off with two vines tied to their
ankles. I used a fast shutter
speed to freeze this jumper in
mid flight, and shot a number
of frames using the motor drive.
The results were incredible and
showed up frozen details that
wouldn't have been discernible
with the human eye.

Motion blur

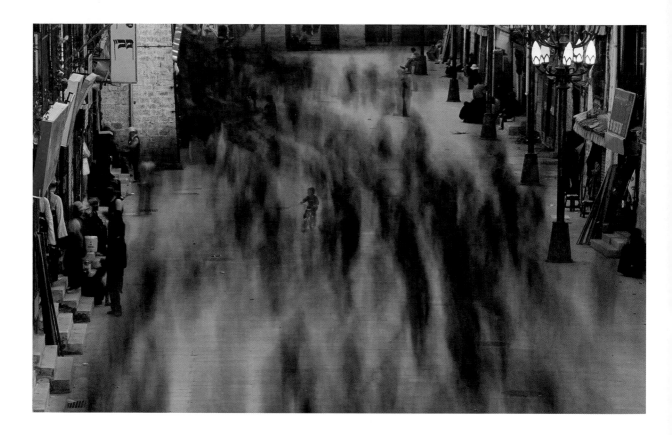

The opposite to freezing the motion is to allow your subject to move during the exposure. If your subject moves an appreciable amount while the shutter is open, it will render as blurred in the final picture. This is called motion blur.

In the early days of photography, **exposures** ran into minutes, and motion blur was something that had to be avoided. People had to sit for portraits with their necks in hidden clamps so that they couldn't move. Now that blur can easily be avoided, you can introduce it into your pictures for creative effect.

When things blur in a photograph they lose their form, so motion blur won't suit every subject. Those things that have a very rigid form, such as trains or cars, will blur so much that they become unrecognizable and uninteresting. Subjects that

work well are water, fog, milling crowds and even plants moving in the breeze.

It is important that things stay recognizable to some extent, so experiment with various **shutter speeds**. If there is too much blur, then you can keep things recognizable by using a touch of **fill-in flash**. This will pick out the subject and super-impose it over the blur. Many cameras have the facility to fire the flash at the end of the exposure (**rear synching**), which means the flash exposure is superimposed on top of the blur not the other way around.

It is also important that some things in the picture are completely sharp and not blurred at all, such as the rocks in a waterfall or buildings being flooded with moving crowds. To avoid **camera shake**, you will need a stable tripod to hold the camera perfectly still. You should also use a **cable release** so that you

Pilgrims on the Barkhor Circuit, Lhasa, Tibet ∧

Nikon F5, Provia 100 ASA film. 80-200 mm lens. Approx 10-20 secs, f22. ND filters

Pilgrims circle the Jokhang Temple day and night. I wanted to take a shot that showed this constant stream and so decided on a long exposure. I found a café terrace overlooking the Barkhor circuit and took a range of shots at different exposures. I had to use the narrowest aperture and neutral density filters to reduce the light levels enough to facilitate a long shutter speed. The boy in the centre just happened to be still for the whole exposure. See also page 124.

don't jog the camera when you release the shutter. The movement of the camera's internal mirror in reflex cameras can cause camera shake on long exposures, so some SLRs and DSLRs have a **mirror lock** setting where you can move and lock the mirror prior to the exposure.

If you are taking a night shot and there are any moving objects, such as people or vehicles, in the scene, then some degree of blur is virtually unavoidable due to the slow shutter speed required. As with most things in photography, though, you should go for the extreme and make it a bold gesture. Don't just use a one-second exposure; go crazy and have a 30-second exposure so that all the cars form a long trail of lights that snake around a city.

Assessing the amount of blur is relatively easy: if your exposure is a second, look through the camera

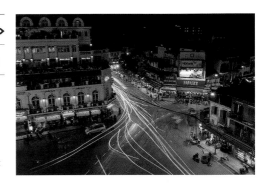

Bustling traffic Hanoi, Vietnam ➤

Nikon D3x, ISO 100, RAW. 32 mm. 15 seconds, f20. Tripod

As a travel photographer you should always be on the look out for convenient viewpoints for photography – in this case a bar overlooking the main junction in the old town of Hanoi. I had to sneak over a railing and stand out on a flat roof to get the best view. I shot with a long shutter-speed to render the traffic as long trails.

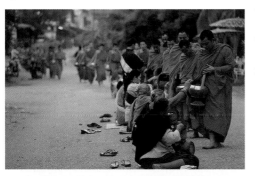

Monks on morning alms round, Luang Prabang, Laos ‹ ⌄

Nikon F5, Astia 100 ASA film. Lens and exposure not noted

The un-blurred image is still atmospheric, showing the monks who go on an alms round each morning. Below, the light levels were low and by selecting a narrower aperture I used a shutter speed of a few seconds to introduce blur. Those handing out the alms were relatively still and so have hardly blurred.

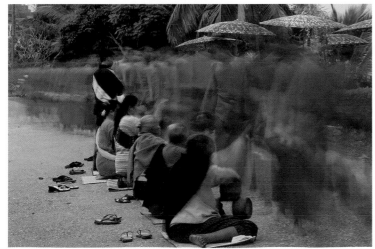

and see how far the subject moves in that time. If you look at the image preview and you want twice as much blur then double the exposure. If you want half the blur, halve the exposure. The degree of blur is directly related to how far the subject moves whilst the shutter is open.

During the day, you might need to employ **neutral density filters** to get a long-enough shutter speed to achieve the blur effect you are looking for. These drastically reduce the amount of light entering the camera and are a great way to introduce blur in situations when people aren't expecting it – in daylight and when people are moving slowly.

📷 Digital SLR
Digital long exposures are affected by 'noise', which is caused by the sensor heating up. Switch on long exposure noise reduction and it will be reduced, although the exposure time will effectively double.

◉ Film SLR
Film is subject to reciprocity failure, whereby it needs more exposure at longer shutter speeds. For more on this, see page 113.

▣ Digital compact
Most digital compacts don't allow very slow shutter speeds but you can still achieve blur on faster moving subjects; you will probably have to use a shutter-speed priority mode to select it. If you have an auto-ISO function, make sure that you switch this off, as it will automatically increase the sensitivity to give a faster shutter speed, precisely to avoid the very blur that you are trying to achieve. Switching off your flash will also force the camera to use a slower shutter speed, rather than illuminate the picture with flash.

Panning

Sometimes freezing movement or allowing it to blur won't be right for your subject. If you are photographing a galloping horse with a slow shutter speed, the image will not have any definition. And, freezing the motion of a speeding car will make it look like it is parked.

To show movement in these circumstances you can use a technique called panning. This is when you intentionally move the camera during the **exposure**. The trick is to use a slow **shutter speed** and to move the camera at the same speed as your subject. Most of the subject will be sharp as it will stay in the same part of the frame, but the background will show **motion blur**, giving an impression of speed. The parts of your subject that are moving independently, such as the legs of a horse, or the wheels or a car, will be blurred, but in a different way to the motion blur of the background.

You can also opt to use panning if you don't have enough light to use a fast enough shutter speed to freeze the movement, or if you have a distracting or boring background that you want to obscure. In the picture of the Mongolian horseman, there was actually a road with telegraph poles in the background. Panning has almost completely obliterated the poles – although you can just see them if you know that they are there.

Wide and telephoto lens panning

You will get a different effect depending on the type of lens you use and the direction of the movement.

If you shoot with a **telephoto lens** and position yourself so the movement is perpendicular to you, then you will get a very flat effect with the background blur running in a parallel sweep. This is a useful technique for a subject that is passing you, such as a car or train. The use of a telephoto lens also helps when you can't get close to the subject.

If the moving subject is coming towards you at an angle, then you can shoot with a **wide-angle lens**. This produces a much more dynamic effect, in which the subject appears to explode into the frame. This makes it a good technique for subjects such as vehicles that have no other moving parts (such as legs or arms) to add interest to the shot.

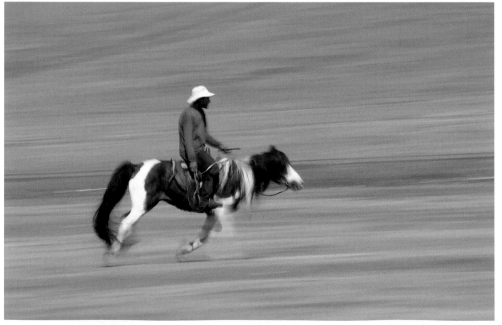

Horseman galloping across the grasslands, Ulan Batur, Mongolia ‹

Nikon F4, Provia 100 ASA film. 80-200 mm lens. 1/15 second, f22

This man was galloping backwards and forwards on the grasslands near the Mongolian capital. I wanted to try a panning shot, partly to make the shot more exciting, and partly as there was a road with telegraph poles in the background. Blurring them was easier than retouching them! I used a telephoto lens as the movement was perpendicular to the lens, and as slow a speed as I could manage. I only had a short while to set the shot up and didn't have time to use any filters to cut down the light. As the man galloped past, I panned with the action. The speed was enough to blur the background, though you can still see a pole if you look for it.

**Speeding traffic,
Hanoi, Vietnam** ∧

Nikon F4. Provia 100 ASA film.
21 mm lens.
Exposure not noted

I wanted a panning shot to
show the lunacy of traffic
in Hanoi. To achieve a more
dynamic shot, I used a wide-
angle lens and positioned
myself so that the traffic
approached on the diagonal
and so appeared to explode
into the frame. All of a sudden,
a couple of people in traditional
conical hats came past to give a
Vietnamese feel to the image.

Technical stuff

The shutter speed you will need to use will vary
depending on the speed of the subject. Slower
subjects need a longer shutter speed to achieve a
good amount of blur. However, you don't want to
have such a long exposure that there is also
movement outside the direction of the pan, as this
will introduce blur into the parts of the subject that
you don't want to show movement. Experiment
between a second an 1/8 second, although outside
of this range can work as well. Make a couple of test
sweeps at the same speed as the subject: start to
follow your subject's movement, trip the shutter and
maintain the motion even after the shutter closes.
Following through like a golf swing will give a much
smoother effect. Some people find that they get a
much better result panning with their camera on a
monopod (a one legged-tripod).

Focus can be an issue with panning but, as you
will generally be using a small **aperture** to balance the
long shutter speed, you should enjoy a large **depth of
field**. Setting the camera to a continuous rather than
a single autofocus mode can help with focusing.

Panning as a technique works best when you
can take a few shots of the scene, such as cars or
horses in a race, or a busy spot in a city, where you can
wait for taxis or even rickshaws to come past. This will
allow you to tailor the settings and experiment with
different shutter speeds, rather than just having to
get everything right in one go.

If you are panning in the daylight, you may need
to use a **neutral density filter** to reduce the light to
allow for a slow enough shutter speed.

◉ Digital compact

It is possible to pan with a compact, although you
will need to force the camera to use a slower shutter
speed by using a shutter-speed priority mode and
switching off the flash and auto ISO setting. You will
also have to anticipate the shutter delay and trip
the shutter commensurately before you actually
want to take the picture.

Aperture and depth of field

If there is movement in your picture that you want to show creatively, then you should base your exposure on the shutter speed, which controls how the movement will render (see page 98). If there is no movement, then the most creative thing that you can do is control the depth of field by basing the exposure on the aperture.

The **aperture** of a lens is the hole that the light passes through to get into your camera. For such a seemingly simple thing, it has a profound effect on your picture. As well as controlling the exposure, the aperture controls the **depth of field**. This is the zone of the picture in front of and behind the actual **focus point** that appears to be in focus. A small or shallow depth of field means that only a limited part of the scene, close to the actual focus point, is acceptably sharp. A large depth of field means that an extensive part of the scene both in front of and behind the focus point appears to be in focus.

Any lens, including your eye, can only focus on one point at a time. Everything in front of and behind

**Buddha image,
Wat Doi Suthep,
Chiang Mai, Thailand** ∧

Nikon D2x, ISO 160, RAW.
200 mm (300 mm equivalent).
1/200 second, f5.6

Cropping in on the hands of this Buddha statue with a telephoto lens and using a relatively wide aperture has thrown the background completely out of focus. This has formed a pleasant golden blur which sets off the image perfectly.

**Tibetan Buddhist prayer book,
Chemrey, Ladakh, India** ⟨

Nikon D3x, ISO 1000, RAW.
60 mm Macro. 1/80 second, f3.2

The combination of a close focusing distance facilitated by a Macro lens, and a wide aperture of f3.2 has given a very shallow depth of field. This manages to isolate a part of the script, making the picture less confusing. The viewer of the picture can see the Tibetan script, and the blurred areas suggest the repetition.

that point will be out of focus and appear blurred. You don't notice this effect as your eye is continually refocusing on each thing that you look at but, if you hold your hand in front of your face, focus on it and concentrate, you will be able to see the out-of-focus background with your peripheral vision. The narrower the hole you view through, the sharper things look. This is why people with poor eyesight tend to squint. Your camera works in the same way: the smaller the aperture that lets the light into the camera, the more of the picture will appear to be in focus. This is the effect of depth of field.

The larger the aperture (designated by the smaller numbers, such f2.8 or f4), then the shallower the depth of field. This means that there won't be as much of the scene in front of or behind the subject that is sharp. If you use a smaller aperture (designated by a larger number such as f11 or f16), then the depth

⊙ Digital compact
Although many compact cameras have manual and aperture priority modes that give some control over the aperture that the camera sets and, therefore, control over the depth of field, these aren't always the easiest modes to use. If you have a simple compact camera you might find that there is a picture mode that will give you more depth of field; if there is not a specific depth of field mode, try using the landscape mode.

of field will be much greater and a large zone in front of and behind the subject will appear sharp.

If you want everything in your scene to be in focus, then you should select the smallest aperture possible. However, bear in mind that your lens will tend to lose overall sharpness slightly after f11, as the light is diffracted by the small hole. This is different from depth of field and can be mitigate by increasing **sharpening** to the image in post-processing. A large depth of field is useful in landscapes or city shots, where you want as much of your scene as possible to be sharp, from the foreground to the horizon.

A shallow depth of field is useful for making objects stand out from their background. If the background is sharp and in focus, then it can be confusing and distract from the subject. Rendering the background out of focus (but recognizable) helps to show the viewer of the picture what you want them to look at. In this way you can use sharpness and blur to set up meaning in your pictures and to convey what are the most important objects: just like pointing at something. The degree of blur is controlled by the size of the aperture and can be affected by the **focal length** of the lens and the **focus distance**.

Limiting depth of field can be very useful for portraits, when you want the background to be completely out of focus. Sometimes, however, you won't be able to get as much of the face in focus as you would like – so the eyes might be sharp but the tip of the nose won't be. This can happen if you don't have sufficient light to use both a small enough aperture (to increase depth of field) and a fast-enough shutter speed (to prevent camera shake). Fortunately, if you are shooting digital, you can increase the **sensitivity** (page

**Grand Palace,
Bangkok, Thailand** ➤

Nikon F5, Velvia 50 ASA film.
28-70 mm lens.
Exposure not noted

It is difficult to get a novel photograph of the Grand Palace, but I made a valiant effort by photographing one of the floating lily flowers sharp in the foreground with one of the giant statues as the out-of-focus background. The result exploits the camera's characteristic depth of field purely for visual effect and shows how you can use it to create a unique image.

**Pilgrim at Ganga Sagar Mela,
West Bengal, India** ⌄

Nikon D2x, ISO 100, RAW.
80-200 mm lens (various focal lengths). 1/320 second, f4

This praying pilgrim has been photographed using the same aperture, but three different focal lengths on a zoom lens. It shows how focal length affects depth of field. The images have been resized so that the subject is the same size for comparative purposes. From left to right: 200 mm (300 mm equivalent); 140 mm (210 mm equivalent); 80 mm (120 mm equivalent).

110), which will allow you to use a correspondingly smaller aperture, giving that much more depth of field.

Another technique that you can employ for stationary subjects is to put the camera on a tripod and shoot with the lens on the smallest aperture for the greatest depth of field. I have used this technique in a number of situations, including when photographing the bas reliefs in Angkor Wat, with exposures of two or more seconds.

As with most things in photography, control of depth of field works better in the extremes. Depending on the intended creative effect, you should either try to limit the depth of field to a small area of the picture or try to have everything sharp and in focus. A middling depth of field, where most things are sharp but not everything, and the viewer can't really tell the photographer's intention, should be avoided. Make your decisions bold and creative by taking control from your camera: use either the **manual exposure mode** or set the aperture in any of the auto modes.

**Dead Vlei,
Sossusvlei, Namibia** ◄

Nikon D2x, ISO 100, RAW.
120 mm (180 mm equivalent)
1/160 second, f5.6

Looking across the massive dry
pan of Dead Vlei, I chose a wide
aperture and a telephoto lens
to give a shallow depth of field.
This was partly for visual effect
to emphasize the cracking of
the pan, by drawing the viewers
eye to that part of the picture,
and partly because this was
late in the morning and the
light was quite poor. Keeping
the dunes and the ancient
camel thorn trees out of focus
has disguised this. Dead Vlei is
deceptively large and walking
across it takes some time. The
trees and the dunes seem a
long way off and shimmer
in the heat haze. This image
manages to capture some of
the feeling of trudging across
the pan.

① **Pro tip**
If you have too much depth of field in your image,
caused by the lens and aperture combination and the
sensor size in your camera, it is possible to change
this to some extent in post-production. To do this, you
create a mask to protect the parts of the picture that
you want to be sharp and apply a blur filter to the rest
of the picture. This is shown on page 272.

Other things that affect depth of field
A **wide-angle lens** tends to have a greater depth
of field for a given aperture than a telephoto lens.
This makes **telephoto** lenses more suitable for
photographing those subjects that you want to
stand out from the background. (See also page 75).

The focus point also affects the depth of field. The
closer the focus point is to the camera, the shallower
the depth of field. This is one of the things that makes
close-up and **macro photography** so challenging: to get
enough **depth of field** you need to use a very narrow
aperture, which often involves the need for extra lighting.

As a rule of thumb, the zone of focus is two thirds
greater behind the point of focus than it is in front. This
means that if you want to get the maximum depth of

field in the foreground, you should consider focusing
somewhat closer than your subject. The depth of field
behind the focus point will ensure that your subject is
sharp but more of the foreground will be sharp as well.

Gauging the effect
When you look though an **SLR** or **DSLR** camera, you are
seeing your subject at the widest aperture of the lens,
otherwise it would all look very gloomy and dark. As
you take a picture, the lens is stopped down to the
chosen aperture a fraction of a second before the

**Bas relief galleries,
Angkor Wat, Cambodia** ◄

Nikon F5, Provia 100 ASA film.
17 mm. 4 second, f22. Tripod

It is difficult to appreciate an
image with maximum depth of
field. The effect is much more
subtle than an image with a
shallow depth of field. To get
the maximum depth of field
on this image, and to keep
everything from the foreground
to the far distance in focus I put
the camera on a tripod, used
the maximum aperture of f22
and focused one third of the
way into the subject. Using a
super wide-angle lens has also
given a greater depth of field
and accentuated the visual
effect of the galleries receding
into the distance.

picture is taken, then is opened again afterwards. This means that you can't see the effect of the aperture on the depth of field when you are setting it.

However, most DSLRs have a depth of field preview button, which allows you to see how much of your picture will be in focus. Unfortunately, the viewfinder may go quite dark, depending on the aperture you have set, so this isn't always easy to assess.

Some cameras have a special depth of field mode where you measure the two points that you want to be the extremes of your depth of field; the camera will set the aperture and the focus point to make sure that they are sharp.

The effect of a smaller sensor

Most DSLRs have a smaller sensor than the 24 x 36 mm of 35 mm film. Typically, this reduces the **angle of view** and effectively multiplies the **focal length** by a factor of 1.5x. So, a 35 mm lens on a camera with a **crop factor** of 1.5x will have a similar magnification and crop to a 50 mm lens on a 35 mm camera or a DSLR with a **full-frame** sensor.

There is a often confusion over what effect the smaller sensor has on the depth of field, with most people stating that the smaller the sensor, the greater the depth of field. Actually, the small sensor inherently gives less depth of field. However, if you take into account the effect of the crop factor on the lens, it gives

Tea plantations on rolling hills, Munnar, Kerala, India ⌄

Nikon D3x, ISO 250, RAW. 32 mm. Polarizing filter. 1/100 second, f11

I wanted to create a picture that showed the actual tips of the tea, with the rolling tea-covered hills in the background. As with so many landscape shots, it was important to have everything in focus. I opted for an aperture of f11, which gives the greatest sharpness on most lenses. Beyond this and you can lose overall sharpness due to light diffracting round the aperture hole. If you need to use a smaller aperture to get enough depth of field, then don't let this hold you back, but I decided f11 would be adequate. I used a polarizing filter to darken the skies and also make the foliage more intense. Focusing around a third of the way into the frame maximised the depth of field, and I checked the effect on the LCD preview screen.

around a **stop** more depth of field. That is to say, you would have to use a 50 mm lens on a 35 mm camera to get the same crop and object size as you would with a 35 mm lens on a camera with a 1.5x sensor. The 35 mm lens gives much greater depth of field than the 50 mm lens, so the overall effect is that a 1.5x crop camera has about an extra stop of depth of field than a 35 mm or full-frame DSLR, for the same object size.

This effect is even more pronounced if you are shooting with a **compact camera**, which typically has a very small sensor. Although the smaller sensor inherently gives much less depth of field, the fact that you will be using a lens with a magnification factor of 4.5x or 5x relative to a 35 mm camera and could have a focal length of just 7 mm, means that the effective depth of field will be much greater. One of the problems with compact cameras is the difficulty of achieving a shallow depth of field, making it almost impossible to have a pleasantly out-of-focus background in a shot.

ⓘ **Pro tip**

If you have an SLR that only has manual focus or if you want to shoot with manual on a DSLR, you can use the hyperfocal distance. This is a focus point for a given lens/aperture combination in which everything from the hyperfocal point to infinity will be in focus due to the depth of field. This also extends to half the hyperfocal distance in front of the focus point, so if the hyperfocal distance is 5 m, you can set the lens to 5 m and everything from 2.5 m to infinity will be in focus. As long as the aperture or focal length don't change, you can just snap away and not bother with focusing; everything will be sharp due to the depth of field.

Another benefit of using the hyperfocal distance is to achieve the maximum depth of field without using the smallest aperture. Most lenses perform better at an aperture of f8 or f11. Although an aperture of f22 will give more depth of field, the overall sharpness might be lower because of diffraction. Focusing on the hyperfocal distance rather than the subject gives a much greater depth of field for a given aperture. It is useful to know the hyperfocal distance at f11 for all your lenses, especially the wide-angles.

There is a link to an online hyperfocal distance calculator on www.footprinttravelphotography.info

Sensitivity

Evening ceremony, Meenakshi Amman Temple, Madurai, India ❮

Nikon D3x, ISO 2000, RAW. 32 mm. 1/50 second, f3.2

Modern digital cameras have seen fantastic improvements in ISO performance, and even current simple compact cameras will outperform many of the DSLRs that were available when I wrote the first edition of this book. It is now feasible to handhold your camera at a high ISO in most circumstances and not have to use a tripod or flash, although you will have to modify your shooting technique. When photographing this evening ceremony in the Sri Meenakshi temple in Madurai, I timed the shot to the instant when the fan was momentarily stationary at the apex of its movement. This was also useful in masking out the two Western tourists standing behind the priest: you can still see their white feet in the crowd behind! This picture also shows the benefits of research and patience: this ceremony where the goddess Meenakshi is brought to Lord Shiva's shrine happens every night, but at a time when most tourists are having dinner, so most people miss it.

There is, of course, a third variable you can employ when working out your shutter speed/aperture combination to achieve a correct exposure: sensitivity. Sensitivity is a measure of how much light a sensor/film needs to achieve a correct exposure. The higher the ISO number the greater the sensitivity and the less light needed to achieve an exposure. (See also Exposure terms, page 83).

One of the most useful features of a digital camera is the facility to change its sensitivity on a shot-by-shot basis. This is done for practical rather than creative reasons, as it allows you to use the **aperture** or **shutter speed** that you want, even if there is not enough light to expose correctly for it.

The most obvious reason to increase the sensitivity is to avoid **camera shake**. Increasing the sensitivity by a **stop** could mean that you are able to use a shutter speed of 1/60 second rather than 1/30 second, thus minimizing the chance of camera shake.

Similarly, increasing the sensitivity by two stops to allow a commensurately smaller aperture to be used can give enough extra **depth of field** to ensure that all of the important parts of a picture are in focus.

It is possible to shoot with a slower shutter speed and your camera on a tripod to avoid camera shake in low light levels, or to permit a smaller aperture. However, if there is any movement in your picture, a slower shutter speed can show blur; if you don't want this effect, then increasing the sensitivity might be your only option.

⊙▭ Film SLR

Increasing the sensitivity on a film camera means using a faster film. To get round the problem of continually swapping films (which usually involves wasting the unfinished portion of the film), you will need to carry a second body with a faster film in it. Faster films suffer from larger and more prominent grain, giving a similar effect to luminance noise. In general, a modern digital camera will give far smoother results than the equivalent speed film. It is possible to uprate a film, by increasing the processing times in order to increase the sensitivity. You can easily increase a 400 ASA film one stop to 800 ASA or, at a pinch, two stops to 1600 ASA before the grain and increased contrast become too prominent.

Foodstall, Jemaâ el Fna, Marrakech, Morocco ❯

Nikon D2x, ISO 640, RAW. 65 mm lens (97 mm equivalent). 1/80 second, f5.0

In order to take this image discreetly, holding the camera by hand, I increased the sensitivity by almost three stops. Without that I would have had to shoot at around 1/15 second – too slow to stop subject blur or camera shake.

High ISO noise

In a digital camera the sensitivity is increased by magnifying the signal recorded by the **sensor**. Unfortunately, this also magnifies any background signals and interference, resulting in **digital noise**. At higher sensitivities your picture may suffer from colour or **chroma noise**, which shows up as random coloured pixels, and **luminance noise**, which gives a general speckling, especially in the shadow areas. In extreme cases, noise can be so unpleasant that it will render a picture completely useless.

In the early days of digital cameras, high ISO noise was such an issue that the rule of thumb was always to use as low an ISO as possible and not to increase it by more than a few stops. As technology has moved on, most modern sensors are capable of shooting at very high ISOs with little or no noise at all. The degree of noise will vary from camera to camera, with smaller **compact cameras** tending to suffer more than **DSLR**s. Many cameras have a 'recommended' range with one or more stops of 'boost' or higher ISOs on top.

Some subjects suit higher noise, and photographer's opinions on what is acceptable seem to vary wildly, so it is impossible to give any firm recommendations as to the highest ISO you should use. As with most things in photography, you should experiment with your own camera to see which sensitivities produce virtually no noise, which give tolerable noise, and which produce so much noise that they render the picture unusable.

When you shoot on a higher ISO, the camera essentially **underexposes** by a given amount and then compensates for this in the in-camera image processing. This is a similar to underexposing your picture and correcting it yourself in post-processing.

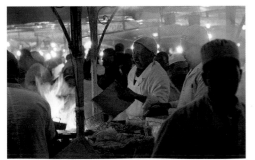

Both will cause noise, so avoid underexposure at high ISOs as the noise will be accumulative. This is why noise is worse in shadow areas.

In general, use the optimum ISO setting for your camera, which is usually but not always the lowest sensitivity possible, as this will give the highest quality results. It will have less noise than higher sensitivities and even a slightly better **dynamic range**. If you do need to increase the sensitivity, then do so freely, but try to keep within the preferred range that you have established for your own camera. If you are shooting in low light and trying to freeze movement in your picture then you may need significantly to increase the sensitivity to be able to take a picture. Remember to set the sensitivity back to the optimum setting when you have finished a particular shot.

Many digital cameras have an **Auto ISO** setting, which allows the camera to increase the sensitivity if it feels the need. The downside to this function is that the camera might change the sensitivity without you knowing. You might want to select a slower speed as you are confident of your ability to hold the camera by hand or because you want to introduce blur, but the camera won't know this and will override your settings. My recommendation is to ignore the Auto ISO facility and manually change the ISO when you feel the need.

High ISO noise ◂

Section of an image shot at ISO 3200 showing high ISO noise. This is a full-sized reproduction at 300 dpi. The top image is without any noise reduction, and the bottom image is with noise reduction applied in Adobe Lightroom. The noise reduction has reduced both chroma and luminance, but has resulted in a slight overall softening of the image. This has been partly countered by increasing the sharpening.

◉ Shooting RAW
All but the simplest RAW-processing software will have some degree of noise reduction and suppression built in. Generally, chroma noise is easier to reduce without affecting the overall detail of an image. There are also a number of third-party software products that are designed solely to minimize the effect of high ISO noise in your picture.

Low-light shooting

Photography has a fantastic capability to capture objects or scenes that are so dark, you can barely see them with the human eye. I have photographed the gloomy interiors of cave monasteries and the mummified bodies of ancient kings lit only by a single candle. In low light and at night, colours appear dull or muted to the human eye but, if you get the exposure and white balance correct, then the colours will render correctly in a photograph.

There are essentially two options when shooting in low light levels: you can use a high **sensitivity** and hand hold the camera; or use a slower **shutter speed** with the camera on a tripod. A higher sensitivity can suffer from **digital noise**, although this is less of an issue with modern cameras; a slow shutter speed can be better quality, but any subject movement may be blurred. Which you choose will depend on the subject, your equipment and how you want the picture to look.

If you don't have a tripod, then you can take reasonably long **exposures** by propping the camera up on a table, especially if you use a beanbag or even some clothing to support it. You can even hold the camera by hand at relatively low speeds such as 1/8 or even 1/4 second, if you brace yourself and your camera against a wall and time the exposure between breaths or even between heartbeats.

Most camera **meters** are sensitive enough for you to be able to measure the exposure at lower levels but, if the light levels are lower than the meter's range, you might have to make an educated guess and **bracket** to get good results. Shooting with digital allows you to review the exposure on the LCD preview screen. To work out the exposure, meter from an averagely lit area, if possible with a **spot meter**. (If you meter from a light source then your picture will be **underexposed**.) Any light sources will inevitably burn out but this can add atmosphere to your picture.

To avoid camera shake, use a **cable release**. This allows you to fire the shutter without touching the camera. Many modern cameras have a digital cable release and some even take an infrared or wireless release so you can fire the shutter from a distance. If the necessary shutter speed is longer than any of the presets (typically up to 30 seconds for a **DSLR**), then you will have to use the **bulb** setting, usually denoted by a 'B'. This will hold the shutter open for as long as

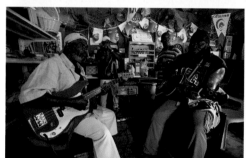

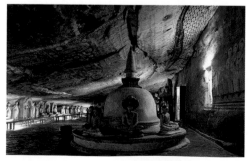

Traditional dancing, Ubud, Bali ◄

Nikon D2x, ISO 640, RAW. 190 mm (285 mm equivalent). 1/80 second, f2.8

Using a high sensitivity allowed me to shoot this traditional dancing in Bali without using flash, which produces a more atmospheric result. I still had to time my shot when the action reached a peak and naturally froze for a split second.

Musicians in a beach bar, Montserrat ◄

Nikon D3x, ISO 1600, RAW. 17 mm. 1/40 second, f3.2

Investigating music coming from a beach bar I found this band jamming. The bar was very dark, so I increased the ISO and used a wide angle lens to minimize the possibility of camera shake. If I had used a long exposure and tripod, I would have seen subject blur.

Carnival dancer, Venice ◄

Nikon F801, Provia 400 ASA film, pushed 1 stop to 800 ASA. Lens and exposure not noted

Using a fast film will give similar results to shooting with a high sensitivity, although the grain will be far more pronounced than the same speed on digital. If you push a film, to make it more sensitive, you need to do this for the whole film, and compensate during developing.

Dambulla Cave Temple, Sri Lanka ◄

Nikon D2x, ISO 100, RAW. 17 mm (25 mm equivalent). 4 secs, f5.6. Tripod

The interior of this cave temple was predictably dark. Shooting with the camera on a tripod allowed me to avoid increasing the sensitivity, in order to give a better quality result. As there was no subject movement there is no subject blur.

you keep the shutter button depressed. You will need to get a remote release with a locking function for this. Some infrared and wireless releases also have a bulb facility. If you don't have a cable release then you can use the self-timer to fire the shutter without touching the camera. Some **SLR**s and DSLRs have a **mirror lock-up** function, which allows you to move

📷 Digital SLR

Long exposures with a digital camera are affected by **noise**, which is caused by the sensor heating up, resulting in random coloured 'hot' pixels on the photograph. More sophisticated cameras have a mode that makes an identical blank exposure after the real exposure and then identifies and maps out the 'hot' pixels. The downside of this mode is that the exposure time is, in effect, doubled, but, as this mode only kicks in above a few seconds or so, you should leave it switched on and let the camera use it when required. Note that this type of noise reduction can only be applied when the picture is being taken, not at the RAW-processing stage.

◉ Film SLR

Films suffer from what is called **reciprocity failure**. This is when the relationship between shutter speed and exposure breaks down. Exposures between 10 seconds and one minute will actually need one or even two stops more exposure than you might expect. This is fairly constant for a given film, so you should soon be able to work out what added exposure your usual films will need. When shooting long exposures with film, **bracketing** is a good idea.

▣ Digital compact

It is usually more difficult to shoot in low light with compact cameras, as they tend to have a lower range of speeds and many don't include a bulb setting. The default setting is usually for the flash to fire at low light levels, so switch off the flash to fool your camera into using the slowest possible shutter speed. Some compact cameras have an **Auto ISO function**, which will automatically increase the sensitivity in low-light situations. Switch this off and select the lowest sensitivity to get the longest exposures. A tripod for a compact camera can be very small and portable, or it can be propped upon a table or other flat surface.

the camera's internal mirror out of the way before tripping the shutter. Sometimes the exposure will be long enough that even the wind or someone walking past the camera can cause camera shake. This is impossible to predict, so it makes sense to take a number of shots in the hope that one of them won't be affected – in effect, bracketing for camera shake.

Long exposures often need some degree of 'warming up' to produce accurate colours. If you are shooting digital then you can do this with the **white balance** function or by correcting the white balance at the **RAW** processing stage. With film you will have to use a screw-in warm-up filter (see page 123).

Focusing can be difficult in low light. One trick is to use a separate flashgun, which has built-in **infrared focus illumination**. When the camera/flash combination has focused, switch the focusing to manual to prevent it changing, turn off the flash and proceed with the long exposure. Even though it will extend the shutter speed, it is worth using a small **aperture** in order to increase the depth of field.

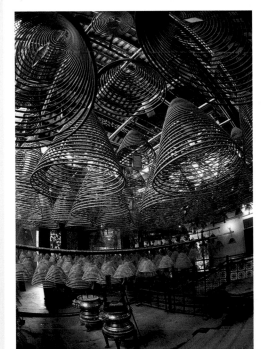

Man Mo Temple, Hong Kong, China ‹

Nikon D2x, ISO 640, RAW. 10.5 mm fish-eye lens. 1/30 second, f2.8

Using a high sensitivity allowed me to hold this shot by hand. A fish-eye lens accentuated the curves of the incense and also helped to minimize the effect of camera shake: wide-angle lenses show up shake far less than telephoto lenses, which magnify any movement as well as the image.

Nature of light

Light is the single most important factor that will make or break your photography. The quality of light can elevate a good shot to a masterpiece or can mean that, no matter how hard you work, you will be disappointed with the result.

Light to the photographer is like paint to the painter: it gives the image life, individuality and atmosphere. It can sculpt detail, show your subject in three dimensions and enhance colours. It can also convey a mood. In many famous locations, such as the Taj Mahal in India, all of the angles have been taken a million times and variations of light are one of the few things that can give you a vaguely original shot.

Many photographers talk about the 'golden hours' just after sunrise and just before sunset. Around these times the sunlight comes more from the side; it is softer and warmer; the shadows are less harsh, and, as the light is more directional, it creates interesting combinations of brightness and shadow. Shooting at this time can create spectacularly atmospheric images. Shooting at sunrise, especially, produces evocative images. The light often seems crisper than at sunset and there are far fewer people to get in the way. The downside is that you will have to get up very early (sometimes at three or four o'clock in the morning) to get in position to take your shots. In these circumstances packing a thermos of coffee and a energy bar in your camera bag can work wonders.

I should point out here that shooting *at* sunrise and sunset is different from shooting *the* sunrise or sunset. I am talking about taking advantage of the quality of the light, not taking yet another shot of the sun slipping into the horizon! On islands, I often head to the sunrise point at sunset and the sunset point at sunrise, just to take advantage of the light actually shining on something.

When gold is just too gold
Although it is probably photographic heresy, I sometimes find shooting in the golden hours too much. The light can be too gold and smother your pictures, particularly if you are shooting something that is already quite yellow, such as Roman ruins or Mediterranean buildings. If you only shoot during the golden hours, there is a danger that all of your pictures will look very similar. There will also be occasions, such as when shooting cities, waterfalls or valleys, when the

Great Hypostyle Hall, Karnak Temple, Luxor, Egypt ‹

Nikon F5, Provia 100 ASA film. 200 mm. Exposure not noted

Most people get to see Karnak Temple in the heat of the day when the light is flat and from directly overhead. I was photographing the pillars of the Great Hypostyle Hall at sunrise when the light was warmer, softer and more directional. This gave a lovely interplay of light and shadow which picked out the carvings. I used a powerful telephoto lens to crop close and isolate a part of the scene and to facilitate a greater subject distance, compressing the perspective and making the pillars appear closer together.

ⓘ **Pro tip**

When shooting into the sun you should be careful to avoid flare – an overall misty effect caused by the light reflecting off the front element or filter, and repeated points of light caused by the light reflecting off the inner elements of the lens. This can be minimized by keeping your front lens element clean and by using a proper lens hood. In excessive cases you might have to shade the lens further with your hand. Sometimes the only way to reduce the effect is to get your hand or finger in the frame. In these instances avoid obscuring any detail and simply retouch out the obstruction in post-production (see pages 268-269).

Excessive flare ‹

The effect of excessive flare can reduce contrast and drastically lighten parts of the picture. A lens hood can help, but, in extreme cases, when the sun is almost shining into the lens, you might need to shade the lens with your hand as well, as in the image on the right.

very directional light at these times just doesn't illuminate enough of the image, leaving most of it in shadow. You need an open space or a high vantage point to shoot a city in the golden hours.

The most productive times for photographers are often the hours just after the morning golden hour before the harsher midday light kicks in and, again, after the midday light softens before the sunset golden hour. This is when the light is soft, fairly directional and relatively neutral in colour. These shoulder times might only last an hour or so in the tropics, longer elsewhere, but they are a fantastic time to shoot. The light will be good and you can let your creativity, not the light, dominate your images.

There are no hard and fast rules for good light with photography. Everything changes with latitude and season. You can count on better light for longer in the northern and southern hemispheres and during the winter months when the sun is generally lower in the sky for more of the day.

Another often overlooked time to shoot is before the sun rises at dawn and after the sun sets at dusk. This very soft light will often produce atmospheric images. The colours will be muted and may even have a blue or a purple tinge. Dawn, especially, is a spectacular time, when your pictures will be full of the promise of the morning; you might enjoy a crisp frost or a moody mist.

As it gets closer to midday, the sun is more directly overhead. The light is harsh and the scene can look flat and featureless or, if there are shadows, they will tend to be deep and unpleasant. Accepted wisdom states that this time of day is only good for mad dogs and Englishmen, yet you can still take great shots even when the light is at its worst. Look at the portrait of the Laotian man smoking: this was shot in the absolute heat of the day when the light was far too harsh for photography. He was having a long and relaxing siesta in the shade, so I was able to chat to him and take my time. The shadow light is soft and even, and allows his personality to shine though.

My belief is that you can take pictures at any time of day, whatever the light and, indeed, whatever the weather, but you might not be able to take the shot you set out to achieve. Try shooting interiors, food shots and even desert pictures showing the heat haze at this time of day. Only a lazy travel photographer would shoot for just two hours a day!

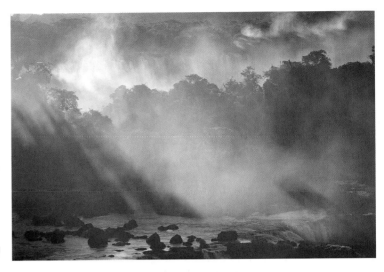

Iguaçu Falls, Brazil ◄

Nikon F5, Provia 100 ASA film. 300 mm. Exposure not noted

Often it is impossible to photograph waterfalls at sunrise or sunset, as the light doesn't reach the bottom of the falls. In this shot, the sunset light backlit the spray on the top of the falls but the tree line and the river are still visible. The film was daylight balanced preserving the warm sunset light.

Laotian man, Si Phan Don, Laos ◄

Nikon D2x, ISO 200, RAW . 70 mm (105 mm equivalent). 1/100 second, f2.8

This portrait was shot around midday, when accepted theory says that you can't take good pictures – especially portraits. This man was having a siesta in the shade. I stopped and chatted with him for a while and shot a few pictures. He was relaxed and happy to be photographed which shows in his eyes. I warmed up the white balance in post-production to cancel out the blue tinge produced when taking pictures in the shade.

**Monument Valley,
Navajo Land, USA** ∧

Nikon D2x, ISO 100, RAW.
38 mm (57 mm equivalent).
1/320 second, f9

You don't need perfect weather
to take pictures. This yellow
booth in Monument Valley is
somewhat incongruous at the
best of times but set against
a stormy sky and heavy rain it
makes a far more striking and
atmospheric image. This rain
front was moving pretty quickly
and driving a dust storm in front
of it; shortly after taking this
shot I was running for cover.

Make the most of the light

It is not just the quality of the light that matters but
also where it comes from. One of the old maxims of
photography was that you should have the light
coming over your shoulder. However, shooting with
the light directly behind you means that your subject
will be lit with **front lighting**, which is flat, rather
uninteresting light. If the sun comes from the side,
then things start to get appealing. **Side lighting** gives
an interplay of light and shadow. As long as you aren't
shooting in the middle of the day, shadows can be a
good thing: they will be softer and you will still be
able to see detail in them. As the light moves round
to the side, there will be more areas of light and
shadow and the image will have more modelling
and interest. **Backlighting**, or shooting with the light
behind your subject, can create silhouettes and large
areas of shadow with small areas of light picked out.
Shooting into the light is a fantastic way to create
atmospheric and moody shots that rely on subtle
differences in the highlights. This works well for
subjects with a bold shape that become silhouettes,
or if there is mist or haze which will be backlit.

Shooting into the light is only possible when the sun
is lower in the sky and the light is more directional.

As with so many things in photography,
experimentation is the key, but be bold and creative.
Know the rules but break them decisively and with
abandon, and you will create pictures that stand out.

When the light is all wrong

We have all been there: you turn up to take a picture of
a building or a spectacular view and the light is wrong.
It might be that a particular building is in shadow in the
morning or that the beautiful sunset light shines in
completely the wrong direction for that sweeping
landscape. You could always come back but, if your
time is limited, then you might miss the shot altogether.

With a bit of planning and a halfway decent
map, you should be able to work out when the light is
going to be pointing in the right direction for you to
take pictures. If you remember that the sun rises in the
east and sets in the west, then you can plan whether
to turn up in the morning or afternoon. You can do
the same with a city map, especially one that has all
of the monuments drawn in three dimensions.

Sometimes, though, your schedule won't let you return at a different time for better light. In this case, use your creativity to shoot a backlit or silhouetted shot. With a bit of effort, you might even take a better shot than if the light was falling directly on your subject.

Fighting the weather

Light is about more than just the time of day; it is intrinsically linked with the weather, which for a travel photographer is the greatest variable you will have to take into account. If a trip is dogged by poor weather then, no matter how good a photographer you are, the pictures you take will be limited. Good research can moderate this risk, but you will still rely to some level on luck.

If the weather is strikingly bad, then you can use it to create atmospheric and unique images. Some countries are even associated with bad weather: Vietnam is synonymous with rain, so a shot of rice fields in the rain could be more evocative than one taken in bright sunshine. Dramatic weather can give dramatic pictures: in the midst of storms you can often photograph spectacular lighting effects against slate grey sky; you may even get to photograph an elusive rainbow.

On cloudy, hazy and foggy days your pictures can look flat and uninteresting but you can liven them up by shooting into the light. This can create dramatic shots, as the light shining through fog or cloud will create a misty, ethereal effect that will mask the poor conditions. Using a **telephoto lens** to isolate a part of the detail can work well in these circumstances.

The most depressing light is grey, overcast light on a drizzly day. Although, even here, all is not lost: interiors and night shots are still possible, and there is a chance that the cloud in the sky might produce an interesting sunset. Close-up portraits can also work well on cloudy days. The softer light can show up the texture of skin and also prevents someone having to squint into the light.

If the weather is poor then avoid shooting long shots as these will show up all of the problems. Instead, concentrate on photographing nearer things and crop out the sky wherever possible; you may get moments of illumination, even though the skies are fairly overcast and the long views are hazy. Shooting close-ups and details will help to disguise bad weather.

Don't take anything for granted. You can't judge the weather by looking out of your hotel room window at 0500. Instead, get into position and hope for the best: something might happen for an instant, even in the worst conditions.

Most importantly, don't become a light snob. Even if you are serious about your photography, there will be times when you want to preserve memories even if the light isn't great. It would be a shame to come away from a trip to Machu Picchu, say, with no pictures, just because the light wasn't to your liking! Don't let poor light spoil your enjoyment of your trip.

How light changes

Next time you are travelling, try a little experiment. Find a landscape or a cityscape, and get to it before dawn. Look at how the light begins as the day breaks and changes as the sun rises. Keep watching for an hour or so. Take a few photographs to remind you. Go off for a well-deserved breakfast and then come back to the same place around midday to see how the light has changed. It will look harsh and contrasty: lit parts will be flat and uninteresting and any shadows will be deep and impenetrable. All of the extra UV around at this time of day means that it may also look hazy with muted colours. Now you know why photographers get up early in the morning…

Uluru silhouetted at sunrise, Australia ➤

Nikon F5, Provia 100 ASA film. 80-200 mm lens. Exposure not noted

Sometimes the light will be coming from completely the wrong place. In these instances, try to shoot silhouettes that will show off a recognizable shape against a vivid sky.

Uluru at sunset, Australia ➤

Nikon F5, Provia 100 ASA film. 80-200 mm lens. Exposure not noted

The classic shot of Uluru shows what can be achieved when the light is perfect and also how this monolith glows red in the warm sunset light.

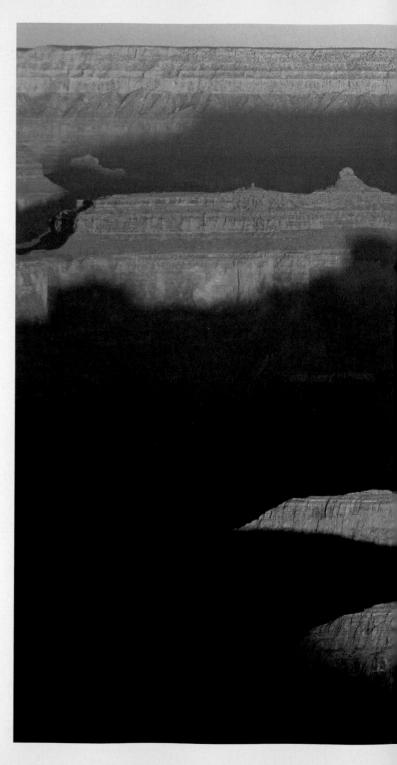

Focus on

Sunrise at Hopi Point on the Grand Canyon
Arizona, USA

This landscape illustrates a number of technical and practical points. First, I had to get up early in order to get in position by sunrise. The shot was taken at the beginning of winter, and it was a leap of faith to get to various viewpoints before dawn three days in a row and wait in freezing temperatures until the sun appeared. The day after I took this picture there was a massive blizzard of snow, which came down for almost two days; if I had stayed in bed on this particular morning, I would have missed this shot completely.

This shot also shows the quality of the sunrise light. It is warm and directional, catching the tops of the rock formations. The contrast is not excessive, meaning that the shadows are not so dark as to obscure detail.

The sky was dull and cloudy, due to an impending snow shower, so I all but cropped it out. This represents an extreme approach to horizon placement but was the right composition for the conditions. Even so, the image follows the rule of thirds, with the top and bottom rock formations each taking up a third of the image and the shadow area filling up the middle third.

This image also illustrates how landscape shots can have more impact if they are shot with a telephoto rather than a wide-angle lens. The 200 mm setting on the zoom lens has allowed a portion of the scene to be isolated and, in effect, magnified.

⊕ **Find out more**　　　　❯

Nikon F5, Fuji Provia 100 film.
80–200 mm lens
Exposure not noted.

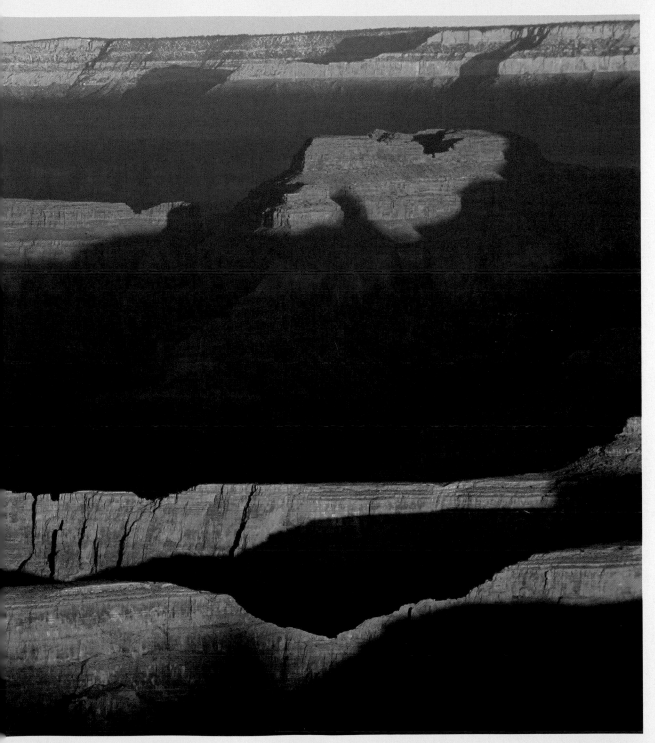

Colour temperature

Although light appears white, it is actually a bundle of different coloured wavelengths, from red through orange, yellow and green to blue then on to violet. Different light sources give off light with different combinations of wavelengths and so have different colour casts.

The colour of light emitted from thermal light sources (those sources, ranging from a candle through to the sun, which give off light as a result of heat) is known as the colour temperature and is quantified on a scale which ranges from red to blue (see below). For instance, incandescent light bulbs give off light that is very warm and orange. Candles have even more red wavelengths, while light from a flash is particularly cold and will have a slight blue tinge.

The colour temperature of light from the sun changes throughout the day as its position alters. At sunrise, the light starts off warm with more red wavelengths and gets more neutral as it moves towards noon. When the sun is overhead, around midday, the light passes directly through the atmosphere, fewer blue wavelengths are filtered out and the light is cold and blue. As it sinks towards sunset, it passes through the atmosphere more obliquely and more of the blue wavelengths are filtered out, making the light warmer and redder. Sunlight in the shadows has fewer red wavelengths and so is cold and relatively blue. Sunlight in deep shade is even cooler and the blue effect is more

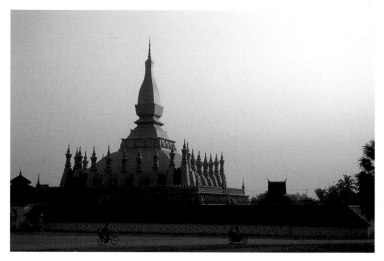

pronounced. There is a similar effect when direct sunlight bounces off snow at high mountain altitudes.

The colour temperature of light is measured in degrees Kelvin (K), which is officially defined as the temperature that a black body would have to be heated to, in order to emit radiation of the same colour. So heat a theoretical black object to 3500K it would glow orange-red. Incongruously, the colours which are perceived as warmer have the lower colour temperatures, while the blues, which are perceived as cooler, have the higher colour temperatures.

Wat Phra That Luang, Vientiane, Laos ⌃

Nikon F4, Velvia 50 ASA film.
80-200 mm lens.
Exposure not noted

The odd-shaped Wat Phra That Luang is one of the iconic sights in Vientiane. Already bright yellow, it positively glows in the early morning light. Setting your camera to daylight, as opposed to the AWB setting, will preserve the warm colours rather than filter them out.

Colour temperature of light (Kelvin)
Note: precise colour temperatures vary depending on the light source.

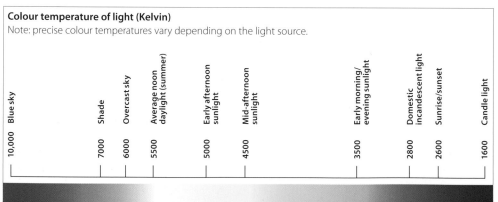

10,000	7000	6000	5500	5000	4500	3500	2800	2600	1600
Blue sky	Shade	Overcast sky	Average noon daylight (summer)	Early afternoon sunlight	Mid-afternoon sunlight	Early morning/ evening sunlight	Domestic incandescent light	Sunrise/sunset	Candle light

● Shooting RAW
If you are shooting RAW, then the white balance can be set during RAW processing, non-destructively, without any loss of quality. There is more about changing the white balance of a RAW file in the Correction section on page 255.

Fluorescent light is off this scale as it is not a thermal light source and emits light which has a lot more green wavelengths, giving pictures shot under fluorescent lights a pronounced green cast.

The reason that we are not aware of all of these colours is that our brain corrects what we see based upon our experience. If you read a book by incandescent light, your brain knows what colour the paper should be and effectively filters out the colour.

Although there will be times when we want to correct the **colour casts** in our photographs caused by colour temperature, there will be other occasions when we want to preserve, or even accentuate them. The human eye tends to perceive warm colours as pleasing and cold colours as less so. In general, much of the process of photography follows this. The warm colours are generally preserved, whereas the colder colours are warmed up. Certainly, though, like many photographic rules, this one should be broken at will for creative effect. By accentuating the blue, you can give a real feeling of cold. Other times, you might want to reduce the warmth from incandescent light, or even cut it out completely if you are shooting an interior. The green cast from fluorescent light just looks awful so, unless you are going for a post-modernist industrial effect, then you should generally remove it. Another light source which causes great problems for photographers is the sodium street lamp, which is an all-enveloping orange, that is all but impossible to remove.

Controlling the colour temperature

One of the main advantages of digital over film photography is its in-built facility for controlling the colour temperature. This is often known as the **white balance** facility. Even the simplest digital camera will have an **Auto White Balance** (AWB) facility that will be able to correct colour casts and adjust for the colour temperature. But herein lies the problem, since there are many occasions when you will want to preserve or even enhance these colours. If you leave the white balance on auto, you risk a bland uniformity in your pictures. When shooting in the golden hour or at sunset, the last thing you want is for your camera to filter out all of the warmth and redness. AWB cannot tell the difference between a sunset, where you want to preserve the colour cast, and an interior shot under incandescent light, where you might want to filter the

Antelope Canyon, Navajo Land, near Arizona, USA ❮

Nikon D2x, ISO 100, RAW. 25 mm (38 mm equivalent) 1/4 second, f11. Tripod

Antelope Canyon is a mecca for photographers. A narrow slot canyon, it has been scoured out of the soft pink rock by flash floods over millions of year. The canyon stretches for hundreds of metres and is up to 40 m deep in places. Shooting in the canyon is quite difficult. The dynamic range can be huge and, in places, the canyon is so narrow that setting up a tripod is all but impossible.

This shot illustrates how the colour temperature of light changes as it becomes more shadowy. At the top of this image the light is semi-direct and fairly warm, getting progressively cooler in the shade towards the bottom of the picture.

Rhinos at Okakuejo watering hole, Etosha National Park, Namibia ❮

Nikon D2x, ISO 800, RAW. 200 mm (300 mm equivalent). 1/30 second, f2.8

The watering hole is lit by sodium lights, which give off very orange light. This can be corrected to some degree in RAW processing although the colours never look perfect and there will always be a cast present. This image was corrected in Lightroom using a colour temperature of 2400K and a tint of +6. Okakuejo is the best floodlit watering hole I have ever seen. On this night I saw ten black rhinos, as well as lion hunting a giraffe and many elephants. Best of all it is attached to a public campsite and so doesn't cost much.

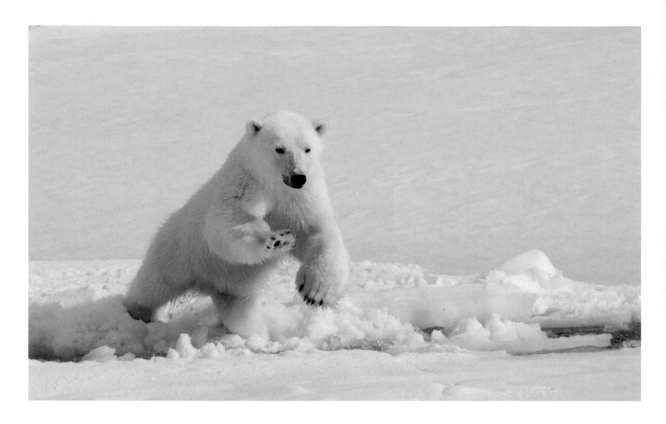

Leaping polar bear, Svalbard, Norway ∧ >

Nikon D2x, ISO 160, RAW. 420 mm lens (630 mm equivalent). 1/1600 second, f9.0

Shot on a daylight white balance setting, this image (right) was too cold because of the light reflecting off the snow. Setting the white balance to the cloudy setting in Lightroom (6500K) gave a much warmer and more pleasing result (above).

Mountain range, Diavolezza, Switzerland >

Nikon D2x, ISO 100, RAW. 20 mm lens (30 mm equivalent). 1/500 second, f5.0

Sometimes, you will want to preserve extreme cold casts in your pictures. This shot of a backlit mountain range is more atmospheric as the blue cast – caused by the combination of shadow, light and snow – is preserved.

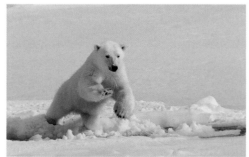

colour cast out. An added complication is that the AWB sensor often does not read through the lens but from the light ambient to the camera. If, for example, you are standing under a fluorescent light and photographing out of a window, you will get very strange results, as the AWB will base its correction on the fluorescent light. In short, like most automatic functions, AWB is a rather blunt tool and you should take control back from your camera wherever possible.

As well as the AWB, most cameras will have presets that are balanced for certain light conditions. Generally these will be:

Daylight/direct sunlight The standard setting to which film is generally balanced.
Incandescent A bluer setting which cools down incandescent light.
Overcast A warmish setting for slightly cold, overcast days.
Shade A warmer setting that radically warms deep blue shadows
Flash Slightly warm to take the edge off cold flash.
Fluorescent Slightly warming but also adds magenta to correct the fluorescent green.

Film SLR

Traditionally, camera film is balanced for daylight, which has a colour temperature of approximately 5500°K. You can also buy Tungsten-balanced film for incandescent studio lights. In general, if you want to change the colour temperature when shooting film, you will have to use a colour correction or warm-up filter. These vary from blue to orange and fit over the lens to filter the light as it enters the camera. These filters will be needed in different circumstances:

Warming filters used in general photography when you want to warm pictures; the effects are more pleasant and subtle.

81A – Slight warming
81B – Warming for overcast light
81C – Warming for overcast light and shadows
81D – Warming for shadows
81EF – Pronounced warming

Cooling filters used for creative effect to reduce warmth in sunsets or to balance shooting in artificial light.

80A – Very blue: approximately converts
 incandescent bulbs to daylight
80B – Strong cooling
80C – Moderate cooling: can reduce
 excessive warmth in sunsets
80D – Slight cooling: can slightly reduce
 excessive warmth in sunsets

Digital compact

You can control the white balance on a digital compact in much the same way as on a DSLR. Almost all cameras will have an AWB facility and most will also have presets, although most won't have the facility to perform a custom white balance. It is also more crucial for you to get the white balance right, as it will not be so easy to correct on a JPEG. Picture scene settings will also affect the white balance: a sunset mode, for instance, should ensure that the colours aren't filtered out. If you are not using a picture scene mode, I would suggest leaving your camera on the daylight setting, as this will provide good results in most cases, and selecting a preset if you are shooting under artificial light. If you forget to make the change, you should pick this up on the preview screen.

If you are shooting **RAW**, much of this is academic, as you will be able to adjust the **white balance**, without any loss of quality, in the RAW-processing stage. However, if you are shooting **JPEG**, you will have to get the white balance correct for the best results.

My recommendation is to leave the white balance set to daylight. This emulates the effect of shooting with daylight-balanced film and will make your camera behave pretty well in most situations. If you are shooting at sunrise and sunset and in the golden hours, your pictures will still have all of the warmth you want. If you want to correct artificial light or warm up shadows, select the incandescent or cloudy setting.

These presets also allow you a degree of fine tuning. If you want to balance shadows and overcast days, you can select these presets directly but you can also use them to enhance a sunset or even to take the UV coldness out of a snow shot. If you shoot at midday, one of these settings could add a warm glow to a

ⓘ Pro tip

Leaving your white balance on the daylight/direct sunlight setting when shooting RAW also gives you a reminder of the nature of the light at the time of shooting. I might process pictures months after shooting them, and I am more likely to moderate an existing colour cast on an image, than remember to introduce it from scratch on an image neutralized by AWB.

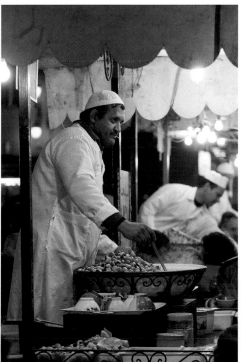

Snail seller, Jemaâ el Fna, Marrakech, Morocco

Nikon D2x, ISO 400, RAW. 86 mm (129 mm equivalent). 1/80 second, f4.0

If you shoot with the camera on daylight, the warm light from an incandescent lightbulb can be too much and should be filtered out (below). This can be done in camera by selecting the incandescent setting or, if you are shooting RAW, it can be fine tuned. In Lightroom I used a colour temperature of 2700K and a tint of +8 (left).

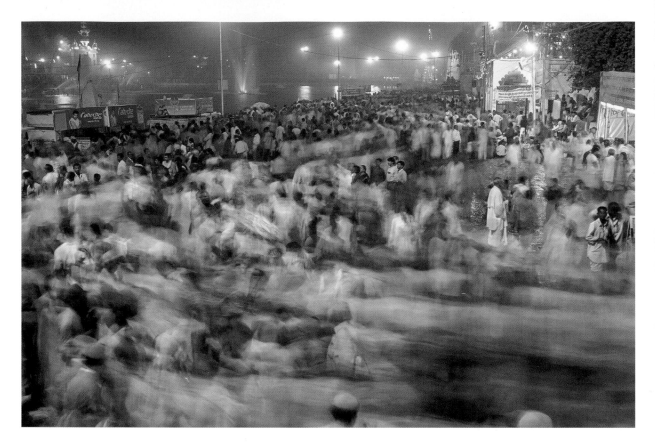

Pilgrims at the Kumbh Mela, Ujjain, India ∧∠

Nikon F5, Provia 100 ASA film. 28-70 mm lens. ~30 second, f16

The main bathing ghat on the River Shipra is lit by fluorescent light, which if shot on a daylight setting will give an ugly green cast (left). This can be partially removed using the fluorescent setting, but a more accurate result can be obtained in post-processing if you shoot RAW. This was shot on film, and the colour cast was corrected in the scanning software (above).

beach or even boost the colours of foliage. The only problem with this approach is that if you shoot in very different light without changing the white balance, your pictures will be very wrong, but it will give you a much better result when you do get things right.

On more sophisticated cameras, you can manually enter the **colour temperature** of the light source. Lower temperatures, such as 2500°K, will cause the camera to add blue to the picture, while higher

temperatures, such as 10,000°K, will make the camera add warmth to the picture. This not only allows you manually to correct any **colour casts** but, more importantly, it also enables you to introduce them into your pictures for creative effect. It might be to add warmth to a lacklustre sunset, or even simulate dusk by combining underexposure with a setting that adds blue to the picture. Some cameras will have a custom facility where you can point the camera at a neutral object and make a **white balance** precisely to balance that light source. This is very useful for accurately balancing very artificial lights, such as sodium or fluorescent lamps. You should consider making this correction even if you are shooting in **RAW**, as you might get a better effect with a manual white balance, than correcting in post-processing.

If there are mixed colours in your shot, then you can decide which one you are going to balance. For instance, you might have a fairly warm interior to a building and let the outside render blue. This will give the impression of being inside in the warm, rather than outside in the cold.

Filters

Filters are pieces of glass or resin that fit in front of the lens and affect the properties of the light in some way, before it is recorded by the camera sensor or film. There are, in essence, two main types of filter: those that have correction effects and those that have a so-called creative effect. Many of the latter are particularly crass, such as fake superimposed rainbows and starbursts on light points. Thankfully, this sort of filter is completely out of fashion, so I will be concentrating in this section solely on the correction filters.

UV filters

You should always have a UV filter fitted on to the lens to protect it against dust, scratches and repeated cleaning. It is far cheaper to replace a filter than the front element of a lens. Ultraviolet light can cause a slight blueish haze in your pictures, especially in snow and at altitudes. A UV filter will absorb small amounts of ultraviolet light, thereby increasing the **contrast** and making the pictures slightly crisper. Note that UV filters need to be the correct diameter to screw into the front of your lens.

Polarizing filters

A polarizing filter can reduce reflections in certain conditions. These might be reflections on water or glass, or less obvious examples, such as those on the surface of leaves or even rocks. A polarizing filter will darken some foliage, and by reducing the reflections on the surface of water, will effectively let you see through it, making it appear clearer and the colours more saturated. You can even use a polarizing filter to reduce the reflections from droplets of water in the sky, which has the effect of darkening a light blue sky and reducing haze.

By reducing reflections, a polarizing filter can help to saturate colours and increase the contrast of your image. The effect is variable, and its exact effect can be somewhat hard to predict. The best way to see if it is worth fitting such a filter to your camera is simply to look through the filter, rotate it and gauge the effect visually as it changes. If it has a beneficial effect on the scene, then it will have an effect on the picture. A polarizing filter will have the greatest effect on the sky if the sky is a weak blue and the sun is coming from the side, but be careful of darkening the sky too much. Assess the effect through the lens and also on the LCD preview screen.

Polarizing filters screw into the filter thread on the end of the lens, and you can control their effect by rotating them. Remember that if you change the orientation of the camera, the effect of the filter will change and you will have to rotate the polarizing filter again. The end of some lenses rotates when it is focused, in which case you will have to set the polarizing filter rotation after focusing. If there is a line on the filter mount, the effect will be strongest if this points towards the sun.

If you are using a camera with auto focus, then you should use a circular not a linear polarizing filter. This refers to the properties of the polarized light not the shape of the filter.

A polarizing filter can reduce the amount of light entering the camera by up to two stops, but the camera meter will compensate for this. Polarizing filters also tend to cool down the picture slightly. The colour temperature controls on a digital camera or in RAW processing can compensate for this and, if you are shooting film, it is possible to buy a combined polarizing and warm-up filter that will give a more pleasing result.

If you are using more than one filter, then the polarizing filter should always be furthest away from the lens. Sometimes, if you use a polarizing filter on a **wide-angle lens** it will darken the sky unevenly, having a greater effect at the edges; this can be alleviated in post-production using vignette controls (page 258).

Neutral Density (ND) filters

An ND filter will reduce the light entering the camera by one, two or three or even ten stops. It is used when you want to shoot at the widest **aperture** in

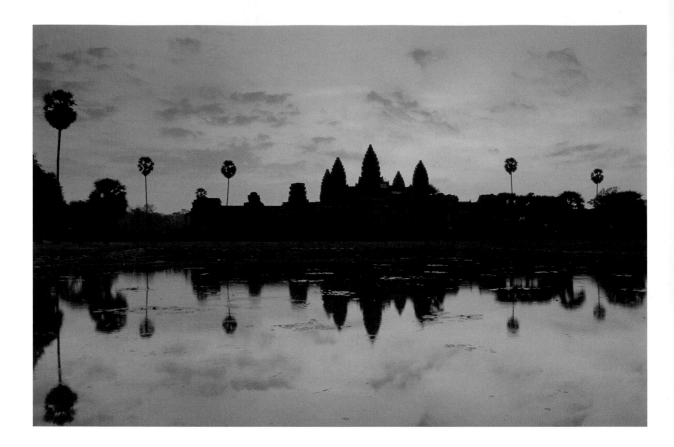

bright light or use a very long **exposure** to introduce movement into your picture. The power of an ND filter is sometimes given by their optical density with .3 equating to –1 **stop**, .6 equating to –2 stops and .9 equating to a –3 stop ND filter.

Graduated neutral density filters
Graduated neutral density filters (ND grads) are rectangular and have a ND filter at one end that gradually fades through to clear at the other. This means that they can be used to darken parts of a picture that are outside the **dynamic range** of the image, while leaving other parts untouched. They are most often used to darken the sky so that it balances the foreground or to balance a reflection. When you photograph an object reflected in water, the water absorbs about two stops of light; to make the reflection exactly match the rest of the picture you can use an ND grad to darken the non-reflected bits of the picture by two stops to match. As the name suggests, a graduated neutral density filter will darken but not colour parts of the picture; graduated

coloured filters are also available but they tend to produce an artificial effect.

Graduated ND filters are made of resin and slot into a holder that fits on the front of the lens. This allows them to be rotated and to slide up and down, so that you can place the gradation accurately. They usually come in three strengths corresponding to one, two and three stops of darkening and will either have a soft or a hard transition. Select the gradation

Reflections of Angkor Wat, Cambodia

Nikon F5, Provia 400 ASA film. Lens and exposure not noted. ND .6 hard graduated filter and tripod

Water absorbs about two stops of light, so reflection shots are darker on the bottom than the top (left). To get around this, shoot with a ND graduated filter. This darkens the non-reflected part of the picture so that it matches the reflections. The effect is more balanced and accentuates the symmetry of the image (above). This symmetry is further enhanced by composing the picture with the reflection line across the middle.

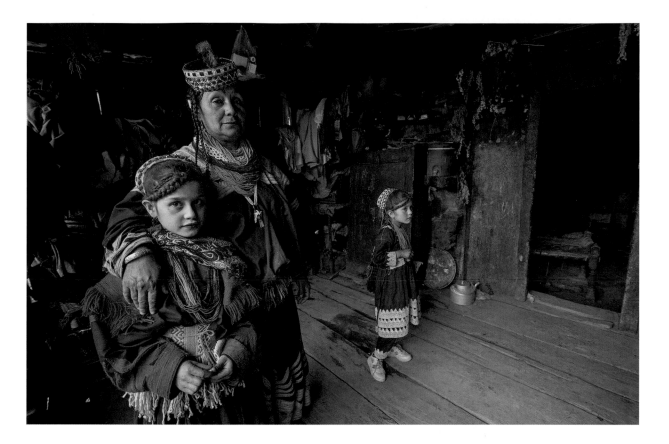

Kalash woman and her daughters on a verandah, Chitral, Pakistan > ∧

Nikon D3x, ISO 320, RAW.
17 mm. 1/100 second, f5.0

This family were standing on their verandah, which resulted in very directional light. The girl in the foreground is slightly overexposed, whilst the girl in the back is in shadow and underexposed. The uncorrected image is to the right. It is all but impossible to correct this image using the RAW processing controls that work on the entire image, but by using three digital graduated filters I achieved the result above. These three graduated filters adjusted the exposure, white balance and highlights, on selected parts of the image. Some corrections were also applied to the whole image.

that best fits your image and the effect you are trying to achieve: a hard transition is useful for reflections, while a soft transition is useful for darkening skies without showing a hard line. A small **aperture** has the effect of making the transition line appear even harder, due to the increased **depth of field**. The effect is easiest to control if you have the camera in a tripod and use a filter holder. Look through the lens and adjust the filter until you get the effect you want.

Some **RAW** and post-processing software has built-in graduated filters. These can be used to apply a number of corrections to images, including those that mirror ND grads, but also apply corrections for **colour balance**, **saturation**, shadow enhancement and highlight recovery. Multiple digital graduated filters can be used on the same image, and the results are often far better than using 'real' filters, leading many photographers to abandon the latter altogether.

Colour-correction filters
If you are shooting film then you will need to use a series of warm-up filters to adjust the colour balance (see page 123). If you are shooting digital, then this is done by the camera's **white balance** facility or in RAW processing.

Black-and-white filters
Photographers shooting with black-and-white film use a series of coloured filters to change the way that various colours in the picture reproduce (see page 138). If you are shooting digital and then converting to black-and-white, you don't need to use these filters.

Flash

Most compact cameras and many entry-level DSLRs have a built-in flash to illuminate your picture when light levels are low. However, flash units, especially small built-in ones, aren't very powerful and tend to produce harsh, contrasty light that hits the subject straight on, creating unflattering pictures with deep shadows behind them.

The light from a flash falls off drastically with distance, following the inverse square law. This means that as the flash distance doubles, the light actual falls off to a quarter. The effect of this fall-off is that a flash can only correctly expose in one plane. If you have an object 2 m in front of the camera and another 4 m in front of the camera, then your camera flash will not be able correctly to expose them both, as the back object will receive a **stop** less light. The result is that either the more distant object will be too dark or the closer object too light. This is also an issue when photographing someone in front of a background. If the background is some distance away from your subject, it will be very dark; if the subject is right in front of the background, they will cast deep shadows on to it. Flash is much more effective if all the subjects in a picture lie on the same plane.

The built-in flash on most cameras is fairly weak and generally only good for subjects up to a few metres away from the camera. What's more, on a **DSLR** its light tends to get obstructed by larger lenses and lens hoods, casting an ugly shadow on the picture. You can increase the effective flash distance by selecting a wider **aperture**, or by increasing the **sensitivity**.

There was very little light at this traditional dance display, so I had no option but to use flash. This has resulted in the background being very dark, but cropping in close on the dancer has stopped this darkness from dominating the picture. I used a diffuser on the flash to soften the light to give a better result. The very short duration of flash exposure has frozen the movement of the dancer.

A separate flash gun can be mounted onto the **hotshoe** on top of most **SLR**s and DSLRs and some **compact cameras**. This hotshoe allows the flash to communicate with the camera, and enables the flash **exposure** to be measured and controlled 'through the lens' (TTL). A separate flash is much more powerful and will be able to illuminate much greater areas. It will also have a wider coverage allowing it to be used with a **wide-angle lens**.

A wide-angle lens will need greater flash coverage than a **telephoto lens**. To provide this, most sophisticated flashguns have a zoom facility that automatically widens or concentrates the flash beam as you change or zoom lenses. You should avoid using a lens wider than the widest setting on the flash, as the picture won't have full and even flash coverage. If you're shooting with a DSLR with a crop sensor, the flash coverage is based upon the lens equivalent. So, if you are using a 12 mm lens on a 1.5x **crop sensor** you will get full flash coverage up to 18 mm. At the telephoto setting, this restriction doesn't apply: you can shoot with a 200 mm lens even if the flash only zooms to an 80 mm setting.

Although flash is less than ideal for lighting your picture, there are some occasions when you will need it; for instance, if there is too much movement in your scene to use a slower **shutter speed** and not enough light to render even with the highest **sensitivity**. In these instances, there are a few techniques that you can use to improve the quality of the light coming from your flash.

Turn down the light

Many flashes tend to **overexpose**, producing light which is too intense. I tend to leave the **exposure compensation** on my flash permanently set at minus two thirds of a stop, causing it to **underexpose** slightly. You should also shoot with the flash on TTL mode, which means that the flash exposure is measured through the lens to give a more accurate result.

Bouncing and diffusers

Most separate flash units will have a bounce facility that allows you to angle the flash head so that the light bounces off a nearby wall or ceiling. This will soften it, giving a better quality, less directional light. Sometimes, though, there won't be a suitable surface for the light to

Monks on their morning alms round, Luang Prabang, Laos ❮

Nikon F5, Provia 100 ASA film. 28-70 mm lens. Exposure not noted. Fill-in flash

An alternative view of the morning alms round in Luang Prabang. On this image I used slow exposure, set manually, and then set the flash to fire. This meant that I would have some subject blur and then a blast of flash to freeze the scene. The result shows a sharp image superimposed over the blur. There is only a relatively small amount of blur as the shutter speed was probably around 1/4 second.

Procession during fiesta, Pamplona, Spain ➤

Nikon F5, Provia 400 ASA film. 17-35 mm lens. Exposure not noted. Slow synch flash

To produce a more dynamic image, I opted to use slow synch fill-in flash on this shot. The ambient light levels were so low that the shutter speed was around a second. This has resulted in a great deal of blur from subject movement as well as camera movement. The burst has frozen the movement and given the subjects definition Without this they would have been fairly unrecognizable. To superimpose the defined parts of the scene over the blur (and not the other way around), I set the flash to rear synch, meaning it fires at the end of the long exposure, not the beginning.

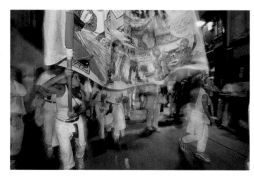

ⓘ Pro tip

There are a couple of refinements that you can make to slow-synch flash. Some flashes allow you to set them so that they fire at the end of the exposure not the beginning. This means that the flash exposure is, in effect, superimposed over the blur, not the other way around. You can also use coloured gels to match the colour temperature of the flash with that of the ambient light. This will make the picture look more balanced.

bounce off, or it will be coloured (and so will add a **colour cast** to your image). In these instances you can use some sort of **diffuser**, which fits over the head of the flash and softens and spreads the light. If your flash doesn't come with a diffuser, you can buy one from a third party, or even just fix a couple of sheets of white tissue over the flash head with an elastic band. If you are not metering the flash through the lens, make sure that any diffuser doesn't obstruct the **sensor** on the flash which measures the exposure. Some flashes have a small card that fits to the flash head when it is pointing vertically upwards, making sure that you always have a surface to bounce off. Bouncing or using a reflector will absorb some of the light, effectively reducing the distance over which the flash can be used.

Ring flash or ringflash adapter

A ring flash is a circular flash that fits around the lens and gives very even light with no shadows. They are perfect for **macro** work, but can also be used as a light source for portraits. It is possible to use a ringflash adapter that fits certain external flashes and emulates the effect of a ring flash for a much lower cost.

Colour balance

Most flash light is slightly cold. You can warm this up by fitting a faintly coloured warming gel to the front of the flash, or even inside the diffuser. This will improve the quality of the flash light, without affecting the rest of the picture.

You can also use this technique to balance the **white balance** of the flash with the ambient light. So, if you are using a flash under incandescent light, a very warm gel will balance the flash to the same white balance, so both can be adjusted in **RAW** processing.

Off-camera lead

Some flashes can be fitted with an off-camera lead, which allows you to fire the flash at a different angle. This makes the lighting less flat and allows you to control the angle of the shadows in the picture. An off-camera lead will allow all of the automatic functions of the flash still to work.

Slow-synch flash

If you balance the light from the flash with the ambient light, then the effect of the flash won't be so harsh. You can either set the **exposure** for the ambient light on the camera manually, or select an auto mode. If you do the latter you will also have to select the slow-synch flash setting (either on the camera or the flash). If you don't, then the camera might automatically set a speed that is too fast for the ambient light to register. If the ambient light levels are low, then you will get some blur in the picture as well as the frozen effect of the flash.

All of these techniques will affect the exposure but if you shoot with the flash in auto **TTL mode**, the camera will measure the intensity of the flash through the lens during the exposure and switch it off when the picture has received enough light. For the best results in auto TTL mode, use a **multi-zone**, **matrix** or **evaluative meter** (see page 85).

Red eye

Red eye is caused by the flash reflecting on the blood vessels inside the eye, causing them to glow with a somewhat demonic gleam. This effect is more pronounced with built-in flashes as they are close to the line between the eye and the lens; the effect can be minimized by bouncing the flash or using an off-camera lead.

Most flashes have a red-eye reduction facility, which gives a few flashes before the main exposure to prompt the iris of the subject to contract. This can reduce red eye, but also reduces the overall power of the flash. Multiple flashes can also be unpleasant for some people and may even cause them to look away, especially if they are unfamiliar with flash photography.

Red eye is very easy to reverse in post-processing; many RAW processors and image manipulation programs have this facility, so I suggest correcting this problem in post-processing rather than using the, quite frankly, somewhat annoying red-eye reduction facility.

Fill-in flash

The best use for flash is a technique called fill-in flash. This is when the flash is fired in daylight to lighten shadow areas when the light isn't right. Most often this is used for portraits when the light is coming from overhead at midday, when people are backlit, or if someone is wearing a hat. Without fill-in flash the face would be obscured by shadows, especially in the eye sockets. Often these shadows will be well outside the dynamic range of the camera and hold almost no detail. Fill-in flash also has the effect of putting a small catch-light in the subject's eye, which can make a portrait more engaging. You can also use fill-in flash for inanimate objects and animals, as long as they are within the range of the flash. If you are shooting close-ups or macro work, then fill-in flash can be used to improve the lighting.

The simplest way to use fill-in flash is to just set the flash to the 'always on' setting, with the camera in one of the automatic modes. This means that the flash will fire whenever you take a picture, even if the camera doesn't think it needs it. For better, more controlled results, manually set the correct exposure for the ambient light and then set the flash to auto TTL mode, using an evaluative meter.

The point of fill-in flash is to lighten the shadows, not obliterate them. The result will look more balanced and realistic if you set the flash (not the camera) to **underexpose** by about one **stop**. In this way the shadows will still look like shadows, without affecting the exposure of the rest of the picture.

Any of the previous techniques for improving the quality of flash can be used with fill-in flash to soften the light and give more natural results.

I am not massively keen on shooting with fill-in flash, as even when done well, it can be intrusive for the subject of the picture. I like to take a number of pictures when shooting a portrait and if your flash fires each time it can ruin the atmosphere of the picture – especially if your subject is from a poorer, rural community. Even though the overall brightness of the flash is swallowed up by the ambient light, people will often react to it. Your first image might show your subject looking relaxed, the second looking shocked, progressing to recoil and, if you are very unlucky, flight!

Where possible I prefer to work with the light that is present, even if this means moving people out of a shady area for more even light. You can also use a fold-out reflector, such as a Lastolite, to lighten the shadows, giving a more subtle and less intrusive effect.

> ⓘ **Pro tip**
>
> **Ring flashes** are perfect for fill-in flash as you can completely avoid the secondary shadows cast by a conventional flash, leaving only the shadows from the sun, which make the picture look more realistic. Ring flashes come in two types: a single circular tube that fits around the lens and gives an even, shadowless light, or a series of small flashes that fit on the end of the lens and allow you to fire each at a different setting, giving more natural-looking light with controlled shadows. It is possible to buy an adapter for certain flashes that converts them to ring flashes, giving all of the benefits without the expense of a dedicated ring-flash unit.

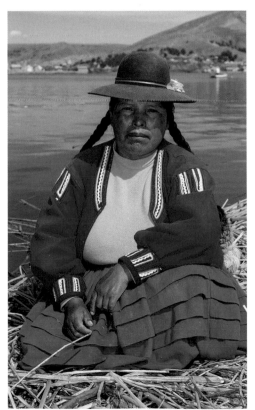

Woman on Uros floating islands, Puno, Peru ‹

Nikon D2x, ISO 100, RAW. 42 mm (63 mm equivalent) 1/250 second, f8. Flash with ringflash adapter

This woman on the Uros floating reed islands was happy to be photographed but her face was in shadow from her hat. For cultural reasons, and because the hat is a significant part of her traditional dress, I wouldn't have dreamt of asking her to remove it, so had to use fill-in flash. I also used a ringflash adapter to soften the light. The result still shows shadows, but they are soft and not too dark, and using the ring-flash avoided the secondary shadow that is often present when using fill-in flash.

Cormorant fisherman, Xingping village, near Guilin, China ➤∨

Nikon F5, Provia 100 ASA film. 17-35 mm lens. Exposure not noted. With (right) and without (below) fill-in flash

This portrait of the cormorant fisherman was shot when the sun was high in the sky and his face was completely in shadow. I shot from a low angle, partly to shine the flash under his hat, and partly to place him and his bird against the striking sky. The flash was on an off-camera lead, so I could hold it in my left hand pointing at the man and bird face on. This ensured that the exposure was more even. The cormorant flapped its wings as I took the picture, and the relatively low maximum synch speed of 1/250 second allowed the wing to blur slightly.

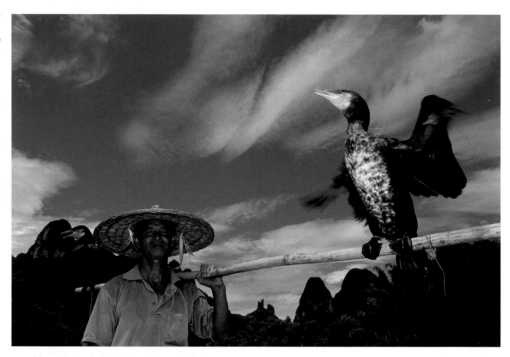

Maximum synch speed

When you are using **fill-in flash**, you have to bear in mind the maximum synch speed of your camera. This is the fastest speed that you can use with a flash. Mechanical camera shutters work by having one curtain that uncovers the film or **sensor** and another that covers it up again, so that it is exposed for the duration selected by the **shutter speed**. The maximum synch speed is the shortest time at which the sensor/film is completely uncovered. This is the moment that the flash is synched and will fire. At speeds faster than this, the second curtain will have started to cover the frame before the first one has finished and there won't be a point where the flash can light the whole picture. This results in part of the picture being dark. The good news is that most modern cameras don't allow you to set a speed faster than the maximum synch speed when you are using a flash. Sometimes the light will be too bright for you to be able to set an **aperture** small enough to balance the exposure at the maximum synch speed.

Focus

Focus is about more than the sharpness of your picture. The point of focus tells the viewer of the image where they should be looking and which objects are important. How the focus and depth of field combine can set up hierarchies and relationships within your picture.

If you have a shallow **depth of field**, then only a specific part of the image will be in focus, indicating that this is the most important element of the picture. Conversely, if you have a large depth of field with more than one object in focus then they usually have equal importance in your picture.

Pin-point focusing may not be essential if you are shooting with a **wide-angle lens** in strong daylight, as you will probably be using a small **aperture** and the resultant large depth of field will make sure that most of the scene in front of you is in focus. However, if you are using a **telephoto lens**, with its inherently shallow depth of field, and photographing a moving object, then accurate focusing is critical.

Most photographers tend to shoot with their cameras set to autofocus, so that the camera focuses the lens automatically. Most of the time this is a really good solution. The camera can react in milliseconds, and many modern lenses even have a focus motor built into them to speed up the focusing even more. The real difficulty with autofocus, however, is making sure that the camera focuses on the right thing. If the camera selects the wrong object as its **focus point**, then, regardless of how quickly and accurately it focuses, the real subject of the picture may well be out of focus. Although you can slightly **sharpen** an image in post-production, in reality, if the picture is out of focus, there is little you can do to salvage it.

Most cameras have a number of settings to help them focus on the correct part of the picture. Consult your camera manual to establish which tools are present in your particular camera; the following list will outline the various possibilities and what they are good for.

Focus modes

Generally, there are three focus modes: **manual**, **single auto** and **continuous auto**. Some lenses have a mode where you can override the auto focus by just rotating the focus ring to make visual adjustments.

ⓘ **Pro tip**
I like my camera to be as predictable as possible, and so most of the time I use a single focus point with continuos focusing, and will move my focus point over the part of the frame I want in focus. This is especially good for keeping the eyes in focus in a close-up portrait. If I want to hold the focus, I simply use the focus lock button, allowing me to focus and recompose instantly. The only change I make is to use a multiple focus point sensor in closest subject mode to track action.

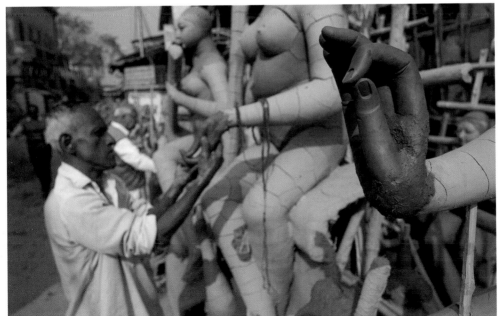

Making clay idols for Durga Puja, Kumartuli, Kolkata (Calcutta), India ‹

Nikon D2x, ISO 100, RAW. 17 mm (25 mm equivalent). 1/400 second, f4.5

When you are using a shallow depth of field, the point of focus becomes more important. I prefer to have foreground items in focus, with the focus falling away in the background. The point of focus on this image. lets the viewer of the image know where they are supposed to look.

**Illuminated Bible,
Axum, Ethiopia** ➤

Nikon D2x, ISO 320, RAW.
50 mm (75 mm equivalent).
1/60 second, f3.2

These images show the effect
of moving the focus point.
Above: moving closer and
shooting with a more oblique
angle, I have used a focus point
that keeps the middle column
of text sharp. The depth of field
drops away quickly and the rest
of the image is out of focus.

Below: from the same close
distance as above, I changed
the focus point so that the
camera focused on the
illuminated page in the
background; the text in the
foreground is out of focus.

**Flamingos, Makgadikgadi
Pan, Botswana** ➤

Nikon D2x, ISO 160, RAW.
600 mm (900 mm equivalent).
1/1000 second, f8

This image was shot with a
300 mm lens and a 2x conver-
tor. Focus has to be very precise
with this lens as there is a very
shallow depth of field. Using a
wide pattern autofocus mode
and continuous autofocus
meant that the camera could
keep the birds sharp, while I
took a number of pictures with
a motor drive. This image is re-
touched from a version shown
on page 152.

Manual focus The photographer rotates the
lens-focusing ring until the picture is in focus. Most
cameras have focus confirmation, indicating when the
camera thinks the subject is in focus. An advantage of
manual focus is that you can focus on an object, then
recompose and continue to take pictures without the
risk that the camera will randomly refocus. Manual
focus is particularly useful if you are shooting to
maximize **depth of field** or if you are using the
hyperfocal distance (see page 109). The

disadvantages of manual focus are that it is slower
than auto focus and, especially if you are shooting a
close-up portrait with limited depth of field, any
movement by you or your subject can throw the
image out of focus meaning you have to readjust.

Single or one-shot focus The camera will focus when
you half press the shutter release button and will hold
the focus until you release it. You can focus, recompose
and take the picture all with the same focus settings. If
you have a **motor drive** on your camera, you can take a
number of shots with the same focus setting before
releasing the shutter button. The default setting is that
the camera won't take a picture until it has achieved
focus, although you can change this as an option. This
method of focusing is called *focus and recompose*, and
is how many photographers use their cameras. The
downside is that you have to repeat the focus if the
subject distance changes at all, even just a few inches if
you are shooting a close-up portrait. Also people tend
to forget about precise composition if continually
moving their camera to focus, then recomposing.

Continuous or servo focus The camera will
continually refocus as you or your subject moves.
Although the camera will attempt to achieve a focus,
it will usually still allow you to take pictures even if it
thinks it is not in focus, although you can usually
change this as an option. This mode is useful if you
are photographing moving objects, especially if you
have a large depth of field. To make sure that the
camera doesn't focus on the wrong place as you
compose your shot, you can hold down the **focus
lock** button (if your camera has one) for as long as you
want the camera to hold the focus setting. Some
larger **telephoto lenses** have a focus lock button on
the lens, which means that you can hold a focus while
supporting the lens. This mode is good for sports
shooting or if you use a single focus point and move
it over the part of the frame you want focused.

Focus points
The focus points are parts of the frame where the
camera can focus. There will usually be one in the
centre, plus others selected by the user. Some more
sophisticated cameras can have literally dozens of
autofocus sensors. These can be combined in various
ways to try to improve the focusing.

⊙ Digital compact

One of the biggest complaints about compact cameras is the delay between pressing the shutter release and actually taking a picture. This is usually a delay in focusing. You can speed this up by half pressing and holding the button. The camera will focus on the subject, then, when you finish pressing the button to take a picture, the camera will already be focused, speeding up the whole process.

Single point sensor Most cameras with more than one sensor will allow you manually to select which sensor is active. The advantage of this mode is that you know which sensor the camera is using and what the camera is attempting to focus on. If you are using a **spot meter** this will follow the focus point. The disadvantages are that, if the sensor isn't pointing at the right thing, then the focus might not be correct. It is possible to select a sensor to fit in with the composition; a sensor towards the bottom of the frame, for instance, will help the composition of a landscape shot much more than using focus and recompose. Combine with continuous focus to keep the selected subject in focus if its distance changes.

Smart sensors Some cameras have smart focus sensors that will attempt to select areas of detail, or even eyes, on which to focus. As with any automatic function, the results can be unpredictable.

Multiple sensor modes Multiple sensor modes are used to attempt to focus on objects that are moving in the frame. These will vary a great deal, depending on your camera, and the explanations in the manual are often less than clear, but it is worth investigating what your individual camera is actually capable of shooting, especially if you like taking action shots. A useful mode is the 'closest subject priority' mode, which uses multiple sensors to detect the closest object to the camera and then to focus on that.

Focus tracking enables the camera to lock on to a moving object and to keep it in focus, allowing you to take a number of shots with a motor drive, each one of which should be in focus as the object moves. This is very useful in sports and wildlife photography. Some sophisticated cameras will even predict the

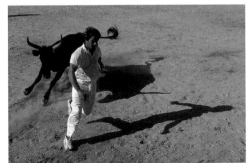

Bull games, Camargue, France ◄

Nikon F5, Velvia 50 ASA film. 20-70 mm lens. Exposure not noted

Using a predictive autofocus mode, I was able to automatically track the movement of this *razatteur* at a *course de cocade* in the Camargue, and to make sure that he was in focus when I took the picture.

Cave near Krabi, Thailand ◄

Nikon D2x, ISO 200, RAW. 200 mm (300 mm equivalent). 1/320 second, f8

Focusing on the edge of the cave means that the boat is out of focus in the background. I used a moderate aperture so that the boat was still recognizable. The result is a picture of the mouth of the cave.

Fishing boat near Krabi, Thailand ◄

Nikon D2x, ISO 200, RAW. 200 mm (300 mm equivalent). 1/320 second, f8

In this image I changed the focus to make sure that the boat is sharp. The edge of the cave is out of focus but, as I used a moderate aperture, it is not completely blurred and you can still make out its shape. Although framed by the mouth of a cave, this is a picture of a fishing boat.

movement of a subject, making the focus more accurate. You will need to use the **continuous focusing** mode to use focus tracking.

With all of these focus settings, consult your manual to find out what your individual camera can do. You should also practise until you are familiar with the settings. Don't wait until you are photographing a hunting cheetah in the Ngorongoro Crater to try and fathom out how to use predictive focus tracking; practise on the dogs in the local park first!

Thinking in colour

It might seem excessive to have a spread on photographing in colour; after all, we see in colour and most of us have already taken many colour pictures in our lives. Yet, successful colour photography needs just as much thought and careful consideration as shooting in black-and-white. When you understand how colours work with each other, then it is possible to take images that work on an emotional as well as a visual level.

Colour wheel

When thinking of colours and how they interact, it is useful to consider the colour wheel, which is a graphic representation of the colours of the spectrum and their relationship with each other. The colour wheel is made up of the primary colours: red, yellow and blue. In between these are the secondary colours of red-orange, orange, orange-yellow, yellow-green, green, green-blue, blue-violet, violet and red-violet. Primary are defined as colours that cannot be made by other colours but can be used to create all other colours.

Although red, yellow and blue are the accepted primary colours, there are other colour models which sometimes confuse people. Computers and digital cameras use the additive colour model where Red, Green and Blue (RGB) are used to make all of the other colours. Printers (inkjet printers and commercial printers that produce books and magazines) use the subtractive model, where cyan, magenta and yellow (CMY) are used to make all of the other colours. These colour combinations are sometimes referred to as additive and subtractive primaries but for the purposes of how colours are perceived, it is worth concentrating on the traditional colour wheel.

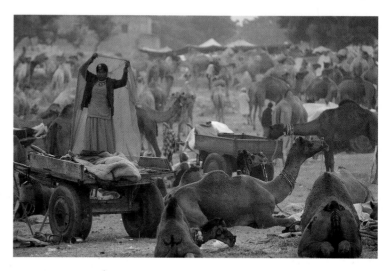

Woman in red, Pushkar camel fair, Rajasthan, India ⋀

Nikon D2x, ISO 400, RAW. 155 mm (232 mm equivalent). 1/50 second, f2.8

Expansive shots like this need a point of interest, and my eye was instantly drawn to this woman adjusting her red shawl. Using her as the point of interest but placing her at the edge of the frame leads the viewer's eye straight into the picture.

This was shot just before sunrise, and the light levels were low. I increased the sensitivity by two stops to 400 ISO and used Vibration Reduction on the lens. This allowed me to handhold the shot at the low speed of 1/50 second.

Dominant colours

Certain colours will always attract attention in a picture. Most notably, red will always attract the viewer's eye first, so, if there is a red object in your picture, such as a person in red clothes or a red car, then it will stand out. This is why red is used as the sign for danger. Yellow can also be a good colour to attract attention in your pictures.

Complementary colours

Complementary colours are two colours that are opposite each other on the colour wheel. If these are used together they will not clash but will create a high **contrast** effect. The complementary colours are red and green, blue and orange, and yellow and violet.

Perception of colour

We perceive different colours in different ways. Reds, yellows and oranges are seen as warm and more pleasing; blues are seen as cold and less pleasing. Greens and violets are more neutral and can be either warm or cold depending on the hue: that is whether they are mixed with blue, yellow or red. Blue-violet is rather cold, whereas violet-red is much warmer. Although we perceive blue as a cold colour, in fact, on the colour temperature scale (see page 120) blue light has a higher colour temperature than red.

When you understand the way that we emotionally perceive colour, then it is possible to

use colours and, especially, **colour balance** to set a mood in your pictures. Preserving or enhancing a blue cast in your picture, for instance, can give a feeling of cold and even sadness. This can be done by setting the camera to a daylight **white balance** setting in dusk or snowy conditions or even setting the camera to the incandescent setting, which will actively add blue to your image.

The warm colours of a sunset or of an interior lit by firelight can be preserved by again setting the white balance to daylight, as an **auto white balance** will assume that you want to remove all **colour casts** and filter them out. If you want to enhance a warm tone, either to warm up a neutral image or to over-correct a slightly cold image, then you use the overcast or the more extreme shade settings. These will warm up the picture and make colours appear warmer and more vivid. The overall effect will be warming and more emotionally pleasing.

Using a limited colour palette

Not every picture will have every possible colour in it. In fact, your images will often be more striking if they use a limited palette. Images comprising just two complementary colours can be very vivid and graphic. For example, if you photograph a red plant against a background of green foliage.

You can achieve a more muted effect by using analogous colours: these are ones that are next to each other on the colour wheel. An image that consists only of yellow, orange-yellow and orange tones – such as a picture of autumn leaves – creates a more relaxed, less jarring effect than if there were complementary colours present. Similarly, a palette of blue, blue-green and green – such as a palm tree and blue sky hanging over tropical water – gives an equally mellow feel.

Sometimes you can find or create an image with a monochrome colour palette. This is when all of the colours come from various tones and shades of just one of the colours in the colour wheel. Depending on the colour, **saturation** and intensity, the effect can either be vibrant or relaxingly muted. You could also create a monochromatic image using a colour that isn't on this colour wheel, such as slightly different shades of brown from timber.

Achieving good colour images

Most of the time you will be finding colour combinations rather than creating them, although training yourself to recognize them is a skill in itself. However, there is more to good colour photography than just spotting interesting combinations. In order to turn these naturally occurring colours into successful images you will often have to change the crop and the composition to focus the attention of the viewer where you want it to be. You will also need to crop out conflicting colours that will spoil the effect. At other times you might have to alter your **angle** or **viewpoint** to place a colour next to a complementary colour.

If, for instance, you have noticed that there is a dominant red in the picture, then you may well have to alter your framing, lens choice and composition in order to enhance its effect. Placing the dominant colour on one of the anchor points of your image is a good way to maximize its prominence in the frame and to create a more balanced image.

You can create a monochromatic image by shooting into the light, especially on overcast or misty days. This will drastically reduce the colour palette. You can then use the white balance to add, enhance or preserve the colours and, therefore, the mood. This can be used to great effect on misty sunrises. If you have a scene which has a limited colour palette, then you can accentuate this by **over-** or **underexposing**, making the colours lighter or heavier and more moody.

Volcano, Bali, Indonesia ⌄

Nikon D2x, ISO 100, RAW. 200 mm (300 mm equivalent). 1/200 second, f3.2

Shooting into the light at sunset has reduced the colours of this image to a single palette. Most of the picture, including the trees in the foreground, are tones of the same colour. Using a powerful telephoto lens and shooting from a great distance has given a very flat image that looks almost painted.

Shooting in black-and-white

Black-and-white photography used to be a complicated process involving tanks of noxious chemicals to develop the film, followed by hours spent in a darkroom laboriously printing pictures by hand.

The advent of digital photography has changed this. Now creating a black-and-white image is relatively easy but, to get the best results, there are a few things you should bear in mind right at the very beginning of the process.

A good black-and-white photograph should be conceived in black-and-white, not just converted because the light was too poor for colour photography, or because the picture looked poor in colour. Neither should it be shot in black-and-white to add a perceived gravitas to an otherwise weak image.

As with colour photography, light is important. Overhead harsh lighting will look just as unpleasant in black-and-white. A black-and-white image can generally stand richer, darker shadow areas than a colour one, but they need to be controlled shadows. Deep shadows in eye sockets or obscuring faces will not look good.

Contrast is vital in black-and-white photography. Avoid large, relatively featureless areas of colour,

Monk at Hemis Gompa, Ladakh, India ⌄

Nikon D3x, ISO 3200, RAW. 55 mm. 1/15 second, f4.0

The simple conversion of this shot to black-and-white was too grey (left) so I changed the way that the reds and orange reproduced in Adobe Lightroom. This made them lighter and increased the contrast of the finished image. Simple sliders darken or lighten how colours are reproduced.

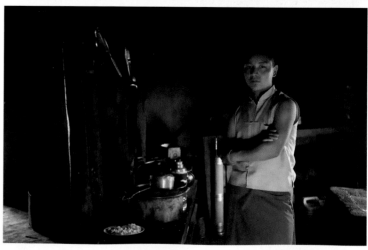

Film SLR

If you're shooting with film, coloured filters can be used to change contrast and alter selected tones in black-and-white pictures.

Yellow
Slightly darkens greens and blues, notably blue skies, making clouds stand out. Reduces effects of blemishes on Caucasian skin.

Orange
Moderately darkens greens and blues, notably blue skies, making clouds stand out.

Red
Significantly darkens greens and blues, notably blue skies, making clouds stand out. Dark blue skies can appear almost black. Cuts out blue haze in long shots.

Blue
Lightens blue skies. Darkens skin tones. Brings out haze and mist, especially in long shots.

Green
Lightens foliage and darken skies slightly. Renders skin tones more deeply.

such as sand dunes or an overcast sky, as these will reproduce in a bland grey tone. Even a gorgeous blue sky will look grey when shot in black-and-white. The pictures will look more pleasing if the sky is dappled with small white clouds or if shafts of light are breaking through dark stormy clouds.

Strong textures will produce good black-and-white images, especially when they are accentuated by soft, directional light. This casts rich shadows that produce vibrant, sculpted images. Look out for the subtle interplay of highlights and shadows. Softer light from overcast skies can also be good for photographing textures, including the skin of portraits. If you shoot from relatively close and crop out any skies, then the weather won't be so apparent.

It sounds obvious, but compositions that rely on colour may not work in black-and-white. The compositional classic of introducing a red object in to a picture – such as a single red apple in a sea of green apples – won't work, as both colours will render as a similar tone. One way to estimate how tones will reproduce in your image is to squint. This will minimize the effect of the colours and approximate what the picture might look like when the colour is removed.

The way that colours reproduce as tones is the single biggest issue with black-and-white photography. Two colours that contrast might be rendered as very similar tones. Film photographers get around this by using coloured filters on the camera to change the way that colours are reproduced (see box left).

Shooting black-and-white with a digital camera
Most digital cameras have an option to shoot in black-and-white but this tends to give a fairly flat, grey

Man at Sonepur Mela, Bihar, India ›

Nikon D2x, ISO 100, RAW. 56 mm (84 mm equivalent). 1/160 second, f4

Skin tones reproduce very well in black-and-white, especially those lit with soft evening light. The colours on the original version were almost too warm from the sunset light. Converting to black-and-white has given a much more restrained result where the attention is focused on the man's face and eyes, not the saturation of the picture. Using the tone adjustment tool, I have darkened the 'reds' in the picture, making them darker and more prominent.

Ethiopian Cross, Lake Tana, Ethiopia ‹

Nikon D2x, ISO 100, RAW. 200 mm (300 mm equivalent) 1/200 second, f3.2

The sky in this silhouette shot was a little bland, but by converting the image into black-and-white and lightening the blue tones using the tonal adjustment tool, I was able to create a much more dynamic result.

image, without the rich blacks that characterize a good black-and-white shot. Also, you won't have any control over the tones that the colours in your picture are rendered to. Colour scenes shot in black-and-white can look flat and grey, because, although colours in the scene might stand out in a colour picture, they can be rendered as a very similar grey tone in a black-and-white image. A more controlled result can be achieved by shooting a colour **RAW** file and adjusting the tones during RAW processing. This allows you to change the contrast and also the relationships between tones in your image.

Film photographers shooting in black-and-white have traditionally used coloured filters (see left) to adjust how the tones in the image are rendered: yellow, orange and red filters will progressively darken blue skies; a blue filter will lighten skies; a green filter will lighten foliage and darken Caucasian skin tones. During post-processing you are able to emulate these filter effects in a controlled fashion. This technique means that you keep your colour original and that you can decide whether an image will look better in black-and-white after shooting it.

If you are saving your images in a **JPEG** format, it is still possible to convert your images to black-and-white in post-processing and to alter the contrast and some of the tones, particularly if you are using a later version of **Photoshop** (from CS3 onwards). However, you will have far more control and will preserve more of the quality and tonal range if you shoot in RAW.

ⓘ The methods for converting your images to black-and-white are shown in the Correction section, see page 284.

Patience and waiting

Some years ago I was in the underwater tank at Mzima Springs in Tsavo West National Park in Kenya. This was an underwater chamber with windows, accessed via a short staircase. It was cramped, dark and stiflingly hot. I sat in there for about 90 minutes waiting for one of the resident hippos or even a crocodile to pass. Eventually a large hippo galloped past on the base of the river and I had time to squeeze off three shots. Two minutes later, a group of tourists came down the stairs, looked cursorily at the windows, as if expecting the whole cast of *Fantasia* to be performing there, and then left disappointed.

Hippo at Mzima Springs, Tsavo West, Kenya ‹

Nikon f801,
Kodachrome 64 ASA film.
Lens and aperture not noted

Although not the best underwater shot in the world, this photo of a hippo underwater took a great deal of patience in a hot and humid tank. The light filtered through the water is very blue, which can only be corrected slightly in scanning.

This was a lesson in patience. A large part of travel photography – where subjects are usually completely outside your control – is waiting. Sometimes this can mean a few minutes; at other times, mind-numbing hours.

There seems to be no end to the things that you might have to wait for: the sun to come out from behind a large cloud; a particular event at a festival, where you have to stake out your position – I once spent six hours marking a spot at the railing of the Palio horse race in Siena, and someone still tried to push in front of me at the last minute – or a train to cut across the countryside. On an atmospheric road like the Leh-Manali Highway, it can be worth waiting for a characteristic lorry to appear; if you shoot wildlife, you will wait hours for the animals to do something interesting; if you shoot landscapes, you might wait days for the light!

Photographers develop all sorts of techniques for killing time: reading, listening to music, texting everyone in your phone or even obsessively checking and cleaning your gear. Whatever pastime you choose, you need to keep alert and ready to take the shot. If you zone out, you may well miss the moment.

You should also be careful of being too patient. If you haven't done your research, you might find yourself waiting for the light to be perfect for one pretty good view, only to find that there is a stunning vista just around the corner that you have completely neglected.

People, people everywhere!

A perennial problem with travel photography is other travellers. In some locations, it seems that you can't point your camera without tour parties in day-glo colours romping through your shot or hippy-clad backpackers adopting self-consciously languid poses in prominent places. However, if you wait long enough, then, at some point, your shot will virtually clear of people. This can take an irritatingly long time, but be ready to take the picture the instant someone walks out of the frame, before the next walks in.

Research can help this process: at the Alhambra in Granada, for instance, entrance tickets have a 30-minute window, which means you get a wave of people who come in the instant their ticket allows, followed by a lull. This pattern carries on throughout the site so all you have to do is stake out your position and shoot when the lull comes. It might take all day for you to get around, but you will get shots without crowds. Alternatively, just shoot at less popular times. Mornings in the Grand Palace in Bangkok are rammed with people; in the late afternoon the place is almost deserted. Similarly, at Machu Picchu, if you shoot in the last hour of the day, there will be far fewer people.

Play the advantage

Some serious photographers advocate that you should wait and show patience when you arrive at a destination and not take pictures on the first day or so; just walk around and soak up the atmosphere. This is probably good advice if you have unlimited time: you can seriously plan your shots and work out the best angles. However, as you have no control over the weather, you risk wasting a good day of sunshine. If the weather changes, you may not be able to shoot anything. Instead, my mantra is always to play the advantage: if the light is good when I arrive at a place, I shoot. I can always goof off once I know I have everything I want in the bag.

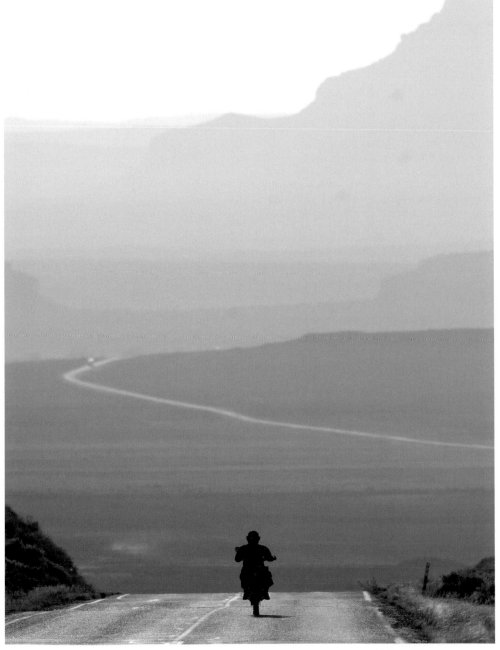

Desert road, Arizona, USA ➤

Nikon D2x, ISO 100, RAW.
420 mm (630 mm equivalent).
1/1000 second, f7.1

Driving along this road, I was struck by the vista and the sight of the road continuing off into the middle distance. I stopped the car and set up the camera with a super telephoto lens (I used a 300 mm lens with a 1.4x convertor). I used a tripod to avoid camera shake and also because small movements with the camera were affecting the composition. The image just didn't do justice to the scene; it needed a vehicle to complete it so I just stayed and waited. Traffic is few and far between in this part of the world but within the hour I heard a motorbike. Once it passed, I moved back into the road to take this image. As it was a motorbike it was near to the middle of the road, and the rider slowed to take in the view, causing the red brake light to come on. The result is a classic road trip shot.

Shooting around a subject

Even the most skilled photographer will have to work at getting a great image. Few can get everything spot on with the first shot, no matter how experienced they are and how much they try to assess and pre-visualize their photographs. For some photographers taking a number of different photographs of a subject is the process that they use to develop their ideas and discover a more creative vision.

Don't just take one photograph of a person or place and move on. Experiment with different treatments. You might already have a good shot in the bag, but by working through the creative process, you can get some more good shots in different styles and prevent your pictures from becoming samey and dull. Try to take both horizontal and vertical shots. Shoot with **telephoto** and **wide-angle lenses**, then walk around your subject and try different **angles**, **viewpoints** and subject distances. Shoot a long shot

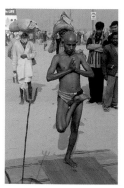
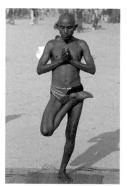
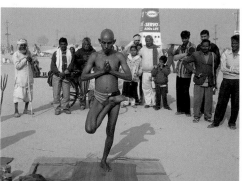

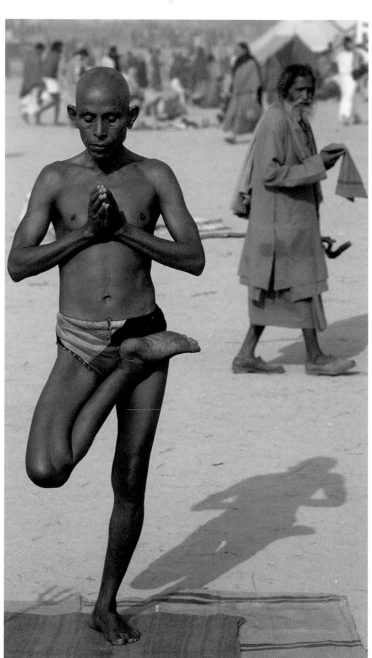

Moai at Ahu Tahai, Easter Island >∨

This stone Moai at Ahu Tahai, just outside the main settlement of Hanga Roa, is the only one on the island with painted eyes. Over the week that I was on the island I took a range of pictures in a number of different styles to try to get different and memorable images. This included a high-key, backlit image, a six-minute exposure to show star trails, and shots at both sunrise and sunset.

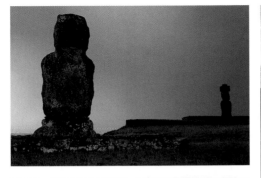

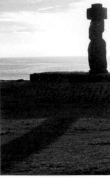

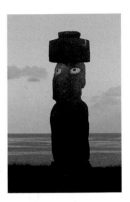

Man performing yoga, Maha Kumbh Mela, Alla-habad, India <

Nikon F5, Provia 100 ASA film. Lens and exposures not noted

Walking around at this Hindu festival I came across this man meditating and standing on one leg. I quickly took a photograph but the shot had people in the background (top left). I centred myself and took another horizontal shot (bottom left) but, by this time, a small crowd had formed and there were even more people in the way. At this point I moved away, hoping that they would clear. After a couple of minutes I could see that the background was free of people, so I took the vertical shot of the man on his own (centre), using a wider aperture to keep the background out of focus. Lastly, a pilgrim walked past in the background and looked back at the man on one leg. I changed the composition to include him in the frame, which also had the effect of not cropping the shadow. This is the shot that works best: if I had only taken the first image it would not have been so good.

and a close-up. You could also try shooting with different **apertures** and **shutter speeds** to get completely different images: some will work; others won't be quite so successful. Shooting around a subject in this way can be useful if you are trying to create a photostory or, for that matter, a range of marketable pictures, as you will get a series of linked but creatively different images.

Although research is important, it is easy to become a slave to what you should be photographing and what angle you should be photographing it from. Instead, use your research as the basis for your photography, and then shoot around the subject. You may well discover a more unique angle or approach all on your own.

If you are shooting a portrait, then taking a number of different shots is always a good idea. People tend to become more relaxed, the more pictures you take. With a digital camera you can show them the first picture on the LCD preview screen before taking a few more shots. Try an

extreme close-up and a long shot and then, maybe, get your subject to carry out a familiar action. With luck, the person will get more and more comfortable in your presence and you will be rewarded with a range of shots. By spending time with your subject you have the chance to get to know them. Don't just be obsessed with getting your shots; try to find out a bit more about them and interact. This, to me, is one of the fringe benefits of being a travel photographer.

Sometimes you might shoot around a subject in a few minutes; other times it might be a process that lasts a few days or even months. If you can, look at your pictures on a computer to work out what has worked and even come up with other treatments. If not, quickly check the LCD screen, but avoid just concentrating on it, and not the subject in front of you.

One thing to be aware of when shooting around a subject is to plan your time. Don't spend so long taking a range of pictures in one place that you miss out on other photogenic locations. Some subjects will only warrant a few minutes of your limited time.

Shooting details

It is possible to spend so much time looking for an expansive view of a building or place that you completely miss the wealth of details that give a subject interest. Details can provide the perfect contrast to endless shots of distant landscapes, as they usually involve photographing something that is smaller, closer and more intimate.

Photographing details can work in two ways. It can show the viewer something more about a place, person or scene to enhance or complement another wider shot; or it can provide an iconic image that manages to sum up a larger subject with one small shot.

In the first case, it might not be clear exactly what the detail shows, without seeing it in conjunction with a wider shot. A photograph of some much painted iron-work, for example, is an interesting pictorial detail

but won't necessarily make people think of Paris, unless it is contextualized by a view of the Eiffel Tower. A shot of the hood ornament of an old American car from the '50s, photographed in front of a weather-board house, on the other hand, might make people think of Cuba and, so, has the makings of an iconic detail shot.

Details also give you the opportunity to take original photographs. Many famous landmarks have been captured countless times but, if you are always on the look out for details, then you have the chance to shoot something that most people won't even notice, let alone photograph.

Some details will be famous, and you will find out about them by doing some background research. For instance, the Bocca del veritas is an old Roman drain cover shaped like a giant face, tucked away in the backstreets of Rome. If you put your hand in the

Hood ornament, Varadero, Cuba ⌄

Nikon F4, Provia 100 ASA film. Lens and exposure not noted

The hood ornament of an old American car set against a tatty blue weather-board house forms an iconic image of Cuba. Keeping the background recognizable but out of focus makes the car ornament stand out and also gives it a sense of place.

mouth and tell a lie, legend has it that your hand will be bitten off. Popularized in the Gregory Peck and Audrey Hepburn film *Roman Holiday*, it is a fantastic, yet somewhat hard-to-find detail of Rome.

You will be able to discover other details that are worthy of a photograph on your own, just by being observant. Walk around, looking for things that interest you, both visually and conceptually, and assess whether they will make a good photograph. This is very good training for a photographer; the more that you develop the ability to see things as potential photographs, the better a photographer you will be. After all, anyone can be motivated to take a picture of the pyramids or the Sydney Opera House, but it takes a lot more effort and creativity to see pictures in a quiet backstreet or in a patch of jungle.

On a practical level, photographing details will often give you more control over **angle** and **viewpoint** than wider shots. You will usually have some time to think about your shot, rather than worrying about people walking into the frame or jostling you for position. Detail shots are also more possible to shoot in poor weather, as they won't show an overcast sky.

To isolate a detail, you can either use a **telephoto lens** or simply move closer to the subject, depending on the perspective that you want to achieve. Before you start snapping away, consider the **mise en scène** and the composition of your shot. Don't automatically photograph a detail head on: think about how it might combine with other things in the frame and whether the shot could show something recognizable in the background to give a sense of place. Compositionally, placing your detail off centre or framing it in some way could produce a more visually pleasing image. Another thing to consider is the **depth of field**. Do you want to isolate the detail completely from its surroundings or to keep both the detail and the background in focus to link them more closely together in the viewer's mind?

Detail shots can be very useful if you are shooting a photostory, as they mix well with wider shots, both visually and by explaining or qualifying the subject. They are also a vital tool for the professional photographer. Publications often use a number of detail shots as well as larger establishing shots and, although the amount of money you will receive per picture might be lower, it soon adds up: sell three or four detail shots and you might get as much as you would for a single image used as a double-page spread.

Bocca del Veritas, Rome, Italy ‹

Nikon F801, Provia 100 ASA film. Lens and exposure not noted

The Bocca del Veritas makes an interesting and atmospheric detail, especially when photographed in warm evening light. An ancient Roman drain cover, it was featured in the fifties film *Roman Holiday*. Good research is the key to locating certain details; try to find out characteristic things about your destination before you arrive.

Pet fish for sale, Hong Kong, China ⌄

Nikon D2x, ISO 200, RAW. 80 mm (120 mm equivalent). 1/125 second, f4

Sometimes you have to be observant to notice good details on your travels. This was the display outside a pet fish shop in Hong Kong. Sometimes isolating details from their surroundings and filling the frame with them can emphasise repetition and create an interesting picture.

Taking pictures for correction

Before digital post-production came into its own, there were many occasions when it was just not possible to take a good picture because of excessive dynamic range, unwanted objects in the picture or unsuitable lighting effects. Nowadays, many of these problems can be solved by digitally retouching the image at the post-production stage.

Objects in the picture

You will often find unwanted objects intruding into your shot. It might be ugly telephone wires across the sky or a brightly clad person in an otherwise empty landscape. It doesn't have to be a large object to ruin your picture; something small in the distance can still be very intrusive. Sometimes you can simply pick things up or even wait for people to move, but often the easiest option is to retouch the picture in post-production. If the background is complicated, then it will be more difficult to get a natural-looking result, but objects lying on grass, tarmac and in clear skies are easy to erase. If an object or person is moving, wait until they are crossing a background that will be easier to retouch. Some people consider retouching to be somehow 'cheating'. My rule of thumb is that I will only remove something that is not a permanent part of the scene. So red anorak, taken out; electricity pylon, left in.

Sun in the wrong place

Close to sunrise or sunset, you may find that your own shadow is in the picture. Often you will be able to alter your position or to crouch down to eradicate it, but sometimes there is only one **angle** for the shot and no way to avoid it. Fortunately, it is now easy to remove the offending shadow in post-production. Compose the shot so that your shadow lies over an area of the picture with little detail; this will be far easier to retouch.

Excessive flare

There are times when a lens hood won't be enough to prevent flare, due to the low angle of the sun, and you will have to shade the lens with your hand. In some instances, your fingers may actually end up in the picture, but, as long as your hand or finger is not obscuring detail or encroaching into the horizon, then retouching is relatively simple.

ⓘ The retouched versions of these shots can be found on footprinttravelphotography.info.

Monk by Lake Tsomoriri, Ladakh, India ◄

Nikon D3x, ISO 160, RAW. 10 mm. 1/125 second, f8.

Photographing a monk walking down a steep slope towards the village of Korzok, I noticed a couple of tourists in the way. In the days before digital post-production, I would not have taken the shot. The two extra tourists are easy to retouch out, improving the shot.

Kubu Island, Botswana ◄

Nikon D2x, ISO 100, RAW. 38 mm (57 mm equivalent). 1/320 second, f9

Sometimes the light will be such that the only way you can take a shot is to have your shadow in the picture. This can easily be removed in post-processing, especially if you are careful to place your shadow over something that is easy to retouch.

Flamingos, Makgadikgadi Pan, Botswana ◄

Nikon D2x, ISO 160, RAW. 600 mm (900 mm equivalent). 1/1000 second, f8

I was able take shots of these flamingos in flight but a couple of them have been cropped at the edge of the frame. These are easily retouched to create a better composition. The retouched version of this image is shown on page 134.

Backlit plant, Arches National Park, Utah, USA ◄

Nikon D2x, ISO 100, RAW. 19 mm (28 mm equivalent). 1/160 second, f5.6

To avoid flare in this heavily backlit shot I had to get my hand in the frame to block the sun. I kept it away from any areas of detail, and completely within the bright sky, so removing it will be a quick and easy process.

Shooting to increase dynamic range

In some shots the contrast will be so great that the camera won't be able to record both the shadow and the highlight detail. It might be that part of the picture is lit by strong sunlight and part is in deep shadow, or there might be multiple light sources. This often happens if you are shooting at night when the ambient light is low and there are illuminated or neon signs present. You get the same effect when shooting through an open window or door, as the light levels inside a room will be far lower than those outside.

These light levels can sometimes be balanced with filters or **fill-in flash**, but on other occasions this isn't possible, as the areas which need to be controlled are too far away for a flash or are the wrong shape for graduated filters. In the days before digital, such images would have been impossible to capture on film but, now, it is relatively simple to take a number of shots at different **exposures** and combine them to produce a single correctly exposed image.

Some cameras have an image overlay facility that will allow you to combine images in camera, but unless you have to deliver your images in a hurry, you will probably get more accurate results working on a computer in post-production.

The key to combining images for dynamic range is the accuracy of the original photography. You will need to shoot with a tripod so that the images line up accurately. It doesn't matter if there is movement in the frame, as long as the parts of the picture you are planning to combine aren't moving. Usually there will be one exposure for the majority of the scene in front of you, but certain areas will either be too light or too dark. It is these areas that should not move between exposures.

The first step is to calculate the exposures for the different elements of the picture that you are planning to combine. In the case of a bright neon sign in a night shot, the difference in exposure could be as great as five or six **stops**. In these instances, the light from the brightest parts of the picture might also affect the rest of the image, so shoot a couple of intermediate exposures to make any blends more accurate. It is better to have too many, rather than too few shots. If you are just shooting two exposures to darken a sky, then the difference in required exposures might only be one or two stops.

Once you have worked out the exposures for the extremes of the scene, start at one end of the range and then take a series of shots a stop apart, until you reach the other end of the scale. For instance, if the ambient light needs an exposure of 1/4 second at f8 and an illuminated neon sign needs an exposure of 1/125 second, shoot these exposures and the four stops in between (1/8, 1/15, 1/30 and 1/60 second). Now you will have all the shots that you need and, as long as you haven't changed the **focal length** of the lens, they should be simple to combine.

There is a semi-automatic process to combine the images, called HDR, or High Dynamic Range. I find that pictures using this technique often look artificial, with too much detail in the shadows. I prefer manually to combine images in **Photoshop**. It is also possible to increase dynamic range by combining different versions of the same **RAW** file, processed for highlights and shadows.

You can use a similar technique to make localized changes to the **white balance** on parts of your picture: for instance, if part of the picture is lit with daylight and another part is lit by artificial light. If you are shooting RAW, you only need to take one picture; you can export two versions at the appropriate white-balance settings, ready to combine in post-processing. If you are shooting **JPEG**s, then you will have to shoot a version of the picture for each of the white-balance settings.

ⓘ For more on combining images to increase dynamic range in post-production, refer to the Correction section, pages 276-277.

ⓘ **Pro tip**
You can even use a version of this technique to remove unwanted people who are moving around in your scene. Take a number of shots, maybe 15 or 30 seconds apart, and combine the bits of the scene that don't have people in them. Obviously, this technique works best if only the people in the shot are moving and the scene is lit with constant lighting. This function is built into some more recent versions of Adobe Photoshop.

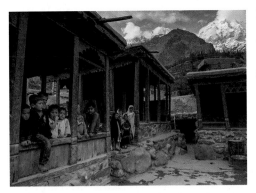

Children at Ganish Village, near Gilgit, Pakistan ⟨

Nikon D3x, ISO 100, RAW. 24 mm. 1/250 sec, f11

This subject had a massive dynamic range, with the mountains being at least two stops lighter than the foreground. I exposed for the mountains, and then lightened the foreground using graduated filters in Lightroom. The wide latitude of RAW made this possible. Using a low ISO meant that the extra noise from the underexposed and subsequently rescued shadow areas was negligible in the final shot.

Chimping, editing and binning

There is a common perception that shooting digital doesn't cost anything, so it doesn't matter how many shots you fire off for a given subject as you can always delete them afterwards. In reality, although digital is much cheaper than film, it still has an appreciable cost.

First, most cameras have a quoted shutter life – how many pictures you can expect to take with them before they wear out. For an entry level DSLR this can be around 50,000 actuations. If you adopt lazy shooting techniques and blast off five shots when you only need to take one, you run the risk of wearing your camera out five times more quickly.

There is also the cost in terms of the extra time spent editing all those unnecessary pictures, or the cost of storing and backing up if you don't. Overshooting is an issue when you are on the road. You might need double the number of memory cards and double the back-up solutions. It is far better to be economical with your shooting and then comprehensive with your editing.

Chimping

Professionals have coined the phrase 'chimping' for the obsessive reviewing of pictures on the LCD screen of a camera, as it is so often accompanied by 'oohs' of delight, 'ohs' of disappointment and facial expressions that make you look like an excited chimp. A quick glance is a good thing: by checking the histogram, reviewing the composition and looking out for obvious faults, such as someone walking in front of the picture, you will quickly know whether to delete and reshoot. Zooming in on the screen can also be a useful way to check images, but don't get so hung up on chimping that you miss out on taking other photographs. Be careful of trusting the LCD preview screen too much for focus or exposure, especially if you are shooting RAW, you'll just be seeing the JPEG preview of your image. Only delete obviously flawed shots at this stage, or images that you have subsequently reshot.

Editing

You can edit on the road, using the camera's LCD screen or a laptop if you travel with one. The aim is to whittle down the shots so that you only keep the good ones. Deleting unwanted pictures as soon as possible will save time and memory space, but you should leave the final edits – especially those concerned with precise focus – to when you can use a good screen at home.

Binning

Someone once asked me how professionals manage to get good pictures the whole time. I started my reply by talking about practice and experience but then admitted that part of being a professional photographer is throwing the rubbish shots away. In truth, we all take bad shots some of the time. A professional should take fewer bad shots, but he or she will also spend more time editing them out.

Nothing is more tedious than having to look at hundreds of unedited shots, when a small selection would be scintillating. Wallowing in poor quality work will make all of your pictures look average. Ask yourself if a shot is really worth keeping, or if you have better similar shots. However, it is also worth remembering that people take pictures for a whole lot of reasons and not every shot has to be a masterpiece. As well as trying to produce great travel images, you are also documenting a trip and recording memories.

Chimping

Checking the preview image and the histogram on the LCD screen is a good idea, as you are able to notice and correct any errors in the exposure. If you know that you have made a mistake, delete it instantly in camera. You should avoiding excessive 'chimping', however. It uses up your battery life and, while you are looking at the pictures you have already taken, you won't be concentrating on taking new ones.

Shir Dor Medrasa, Samarkand, Uzbekistan

Nikon F5, Provia 100 ASA film. 80-200 mm lens. Exposure not noted

I was using a telephoto lens to take detail shots of the Registan, the historical square in the centre of Samarkand, when this woman walked by. Her headscarf seemed to match the blue tiles, so I zoomed in to isolate a part of the facade and took some shots as she passed. Pictures taken with a telephoto lens are more susceptible to camera shake and errors in focusing but it is hard to assess your images on the LCD screen. You can delete pictures with obvious errors but it is best to wait to do precise edits until you can view them zoomed to 100% on a computer.

Camera settings

Even the simplest cameras have manuals that run to hundreds of pages, explaining a range of settings that you probably never knew existed and certainly don't understand. Here's a quick summary of features that I think are important:

Settings that don't depend on camera image format
Auto mode Many compacts, and even DSLRs, have an Auto mode that takes control of all the camera settings and allows you to point and shoot. Don't buy a sophisticated camera and use it as a point and shoot!

Picture scene modes These allow you to tell the camera what you are photographing, but it's best to learn how the settings work independently to get a greater degree of control and creativity, or consider shooting RAW.

Auto ISO and built-in-flash Both intervene in low light levels, but they don't know if you are trying to shoot with a long shutter speed to introduce blur. Switch off unless you think you actually need them.

Dynamic range settings Some cameras have settings which allow you to improve the dynamic range of your image, giving you the ability to record images with greater contrast. Try this for very high contrast subjects.

Settings dependent on camera image format
These settings will depend on whether you are a shooting with your camera set to RAW or JPEG. RAW is a high-quality format that records everything that the sensor sees, allowing the image to be processed later on a computer. The camera settings are tagged onto the RAW file as suggestions, but these can be over-ridden by the default settings on the RAW-processing software or by any changes you make. The beauty of shooting RAW is that you don't have to make these settings in camera and, if you get them wrong, it isn't an issue. With JPEG, these settings are all applied to the image before it is saved. Settings can be revised later, but you will lose quality.

Picture styles These allow you to set the contrast, saturation and even the sharpening in one hit. As with the picture scene modes, this can be useful if you remember to set them.

White balance Whether shooting JPEG or RAW, my advice is to go for the daylight/direct sunlight setting and deviate to the presets as necessary (see page 121).

Contrast and saturation Settings for saturation and contrast, combined with the white balance setting, control how the colour of your image is rendered. Some cameras allow you greater control of the contrast of your image using a tone curve – a graph which applies a correction to a tone, based upon an input-output value.

Sharpening Every digital image will need some degree of sharpening. The camera introduces contrast on the edge detail to compensate for the slight softening effect of digital capture.

Noise reduction Digital cameras suffer from varying degrees of noise: random speckling – especially in shadow areas – and, in some cases, random coloured pixels. This is especially noticeable if you shoot with a higher sensitivity. Most cameras have software noise reduction, but this can obscure detail.

Settings for shooting RAW
As these settings are just suggestions for shooting in RAW, setting them is not important. All they will do is affect the JPEG preview, and you can simply over-ride these settings in RAW processing. If you regularly switch between RAW and JPEG, or shoot RAW and JPEG, then bias settings for JPEG. Against accepted wisdom, I always turn sharpening on for RAW: it won't affect the RAWs, just the JPEG previews, but makes it easier to zoom in and check focus on the LCD screen.

Settings for shooting JPEG
These settings need to be right, but it's best to under-apply them, rather than set them too strong, as their effects on the image are essentially destructive. You can enhance their effects slightly in post-processing, but it's difficult to undo them.

Picture styles Setting a different style for every scenario can give the best results and be quicker than setting saturation, contrast and sharpening separately.

White balance Auto white balance removes desired colour casts as well as unwanted ones. Set to 'daylight' and use an artificial setting if shooting in artificial light, or a 'shade' setting if your pictures are too cold.

Contrast and saturation It takes too long to set these individually so leave them on a normal setting. If editing pictures in Photoshop, use a lower value.

Sharpening Sharpening is vital, but it is best to set it to a moderate setting and then add more sharpening in post- production. Auto settings often are too strong.

Noise reduction As with sharpening, noise reduction is a destructive process, so it's best to use a light or normal setting. Auto tends to over-correct. You can always apply more noise reduction later.

Digital on the road

Digital is well suited to travel photography. First, you can check that both you and your camera are working as you go along, rather than waiting for the films to be developed. You can also create a number of copies of your work. And, you get to show people your pictures instantly, which is perfect for portraiture. There are, however, a couple of things to consider in order to get the most out of the digital experience.

Backing up

Backing up your pictures is vital when you are travelling. Digital images are inherently ephemeral and can be corrupted, or the storage device can be lost or stolen. One copy of a digital image is just not safe. The good news is that you can quickly make multiple copies, making digital even more secure than film.

I advocate making at least two copies, preferably three, before you erase and reuse any memory cards. I travel with a laptop and will copy images to the laptop and back this up to an external hard drive. I use the bundled Apple Time Machine software for this, which means if I have any disc problems, I can completely restore my entire laptop hard drive. In an emergency I could even use it to install a completely new replacement drive in the laptop if needed. To be really sure, use an additional back-up drive or write a DVD to give you a third copy, or simply bring enough memory cards that you never have to reuse any. For my third back-up, I copy the card onto a *Hyperdrive Colorspace* which has a built-in screen and card readers. If you don't have a laptop with you, then consider one of these back-up devices and carry enough memory cards to ensure that you don't have to reuse them. Camera memory is so cheap these days that you can buy a number of cards cheaply. As an extra security, there are internet cafés all over the world that will write your pictures to a DVD, or allow you to copy cards to your own external drive. Consider making two copies and posting one of them home. You can even send your best images to a third party for storage or distribution, using a proprietary website, such as *Photoshelter* or *Flickr*.

I always store my back-up drive away from the laptop, often keeping it on me, so I still have copies of all of my work, even if someone steals my bag or raids my room. Remember that digital allows you to make unlimited copies; utilize this facility and you should never lose your pictures.

Plaza Murillo, La Paz, Bolivia ∧

Nikon D2x, ISO 100, RAW.
13 mm (19 mm equivalent).
1/500 second, f6.3

La Paz has a reputation for street crime, although I never had any problems. Even if you're shooting in supposedly safe areas, it is always worth regularly copying your pictures to a back-up drive. Having your camera stolen is bad enough but losing two weeks' worth of pictures because you have them all on a single 32 GB memory card in your camera would be a tragedy!

Dust busting

One of the advantages of shooting with a **compact camera** is that it has a fixed lens and therefore doesn't suffer from dust and dirt on the **sensor**. Unfortunately **DSLR**s and mirrorless cameras, with their interchangeable lenses, can let dust and dirt into the camera. These will appear on the picture as black spots and even hair marks. Retouching such marks on the finished picture takes a lot of time and is, quite frankly, boring work. It is much better to avoid the problem in the first place.

The simplest way to avoid sensor dust in dusty conditions is to restrict the number of times that you change the lens. This can be restrictive on your creativity, so some photographers use a mega-zoom lens, such as an 18-200 mm, which means that they never have to change it. Alternatively, if you have two cameras, then consider using them both in dusty conditions. Fit a **wide-angle** zoom to one and a **tele-zoom** to the other and you should be able to avoid changing lenses.

Unless you are in a particularly dusty environment, however, then you shouldn't be too worried about changing lenses. As long as you are quick and don't leave the camera open without a lens, then you shouldn't have too many dust problems. Some photographers advocate giving a lens a quick blow with a blower before putting it on the camera, but in fast-moving situations this might not be possible.

Some cameras have an automatic retouching facility, whereby you take a reference picture and then the propriety **RAW**-processing software retouches any dust marks for you. This can be a quick way to avoid the dust problem, but you have to use the camera manufacturer's software and, if you are in dusty conditions, you might have to take a reference picture every few hours in order to reflect the current condition of the sensor.

Camera cleaning

To see if your sensor needs cleaning, take a picture of a plain white sheet of paper from about 10 inches away. Switch to manual focus and focus your lens at infinity. Open up two **stops** from the metered **exposure** and you will get a plain white picture. Look at every part of this image at 100% on a computer or even the LCD preview screen; any black specks or dirt that you see will be on the sensor. You will have to clean the sensor or get ready for a great deal of retouching.

Some DSLRs have built-in sensor cleaning, which vibrates the sensor to shake off any dust. Often this will solve the problem but if it doesn't, or if your camera doesn't have this facility, you will have to clean the sensor manually. This should be approached with extreme care as it can irreparably damage your camera. In fact, some photographers and camera manufacturers recommend that you use a professional service centre to clean your sensor but, obviously, if you are on the road, this may not be possible.

If you're going to do it yourself, the simplest way to clean the sensor is to trip the shutter without a lens on. Use the sensor cleaning mode if there is one, or the bulb setting (which will keep the camera open as long as you hold down the button) if not, and give a few good blows with a blower brush from the centre of the sensor outwards. Never use a can of compressed air on your sensor, as this can leave deposits that can ruin it. I tend to hold the camera upside down whilst I do this in the hope any dislodged dust will fall out! Make sure that you have a freshly charged battery in the camera when you do this.

Some people advocate using a cleaning solution on the sensor, but in all truth, this scares the hell out of me! If a blower doesn't remove any marks, then I use a special, statically charged brush from a Canadian company called *Visible Dust*, which gently lifts dust from the sensor. Use any cleaning brush with care,

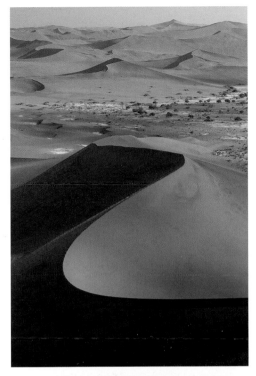

**Big Daddy,
Sossusvlei, Namibia** ◄

Nikon D2x, ISO 100, RAW.
70 mm (105 mm equivalent).
1/200 second, f7.1

Big Daddy is the tallest sand dune in the world. No matter how careful you are when changing lenses in conditions like this, you will get some dust and dirt on your camera sensor, which will cause spots and black marks on your pictures. If you are shooting film, dust can cause long scratches.

**CD-writing advertisement,
Jaisalmer fort, Rajasthan,
India** ◄

Nikon F5, Provia 100 ASA film.
Exposure and lens not noted

This sign was painted on a wall inside the old fort at Jaisalmer. There are very few places in the world where you cannot find somewhere to write your memory card to a CD or DVD. If you don't travel with a laptop or a back-up device, this might be your only chance to back-up your pictures. If possible, make an extra copy and post it home for safety. Some internet cafes will allow you to copy images from your cards onto your own removable hard drive.

since, if the shutter closes on it (because you release the button or the battery goes flat) then the shutter can be utterly ruined. Generally keeping all of your gear (and hands) dirt and dust free will also help. Make sure the body of the camera is clean by using a small paintbrush to dust it, and vacuum any dust from the actual bag whenever possible.

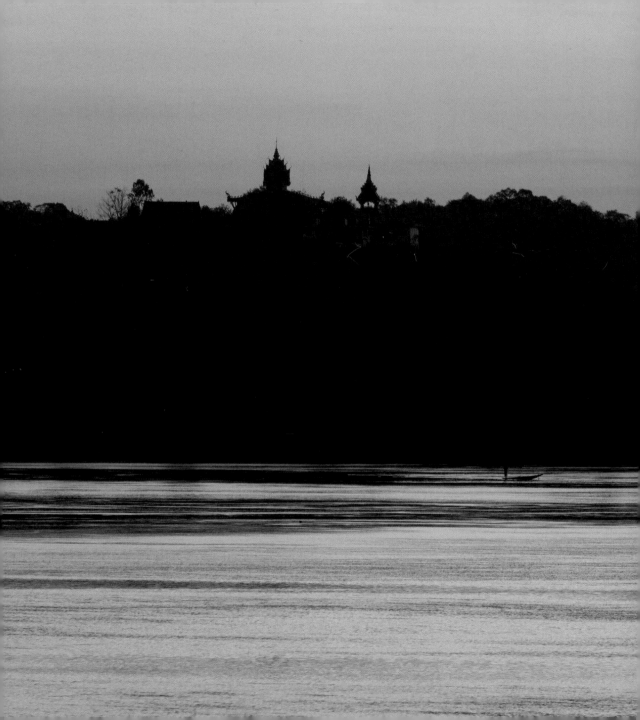

A travel photographer has to master a number of different styles of photography and be flexible enough to shoot in a range of different situations. You might find yourself shooting from a plane one day, making portraits the next, then finishing up in a city or, even, underwater. That is the beauty and the thrill of travel photography: there is never a dull moment and every day can be different.

This diversity might seem daunting but, once you have mastered the technical aspects of travel photography, as detailed in the Execution section, then you should be ready for any eventuality.

In this section you will find a number of practical tips to help you take successful photographs in any number of situations you might encounter but, more importantly, this section should inspire you to get out there and try a new experience. Travel photography is a great motivator and a fantastic excuse to be adventurous and explore the wonderful world around us.

Sunset over the Mekong River, Si Phan Don, Laos ◂

Nikon D2x, ISO 100, RAW, 200 mm (300 mm equivalent), 1/20 second, f2.8. Tripod

Shoot local

Amateur photographers sometimes ask me how they can be good at travel photography when they have a full-time job and only go away on one or two trips a year. Certainly, there are a lot of technical skills to master and even professional photographers get stale if they don't practise, so the answer is to shoot closer to home in order to hone and develop your skills.

Travel photography is not just about going away. No matter how gloomy or depressing you might find your neighbourhood in the middle of winter, the chances are that someone, somewhere is planning a photographic trip to your locality.

There might be a national park, a river or a stretch of coastline near to you that you could photograph. A city is always an interesting subject, while a small village may be surrounded by photogenic countryside. If you are stuck for ideas, search one of the online photolibrary sites and see what other people have found to be notable subjects in your area.

Also, don't just think about travel photography in isolation. No other sphere of photography encompasses so many different disciplines. You could shoot food, interiors, a city at dawn, landscapes by moonlight or urban wildlife, and still be developing your travel photography skills. Find a particular aspect of your home town that actually interests you and try to look at familiar surroundings through fresh, photographic eyes, as you would if you were visiting a new place for the first time.

There are many advantages to shooting close to home, not least the fact that you have virtually unlimited time. This is something you just don't get when you are on the road. Time at a destination gives you a number of practical benefits. You can wait for the weather to be good – or even for the weather to be dramatically bad! You can photograph at sunrise whenever you want, or in the sweet spot at dusk. You can make sure that you are around for any festivals or events, and you will always have a place to stay, even at the busiest times of the year. You will also be able to re-shoot something if it is not quite right, which is not only a great way to get better pictures but will also enable you to develop your skills by learning from your mistakes. You can experiment to see what works for a given subject and what doesn't; if you want, you can come back to a subject again and again

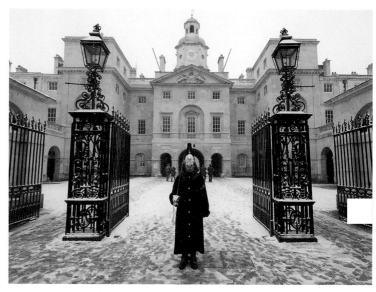

Horse Guard in the snow, London, England ∧

Nikon D3x, ISO 640, RAW. 19 mm 1/320 second, f5.6

Shooting locally allows you to take advantage of good and bad weather conditions. In this case, a rather disgruntled Horse Guard was standing guard in the snow. As well as shooting in more familiar locations, you are able to catch unique moments and show your location in a way that is less well known.

Pearly King, Covent Garden, London, England ➤

Nikon D3x, ISO 100, RAW. 105 mm 1/160 second, f4.0

The Pearly Kings and Queens are a London institution. Primarily charity fund-raisers, they dress in ornate costumes decorated with mother of pearl buttons. Shooting street portraits in your home town makes it much easier to communicate with people as you will share a language. You are also able to work your way through a list of local characters.

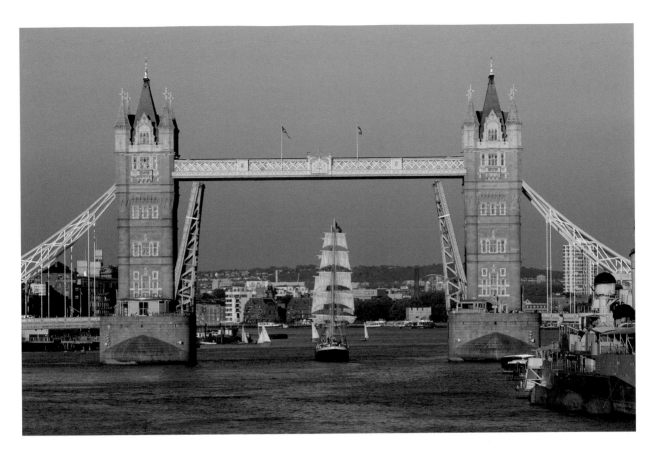

until you get it right. Being close to home also gives you the space to experiment with different styles of photography until you can develop your own style.

The same familiarity that can make your local area seem dull can also be used to your advantage when shooting. Use your local knowledge to locate the best **angles** and to explore lesser-known neighbourhoods in greater depth. Speaking the same language as your subject is a massive help in portrait photography but will also make it easier to gain access to windows, rooftops and balconies to shoot more visually exciting angles.

I live in London, one of the greatest cities in the world, yet I have to make a conscious effort to get out and photograph there. In truth, I sometimes struggle to find things that really inspire me about my home town, compared to more exotic locations, yet it is a magnet for millions of tourists and photographers from all over the world. If you find it hard to maintain your enthusiasm about the place in which you live, try giving yourself a photographic project or set yourself targets to test your skills.

For a project, consider focusing on one aspect of your locality. This could be a river, a particular animal, a market or a particular time of day, such as dawn. Expand and develop this idea and work out what shots you need; then set yourself the goal to get out there and take the pictures. Setting targets can add an element of challenge to your photography and also help you to refine your skills. How about spending a day shooting with your camera in vertical format, or with only a **wide-angle** or **telephoto lens**, or at the widest **aperture**?

I once conceived a test to shoot a whole film of street portraits, with a different person for each shot. You could try a similar thing on a digital camera by taking 36 shots of 36 different people, although it is easier to cheat! Not only will this teach you how to approach people, ask permission to take their picture and to make them relax, but it is good practice in making each shot count!

Shoot locally, and you won't just be rewarded with some great shots of where you live, but you will be more practised when you hit the road.

Tall ship passing through Tower Bridge, London, England ⌃

Nikon D2x, ISO 100, RAW. 135 mm (200 mm equivalent). 1/250 second, f6.3

There are countless shots of Tower Bridge, fewer with the bridge open, and even fewer with a tall ship passing underneath in the golden hour before sunset. Keeping an eye on the newspapers and even the morning travel information slot on breakfast television can give you pointers as to what is coming up. You can also make sure that you are around for the best weather and talk your way into the best viewpoints, all the time honing your skills for the your next overseas trip.

Portraits

It doesn't matter where you are travelling, sooner or later you will see someone you want to photograph. Whether it is a woman from the Akha hilltribe in northern Thailand, a cheeky child in Mexico or an Indian holy man, the issue is how to take their picture in a way that says something about their personality but doesn't intrude or offend.

Some photographers clumsily sneak a picture and then hurry away; others brazenly take photos as if their subjects were animals in a zoo. Neither method is recommended. Not only is it rude and, in some countries, potentially dangerous to take pictures without the subject's consent, it will also often produce disappointing photos that show no affinity with your subject.

You will frequently hear that the only way to get natural, un-posed pictures is to shoot unobserved in a candid style, but I would counter that the way to get natural pictures is to spend time with your subject. Even lingering for a few minutes can be enough to allow someone to relax and to ignore your presence completely. The picture might appear candid, but you can take your time as you have their permission. When photographing the monk on page 225, I spoke to him, and then just waited as he went back to his writing; resulting in a natural picture; I had time to think about composition and wait for the right moment.

For me, the best way to make evocative and sensitive portraits is to pluck up the courage to walk up to someone and interact with them. Photography can actually be a great way to break the ice: few of us would walk up to a stranger and just say 'hello', but, if you want to take a person's picture, then you have a reason and an incentive to speak to them.

Many people will never do this, and so they either rely on stealing pictures, or just forego the chance of taking a picture at all. Others do ask, but then get flustered, snap off a few quick shots, and then bolt for safety, with little more than a disappointing picture and bad memories for their trouble. This can be avoided if you prepare for the portrait before you even approach your subject, meaning that when it comes to take the picture, the only thing left to do is to concentrate on the person in front of you.

Creative workflow for portraits
At the beginning of the Execution section, I set out my compositional workflow, and the creative steps I follow

One of the great things about portrait photography is that you can shoot portraits at any time of day, in all weathers. This priest is standing in the doorway of a monastery; I was just outside in the rain, which probably accounts for the slight look of bafflement on his face. I actually prefer shooting portraits on overcast days or in shadow, as it gives a very soft light that shows up all of the detail and texture on peoples' faces. It also avoids the problem of having your subject squinting into the sun. With digital photography it is simple to warm up the slight blue cast given from shooting in overcast or shadow light; for this picture shot on film, I had to use a screw-in warm-up filter.

This man was making traditional Indian sweets in a small kitchen connected to a shop. He was more than happy to be photographed, but either due to a busy workload or shyness, he was very keen to be working. This was perfect for me as I was able to squeeze myself; unto the small gap between the fryer and the wall and take a number of pictures when his pose was right. His quiet concentration and tight contracted pose add to the atmosphere of the image. Needless to say my pose was neither as calm or as effortless. The large yellow pot in the foreground needed to be darkened slightly in Photoshop as it was nearer to the window and rendered too bright..

when approaching a subject. I mentioned how this workflow, with a few amendments, can be adapted to almost any style of photography. This workflow is the basis of the methods I use for shooting portraits, when pre-visualization and pre-planning are even more important, if you don't want to end up nervously rushing the moment. If I see someone I want to photograph, I will pre-visualize the image and plan my shot before I even approach them. This is why I seldom ask people who are walking if I can take their picture; they are usually too busy anyway.

1. Pre-visualizing picture style
As with any style of photography, pre-visualizing your picture will influence all of the subsequent creative and technical decisions. Ask yourself that vital question: what is it about this person that makes me want to take their picture? Quite literally, try to decipher what you find remarkable about them: this will influence what picture style you choose.

Buffalo seller, Sonepur Mela, Bihar, India

Nikon D2x, ISO 200, RAW.
12 mm (18 mm equivalent).
1/100 second, f5.0

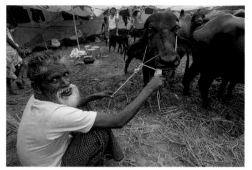

By framing wider and shooting an environmental portrait I was able to give much more of a sense of who this man was and what he was doing. Shooting close with a very wide-angle lens gave some distortion on his face and also exaggerated the perspective of the buffalo. The strong diagonal between the man and the buffalo links the two faces, which are both looking quizzically into the camera.

Head shots (Images, pages 156 and 162) If you want to photograph someone because they have a great face then you need to get in close to show this, so opt for the classic close-up head shot showing the head and sometimes the shoulders of the subject. These are immediate and dramatic portraits, which emphasize the eyes and the face.

One of the advantages of a head shot is that, if there are crowds around, you can crop out the surrounding chaos from your picture. Physically moving in close can prevent other photographers from interacting with your subject and also makes it impossible for people to walk into your shot. You can crop tightly into the face or even just part of the face to create a more dramatic image.

Half- or full-length portraits (Middle and right-hand images, page 160) If what someone is wearing – whether it be a uniform or some characteristic local jewelry – is the remarkable thing about them, then shoot a half- or full-length portrait. This can give a clearer sense of their identity than a simple head shot, showing how people are dressed and what they are holding. The objects that people hold often say a lot about them: a musical instrument, a vegetable, a fishing net can all help to construct meaning.

Action portraits (Bottom image, page 157; left-hand image, page 160) If what someone is doing is the most significant thing about them, then opt for an action portrait, which shows them undertaking some sort of activity. People are often more willing to be photographed when they are doing something familiar. However, many will stop what they are doing in order for you to take their picture; encourage them to keep going. Not only will it make the photograph more natural but it can also provide an idea of their profession or character.

When shooting action portraits you should still try to get the eyes and face in the shot, even if they are not looking directly at you. A shot of the back of someone's head is usually far less interesting.

Environmental portraits (Top image, page 157; bottom image, page 158; page 163) If your subject's relationship with their surroundings is more significant than their face or their clothes, then consider opting for an environmental portrait. This places them in surroundings that says something about them and which will often be the most remarkable thing about them. Many photographers find this style of portrait far easier to take, as you don't have to engage quite so closely with people. It doesn't have to be a natural backdrop; it could be an urban or even an historical scene. The environment should be carefully chosen to convey some meaning about your subject.

Groups Sometimes the most notable thing about a person is the community of which they are a part. Photos of groups of people can work very well, especially if they are interacting with each other. Groups have their own dynamic, which can set up meanings and relationships within the picture; it also often allows you to take pictures without having to direct people.

Shooting groups does throw up its own problems, though. You should take a number of pictures in quick succession, as one or more people in the group may be blinking or pulling a silly face in any one shot.

2. Plan your image

Once you have decided upon what you are trying to convey with your photograph and previsualized the picture style, then is the time to plan the image based upon the creative workflow from page 62. Some of the most significant things to consider are as follows:

Mise en scène If you combine your subject with a significant object, background or other people then you can convey more about them than simply what their face looks like. This is essentially the basis of an action or environmental portrait. Often the choice of background can be the most significant thing you can change for a picture, so change your position to ensure you get the background that you want.

Angle One of the best ways to change the background, or to combine your subject with another person or object, is to change the **angle** you shoot from. In an urban environment, for instance, most people will stand with their back to a wall to keep out of the way; take their picture and you will have a dull wall as a background. If you move to the side you can photograph your subject with a more interesting and significant background. If

Fruit stall, Old Delhi, India ∧

Nikon D2x, ISO 100, RAW.
14 mm (21 mm equivalent).
1/200 second, f4.5

The young man on the left called me over, asking me to photograph the old man, who nodded agreement, and much to the amusement of the first man, I took a few shots. I zoomed out to include him in the shot, although he is completely unaware that he is a part of the picture. Often combining different elements in a picture can convey a very different meaning.

Boy at chai stall, Delhi, India ＞

Nikon D3x, ISO 400, RAW.
32 mm. 1/40 second, f4.5

This boy works at a *chai* stall in Old Delhi, and on numerous visits over the years I have watched him grow up. Drawn by his cheeky smiling face, I wanted an environmental portrait, with the stall in the background. I manoeuvred him into the right position by gently taking his elbow out of frame.

you ask to take someone's picture and then walk to the side, they will invariably look at you, resulting in good eye contact, more pleasing dimensions and often a slightly quizzical look on their face.

Viewpoint The **viewpoint** that you use will also affect the background of the image. Shoot from a low viewpoint and you can place your subject against a clear sky, cutting out any distracting people or objects. Shoot from a high viewpoint and you can cut out a busy background or an overcast sky.

The viewpoint can also have a profound effect on the character of your picture. If you shoot from the same eye level as your subject, then you can create a very sympathetic portrait, especially when photographing children. Shoot from below and your subject can appear to have more power in the picture; shoot from above and the viewer of the picture will effectively be dominant over the person in the picture. This can be seen in the examples on page 160.

Lens Conventional wisdom says that head shots should usually be taken with a mildly **telephoto lens** (such as an 80 mm lens) as the subject distance needed for a head shot gives a pleasing perspective on the face. The subject distance needed for a more powerful telephoto lens (like a 180 mm) may compress the perspective of the face too much. However, you can create dynamic images by using a mild **wide-angle lens** (such as a 35 mm or even a 28 mm) and getting in close to give a slight distortion to the face, especially if the subject is leaning towards you. Remember, the perspective of a given lens is the same for a given subject distance, whether you are shooting with a **full-frame DSLR**

or one with a **crop sensor**; it is just the crop that changes (see page 26).

Your lens choice will also allow you to vary the subject distance; a wider lens will also allow you to stand closer for a more engaged picture and also make the background appear to be further away. A telephoto lens will allow you to shoot a more tightly cropped head shot, without standing too close to your subject. It will also make them appear closer to the background, establishing a relationship between them.

3. Prepare your camera

Once you have approached someone to take their picture it is impolite to ignore them and start fumbling with your camera, so make sure your equipment is completely set up in advance, that you have the right lens and enough space on your memory card and even consider moving the focus point so that you can just start shooting right away (page 134). If you are using manual exposure, then calculate the exposure in advance against something in the same light as your subject, and set the aperture and shutter speed.

4. Approach your subject

Even when you've prepared everything in advance, approaching people can be difficult, especially if you don't speak their language. In developing countries there may be a great disparity of wealth and culture

Mother and child, Pisac market, Peru **>**

Nikon D2x, ISO 100, RAW. 38 mm (57 mm equivalent). 1/160 sec. f6.3

Sometimes even simple combinations in the frame can be effective; in this instance the inclusion of the child changes the identity of the woman to 'mother'. A tight crop filled the frame with frilly colour and I took a few shots as the baby yawned and looked around.

Sadhu, Pushkar Lake, Rajasthan, India **< ^**

Nikon D2x, ISO 100, RAW.
L: 60 mm (90 mm equivalent).
R: 32 mm (48 mm equivalent).
1/160 second, f4

Photographing this sadhu from the front, placed him against a bland background and gave a flatter perspective on his face. Simply moving to the side allowed me to change the background adding an out-of-focus splash of colour through the Rajasthani saris, giving a sense of place and a more engaging photograph. This angle also gives a more pleasing perspective on his face.

between you and your subject, which can make it even more awkward. Practice really helps. The more you do this, the easier it becomes, so practise in your home town where you can approach people, speak to them in their own language and develop the techniques that you will use when you travel.

If I want to take someone's picture because they have a great face, I will often simply tell them this when I approach them. This is the most direct way to break the ice even if I have to use a smile and sign language to do it.

You will need to be sensitive but also assertive enough to actually ask the question. Self-deprecating humour is often a great way to win people over. You should always try to look people in the eye, so taking off sunglasses is a good idea. Learning a few words of the language can help – 'picture' and 'please', for instance – but sometimes just a gesture or a smile can be enough. If people say no, then just smile and move on.

Needless to say, you should be aware of cultural issues when approaching people for photographs. Many places, especially Muslim countries, have strict taboos about photography. Photographing children may be absolutely forbidden in some cultures, and male photographers should be particularly careful about approaching women. Do your research in advance and consult a guidebook that includes cultural information.

However, even in sensitive cultures, you can often take portraits of people by spending time

developing a rapport with them. Bear in mind that in many countries, men will feel more comfortable with a male photographer, and women with a female photographer. If you have a guide, use them to translate questions about your subject, but make sure that the subject looks at the camera and not the guide. Ask to have a go at whatever your subject is doing; it can be a great way to break down barriers. This might be trying to pedal a rickshaw, carry a yoke or balance a pail of water on your head. Anything that makes you look a bit stupid can help to make your subject relax.

People tend to be more comfortable having their pictures taken in public areas, such as at markets and, especially, festivals, and these can be rich hunting grounds for portraits. Stallholders are often gregarious and used to dealing with people. They can be happy to be photographed, especially if you buy something from their stall. I am not just talking about souvenirs or trinkets here: I have bought paprika and saffron from stallholders in Uzbekistan and Egypt in order to establish a connection with them. They have generally overcharged me, and I have sealed the deal with a few photographs. We parted, both smiling, and each getting what we wanted out of the encounter.

The effect of viewpoint ∨

Boy sitting in a tree, Ethiopia (left)
Nikon D2x, ISO 200, RAW. 28 mm. (42 mm equivalent). 1/320 second, f4

Girl in Kochi, Kerala, India (centre)
Nikon D3x, ISO 100, RAW. 26 mm. 1/100 second, f5.6

Boy begging in Varanasi, Uttar Pradesh, India (right)
Nikon D3x, ISO 400, RAW. 24 mm. 1/250 second, f5.0

Just by varying the viewpoint, you can alter the entire atmosphere of the picture. Shooting from below, as with the boy with the flute in Ethiopia gives the subject a sense of dominance and power in the shot. Shooting at someone's level gives an engaged and sympathetic portrait, whereas looking down on someone makes them appear frail and weak, as with the child begging in Varanasi.

5. Work with your subject

Often people stiffen up completely when you take their picture. In the developing world, people tend to stand bolt upright and look serious, as if they are posing for an ID card picture; in the West, people are apt to give a horribly forced rictus smile, and younger Asian people often grin while flashing a 'peace' sign.

To take a good portrait you will have to use your personality to make your subject relax. If you are shooting digital, show your subject the picture on the LCD preview screen and then take a few more shots afterwards; they will often be far more relaxed after seeing the first image. This can also be a good way of getting close to your subject if you are nervous about approaching them directly; or think that they might be uncomfortable with being approached. Take an environmental portrait, walk towards them to show them the result, then shoot a close-up portrait once you have closed the distance. However, don't force someone to look at their picture if they seem uncomfortable with the whole process; just thank them, smile and move on.

Inexperienced sitters may blink or glance away, so take a few shots in quick succession and keep shooting as the subject gets more relaxed. Avoid

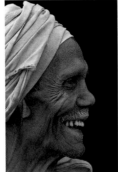
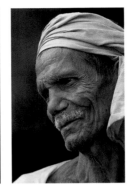

Man at the Sonepur Mela, Bihar, India ‹

Nikon D2x, ISO 100, RAW. 165 mm (247 mm equivalent) to 200 mm (300 mm equivalent). 1/250 second, f4

The Sonepur Mela is a vast religious and livestock fair, most famous for its *haathi*, or elephant bazaar. Very few tourists make it to the festival, and it is a fascinatingly traditional place to walk around and take portraits of people. This man was happy to be photographed. He was standing in front of a large area of shadow that provided a good background, and the light on his face gave a good contrast. I shot a number of images as he reacted to me and also to his friends who were joking with him. This is one of the secrets of portrait photography: keep shooting and interacting with people and photograph their expressions. If you are shooting digital then showing them the preview picture can relax them even more.

taking the same picture over and over again though; shoot around the subject, taking both environmental and closer shots from a variety of **angles**.

People's faces are at their most expressive when they are effectively in neutral, so a slightly quizzical or thoughtful look is much better than a fake smile. However, if you want your subject to smile – to express their personality, say, or even to reveal some notably bad teeth – you should try to get them to laugh so the smile will be dynamic and not fixed.

Don't be afraid of directing your subject. You might have to get them to move a few steps for better light, or to put them in front of a different background or to combine them with a particular prop.

Paying for pictures

I generally find people are more than happy to be photographed and often ask me to take their picture, rather than the other way around; especially in India, where a different concept of personal space seems to exist than in Europe. Sometimes, though, people will want paying in return for having their picture taken. I am generally quite happy to do this, and not just because I am a professional photographer. Often travellers move through communities and leave very little behind. Any money we do pay out generally goes to younger tour guides and hustlers, overturning the hierarchy of fragile cultures, where money and respect traditionally lay with older people. It is the older members of a community who are most likely to wear traditional clothes and to have the most characterful faces, so by paying to take their photograph, we can go some way to redressing the balance, demonstrating that we value both their seniority and their customs.

Paying for pictures also means that you are photographing someone who is truly willing to be photographed, which means they can be more relaxed, interactive, and you should get better portraits. I do avoid paying children for pictures, though, and never hand out sweets or pens to them, as it encourages pestering and begging. I also wait for people to ask me, rather than offering them money, to avoid inadvertently insulting someone. I always make sure that I have a few small-denomination notes in a separate pocket to pay for pictures: it can be embarrassing to pull out a large denomination note in front of someone by accident, and it is usually hard to put it back.

In some places, people will actively offer to be photographed, in return for a modest fee, often dressed in their traditional clothes. From hilltribe communities in northern Thailand to the Jemaâ el Fna main square in Marrakech – and even in European cities where those silly buskers paint themselves silver and stand perfectly still – you will find people professionally posing for

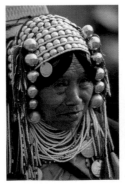
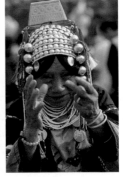

Akha woman, Mae Salong, Thailand ‹

Nikon F4, Velvia 50 ASA film. 80-200 mm lens. Exposure not noted

This old woman has a great face and was playing up for the camera. She hung out in the centre of town and charged tourists a few baht for pictures. Even though we had no shared language we spent about 15 minutes talking and interacting. I shot a number of close head shots as she had an amazingly mischievous face. In the picture on the right she is actually counting off the number of shots on her fingers, in order to charge me extra for the pictures.

pictures. For some it is their full-time job and you will be in trouble if you try to get away without paying them!

If you have spent time with someone, it can be really satisfying to send them some of your pictures. On a return visit to Zanzibar, I once tracked down an old man I had photographed five years previously. It was easy to find him – I just showed people the pictures I had taken – and he was amazed and thrilled when I gave the photos to him. I have done a similar thing with Indian sadhus at festivals. As well as getting me really good access at future events, it has added to the number of friends I have all over the world.

In developing countries it is often better to get someone to write their address in the local script and language. Just stick this on an envelope and write the country name underneath. I tend now to photograph the address right after the portrait to help with identification when I am sorting pictures.

The eyes have it

According to the old saying, the eyes are the windows to the soul. They are certainly the most important part

Pilgrim at Ganga Sagar Mela, West Bengal, India ❯❯

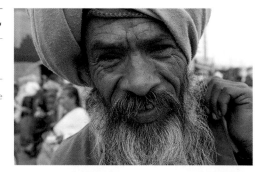

Top: Nikon D2x, ISO 200, RAW. 28 mm (42 mm equivalent). 1/100 second, f6.3

This happy pilgrim came up and asked me to take his picture in the middle of a crowded Hindu festival on an island in the mount of the River Ganges. He was fascinated to see his picture on the back of the camera: a moment captured by a fellow photographer.
 Bottom image © Findlay Kember.

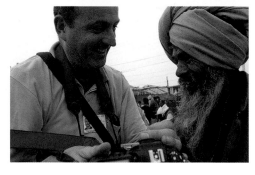

Toothless smile, Socotra, Yemen ❮

Nikon D2x, ISO 100, RAW. 56 mm (84 mm equivalent). 1/160 second, f5.6

Cropping in tightly draws attention to this man's face, and obviously to his missing teeth. I was in the highlands in the centre of the incredible island of Socotra, off the coast of the Yemen. Just outside a village, a group of local men were relaxing and chatting. I started speaking to them for a while and then asked if I could take a few pictures. This man was happy to be photographed, but stood to attention. When the camera wasn't pointed at him he was animated and happy, but he froze as soon as I raised the camera. I worked hard trying to get him to relax and loosen up, and finally managed to take this shot whilst not actually looking through the camera. He is doing what a lot of older people will do in developing countries: looking at the camera but not directly at the lens. This seems to be a cultural thing which I have learned to accept.

of a portrait, and you should always ensure that they are in focus, even if the **depth of field** is so shallow that the tip of the nose is slightly less sharp. If you are shooting a close-up portrait with a **telephoto lens**, the focus will be critical. One of the best ways to keep the focus is to switch to one of the off-centre focus points (if your camera has this facility), so that the focus point is actually over the eyes, which will keep them in focus, even if you or your subject move.

Control the eye contact in your image; your subject should either be looking into your lens or boldly looking away. The worst thing is to have someone looking towards a point just outside the frame, especially if they are looking at another photographer who is standing next to you and taking a portrait with great eye contact! It is perfectly possible to indicate to people where to look with sign language. Point to your eyes and then point into the lens; most people will understand you. You can do the same by pointing to your eyes and then pointing to something out of the frame for them to look at. You can also direct people to tilt hats to avoid their faces being in shadow.

Children

Children can make wonderful subjects for photography, as they are often more spontaneous and less inhibited than adults. As long as it is culturally acceptable, parents may be happy for you to photograph their children, even when they don't want to be photographed themselves, or they might be happy to be photographed with their children, rather than on their own. Always be sensitive to the parents' wishes and be aware of any cultural issues before you start snapping away.

Children are often very animated, so actually taking their picture can be difficult. Use autofocus and a fairly large depth of field to keep fidgety kids in focus.

Don't try to organize groups of children; rather, allow them to form groups organically. The resulting pictures will be more spontaneous, even if some of the children are looking away or aren't in quite the right place. Kids always like to see the pictures that you have shot on the preview screen, although be careful of countless grimy fingers jabbing at cameras and lenses.

Villagers at Yakel village, Tanna, Vanuatu ‹

Nikon D2x, ISO 320, RAW. 70 mm (105 mm equivalent). 1/125 second, f4

Yakel is a kastem village that has decided to opt out of modern life completely. They also revere Britain's Prince Philip as a god. In the centre of the village is a massive tree with a treehouse, where all of the men meet and lounge around. Shooting with a vertical crop to show the massive tree creates an environmental portrait that gives a real sense of a place unchanged for generations. I increased the sensitivity on this shot to avoid camera shake.

If you try to organize groups of people, the pictures always seem to look forced. Photographing natural groups will result in more natural patterns, poses and expressions.

ⓘ **Pro tip**

More than most styles of travel photography, portraits suffer from poor light. If the light is coming directly from overhead, there will be horrible shadows in the eye sockets and across the face. Even in good lighting conditions hats can cast ugly shadows on a person's face and obscure their eyes. One of the ways that professionals combat this is to use **fill-in flash** (see page 131).

This basically fires the flash to fill in the shadows, even though the ambient light levels might be high. Fill-in flash is also good for putting a slight 'catch light' in the eye. If you're using this technique for a portrait, consider reducing the power of the flash, so that the effect is much less pronounced, and using the flash with an off-camera lead, so that you can control the angle of the light.

Some professionals carry a fold-out reflector to fill in the shadows instead of using a flash, as this gives a much more natural effect. The problem with this approach is that you really need someone to hold the reflector for you and it is likely to attract far more attention than a flash. Remember that firing a flash in the daytime – often in bright sunlight – is far less intrusive than firing it at night when the ambient light levels are lower.

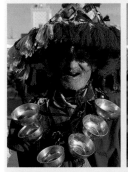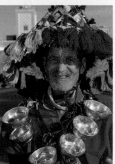

Water seller, Jemaâ el Fna, Marrakech, Morocco ⌃

Nikon D2x, ISO 100, RAW. 52 mm (78 mm equivalent). 1/400 second, f8.0. With and without fill-in flash

These two shots illustrate the use of fill-in flash. In the first shot the shadows from the hat obscure the face. In the second the shadows are filled by the flash. The ambient exposure was calculated manually and the flash shot on Auto TTL, using a multi-zone meter and exposure compensation for the flash set to -1 stop.

Candid and creative portraits

**Grumpy Frenchman,
Paris, France** >

Pentax MX, Kodachrome 64.
Telephoto lens.
Exposure not noted

This man was feeding sparrows in Paris for the attention of the tourists but didn't look too happy that some of the birds seemed to prefer the tourists to him. The background is typically Parisian and the arch of birds suddenly formed. Luckily I had everything ready and was able to just snap the moment.

I would term this a semi-candid portrait: the man was aware that there were people around taking pictures but was not aware of me in particular. The result is a totally natural, spontaneous expression.

This is the very earliest picture in the book, taken when I was in my teens probably on my first proper solo trip overseas. Shooting Kodachrome film and with an old completely manual camera, I was solely concentrating on taking pictures – the start of a life of photographing on the road!

It isn't always possible or practical to ask for permission to take every portrait, and sometimes you will end up shooting so-called candids, where the subject is unaware that they are being photographed. Other times you might want to shoot a creative portrait that merely gives an impression of your subject.

Candid portraits

A candid portrait is taken without the subject's knowledge, which throws up a number of moral and practical considerations. Part of the justification for candid photography is that, in certain situations, asking for permission to take a picture will be more intrusive than just taking it. Certainly, asking for permission can lead to less natural pictures. However, there is a difference between taking pictures of people without their knowledge and thoughtlessly snapping pictures of people, knowing that they aren't willing to be photographed. Unless it is sensitively done, candid photography can be very intrusive, so my general rule is to avoid photographing strangers in private situations. I am more comfortable with the

idea of the semi-candid photograph, where people are aware that a photographer is present, but they are in a public arena, such as at a festival, carrying out a public performance or at a market that is popular with tourists.

If you are going to shoot candid portraits, you should make sure that you are very familiar with your equipment, and prepare as much as possible before even raising the camera to your eye. The whole point

**Hmong woman,
Sa Pa Sunday market,
Vietnam** >

Nikon F4, Velvia 50 ASA film.
200 mm lens.
Exposure not noted

A true candid portrait. Engrossed in conversation, this woman was unaware I was around and was acting completely naturally. Shooting with a long telephoto lens allowed me to take this picture from a distance, and shifting the focus point allowed me to make sure that her face was in focus.

of candids is to be unobtrusive; if you are endlessly messing around with the focus or the exposure then you will be spotted and miss the spontaneity of the image. Using autofocus and auto exposure can help with this. You should also move slowly and gently so as not to draw attention to yourself. Try taking a couple of shots then sidling away, before returning for a few more, rather than standing shooting for a period of time.

There are ways of shooting candids that are much less intrusive than walking up and sticking a camera in someone's face. The classic candid involves shooting from a distance with a **telephoto lens**, but you can also compose a picture in such a way as to allow space for a person to walk into your shot. This gets over the necessity of actually pointing a camera at someone. Another option is to shoot with a very **wide-angle lens** so that the subject is in the side of the frame but unaware that they are being photographed as the camera is not actually pointing directly at them.

It goes without saying that you should never use candid-style photography as a way of photographing people who do not want their picture taken. This is especially the case if there are cultural or religious reasons why they don't want to be photographed. Always treat the people you photograph with respect, and never use photography to ridicule or poke fun at them.

Finally, if you are thinking of trying to publish candid pictures anywhere, even on a personal website, remember that some countries (notably France and Spain) have privacy laws.

Creative portraits

You don't actually need to be able to see a person's face in order to convey something about them; sometimes a small detail – such as their hands or their eyes – can be enough. Old gnarled hands may say as much about a person as a head and shoulders portrait.

You don't even have to show any recognizable part of your subject. Instead you can just suggest the person. One way of doing this is to have a person rendered out of focus by a shallow **depth of field**, while a prop or something that relates to them is rendered in focus, such as in the portrait of the Ethiopian priest holding a cross on page 81. You could also shoot someone in silhouette (as with the Rajasthani musician on page 184) or take a picture of an object that they

use regularly, especially one that shows evidence of that use: a tool with a worn handle, for instance, or a pair of old shoes.

Creative portraits give you absolute freedom to convey something special about your subject and can produce results that will interest and intrigue the viewer of your picture.

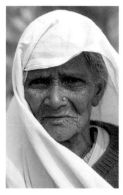

Pilgrim at the Kumbh Mela, Allahabad, India ‹

Nikon F5, Provia 100 ASA film. 28-70 mm lens. Exposure not noted

Photographing this woman, I was struck by her hands gripping her staff. The lines on her well-worn hands say as much about her hard life as her face. It also creates a more unusual and striking portrait.

Woman's shadow on drying sari, Rishikesh, India ‹

Nikon F4, Provia 100 ASA film. 180 mm lens. Exposure not noted

A portrait is a picture that shows something about someone. To me, it doesn't necessarily have to show their face or even their body at all. This shadow of a woman holding up her sari to dry after religious bathing in the Ganges tells a story about the woman and produces a graphic image.

Stallholder in the souks, Marrakech, Morocco ‹

Nikon D3x, ISO 400, RAW. 16 mm. 1/13 second, f3.5

You don't need a telephoto lens to shoot candid portraits. If you photograph something up close with a very wide-angle lens, then you can include someone in the picture without them being directly aware that they are being photographed. This can be a good technique in places where people are nervous of cameras and become very stiff when being photographed.

Cities

Cities and towns make fantastic subjects for photography, but they also present a unique set of problems to the travel photographer. Some of these are technical, others more organizational in nature.

Planning

Many cities are sprawling, and their scale can be daunting. You might struggle to find your way around and have to travel miles to photograph everything that you want to see. The first thing that you should do is to plan just what you are intending to photograph. Don't be so ambitious that you end up running around the whole time; not only will this result in poor pictures, but you won't be able to enjoy and appreciate the city. Check out guidebooks, photolibrary websites and even postcard racks when you arrive. Work out the locations where you want to photograph and which viewpoints look best at certain times of day. If you are not familiar with a city, try to get hold of a city map in advance, ideally one with the main buildings marked in relief. This can really help you to plan you time. If you remember that the sun rises in the east, it is pretty simple to work out which buildings are best photographed in the morning or evening light. Be aware of distances: a city like Venice is pretty compact but Budapest, for example, is unexpectedly large, and even a few blocks can be a long walk. Try to group sites together and photograph them at the same time. Aim for the most important things first, in case the weather subsequently takes a turn for the worst.

Misty sunrise over the River Seine, Paris ⌄

Nikon D2x, ISO 100, RAW. 100 mm (150 mm equivalent). 1/40 second, f5.6. Tripod

It is often difficult to take advantage of sunrise or sunset light in a city, as you need a somewhat open space to allow the low directional light to reach the subject. Shooting the Île de la Cité, I really wanted to capture the misty light and evocative atmosphere of the waking city. There were a few cars around, so I waited until the bridge was clear to preserve the feeling of emptiness. A relatively slow exposure was needed, so I used a tripod to avoid camera shake.

Some are even al fresco, allowing you a completely unimpeded view. Also, remember that you can shoot from your own hotel room at all times of day. See if you can reserve a room with a view when you are booking and always ask again when you arrive. You might have to shoot through glass, if the windows don't open, so ask to see your room before you check in to see how clean or tinted the glass is.

Sometimes the only viewpoint that you will find is a monument, such as a church or tower, which may have limited opening hours. Check the earliest and latest times so that you can be there for the best light. Be prepared to revisit this viewpoint a number of times, as the light changes at different times of day.

Bear in mind that the most obvious viewpoint might not be the best: if you are on the tallest monument in the city, then you won't be able to include it in your picture! There is nowhere that illustrates this better than Paris: the Eiffel Tower has the best views in Paris but other locations will allow you to include the tower itself in your picture. Other viewpoints might not have such expansive views but

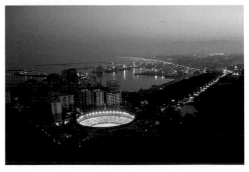

When you are booking a hotel, try to find one that is close to the main areas that you want to photograph. Being able to pop back to your room to pick up a different lens or have a siesta can make a world of difference to your photography. Commuting in to the centre from a long way out can be tiring and makes early starts much more difficult. If you are photographing in a very sprawling city, then consider moving hotels to get a base in a different part of the city when you have finished shooting your local area.

Viewpoints

It is vital to find a good viewpoint from which you can look over all or part of the city. This doesn't just give you a good establishing shot, it also allows you to take advantage of sunrise or sunset light.

Some cities such as Paris, Prague and Rio de Janeiro have natural vantage points. For others you might have to climb a building, monument or a hotel. Many high-rise hotels have bars and restaurants on the top floor with tremendous views, which means that you don't have to be a guest to take pictures.

Medina, Fes, Morocco >

Nikon D2x, ISO 100, RAW.
86 mm (129 mm equivalent).
1/400 second, f5.6

The Medina at Fes is a
fascinating place to wander
around, but it is difficult to get
an idea of its scale. If you get to
one of the hills overlooking the
town you can see the whole
of Fes. This crop takes in the
ruins in the foreground and the
hills in the background as well
as the sprawling Medina. The
towers are minarets, attached
to mosques and Quranic
schools. Shooting from this
distance shows the buildings as
a confused jumble, and it is easy
to see how people can get lost
for hours wandering around the
warren of alleyways.

Doge's Palace, Venice, Italy >

Nikon F5, Provia 100 ASA film.
17-35 mm lens.
Exposure not noted

If you tilt a lens, especially a
wide-angle lens, you can get
distortion called converging
parallels where buildings
appear to narrow at the top.
Shooting from the balcony of
San Marco, I was able to capture
the whole facade of the Doge's
Palace without tilting the
camera at all. The result is a shot
without any vertical converging
parallels that looks startling
geometric, even though it
was shot with a wide-angle
lens. The wide-angle lens has
exaggerated the distortion
effect of the building receding
into the distance.

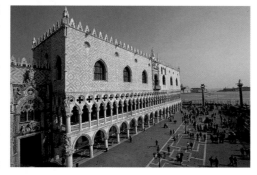

and uninteresting. Sometimes you will have to wait
until the sun is higher in the sky to take pictures. At
other times the sun might not actually reach street-
level, especially if there are high buildings blocking out
the light. If the weather is really bad or in the middle
of the day when the light is poor, use your time to
photograph interiors. Many museums, churches and
other monuments allow photography, although you
may be restricted in your use of a tripod or a flash in
these locations. You should also take pictures in bars
and restaurants, as food and nightlife are often key
to a city's character. When the weather is really poor,
night shots are often still possible: reflections on wet
pavements can be particularly effective.

Sunrises and sunsets can cast particularly
evocative light on cities. Dawn is especially
atmospheric, as there are usually far fewer people
around. Bear in mind that there may only be a few
angles that are possible at these times of day. High-
rise buildings will obstruct the light, so look out for
open spaces, such as parks or riverfronts: sunrises
near water often have a wonderful misty quality.

Street life
Don't just look for the big picture when
photographing a city. Although the famous
monuments and sweeping views are important,
smaller, more intimate scenes often say as much
about a place. Photograph buildings that are not
devoted to tourism but are used by the people who
actually live in a city, and look out for iconic details
that sum up the place, such as a black cab in London
or a gondola in Venice.

Although it is important to make a plan, make
sure that you also allow yourself some time to wander
around aimlessly. Choose an interesting district and
spend some time exploring. Look for small, interesting
details and street life to give your pictures a more
human dimension. A guidebook will tell you where
to find the older, more picturesque parts of town,
where small shops and businesses, local squares,
neighbourhood churches or temples and even
people's houses show a more authentic face of the
city. Also keep a look out for characteristic modes of
transport, local customs and pastimes.

A city is about more than just buildings, so your
pictures will be quite dull if that is all they show.
As well as interesting locations, take photos of the

are worth using if they allow you to look down onto a
square or a waterfront area.

Light and weather conditions
Good light is vital when you are photographing a city.
On dull days and in poor weather a city can look grey

people who live and work there. Do your research and try to find out about any local characters who are integral to the life of the city. These might be the *dhabba wallahs* who deliver food to office workers in Mumbai or the pensioners who practise tai chi at sunrise on the waterfront in Hong Kong.

The more famous parts of a city will usually be swamped with tourists, but away from these areas you can photograph people going about their daily business. Try not to be too intrusive and always seek permission. People might expect to get snapped walking across the piazza San Marco but not when they're sitting outside their own house.

Identify any markets or souks where you can walk around and be rewarded with countless details and portraits. Not only will you get shots of locals both selling and buying, but you can also photograph traditional local goods and colourful produce. Try to shoot items that are typical of the city. In Venice this could be carnival masks and ice cream; in other places it might be spices, dates and carpets. Most markets start early; for the best photographs, try to get there at the beginning of the day before the tour groups arrive.

Distortions

If you tilt your camera upwards to fit in a tall building, often you will get an effect caused **converging parallels**, where the building appears to narrow near the top. This effect is more pronounced with a **wide-angle lens** and occurs because the top of the building is further away from the camera and, therefore, smaller.

There are a number of techniques that you can employ to handle the distortion of buildings, without resorting to expensive shift lenses. The first is just to embrace and exaggerate the effect. Move in closer, use a wider lens and tilt the camera more to create a more pronounced convergence. Alternatively, you can avoid the problem completely by not shooting the full face of the building and using a **telephoto lens** to crop a portion of it. To cancel out the convergence but still get a photograph of the whole of the building, you will need to use a wide lens but not tilt the camera at all. This will mean that you get a large amount of foreground but little or no distortion. The unwanted foreground can be cropped out in post-production or you could position yourself so that it is interesting and becomes a part of the picture.

Antananarivo, Madagascar ∧

Nikon D2x, ISO 100, RAW. 18 mm (27 mm equivalent). 1/200 second, f4

You will often struggle to find a view of a city where you can benefit from the evocative sunrise or sunset light, as other buildings will generally block out the light. I noticed this west-facing view of the capital of Madagascar which had an open space in front. Returning at sunset to photograph the city in golden light, I positioned myself on the other side of the lake to include the reflections.

Notre Dame, Paris, France ＜

Nikon D2x, ISO 125, RAW. 18 mm (27 mm equivalent). 1/100 second, f8

Shooting up close to the façade and tilting the camera to include the blue sky distorts every line and angle in the building. The golden hour before sunset has cast a warm glow on the stonework, giving even more contrast with the sky. I increased the sensitivity slightly and biased the exposure to give greater depth of field.

Religious buildings

Interior of Narga Sellase church on Dek Island, Lake Tana, Ethiopia ◄

Nikon D2x, ISO 100, RAW.
12 mm (18 mm equivalent).
2.5 second, f10. Shot with tripod

The interiors of the ancient churches and monasteries on Lake Tana are often painted with bright murals, some of them many hundreds of years old. The colours are natural pigments and depict characters from the bible as Africans. Photographing the interiors needs a tripod and a very long exposure, especially if you're using a narrow aperture for a greater depth of field. The priest standing in the background was entranced by the camera's ability to photograph in this low light and was happy to provide a human element in the background. I had to use a long exposure of 2.5 seconds in order to get enough depth of field in the dimly lit interior so the priest had to stand very still.

The key thing to bear in mind when photographing a religious building is that your pictures are less important than the sacred function of the site. It is not worth causing offence just for the sake of a photograph. Not only is it morally unacceptable, in many parts of the world it can actually put you in danger, so, if there is a sign telling you not to take pictures, then you should definitely respect this.

Some religious sites will allow you to take pictures in an outside compound but not inside the sacred building itself; some let you photograph everywhere, while others ban photography completely. The onus is on you to find out what the official policy is. Be careful of local guides who may encourage you to take pictures, either just to please you and get a tip, or so that you can then be 'fined' for breaking the rules.

Even if you are allowed to take photographs, you should be sensitive about intruding on worshippers. They may not want to be photographed, although, if you tread softly and show a genuine respect and appreciation for their religion, many people will

Prayers, Lamayuru Monastery, Ladakh, India ◄

Nikon D3x, ISO 1600, RAW.
125 mm. 1/25 second, f2.8

You will sometimes be able to photograph ceremonies and services inside places of worship. If this is the case, then the most important thing to remember is not to intrude; find a place where you can sit without getting in the way, and shoot quietly. In low light levels, you should never use flash. As well as ruining the atmosphere of your pictures, it will be terribly intrusive. Increase the ISO and shoot using available light. You will have to use a wide aperture, so compose your pictures in such as way as to take advantage of the limited depth of field.

be happy for you to take pictures. On a number of occasions I have actually been press-ganged into serving as the 'official' photographer for eager pilgrims and worshippers: an amazing experience that resulted in some very pleasing shots.

Rather than just rushing in, firing off a few shots and rushing out again, try to find a relatively inconspicuous place to sit and wait. Not only will this give you the chance unobtrusively to take pictures

of people coming and going, it will also give you more chance to soak up the special atmosphere of the religious site. If it is a place of great pilgrimage, such as the Golden Temple of Amritsar, then you will be sharing the space with people who have travelled from all over the world to worship there, and their excitement and reverence can be palpable. Although you should not impose on people, it is vital to get this human element in to your pictures.

Many of the most famous religious buildings get completely flooded by tour groups who charge around and treat the place as if it were a tourist attraction, rather than a place of worship. The contrast between their behaviour and yours can actually work in your favour and help you to form a bond with the local worshippers.

Try to learn about the religious, cultural and historical background of the building that you are photographing. This will help you to behave in an appropriate manner – such as not pointing your feet at a Buddha image – and will ensure you photograph the rituals, statues or objects that are particularly poignant or significant. If you are photographing an interesting detail, use a **telephoto lens**, wherever possible, and avoid crowding in on a religious icon: this can be as rude and inappropriate as taking an unwanted photograph of a worshipper.

When photographing the interior of a religious building, don't use **flash**. This will be intrusive and will result in lousy pictures anyway. If you aren't allowed to use a tripod, bump up the **sensitivity** instead.

Monks at Wat Doi Suthep, Chiang Mai, Thailand ❯

Nikon D2x, ISO 250, RAW. 116 mm (174 mm equivalent). 1/125 second, f3.2

The height ranges, strong diagonal and lack of concentration of the four novice monks adds a human touch to this image, taken during devotions at a Buddhist monastery in Thailand. Light levels were low, so I increased the sensitivity rather than use flash.

Golden Temple of Amritsar, India ❯

Nikon D2x, ISO 100, RAW. 19 mm (29 mm equivalent). 1/400 second, f11

The Golden Temple is one of the most relaxed and spiritual buildings I have photographed. Although the Granth Sahib, the Sikh holy book, is read aloud continually, there is no formal worship. People seem to come and go as they please and spend as much time as they like sitting around in contemplation. The Golden Temple itself is beautiful – although very difficult to photograph as the light can reflect strongly. I composed this image to include a bathing pilgrim for context, and also to provide some foreground interest and depth to the picture.

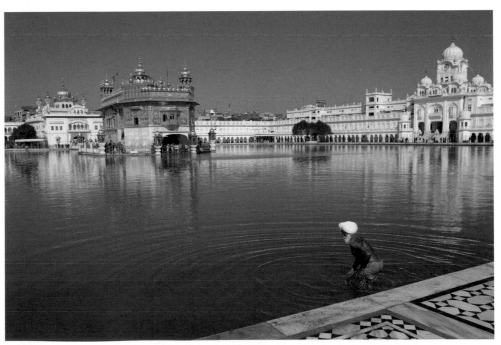

Ruins and archaeological sites

Ruins are popular with both tourists and photographers but, if you don't approach them in the right way, you will have a miserable time and come away with reams of disappointing pictures. Good light is the absolute key. Most ruins I have ever seen, including the so-called 'rose-red city' of Petra in Jordan, tend to look featureless and beige if they are photographed in the midday light.

On a photographic trip to Luxor in Egypt, I made a point of getting up very early every morning so that I could be at Karnak Temple just before sunrise. For three hours I had the place virtually to myself. The light was fantastic and I could work at getting the pictures I wanted. By 0900 the light was becoming quite harsh, so I would walk across the car park, where the first of the restaurants was opening, to have a big, leisurely breakfast. From here I could watch the tour groups arrive, about to start their sightseeing in the mounting heat. Their heads would all be hung low like recalcitrant

Sacsayhuamán ruins, Cuzco, Peru

Nikon D2x, ISO 100, RAW. 95 mm (143 mm equivalent). 1/125 second, f6.3

The Inca ruins above the city of Cuzco contain some of the most impressive stonework I have seen. However, the weather was very overcast and the stones just looked dull. There was also no sense of scale, until a woman in traditional dress walked past and I was able to take a couple of shots. Although she is small and in the bottom corner of the image, the red of her top attracts the eye.

The Treasury, Petra Jordan ◄

Nikon F5, Provia 100 ASA film. 80-200 mm lens. Exposure not noted

I loved the first glimpse of the Treasury through the narrow walls of the siq and wanted to take a picture that conveyed this. Shooting far back with a telephoto lens emphasized the narrowness of the cleft of rock, which Roman legions once fought their way down. The light from the setting sun made the rock walls glow golden for only a few minutes which gives a novel twist to the image.

school kids, knowing they had an arduous day ahead of them. I would return to my hotel to rest, work on pictures and relax, before heading out again around 1500 when the light and the heat started to soften.

Shooting ruins is about more than just pitching up at the right time of day, though. A lot of ruins can look yellow and flat in the **golden hours**, if the warm, golden light is falling on them directly. The best light comes from the side, where it casts soft shadows that pick out details and textures. This is especially the case with carvings and bas reliefs. The modelling effect of the light makes them stand out, and the shadows balance the all-over glowing warmth of early morning and late afternoon light. If possible, try to get a high **viewpoint** for photographing at sunrise or sunset. This can help you to take advantage of the light and will give you a good establishing shot of the whole site.

It is very easy when photographing ruins to just walk around and snap absolutely everything,

which will result in a lot of similar pictures of different things. Try to vary your coverage: plan in advance what is important and what time of day you want to photograph it, especially at large sites like Angkor Wat in Cambodia. Allow time for moving around and don't try to cram in too much.

I usually avoid using locals guides to show me around sites, as they tend to rattle off endless facts and figures, which can be distracting. With a bit of basic research, I can usually work out what I want to photograph and roughly how to find it. I like to walk around at my own pace to soak up the atmosphere and look for **angles** to take pictures. If you are travelling in an organized group, just explain to the guide and tour leader that you want to explore on your own, and fix a time to meet up again.

There is a tendency to try to capture the big picture when photographing ruins, yet the beauty is often in the detail, such as the carved apsara figures on the ruins of Angkor Wat. Go in for a close-up, if you can, or pick them out with a frame-filling **telephoto lens**. Rather than just photographing your subject in isolation, try to combine it with something. This might be a different sets of ruins, a group of people or some local wildlife. Shoot with something in the foreground, the middle ground and the background to give your pictures more depth. Try shooting into the light to give a more creative impression of your subject: unless you are a working archaeologist, you should be trying to achieve an interpretation of the ruins rather then a literal record.

Many large archaeological sites have museums on site. These are often terrible places for photography but, as many of them house the best sculptures and artefacts found at the site, you may not want to exclude them from your itinerary. Fortunately, many museums connected to archaeological sites are located outdoors, which makes photography much easier. Some indoor museums ban photography completely; others do not permit the use of a **flash** or a tripod. It is difficult to take interesting shots in these instances, as you have to rely on how the objects are lit and will have to balance the artificial light and low-light levels. For more technical information on taking photographs in these conditions, see page 112.

Most of the people walking around ruins will be tourists. Incorporate some of them into your shots to give your pictures scale or to show the vast hordes of people who are shepherded around some sites. Local people hanging around ruins are often trying to sell you something; they are usually quite canny and will often expect a tip if you take their picture, but you might get an entertaining conversation thrown in for free.

Great Hypostyle Hall, Karnak Temple, Egypt ◄

Nikon F5, Provia 100 ASA film. 17-35 mm lens. Exposure not noted

The Great Hypostyle Hall is a forest of massive stone pillars at the centre of the ancient Karnak Temple complex near Luxor. Shooting vertically upwards with a wide-angle lens gives a sense of the pillars towering overhead and also visually sets them against a blue sky. Another interpretation of the pillars can be seen on page 114.

Faces at the Bayon, Angkor Wat, Cambodia ◄

Nikon F5, Provia 100 ASA film. 180 mm lens. Exposure not noted

Photographing the Bayon is quite difficult. It is an atmospheric place but there are few angles, other than the standard front-on view of one of the great iconic faces. However, it is possible to shoot with a telephoto lens and show two faces together. The dark and light stone emphasize the contrast in the faces. Sometimes the temptation is to try to show the scale of a place using a wide-angle lens and a long shot but often using a telephoto lens to isolate a detail can produce a less cluttered image.

Photographing the great travel icons

The world's great iconic sites – such as the Taj Mahal, Machu Picchu, Angkor Wat and the Pyramids, for example, – have been photographed countless times, since the earliest days of photography, and their familiarity can be off-putting to the travel photographer who is keen to get a unique shot. On the other hand, these landmarks are amazing, compelling subjects and seeing them is the reason why many people travel in the first place. Come home from a trip to Agra without shots of the Taj, just because it has been photographed so many times before, and your friends will think that you are crazy. Instead, don't just take the same shots as everyone else; treat the very popularity of these subjects as a challenge.

There are always novel **angles** that are less familiar. How about photographing the Pyramids from the startlingly green golf course nearby, or the Taj Mahal from the far bank of the River Yamuna, where it nestles into the surrounding countryside. Sites that attracts locals, such as Angkor Wat, have endless possibilities. Photograph a group of monks on a once-in-a-lifetime pilgrimage and you will have a shot that is truly special.

Combining people and objects with pictures of iconic sites is a great strategy for creating individual images. Don't just shoot obvious portraits with the icon in the background; try photographing someone else snapping a group of locals or a view of everyone's feet as they file past. Try composing to include two different parts of the same landmark, or to combine the landmark with a completely separate object. If an interesting object isn't available, then why not take one with you? Buy an alabaster Taj Mahal at a souvenir

Machu Picchu lit by a patch of sunlight, Peru ∧

Nikon D2x, ISO 100, RAW. 15 mm (22 mm equivalent). 1/125 second, f6.3

Don't just photograph on sunny days, sometimes a stormy day will produce more dramatic images. I stood in the rain for hours seeing patches of light on neighbouring hills until eventually one passed right over the ruins, creating this lighting effect.

Chichén Itzá, Yucatàn, Mexico ‹

Nikon F5, Provia 100 ASA film. 28 mm lens. Exposure not noted

It is hard to get an interesting shot of Chichén Itzá, especially now it is forbidden to climb on neighbouring structures. Trying to produce something vaguely original, I photographed the pyramid in the process of being eaten by a stone creature on another building. Combining objects in the frame is a good way of producing something original. I would have used a telephoto lens to make the pyramid bigger compared to the head but I was standing on a ledge, holding on with one hand.

stand and photograph it up close with the real thing behind: a little kitsch, perhaps, but the picture will stand out. I once missed the change of buying a Taj Mahal snowglobe in Agra: something I instantly regretted. That could have made an interesting image.

Avoid shooting simple record shots: move in close and shoot details. Most buildings have a wealth of architectural features that can show something about a place that people might not have seen before.

Travelling in the off season when the weather is less predictable can sometimes produce great photos. I have seen fantastic shots of a wet Angkor Wat lit by shafts of sunlight cutting through dark clouds and of the Great Wall of China covered in snow. It is a risk travelling at these times, as the weather may be too poor to take any pictures at all, but at least there will be fewer crowds. If it works, then you can get a picture that is totally unique.

Pictures of the world's most iconic sites are often taken in the middle of the day or at sunset, both of which are popular times that attract big crowds. Get up at sunrise and you may find that a site is all but deserted. It may not be open at this early hour but you should still be able to find a **viewpoint** where you can take photographs in glorious isolation. If you can find a suitable spot, then take some shots at night, too, when the scene is lit by moonlight. This was how I photographed Uluru (see page 189) under a sky of star trails.

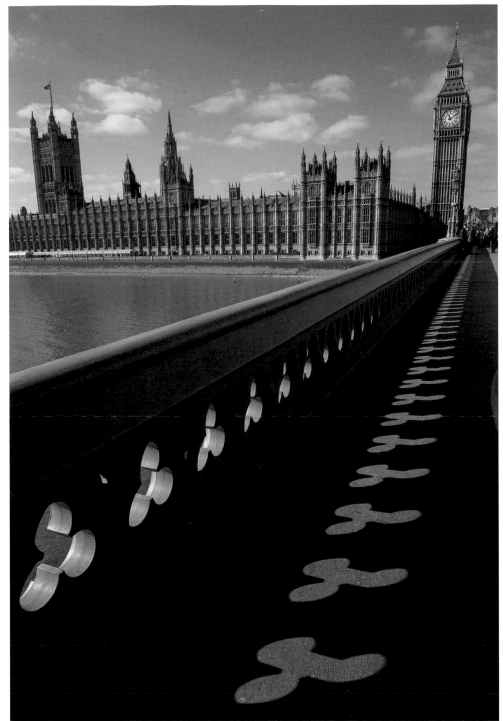

Light patterns on Westminster Bridge, London, England ❯

Nikon D3x, ISO 100, RAW.
24 mm. 1/160 second, f11

Travel photography is all about keeping your eyes open and looking out for novel things to photograph. In this case I noticed these rather interesting light patterns leading towards the Houses of Parliament and thought it would make an amusing photograph. I composed the shot so that all of the elements were present in the picture: the Palace of Westminster, the holes in the bridge and the light patterns. A strong diagonal leads the eye up to the Palace and the clocktower which fill the top part of the picture. Finally, I just waited until the people on the bridge cleared slightly before taking the picture. People will generally clear momentarily if you wait long enough, but you have to be ready to take the shot the second they do. This light effect only happens at certain times of day, and at certain times of year. I really hope that the bridge designer incorporated this light effect as a protest against politicians!

Festivals

There is a spectacular array of religious, cultural and just plain bizarre festivals happening around the world, and they can be fantastically rewarding occasions to take photographs. Festivals are often what define a place: Rio for Carnival, New Orleans for the Mardi Gras or Pushkar for the camel fair; visit at other times and you may well feel that you have missed out.

Yet festivals are a difficult time to visit a destination: accommodation is often booked up; there can be too many crowds, and many sights and museums will be closed. To me, that sounds perfect! I have been to festivals all over the world, and I often time trips specifically to photograph them. I am, quite literally, a festival junky.

Research and exploration

If you are hoping to photograph a festival, it is vital to do some research and planning in advance to find out what is happening and when. If you wait until you get to the festival, it will be too late. Take your information from a number of sources and be circumspect about information on the internet: often websites just repeat incorrect information verbatim, so be suspicious of near-identical Wikipedia text on two different sites.

Allow yourself plenty of time. Whenever possible, get there a day or so early and use the time to confirm what is happening and to look for good angles. Try to establish a schedule of events that make up the festival and choose what you want to photograph. If the festival includes a procession, walk the route beforehand and work out the vantage points that you are going to use. This might involve knocking on a few doors and charming or paying your way up to a balcony or open window. Consider the angle the light will be coming from at the time of the procession.

Try to find out if there are any key moments or vital customs that you should photograph: the first beer barrel being tapped at the Munich Oktoberfest; the blessing of the horses in church before the Palio horse race in Siena or locals blessing monks with water at the rather wet New Year celebrations in Laos.

Give yourself as much time as possible at the festival itself. There is no point turning up for a day and expecting to get really good pictures; it can take that long just to get used to the chaos. Book accommodation in advance and get a place as close

Elephant ordination ceremony, Sukhothai, Thailand ❯

Nikon D2x, ISO 100, RAW. 120 mm (180 mm equivalent). 1/400 second, f6.3

In Thailand every male is supposed to spend some time in a monastery at least once in their lives. At Sukhothai they process to the monastery on elephant back in a spectacular ceremony, dressed in make-up and bright clothes. Presumably this excess is supposed to contrast with the austere life that they will be leading in the monastery. I managed to find a high angle to look down on to the procession over the heads of the crowd and then waited for the elephants to process past, with the gate of the monastery behind.

Pi Mai Lao, Luang Prabang, Laos ❯

Nikon D2x, ISO 200, RAW. 24 mm (36 mm equivalent). 1/1000 second, f5.0

Pi Mai Lao (Lao New Year) is part of the giant water-fight, which engulfs the region of Southeast Asia every year as a celebration of the Buddhist New Year. This drenchfest grew out of the tradition of gently sprinkling people with water as a blessing. As well as the general drunken hilarity and chaos, there are religious processions and offerings are made to monks and at local monasteries. Good preparation is essential for a festival such as this; I shot with my gear in a professional *Kata* raincover to avoid water damage.

Bathing elephants and pilgrims, Sonepur Mela, Bihar, India ‹

Nikon F4, Provia 100 ASA film. 80-200 mm lens. Exposure not noted

Walking across an old railway bridge to get to the festival, I noticed the elephants amidst the crowds of bathing pilgrims. The bridge provided a perfect high viewpoint but I had to hang over the edge to get the shot, much to the consternation of the attendant police.

to the action as you can afford. There is nothing more depressing that commuting in to a festival; not only are you more likely to give up and go home early but you have to carry a whole day's worth of equipment with you. Being able to pop back to your hotel, check your equipment and take a 30-minute siesta can be a life-saver.

Planning your shots

If you just wander round and snap pictures, you will get fairly haphazard coverage of the festival. Although it may sound a bit tedious, it pays to make a list of all that you want to photograph. This should include all the key events and also behind-the-scenes shots of people getting ready or making their costumes, food shots – giant frothing steins for Munich or a massive steaming vat of paella for Pamplona – and the crowds along a procession route.

Try to be creative with your range of shots as well. Imagine that you are shooting for a magazine that is going to illustrate a feature with your pictures. Think of all the different style of shots that you might need: a big horizontal 'establishing' shot for the opening spread, a vertical full-frame portrait, a close-up food shot or other details. This will help you to construct the story of the festival and allow people who look at your work to build up a complete picture of what the event is all about.

Getting in place

You should find out if there are any events that require tickets and also whether there are any rooftops or balconies that you can shoot from to get a better view. Do some research on photolibrary websites to see what

angles other photographers have managed to achieve and whether they are worth finding. All of this should be sorted out in advance, but make sure that you are flexible with your plans. Sometimes crowds or official crowd control mean that you won't be able to get to the spot you were hoping for. At many of the more popular events vantage points are rented out as a commercial venture. In Pamplona, a balcony overlooking the bull run costs around €50 but offers a fantastic view, especially since the vantage points right up against the barriers are taken by press photographers with passes. For the Palio horse race in Siena, balconies overlooking the race are sold weeks in advance but are among the best places to see the action.

The famed war photographer Robert Capa once said, "If your pictures aren't good enough, then you aren't close enough". This is great advice if you are shooting a festival. Get as close to the action as you

Venice Carnival, Italy ›

Nikon F801, Kodachrome 64 ASA film. Lens and exposure not noted

Festivals are a perfect time for shooting portraits – even if your subject is wearing a mask, as with this image from the Venice Carnival. I used a mild telephoto lens to shoot this picture, so that I could keep close when I was photographing. This is useful for three reasons: it means that you can still interact with people and can command their attention; it makes it harder for any other photographers to cut in, and it also deters people from walking in front of the camera. All of these points are especially important at crowded festivals. Despite the mask, I have still managed to establish good contact with the woman – at least I think that this is a woman…

Lisu New Year, Soppong, Thailand ›

Nikon F4, Velvia 50 ASA film.
80-200 mm lens.
Exposure not noted

I was staying at a traditional
Lisu village for their New Year
celebration. Most of the dancing
happened at night, but some
was still going in the morning as
the sun came up. I used a little
fill-in flash to lighten the shadows
and a telephoto lens to shoot
across the circle of dancers.

Procession of the akharas, Maha Kumbh Mela, Allahabad, India ›

Nikon F5, Provia 100 ASA film.
80-200 mm lens.
Exposure not noted

This procession of devotees of
the Juna akhara happened on
one of the main bathing days of
the festival. Tens of millions of
pilgrims attended to try to bathe
in the Ganges. Moving around
was all but impossible, even with
an official press pass so I staked
out a position that allowed me
to shoot with a telephoto lens
and shot the floats as they came
towards me.

Korzok Gustor Festival, Ladakh, India ›

Nikon D3x, ISO 400, RAW.
24 mm. 1/640 second, f8.0

This rather feisty yak is
ceremonially released for merit
during the Korzok Gustor
festival near Tsomoriri lake in the
remote high-altitude Himalayan
region of Ladakh, India.
Shooting with a wide-angle lens
I was able to get dangerously
close to the action, resulting in
a dynamic and exciting shot,
where the slight distortion adds
to the mood. I will often zoom
to a wider setting simply to
allow me to get closer to the
action.

can: your pictures will be far more immediate and will
intrigue and engage those looking at them.

Try to get to your chosen vantage point early to
stakeout your space and, if you can't get close enough
to the action, try to find a spot a short distance away
and shoot over people's heads with a **telephoto lens**.
Collapsible step ladders, designed especially for press
photographers, can be useful, although it is often
difficult to use them in a crowd, and you run the risk

of being moved on by an overzealous police officer.
In general, you should carry only the minimum
amount of equipment.

At fast-moving events, don't keep running
after the action; you will never be in one place long
enough to compose yourself and take any creative
pictures. Try to predict where the action will go and
get in place, so that the action can come to you.
This will give you time to think about what you
are photographing and to make creative decisions
rather than just banging off snapshots. It takes some
practice and there will be times when you get it
wrong, but the successful shots are likely to be far
more memorable. This is particularly crucial if you are
photographing a procession or parade. Once you've
found a good spot, decide which lens and techniques
you are going to use. Change lenses while you are
stationary and work out the **exposure**. When the
procession passes you will be ready to take the shots
you want and can then move on to the next point.

Protecting your gear

Festivals can be a hostile environment for both you
and your equipment. Dust, crowds, water and even
tomatoes can ruin your precious camera and lenses.
Some festivals, such as the Tomatina (the world's
largest tomato fight held in Spain) or Songkran (the
Thai water-throwing festival) are extreme cases, where
you should either use a good rain cover or a small,
disposable waterproof camera. In dusty conditions, you
can protect your camera with a plastic bag or cling-film.
A **zoom lens** on a **digital SLR** is a good idea as it means
that you have to change the lens less often. Carry a
spare set of batteries, film or memory cards with you
and, for yourself, make sure that you have a bottle of
water and a couple of energy bars tucked into your
bag. There is no point in having a spare set of camera
batteries, if you are too exhausted to keep going!

Faces that you meet

Festivals are a great time for portraits. People are often
relaxed, happy and more open to having their photo
taken than during their day-to-day lives. Festivals
also tend to attract a wide range of people, making it
possible to photograph many different characters in
one place. The Pushkar camel fair, for instance, attracts
camel traders, holy men and pilgrims and can be a
fertile ground for shooting portraits. Don't ignore

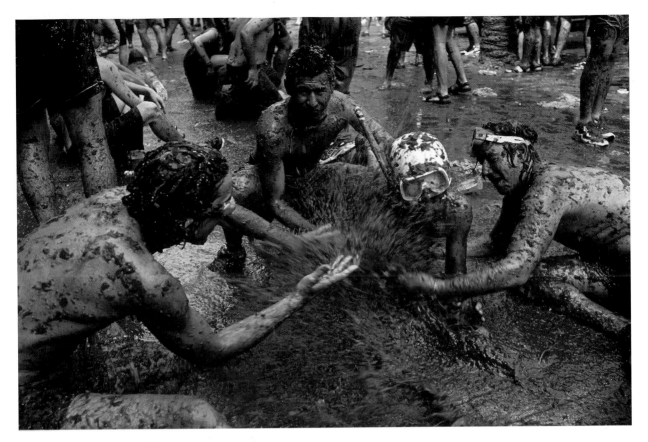

Tomatina Festival, Buñol, Spain ∧

Nikon F5, Provia 100 ASA film. 17-35 mm lens. Exposure set to automatic. Underwater housing

The Tomatina is a completely mad festival: an hour long mass tomato fight in the main street of the tiny town of Buñol near Valencia. I was shooting with a camera in a waterproof housing which meant that I could get right into the middle of the action and not have my camera ruined. Unfortunately having a camera made me a target for vast swathes of tomatoes. I was photographing the aftermath of the fight and the man in the snorkel and mask was posing for me when his friends decided he hadn't had quite enough tomato!

your fellow revellers and other tourists, either: their involvement and enjoyment can really give life to your festival pictures. For more on portrait photography, see pages 156-165.

Technical stuff
If you are walking around at a fast-moving festival or in changeable light, I would suggest setting both the focus and camera meter to automatic in order to get more accurate exposures. However, if you are in one place for a while, photographing a parade, say, then **manual exposure** or calculating **exposure compensation** from a **histogram** will give you more precise results. Take test shots before the procession reaches you and make any adjustments. Don't wait until the perfect shot appears before realizing your exposures are all wrong!

When shooting a festival, you are not able to choose when to take your pictures, and you may well have to shoot in the middle of the day when the light is awful. To avoid the deep shadows caused by the sun being directly overhead, consider using a **fill-in**

flash to give a more balanced picture, particularly for close-ups and portraits. A flash can also be useful at night when there is too much movement to use available light, though a **slow-synch flash** setting is usually preferable in these instances, as it enables your camera to balance available light and flash to give a less stark effect and show some movement.

In the excitement of the festival, don't just snap away without thinking. Remember to vary **viewpoints** and lens perspectives and creatively to interpret any movement. Take lots of pictures – especially if you are shooting digital. People are likely to walk into your frame or generally get in the way, so it's a good idea to take more than one shot at a time.

Are we having fun yet?
Above all, when photographing a festival, remember to enjoy yourself. Don't get so hung up on taking the perfect photograph that you forget to experience the festival itself and all that it has to offer. It would be a shame to come away with great photographs but no memories.

Performances

Many commercial performances, such as concerts, theatre, ballet or opera, will ban the use of cameras, but, luckily, performances organized specifically for tourists will often welcome their use, although you might be asked to pay extra for the privilege.

There are two basic strategies for shooting a staged performance: sitting near the front with a **wide-angle** lens or hanging out at the back with a **telephoto lens**. Sometimes the event and the seating restrictions will dictate which of these options is open to you but, given the choice, I prefer to be near the back (partly so that I can cut away without anyone noticing if the performance is bad).

If you are near the front and the performance is on a raised platform or stage, not only will you have to be careful about getting in other people's way, you will also be shooting upwards, which will make it difficult to get a good **angle**. Using a wide-angle lens means you will get a lot more of the background in – sometimes even the wings and lighting rig of a stage – which can ruin the mood of a shot. Shooting from the back with a telephoto lens will drastically reduce the amount of extraneous background in the shot, even if you zoom out and shoot the whole of the stage. It also gives you the freedom to stand up and move around to get different angles without spoiling anyone else's view.

One downside of shooting from the back of a room is that it might be out of the range of your **flash**. However, shooting an entire performance with a flash can give rather harsh shadowy light and might spoil the event for everyone else. I prefer to shoot using a higher **sensitivity** and the available light. Proper stage lighting is often more than adequate to allow relatively fast **exposures** but, if the light levels are lower, then you might need to use a tripod or, better still, a monopod to reduce the chance of **camera shake**. Subject blur is another issue at slower **shutter speeds**: to avoid it, select a higher sensitivity or time your shot for a natural break in the action, such as when a character pauses to turn to the audience with a look of surprise: these are often the most dramatic moments of a performance anyway.

Often there won't be enough light or there will be too much movement, and you will have to use flash. You can improve the quality of the flash light by fitting a **diffuser** or using a single sheet of white tissue

Kathakali dancer putting on make-up, Kerala, India ◄

Nikon F801, Velvia 50 ASA film. 80-200 mm lens. Exposure not noted. Slow-synch flash

This demonstration of South Indian Kathakali dancing included the dancers putting on their make-up. As it was organized for tourists, photography was welcomed. This was shot with a slow synch speed so that the ambient light registered in the image, which prevented the flash light from looking too harsh. A telephoto lens allowed me to shoot a tight head shot without needing to move too close.

paper over the flash head. Try using a slower synch speed so that the ambient light of the stage area also registers and there is not such a **contrast** between the subject and the background, or simply zoom in so that the subject fills the frame, making the disparity between subject and background less obvious.

Digital photography will allow you to correct any **colour casts** from artificial lighting using your camera's **white balance** facility. If you are shooting film, then you will have either to live with the colour cast or use a filter to balance it. Unfortunately, this will reduce the light levels further, so you may have to opt for the closer **viewpoint** and **slow-synch flash** strategy.

Sometimes it is possible to get behind the scenes and shoot people putting on make-up and getting into costumes before a performance.

ⓘ For more detailed information on the use of flash, refer to the Execution section, page 128.

**Balinese dancer,
Ubud, Bali, Indonesia** ❯

Nikon D2x, ISO 640, RAW.
175 mm (263 mm equivalent).
1/100 second, f2.8

This dance performance was
well lit, so I was able to use a
high sensitivity and shoot from
the back, behind the seated
audience. This meant that I
could move around and I didn't
have to stay till the bitter end!
The built-in Vibration Reduction
on the lens helped me to hand
hold the camera and I didn't
have to use flash. This meant
that the background was well
lit and I managed to avoid
excessive contrast. Often the
dancers were moving too fast
for the shutter speed which
would have led to subject blur,
so I waited for natural pauses
in the action before taking
a picture. Luckily in Balinese
dancing there are lots of breaks
where dancers maintain their
poses and are almost still.

Sunsets and sunrises

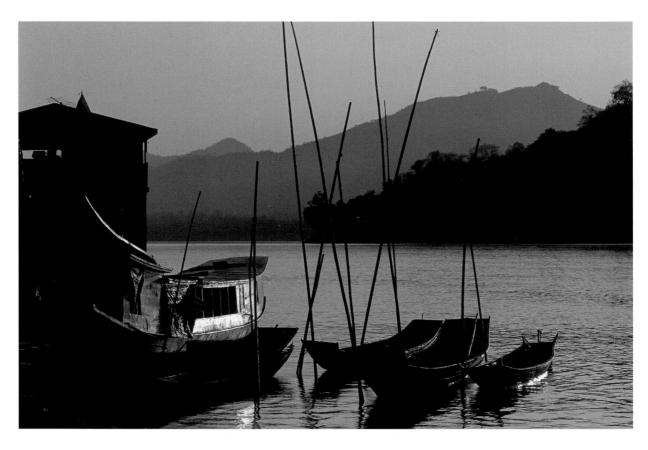

Sunsets are perennial favourites for all travellers, especially sunsets over water. Every night in 'sunset points' all over the world, coaches disgorge hordes of camera-toting tourists who click away at the setting sun, with wild abandon. The problem with this approach is that as well as getting sun spots burned into your eyes, you will also get disappointing pictures: the contrast between the sun and the surrounding sky is generally so great that the sun will either be bleached out completely, or the sky around the sun will render very dark, almost black.

Photographing the sun
No camera has a **dynamic range** high enough to balance the sun, while it is still well above the horizon, with the surrounding scene. In these instances, it is

better to keep the sun out of your picture altogether and use a mildly **telephoto lens** to isolate another part of the scene.

The only time when you might get the sun to render along with the sky is in the last few seconds of a sunset when the sun turns a dull red before it slips below the horizon. This effect is accentuated in locations where there is a lot of dust in the atmosphere, such as deserts. If you are trying to photograph the setting sun at this time, you will get a much more impressive picture by using a telephoto lens to help you fill the frame. A telephoto lens will also create far more dynamic silhouettes, as it will alter the perspective between your subject and the sun, making the subject appear larger, although you will have to maintain some distance away from the subject.

Boats on the Mekong at sunset, Luang Prabang, Laos ∧

Nikon F5, Provia 100 ASA film. 80-200 mm lens. Exposure not noted

It is often better to photograph things bathed in warm sunset light rather than the actual golden ball of the sun! This sunset over the Mekong has turned the whole picture a fantastic golden colour and the boats are picked out with reflected highlights. Using a telephoto lens has isolated a part of the scene and emhasized the specular highlights on the boat.

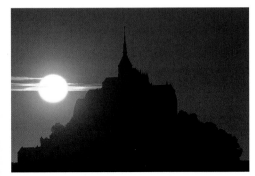

📷 Digital SLR

If you use the auto white balance facility (see page 121), all of the lovely rich colours will be filtered out of the picture. You should either set the white balance to daylight or, even better, shoot RAW and adjust the colours later.

⊙_ Film SLR

If you shoot a sunset with a daylight-balanced film, the colours will be emphasized, making reds appear even more vibrant. They will actually often appear far richer on transparency film than they do to the human eye. The colours after the sun has set will also appear more intense, often turning a rich purple. However, bear in mind that film has a limited dynamic range, which isn't very good at dealing with the extreme contrast of sunsets.

⊙ Digital compact

Digital compact users shooting with the auto white balance facility will find that a lot of the colour is lost. Setting the white balance to daylight, or the picture mode to 'sunset' will preserve the colours.

Remember that, even when the sun appears at its weakest before it sinks below the horizon, it can still damage your eyes if you stare at it for too long, especially if you use a telephoto lens.

Silhouettes

I usually avoid taking pictures of just the setting sun. Apart from the problems with **contrast**, this is because very few sunsets have any sense of place. Even if you manage successfully to capture the red ball of the sun slipping into the sea, no one will have a clue where the photograph was taken.

One of the classic ways to introduce a sense of place into your sunset shots is to create a recognizable silhouette, whether it be a giraffe against an African sun or the millennium wheel in London. In order to make sure of the **exposure**, meter from the sky, not the silhouetted subject. If the sun is still in the sky, you can use the silhouetted object to mask it out, so that the contrast isn't so extreme in your picture. Usually, a silhouette shot will work better if you don't have the sun in the picture at all; instead, create a silhouette by placing

your subject against a large patch of coloured sky. A more contemporary, less saturated silhouette effect can be achieved by using **backlighting**: effectively **overexposing** the shot so that the sunset is brighter and more detail is visible in the subject.

One of the big problems of shooting a silhouette with the sun in the picture is **flare**. This is where the sun reflects off the inner surfaces of the

Sunset over Mont St Michel, France ‹∨

Above: Nikon D2x, ISO 100, RAW. 300 mm (450 mm equivalent). 1/640 second, f18

Below: Nikon D2x, ISO 100, RAW. 300 mm (450 mm equivalent). 1/400 second, f6.3

If you have a sunset which actually has the sun in the picture, the dynamic range will be far too great: the sun will be too light and the sky will be too dark. If you wait until the sun disappears, then there will be far less contrast and you will get a more even sky and, in this instance, be able to create a perfect silhouette. The small band of cloud has caught the light and breaks up the expanse of sky.

Sunrise over lake, Suzhou, China 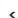 ‹

Nikon F4, Velvia 50 ASA film. 200 mm lens. Exposure not noted

In this image the layer of haze and pollution has helped to balance the brightness of the sun and stopped it burning out. A telephoto lens was used to isolate the bridge and its reflection. On the bridge there is a procession of people behind yellow banners, but I never found out what they were doing.

Musician at sunset, Jaisalmer, Rajasthan, India ❯

Nikon F4, Provia 100 ASA film. 80-200 mm lens. Exposure not noted

It is a bit of a cliché but sometimes clichés can work! This musician was serenading tourists at the sunset point overlooking the town of Jaisalmer. By using him to block the sun I was able to create a perfect silhouette without getting any problems of excessive dynamic range.

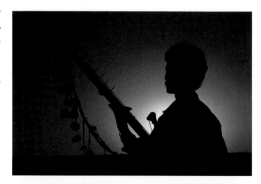

Misty sunrise, Kerala, India ❯

Nikon D3x, ISO 800, RAW. 70 mm. 1/100 second, f5.6

Sunrises are often far more atmospheric than sunsets, as there are fewer people and you often get a glorious misty effect; especially if you are photographing near water. Water is also perfect for reflections, as in this shot, taken from a bridge. The problem with sunrises, is that you never know what you are going to get until they happen; you will have to get up and leave your room in complete darkness.

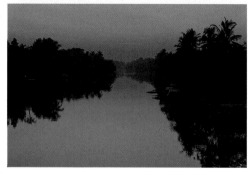

lens, creating a number of bright spots, often in the shape of the lens aperture hole. You can also get reflections from dust on the outer element of your lens, which causes a loss of sharpness and **contrast**. Apart from cleaning your lens, you can minimize **flare** by always shooting with a lens hood (see Preparation, page 32).

Sunsets in poor weather
Cloudy and stormy skies can create very dramatic sunsets. Keep shooting after the sun goes down; not only will the brightness of the sun not dominate the picture, but often the light will shine onto the clouds long after the sun has disappeared, turning them a rich range of reds. If the clouds are quite thick, then you will get corresponding areas of dark cloud that will add drama to your photographs.

Spectacular sweeps of stormy sky at sunset can be photographed with a **wide-angle lens** to give a feeling of the expanse of the sky, or with a mildly **telephoto lens** to make your pictures feel more

immediate. A more powerful telephoto lens can be used to isolate a small part of the sunset and create a more dramatic photographic interpretation.

Don't forget the sunrise
Sunrise can be an even more evocative time to take pictures. The light is often clearer and crisper than at sunset and colours appear softer. If you are near water then there is always the chance of mist. Sunrises are also useful if the light is coming from the wrong direction at sunset. The downside of shooting sunrises is that you have to be up early, but at least there will be far fewer people to get in your way! You might have to commit yourself to getting out of bed a couple of hours before the sun is due to rise, depending on how far you have to travel. Make sure you have time to photograph the dawn: this can often give a completely different effect to the sunrise itself, and is a perfect time for shooting silhouettes.

Sunrises can be a leap of faith: the weather might not look good when you get out of bed, but don't be deterred. Often conditions will change and the only way to really see how a sunrise, or for that matter a sunset, will appear is to be there with a camera, and see it for yourself.

It can be hard to find out the actual sunrise time by asking local people, so I always research this in advance using *Accuweather*, which has comprehensive sunrise and sunset times, as well as fairly accurate extended forecasts. Research can also give you a more accurate idea of the sunset time, so you can get into place in time and photograph how the scene changes as the sun gets lower in the sky.

Keep shooting
Whether you are photographing a sunrise or a sunset, you should always take lots of pictures, rather than just waiting for a perfect moment. Sunsets often get better and better as time goes on, or they may drop off dramatically, especially if there is a thick band of cloud on the horizon. If you wait for the right moment, you may well miss it. By shooting digital, you can always delete the unwanted shots.

ⓘ For more detailed information on white balance, refer to the Execution section, page 121.

Night photography

Night photography is a misnomer, since the best time for night photography is actually at dusk when there is still some light in the sky. If you wait until later, all you will end up with is a series of lights in a sea of inky black.

There is a point as it gets dark at which the light levels in the sky balance both the ambient light in the scene and the light given by floodlights on buildings. This is the perfect time to take pictures, as you will be able to record the maximum amount of information in the scene. The sky will often appear as a luxuriant dark blue or, if you are looking towards where the sun has recently set, it might render as pink or purple. The conditions change very quickly, so make sure that you are ready and then keep shooting until the moment is gone. Generally, there is only a window of ten or 15 minutes when the light levels are perfect, so you are unlikely to be able to take more than one view on a night shoot. To extend this window of opportunity, take the first shot pointing east, away from where the sun has set, and the second one towards the west. As a result of the differing light levels in the sky, there can be a gap of up to 30 minutes between when the light is perfect for each one. In these cases you might be able to fit in two different set-ups in a night, provided you shoot them in the right order.

Even at the best time for night photography some of the scene will be too bright. Any light sources will be outside the **dynamic range** and will **overexpose**. As long as they only account for a small part of the picture, this isn't a real problem, although you will need to be careful with your metering to make sure that they don't influence the rest of the **exposure**.

The best way to work out the exposure is to meter a midtone with a **spot meter** and then manually set the exposure. If you don't have a spot meter on your camera, meter on a similarly lit midtone near you. If you meter from the whole scene then any light sources will fool the meter into **underexposing** by about two **stops**. In this instance, you might need to set the **exposure compensation** or the manual exposure to +2 stops to compensate. On a **DSLR** you can check this exposure using the preview image, **histogram** and **clipped highlights** indicator.

If you have to photograph when the sky is dark, aim to fill as much of the frame as possible with lit areas. Crop tightly and exclude as much of the black

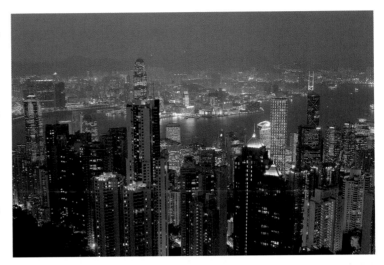

Hong Kong, China ∧

Nikon D2x, ISO 100, RAW. 28 mm (42 mm equivalent). 2.5 second, f4. Shot with tripod

The hazy sky reflected the light from the city, stopping it from rendering too dark in this classic Hong Kong night shot. As I was using a 28 mm lens and the scene was some distance away, I didn't need so much depth of field and used a wide aperture. This allowed for a relatively brief exposure, as there was a lot of wind and so I wanted to minimize camera shake.

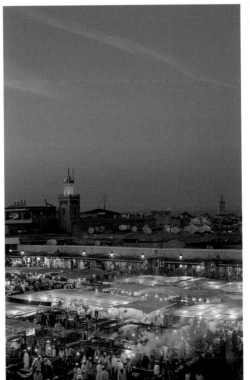

Jemaâ el Fna, Marrakech, Morocco ‹

Nikon D2x, ISO 100, RAW. 35 mm (53 mm equivalent). 1/20 second, f3.5. Tripod

The best time for night photography is when there is still some light in the sky and the ambient light balances the floodlit parts of the scene. In this photograph of the main square in Marrakech I opted for a vertical orientation to include the pink clouds in the frame. There is a small window of opportunity when the stalls are busy and lit before the sky gets too dark.

Tokyo neon, Tokyo, Japan ◄

Nikon D2x, ISO 400, RAW.
130 mm (195 mm equivalent).
1/80 second, f2.8. Tripod

It is surprisingly hard to shoot neon signs as they are very bright compared to the ambient light. The only way is to shoot in the early evening when the ambient light levels are higher; alternatively shoot two exposures and combine in post processing (see page 276). I had to increase the sensitivity and use a relatively fast speed as I was shooting from a foot bridge that was vibrating as pedestrians walked over it, and also because I didn't want the train to blur.

Hong Kong by night, China ◄

Nikon D2x, ISO 100, RAW.
12 mm (18 mm equivalent).
1/100 second, f4. Tripod

I had just arrived in Hong Kong and got to my room as dusk was falling. I wandered out onto the balcony and noticed this fantastic scene below me. I only had a few minutes to drag my tripod out of my pack and set everything up. This was my only chance to shoot this view, since, for the rest of the trip, I had to concentrate on photographing more famous sights.

Rio Harbour from Corcovado, Rio de Janeiro, Brazil ►

Nikon F5, Provia 100 ASA film.
28-70 mm lens. Tripod
Exposure not noted.

I was plagued with poor weather in Rio but persevered and shot into the haze and also took a lot of night shots. Here, the cold ambient light has turned a vivid blue and balances the lights of the city. There is still enough light to be able to see the detail of the islands in the bay.

slow, and any movement in the scene will be blurred in the final picture. In fact, if the shutter speed is slow enough you can make even a slow-moving crowd of people, say, effectively disappear.

A really dynamic effect is achieved when vehicles move during the exposure so that their head and tail lights create a long trail of white and red in the picture. The length and smoothness of these trails will depend on the number of cars and how far they have moved during the exposure, but the effect starts to look good around the 20-second mark. Ensure the traffic isn't stationary at junctions and take a number of shots: the effect will look wildly different in each.

Unless you are shooting super-long exposures by moonlight (see page 188), then you will need some level of artificial illumination to take night photographs. I have shot in deserts and used gas

🌐 **Shooting RAW**
Shooting RAW will give you a greater dynamic range and more control over the white balance. Although you can filter out all of the colour from artificial floodlights, often the picture will look better if there is some warmth left. It is easier to judge this when RAW processing. Some urban scenes are lit with orange sodium lights. You can filter this out to some degree but you will never completely correct the colours. Some photographers try to moderate the wide dynamic range by underexposing by a stop or more to bring the highlights into range, then lightening the underexposed shadows in post-production. This can lead to more noise in the shadow areas but this is less of an issue with modern DSLR sensors.

sky as you can. (Some subjects, such as skyscrapers, won't suit this treatment.) If there are fountains or rivers nearby, try to combine the subject with its reflection. You can use a **graduated ND filter** to darken your subject by one or two stops so that its brightness matches that of the reflection.

Another way to fill the foreground of a night shot is to use the reflections of lights on a wet pavement. As long as it isn't actually raining, then poor weather shouldn't stop you from taking night photographs and, sometimes, they might be the only decent shots that you come away with on a weather-affected trip.

With a modern digital camera, it is possible to use a very high **sensitivity** and hand hold a night shot without **camera shake**, especially if you are photographing when there is still light in the sky. Generally, though, the low light levels will demand that you use a tripod to avoid camera shake. This means you can also use quite a small **aperture** to get as much **depth of field** in the scene as possible, although the **shutter speeds** are likely to be quite

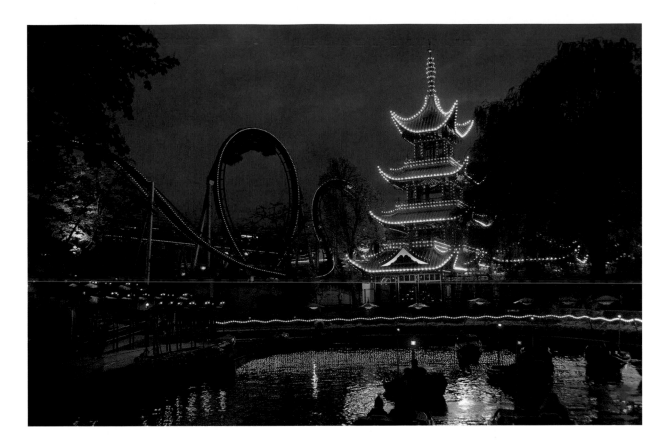

lanterns and even the light from bonfires to illuminate the foreground and balance it with a dusk sky. In a town or city with street lighting, you will need to find a suitably elevated vantage point. This isn't always easy: public viewpoints usually close at night and, if they are open, often forbid the use of tripods. Some cities have natural vantage points, such as Montmartre in Paris, but in others you will have to

⊙⎯ Film SLR
When shooting film it is worth bracketing to ensure that you have the correct exposure.

⌷ Digital compact
Most compact cameras will have a night photography picture mode, which will switch off the flash and bias towards long exposures and often select a white balance mode that will correct the colours. If your camera doesn't have a night mode then simply switching off the flash will force the camera to use a slower shutter speed. You will need a tripod but a small table-top version should be sufficient.

rely on the views from hotels, restaurants or even your own room. (If you have to photograph through glass, switch off the interior lights to avoid reflections.) Search out a number of locations during the day to see which has the best view. Plan your shots and check what you will get in the foreground and the background. You should also consider where the sun will be setting as this will affect the colour of the sky. Often the accepted 'best' view may not be the best for night photography and a slightly different **angle** will give a shot that most people haven't seen before.

Problems with dynamic range
There will be some subjects, such as neon signs and large bonfires, which will be too bright to register along with the surrounding area, as the dynamic range will be too great for your camera. In these instances you can either zoom in to crop out the darker surroundings, or shoot a range of shots at different exposures and paste them together in post-processing to increase the effective dynamic range of your camera (see pages 147 and 276).

Tivoli amusement park, Copenhagen, Denmark ⌃

Nikon D3x, ISO 1600, RAW. 35 mm. 1/20 second, f4.

I couldn't take a tripod into this amusement park and so had to shoot with a very high ISO. The sky in this picture just balances the lights, and the reflections in the water help to fill the foreground with colour. When taking the picture, I waited until the rollercoaster was just at the top of the loop before taking a shot. Using a long exposure on a tripod would have blurred this moving rollercoaster far too much.

Shooting star trails

If you shoot a super-long exposure of many minutes then you can create star trails, where the stars appear to move during the exposure, although in reality you are recording the movement of the earth relative to the stars.

The length of the trails is governed by the length of **exposure**, but this is limited by the level of ambient light. If light levels are too bright, then you won't be able to have the shutter open long enough to create long trails. The **aperture** affects the brightness of the trails, so you can't simply use a very narrow aperture or an **ND filter**, as these will make the star trails too dark, with darker stars not registering.

Technically, although you will need a very stable tripod and a locking **cable release** to allow long bulb exposures (see page 32), the biggest issues will be calculating exposure and focusing in the dark. Take a test shot at the highest **sensitivity** and widest aperture. Experiment until you have a well-exposed picture, and vary the focus until the picture is sharp. Switch to manual focus to prevent the camera refocusing, then reduce the sensitivity to the lowest setting, counting the numbers of stops the sensitivity is reduced. Reduce the aperture by a few stops too, avoiding using an aperture smaller than around f8, for bright trails. Calculate the final exposure by counting the combined number of stops from the sensitivity and aperture from tested exposure. Each stop reduction will double the exposure time.

You should also use the long exposure noise reduction facility, even though this will double the effective exposure time.

Star-stacking

If the ambient light levels are too high for creating long star trails with a single exposure, then you can try a technique called star stacking, where you take a series of exposures and stack them together in post-processing. The program can automatically avoid **overexposure** in brighter areas of the picture, and if something like a car with bright headlights drives through the scene, you can simply not use that particular frame.

You will need a good tripod, as the camera can't move at all between exposures, and if possible use a **mirror lock-up** to reduce the chance of **camera shake**. Once you have composed and checked the focus (remembering to switch to manual focus to prevent refocusing), you will need to alter the aperture and sensitivity to give a 30-second exposure. This is usually the longest possible timed shutter speed. Switch off the **long exposure noise** reduction, use a **motor drive** mode and then just lock open the shutter using a locking cable release. The camera will take a series of 30-second exposures consecutively. If you take 120 exposures, then it will have the same effect as a 60 minute exposure. The resulting images can automatically be stacked using a simple free multi-platform program such as *StarStaX*.

Milky Way over Lake Tsomoriri, Ladakh, India ◄

Nikon D3x, 3200 ISO film. 22 mm. 30 seconds f2.8. 42 frames, stacked in *StarStax*

The ambient light on the lake was such that I wasn't able to shoot a really long single exposure, without it rendering too light, so I shot a series of 42 pictures and assembled them with *StarStax*, giving an overall exposure time of 21 minutes. The ambient light was dark enough that I had to use a high ISO to get away with a 30-second exposure. Luckily using a stacking program also had the effect of minimizing the high ISO noise. A single frame from the set is shown below.

Uluru, Australia ►

Nikon F5, Provia 100 ISO film. 70 mm. 20 mins, f22

In order to get the moonlight on this face of Uluru, I had to get up at 0300. By the time I made this exposure, the sky had started to lighten. I couldn't check the focus as I was shooting film, so I picked my vantage point during the day, prefocused, then marked the lens with a chinograph pencil. At night all I had to do was go to the same place and select the same focus! This image was bracketed to get the correct exposure.

Stops:	0	1	2	3	4	5	6	7	8	9	10
Exposure:	2 secs	4 secs	8 secs	15 secs	30 secs	1 min	2 mins	4 mins	8 mins	15 mins	30 mins

Digital SLR

Using noise reduction (see page 113) is even more important with super-long exposures but will extend your exposure times dramatically. A 20-minute exposure will call for a 20-minute noise reduction exposure afterwards. As this happens automatically you can, in fact, move the camera during this time, if you are confident you have the shot in the bag. On the plus side, there is no reciprocity failure with digital, so exposure times are still likely to be lower than with film. They are also easier to calculate.

With a DSLR you can check both the exposure and the focus by selecting a high sensitivity and a wide aperture and then shooting a test picture with a relatively short exposure, from which to extrapolate. For instance, if your test exposure is four seconds at 800 ISO and f2.8, this equates to over 30 minutes at 100 ISO and f22. (The exposure is reduced by three stops from 800 to 100 ISO and by six stops from f2.8 to f22. This slows the four-second exposure down by nine stops to 30 minutes, as can be seen on the chart left.)

Film SLR

Film SLRs can produce clean, noise-free images, even for very long exposures, but they suffer from reciprocity failure (see page 113). Shutter speeds longer than a minute need about two stops extra exposure and, possibly, three more stops for speeds longer than 10 minutes. In order to get the correct exposure, you should bracket, which, with exposures of five, 10 and 20 minutes, can take some time!

Digital compact

Super-long exposures are beyond the reach of a compact camera.

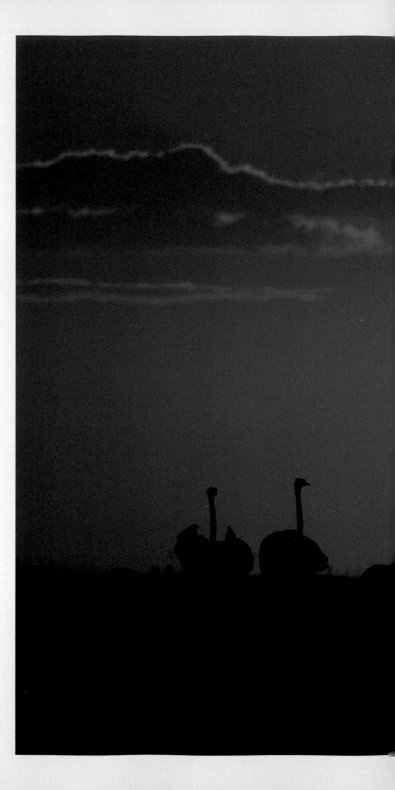

Focus on

Ostriches at sunset
Makgadikgadi Pan, Botswana

Without a sense of place, sunset shots can appear dull and fairly generic. Similarly, many wildlife shots can be purely representational rather than creative. This shot illustrates how to improve both wildlife and sunset shots. Photographing the two together produces a dynamic wildlife shot and a sunset with a sense of place.

This was the end of a long game drive, and the light had almost disappeared. The weather was quite overcast, and I had barely seen the sun all afternoon. In truth, I was about to give up and head back to camp for a cold G&T, but the skies cleared just before sunset. The ostriches were on a small crest that silhouetted them perfectly.

Technically, it was a fairly simple shot. A very powerful telephoto lens (a 300 mm lens with a 2x convertor, giving 600 mm on a DSLR, equivalent to 900 mm on a 35 mm frame) magnified the sun. Even this didn't totally fill the frame, so I composed the picture so as to include all the ostriches, rather than having the sun in the centre of the frame. As I was holding the camera by hand, an ISO setting of 400 was used to ensure a fast shutter speed at the maximum aperture. With a lens like this, camera shake is a real possibility, even at relatively high speeds but resting the lens against the vehicle and switching off the engine helped to keep the camera still.

To work out the exposure, I spot-metered on the sky slightly away from the sun and used this as a midtone. This exposure meant that the sun bleached out completely but the alternative would have been to meter for the sun and make the rest of the image too dark.

The join between the silhouettes and the highlight of the sun has formed a fringe, rather than a soft gradation, which is an effect that you often see in digital shots with substantial backlighting. This, along with the bleaching of the sun could be altered in Photoshop but I actually like the dynamism of this effect.

⊕ **Find out more** >

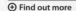

Nikon D2x, 400 ISO, RAW.
600 mm (900 mm equivalent).
1/1600 second, f8

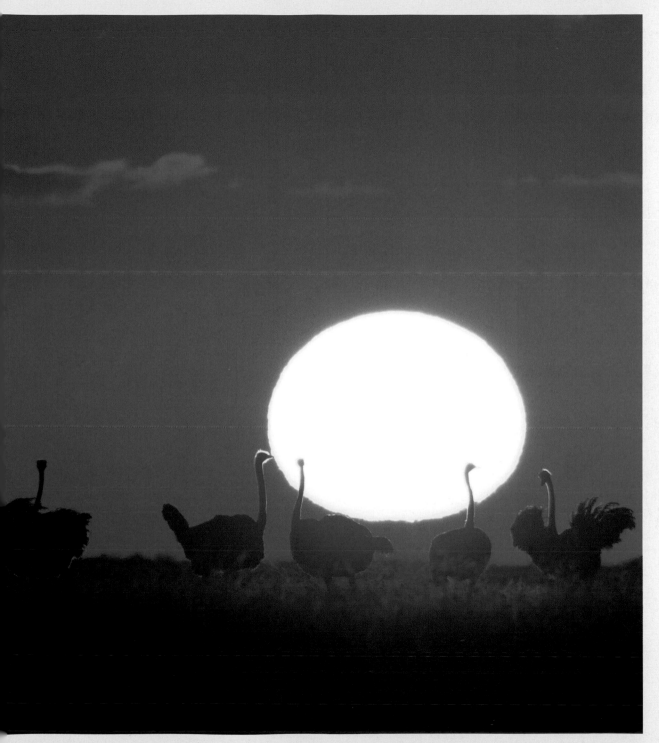

Wildlife

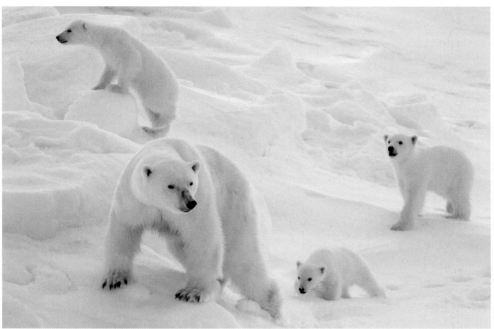

Polar bears, Svalbard, Norway ⟨

Nikon D2x, ISO 160, RAW. 420 mm (630 mm equivalent). 1/1000 second, f5.6

It is rare to see a polar bear with three cubs, especially in the Svalbard Archipelago. On this expedition I was very lucky with sightings, although there were long periods of waiting, punctuated by exhilarating encounters with wildlife. Growing up in Europe, it is easy to think of it as a safe and rather tame place, yet there are parts of Norway where you are unwise to venture without a rifle for fear of polar bear attack. This image was shot using a 300 mm lens and a 1.4x convertor. I increased the sensitivity by two thirds of a stop to allow a slightly faster speed, as I was shooting from a boat and holding the lens by hand.

A large part of the skill involved in wildlife photography is finding the wildlife, getting close enough to it and anticipating what it is going to do. Only then will you be in the right place at the right time to take pictures.

There is no substitute for knowledge on a wildlife shoot and, fortunately, there are commercial guides in most well-known wildlife destinations who will know more about a particular species or ecosystem than you could ever find out on your own. The only problems may be finding them and affording them. Do research before you travel; try to get some recommendations, and also consider using local independent specialist guides. Some of these may be photographers themselves and will therefore understand your requirements. Group tours can be a good option, as they spread the cost, but check how long you actually get viewing the wildlife, as some – especially African safaris – just power round at speed and try to tick off as many animals as possible: this quantity not quality approach seldom produces good pictures.

Be realistic with your expectations. Top wildlife photographers spend months in the field just waiting for something to happen. If you have just two days, then your chances of seeing an animal hunting in perfect light conditions are limited. Luck plays an important role in wildlife photography and the more effort you put in, the more luck you are likely to have. You should be prepared to sit and wait when you are with animals to increase your chances of witnessing some behaviour that is worth photographing.

In the tropics, such as on an African wildlife safari, game viewing is best in the early morning and late evening, just after sunrise and before sunset. At these times the light is better and the animals are more active, compared to the hot hours in the middle of the day when they tend either to go to ground or to laze around in the shade. In colder climates, animals might take longer to get going but are then active throughout the day, although the light might not be ideal. In the Arctic, there can be 24 hours of daylight, and so animals can be encountered at any time.

Walrus, Svalbard, Norway ⟩

Nikon D2x, ISO 320, RAW. 420 mm (630 mm equivalent). 1/640 second, f5.6

This walrus, which had hauled itself out on a beach in the Svalbard Archipelago, looks almost human with its head on a rock for a pillow and a flipper over its face. I was able to sit down some distance away from these strange animals and take a number of photographs without disturbing them. This image was shot using a 300 mm lens and a 1.4x convertor to increase the focal length.

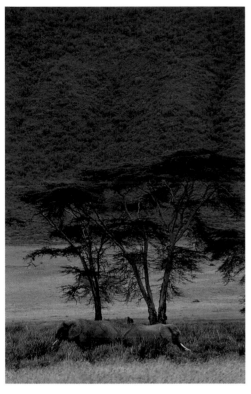

Elephants at the Ngorongoro Crater, Tanzania ‹

Nikon F5, Provia 100 ASA film. 200 mm lens. Exposure not noted

The Ngorongoro Crater is one of the most amazing places I have ever visited. An ancient volcanic crater, its 600 m walls encircle a flat base that is literally teaming with wildlife. I was trying to show the environment as well as the wildlife and so composed this shot of the elephants in such a way as to show them with the soaring crater walls in the background.

Don't get hung up on wildlife photography being only about exotic animals in the wilderness. There is wildlife to be watched and photographed all over the world, and you don't even need to head out into the countryside to find it. Many animals and birds have adapted to the urban environment. These subjects are more used to humans so you can get closer to them than to animals in the wild. Some, such as the monkeys that live in Indian cities, will even interact with the people around them.

Don't get so swept up in the excitement of seeing the wildlife that you snap away without any thought or creativity. A picture of an animal standing still or, worse, of its backside as it walks away will seldom produce an interesting photograph. More extreme behaviour, such as fighting, mating and hunting, will produce exciting pictures, but you should also be aware of patterns, reflections and interaction between different species: these might give your pictures an edge.

Animal portraits can be a tremendously rewarding subject for photography. The rules are much the same as for human portraiture: focus on the eyes and try to have eye contact with your subject or else ensure it is obviously looking at something else. Your subject should only have its eyes closed if it is sleeping or yawning, not because it has just blinked.

It is always worth looking for humour in your wildlife shots. Animals often do strange things that can produce unique and interesting pictures. Certain of our nearest relatives from the primate and ape families look strikingly close to us and often adopt remarkably human poses but, in general, it is best to avoid overt anthropomorphism.

Unless you can get right up close to your subject, you will need quite a powerful **telephoto lens** to fill the frame, even if you are photographing relatively

◉ Digital compact

If you are shooting with a compact camera the lens probably won't be powerful enough to get a frame-filling picture of an animal unless it is pretty close. Instead try to shoot the animal as part of the landscape. This will make a positive out of the equipment's limitations. To work around the shutter delay on many compact cameras, half press the shutter button to focus the camera and then hold it until you are ready to take a picture. With the focusing out of the way, the delay will be much shorter.

large animals. If you don't have one, then compose your pictures to include the animal in its environment. This might be a rhino with the soaring walls of the Ngorongoro Crater behind or a polar bear in an expanse of pack ice.

If you do have a powerful **telephoto lens**, then you will have to be careful with focus, as they have an inherently shallow **depth of field** and are also susceptible to **camera shake**. You will have to use quite a fast **shutter speed** to limit the effects of camera shake and the commensurately wide **aperture** will make the depth of field even shallower! To get around this, use a lens with **vibration reduction**, which will allow you to use a shutter speed two or even three **stops** slower without shake, or increase the **sensitivity** by a stop or two. This should enable you to set an aperture that gives you a workable depth of field.

Shooting with your camera on a tripod will keep it still but doesn't allow you to be very responsive if there is any action. Many wildlife photographers use

Baby mountain gorilla, Democratic Republic of Congo ❯

Nikon F4, Provia 400 ASA film. 28-70 mm lens. Exposure not noted

Photographing the endangered mountain gorillas in central Africa was intensely rewarding, although the forest they live in is a difficult place to photograph. Light levels are low, and the dark foliage can make it hard to get the correct exposure, or a clear shot. This little fellow was intrigued by the human visitors and spent about 20 minutes playing up to the camera.

Speeding zebra, Ngorongoro Crater, Tanzania ❯

Nikon F5, Provia 100 ASA film. 80-200 mm lens. Exposure not noted

Panning this shot of a zebra in the Ngorongoro Crater gives a more dynamic image and a sense of the view that a predator might see as animals run away. Just because you are shooting wildlife doesn't mean that you should forget all of your photographic techniques. I probably used a speed of around a 1/2 or 1/4 second to get enough blur in the background.

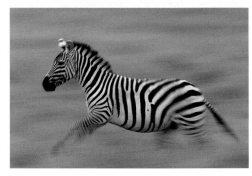

a monopod, which helps to support the camera but is more manoeuvrable. If you are in a vehicle, then switch the engine off when you are taking pictures to avoid camera shake, though be aware that there are times when this won't be safe. I have been driving a vehicle that was charged by a elephant, and I was glad that the engine was on ready for a speedy getaway!

If your subject is moving, then a wide pattern, **continuous autofocus** mode will help to keep it in focus. Predictive autofocus can help to keep the picture in focus if your subject is moving fast. Although you might spend a long time waiting around for something to happen, you will have to be ready the instant that it does. If you are manually exposing, then you should have the exposure set and the camera readily to hand. Watch animals through the camera lens so that you are ready to capture any movement or reaction that might be over in a split second. And be aware of your surroundings: something better might be happening a few feet outside your frame or a bear might be walking up to that open window right behind you…

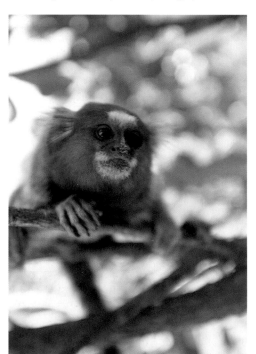

Squirrel monkey, Rio de Janeiro, Brazil ❮

Nikon F5, Provia 100 ASA film. 28-70 mm lens. Exposure not noted

You don't have to trek into the wilds to photograph wildlife: this curious little fellow was at the top of Sugar Loaf Mountain in the middle of Rio. He was looking at his reflection in the end of my lens and I managed to get this close-up portrait.

Landscapes

Probably the hardest thing about shooting landscapes is getting yourself and your equipment to the scene that you want to photograph at the right time. Even then, there are a number of things out of your control that can go wrong: weather, light, a group of tourists in the way or even a farmer burning off stubble. This means you will have to rely to some extent on good luck to get your shots. Planning and persistence can get you in the right place at what should be the right time and then you have to hope that good fortune will do the rest.

Weather and light

The weather and the light play a crucial role in landscape photography. If you do have bad weather, then you want it to be really bad! An overcast scene with light-grey cloudy skies and muted overall lighting is unlikely to produce an atmospheric picture, but shafts of light scything through dark storm clouds or a rainbow over-arching a rain-drenched landscape will give you images that are truly memorable.

Sometimes you will have to wait for the elements to come together for your photograph: for a cloud to move in front of the sun or for the sun itself to sink closer to the horizon. A good landscape shot can be worth the wait; just make sure that you are not sitting it out for an average view when there is a stunning shot just over the hill. The only way to ensure this is through research and by scoping out the area at times when the light or the weather are too poor to take pictures.

Landscape photography works best when there is both light and shadow in the picture. If possible, try to have the light hitting your scene from an angle. When the sun is lower in the sky and the light is softer, you will get shadows in the picture, but they will be light enough to show detail. A map, compass or a sunrise/sunset calculator can help you to work out where the sun is likely to rise or set, so you can work out if a particular scene will get any better or whether you should move on to another location.

Filters can help to improve landscape shots. A range of **graduated neutral density filters** will help to reduce light levels when you want to use a slow **shutter speed**. A **polarizing filter** is vital for boosting skies and cutting unwanted reflections. It also reduces haze in mountainous areas. If you are shooting film, then make sure you have a light and medium warm-up filter. An 81B or an 81D will warm a picture and make the colours

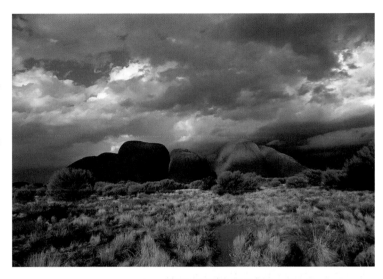

Kata Tjuta, Northern Territory, Australia ∧

Nikon F5, Provia 100 ASA film. 17-35 mm lens. Exposure not noted

This was the one moment where the sun broke through the clouds all day. I was photographing Kata Tjuta in a heavily overcast sky, trying to make a good image, when I saw the sunlight approaching across the ground. I set up the camera with a very narrow aperture for maximum depth of field on the foreground, and managed to get a few shots before the patch of sunlight passed.

Rock formation and clouds, Utah, USA ∧

Nikon D2x, ISO 160, RAW. 200 mm (300 mm equivalent). 1/320 second, f5.6

Apart from this photogenic rock formation, which I noticed passing by in a car on a road trip through Arizona and Utah, I was most struck by the cloud formation. If there is an interesting sky in the scene then consider composing the picture to include any cloud formations.

look richer and more pleasing. If you are planning on shooting some long **exposures** for waterfalls, say, then one or two standard **neutral density filters** might be necessary to reduce light levels.

Composition

Composition is vital for landscapes. The **rule of thirds** says that your picture will be more balanced if you place the horizon on the bottom third of the frame to accentuate a striking sky or on the top third, if there is an interesting foreground. Your picture will probably be more memorable if you exaggerate this rule, creating an extreme composition that crops a bland sky out of the picture completely or shows a small strip of land being dominated by an expansive sky.

To give a sense of perspective and depth to your picture, try to compose your shot with something in the foreground, something in the middle ground and something in the background. Shoot with a **wide-angle lens** and tilt the camera down slightly to include both the foreground detail and the background in the same shot. This works especially well if you shoot with the camera vertical. You can also shoot from a low **angle** and have the interesting detail looming large in the foreground.

As well as following or exaggerating the rule of thirds, it is useful to have a point of interest in your landscape pictures, so that the viewer will know where they are supposed to look. Use strong diagonal and curved lines to lead the eye into the picture towards the point of interest and use overhanging branches to frame your image. A recognizable object, such as a tree, a person or a vehicle, will also provide a sense of scale. This will help the viewer to appreciate the size of objects in your scene. The objects don't have to be photographed in close up – a tiny person in silhouette on a horizon can be enough to show the true scale of a landscape.

Colours can work well to draw the viewer's eye into a picture: a dominant colour like red will always attract attention. This doesn't have to be the age-old cliche of having a person in a bright red coat; a tree covered in autumn leaves, or even a formation of red earth or rock can be just as effective.

Don't just look for untouched landscapes. The human effect on the environment, both positive and negative, can make for some interesting images. This might be a series of ploughed fields, a small cottage,

Island of Amantani, Lake Titicaca, Peru >

Nikon D2x, ISO 160, RAW.
22 mm (33 mm equivalent).
1/60 second, f11

Staying on the island of Amantani, I could get up early for sunrise. The night before there had been a massive storm, and at the altitude of 12,500 ft, much of this fell as sleet and ice. There were still patches of ice the following morning and these can be seen on the areas of clear ground.

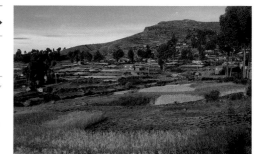

Beach on Tresco, Isles of Scilly, England >

Nikon D2x, ISO 125, RAW.
19 mm (28 mm equivalent).
1/200 second, f6.3

If you shoot a landscape with a wide-angle lens, it helps if you have an object in the foreground. The blue flowers balance the beach and the blue sky in the top right of the frame. The extreme composition follows my 'rule of not centred' (see page 76).

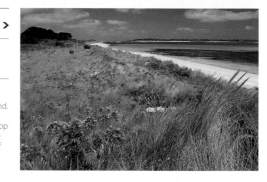

an abandoned car or a line of electricity pylons marching across the landscape.

There is tendency to try to include too much in a landscape shot and to use a wide-angle lens to create a sweeping vista. Sometimes you can produce a more striking picture by using a **telephoto lens** to isolate part of the scene. This creates a more immediate image that

Grand Canyon, Arizona, USA >

Nikon F5, Provia 100 ASA film.
Lenses and exposures not noted

This series of pictures was taken at various lookouts and shows how light changes, and why photographers always advocate getting up early – especially when photographing landscapes. First, predawn, the silhouetted outline of the opposite rim; dawn, muted soft and atmospheric light; sunrise light just catching the top of the rock formation, with other colours muted and soft; sunrise light shining on rock formations and lastly a couple of hours after sunrise, when the light is harsh and over-contrasty. It is not yet overhead and is casting deep, ugly shadows. Time for breakfast!

says something about the whole scene without having to show it all. It also allows you to fill the frame and to exploit the telephoto lens's inherent compression of perspective to make objects look closer together. Shooting vertically with a telephoto and cropping tightly can make a detail in a landscape appear bigger and more impressive. If you are determined to shoot a wide shot, then consider shooting a panorama (see page 204). This can convey the width and majesty of a scene, without an excess of foreground or sky.

An oft-quoted rule is that you should always shoot with the light coming over your shoulder. Like most rules, this should be largely ignored. A more atmospheric effect can be achieved by shooting into the light, as this will reduce the number of tones and colours that are apparent in the image. It can be a good solution if the weather isn't too good or if there is some fog or mist in the scene. Another technique that can make your pictures stand out is to shoot a long **exposure** during the day to allow the movement in trees or grasses to blur slightly. This will contrast with the sharpness of the rest of the picture – enhanced by the lack of movement and the **depth of field** given by using an **aperture** small enough to balance the slow **shutter speed**. You might have to use a **neutral density filter**, as well as a small aperture, to reduce the light levels enough to use a slow shutter speed. A speed of around one to five seconds is a good place to start, depending on the degree of movement and the amount of blur you require.

Shooting landscapes with a tripod can be a good discipline, forcing you to concentrate on your composition and adopt a slower, more considered

Small hut, Vis, Croatia ‹

Nikon D2x, ISO 160, RAW. 135 mm (202 mm equivalent). 1/320 second, f5.6

Riding on a motorbike around the island of Vis, I came across this small hut, set under a tree amidst farmland. I was attracted by the light and also by the dramatic hillside in the background. Man-made details can sometimes give a point of interest to landscapes and you shouldn't just automatically crop them out.

style. A tripod can also free you to use a slower shutter speed and a commensurately smaller aperture to achieve the largest possible depth of field. In general, you should aim for everything in the scene to be in focus.

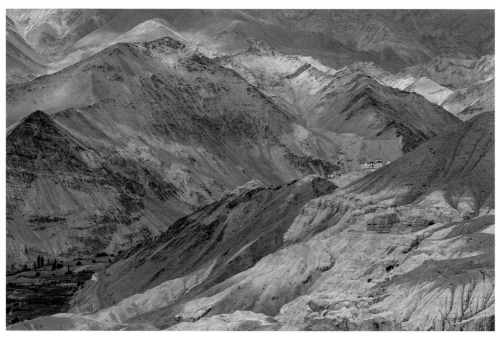

Moonland on the
Srinagar-Leh Highway,
Lamayuru, Ladakh, India ◄

Nikon D3x, ISO 160, RAW.
74 mm (202 mm equivalent).
1/640 second, f6.3

You don't always need perfect or even dramatic weather to shoot good landscapes. Sometimes composition can be all you need. This was shot on a largely overcast day, although I waited for a while until some weak sun broke through the cloud and lit parts of the scene. This provided some contrast, which I later enhanced at the RAW-processing stage. Although this was shot with a mild telephoto lens, the great distance from the subject has given a very flattened perspective. The composition includes a few things to give a sense of scale: the Lamayuru Monastery in the distance and the stretch of the Srinagar-Leh Highway next to the green valley. The rest of the picture is a subtle mix of muted tones.

Look out for small things in the frame that don't belong there. Pieces of litter can be easy to miss when you are shooting but will stand out in the finished picture. Scan the frame before you take the picture: although you can re-touch some things in post-production, it is easier to avoid them in the first place by changing your composition or picking up a few bits of litter – a bit of manual re-touching!

You don't need to wait for perfect skies to take pictures. In fact the archetypal cloudless blue sky can look quite dull and featureless in a photograph. Having some clouds will add texture and interest to the picture. Even a stormy sky can be more visually stimulating, especially if there is some sunlight coming through the clouds and lighting up a part of the landscape.

Water and reflections

Waterfalls are a perennial favourite with photographers. They can either be photographed with a very fast **shutter speed** to freeze the movement into a bubbling froth or, alternatively, you can shoot with a slow shutter speed to let the water blur atmospherically, although this is a technique which

Iguaçu Falls, Brazil ◄

Nikon F5, Provia 100 ASA film.
17-35 mm lens.
Exposure not noted

Looking up to the mouth of the Devil's Throat, the main cataract of the Iguaçu Falls, this image shows the power of this waterfall, which forms a border between Brazil and Argentina. I spent a few days at the falls and took a range of shots: some with very long exposures, and some, like this, freezing all movement with a fast shutter speed.

is easy to overdo if you use it the whole time. If you do blur a waterfall, then make sure that there is something stationary like a rock or the river bank in the picture, which will be not blurred to give a **contrast**.

Reflections in lakes and pools can also produce great shots. In these cases the normal compositional rules don't apply: placing the horizon in the middle of the frame with the subject on the top and the reflection on the bottom will set up a visually balanced shot. The water will typically absorb one or two **stops** of

light but you can balance this with a **graduated neutral density filter**, or by using a digital graduated ND filter in post-processing.

In the wilderness

Getting completely away from civilization and into the wilderness can result in some great photographs but also throws up a number of practical issues. Apart from your own survival, there is the issue of being away from power for a period of time.

One of the drawbacks of digital compared to film photography is its total reliance on power and bespoke batteries. Battery life has improved so much in recent years that this isn't usually an issue but, if you are away from electricity for a period of time, plan ahead to ensure that you can keep on taking pictures.

Take as many spare camera batteries as possible, especially if you are going to be in cold conditions where the battery life is diminished. A laptop might not be practical for both weight and battery reasons, so consider a back-up device, such as the *Hyperdrive Colorspace*, which can be charged from a USB power-pack. Take at least one spare camera body and a few

spare lenses. This can mean a lot of extra weight, but it will seem worth it if you have a technical failure and you are days away from civilization.

If you have a vehicle, you can get AC power from the cigarette lighter socket by using a power inverter. These usually produce enough power to charge up a laptop and a camera battery. It is also possible to buy fold-out solar chargers. Although these produce less power, you should be able to recharge camera batteries if you get enough sun.

You can eke out the battery life of your camera by avoiding some its more power-hungry functions. Switch off any **vibration reduction** or **image stablization** modes unless you really need them. Instead of using the LCD screen on your camera, use an optical viewfinder, if your camera has one, and avoid spending too much time reviewing images. You obviously want to check that your camera isn't broken and your exposures are good, but switching off the LCD screen can allow you to take far more pictures on a single charge. Similarly, manual focus will use far less power than sticking to the autofocus modes.

Deserts

Deserts need to be photographed in the early morning or late afternoon light. Much of their detail and texture is subtle and can be lost if you take pictures when the sun is higher in the sky. The light at sunrise and sunset may cause the desert to glow orange or red, and the low angle means that even a ripple in the sand will cast a small shadow, giving contrast and definition.

Photographing at these prime times will usually require you to spend the night in the desert, which allows you to shoot some super-long **exposures** by moonlight as well. In most desert regions there is little or no light pollution and countless stars are visible. These will produce stunning star trails if you photograph with a long enough exposure (see page 188).

If you do have to take pictures in the heat of the day, then turn this to your advantage: shoot with the longest lens that you have and try to photograph something a long way off that is distorted by heat haze. You might even be able to photograph a shimmering mirage, where the heat haze resembles water. A powerful **telephoto lens** will exaggerate and magnify both of these phenomena.

Bear in mind that deserts can be highly reflective, so be careful with exposures. You might need to **underexpose** slightly to make the colours more saturated. If you are shooting digital then check the **histogram** to ensure that you have exposed correctly. A **polarizing filter** can reduce glare and darken skies, making them appear more vibrant.

Composition

When confronted by a massive sweeping landscape, such as a desert, the temptation is to try to fit too much of the scene in to the frame by shooting with a **wide-angle lens**. This can make even large features, such as towering sand dunes, look small and insignificant. To avoid this, use a **telephoto lens** and pick out a part of the landscape that you want to magnify so that it appears more striking. Also pick out areas of light and shadow to introduce **contrast** into your picture. A telephoto lens will, effectively, compress the perspective making objects appear closer together and making large objects seem even more dominant.

It can be very hard to convey the true scale of many deserts. Without a point of reference, dunes could be massive or just mere ripples in the sand.

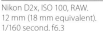

Dead Vlei, Sossusvlei Namibia

Nikon D2x, ISO 125, RAW. 12 mm (18 mm equivalent). 1/160 second, f6.3. Polarizing filter

From the top of Big Daddy, the tallest sand dune in the world, the true scale of the Namib Desert and the dry pan of Dead Vlei can be seen. This scene was topped by the most fantastic sky, and so I composed the shot vertically to include the cloud pattern.

Dead Vlei, Sossusvlei Namibia ⌄

Nikon D2x, ISO 100, RAW. 12 mm (18 mm equivalent). 1/160 second, f6.3

The shot above is of Dead Vlei taken from a distance; this is essentially a close-up of one of the desiccated camelthorn trees that once grew out of it; it is composed with the pan and the dunes in the background. There are often a lot of details to be photographed in deserts, but compose your picture with a significant background to give a sense of place.

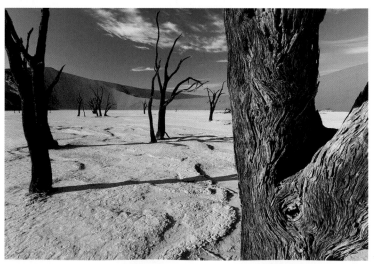

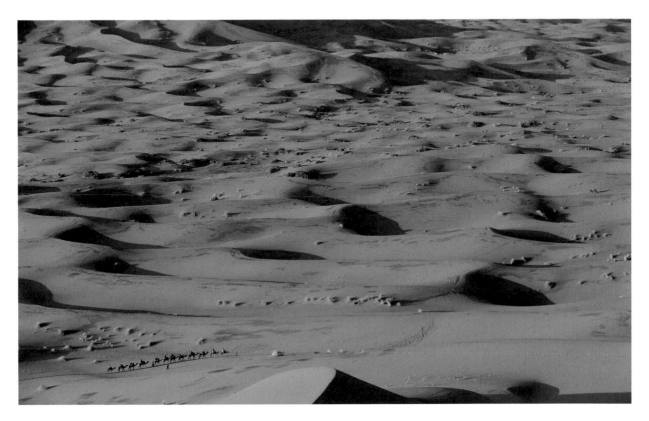

Camel train in the Sahara Desert, Morocco ∧

Nikon D3x, ISO 250, RAW. 92 mm. 1/400 second, f6.3

It can be hard to judge the scale of a desert especially if the dunes stretch as far as the eye can see. After climbing to the top of a sand dune to photograph the sunset, I waited for this caravan of tourists to pass, which gave a real sense of scale and also introduced the feeling of a journey to the picture.

Having a recognizable object, such as an animal, plant or person – even in the far distance, can allow the viewer of the picture to gauge the scale of what they are looking at.

A surprising amount of life manages to survive in deserts. As well as large and elusive mammals, you may encounter plants and insects that have adapted perfectly to the harsh conditions. These can make fascinating subjects; even tiny trails in the sand can provide a foreground to a shot and a point of interest and scale. Much of the life in a desert occurs on a small scale, and so a **macro lens** can be useful.

Dust and dirt

The biggest practical issue when photographing in desert conditions is dust. This can completely clog the moving parts on **compact cameras** and work its way into lens mechanisms. If you are shooting with a

DSLR, avoid changing lenses to minimize the chance of dust and dirt getting on the **sensor**. Shooting with a **zoom lens** can give you more choice of **focal lengths** without changing lenses. If you have two camera bodies then shoot with a wide zoom on one and a telephoto zoom on the other and you might not need to change lenses at all. If you are going to photograph in a lot of dusty conditions, then consider a wide-range zoom, such as an 18-200 mm, which could be the only lens you will need.

To avoid scratching lenses, always have a **UV filter** on the lens and blow large bits of dust off with a blower brush, before wiping with a lens cloth. It is worth using a blower to remove dust from the camera before putting it away in a camera bag, and be careful of having dust and sand on your hands when you handle your equipment. A rain-cover can also help to prevent sand getting blown into the camera.

Snow and mountains

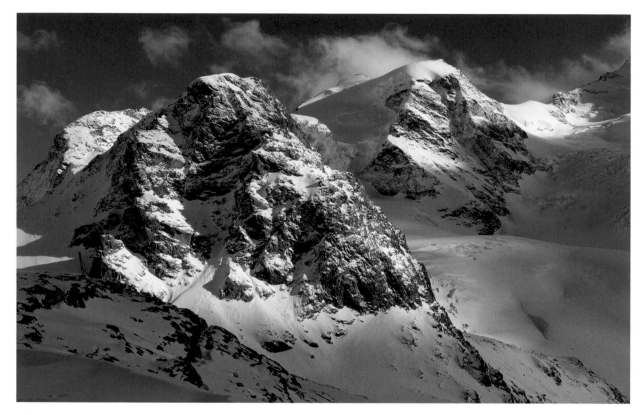

Whether it is a seasonal Christmas flurry, the Arctic wastes or permanent glaciers at the top of a mountain, snow can give you some great pictures. But there are a few practical and technical considerations that you will have to overcome in order to get the best photographs.

Cold and condensation

Cold conditions will hamper the performance of your batteries: they might show half full but then be dead a few minutes later. Take at least one spare, and recharge them fully whenever you can. Keep the spares in a pocket close to your body to maintain the temperature.

Condensation can form on your camera and lens if you take it from the cold into a warm and humid environment. In extreme cases this can damage equipment. Try to minimize the camera's exposure to changes in temperature. If it is safe to do so, leave your camera bag outside when you go inside to warm up or, if you do take your camera in with you, switch it off and leave it in a closed camera bag until its temperature stabilizes. Resist the temptation to review your pictures until your camera has had a chance to warm up.

Generally, cameras should still perform in the type of cold conditions that most people will encounter, but in extreme cold they can malfunction. If you are likely to be taking pictures in sustained temperatures below -20°C, it is worth doing some research into the precautions you should take.

Photographing snow

Shooting snow and ice will tend to fool the camera meter into **underexposing**, so you will need to give between one and two **stops** more **exposure**, possibly even more. The snow will also tend to give colder, bluer shots. This can be adjusted with the **white balance**

Mountain range, Diavolezza, Switzerland ⌃

Nikon D2x, ISO 100, RAW. 35 mm (52 mm equivalent). 1/250 second, f8

The stunning range at Diavolezza is strongly sidelit, throwing deep blue shadows across the mountain faces. This gives a far more atmospheric image than more conventionally lit mountain shots. The Alps are some of the most beautiful, diverse and certainly accessible mountains in the world. I stayed at a small guesthouse at almost 3000 m at the top of a cable car and was able simply to walk out and take pictures day and night.

facility or by using the cloudy or shade settings to warm up your shots. Don't always filter out all of the blue though; sometimes letting shadow areas turn blue will accentuate the feeling of cold. Snow reflects a lot of UV light, so shooting with a **UV filter** can help to minimize excessive blue, and will also protect the front of the lens from condensation and snowflakes.

Photographing mountains

Compositionally, mountains present some problems. Shooting with a **wide-angle lens** can make them look like unimpressive bumps. A **telephoto** will fill the frame and make the picture more dramatic, particularly if you turn the camera to the vertical format. If you do shoot with a wide-angle lens, then include a lot of foreground so that the mountains are at the top of the frame. This will make them appear bigger. Another way to photograph mountains is to shoot a panorama using a mild telephoto lens (see page 204). This will give a sense of drama and also take in the sweep of the mountains.

If you are staying or trekking in the mountains then you have a good chance of being around when the sunrise or sunset light makes the mountains glow orange, red or pink. Bear in mind that you won't get these colour changes unless the sun is close to the horizon and not when it is obscured by another mountain. Good picture research will let you know which mountains are actually capable of glowing red in sunrise or sunset light.

The weather can change very quickly in the mountains. Even if your subject is completely enveloped in fog and cloud, a clear shot may only be minutes away. The same can happen in reverse, though, so always shoot whenever you can. Don't wait around for perfect blue skies. Mountains are dramatic and shooting them in dramatic weather conditions can give a more atmospheric shot. A bolt of sunlight striking a peak through grey cloud can be more visually exciting than a well-lit mountain under clear skies.

There is even more ultra violet light in the mountains than in snow scenes at lower altitudes. This can cause haze as well as excessive blueness. If a UV filter doesn't address this enough, use a **polarizing filter**. This will have a much more pronounced effect, so be careful of darkening the sky too much.

Remember to look after yourself when shooting in mountain conditions. The cold can be crippling, especially at altitude, so dress warmly in layers to maximize heat retention. Altitude can also cause problems: as well as making you breathless, it can cause you to make elementary mistakes. In extreme cases altitude sickness can be fatal. Drink lots of water and eat more calories, especially sugars, than you would normally to keep energy levels up. Be careful of sunburn. You can burn even on overcast days at altitude, so cover up and use high-factor sun cream.

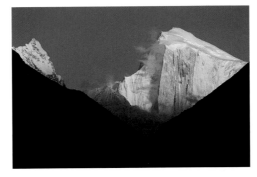

Spantik (Golden Peak), Karimabad, Pakistan ‹

Nikon D3x, ISO 100, RAW. Tripod. 420 mm. 1/320 second, f9

It is often hard to photograph mountains glowing in sunrise or sunset light, as neighbouring peaks often obscure the light. The so-called Golden Peak in the Hunza Valley is one that catches the sunset light, and is possible to observe without serious trekking. I shot with a powerful telephoto lens and a tripod.

Looking down the glacier, Jungfraujoch, Switzerland ‹

Nikon D2x, ISO 100, RAW. 116 mm (174 mm equivalent). 1/400 second, f7.1

Looking down the Aletsch Glacier to the mountain peaks swathed in cloud, it was almost impossible to remember that I was in Switzerland and not the Himalayas. In RAW processing I maintained the light blue cast to accentuate the coldness and mysticism of the shot.

Snowy face of floating pack ice, Svalbard, Norway ‹

Nikon D2x, ISO 100, RAW. 175 mm (262 mm equivalent). 1/640 second, f5.6

This is a detail of a massive floating slab of ice and snow in the remote Svalbard Archipelago. I had to meter manually to get the exposure correct, and use a cloudy white balance so that the snow rendered white, rather than pale blue.

Shooting panoramas

A panorama is a series of pictures joined together to give a wider field of view than is possible with a single picture. With advances in digital photography and image-manipulation software, they are remarkably easy to create, although there are a few things to bear in mind if you want to get the best results and spend the minimum amount of time re-touching in front of a computer. As with many things in digital photography, the more effort you put in when you are shooting the pictures, then the less time you will have to invest in post-production.

Not all subjects suit the panoramic treatment. Choose a scene that won't have lots of dull blank spaces in the finished image. It is possible to shoot a complete 360° panorama, but you could also strip together two or three images to get a slightly wider picture.

A tripod is pretty vital for shooting a panorama. You can stitch together a series of hand-held shots but they often won't fit together accurately. If you do shoot

without a tripod, crop more loosely and leave a larger overlap to increase your chances. It is worth spending some effort to make sure that your tripod is absolutely level. A small spirit level that fits onto the flash **hotshoe** will help to get the camera straight for a single shot, but the best way to line up the tripod for an accurate panorama is to use one with a built-in spirit level. This, combined with a hotshoe spirit level, will make sure that both camera and tripod are straight, helping the shots line up. It is worth carrying out a test pan, though, to check that everything is positioned correctly.

Shoot with a longer **focal length** to minimize distortion and to make it easier to match the pictures together. Similarly, avoid close foreground objects; unless you have an expensive custom panoramic head, it will be very hard to blend closer objects, as

ⓘ The post-production of a panorama can be found on page 282.

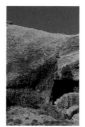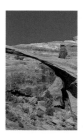

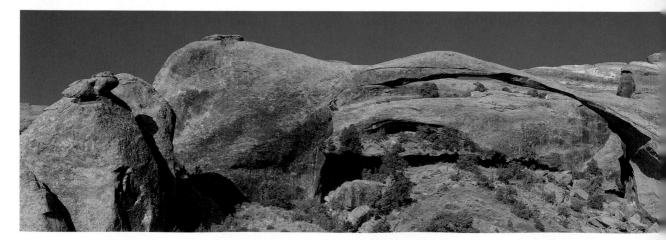

they are subject to more distortion as you rotate the camera. It is possible to shoot with the camera in vertical orientation to give a deeper shot, but you will have to take a lot more images.

Avoid rapidly changing light, such as when the sun is continually going in and out of clouds, as this will make it almost impossible to match the elements of the picture. Use a **continuous autofocus**, so that the camera focuses before each shot: if using a **single focus** mode you would need to release the shutter release button before each shot. Selecting a small **aperture** will give a greater **depth of field**, ensuring all of your picture is in focus. If you do have to vary the **exposure**, don't change it by more than a **stop** per picture, even if it means that you have to take more shots, just to increment the exposure. Change by less than a stop if you can. The panorama will be much easier to blend together if you take a number of shots and overlap each one by between a third and a half of the preceding frame.

⊙ Film SLR

It is possible to shoot a panorama with film and then scan the results, but inconsistencies may be introduced into the images during this process. Some medium-format cameras can shoot a panorama on a single frame. There are some film cameras where the lens actually moves during the exposure to expose the film in a very wide panorama.

⊡ Digital compact

It is difficult to shoot a series of panoramic shots with a compact camera and line them up correctly. However, some compacts do have a panoramic mode that produces wider-than-normal 16:9 format images, and many smartphones now have a panoramic mode that will allow you to simply pan the camera, and it will automatically join images together.

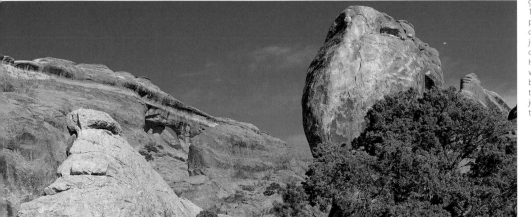

Landscape Arch, Arches National Park, Utah, USA ❮

Nikon D2x, ISO 100, RAW. 75 mm (112 mm equivalent). 1/320 second, f7.1

Landscape Arch is a difficult shape for photography. Long and thin, it is the perfect subject for a panorama. I opted to shoot with the camera in the vertical orientation to give a deeper shot. I also used 15 images, even though a panorama of the arch itself could have been achieved with just eight. This meant that I could include another arch – Hidden Arch – in the picture. I was also able to use the two big boulders to form the ends of the panorama. The result was joined together in Photoshop, then cropped and straightened.

Jungles

Rainforests and jungles are amongst the oldest eco-systems on the planet. They are majestic, humbling and yet often unfriendly places for you and your equipment. Moisture and humidity levels can be phenomenal and, at the first sign of rain, the paths can be full of little wiggly leeches, waiting to latch on and suck your blood.

Protecting your gear

To avoid moisture and even mould forming on your equipment, keep it sealed in zip-lock plastic bags when not in use, protected by a desiccant-like silica gel. This will absorb water but will need to be 'recharged' by heating when it is saturated.

When shooting, you can protect your equipment from rain or dripping foliage by using a rain-cover, or improvise by using a shower cap (taken from any hotel you pass through) or by wrapping the camera and lens in cling film (avoiding the front of the lens and the viewfinder, of course). To protect the front of your lens from moisture, always use a **UV filter** and carry a roll of soft toilet paper to wipe it. Seal this in a plastic bag to keep it dry.

Protecting yourself

You need to look after yourself as well as your equipment. If you are exhausted and struggling, then you are not going to take good pictures. Worse still, you are likely to drop or damage your cameras and lenses.

Don't be too ambitious about what you can carry. In addition to overnight supplies (if required), always carry water and energy bars with you to keep you going during the day. As well as food and drink, take strong bug repellent and make sure that you are wearing proper boots and socks. Consider treating these with a repellent, too, to put off the leeches! I was told by an old hand in rainforest exploration that, if you are staying overnight in a jungle, then you should maintain two sets of clothes: a dry set and a wet set. Wear the wet set during the day, when the sweat, humidity and rain will soak it through. Keep the dry set in a plastic bag to put on at the end of the day when you are under cover.

Seeing the wood for the trees

Photographing a jungle is remarkably difficult and, despite the beauty around you, it is easy to take

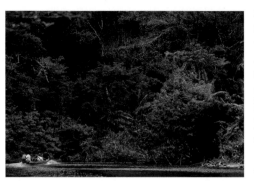

pictures that are dull, without any point of interest. As with many photographic subjects, the solution is to go far or go close. Either zoom in on a detail or try to find a lookout point that will let you shoot a vast stretch of the jungle.

Unobscured overviews are quite difficult to find, so you will probably have to rely on maintained viewpoints for tourists. Try to get to them as early as

Travelling in Taman Negara, Malaysia ◄

Nikon F5, Provia 100 ASA film. 200 mm lens. Exposure not noted.

Taman Negara is the oldest rainforest in the world, yet only a few hours from the modern city of Kuala Lumpur. I spent a number of days here, trekking through the jungle. This image shows a boat on the Negara River. I used this composition as I wanted a sense of a tiny craft, dominated by the massive jungle.

Single red leaf, Khao Sok National Park, Thailand ◄

Nikon F4, Provia 100 ASA film. 70 mm lens. Exposure not noted.

As with many subjects, it is all too easy to try to capture the big picture when photographing in a rainforest and to miss out on little details, such as this brightly coloured leaf. Shooting with a wide aperture has thrown the background – a mixture of light and shadows – out of focus. This was shot on an arduous walk through the rainforest, ending up with a refreshing swim in a waterfall.

you can in the morning, before the heat of the day burns off the mist that often forms at dawn. Aerial walkways are fantastic for photography, as they let you get up into the canopy to photograph parts of the jungle that are otherwise hidden. Even from a **viewpoint**, you should try to concentrate on a point of interest for your photographs. Look out for any rivers or waterfalls, as these not only make interesting subjects but also tend to be more open, which means you can get special lighting effects as the sun breaks through the canopy of trees.

Close-ups are far easier to arrange. Once you stop seeing the jungle as a single entity, you will begin to appreciate the shape, texture and colour of the various plants. Build layers into your pictures: shoot a close-up, but have a recognizable background to give a sense of place. This can be rendered out of focus by using a shallow **depth of field**. Although there is a lot of impressive wildlife in jungles, you will be very lucky to see it, let alone photograph it. Flowers, insects and small reptiles can be easier to spot and will give you more chance of taking a picture.

To convey a complete sense of the jungle experience, don't just concentrate on the nature around you but also on your journey in and out of the jungle, whether by boat or on foot.

Technical considerations

Light levels in jungles and rainforests are generally very low and, in order to avoid **camera shake** and have adequate depth of field, you should always try to use a tripod. You could just increase the **ISO** or use a wide **aperture** but you won't get the same quality of shooting with maximum depth of field that will make your pictures really stand out.

The dark green of vegetation and the many shadows from the leaves will fool your camera meter into **overexposing** if you rely on shooting on auto. You will often need between one or two **stops** less **exposure** to render the light correctly. If you are in doubt, bracket with film or check the **histogram** on the back of a digital camera to ensure you have worked out the exposure correctly.

The light in the shadowy world of the jungle will be quite cold and blue. To restore the true colours as you see them, use a **warm-up filter** (if you are shooting film), select the shade setting on your digital camera when shooting **JPEGs**, or edit **RAWs** in post-processing.

Coco de Mer forest, Praslin Island, Seychelles ∧

Nikon D2x, ISO 100, RAW. 10.5mm fish-eye lens. 0.6 second, f11. Tripod

The distortion inherent in a fish-eye lens has given a sense of the palms in the Coco de Mer Reserve towering over the path. A fish-eye lens has massive depth of field and most of the scene will be in focus irrespective of the aperture that you use. I used a narrow aperture in order to facilitate a slow shutter speed to introduce a little subject blur to some of the leaves.

Beaches and coastline

Photographing beaches is particularly hard. Although they can look amazing to the human eye, when you try to photograph them any slight defect in the distance – seaweed, rubbish, footprints or a fat tourist in a thong – will mar the picture. A bit like a beautiful model, a beach is supposed to look perfect.

Light is vital to beach photography. Sometimes, the warm light from sunrise and sunset can make the sand look too yellow. When the sun is a little higher in the sky, colours look more natural and the angle casts less of a shadow making any footprints or messed-up sand on the beach less prominent. Early mornings are the best time to shoot, as there will be few people around and, if the tide has been in overnight, it should have wiped away any footprints from the sand.

To get the classic beach shot, try to shoot with, not against the light. This might dictate whether you photograph from the sea up the beach, or down the beach towards the sea. For the latter shot, use a **polarizing filter** to cut through the reflections on the water and bring out the colours. This can enhance the turquoise of tropical water, especially if you warm up

the **white balance**, too. Be careful of over-polarizing, though, as it might cause an already blue sky to render too dark. Boats can be useful for getting a good **angle** when photographing from the water up a beach. You could just wade into the sea on foot but being on a boat will make it easier to look down into the water and bring out the colour. It also lessens the risk of slipping or dropping your camera.

If there are waves, then time your photograph to the moment when they are just starting to break. Alternatively, catch them as they come crashing in, with spray shooting into the air. Use a fast **shutter speed** to freeze this, or a very slow one to create blur.

Pebble beaches can be easier to photograph than sandy beaches, as the pebbles show up fewer imperfections and can add a real point of interest to the foreground. Shoot from low down with a **wide-angle lens** to accentuate the pebbles in the foreground and use as small an **aperture** as possible for the maximum **depth of field**.

Don't just photograph in ideal weather. Beaches and coastlines can look very dramatic in stormy weather, and the waves will be larger and

**Beach on Sark,
Channel Islands** ‹

Nikon D2x, ISO 200, RAW.
165 mm (248 mm equivalent).
1/100 second, f4

Looking down from the cliff gives an interesting angle on this rocky beach. The sunset light has caught the wet rocks and made them glisten a vibrant gold colour. Even though I was shooting at a sensitivity of ISO 200, I still had to shoot a number of frames to ensure that there wasn't any camera shake. This is a simple shot but demonstrates that photographing the sunset doesn't just involve getting pictures of the sun.

more intense. In fact, extreme tides can be more of a problem than extreme weather. When I was photographing the islands near Krabi in Thailand for *Unforgettable Islands*, the sea was so far out for much of the day that I could barely shoot. If you are planning to photograph in a tidal area, check the tide times and schedule your photography around them.

Without a point of interest in the picture, a beach can look like an expanse of nothingness. Consider focusing on a boat out to sea or on an object on the beach. Place an object in the foreground with the beach in the background or use overhanging palm trees to break up large expanses of sky and to frame your shot. Try to get some shadows in the picture to add **contrast**. If you are shooting at sunrise or sunset, include a recognizable silhouette to give the picture more of a sense of place.

In many parts of the world, people live on or near the beach. If you get up early in the morning, you may see them landing, sorting and selling fish. Look out for traditional boats pulled up on the beach or moored offshore. Why not document all of the traders offering drinks, local fruit or massages along a popular stretch of beach? In tourist areas you can also photograph children's toys, beach bars and watersports. A more artistic shot might show footprints leading into the distance or patterns in the sand.

Getting sand in your camera shouldn't be too much of an issue, unless the sand is very fine or there's a particularly strong wind. Be careful not to change a lens with sand on your hands and not to put your camera down anywhere that has sand on it. If you get salt water spray on your camera, wipe it off with a damp cloth to prevent any rust forming.

Cliffs and coastline

Rugged coastline and towering cliffs might seem like photogenic subjects but they can be remarkably difficult to photograph well. The biggest problem is access: photographing from the top of a cliff and looking out to sea won't show much of the cliff itself and certainly won't convey its height, while photographing from beach level looking up may just show an expanse of rock, with little else in the picture. Often you won't have access to a ground-level shot anyway, as the tide might be in or the cliffs might plunge straight into the sea. You can shoot from a boat, which allows you to get both cliffs and

sea in your picture, but this tends to produce quite a flat picture. Probably the best way to shoot cliffs and coastline is to find a vantage point where the coast meanders and you can shoot along the cliff face, showing the sea, the clifftop and the coastline stretching off into the distance.

Tropical *motu*, Huahine, French Polynesia ◄

Nikon D2x, ISO 100, RAW. 17 mm (250 mm equivalent). 1/200 second, f5.6 Polarizing filter

To bring out and enhance turquoise tropical water, use a polarizing filter to reduce reflections on the water and warm up the water slightly by increasing the white balance. This technique works better towards the middle of the day when the sun is more directly overhead.

Stormy sunset over the Blue Lagoon, Yasawa Islands, Fiji ◄

Nikon D2x, ISO 200, RAW. 200 mm (300 mm equivalent). 1/200 second, f6.3

I was plagued with stormy weather when I was shooting in the Yasawas. For most of the time, the fabled Blue Lagoon was choppy and a disappointing grey colour. The poor weather gave an electric sunset though, where the orange sky contrasted with the purple of the water. The picture looked somewhat empty until I saw a small boat motoring along. I pre-focused and waited for it to get into the right place at the end of the headland before I took the picture.

Adventure sports

These days it seems that there is no location so remote that it doesn't offer the chance to try out exciting sports, such as bungee jumping, whitewater rafting, dune boarding or zorbing. These adventure sports merge action, sport and travel in a dynamic combination that is popular with travellers and a great subject for photographers.

You can employ a range of techniques to capture the movement inherent in adventure sports. Experiment with freezing, blurring and **panning** to give a photographic impression of the action. A lot of adventure photographs are taken from a few key **angles** using a **telephoto lens**. To make your pictures a little different and more dynamic, get in closer and use a **wide-angle lens**: the distortion can add to the feeling of movement.

For the most exciting angles, put yourself in a position that a photographer wouldn't normally use to take pictures – even if it means some discomfort.

When photographing kayakers or rafters, for instance, try to get in the water and shoot from water-level, using an underwater housing, of course. Alternatively look down on the action from a bird's eye view. Also experiment with the **viewpoint**: shooting from ground level looking upwards works well for skiing and snowboarding shots. Other novel and exciting

Kayakers, Moorea, French Polynesia ◄

Nikon D2x, ISO 100, RAW. 200 mm (300 mm equivalent). 1/1000 second, f5.6

Adventure sports don't have to be about fast action. I noticed that these two paddlers were set against a very shadowy background and even the sea was really dark. They were strongly side-lit, so I was able to pick them out with a telephoto lens and even accentuate the surrounding darkness with the exposure. The overall result is a picture with very muted tones that illustrates the fact that not every image is going to have a conventionally perfect histogram.

Kite-surfer, Huahine, French Polynesia ◄

Nikon D2x, ISO 100, RAW. 80 mm (120 mm equivalent). 1/250 second, f6.3

This was essentially a grabbed shot from the back of a boat that I was using to get between the main island and an outlying motu, or coral island. This man was kite-surfing along very fast and, as he got closer to the boat I was able take a few shots before he passed.

angles can be achieved by using a remote camera. A number of the close-up pictures that you see of the bull run in Pamplona in Spain are shot in this way. If your camera doesn't come with a remote, third-party wireless controls are available to buy for many models.

Don't just photograph other people enjoying themselves; get in on the action yourself. I have bungeed, rafted and kayaked with a camera. To avoid damaging your most expensive equipment, take a cheaper body or even a **compact camera** with you. Underwater housings for compacts are much cheaper than those for **DSLRs**.

To take a dynamic photograph in the middle of a bungee jump, say, or when mountain biking, turn the camera back on yourself. Shoot with a wide-angle lens and trigger the camera when the background is at an interesting angle, such as when turning a corner on a bike. This will give a more exciting shot than if you point the camera in the direction you are going. If you are mountain biking or off-road motor biking, you may be able to fix the camera to your handlebars, pointing at you with a very wide-angle lens. In this

case you will need to pad your camera with foam and gaffa tape to protect it in case of any crashes.

Remember to shoot around the action. Sometimes the apprehensive preparations beforehand and the exhilaration afterwards can produce particularly evocative images. These sort of pictures will also complete the sequence if you are shooting a photostory (see page 224).

People doing adventure sports on the road will usually be other travellers, so you should be able to count on their co-operation. This makes it much easier to ask them to do something in a particular way or even to repeat an action. In return, they will get their adventurous moments photographed by a talented photographer.

If you are thinking of trying to make your travel photography pay, then shooting good-quality adventure sports can be a perfect niche – especially if you manage to get close to the action and get your images model-released (see page 305).

Rafting the Zambezi, Livingstone, Zambia ∧

Nikon D70, ISO 200, RAW. 17 mm (26 mm equivalent). 1/1000 second, f5.6. Ewa-Marine underwater housing

The Zambezi has some of the best white-water rafting in the world. I wanted to shoot from on-board the boat and so took out an underwater housing and a cheaper camera body in case of disaster! The Ewa-marine housing doesn't allow access to the camera functions and so I was shooting on aperture priority. A relatively wide aperture meant that the camera would set a correspondingly fast shutter speed. A multi-zone matrix meter and shooting on RAW ensured that the exposures would be fairly accurate. Then it was just a case of hanging on with my feet as we hit the rapids!

Interiors

Whether it be the inside of a bar, a museum, a public building or a religious monument, interiors are an integral part of travel photography. They provide a good contrast to a series of outdoor city shots, and you can shoot them when the weather is bad and at midday, when the sun is in the wrong place for daylight photography.

Technically, the biggest problem you will have to overcome is the low light level, especially since many locations that allow photography forbid the use of **flashes** and tripods, either to prevent damage to floors and paintings, or to protect their lucrative postcard concession. If you can use a tripod, check that yours does not have spikes that will damage the floor; most have rubber feet that can be screwed down to cover outdoor spikes.

When shooting in low light, ideally you should opt for a slow **shutter speed** and a narrow **aperture** to achieve as much **depth of field** as possible. However, if there are moving people in the shot that you don't want to be blurred, then you will have to bias the shutter speed so that they are still recognizable.

If you can't use a tripod, then placing the camera on the floor or on a chair or bar top will keep it still and produce some interesting **angles**. In other situations you will have to hold the camera by hand: brace against a wall or pillar to help keep the camera still and shoot with a **wide-angle lens** to minimize **camera shake**. A wide-angle lens will also give more depth of field, which will be useful if you are using a wide aperture to allow the fastest possible shutter speed. In this instance, composing your picture so that all of the main points of interest lie in one plane should compensate for the shallow depth of field.

Many photographers don't even consider using a tripod, relying totally on drastically increasing the **sensitivity**, which allows them to hand hold the camera in very low light levels. Most modern **DSLRs** can shoot with very high sensitivities, without significant noise, although the **dynamic range** will be slightly reduced, which can be an issue if there is a lot of **contrast** in your scene. If you have a lens with **vibration reduction**, then you can recover another two or three **stops**. I always take a number of shots when holding a camera by hand at low speeds to increase the chances of getting at least one shot without camera shake.

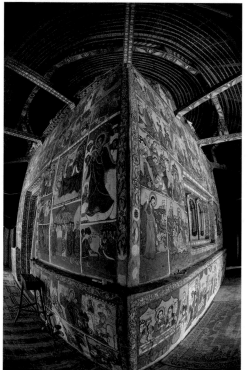

Church on Zege Peninsula, Lake Tana, Ethiopia ◄

Nikon D2x, ISO 100, RAW. 10.5 mm fish-eye lens. 1/2 second, f5.6. Tripod

Shooting with a fish-eye has captured all of the brightly painted, yet rather cramped inner sanctum of this ancient church in Ethiopia. The bottom of the structure is lit by light coming through a doorway and is brighter and somewhat blue, as I had to use a white balance to cool down the artificial light of the interior.

Luxor Museum, Egypt ◄

Nikon F5, Provia 100 ASA film. 28-70 mm lens. Exposure not noted

Luxor museum has some wonderful artefacts and many of them are very well lit and arranged. Many museums are happy for people to take photographs although some will make an extra charge. Don't just photograph things on their own from the front: try to combine exhibits to create a more interesting composition, and even consider photographing visitors to the museum reacting to, and interacting with, exhibits.

Remember to take some pictures vertically. Combined with a wide-angle lens, the vertical orientation will enable you to include a wall and a ceiling in the same dynamic shot. Wide-angle lenses give some degree of distortion, especially when you tilt the camera but, as you are unlikely to be able to

get rid of this completely in an interior shot, I would always choose to exaggerate it.

You can also shoot environmental portraits in an interior. These can give an insight into someone's life or work and might be the only portraits you can shoot if the weather is bad. The shallow depth of field resulting from the low light levels means you need to be careful with your focusing. Using a **continuous autofocus** mode can help, as it will compensate for any slight variance in subject distance made by you or your subject. You have to be careful to avoid both blur from a moving subject and camera shake from the longer **exposures**.

To get a correct exposure for an interior, meter away from any windows or light sources. Many interiors are supposed to be slightly dark and dimly lit, so consider **underexposing** the interior by about a stop to preserve this and make your picture appear more natural. **Overexposed** and **blown highlights** are not necessarily a problem, unless they dominate a picture or obscure necessary detail. In many situations, you will find it hard to avoid having some light sources in the picture and, in daylight, any windows are likely to be completely overexposed. Make sure these bleached-out windows don't fill up too much of the frame. You could also shoot two pictures at different exposures and combine them in post-processing to maximize the dynamic range. Alternatively, shoot at a time of day when the interior light balances the light levels outside. The difference in **white balances** will accentuate a feeling of cold outside and warmth inside.

Most objects in museums are kept behind glass, which makes photographing them difficult. If you are allowed to use flash, then hold the camera lens and flash right up against the glass to minimize reflections. This technique will also limit the effect of natural light reflections, if flash is prohibited. The wide aperture that you will need to photograph in the relatively low light levels will help to mask any dirt or scratches on the glass. If you can do it discreetly, it is worth carrying a cloth to quickly clean generations of grimy fingerprints off the glass before you take a picture.

ⓘ For more detailed information on photographing in low light, refer to the Execution chapter, page 112.

Prague Cathedral, Prague, Czech Republic ⌃

Nikon D3, ISO 1600, RAW. 14 mm lens. 1/125 second, f5

The amazing high ISO performance of modern DSLRs means that you have the option of using a high ISO and hand-holding when tripods aren't allowed. The 14 mm lens gave a massive depth of field and minimized the appearance of any camera shake.

Stereo Bar, Tallinn, Estonia ❯

Nikon D2x, ISO 100, RAW. 200 mm (300 mm equivalent). 1/1000 second, f5.6

This brightly lit bar is modelled on a radio. I was most struck by these designer seats. The lighting colour changed every few seconds, but I was able to set a white balance in RAW processing that removed the cast from the artificial light, retaining the actual colour of the light itself. I took this shot in a few of the different colours, but this light blue was the most atmospheric.

Markets

Markets are often wonderful places for photography, combining food and a wide variety of goods with animated people in a bustling and exciting environment.

Lighting

The wide **dynamic range** between shadow and sunlight is one of the biggest issues facing the market photographer. In outdoor markets, people usually hide under whatever shade they can find, which means there is a massive **contrast** between the parts of the scene lit by the sun and the people in the shadows. You can try using **fill-in flash** to compensate for this but, although it is fine for lightening shadows on a face, using the flash to light up half your picture can produce quite flat results and can be quite intrusive. You can zoom in and photograph only the shadow area, but this might result in a shot that is cropped too closely, cutting out the produce that the person is selling.

The best conditions for photographing markets are even lighting, so, if the market is held outdoors, wait for an overcast day or for the sun to pass behind a cloud. This will produce far less contrast between the lit and shadow parts of the picture. What's more, the vendors will usually be more animated and active in these cooler conditions, giving better portraits. Even if you do have to photograph in bright sunlight, there will always be a few parts of the market where the light is right: either the stallholder and their produce will both be in the sunlight or all of the stall will be in the shade. Explore, and you will find them.

Some markets are completely covered. Although this will present some problems with low light levels or artificial lighting, you should experience fewer extremes of contrast. To compensate for lower light levels, consider bumping up the **sensitivity** of a digital camera as much as you need, and use the **auto white balance** facility to remove casts from artificial lighting. You can fine tune this in post-processing if you are shooting **RAW**. If you are shooting film, then a 400 **ASA** film will help with **exposures** in low light but you will be pretty stuck with any **colour casts**.

Local food and goods

Local markets can be good places to look for shots of local food delicacies, including bizarre fruits and vegetables and even bush meat. As well as taking close-up shots of foodstuffs, try to take longer shots

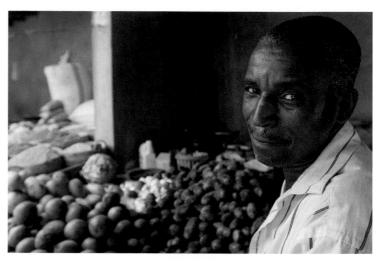

Stallholder in vegetable market, Lamu, Kenya ∧

Nikon D2x, ISO 100, RAW. 17 mm (26 mm equivalent). 1/100 second, f4

Markets are great for portraits: stallholders are often happy to be photographed – provided you ask permission first! Much of this market was covered, which meant there were low light levels but, without direct sunshine, the contrast wasn't too great. I shot quite close to the man and composed to have the rest of his stall in the background.

Piles of spices, Marrakech, Morocco ＜

Nikon D2x, ISO 100, RAW. 65 mm (98 mm equivalent). 1/30 second, f5

Taking a shot from the side of the stall allowed me to have the rest of the market as an out-of-focus background. The light levels were quite low and the depth of field quite shallow. Consequently, I focused on the front pile of spices: I prefer pictures where the background not the foreground is out of focus.

that show the items in their market context. In many parts of the world, it is usual to find stalls selling prepared food right next to great slabs of fly-covered meat or pungent raw fish. If this is the case, then take some pictures that show this. The sights that are interesting to you are likely to interest the viewer of your pictures as well.

In addition to food, you can usually find all manner of tourist tat, clothes and household goods for sale. In some towns, almost everything seems to be sold in extended markets rather than in conventional shops and, if you wander around these markets, you will find endless subjects to photograph. Take some close ups of the goods for sale but also take photographs that show the general market environment. Many stalls are up on tables, so you can sometimes take low-viewpoint shots of items for sale without having to scrabble around on the ground.

Market portraits

Stallholders in markets are often among the most animated and vocal people you will meet in a town and will generally be comfortable performing in public. In more touristy places they may be used to having their picture taken but also thoroughly fed up with rude tourists stealing pictures without asking. Use your judgment and always find a way to seek permission. I think it is better to take pictures from up close rather than further away with a **telephoto lens**, as it allows you the chance to build a rapport with the person you are photographing. Ask them about the items they are selling and show an interest. If there is something notable on the stall, take a portrait of the stallholder with that object: it might be a local delicacy, goods used for traditional medicine or some sort of authentic costume. Sometimes you will be asked for money for taking a picture; at other times, try to find a small item to buy and then ask to take a picture afterwards.

In the souks, Marrakech, Morocco　>

Nikon D3x, ISO 400, RAW. 14 mm . 1/50 second, f3.5

The souks of Marrakech are amazingly atmospheric places to just wander and take pictures. They are a warren of tiny alleyways, covered by shades to keep out the direct sunlight. The result is a wonderfully diffused light. As well as having to manage low light levels, you will encounter a range of colour balances from different light sources, depending on where you are in the souks. This might be cool shade light, daylight shining through the roof or even incandescent light. Use a high ISO and shoot RAW so you can sort colour casts later.

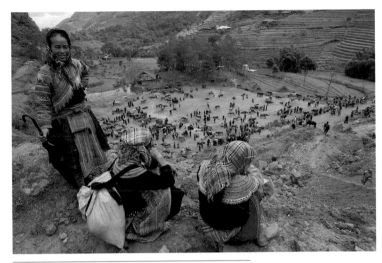

Flower Hmong women, Bac Ha Market, Vietnam　∧

Nikon D3x, ISO 320, RAW. 26 mm. 1/320 second, f8

Markets are fantastic places to photograph people, and as very public and busy places, you can try shooting candid portraits. These women were looking over the buffalo market, and I was able to quietly sit behind them and photograph when the woman on the left turned round. Outdoor markets can be great for photography as you don't have to deal with low light levels or colour casts, although on very sunny days, people often hide away in shadows, creating problems with contrast. Overcast days are perfect, as the flat even light allows you to take pictures all day, as the market develops.

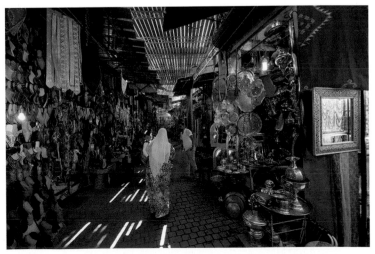

Food and drink

For many travellers, food is one of the highlights of their travels. It can say a lot about a culture, with most countries, regions and even cities having their own characteristic dish or culinary style. Food can be hard to photograph but, with a few simple rules, you can produce colourful pictures that look almost good enough to eat.

First, do your research. Find out which foodstuffs a place is famous for and where to find them. This might be a particular restaurant, night market or a specific area of town. Remember that some foods are seasonal, others available all year round.

Roadside stalls are great places to find local delicacies, including the truly weird stuff, such as fried spiders, roasted crickets and cooked snake. The food is usually piled up attractively to entice customers and the stallholders are often happier for you to photograph their food than to pose for a portrait. If you shoot with a **wide-angle lens** you may be able to get them in the picture, too, but bear in mind that you may be expected to buy and, of course, sample something from the stall in return! On some stalls the food may be prepared in front of you before being sold. This can be a great opportunity for the food photographer, as it allows you to photograph both the cooking of the food and the finished dish; you may even be able to shoot a portrait of the cook in action.

If you photograph your food in a restaurant in the evening, the chances are that it will be lit with some sort of artificial light. Alcohol and bar shots still look good when lit with artificial light but food shots don't. Although you should be able to colour correct the cast using your camera's **white balance** facility, you will have little control over how the food is actually lit.

A better idea is to shoot at lunchtime, when many restaurants have outside eating space, meaning that you can take your food photographs in daylight. Bright sunlight is likely to produce extremes of **contrast** so consider shooting in a shaded area where the light is more even. Adjust the white balance to warm the light and consider using small reflectors to add some highlights. You can buy small fold-out reflectors or use aluminium foil.

Food looks good when photographed close up. Keep your shot simple and fill the frame to avoid distraction. Look for bright colours and contrasts and

Roadside kitchen, Xian, China ◄

Nikon F4, Velvia 50 ASA film. 28-70 mm lens. Exposure not noted

This roadside kitchen in the Muslim quarter of Xian was cooking up a great cloud of steam. I changed the angle so that the steam was slightly backlit and composed the picture vertically to show as much of it as possible. The light was quite muted and I used a warm-up filter to take the coolness out of the shadows.

Barbecued guinea pig, Peru ▼

Nikon D2x, ISO 100, RAW. 70 mm (105 mm equivalent). 1/100 second, f5.6

A local delicacy that I just couldn't bring myself to try: my old childhood pet would never have forgiven me! These cooked guinea pigs make the sort of detail shot that is relatively easy to sell to magazines. Food pictures – especially the bizarre things that people eat – are often used in publications.

also for repetition, when a number of similar foods are presented together. Be aware of your **focus point** and **depth of field**, so that the parts that you want to be in focus are sharp. As well as shooting close-ups, try to take a longer shot that shows the food in its surroundings and, possibly, even in the process of being eaten.

Drink and be merry

As well as characteristic foodstuffs, many places have their own alcoholic drink, which is a key part of the local culture. It might Calvados in Normandy, Tequila in Mexico or vicious snake Lao lao (rice wine) in Laos. There are also some famous tourist drinks that you should try to photograph: maybe a Singapore Sling in Singapore or a Mojito in Old Havana. You could also photograph tea in Arabia, chai or lassi in India and coffee in Ethiopia.

Often the preparation of the drink is at least as important as its consumption, so try to include this in your pictures. You might photograph the elaborate ritual of the Japanese Tea Ceremony or the numerous processes involved in producing a bottle of wine. Wineries and breweries can be a great source of atmospheric photographs – not to mention a drink or two.

Roadside foodstall, Fatehpur Sikri, India ⌃

Nikon D2x, ISO 100, RAW. 48 mm (72 mm equivalent). 1/400 second, f6.3

Filling the frame with this brightly coloured dish that was for sale at a roadside stall has created an interesting image and greatly amused the stall holder! Using a lens which has the ability to focus at very close distance allowed me to get very near to the dish, which was delicious by the way!

Calvados, Mont St Michel, France ❯

Nikon D2x, ISO 200, RAW. 50 mm (75 mm equivalent). 1/13 second, f1.8

Photographing a regional drink can be a good excuse for trying a couple of glasses. This shot was taken at a local bar, using available light. The low light gave a shallow depth of field, so I made sure to focus on the label of the bottle.

Close-up photography

Crab on Cousine Island, Seychelles

Nikon D2x, ISO 100, RAW. 200 mm (300 mm equivalent). 1/320 second, f5.0

You don't need a macro lens to take close-up pictures. The magnification given by a strong telephoto lens allowed me to magnify this crab in the frame, and also to shoot from a subject distance that didn't scare it away. In order to improve the composition, I moved the focus to one of the lower points, and shot on autofocus as the crab kept scuttling away. The light was such that the crab's shadow was larger than it was, and I made sure that the image was framed in such a way that the shadow wasn't cropped.

If you get into close-up photography, you will never run out of interesting subjects to shoot on your travels: food, vegetables, flowers – even Madagascan miniature frogs!

A lot of camera lenses will have a focus mode that should allow you to get relatively close to a subject. Wide lenses tend to focus closer than **telephoto lenses**, but telephoto lenses have a greater magnification. Depending on the **focal length** of the lens and the closest focus, this can give quite a good magnification. If you are interested in this style of photography, it is worth checking this before you buy a lens, or you could consider buying a specialist **macro lens** (see Pro tip, right).

The main issues with close-up work are lighting and **depth of field**. At close distances you will get a very shallow depth of field, which makes accurate focus critical and also means that, potentially, only a small part of your picture will be sharp. To increase the depth of field, use as small an **aperture** as possible. If you have a tripod and your subject isn't moving then using a commensurately slow **shutter speed** shouldn't be a problem but bear in mind that even a breath of wind can cause **motion blur** for very small objects.

Another way of ensuring that more of your subject is in focus is to compose your picture so that your subject is roughly parallel to the **sensor/ film**. You will still have the same depth of field but by photographing more flat-on to your subject you can maximize the amount that falls into this 'sharp' zone.

> ⓘ **Pro tip**
> Close-up pictures that produce a life-size or larger image on the film or sensor are termed 'macro'. In order to shoot genuine macro pictures you need either a specialist macro lens, which is designed to have a closer minimum focusing distance, or special extension tubes that fit between a normal lens and the camera to bring the focus closer. My preferred option is to use a specialist macro lens, which can also be used as a back-up prime lens. A 60 mm is a good general macro lens, especially with a crop-sensor DSLR. A 105 mm lens is perfect on a film SLR or full-frame DSLR, and can also double as a back-up medium telephoto and portrait lens.

Due to their small sensors and inherently large depth of field, compact cameras are ideal for close-up work, generally giving closer focus and more magnified results than a SLR or DSLR with a non-specialist lens. You will usually have to engage the close-up mode, often by selecting a rather sweet picture of a flower on the focus setting. Sometimes there will also be a close-up picture mode, which should bias the image towards maximizing the depth of field. The proximity of a compact camera's flash to the lens helps to avoid the deep shadows given by more sophisticated cameras, although the lighting will be fairly flat.

Sometimes your subject won't suit this approach and so you will have either to increase the **sensitivity** or increase the amount of light in order to be able to use as narrow an aperture as possible. The easiest way to do this is to use **flash** but beware: the light from the built-in flash of a **DSLR** or **SLR** and, especially, a separate **hotshoe**-mounted flash may be obstructed by the lens on very close-up work and won't light the subject properly. It may also cast intrusive shadows if your subject is not flat.

If your flash isn't lighting the subject properly, then you can use a **TTL off-camera flash lead** (see page 130) that will allow you to connect a flash to your camera without using the camera top hotshoe and to hold it at any **angle** to the subject and still meter the flash **exposure** automatically through the lens. This off-camera solution will allow you to position the light but will give quite harsh shadows that will need to be balanced with a reflector. Fit the flash with a portable softbox, or even use a **ring flash** or **ring flash adapter** (see page 131), which produces a very even lighting effect.

If you are shooting with natural light, then your subject will often be lit from above, casting deep shadows. An easy way to improve this lighting – or the shadows given by directional flash light – is to use a reflector. There are a number of small fold-out reflectors available, which can be used to bounce a bit of light back to the shadows of close-up pictures and portraits. Failing this, just scrunch up some aluminium foil and keep it in the bottom of your camera bag. This is highly reflective and can even support itself.

Close-up work isn't just about magnifying objects with your camera and exposing detail that is largely hidden to the human eye – although that is a fascinating and engaging thing to do. Close-up work is also about revealing form, texture and patterns. Repetitions and contrasts work well, as do completely abstract representations of the miniature world.

Mini land frog, Antsiranana, Madagascar ◄

Nikon D2x, ISO 400, RAW. 60 mm macro lens (90 mm equivalent). 1/100 second, f5.0

This is supposed to be one of the smallest frogs in the world. It is barely a centimetre long. Shooting with a macro lens allowed me to get in very close, but the shallow depth of field means that only a small amount of the head is in focus.

Tiny chameleon, Antsiranana, Madagascar ◄

Nikon D2x, ISO 400, RAW. 60 mm macro lens (90 mm equivalent). 1/80 second, f5.6

Shooting this chameleon from the side means that most of the subject is within the shallow depth of field and so the image has the impression of being much sharper than the land frog even though it was shot with a similar aperture.

Desert plant, Socotra, Yemen ◄

Nikon D2x, ISO 100, RAW. 52 mm (78 mm equivalent). 1/200 second, f8

This desert plant was growing on the remote island of Socotra, off the coast of the Yemen. Flowers and plants are good subjects for close-up photography: they are often colourful and seldom move!

Abstract, quirky and humorous photography

Your photography doesn't have to be representational, you can also use your camera to show things in an abstract or quirky way.

Abstract photographs use the form, texture or colour of a subject to create a visually pleasing or intriguing picture that doesn't rely on knowing or even recognizing the subject matter. Some shots concentrate on an isolated part of a more recognizable subject; others choose an unusual **angle** to make a recognizable subject look completely different.

Photography is a perfect tool for this as many of its inherent qualities are essentially abstract. The treatment of movement to create blur or freeze objects, the manipulation of focus and the distortion of perspective can all be combined to create an abstract effect. The most useful technique, however, is the magnification and cropping that you can achieve through lens choice and **subject distance**. This allows you to isolate a part of your subject and present it as a whole. Sometimes you can use this to remove any clues as to the scale of what you have photographed, which can render it completely unrecognizable.

This sounds like a complicated process but, in fact, abstract photography is about the freedom to photograph things exactly as you want in order to create a different vision of them. There are really no hard and fast rules about what is or isn't abstract, so experiment with different techniques.

Quirky and humorous photography

The world is a pretty strange place. There are all sorts of weird and wonderful things out there, from the massive fibreglass fruit that grace certain New

Ski trails in the snow, Diavolezza, Switzerland ➤

Nikon D2x, ISO 100, RAW. 200 mm (300 mm equivalent). 1/500 second, f7.1

Cropping out all of the extraneous detail and just showing the ski trails creates an abstract view of this ski slope in Switzerland. It is difficult to get any sense of scale, which in turn makes it hard to see what it shows. In essence, the image has been reduced to a study of form and pattern. Using manual exposure and setting the meter to +2.5 stops from the suggested reading ensured that the snow reproduced as white.

Zealand towns to the latex policemen placed in police cars on American highways to deter speeding motorists. A big part of the appeal of travel comes from the wonder of exploring. Taking pictures of the quirky things that you see on your travels can be a great way to bring some of this wonder home with you so that other people can appreciate it.

Some quirky sights are intentional and may have become tourist attractions in their own right, such as the much-photographed silhouette of John Wayne in Monument Valley. Others are completely unintentional: the result of an accident or the vision of someone with an alternative view of life, such as the giant scorpion on a hill above the town of Mai Sai in Northern Thailand. These are the true gems.

Use humour in your pictures, but don't use it as an excuse to ridicule people. Not only is this morally questionable, it might also leave you open to legal action if you publish the picture anywhere, including on a personal website. Rather than looking for humour in the individual; look for humour in the situation. Sometimes including people's reaction to something strange can make your picture more approachable: discovering that locals might find their world as bizarre as we do can create a shared moment of unity.

Try to photograph contrasts between people and things or even between incongruous inanimate objects. There is a wealth of humour in some signs, for instance, usually due to the unfortunate juxtaposition of a sign and its surroundings or an unintentional disjunction between the wording and the image on the sign itself. One sign that has always amused me is in a snake pit in Nairobi Snake Park: 'Trespassers will be poisoned'!

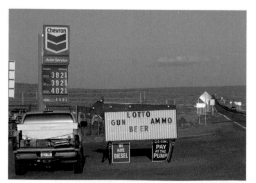

Lotto, gun, ammo, beer! Utah, USA ◄

Nikon D2x, ISO 100, RAW. 70 mm (105 mm equivalent). 1/500 second, f7.1

The sign really says it all: a small piece of Americana by the side of the road. Although the major part of photographing signs such as these is looking out for them, it is worth thinking about the composition to make sure that you create a photograph rather than simply snapping a picture of the sign.

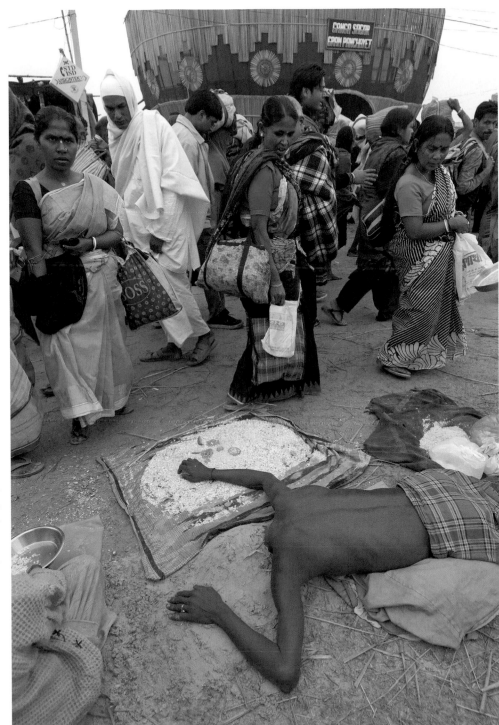

**Beggar at Ganga Sagar Mela,
West Bengal, India** ❯

Nikon D2x, ISO 250, RAW.
14 mm (21 mm equivalent).
1/125 second, f5.6

This man had quite literally
buried his head in the sand.
He was busking for coins and
presumably has an air tube
sticking out under the cloth to
breathe through. It would be
an interesting image if I had just
cropped in to show the man,
but by thinking about the mise
en scène and including the
reactions of the people walking
past, it is much more effective.
I was quite close to the man,
shooting with a very wide-
angle lens which allowed me to
look downwards and forwards
at the same time.

Reportage

The planet isn't always a fair and fluffy place, in spite of what a lot of travel brochures might want us to believe. There is poverty and hunger in many parts of the world; the environment is under threat from pollution, and more and more species are threatened with extinction. There is no reason why your pictures can't reflect this.

First, learn about the issues that you are planning to photograph. There are enough facile pictures purporting to be serious reportage in the world. Doing research in advance and taking the time to photograph something well can make the difference between being a serious documentary photographer and a voyeuristic tourist.

It is very easy for images of poverty or desolation to be exploitative, so try to have a target audience for your shots. If you are not at the stage in your photography where you could offer them to a magazine, then how about holding an exhibition somewhere? Work in conjunction with a charity or NGO that specializes in the area you have photographed, and use the exhibition to raise some money. Even if this is not the goal of your photography, try to build up your photographs as if they were going to appear in a magazine or exhibition. Take a range of shots and work at the subject as if it were a photostory (see page 224).

It is always a temptation to shoot reportage images with a **telephoto lens**. This keeps you away from the subject you are photographing, which may make you feel more comfortable in an awkward or distressing situation. However, unless the telephoto lens is being used for visual effect, to compress the perspective and place the subject of your picture closer to a meaningful background, then you will get more immediate and engaging pictures if you get close and

Woman on railway tracks, Kolkata, India ⌄

Nikon D2x, ISO 100, RAW. 200 mm (300 mm equivalent). 1/180 second, f4.5

Shooting into the light and underexposing slightly has given this image a muted colour palette which suits an image of people eking out an existence on the railway tracks leading through Kolkata. Compositionally, the rails form a strong diagonal, leading through the picture.

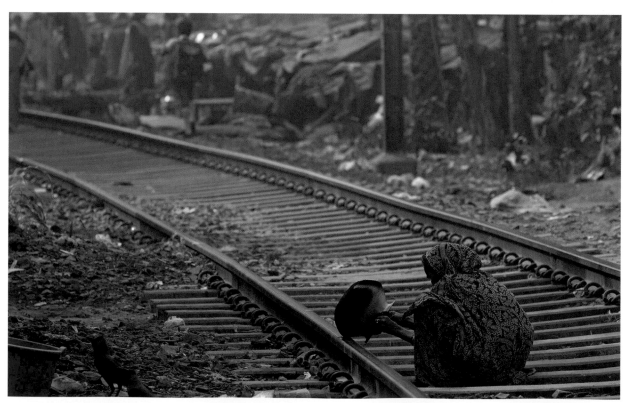

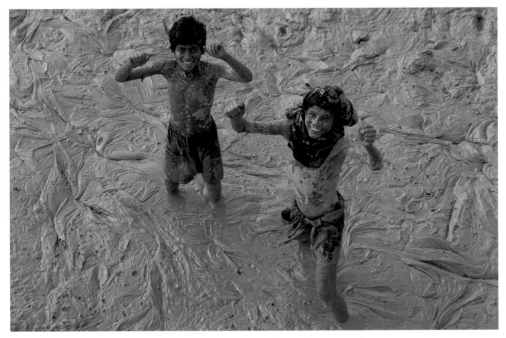

Kids begging for coins in the mud, Ganga Sagar, West Bengal, India ‹

Nikon D2x, ISO 100, RAW. 70 mm (105 mm equivalent). 1/320 second, f5.6

These boys were begging for coins from pilgrims walking across a bridge leading to the ferry point for pilgrims to the Ganga Sagar Mela. There is a lot of poverty in this part of West Bengal and many of the local villagers treat the annual mela as a major revenue earner. Shooting from above places them completely against a background of mud and also sets up a power relation between the boys and the viewer of the picture.

shoot with a **wide-angle lens**. This will mean you have to engage more with the person or people you are photographing, which is not a bad thing. The pictures will be more intimate and you will also learn more about the situations you are photographing. Shooting from up close will give you more time to develop ideas and build your coverage than shooting from a distance and moving on before you are spotted. You should never treat anyone as if they are just a subject for you to photograph; getting up close means that you have actively to seek their permission and co-operation.

Stylistically, many people shoot reportage work in black-and-white as it is perceived to be more sombre and serious than colour. Certainly, it is sometimes hard to convey the gravitas of a subject with crisp, colourful images shot in bright, sunny conditions but just shooting in black-and-white can be too obvious a solution. Using muted and sombre colours instead can be more effective. You can achieve this by your choice of subject and also by your treatment: a slightly **underexposed**, backlit shot will give less vibrant colours, as will taking down the **saturation** levels slightly in post-processing.

Man and dog begging, Siem Reap, Cambodia ‹

Nikon D2x, ISO 400, RAW. 32 mm (48 mm equivalent). 1/50 second, f4.5

Cambodia is a poor country which is still suffering the effects of war and the brutal Khmer Rouge regime. Parts of the countryside are littered with land mines, and there are many people who are disabled and missing limbs; many of these turn to begging to survive. I couldn't work out if this man was begging with the dog, or whether the dog was competing with (and upstaging) him. I would have liked to have re-touched out the feet and motorbike wheel at the edge of the frame, but there is a pretty strong convention that reportage pictures should maintain their integrity and not be re-touched in any way.

Photostories

A photostory uses a group of images to work together and tell a story that imparts greater meaning than the individual images themselves. The 'story' can either be the narrative of a journey or event or else it can involve shooting around a subject so that the viewer gains a deeper understanding of it. Shooting a photostory is a true test of your skill as a photographer, as you have to be consistent and shoot a range of pictures in a limited period of time.

The idea behind the story is important. Rather than just shooting a story on Paris, say, try to find a more targeted angle, such as the catacombs or the Sunday bird-market on the Île de la Cité. You should plan what you are going to photograph and make a shot list of all of the elements that you want to include. Be realistic: the list should be based upon your available time and the accessibility of your subject. There might be some shots that you are just not able to take without special permission.

Another option that has been used successfully in a number of magazines is to shoot a 'Day in the Life of…'. This might involve following the day-to-day routines of a particular person, such as a rickshaw driver, or documenting 24 hours in a single location, such as St Mark's Square in Venice. The inherent limitations of this format – that all of the pictures have to be taken in a 24-hour period – can legitimize any lack of time that you might have, as well as challenging your photographic skills and creativity.

A good way to envisage a photostory is to imagine that you are illustrating a feature for a magazine. Look through a few magazines to see the sort of pictures that are used in this context. Generally, you will see an establishing shot that will work across a double page spread. This should be more than a simple illustrative shot: it needs to set the scene, either of the event or the place, and it should start to tell the story by combining two or more key elements. Also consider shots that show the location, any action or transport, as well as portraits and details that explain things about the story: these could be close-ups of hands, plants, foods, signs or parts of a building. Obviously the type of shot that you aim for will depend on the story that you are trying to tell: some photostories will demand a lot of people shots, others none at all.

Pilgrims on boat to Samye Monastery, Tibet ◀

Nikon F4, Provia 100 ASA film. 17-35 mm lens. Exposure not noted

The monastery is reached via a long boat ride down a fairly fast-flowing river. A large busload of pilgrims were crowded onto the boat, and they were very welcoming, dragging me around the entire monastery with them. The monks and the boatmen were surprised to see me but were very friendly. This image is a good establishing shot and has been used as an opening double page image in a couple of magazines.

Young Tibetan child, Samye Monastery, Tibet ◀

Nikon F4, Velvia 50 ASA film. 80-200 mm lens. Exposure not noted

Carried over the shoulder of his mother, this young Tibetan child was more interested in me than in looking where the boat was headed.

Main prayer hall seen through a prayer flag, Samye Monastery, Tibet ◀

Nikon F4, Provia 100 ASA film. 28-70 mm lens. Exposure not noted.

I only had a few days at Samye and so wasn't able to wait around for the light. I took this shot through a prayer flag both for the visual effect and to disguise the fact that the lighting wasn't as good as I would have wanted.

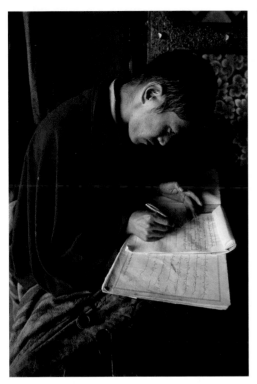

Monk in Samye Monastery, Tibet ‹

Nikon F4, Provia 100 ASA film.
50 mm lens.
Exposure not noted

There was very little light for this image, so I used the 50 mm lens, which has a maximum aperture of f1.8. This allowed me to handhold at a relatively low speed. I had spoken to the monk and taken a few shots of him looking at the camera, then simply waited for him to lose interest and go back to his writing practice. This enabled me to take a series of pictures that on the surface appear candid, but were taken with time and, crucially, the permission of the person being photographed.

Samye Monastery, Tibet ›

Nikon F4, Velvia 50 ASA film.
80-200 mm lens.
Exposure not noted

In the morning I walked through the town and climbed a nearby hill to take pictures of the monastery. The main prayer hall had recently been renovated following the destruction of the monastery by the Chinese. I used a telephoto lens and a vertical orientation to show the monastery in its location, surrounded by hills.

When shooting a photostory, bear in mind that not every shot has to be a masterpiece. The meaning is accumulative, so some pictures will exist to support the others and to qualify a part of the story. I once photographed a story about the land divers of Vanuatu in which I included shots of the preparation of the vines that are used to break their falls. On their own these shots aren't that inspirational but, when combined with images of the divers throwing themselves off high towers, they illustrate the crudeness of the equipment and the bravery of the jumpers.

Try to shoot with a range of photographic techniques and to vary your **viewpoint** and lens **focal length**. This will make your shots more diverse and the photostory more interesting. However, while you want your images to be varied, they should also look as though they belong together. To achieve this, process all the **RAW** files for a photostory in a similar way or,

ⓘ For more detailed information on how to sell, market and publish your work, refer to the Profession section, pages 292-309.

if you're shooting with film, use the same type of film throughout the story, so that the colours match.

How you edit your pictures will play a crucial role in the success of your photostory. You are trying to tell a story and to entertain, so select a series of pictures that complement each other. Each picture should contribute something to the story; there should be no pointless repetitions or weak shots. Although the pictures should convey the meaning, most photostories also have captions with them, so keep story notes, including people and place names.

Finally, try to do something with your photostory: set up a web gallery or submit it to a magazine, competition or even a commercial website. The BBC often carries amateur photostories on their news website, and the *Wanderlust Magazine* Travel Photograph of the Year competition currently offers a large cash prize for a portfolio of five pictures illustrating a theme.

Aerial photography

You don't need your own plane to be able to shoot aerial photography. Many places around the world have helicopter or fixed-wing scenic flights, sometimes at remarkably reasonable rates, and there are some remote destinations that can only be reached by an air transfer, allowing you to take some aerial shots en route.

Flying machines

If you have a choice of aircraft, an over-wing plane is preferable as the wing is above the cockpit and therefore out of the way. It may also shade out the sun at certain angles, preventing lens **flare**. You should be ready to work quickly if you are shooting from a fixed-wing plane, as they move fast relative to the ground. Using autofocus can help ensure your pictures are sharp.

A hovering helicopter is a more stable platform for photography, allowing you to take a little more time to compose, especially if you build a rapport with the pilot and they are willing to follow your directions.

Hot air balloons are great platforms for photography: they move at a slow and sedate pace and the basket is typically open, allowing for a completely unobstructed view. The best thing about hot air balloons is that the conditions for flying are best in the early morning and late afternoon: the perfect time for taking pictures. There are balloon operators in many top tourist locations, from Egypt and the plains of Africa to Australia and Thailand.

Although commercial flights are not ideal for aerial photography, don't dismiss them entirely, as they may be the only way you will get to shoot from the air. I have been on a commercial flight between Tibet and Nepal that circled around Mount Everest so that both sides of the plane could see it. There are a few things you can do to give yourself a better chance of getting a decent picture. Ask at check-in or when boarding which is the most scenic side of the plane for a given journey, and try to get a window seat on that side. Avoid sitting over the wing, which will obstruct your view, and try to avoid shooting into the sun, as flare and reflections will be much worse through the dirty and scratched windows that are typical on passenger jets. You can assess which side is likely to suffer from this by working out which way the plane will be heading relative to the sun at any given time of day. Whichever side you are sitting, clean the inside of the window before taking a shot.

Great Barrier Reef, Australia ◄

Nikon F4, Provia 100 ASA film
17-35 mm lens.
Exposure not noted

On a helicopter transfer to Heron Island on the Great Barrier Reef, I was able to take a number of pictures of the reef. The colours of the reef are fantastic from the air; to keep a limited palette of colours, I cropped out most of the sky to focus attention on the reef.

Nelspruit Airfield, South Africa ◄

Nikon D2x, ISO 100, RAW.
31 mm (46 mm equivalent).
1/800 second, f5.6

Pilots love the phrase 'air-to-air photography'. It is basically a code for flying close to each other and shooting out of open doors or windows. We were flying in to Nelspruit and heard a Parks plane asking for permission to land. We asked them on the radio to fly close and then opened the plane door in mid air for me to lean out and shoot some pictures. The result shows the incoming plane and also a fire-fighting plane on the ground.

Technical considerations

Probably the biggest issues with aerial photography are **camera shake** and **motion blur**. The speed of fixed-wing planes and the vibration in helicopters means you need to use a **shutter speed** at least two stops faster than if you were on the ground. This is usually possible without using a faster **ISO**, as you

don't need so much **depth of field** when shooting from the air and can use a relatively wide **aperture**. The blur is greater if you are using a **telephoto lens** or are flying closer to the ground. It is worth taking a number of shots at a time: in effect, **bracketing** to minimize the chance of both camera shake and out-of-focus images. This can also help with composition problems caused by your camera bouncing around. Avoid resting your camera against the plane window or door frame, as this will increase the vibration.

A wide aperture will help to minimize the visibility of reflections or marks on any windows you have to shoot through. Reflections can be further reduced by wearing dark clothing and creating a shield around the camera with a black cloth. You should be careful of shooting into the sun through a window as this can result in very bad reflections. You may not notice them while you are taking the photos, but they will be obvious when you look at the pictures afterwards.

Flight of the angels, Victoria Falls, Zambia >

Nikon D2x, ISO 160, RAW. 42 mm (63 mm equivalent). 1/500 second, f3.5

There are a number of commercial options for the flight of the angels over Victoria Falls, but we were able to do this in our own plane. The flight paths are rigidly controlled, and we had limited time to make the flight. All the same, we were able to make a couple of passes over the falls. I was photographing through the open door of our old and rather battered Cessna.

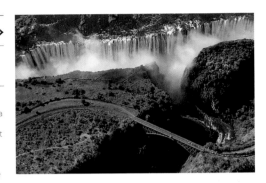

If possible try to not shoot through glass at all. The classic way to take aerial photographs is to remove the door or open it in flight. This avoids reflections and means you can shoot with a **polarizing filter** but, quite apart from the dangers of hanging out of a plane, there are a couple of practical implications. The buffeting wind can cause camera shake, especially if you lean out, and you have to be careful of dropping loose lenses. I prefer shooting through an open window, if possible, so that I can keep lenses and filters on the seat beside me. Bear in mind that a **zoom lens** will allow you to switch between wide and telephoto formats without swapping lenses at all. I also find that I can concentrate more on composition when I am not hanging on for dear life!

Light is just as important when shooting from the air as on the ground. In the early morning or evening you will get lovely warm colours and interesting directional lighting with atmospheric shadows and highlights. Midday light looks especially bland when shooting from the air, especially as the distance from your subject can magnify haze. A polarizing filter can cut down haze giving sharper more **saturated** pictures but don't use one when shooting through a plane window, as it will show up faults and stresses in the plexi-glass as multicoloured patterns.

Finally, don't just treat the plane as an elevated platform: look out for patterns or views that are wildly different to shooting at ground level. Air-to-air shots, either of clouds or other planes, can give a whole new view on the world. Consider taking some photos with the plane in the frame to give your pictures a context. This could be a wing or a cockpit shot. Compositionally, don't forget to take vertical shots as they can enable you to get the land and the sky in the same picture.

Sunrise over Kruger National Park, South Africa <

Nikon D2x, ISO 200, RAW. 80 mm (120 mm equivalent). 1/800 second, f2.8

The muted colours and peaceful misty feeling of this image belie the fact that we were hurtling along at a few hundred feet. The backlit mist is casting deep shadows through the trees. Shortly after this we came across two black rhinos in the river and were able to photograph them from the plane.

Cloud, Mozambique <

Nikon D2x, ISO 100, RAW. 70 mm (105 mm equivalent). 1/640 second, f4.5

We flew past this bizarre cloud on part of a long-haul from Zambia, through Mozambique to the Bazaruto Archipelago. It was just hanging in a cloudless blue sky. A large part of travel photography is about learning to see and notice beautiful and remarkable things in the world around you.

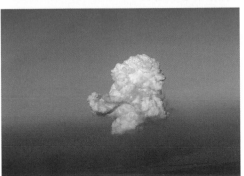

Photographing from a boat

Over the years, I have often taken photographs on board boats: from icebreakers in the Arctic to dugout canoes in Africa and almost everything in between. Boats and ships can be great platforms for photography, but they also present a number of unique challenges.

Your **viewpoint** is likely to be limited by the size of the boat on which you are travelling: if you are on a ship, you will be photographing from a high vantage; if you are on a small inflatable or canoe, you will be shooting from lower down. However, you can vary the perspective by shooting with a **telephoto** or **wide-angle lens**. A telephoto allows you to isolate details but is more susceptible to **camera shake**; a wide or ultra-wide lens will allow you to include the boat in your picture, giving it a sense of place.

Water creates spectacular light and movement effects. Try shooting into the light for a misty effect, and use a telephoto lens to isolate water or ripple patterns. Sunrise and sunset are especially atmospheric near water, as are times of dramatic weather with stormy clouds.

Remember to shoot details, such as ropes or the ship's wheel. This will break up those endless shots of water. You should also be aware of other water users, whether it is people washing in a river or other craft at sea. It is always worth keeping a camera ready with a telephoto lens in case of wildlife encounters. These often happen very quickly, so be ready and carry your camera with you at all times. You don't want to be running down to your cabin or messing around in a camera bag as a whale breaches nearby.

Take shots of any other people on board. The prow of a ship stretching into endless water can make an interesting picture but put a person in the frame and it will show the true scale of the scene. Record your fellow passengers' reactions and expressions to give your pictures human interest.

Protecting your gear

A boat is a potentially hostile environment for a camera. If there is any chance of your camera coming into contact with water then you should use a waterproof cover or even a waterproof housing. Collapsible bag housings are easy to transport and will keep your camera completely dry. They even float if they fall in the water. Although they can make

handling difficult, they could save you hundreds of pounds' worth of damage. If you are only likely to encounter light spray, then humble cling-film or a hotel shower cap will suffice. Use a **UV filter** to protect the lens element, especially if you are exposed to salt water, and carry some soft tissues with you in a plastic bag to clean the end of the lens.

If you are in a small craft, it is worth considering putting the rest of your equipment in a waterproof case or bag, especially if there is any risk of the boat capsizing. On short excursions leave any spare gear in a safe place on dry land, so that, if the worst happens, you have some back-up kit. Even large ships often move around unexpectedly, so be careful of leaving cameras on tables or even in an open camera bag. Hit a big wave and everything could end up smashed on the floor, or over the side and at the bottom of the sea.

Lamu waterfront, Kenya ◄

Nikon D2x, ISO 100, RAW. 105 mm (137 mm equivalent). 1/400 second, f5.6

It might sound obvious, but often the only way to get a good angle on a waterside location will be to shoot from a boat. Photographing from a small boat allowed me to shoot traditional dhows moored against the atmospheric waterfront of the Swahili island of Lamu; a scene which appears to have changed little since it was one of the bases for trade and exploration in East Africa.

Boat rail, Dalmatian Islands, Croatia ▼

Nikon D2x, ISO 160, RAW. 145 mm (218 mm equivalent). 1/320 second, f5.6

Set against a muted pastel blue palette, this railing forms a stark contrast and an interesting detail. Sometimes, photographing less will actually give you a picture that says more. This image sets up a number of questions, as well as being visually pleasing.

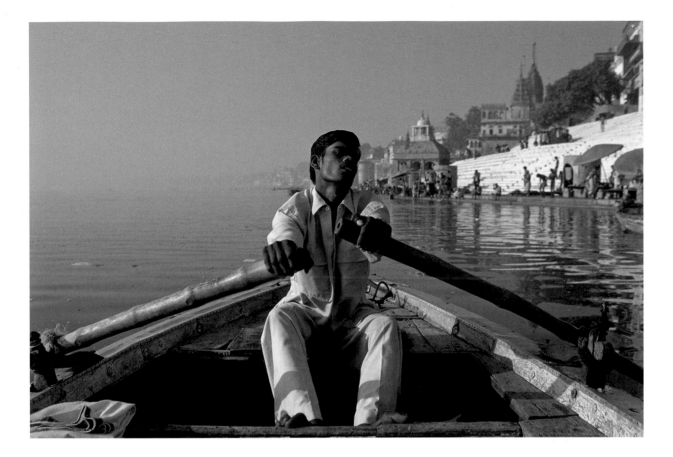

Rowing down the Ganges, Varanasi, India ∧

Nikon F4, Provia 100 ASA film.
17-35 mm lens.
Exposure not noted

One of the best things to do in Varanasi in northern India is to catch a rowing boat down the River Ganges at sunrise. Hindu pilgrims from all over India travel to Varanasi to bathe in the sacred river, believing it will wash away their mortal sins. The light in the city is truly beautiful, especially early in the morning. As well as photographing the bathing pilgrims, I wanted to photograph one of the boatmen who row the heavy boats up and down the river. Loosely composing the shot and using a wide-angle lens has included a large swathe of the river and the stone ghats that line the bank. This gives the image a sense of place.

Technical considerations

The biggest problem on water is the movement. Not only do you have the risk of camera shake from waves or engine vibrations, but the pitching and rolling of the boat can make composition virtually impossible. Shots of water will show dramatically when a horizon isn't straight and, if you try to compose too tightly, your subject will often be off the edge of the frame.

To avoid shake in a fast-moving or vibrating boat, try using a faster **shutter speed** of at least 1/500th second and even consider applying **vibration reduction** or **image stabilization**, which is built in to some cameras and lenses to minimize movement. Although this can stop camera shake, it can also cause the image to jump slightly as the picture is taken, playing havoc with composition. For the best chance of achieving a well-composed picture, you should always take a large number of shots in rapid succession. Sometimes it will be only the fourth or fifth image that is correctly composed with a straight horizon.

When shooting from a moving boat, use autofocus to make sure that the image is sharp. A central focus point may lure you into shooting with very poor composition, so instead select a different sensor at the top, bottom or sides of the image. Using a **polarizing filter** can cut down reflections on water and give more vibrant colours.

▣ **Digital compact**
Some compacts have an anti-shake setting but, in many cases, all this does is use a more sensitive ISO and faster shutter speed. Selecting an action or sports picture mode will help you take pictures without shake. If your compact has a mode that allows you to take a number of pictures in quick succession then this can help address composition problems caused by shooting on a moving boat.

Photographing from a train

Travelling by train allows you to appreciate the scenery en route but denies you the freedom to stop when you want. You might only get a glimpse of a potential subject before you speed past it.

Getting a clear shot

Train windows can be fairly dirty, and they also suffer from reflections, so try to find a window that opens: the corridor or even the toilet cubicle may be your best bet! If the train is moving slowly, you may also be able to shoot out of an open door. You will need to lean out if you are going to get the classic shot along the side of the train as it goes around a corner. This is potentially very dangerous, so only lean out of the side of the train away from the other tracks to avoid any oncoming trains.

You can increase your chances of getting some good views by choosing a special train with an observation car, if one runs on the route. These will have large windows and may even have an outside viewing platform, making photography easier. The downside of these trains is that they tend to be run for tourists, so are not the best places for capturing authentic local colour.

Even if you manage to get a clear view, it is often really tough to get a shot without posts, electric wires and signs getting in the way. A solution to this is to take a few shots in rapid succession using a **motor drive**; with luck, you should get at least one picture that is clear of obstructions. A mild **telephoto lens** will also help to pick out details and help to crop objects like telegraph poles out of your composition.

Trans-Mongolian Express at Beijing Station, China ⌄

Nikon F4, Provia 100 ASA film. 21 mm lens. Exposure not noted

A major part of the excitement of a rail journey is the anticipation before it starts. Railway stations are wonderfully evocative places and there are many possibilities for photographs. This image shows some of the preparations before the marathon journey from Beijing through Mongolia and Siberia to Moscow. A wide-angle lens allowed me to photograph the train and the railway worker on the trolley before getting on the train.

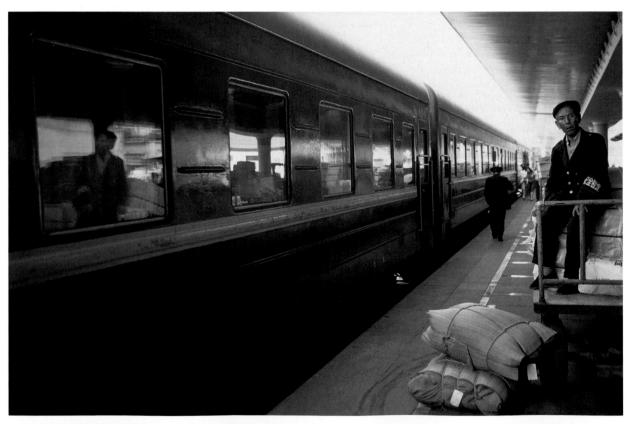

Remember to use a fast **shutter speed** to avoid blur,
especially if you are photographing objects close to
the train where the relative speed will be greater.

A sense of the journey

A railway journey makes a fascinating subject
for photography. In many parts of the world, but
especially in India where the railway is the largest
employer in the world, trains are like mobile towns,
with all manner of things going on: buskers, traders
and tea-sellers move amongst the crowds of
passengers, giving a unique flavour to the journey.
There are further opportunities to capture local
colour at the stations but, if you get off to take some
photographs, be careful not to miss the train! You
should also be aware of any local restrictions to
photographing trains and stations; in some countries
you might end up being arrested as a spy.

Do plenty of research about the journey to find
out about any notable sights or even places where
the train might curl around itself on a particularly
tight curve. On the Trans-Mongolian Railway there is a

monument where Asia meets Europe. Photographing
this from a moving train is quite a task, requiring a
good guidebook and close attention to the kilometre
markers. The potential for another spectacular shot on
this route occurs as the Trans-Mongolian passes from
China into Mongolia. The gauge is different in the
two countries, so the entire train is taken into a giant
shed, winched up and placed on a new set of wheels.
To photograph this bizarre event you will need to
befriend the carriage attendant and stay on the train
instead of getting off just after the border.

Don't just take pictures from the train looking
out of the window. On board there will be signs and
other interior details that make interesting and quirky
subjects. A shot of the massive samovars that supply
hot water in some of the Russian trains, for example,
would provide a unique insight into the journey. If
you're on a sleeper train, get to know the conductors,
not only for the chance of portrait shots, but also for
local information.

Try to get shots from inside the train of people
looking out of the windows, using **fill-in flash** to
balance the light levels inside and out. More difficult
is trying to get a shot of the train as it passes through
the countryside, as it will involve getting off the train
to find a good position. This is impractical if you are on
a train that only runs daily, like the Trans Mongolian,
but, if you are on a regular train route that runs every
hour or so, it is a lot easier – especially if you have a
rail pass that allows you to board any train.

Ⓦ The URLs of the sites and products mentioned
in this chapter, as well as other tips, are given on
the website footprinttravelphotography.info

Focus on

Tea shop, Hama-Rikyo Detached Garden
Tokyo, Japan

I was looking for a shot that showed the contrast between the new and old of Tokyo, but I had travelled there virtually straight from Ethiopia and Kenya and so had little time for research before I left. I was photographing the parks that are dotted around Tokyo, exploring the theme of them being islands of serenity in such a bustling city. I was looking for an image that contrasted them with the more familiar images of towering buildings and blinking neon. To try to locate a single shot that summed this up, I searched for locations on a number of photolibrary sites and also pored over the parks section of the tourist board website – all to no avail. Once in Tokyo, I combed most of the parks myself and worked out possible angles from tourist street maps. Finally, I found this angle in the Hama-Rikyo Detached Garden, one of the oldest in the city. The light wasn't very good at the time, so I returned when the park opened the next morning. Luckily, the light was much better.

I composed the image with the tea shop in the middle of the frame to accentuate the reflections. Using a tight crop cut out as much sky as possible from the frame. This had the effect of making the reflections appear stronger and making the image more graphic.

I also used an ND.6 graduated filter with a hard transition to balance the reflection with the rest of the scene. This lightened the non-reflected part of the scene by two stops to balance the images, as water tends to absorb light. Although there was enough light to hold the camera by hand, I used a tripod to ensure that the ND graduated filter was lined up correctly.

When you see a scene like this, it is important not to take just one shot and move on. I took a range of different shots here, including vertical images.

⊕ **Find out more** **>**

Nikon D2x, ISO 100, RAW.
32 mm (48 mm equivalent).
1/250 second, f8.
Graduated ND filter. Tripod.

Underwater photography

The biggest problem with underwater photography isn't, as you might imagine, keeping your camera dry. There are a number of housings that will fit anything from the smallest compact to the largest professional SLR to ensure that your camera stays watertight. Instead, the main issue that all underwater photographers have to deal with is light.

Problems with light

Water absorbs the red wavelengths of light but not the bluer wavelengths. Once you get a couple of metres below the surface, your pictures will come out with a pronounced blue cast; by ten metres they will be completely blue. Water also reduces the overall light levels, requiring longer **exposure** times with a greater chance of **motion blur**.

There are two ways to get round this. The first is to shoot only in the first few metres of water and the second is to use a **flash**. Many cameras have a built-in flash, but these are worse than useless underwater. Not only is the output far too low to light a picture more than a few inches away, but you will suffer from 'backscatter', where the flash illuminates floating bits and air bubbles in the water making them appear as out-of-focus white blobs.

Shooting in the top few metres of water might sound restrictive but the light will be so much better. You might even be close enough to the surface to see dappled sunlight through the water. You will also able to shoot upwards to get the surface in the picture, which can look particularly dramatic. On a practical level, diving (or even snorkelling) at this depth is far less challenging, allowing you to spend time thinking about your pictures rather than your breathing.

If you choose to photograph deeper without a flash, bear in mind that you will have to make the most of blue pictures, as there will be a limit to how much you can correct the colours. One way to do this

> ### ⓘ Pro tip
> To avoid backscatter and to get a more pleasing indirect lighting effect, professional underwater photographers use a waterproof, off-camera flash. These are connected to the camera and housing and held away from the camera on long arms. Off-camera flashes are ungainly and cost a great deal of money so are only worthwhile for specialist photographers with diving experience.

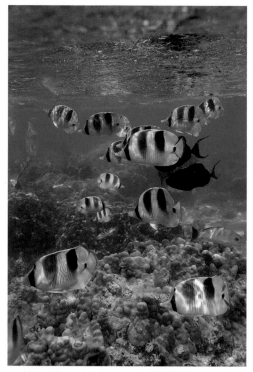

Fish on the reef, Huahine, French Polynesia ‹

Nikon D2x, ISO 100, RAW. 20 mm (30 mm equivalent). EWA-Marine underwater housing. 1/350 second, f9.5.

Snorkelling with an underwater housing means that you are shooting in the top few metres of the water and so experience fewer problems relating to light absorption. Here, I was shooting around midday when the sun was very strong, and it penetrated down to the coral and lit these brightly coloured fish. I still had to adjust the white balance in RAW processing to remove the blue cast.

> ### ⓘ Pro tip
> There are other uses for an underwater housing. I have shot a number of festivals with one, including the Tomatina tomato fight and the Songkran and Lao New Year water festivals in Southeast Asia.

Reef sharks, Huahine, French Polynesia >

Nikon D2x, ISO 400, RAW. 20 mm (30 mm equivalent). EWA-Marine underwater housing 1/320 second, f8.5.

These sharks are regularly fed and so are used to tourists, though it was still rather scary to see them looming up out of the gloom. A host of small brightly coloured fish were attracted by the feeding and the water was soon alive with movement and colour. Although I was snorkelling and never went very deep, the picture still had a pronounced blue cast which was corrected in RAW processing.

I used a wide-pattern focus setting that uses all of the focus sensors on my camera and I set them to focus on the closest object. A wide-angle lens allowed me to get in as much of the scene as possible and I taped this at the widest setting. I had to be careful that it wouldn't change and that the underwater housing wouldn't obstruct the lens, producing a vignette. As I had little access to the camera settings, I shot with the exposure set to automatic Program.

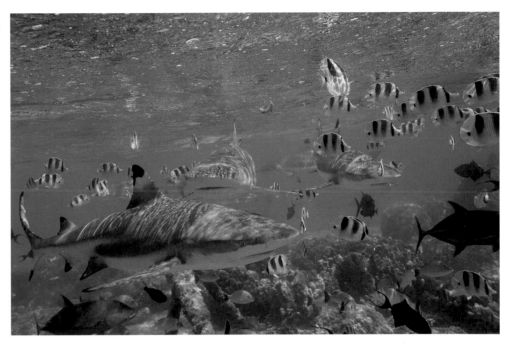

Purple coral growing on rock, Heron Island, Australia <

Nikon F5, Provia 100 ASA film. 21 mm lens. EWA-Marine underwater housing. Exposure not noted.

Snorkelling allows you to look down on things, such as this small outcrop of purple coral on the Great Barrier Reef. Shooting close to the surface meant that the subject is lit by pleasing, dappled sunlight, creating an atmospheric lighting effect.

is to compose your picture to show light and shadow. Introduce highlights, by pointing the camera up to the surface, and shadows, by pointing down to the depths. Combine either of these with something in the foreground and you will have a far more interesting shot than a flat blue image that is evenly but poorly lit. The blue effect is less pronounced with objects that are close to you, as there is less water between them and the camera, and at midday, when the overhead light is stronger and able to penetrate deeper.

In order to compensate for the absorption of light at all depths, consider increasing the **sensitivity** of the camera, so it can use a faster **shutter speed** and avoid blur.

Underwater composition
The refraction caused by water will actually change how your lens behaves, reducing the **angle of view** by a quarter and making objects appear about 25% closer and about a third larger. The upshot is that you will need to use a **wider-angle lens** than you would under normal conditions. Be careful that it is not masked at the edges by the housing, giving a black, vignette effect.

Don't be too ambitious with your shots. Unless you are an experienced dive photographer you are unlikely to get good pictures of tiny fast-moving fish, so concentrate on larger subjects: corals, turtles, large fish and even tightly packed shoals. Don't forget other divers and snorkellers, either. They can make fantastic subjects, especially if you can shoot them from below, backlit by the sun, and they are generally far more compliant than other underwater creatures.

Manual focusing can be very tricky through a diving mask and a housing, so opt for autofocus. I tend to choose a setting that uses a wide array of sensors that are set to focus on the nearest object. I also set the autofocus so that the camera won't fire until the subject is in focus, which will help to avoid blurred shots. As the light levels will change with depth, it is all but impossible to shoot with manual exposure so use an auto-exposure mode, probably the **Program mode**.

It can be very difficult to keep the camera still enough to compose and focus your picture properly, especially in strong currents. Resist the temptation to hold your breath when diving and taking a picture, as this can be very dangerous, and remember that

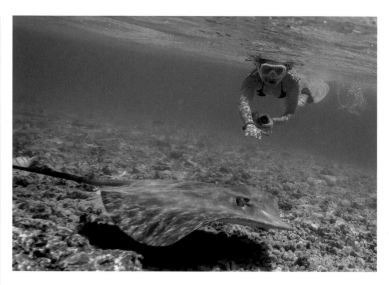

📷 Digital SLR

To moderate the blue casts from shooting underwater, shoot using the 'shade' white balance setting or a warmer manual setting, if your camera has this facility. You should also shoot in RAW so that you can boost the red channel and bring back the 'real' colours in post-production. The refraction effect of the water combined with the lens magnification factor of many DSLRs will cause a 35 mm lens to behave like a 75 mm lens; use a wider-angle lens to compensate.

🔍 Film SLR

Many serious underwater photographers have shot film but, if you don't have underwater lighting, you will struggle to correct the blue colour cast at all on scanned film. It's also worth bearing in mind that there are only 36 shots on a roll of film, meaning you will have to make a lot more trips to the surface than someone using a digital camera.

📷 Digital compact

Compact cameras are fairly well suited to underwater photography. Not only are the housings for them relatively cheap and small but you are risking a lot less by diving with a compact as opposed to an expensive SLR system. They are a lot easier to handle and shoot one-handed and the live preview facility makes focusing much easier than squinting down an optical viewfinder. Even if you shoot with a DSLR for the rest of your travel work, you could do far worse than taking along a compact and casing for underwater shots. The drawbacks of using a compact are the weak flash and the fact that you will probably be shooting JPEGs, making any post-production colour balancing a lossy process.

all the difficulties associated with photographing underwater are magnified at greater depths.

Keeping it dry

There are two basic types of housing: hard plastic and rubber bag. Each has its own advantages and disadvantages. Hard plastic housings are expensive and tend to be designed for a particular model of camera. What's more, their size and weight makes them unsuitable for general travelling. They do offer access to all of the camera functions, though, and are waterproof to a great depth. Hard cases for compact cameras are far smaller and much more affordable.

Rubber bag-style housings will fit a number of different camera models but offer little control to the photographer. You will struggle to zoom when underwater and will have to programme all the settings before you dive. They are relatively cheap, pack flat and are very light but do get compressed at depth. They might not leak at 10 m but your camera will resemble shrink-wrapped sausages. These housings are, therefore, more usable at a shallower depth.

Leaks can be catastrophic for expensive photographic equipment. Service your underwater housings regularly and, before you dive, take the empty housing down to your diving depth to check for leaks. Condensation can also be a serious issue, so use packs of silica-gel desiccant in the housing to avoid moisture damaging your equipment. I would also recommend taping up battery and flash card compartments and even wrapping your camera in cling-film to stop small leaks of water seeping in. Re-check the housing is watertight at regular intervals during your dive.

A lot of equipment is buoyant, so may be easier to handle if it is weighted down underwater. You should definitely attach all of your kit to your person during a dive, so that if you drop it, it can't either float away or sink to the bottom.

**Swimming with rays,
Moorea, French Polynesia** ⌃

Nikon D2x, ISO 100, RAW.
16 mm (24 mm equivalent).
EWA-Marine underwater housing
1/400 second, f8.

Rays don't fill much of the frame unless you manage to get underneath them and shoot from below. Shooting a snorkeller reaching out to a ray underwater is a way of filling the frame and shooting a more interesting image. Don't forget people when you are photographing underwater. They will often be the largest and slowest moving thing that you will encounter, and probably the most compliant, making photography much simpler.

Other tourists

There is a temptation only to shoot pictures with no tourists in them, but other travellers, their reactions, interactions and pursuits can create a number of interesting images. Photographs of travellers interacting with locals can make it easier for people looking at your photographs to imagine being in a particular situation. There are also a number of opportunities for humorous encounters and for showing tourists in incongruous positions.

In many popular places you won't have any option but to include tourists in your pictures. Some sites are so crowded that there will always be someone around. If this is the case, try to incorporate them in such a way that they complement the image. If there is a group of people posing for a picture in front of a famous monument, get up close behind the person taking the picture and get a

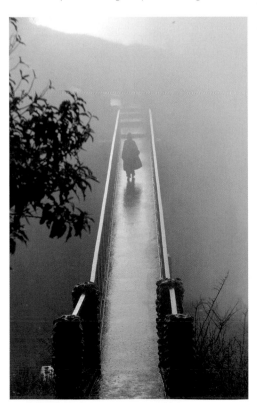

Waterfights at Lao New Year, Luang Prabang, Laos >

Nikon D2x, ISO 400, RAW. 24 mm (36 mm equivalent). 1/800 second, f5.0

Tourists and their interactions with locals are an important part of any destination. This picture of Westerners taking part in the chaotic waterfights at Lao New Year shows what it is like to actually visit the city at this time; it helps someone looking at the picture to imagine what it would be like to be there.

Elephant ride, Thailand >

Nikon F4, Provia 100 ASA film. 28-70 mm lens. Exposure not noted

Elephant rides are always popular but photographing from an elephant is not easy. Photographing during a ride, rather than at a staged moment such as the mounting or dismounting will give much more natural pictures. Cropping widely and including the river that the elephant is walking through places more emphasis on the environment and the elephant, and less on the people.

In the spray at Victoria Falls, Livingstone, Zambia <

Nikon D2x, ISO 100, RAW. 70 mm (105 mm equivalent). 1/320 second, f5.0

If you travel with other people, you will always have someone to include in your picture. In this case I sent them out into the spray which hangs over Victoria Falls, drenching everything. This small footbridge was glistening in the late afternoon light. Backlighting has added to the misty effect and the figure in the picture provides just a suggestion of a person, without giving any details about them at all.

shot of all of them. Or take a picture that illustrates the very act of sightseeing: the crowds that gather in front of Angkor Wat, for instance, waiting for that perfect sunrise shot. After all, tourists are as much a part of the travel experience as buildings and local people, and your pictures should reflect this.

Sometimes there will be so many people that you won't be able to photograph them in a controlled fashion at all. In this case, simply take a picture of the crowds. It might be a sea of silhouetted figures in St Mark's Square in Venice or the Spanish Steps in Rome completely covered by tourists. You can also take a picture conveying the vast numbers of tourists visiting a famous travel monument by shooting with a long **exposure** so that they form a river of blurred figures. If you use enough **neutral density filters** you can even shoot an image like this in bright sunlight. This will create the impression of crowds of tourists, without actually showing them.

Another option is to photograph the people with whom you are travelling. This can be a good way

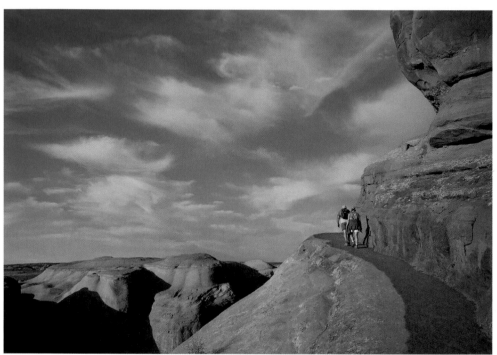

Tourists trekking in Arches National Park, USA ‹

Nikon D2x, ISO 125, RAW. 20 mm (30 mm equivalent). 1/160 second, f8

The trail to a popular sunset point in Arches National Park leads through some fantastic scenery and, at one point, is cut into the side of an almost sheer cliff face that drops away sharply. Including some tourists in the picture adds interest and a sense of scale, even though the picture shows very little about them.

to balance your needs as a photographer with the needs of a travelling group. It certainly means that you will have a ready supply of models. This can be especially useful if you want a silhouette in front of a sunset, or a willing body to throw themselves from a bridge on the end of a bungee rope. If you have been taking shots of the other travellers for a period of time, they are more likely to be relaxed and natural in front of your camera. You will also have the language skills to communicate with them and will be able to direct them if necessary. Another advantage of photographing fellow travellers is that you can get them to sign **model releases**, which will make your pictures more saleable if you decide to put them in a photolibrary.

Try to take natural-looking shots. Posed pictures of travellers grinning at the camera have their place but not within a travel photography portfolio! And avoid merely documenting other people's enjoyment of the trip; it is important to take part and enjoy yourself as well.

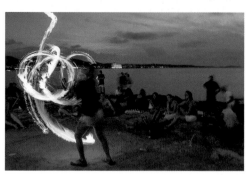

Fire juggler outside Café del Mar, Ibiza, Spain ‹

Nikon D2x, ISO 100, RAW. 17 mm (26 mm equivalent). 1 second, f4.5

Famous for its chill-out sunsets, the Café del Mar attracts tourists and buskers to watch the sun slip into the sea. Shooting with a slow exposure I was able to record the ambient light and the movement of the fire juggler who was entertaining the crowd.

You don't have to have recognizable people in your shots for them to be effective. Having a small figure in the distance can give scale to a landscape, while a group of people trekking or kayaking in a corner of the frame gives you a picture in which the activity and the location are of equal importance. Be prepared to direct people so that they can be in the desired part of the image.

Family travel

Unless you have the world's most understanding partner and the best behaved children on the planet, then a family holiday is fairly incompatible with travel photography. The time and flexibility needed to get up for sunrise, still be out photographing at sunset or wait in one place for the light to be right can drive the rest of the family mad! You can still shoot travel material on a family holiday, but you will have to be realistic about how much you are likely to achieve.

If you are staying in a city, then it is a lot easier to find things to photograph, but don't despair if you are staying at a beach resort. There are always beautiful images, beach shots and sunsets to photograph. If all else fails then shoot a series of images about people on holiday. Try to find out about locations close to where you are staying so that you can get up and take some photographs at sunrise, without inconveniencing the rest of the family. You could also negotiate a day off to devote to photography in return for giving your partner a day off later in the holiday.

You might travel thousands of miles and take pictures of other people's kids but how about your own? Your small subjects are likely to be more relaxed than strangers' children and you might get images that you will treasure forever. If you are trying to make some money from your photography, then having a family in tow can be a positive advantage. Limiting your photography to places where families hang out and taking pictures of your own family at play can be just what a lot of travel companies are looking for. What's more, **model-released** images (see page 305) can command much higher prices.

Amber and Alex at the Gorges de l'Ardèche, France ❮

Nikon D3x, ISO 250, RAW. 14 mm. 1/125 second, f5.6

Many people love to photograph children when they travel, so why not spend the time capturing your own children as they explore the new and unfamiliar world around them? Here, my children try their hands at rowing on the Ardèche with varying degrees of success.

Tresco, Isles of Scilly, England ❮

Nikon D2x, ISO 100, RAW. 86 mm (129 mm equivalent). 1/250 second, f6.3

You might not make it to the most exotic places if you travel with your family but there are still options for travel photography if you use your creativity. This image of Tresco Island works on a number of different planes to create an interesting image. Learning to take interesting pictures in less exciting places is a great way to test and develop your travel photography skills.

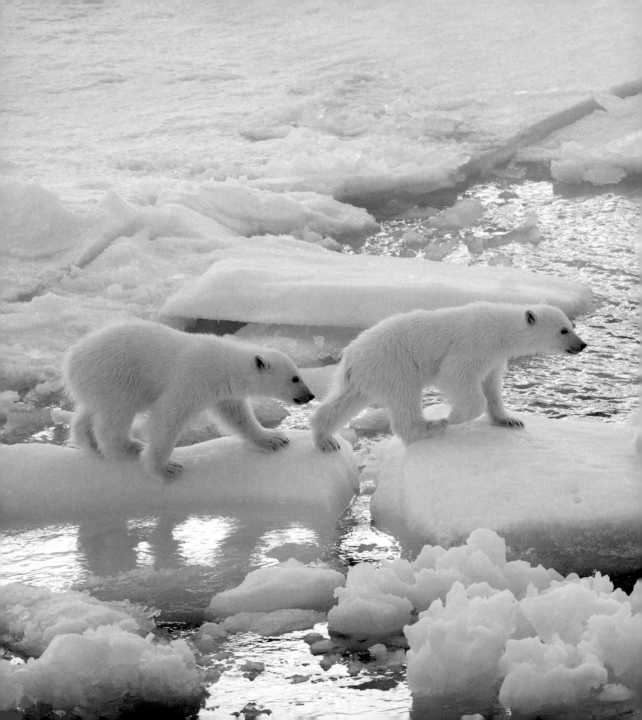

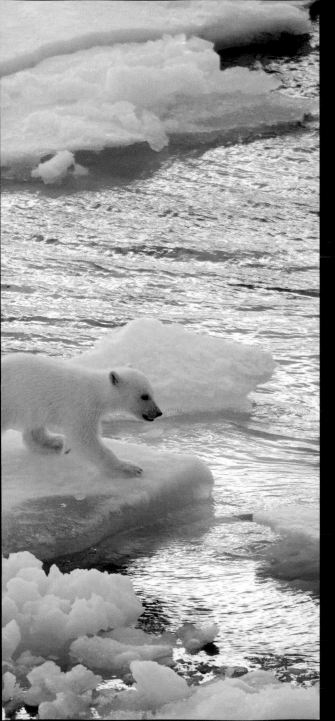

Post-processing your images is an integral
photography, especially if you are saving y
format. This section will look at some of the
enhancements and edits that you can carry
these techniques will compensate for the i
the photographic process and, in essence,
more real. I have avoided the term 'manipu
about getting your images closer to how y
you took it, rather than creating new image
for so-called digital art, but not in this book
enhancements will also be relevant to film
who scan their pictures to make digital ver

Polar bear cubs in Svalbard, Norway

Nikon D2x, ISO 160, RAW. 300 mm (450 mm equivalent).

The white balance of this image was altered and the sp
RAW processing, using Adobe Lightroom.

Principles

Digital correction, as opposed to digital manipulation, is about enhancing your photographs and getting the most out of them. It is about compensating for the inherent weaknesses in the photographic process rather than trying to create something new. I have never really liked heavy digital manipulation. This section won't be teaching you how to add a perfect sky to an overcast picture or how to drop an unrealistically large moon into your night shots. It will show you how to process your RAW files and make improvements to them. This will include increasing your camera's dynamic range and retouching out dust marks. There are usually a number of different ways to carry out each correction to an image, so, in most cases, I have detailed what I consider to be the simplest, most appropriate solution.

This section also covers some of the enhancements that you can carry out on **JPEG** images or on the high-quality images produced from **RAW** conversions. If your camera doesn't allow RAW shooting, or if you just want to shoot JPEGs, then these enhancements will enable you to get the most from your pictures. However, you should bear in mind that the more you tweak the tones, colours and **contrast** of an image, the more quality you will lose. For minor corrections, this may be largely indistinguishable but, if you make a major edit, such as correcting a strong **colour cast**, then you might see areas of banding on your image. This is when areas with smooth gradations, such as the sky, lose their smoothness and appear patchy.

 Image correction is not confined to users of digital cameras. Many film photographers scan their pictures to create a digital version that can be corrected, enhanced, printed and displayed online. In general,

Bathing elephant, Sonepur Mela festival, Bihar, India ⌃

Nikon D2x, ISO 200, RAW.
12 mm (18 mm equivalent).
1/200 second, f5.6

To get the best angle for this shot I had to stand in the river. Getting close added some dynamic distortion on the elephant's trunk and there is a bit of subject blur from the movement. While slightly overexposed, this image was corrected in RAW processing by reducing the highlight exposure by half a stop and using the highlight recovery tool. I also cropped out a press photographer who was in the boat on the right. The uncropped image is on page 254

Pico do Arieiro, Madeira ⌃

Nikon D2x, ISO 100, RAW.
12 mm (18 mm equivalent).
1/160 second, f8

The sky in the top left was backlit and bleached out. To bring this back into register, I previously had to paste together two versions of the RAW file in Photoshop to make a more evenly exposed composite. Using the new graduated filters in Lightroom I was able create this version with less effort.

you should scan at the highest **resolution** and **bit depth** that you can and save the image in **TIFF** format ready for post-processing. There are a number of commercial laboratories offering high-quality scans from negatives and transparencies. Flat-bed scanners can also be used to scan transparencies and negatives, but you will usually get far better quality using a bespoke film scanner. For my archive of transparencies, and for all of the images in this book which have been scanned from 35 mm film, I have used the Nikon Supercoolscan 5000, a professional quality film scanner.

 There are whole books written on RAW processing and countless more on the corrections that you can make to your photographs. This section aims merely to provide an introduction to what you can do with images on your computer. Certainly, if you master these techniques you will be able massively to improve your pictures but, if you want to take your skills further, then I would suggest investing in one of the many **Photoshop** books on the market. I recommend *Get The Most From Photoshop*, by Simon Joinson, an old friend whose expert advice has been a great help in the production of this book.

 Two other books that are worth considering are *The Adobe Photoshop Lightroom 5 Book for Digital Photographers* and *The Adobe Photoshop Book for Digital Photographers*. Both of these books are written by Scott Kelby and published by Peachpit Press. Scott also runs an online training site, *Kelby Training*, which extensively covers both Photoshop and **Lightroom**.

Software

There are many different software options available for processing RAW files and correcting images on a computer. However, Adobe Systems have largely cornered the market and their flagship product Photoshop has, become a general term to describe image manipulation. People now talk about images being "photoshop'd", irrespective of the software used. To reflect this trend, this book concentrates on Adobe Photoshop for image correction and Adobe Lightroom for RAW processing. Even if you don't use this software, this section should help you to understand the sort of tools that you will find on competing programs and what you can do with them, although for more precise information you might have to refer to the manual.

Bear in mind that software programs are regularly updated; there will be slight differences in the nature, look and location of certain tools, depending on the version you are using. There will also be a marginal difference in appearance, depending on whether you are using Windows or Mac OSX.

Image-correction software

Adobe **Photoshop** is the pre-eminent image manipulation and correction program but it is expensive, costing the same as an entry-level camera. To save money, many photographers stick with older versions of Photoshop or use alternative programs, such as *Paint Shop Pro* and *Corel PhotoPaint*. Most of these programs will behave in a similar fashion, especially when dealing with simpler corrections. The tools might look slightly different and may be located in a different place, but they will essentially do the same thing in the same way. This section focuses on the latest version available at the time of writing: Photoshop *Creative Cloud (CC)*, although I try to outline any differences between this and some earlier versions.

Adobe introduced *Creative Cloud* as a subscription model whereby you effectively lease rather than buy the software. The advantage of this is that you will always have the latest versions of the software; the downside is that, if you stop your subscription, then you can no longer use it. Photoshop CC will be updated incrementally, and some functionality and interfaces will be different from those shown here.

Although simpler and cheaper than Photoshop, Adobe **Elements** offers a lot of the functionality of its more expensive sibling and is still offered as a standalone piece of software rather than part of the Creative Cloud. Many of the Photoshop tools covered here can also be found in Elements, and it represents an excellent solution, especially if combined with Adobe **Lightroom**. Elements also offers a number of step-by-step task-based solutions and auto-fix solutions that can often improve your images without complicated editing. I have indicated when you can perform any of the editing functions using Elements and have also highlighted some of the one-click solutions that Elements offers. At the time of writing the current version of Elements was version 11. As the software is so cheap, it makes sense to keep up to date with the latest, most functional version.

Other task-based imaging software options include Google's *Picassa* and many of the simple image-viewing programs that have one-click solutions to enhance an image. Some of these programs will have Enhance or Adjust facilities that will offer limited editing of exposure, colour balance and saturation.

RAW-processing software

All of the main camera manufacturers have bespoke software available for processing RAW files from their own cameras. Often these produce higher quality RAW conversions, as they are designed to get the best out of one manufacturer's camera, rather than out of all of them. There are also a number of third-party solutions on the market, some of which are surprisingly versatile and good value. (There are even a number of free programs available.) *Bibble* is a relatively cheap program that has a number of fans, as does the more sophisticated *Capture One*, by manufacturer of high-quality digital camera backs, Phase One. If you use the Mac OS, then *Aperture* is an integrated management and RAW-processing application.

Adobe Lightroom is a combined image-management and RAW-processing solution that also allows you to manage printing, slide shows and even web gallery creation. Lightroom uses the same RAW-processing engine as the Adobe **Camera Raw** (ACR) plug-in that is a part of Photoshop. The controls that I outline here are common to both Lightroom and ACR and, indeed, a number of third-party and camera manufacturers' products, although the look and feel will be different. If you use Elements, then it comes bundled with a cut-down version of ACR, which has many, but not all of the tools present on the full version.

In this chapter...
I have used the convention of showing the location of menu commands in square brackets and using > to show sub-menu entries. So [View > Show Histogram] means that you find the Show Histogram command in the View menu.

Storage and image management

Managing and storing a large collection of digital images can pose a few problems but not as many as storing the equivalent number of transparencies. I still have three filing cabinets of mounted transparencies in the corner of my office that I am in the process of scanning. All of the best shots from these filing cabinets can be stored on a couple of high-capacity hard drives that would take up far less space.

The key to managing your digital image collections – whether shot with a digital camera or scanned from film – is the software that you use. Adobe **Lightroom** is a combined image-management and RAW-processing program, but there are other image-management programs available. Some are free; others you have to pay for. The one that you choose will depend on the number of images you have, your budget and your own preferences. Most program providers will allow you a free trial, so it is worth exploring the different options. After I import the pictures into Lightroom, I edit them and then, automatically, give each one a unique sequential number. This means that pictures can never be accidentally copied over each other.

Organization

You will need to decide what file structure you are going to use to organize your pictures. File management software, such as Lightroom, can organize images in folders by date, or you can instruct it to use your existing folder structure. This is the option I prefer, as it allows me to order images by country and to place; and locate pictures easily. Some software, such as *Apple Aperture*, gives you the option of storing original image files inside its catalogue, which ties you to a particular software option, and the resultant massive catalogue file is less easy to back-up. Whatever structure you decide to use, give it some thought in advance and make sure that your system can grow as your library grows.

It is important that once you have imported your images into a catalogue, you don't move or rename them outside the software, as this will result in the software 'losing' them. It sounds obvious, but you should also make sure not to delete any of the original files, as these are still needed.

Captions and keywords

The larger your image collection, the more difficult it will be to remember where each picture was taken and what it shows. Most image-management programs allow you to caption your images. This can be good practice, even if you aren't planning on selling your pictures; if you are thinking of working professionally, then it is vital.

You can also apply keywords to your image. These are words or phrases that will help you (or someone else) to locate your images. Keywords can be descriptive (such as green, leaves, woman), photographic (blur, vertical, landscape) or conceptual (alone, bravery, childhood). Keywords aren't so important if you will be the only person looking through your pictures but, if you are thinking of publishing them on a searchable website or working professionally, then they can make the difference between your pictures being found or never seeing the light of day. Many of the photo-sharing sites, such as *Flickr*, will automatically import keywords as tags. These can be searched for and will help to get your work seen by more people.

In Lightroom you can apply captions and keywords to your **RAW** files. These are remembered by the software, along with any of the RAW-processing commands, and applied to the image every time you export a finished version. This information is stored in the image metadata, along with the information that is written there by the camera, which includes the equipment used and the **exposure**. You can also include copyright information and your contact details. This information can be added automatically to all of the pictures you import into Lightroom and is useful if you make pictures publicly available. Although this information could be stripped out by unscrupulous users, it gives genuine clients a means to contact you if they want to use a picture.

Back-ups

It is vital to back up your pictures. There are currently no storage options available that are not susceptible to corruption or deterioration over time. Add to this the risk of fire, flooding, loss or theft and you can see that having a comprehensive back-up strategy is essential to protect your photographs.

The secret to any back-up strategy is anticipating all of the things that could go wrong. The first thing that you need to address is corruption of digital media, due to corruption of the data on a disk or a complete mechanical failure. The simplest solution is to keep a copy of all your pictures on a second hard drive. Hard

Lightroom library module

The Library module allows you to import, edit, store and organize your images. The main parts of the library module are as follows:

1 *Folders and Collections panel* – allows you to organize your pictures into folders and add them to various collections.
2 *Main window* – displays a preview of the selected image, or a lightbox of thumbnails if you click the thumbnails icon.
3 *Filmstrip* – shows pictures in any selected folder. Can be filtered by metadata, rating or colour label.
4 *Histogram* – shows a histogram of the selected image.
5 *Metadata panel* – allows you to view and edit the metadata of your image. This includes adding keywording, captioning and copyright information.
6 *Module picker* – allows you to select various modules, including Web, Develop and Library.
7 *View options* – to select thumbnail grid, side by side compare or loupe mode

drives have never been cheaper or larger, allowing you to keep a copy of all your work for a relatively small amount of money. You can either maintain the back-up automatically using software, or manually. Remember also to back up any catalogue files from your image-management software or you could lose any captions, keywords and edits that you have made.

If you do have a problem with a hard drive, there are a couple of solutions you can employ. A recovery program will bypass the disk's directory structure and find lost documents directly. If this doesn't work, there are companies that specialize in data recovery, although the problem with digital imaging is that the file sizes are often very large and many of these companies charge by the megabyte. The easiest and cheapest option for file recovery, though, is a recent and comprehensive back-up.

If all of your back-up options are stored in the same place, then your work is not secure. A fire, flood or break-in can cause you to lose all of your back-ups in one go. Storing a hard drive in a separate location is a good start but these are more difficult to keep updated. I keep a full set of disks in a fire safe in my office!

You can also use 'cloud' storage options, which can store your images on a remote server, which is accessed via the internet. Whatever happens locally, you have copies of your images. Some cloud services can also be used to display online galleries of images. If you save your best images as high-quality JPEGs, you can back up many thousands of images for a relatively small amount of money. One of the cheapest cloud solutions is Flickr. Currently this allows you to store a Terabyte (TB) of images for free, although you will need a good internet connection to upload such large amounts of data. The best option is to have at least two back-ups, with one stored either off site or online.

Storing film

Storing film presents a number of unique problems. Film needs to be stored in a cool place in acid-free archival sheets or it can rapidly degrade and fade. If you have mounted transparencies, then the best place to store them is in hanging sheets in a filing cabinet. Strips of negatives and un-mounted transparencies can be stored in sheets in a lever arch file. Never store film together with prints, as the latter often contain residual chemicals that can affect film.

One of the best long-term solutions for storing negatives or transparencies is to scan them and store the image files on your digital system.

Editing your work

Once you have imported all of your pictures into your image-management software, the next step is to edit them. For me, this involves assessing each picture and throwing away any that don't make the grade for any reason, whether it be focus, composition or subject matter.

Some photographers advocate that you should never throw any pictures away; others simply don't want to spend the time editing. I feel that editing is a vital step for a number of reasons. Firstly, if you edit with the vital metadata showing, then you can review your technique as you go through your pictures and learn where you need to improve. For instance, if you see a series of pictures with **camera shake**, check the lens and **shutter speed** used. This will let you know what speed you should use next time you take pictures in low light. You might also check the **ISO sensitivity** and realize that you could have increased this further to allow a faster shutter speed to have been used. Look for patterns or errors, and then work out what you should have done at the time. In this way, you can be continually learning and developing your technique.

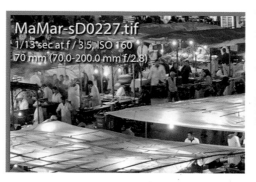

Secondly, if you edit once properly, then you can make subsequent selections of pictures far more quickly, safe in the knowledge that all of your potential choices are of a good enough quality to be used. Finally, if you are shooting **RAW** then the file sizes will be relatively large. The amount of disk space needed for storing and backing-up superfluous pictures will quickly mount up. I can easily shoot 5000 pictures on a trip, and on average I usually discard between 40% and 60% of them. At 50MB

Image Info Overlay ‹

When you are editing your pictures you can overlay the essential metadata that shows what focal length, shutter speed and aperture you used to shoot the picture. This can help you to improve your technique and identify any mistakes that you have made.

Selection of edited images in Lightroom ‹

Lightroom has a comprehensive series of editing tools, allowing you to select pictures as picks and flag them for deletion. The pictures selected for deletion can be thrown away as a single batch.

for a RAW file, this can equate to 125 GB of pictures to be thrown away, which is a significant volume of data to be keeping for no reason. Stringent editing can halve all of your storage and back-up costs, as well as making the whole process of management and storage much simpler.

When you are editing pictures, there are some things that can be corrected in post-production, such as moderate **over-** or **underexposure**, and something that cannot, such as focus or the appearance of camera shake. Consider which pictures can be adequately corrected when you are deciding which pictures to keep and which to delete. You should also bear in mind which pictures might benefit from a degree of cropping. This can dramatically improve an otherwise lacklustre image which might otherwise be deleted.

Although you should be stringent with your editing, don't throw away irreplaceable or personal shots just because they are flawed in some way. These are always worth keeping, even if you store them in a separate folder to your main collection.

Editing tools

To adequately check the focus, you should always zoom to 100%. If you assess pictures on a thumbnail, or even a standard preview, then you can inadvertently keep a better-looking but out-of-focus version of two options, throwing away the correctly focused version. Zooming to 100% can take some time, as **Lightroom** has to draw a full-sized preview each time. You can get around this by creating all of the 100% previews in advance [Library > Previews > Build 1:1 Previews]. This might take 5 or 10 seconds per picture, but this can save the equivalent amount of time every time you zoom. I will often create previews overnight, before I start editing a batch of work.

There are some specific tools that you can employ when editing a batch of images in Lightroom. If you hit the P key, you can flag a picture as a 'Pick'. If you hit the X key you can flag a picture for deletion. If you want to Unflag any of your pictures, then use the U key. All of the pictures that are flagged for deletion can be thrown away as a batch once you have finished editing.

When you are editing your pictures, switch on the Metadata Overlay using [View > Loupe Info > Show Info Overlay]. You can configure what information is shown by selecting [View > View Options…]

Side by side comparison of images during editing ∧∨

If you edit pictures without zooming to check the focus, then you run the risk of keeping an apparently better image that in fact lacks critical focus and throwing away the more in-focus shot. I slightly prefer the facial expression of the picture on the right, but when zoomed to 100%, the image on the left has the better focus.

Focus on

Snake charmers, Jemaâ el Fna, Marrakech, Morocco

This picture is a true example of pre-visualization. I have travelled to Marrakech a number of times, and before my most recent trip, I was trying to think of a unique way to photograph the snake charmers in the main square. I came up with the idea of shooting with the camera right up close to the snakes from a low angle.

I used a collapsed tripod to hold the camera right in front of the snakes and a wireless release to trigger the shutter. My closest hand was still only a couple of feet from the snakes which was a rush, even though I assumed (hoped?) that they would have had their fangs removed. I was using the Nikon 14-24 mm lens which has an incredibly wide field of view and a very close focusing distance. This allowed me to get really close, which gave a very dynamic image.

I didn't use Live View, which as the name suggests gives a live view of the subject on the LCD preview screen, mainly as I wanted to keep an eye on the snakes just in case, but adjusted the composition based on each picture as it appeared on the screen after shooting.

This image needed a lot of post-processing. The snakes were very dark and in shadow, and the background was in bright sunlight. Even shooting RAW, the dynamic range of the scene was too great to process into a single image, so this shot is actually a composite of two different versions of the same RAW file. These were biased to bring out the two main parts of the picture.

Creating this image wasn't too time-consuming, since most of the versions came from the same exposure, so there was no problem aligning them.

Some people would say that this is cheating, but I would say that all I have done is use post-processing to compensate for the limitations of the photographic medium. In the same way that photographers used to adjust images in the darkroom, I have worked on the highlights and shadows to create a more realistic image. This image looks more like the scene I saw when I was shooting, which is what travel photography is all about.

⊕ **Find out more**　　　　　　　>

Nikon D3x, 400 ISO, RAW.
22 mm. 1/250 second, f8

Cropping and straightening

Cropping can be used to zoom in closer or to change the composition of an image. Most professional photographers and all magazines will use it as a creative tool to improve images. Cropping can either be done in RAW processing or in Photoshop. Both use a similar process, although I tend to prefer making crops at the RAW-processing stage, as the software will remember the crop and you can go back and edit it indefinitely. The actual RAW file is not cropped; all of the information is preserved in case you change your mind.

One important thing to remember when you are cropping is that the cropped information is lost as soon as the file is saved. In other words, if you crop half of a 12 megapixel image, you will be left with 6 MP. If this is then blown up to the same size as the original, there will be a loss in quality. However, thanks to the high **resolution** of most current digital cameras, this isn't likely to be a real issue unless you crop massively into the frame.

Cropping in Photoshop or Elements
- Select the Crop tool.
- Adjust the handles on the corners and sides of the image to change the shape of the crop. If you hold down the Shift key when you are doing this, it will maintain the **aspect ratio** of your image. You can click inside the frame to move it around the picture. The cropped-out part of the image will be masked in grey.
- Double click inside the frame to make the crop.

Cropping in Lightroom
- Select the Develop module and click on the Crop Overlay tool.
- Draw over the area you want to crop. If you hold down the Shift key while you are doing this, it will maintain the aspect ratio of your image.
- Adjust the corners and change the shape of the crop until you are happy, or click inside the frame to move it around the picture. The cropped-out part of the image will be masked in grey.
- Click again on the crop or any other tool. The crop will be carried out on the preview image and a crop icon will appear in the corner of the image thumbnail.
- If you want to change or remove the crop, go back into the cropping tool and adjust the crop.

- The RAW file itself is not affected, but any images that you then export from **Lightroom** will be cropped.

Straightening
If you aren't shooting on a tripod and using a spirit level, it is highly likely that your horizon won't be entirely straight. Most of the time this isn't noticeable, but if you have an obviously flat horizon, such as the sea, then it can look plain wrong! This effect can be exacerbated when shooting from a boat. You might have to take a number of shots to get one with a straight horizon.

Lightroom tools ⌄ ‹

Lightroom has a comprehensive set of tools to straighten and crop an image. There is an artificial horizon tool and a slider which allows you manually to straighten in either direction.

When you straighten in Lightroom, the blank space of the image is automatically cropped out. Best of all, these edits are non-destructive. They are remembered by Lightroom and applied when you export or output the image. The original RAW file is left untouched, and you can revert to the original uncropped and un-straightened version at any time.

Luckily, you are able to correct this easily in post-processing. Again, you can choose to do this in RAW processing or in **Photoshop** and, again, my preference is at the **RAW**-processing stage. Lightroom has dedicated tools for correcting horizons and the RAW software will remember the change, so that any subsequent versions will have a corrected horizon. If you correct the horizon in Photoshop, it is a more arbitrary process, and you will have to make the correction again if you re-export a different version of the RAW file or work on a new version of an original **JPEG**.

The Straighten and Crop tools are fairly interlinked, as the software has to crop out any blank areas created by the rotation. Lightroom does this automatically but you will have to do it yourself in Photoshop or **Elements**.

One thing to be aware of is that some of the edges of the picture are cropped when you straighten a horizon. If you have any vital detail near the edge of the frame, this will be lost. In these instances you will have to take a judgement as to whether to lose the detail or keep a wonky horizon! If you are photographing from a boat and know that you will need to straighten the horizon later, it is worth composing the shot with a very loose crop so that you won't have to lose any detail later.

Straightening in Lightroom

- Select the Crop Overlay tool. This activates and shows the Straighten tool. You have two options: a slider and a horizon tool; I prefer the latter.
- Using the Straighten tool, click and drag a line along the horizon you want to straighten. Lightroom will automatically crop out the extraneous parts of the image. The slider allows you directly rotate the image but I find it less precise.
- You can also use the Straighten tool to straighten vertical lines, such as trees or buildings.
- The software will remember the change and will apply it to the preview image and any subsequent exports of the RAW file. As with any change to a RAW file, this is non-destructive, and you can reverse this change at any time.

Straightening in Photoshop

- Select all of the image using [Edit > Select All]
- Activate rotation using [Edit > Transform > Rotate]
- Drag the handles on the corners of the image, manually rotating it until the horizon looks straight.

Straightening an
image in Camera Raw ∧

- Double click in the selected area to make the rotation.
- Crop out the blank parts of the image using the techniques on page 252.

Rotating an image
in Photoshop to
correct a wonky horizon ∧

Straightening in Elements

- Click on the Straighten tool
- Click and draw a line along the horizon you want to straighten.
- Crop out the blank parts of the image using the techniques on page 252.

Developing RAW files in Lightroom

A RAW file holds a lot more information than a JPEG and allows you to perform edits and enhancements without any loss of quality. Most notably, you can change the white balance setting visually using a calibrated screen in a controlled setting. The drawback is that you have to process the RAW file on a computer using special software.

Photographers disagree as to how much editing and correction work should be done in a **RAW** processor and how much should be done in **Photoshop**. My method of working is to use RAW-processing software to carry out changes to the whole of the image and then to use Photoshop for local changes on selected areas. Recent versions of **Lightroom** and Adobe **Camera Raw** (ACR) allow you to make localized corrections to areas of the image. There is even a tool that seeks to emulate the use of a **graduated ND filter**. Combined with the tools for straightening, cropping, combating red eye and simple retouching, this means that, on the face of it, you could now perform most of your post-processing in Lightroom. Even so, the selection tools in Photoshop are currently more sophisticated, and the program allows you

to work in layers for greater flexibility. Photoshop's retouching tools are also far more advanced than those of Lightroom and ACR, so I would still advocate using it to make local corrections. I also find the controls on Lightroom tend to be more intuitive and more geared towards photographers than those on Photoshop.

I make as many corrections as possible in Lightroom. As it is non-destructive it doesn't change the original RAW file; it simply records all of the settings you have made in a separate structure. If you need to revisit the original image then you have the option of starting from scratch, or editing your previous settings.

When I have completed all of my edits in Lightroom, I export the image as an 16-bit **TIFF** and then perform final tweaks and any retouching in Photoshop before converting the file to an 8-bit TIFF and archiving the image. You can skip the 8-bit TIFF stage and simply use the edited RAW as a master image to export and publish as needed, but I have some pictures that are edited in Photoshop, as well as some scans from transparencies in TIFF format. Using TIFFs as my finished master copies means that I always know that these are the latest finished versions, with all tweaks and changes made.

Lightroom Develop Module Interface ‹

This image is the unedited version of the image shown on page 242.

1 *Module selection* Lightroom uses seven different modules to manage your pictures.
Library allows you to move, sort and organize pictures, as well as view and edit the existing metadata, creating captions and keywords.
Develop is where you apply different settings for RAW processing. These are the tools that also appear in ACR and most other RAW processors.
Map allows you to read gps tags and plot them on a Google map.
Book allows you to create photo books to be printed by the more popular third-party sites.
Slideshow allows you to create and export slideshows of images.
Print is where you can tailor print settings for different printers.
Web allows you to create and upload online galleries.

2 *Histogram* – shows the levels in the image.
3 *View options* – allow you to change the view.
4 *Image editing tools* – allow you to crop, straighten, retouch, correct red eye and make localized corrections to your image.
5 *Develop module panels* – allow you to access the various panels of tools to develop your RAW files. Once you have made the settings, you can select multiple images in the Filmstrip, and are able to synch the RAW settings by clicking the Sync… button.
6 *Clipping indicator* – shows areas of overexposure. Activate using [View > Show Clipping].
7 *History panel* – allows you to move back one or more RAW-processing steps.

Getting started

To process your RAW files in Lightroom, add the desired pictures to a collection, or navigate to them in a folder, then click on the Develop panel selector. You can select any pictures in the film strip and process them using the Develop tools.

The tools in the Develop module are broken down into panels by Lightroom, but other RAW processors will organize them in a different way and some won't have as many options. The RAW processing tools that appear in Lightroom also appear in the Adobe Camera Raw, in Photoshop CS6 and CC. Earlier versions might have similar tools, but will not be able to access RAW files from more recent cameras. To get around this, you can convert your RAW files to the open Adobe DNG (Digital Negative) format first, using the free Adobe *DNG Convertor*, before processing the DNG in your version of Lightroom or ACR.

If you use ACR with Adobe Elements 11, then you can only access a more limited selection of tools: Auto, Basic controls, Sharpening and Noise reduction controls.

RAW-processing tools

Although there are a vast array of tools in Lightroom, in my experience, you can process the vast majority of your images just using the Automatic functions and the Basic panel tools. That doesn't mean that you don't need to understand the other options, but if you have correctly exposed in camera, then most RAW processing should be able to be carried out with a few simple steps.

Automatic

Most RAW processors will allow you automatically to set the **white balance** and the tone. Often this will give a good result – usually better than the equivalent functions on a camera, as the processor is analyzing the **histogram** of an existing image, rather than calculating things on the fly. Although I wouldn't necessarily recommend it as the best working method, batch processing all of your RAW files to **Auto White Balance** and Auto Tone will probably give you better results than shooting **JPEG**, particularly as you can always manually reprocess any files that are unsatisfactory.

Basic panel

These controls allow you to make all of the basic edits to your image: controlling white balance, **saturation**

and tonal corrections. These tools work with sliders, and the default setting is zero unless otherwise stated.

White balance This should be the first and last adjustment that you make to an image. First, so that you make all subsequent changes to a white-balanced image and last because many of the subsequent alterations, especially the saturation, will have an effect on the white balance of the image. You can either select a custom preset, similar to the ones on your camera (cloudy, daylight, etc) or drag the temperature and tint sliders until you achieve the effect you want. The tint ranges from magenta to green and is useful for correcting casts that can't be altered with the temperature slider. There is also a dropper to allow you to select a part of the image to neutralize to remove any **colour cast**.

There are a raft of controls to adjust how tones are reproduced in Lightroom. They don't apply on selections; rather they affect certain tonal groups, such as midtones or shadows.

Exposure The Exposure slider affects the overall image brightness, but aims to avoid blowing out any highlights. This slider can also bring back an **overexposed** image, if you move it into the negative zone. Each whole increment corresponds to a **stop** of exposure on your camera.

Contrast This changes the **contrast**, mainly in the midtones. It has the effect of spreading out the histogram. Positive numbers will increase contrast, making mid to dark tones darker and mid to light tones lighter. Decreasing the contrast will have the opposite effect, making the histogram contract.

Although predominantly affecting midtones, large changes of brightness and contrast can also affect the **clipping** of highlights and shadows, so you might have to revisit these controls after adjusting contrast.

Highlights Slide to the left to bring back detail in overexposed highlights. Use it in conjunction with the clipping indicator to rescue highlights that are slightly burnt out, although it won't be able to recover very overexposed areas. Drag to the right to brighten highlights, whilst avoiding clipping where possible.

Shadows Drag to the left to darken shadow areas, whilst attempting to minimize clipping. Drag to the right to lighten shadows. This will lighten dark tones in an image, without affecting the blacks. If you lighten them too much, the image will look unnatural, and

ⓘ **Rotating images**
Most cameras have an orientation sensor that will automatically rotate your images so that they are in the correct vertical or horizontal orientation. If your camera doesn't do this, you will need to rotate them manually. In Lightroom there are rotate left and right arrows in the Library module tool bar or you can select [Photo > Rotate Left (CCW)] or [Photo > Rotate Right (CW)] in any module. These commands can be applied to multiple selected images.

there will be increased noise in the lightened areas. Counterintuitively you might need to darken the black point slightly when using the shadow slider to make the effect look more natural.

Whites This will increase or decrease the white clipping point on your image.

Blacks Reduces or increases the tones that are rendered as clipped blacks with no detail.

In some RAW-processing software, and earlier versions of **Lightroom**, there is also a Brightness slider which affects midtones; the Shadows tool is called Fill Light and the Highlights tool is called Recovery.

Clarity The Clarity slider gives the image greater depth by introducing some local **contrast** to the image. It can make the image appear crisper but, if it is overused, it can cause halos to form on edge details. I seldom use this tool, as it can be quite destructive, but if you do use it, zoom to 100% to assess the effect.

Basic tools panel ‹

In the Develop module the right-hand panels show a number of options for RAW processing. If you are bewildered by the many options, then the most useful panel is the Basic panel, allowing you to set the white balance for the colour temperature, as well as the black point, white point, tones, saturation and contrast. Often most of your RAW images can be processed using these options alone. These are the main options that are available if you use ACR with Adobe Elements. The dropper tool at the top left will neutralize the colour balance of an image based upon where you click.

Tone curve panel ›

This panel allows you to map how the tones are reproduced in your image. You can adjust the tone curve to change certain tones, either by clicking and dragging on the tone curve itself, or using the sliders to darken or lighten the highlights, lights, darks and shadows in your image. The *Targeted Adjustment* tool, which allows you to click and drag an element in the picture to lighten or darken it, is on the top left of the panel.

Saturation/Vibrance The **saturation** control affects the richness of the colours in your image. Generally, **RAW** files are less saturated in order to preserve the full range of colours for you to edit. Vibrance is a smart saturation control, which will make the colours richer without causing already saturated colours to clip. It also aims not to over-saturate skin tones. Vibrance is generally the best of the two controls to use. The default setting is zero; consider increasing it slightly.

Tone Curve panel

If the Auto and Basic panel aren't powerful enough to affect your image, then you can make more profound changes in tone using the Tone Curve **panel**. The **tone curve** occurs throughout digital imaging and is a very powerful tool to change the rendition of tones. It allows you to change various ranges of tones without affecting the rest of the picture. You will find a tone curve control in **Photoshop** and all but the simplest of image-manipulation programs. The horizontal axis represents the original (input) tonal values of the

image, and the vertical shows the resultant (output) tonal values. The left of the graph represents the shadows, moving along to the highlights on the right.

There are different preset graphs that you can choose as your starting point. The default is often medium contrast but, as your camera records images with a linear tone curve when you shoot RAW, it makes a lot of sense to start with a linear graph, so I make sure this is my default setting.

Clicking and dragging a portion of the graph affects the contrast of that portion of the input tones. Managing a tone curve in this way is a difficult skill to master, so Lightroom has sliders to do the job for you. These allow you to increase and decrease the contrast of the highlights, lights, darks and shadows. When you use these sliders you can see the shape of the tone graph changing.

If this all sounds too complicated, then there is also a very useful Targeted Adjustment tool at the top left of the panel, which can achieve the same thing in a more interactive way. If you click on this, and then click in a tonal area on your image and drag the cursor up or down, you can progressively lighten or darken those tones in the image by automatically adjusting the tone curve. The tool also allows you to click on a tonal area, such as a shadow, and use the up arrow to lighten and the down arrow to darken.

Digital graduated filters

If the Basic and Tone Curve panels can't balance the contrast in your image, then Lightroom has a digital graduated filter tool, which can emulate traditional graduated **ND filters**. The filters can also be used selectively to affect white balance and are featured on page 274.

Advanced controls

Lightroom's advanced tools allow you a much greater degree of control over your image. This includes corrections for some of the inherent weaknesses of the digital photographic process, such as noise reduction, **sharpening** and corrections for lens defects.

Detail panel

This allows you to minimize the effect of noise and add sharpening to your picture.

Sharpening All digital images need some degree of

sharpening. This is not a fault with your camera, just a side product of how the sensor is designed. There is a lot of debate as to when and how to sharpen your images, and this is discussed further on page 286. For now, leave the sharpening set at the default of 25.

Noise If you shoot with higher **ISO sensitivities**, then your image can show **digital noise**, especially in the shadow areas. There are two types of digital noise: **luminance** and colour (**chroma**) noise. Both can be reduced at the RAW-processing stage in Lightroom, although there are also third-party filters available that can be used in Photoshop and will allow greater control and often produce a better result

Luminance noise manifests itself as light and dark speckling. The default setting for this tool is 0 (off). Controlling luminance noise can affect fine detail so zoom to 100% to check the balance between losing detail and reducing noise. Controlling **colour noise**, which shows up as random coloured pixels, is less intrusive to the image, so the default for this is 25.

Reducing luminance noise has the effect of decreasing the overall sharpness of the image, so my very simple rule of thumb is to add the amount of luminance noise reduction you set to the default **sharpening**. So if you feel that you need an amount of 30 for luminance reduction, set the sharpening to 55 (30 plus 25).

HSL/Color/Grayscale panel

The HSL (which stands for Hue, Saturation and Luminance) and Color options essentially do the same job, allowing you to modify colour groups in your picture. Color allows you to edit the hue, **saturation** and luminance for a single colour at a time, whereas HSL allows you to set either the hue, the saturation or the luminance for all colours at the same time. This is a really useful tool for bringing

out colours that are not reproducing correctly. For instance, you can use the Aqua sliders to change the Hue and Saturation of this group of colours to make the sea in a tropical beach photograph more vivid. The Grayscale option is covered in the black-and-white section on page 284.

Lens Corrections panel

The Lens Corrections panel allows you to compensate for any defects in your lens.
Basic This section makes some basic automatic corrections to the image, using a sample of the tools below.
Lens profile Some lenses have a built-in Lightroom profile to correct any distortion, vignetting or chromatic aberration. If your lens is not included in the Profile section, you will need to do this manually.
Chromatic Aberration Sometimes the highlights of the photograph will show a coloured fringing, caused by the lens focusing different wavelengths of light slightly differently. This can usually be removed by clicking the Remove Chromatic Aberration box in the Color section. If not, then try using the Defringe tool.
Lens Vignetting On some lenses, the corners of the picture come out darker, which can be reduced with the Lens Vignetting slider in the Manual section. This effect can sometimes be caused by using a **polarizing filter** on a **wide-angle lens**.
Transform A comprehensive series of tools that allow you to correct perspective distortions in your picture.

ⓘ **Simple workflow using basic tools**
Below is a simplified workflow using the sort of basic tools that are found on most RAW software. This includes the simplified version of ACR which is bundled with Adobe Element/ Note: not all of these options will be needed.

1 Adjust white balance using temperature and tint sliders.
2 Set overall brightness using Exposure slider.
4 Set white point using Whites slider.
3 Set black point using Blacks slider.
4 Recover highlights using Highlights/ Recovery slider, if necessary.
5 Lighten shadows using Shadows/ Fill Light slider, if necessary.
6 Set midtones using Brightness slider, if present.
7 If necessary, increase or decrease contrast and saturation/ vibrance using the appropriate sliders.
8 Make final adjustment to white balance.

Lens Corrections panel ◄

Two of the sections on the Lens Corrections panel showing some of the options for correcting Chromatic Aberration, vignetting and perspective.

Adjusting your images in Photoshop and Elements

If you save your pictures as JPEGs then you will need to do any corrections to them using Photoshop. If you are shooting RAW, I would recommend doing as much as possible using RAW-processing software and then exporting the files as 16-bit TIFF files in order to carry out the last few small corrections in Photoshop. Although editing in Photoshop will cause a loss of quality, this is minimized if you only make relatively small corrections and have your images in 16 bit not 8 bit. If you use Adobe Elements, then your ability to work in 16 bit will be limited.

Elements is aimed at photographers, where as **Photoshop** covers a broad spectrum of digital imaging. As such, Elements has a number of task-based solutions for editing images and more automatic fixes than Photoshop. In addition, it also shares a number of powerful image-editing tools with Photoshop and is a very cost-effective option when compared to the full version of Photoshop for easy correction of images.

Interfaces
Adobe Photoshop takes a very tool-based approach, whereas Elements offers more task-based solutions. With Photoshop there is a Toolbox on the left of the screen and a series of floating palettes, which give access to detailed options for tools. These palettes can be 'docked' on the right-hand side of the screen to make them easier to manage. At the top of the screen, under the standard menus, is a Tool Options bar that offers simple options for each tool that is selected.

Adobe Elements boats a comprehensive set of tools and options, which are accessed through a series of targeted panels.

Quick and the Guided modes
The Quick mode contains a series of easy and automated fixes for your pictures. These include **exposure**, levels, colour balance and sharpening. Each option has a series of visual variations that you click on to change the look of your image. The best balance between functionality and user-friendliness is the Guided mode, which gives you access to a number of photography-based tasks, including Levels, Depth of Field and Remove a Color Cast. The Expert mode gives you more direct access to the widest functionality, but many of the tools and commands are hidden in the Image and Enhance menus. In this mode, on the right hand side of the Expert window is the Panel Bin, which contains Layers, History and Histogram panels.

Adobe Elements interface ◄

Adobe Elements allows you to edit your images in three modes: Quick, Guided and Expert. Guided gives you access to a number of task-based solutions.

1 *Full/Quick edit tabs* – select either the full range of tools or limited task-based options.
2 *Photo Bin* – shows thumbnails of all your open files.
3 *Task Bar* – the most frequently used tasks, such as rotate and undo.
4 *Image editing tools* – these panels are activated when you select Guided editing mode.

Photoshop CC interface ❯

The Photoshop interface can appear confusing; in fact, it has an underlying simplicity. Once you grasp this, it is far easier to approach.

1 *Tool box* – click on a tool to activate it. Some tools have a number of similar options: click and hold to access sub-menus of different tools.
2 *Tool options* – once you activate a tool a number of simple options can be accessed in this bar.
3 *Histogram* – the histogram is a visual representation of the tones in your image and provides a visual guide when you are editing the tones in your image.
4 *Palette tabs* – these give access to a series of palettes, including Layers and History. Palettes can either auto hide, as in this example, or be docked and visible, which takes up more space.

This image of Dead Vlei in Namibia is underexposed and also lacks contrast. Over the next few pages I will show how this image could be improved in Photoshop. These are the tools you would have to use if you were shooting in JPEG format.

Automatic tools

If you are not very confident with **Photoshop** or **Elements**, then it is worth trying some of the auto corrections that are available. These tend to be a little heavy-handed in their approach, but they can produce good effects, unless your image is non-standard in some way. Images with lots of dark or light tones, or those with intentional **colour casts**, such as sunsets, may be over-corrected if you use the automatic tools. A good approach can be to try the auto corrections first, and then tweak the result using the more advanced tools.

Auto corrections in Photoshop

Auto Levels [Image > Adjustments > Auto Levels] Corrects the levels, ensuring that there is a black point and a white point in the image. Also attempts to correct colour casts but can often over-correct.
Auto Contrast [Image > Adjustments > Auto Contrast] Adjusts the image **contrast** but doesn't affect the colour. If you have any intended casts to your image, this is the tool to use.
Auto Color [Image > Adjustments > Auto Color] Neutralizes any colour cast without altering the tonal levels of the image.

Fade [Edit > Fade…] If the auto functions are too strong, then it is possible to fade the effect. Immediately after using one of the auto functions or, indeed, after using any tool, select the fade command. (The name of the fade tool will change, depending on the tool that you have used previously.) This will open a window with a slider that moves between 0 and 100%. 100% will apply the tool completely; 0% will completely reverse its effect. Simply move the slider until you are happy with the effect.

Auto corrections in Elements

The Enhance menu gives access to Auto Levels, Auto Contrast and Auto Color Correction tools but also to a comprehensive Smart Fix function that works on both

> ⓘ **Rotating images**
> If your camera doesn't have an orientation sensor, which automatically rotates your images so that they are in the correct vertical or horizontal orientation, then you will need to rotate them manually. In Photoshop the rotate commands are in the [Image > Rotate Canvas] menu. In Elements they are in the [Image > Rotate] menu.

the colour and levels of the image. If you select Adjust Smart Fix… from the Enhance menu, then you can fade the strength of the Smart Fix using a slider.

Tonal correction tools

There are a number of tools which offer precise control of the range of tones in your image. As with the similar range of tools in RAW-processing software, these tend to work on tonal groups, such as midtones, or highlights.

Brightness/Contrast [*Photoshop*: Image > Adjustments > Brightness/Contrast…] [*Elements*: Enhance > Adjust Lighting > Brightness/Contrast…] This allows you to alter the brightness and the contrast of the image using simple sliders.

Levels [*Photoshop*: Image > Adjustments > Levels…] [*Elements*: Enhance > Adjust Lighting > Levels…] This allows you to set the black and white points of your image and also the midtone to ensure that the highlights are white enough and the shadows are black enough. It gives you a **histogram** of the image, with a black slider at the shadow end, a white slider at the highlights end and a grey slider in the middle. Although not all images will have black and a white in them, this tool allows you to stretch out the tones of the image to make the shadows darker and the highlights lighter, generally introducing more contrast into the image.

If you hold down the Option key when you are dragging the shadow slider, then the image will go white, with the darkest points in the picture shown in colour. As you drag the slider these darker points will gradually become coloured and then black, indicating that you have reached the black clipping point on the image, where the darkest shadows no longer show any detail. You can leave the slider here, or keep sliding, depending on your image. Holding down the Alt key while dragging the highlight slider will have the opposite effect, turning the whole picture black and showing the lightest points moving gradually to white until they indicate that there is a **clipped** white in the picture.

Obviously, not all images have a black or a white point, so you should use this function intelligently. The default setting is for the Levels tool to work on all of the Red, Green and Blue channels together but you can also work on any of these channels independently by clicking on the pop-up menu. This will change the colour of the image.

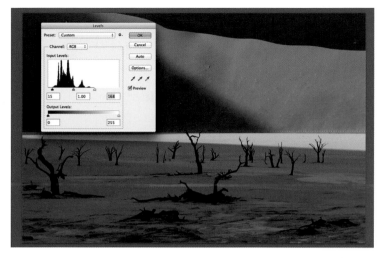

The Levels tool has three droppers, representing the black, white and grey points. If you click on the dropper, then click on the corresponding part of the image, it will automatically set the levels. For instance, if you use the black dropper and click on an area of shadows, this will be set as the black point. The white dropper works in the same way to set the white point. The grey dropper won't change the tones but will neutralize any colour cast based upon the point you click. If you click on a coloured part of the picture then this tool won't function properly but, if you click on something that should be a neutral tone (black, grey or white), then Photoshop will use this as a reference to remove the cast.

Curves [*Photoshop*: Image > Adjustments > Curves…] This is one of the most difficult tools to master, but it is useful as it allows you to change tones locally within the image. The **tone curve** is a simple graph. The horizontal axis represents the input tones and the vertical axis represents the output tones. The point where the axes meet is the black point moving through to white. A simple straight line graph means that the output tones are the same as the input tones; that is to say, the image is unaltered.

To alter the tone curve, click on the line to create a point and then drag to reshape the graph. Wherever the new line comes below the original straight line, the output tones will be darker. If the new line is

Levels tool ⌃

The Levels tool allows you to stretch a flat range of tones on an image so that it fits across the entire range from black to white. Simply set the black and white points using the sliders at the foot of the histogram, and then adjust the midtone slider to set the overall brightness of the image. Bear in mind, though, that not all images have a black or a white point. This is probably the single most useful tool in Photoshop for editing your images.

The left and right droppers allow you to set the black and white points respectively. Click with the middle dropper on a neutral tone to remove any colour casts.

To brighten the highlights drastically to compensate for the underexposure in the image above, I set a white point at 168. As the image was already dark, I only had to move the black point to 15. The midtones seemed okay on this image, so I left the midtone slider alone.

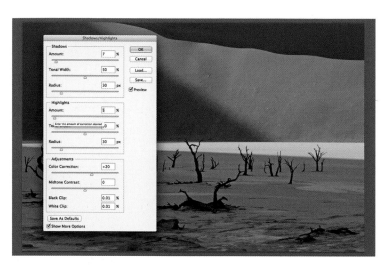

Adobe Elements has a simplified version of this tool [Enhance > Adjust Lighting > Shadows/Highlights…], with sliders to Darken Highlights, Lighten Shadows and alter the Midtone Contrast.

Colour Adjustment tools

Elements and Photoshop have a comprehensive set of tools that allow you to correct and enhance colours. Both have a Hue/Saturation tool but, as this is such a complicated tool to master, I have omitted it here, especially as there are enough options left to do the job.

Color Balance [*Photoshop*: Image > Adjustments > Color Balance…] The Color Balance tool, found only in Photoshop, allows you radically to affect the colour balance of your image. Although the tool itself is simple to use, working out what corrections to make takes a great deal of practice. Basically, if there is a cast on your image, then move the slider in the opposite direction to cancel it out. For instance, if there is a magenta cast, then move the slider away from the magenta, towards the green. You can make different corrections for the shadows, midtones and highlights.

Variations [*Photoshop*: Image > Adjustments > Variations…] [*Elements*: Enhance > Adjust Color > Color Variations…] If you are working on an 8-bit image and don't fancy dealing with the Color Balance tool, then the Variations tool can make life a little easier. It calls up a window with a series of thumbnails of the current version of the image plus a number of different corrections, each showing the effect of adding more green, yellow, red, more magenta, more blue and more cyan. You cancel out a colour cast by selecting the opposite colour. So to cancel a **yellow cast**, click on the blue preview. The current correction image will change and all of the other previews will update ready for the next change. You can click as many times as you like; to reverse a click, just hit the opposite colour. So to reverse a correction of adding more green, add more magenta.

You can select whether you are working in the highlights, midtones or shadows, and you can also choose whether you want the selected tonal area to be lightened or darkened by clicking on that preview. A separate mode allows you to increase and decrease the **saturation**. If you want to go back to the beginning, simply click on the original image.

above the original line then those tones will be lighter. The steeper the graph the higher the **contrast** of the picture. Note that if you change the graph too radically, then the picture can become 'posterized' (banded) and look very unnatural

Elements has a similar tool [Enhance > Adjust Color > Adjust Color Curves…] that gives the ability to alter the tone curve using sliders and presets but doesn't give the option of altering the curve for the individual Red, Green and Blue channels.

Shadow/Highlight [*Photoshop*: Image > Adjustments > Shadow/Highlight…] This has to be one of the most useful tools in **Photoshop**. It has two simple sliders which allow you to darken the highlights and lighten the shadows by a percentage. The effect is previewed in the image window. This is a very powerful tool, so be careful of making changes that are too extreme. As with most post-production techniques, the result is far better if you are subtle. Sometimes the **dynamic range** of your picture may be too great to be rescued using this technique, but in those cases there are other tools that you can use.

If you click on the Show More Options checkbox, you will be presented with a lot more controls, the most useful of which is the Midtone Contrast slider. This allows you to add a little more contrast to the midtones, giving the images more punch.

Shadow/Highlight tool ⌃

This tool allows you to lighten the shadow areas of your image and recover slightly blown highlights by using simple sliders. The results will look far more natural if you only move them a few percent. You are also able to introduce some midtone contrast using this tool, which can give your image a little more punch. This tool is also very effective if you use it on a selection, so as locally to correct a part of the image. See page 268.

The dark tones in this image are still slightly dark. These can be lightened using the Tone Curve Tool, or it is possible to lighten them slightly using the Shadow/Highlight tool. This is the same as using Fill Light and Recovery tools in Lightroom or ACR. This image only needed a very subtle change of 1% to lighten the shadows only.

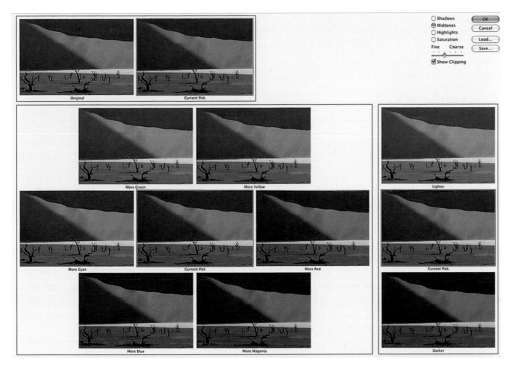

Variations tool

If you are running Photoshop CS6 or CC on a Windows platform, or are running an older, non- 64-bit version of Photoshop on the Mac OS, then you will have access to the Variations tool. This is a visual way to correct colour casts on your image, which allows you to click on images representing different colour casts. There are settings for highlights, midtones and shadows, and you can change the increment from coarse to fine for more control. There is a similar Variations tool in Adobe Elements, which does a similar thing, but with a different interface.

The result

The finished result is much brighter and has much more vivid colours than the original. The shadows are richer and the highlights are much brighter. From the histogram (right) of this image though, the banding caused from editing an 8-bit image (such as a JPEG) can be seen. For critical reproductions then, slight banding can be visible, especially in areas that should have smooth gradation.

The default setting is for quite extreme corrections but you can change the degree by using the slider. I tend to prefer to set the slider to the finest setting, even if that means having to perform multiple changes for each variation.

Even if you habitually work with 16-bit images and can't use Variations, which only works with 8-bit images, it is still worth experimenting with this useful tool, as it can help you to recognize various colour casts and how to correct them. Currently, Variations does not work on Apple OSX running the 64-bit version of Photoshop, which includes CS6 and CC.

Adjusting colours in Elements

Elements also has a couple of task-based tools to adjust colours and also remove casts, in addition to the Variations tool. The Color Cast tool [Enhance > Adjust Color > Remove Color Cast…] gives you a dropper to click on a part of the picture that should be a neutral tone (grey, white or black). Elements removes any casts based upon this neutral point. The Skin Tone tool

[Enhance > Adjust Color > Adjust Color for Skin Tone…] seeks to improve on skin tones using simple sliders.

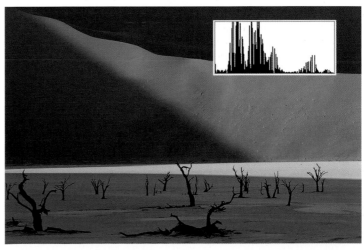

Making selections

Selections are the cornerstone of both Photoshop and Elements, allowing you to limit your edits and corrections to selected areas within the picture. This might be altering the brightness or the colour balance or even pasting elements inside a selection. At its simplest, the default selection is the whole image [Select > All] but there are also a range of tools that allow you precisely to define the part of the image that you want to work on.

Making a selection
All of the following tools allow you to use keys to alter your existing selection: hold down the Shift key and whatever you select will be added to the selection; hold down the Option or Alt key and it will be subtracted from the selection.

Lasso tool
This isn't a particularly precise tool but it is useful for creating a rough selection, which can then be edited in the Quick Mask (see below). There are three different settings: Lasso, Polygonal and Magnetic, and each has a slightly different effect on the nature of the selection.

With the plain Lasso tool, you simply draw a freehand line around the part of the picture that you want to select. When you release the cursor, the tool automatically completes the selection by the shortest possible route.

If you hold down the Option key *after* you have started selecting, the Lasso turns into a Polygonal tool. This draws a straight line between each point you click on. You can either close the polygon yourself, or double-click to have **Photoshop** close it automatically for you.

The Magnetic Lasso is a combination of the two tools, working with both points and freehand lines, but it also automatically jumps to select any nearby edges that you drag the cursor over. The frequency of points and the width of the area that it covers can be defined in the Tool Options palette. Double-clicking on any tool opens this palette.

Selection tool ▶

To choose between the Magic Wand and the Quick Selection Tool, click and hold on the tool icon to see the pop-up menu.

Magic Wand
The Magic Wand selects similar areas of tone in your picture, starting where you click, and is perfect for selecting areas of sky. You can set the Tolerance in the Tool Options: the smaller the number, the fewer variations of tone it will permit, making your selection smaller but more detailed. Shift-click on each new area to add it to your selection. In this way you can select a whole sky bit by bit and avoid selecting any trees or buildings. If you click 'Anti-aliasing' in the Tool Options, then the selection will be smoothed, avoiding jagged edges at pixel level.

Quick Selection
If you have a later version of Photoshop, from CS3 onwards, or **Elements** 6 or later, then there is the choice of a Quick Selection tool that allows you to 'paint' across an area and have the program base the selection on that sampling. This tool is brush-based, so changing the brush options will affect the sampled areas. There are three checkboxes in the Tool Options: to make a new selection – this is the default when you first select the tool; to add to an existing selection (default switches to this once you have made a new selection), and to subtract from an existing selection.

Color Range
The Color Range tool is only present in Photoshop [Select > Color Range…]. It lets you make a complex selection based upon areas of colour, in a similar way to the Magic Wand tool. Unlike the Magic Wand tool, though, the areas don't have to be contiguous and you get a preview of the effect. This tool can be useful for selecting certain colours in your picture that can then be edited as a whole. For instance, you could select all of the sea in a picture and then increase its **saturation** to make it more vibrant, or select the red of a field of flowers in order to make the colour more realistic.

The default setting gives you a dropper that will select an area based upon where you click. The Fuzziness setting is similar to the Tolerance of the Magic Wand.

The most useful part of this tool is the dropper with the + sign next to it. This gives you an

Lasso tool ◀

The Lasso tool has a number of variations. Click and hold on the tool icon to select the tool that you want.

accumulative selection, so you can click all over an area that you want selected – such as a large blue sky – and progressively select it all. The preview picture will show the effect, and you can even use the Selection Preview pop-up menu to display a mask of the selection on the original image.

Masking

Both Photoshop and Elements have a comprehensive masking tool that literally allows you to paint a mask and then convert it into a selection. The beauty of masking is that you can paint over it in order to refine your selection, thus allowing you a much greater level of control, especially for complicated selections. If you use a soft-edged brush, then the edge of the mask and subsequently the edges of the selection will be feathered. To judge the precise effect of your painting on the mask, zoom to 100%. The bits that you paint over are masked, or not selected. To reverse this selection choose [Select > Inverse]. You can delete part of the mask by selecting it with a selection tool and then simply hitting the delete key.

Quick Mask in Photoshop

Once you have a rough selection, click on the Quick Mask Mode icon in the tool palette to superimpose a red mask over the non-selected bits of the picture. Add to the Quick Mask using the Brush tool and delete from it using the Eraser tool. If you paint with the brush opacity set to, for instance, 50% in the tool options then the masking will only be applied at 50%. You can build a selection by selecting any number of brushes and opacities. When you have finished creating the Quick Mask, you can turn the non-masked area into a selection by deselecting the Quick Mask icon in the tool palette. You can then use this selection or save it to work on later.

Masking in Elements

Masking is accessed through the Selection Brush tool. Either start with a rough selection and click on the Selection Brush tool to activate the Masking function or just use the tool to draw a quick selection. You can switch between Mask and Selection using the Mode selector in the Tool Options Bar. You can also select the brush options here. To add to the mask, just paint; to subtract from the mask, hold down the Alt key while painting.

Making a rough selection ❯

In order to make a rough selection use either the *Lasso Tool*, the *Magic Wand* or the *Quick Selection* tool, depending on whether there are elements of detail in what you are selecting or whether they are more continuous areas of tone. If they are areas of continuous tone and if the join between the selected area and the rest of the picture is quite marked, then you can usually use one of the more automatic selection modes.

Refining your selection using the Quick Mask tool ∧

Click on the *Quick Mask Tool* shown selected at the foot of the Tools. This allows you to draw on the image to create and edit the mask. In this way you can paint over any parts of the image that you don't want to be selected. To activate the selection, click on the Quick Mask Tool again.

Modifying your selection

There are a number of commands, accessed through the Select menu of both **Photoshop** and **Elements**, that will help you to control or modify your selection.

Deselect [Select > Deselect] Deselects the current selection. This command can be reversed by using Reselect [Select > Reselect], Undo or the History palette.

Feather [Select > Feather…] [*for version CS3*: Select > Modify > Feather…] Feathers the edges of your selection, so that any edits you subsequently perform don't have a hard line. Enter the number of **pixels** into the dialog box to control the fineness of the feathering: the greater the number, the softer the selection line will be. Fine feathering will heavily disguise the edges of a selection and make any changes to levels or curves much harder to detect, although the effect also depends on the resolution of the image and the size of the selection.

Expand [Select > Modify > Expand…] Expands a selection by a given number of pixels and is useful for removing a series of small selections from a larger selected area. The Magic Wand tool often leaves you with scores of tiny selected areas that are out of the tolerance of the larger selection and so show up as small deselected areas. If you expand the selection by two pixels and then contract it by the same amount,

many of these will disappear. It will also smooth the edge of the selection.

Contract [Select > Modify > Contract…] Contracts a selection by a given number of pixels. This can be used to remove the slight fringing that you can get on some automatic selections, such as those produced by the Magic Wand tool. This slight fringing can be very obvious if you copy and paste a selected element from one picture into another.

Grow [Select > Grow] Expands your selection to include similar colours, loosely based upon the tolerance that you have selected in the Magic Wand tool. It will only expand the selection to contiguous colours, resulting in one bigger selection.

Similar [Select > Similar] Works like the Grow command but operates on non-contiguous areas, so that all of the similar colours in the picture are selected, even if they are not connected to the selected area.

Inverse [Select > Inverse] Inverts your selection: selected areas are deselected and deselected areas are selected.

Refine Edge [Photoshop CS3 and later: Select > Refine Edge…] A custom tool that allows you to feather the edge of a selection and get a live visual preview. You can also adjust the edges to maintain edge detail and expand or contract the selection. Users of Elements 6 and later have a similar tool but without the live preview.

Saving selections

Once you are happy with your selection then you can save it in the document so that you can call it up and use it at any point in the future. This can also be useful if you are trying to make a very complicated selection and want to save it as you go.

To save your selection, go to [Select > Save Selection…] and give the selection a name. If you choose to save to a selection that you have already saved to the file, then you have the option to replace, add to or subtract from that selection.

To use a saved selection, go to [Select >Load Selection…] and select the name of the selection from the pop-up menu. You have the option to replace, add to or subtract from any selection that might be active on the document at the time.

① Brushes

Whether you are drawing, painting, retouching or altering a colour mask, you will be using a brush whose properties will affect the result that you can achieve. Tools that use a brush include the Dodge/Burn tool, the Clone Stamp tool, the Spot Healing Brush tools and, of course, the Brush and Eraser tools that are used to modify the Quick Mask. Photoshop has a Brushes palette of rather daunting complexity but the most useful brushes options are contained in the various Tool Options relating to these tools. This appears at the top of the screen when you select a tool.

Click on the brush icon to open a pop-up window where you can set the Master Diameter and the Hardness of the brush. This governs the diameter of the brush in pixels and the degree of hardness at the edges. It can be quite difficult to control the brush using a mouse, so many Photoshop users use Pen and Tablet instead, which has an electronic stylus that offers a greater deal of control and even pressure sensitivity.

Refining your selection using the Refine Edge tool ∧

Open the Refine Edge tool [Select > Refine Edge…]. If you are editing a Layer Mask then you can access the same tool by selecting [Select > Refine Mask…]. The tool will have the same options, but will affect the mask not the selection.

View Mode – whether the selection is shown as a dotted selection as above, or as a mask.
Radius – can help to improve your selection over areas of fine detail or fine transitions.
Smooth – will smooth the edge of the selection. You can preserve detail using the radius setting above.
Feather – feathers a selection by a given number of pixels to make the transition less pronounced.
Contract – will shrink the selection, which can be useful for reducing any fringing caused by an imprecise selection.

Selective corrections

Sometimes you will need to alter the tones or colour of just a part of the image, locally to darken a part of the sky, for instance, or to lighten some of the shadow areas. There are two different ways to achieve this: using selections or freehand Dodge and Burn tools.

Local corrections using selections

Once you have mastered the image adjustment controls and also have the ability to make a selection, then you will be able to make localized corrections to a selected area of your image. You will be able to lighten shadow areas and darken highlight areas, for instance, and to do it in such a way that it doesn't affect the whole picture. It is also possible to change localized areas of **white balance**. You may have a picture that is partly lit with artificial light and partly lit by natural light. If you select the artificial light portion, then you can locally change the colour balance.

Selective corrections should look as natural as possible. Anyone looking at the picture shouldn't be able to see that you have done anything to the image at all. The secret is in the accuracy of your selections. The best way to achieve this is by using the Quick Mask function in **Photoshop** or the Mask function in **Elements** (see page 265). If there is a hard line border between two areas, then make sure that your selection exactly follows the line between the two areas. Zoom your image to at least 100% so that you can precisely judge the effect.

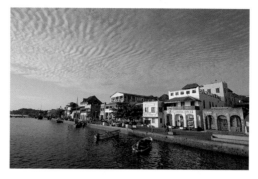

Local tone corrections

It was the sky that attracted me to this shot of the waterfront on the island of Lamu in Kenya, but it didn't really come out in the photograph (left). By making a selection and then creatively enhancing the sky, I was able to make the picture look more like how I remembered the scene in real life (below).

Once you have a selection you can locally affect parts of the picture, for instance by lightening or darkening the sky. If you have a hard transition on the area that you want to change, then use a very small feather of only a few pixels. If you are selecting a region of your picture, such as a part of a shadow area, then a much larger feather will disguise any changes that you make.

If you subsequently decide that the correction is too obvious, then you can go back to the selection using the History palette, select another feather and try again.

The *Shadow/Highlight Tool* (see page 262) is particularly effective when changing the tone of a selection, as it makes corrections based upon the tonal areas of your image.

Sometimes you will want to correct or enhance certain colours in your image, especially if there are two light sources in the image and you want to affect only one of them. Your camera's white balance facility is a fairly blunt tool and can only compensate for one type of colour temperature in a whole picture.

In this image of the main square in Marrakech (below), I wanted to correct the colour balance of the stalls selling food, so they didn't look so yellow from the incandescent light, but I also wanted to preserve the colours in the sky.

It is very difficult accurately to remove a colour cast in Photoshop, especially the warmth from shooting under tungsten lights. Rather than processing the RAW file for the sky and attempting to take out the cast on the foreground in Photoshop, I opted to work the other way around: processing the RAW file to filter out the cast on the stalls and then re-introducing the colour into the sky. The result was a shot with a less orange foreground but a very insipid sky. I then made a selection for the sky and feathered it by about 20 pixels to disguise it. I applied a relatively subtle warming to the sky using the Color Balance tool, then contracted the selection by 100 pixels. I feathered the selection again, this time by 50 pixels, and made another subtle correction. I repeated this process twice more, until I was happy with the sky. Making subtle corrections on different feathered selections helps to disguise the changes. I also added some red to the sky, which had the effect of making the sunrise look more as I remembered it, without changing the colour of the foreground (above).

Selective corrections are far easier to disguise on irregular-shaped selections where you can hide the edges using the feather command. The effect can be made even more subtle if you apply the corrections using the Shadow/Highlight tool. [*Photoshop*: Image > Adjustments > Shadow/Highlight…] [*Elements*: Enhance > Adjust Lighting > Shadow/Highlight…]. This can lighten shadow areas or darken highlight areas within a feathered selection. As long as you have a large enough feather and don't attempt drastically to lighten or darken parts of the picture, then you can make changes in such a way that is hard to see that anything has been done.

With Photoshop, you can also change localized tones on the picture by using the Levels and Tone Curve tools on a selection. Or, if you are trying to correct the colour in specific areas of a picture, use the Color Balance tool or the Variations tool. Making slight corrections will look more realistic, even if you are still left with some **colour cast** in the picture.

With Elements, you can change localized tones on the picture by using the Levels and Brightness/ Contrast tools on a selection. You can also locally colour balance an image using the Color Variations tool or try any of the Auto Fixes.

Dodge and Burn tools

Dodge and Burn tools emulate the way that photographers used to make corrections to their images in a black-and-white photographic darkroom.

They work best if you are trying to make subtle changes. With both Photoshop and Elements, you can select the Dodge tool from the Tools palette to lighten or the Burn tool to darken a specific area. Set the size and hardness of the brush, and then select whether you want the change to apply to the shadows, midtones or highlights. Working on the midtones will create a more subtle effect than trying to change the highlights or shadows directly. The last setting is the **exposure**, which affects the intensity of the correction: the lower the number, the more subtle the outcome. Once you have chosen the settings for the tool, then simply paint over the area that you want to correct.

There are dodge and burn tools in **Lightroom**, although I prefer to make local corrections in Photoshop, which offers a greater level of control.

Layers

The Layers function in Photoshop and Elements allows you precise control over the various constituent parts of your picture. The easiest way to think of layers is to imagine that you are working on a series of transparent sheets. If you put them all together in the right order, you will get the whole picture but you are also able to isolate each layer and work on that individually.

Why would you want to do this? Layers allow you to assemble various elements of a picture and work on them separately. For instance, if you want to paste a new sky into a picture, then **Photoshop** will automatically create a new layer for it. This allows you to make corrections to either the background picture or to the newly pasted bit of sky, without affecting elements on the other layer.

Layers on Photoshop and **Elements** are managed through the Layers palette [Windows >Layers]. The Layers palette has a sub-menu, accessed through the top right corner. To select a particular layer, click on it in the Layers palette. Anything that you do will only apply to this layer until you click on another layer. You can also click on and delete any layer, or Shift-click to select multiple layers and merge them together to create one combined layer. These commands are accessed through the sub-menu.

Not all of the layers have to be visible at any one time. Click on the eye icon in the palette to make a layer visible or invisible. Clicking and dragging will change the order of the layers, which is reflected in the image. Each new layer is transparent, unless anything is pasted or drawn into it. You can change the opacity of the contents of a layer by using the Opacity slider.

Photoshop and later versions of Elements (from version 9 onwards) allow you to create Layer Masks for various layers, so that only the un-masked portion can show through.

Adjustment layers

Layers don't just have to contain picture elements. You can create Adjustment Layers [Layer > New Adjustment Layer > *then select adjustment from list*] that will act in the same way as certain commands. Amongst the most useful commands that can be applied to an Adjustment Layer are Levels, Curves, Color Balance, Brightness/Contrast, Hue/Saturation and Black & White (to turn part of the picture into a controlled grayscale). Elements has a

similar function, accessed via the same menu command, but offering a much smaller range of adjustments. The most useful being Levels, Brightness/Contrast and Hue/Saturation.

The advantage of using an Adjustment Layer, rather than just applying these commands to the whole image, is that you can go back to the Adjustment Layer at any time and change the settings. You can also switch it on or off by clicking on the eye icon.

An Adjustment Layer only affects the layers underneath it; anything in a layer above will be unaffected. You can change which layers are affected

Switching layers on and off ◄

Clicking on the eye icon on the palette toggles the layer's visibility, in effect switching layers on and off. This allows you to change which layers can be seen. The active layer is the one that is selected – rock highlights in this instance. To select or edit a different layer, simply click on it.

In this instance, I duplicated the Background layer twice and created layer masks to isolate the shadow area and also the highlights on the rock. This allowed me to correct these individual areas on the duplicated layers using the [Image > Adjustments > Shadow/Highlights…] tool. If I had used this tool on the whole image it would have had an adverse effect on the rest of the image.

Adjustment layers ▶

Adjustment layers are very useful as they allow you to edit parts of the image non-destructively. Unlike applying image adjustments to the whole image, you are able to revisit the settings of the relevant tool, or simply delete it by editing the adjustment layer. An adjustment layer only works on layers that are underneath it. Some of the most useful tools that can be applied to an adjustment layer are:
Brightness/Contrast…
Levels…
Curves…
Exposure…
Vibrance…
Color Balance…

Creating new layers ◀

Whenever you copy and paste something into a document, Photoshop will automatically place it on a new layer – even if you paste something from the same document. To create a new blank layer, simply click on the new layer icon. To duplicate an existing layer select [Layer > Duplicate Layer…].

If you have a selection active, you can create a layer mask on any layer by clicking on the Create layer mask icon on the Layers palette.

The most useful icons in the footer of the layers palette are, from right to left:
1 Delete
2 Create new layer
3 Create a new group
4 Create new fill or adjustment layer
5 Create layer mask

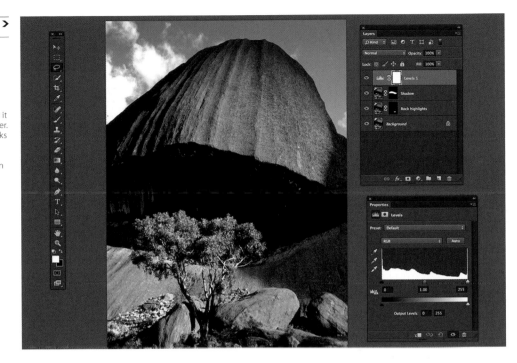

by clicking and dragging to change the order of the layers. If you change the opacity of an Adjustment Layer, then it will have the same effect on the strength of the adjustment. So, dragging the Opacity slider to 75% will fade the strength of the adjustment to 75%.

When you create an Adjustment Layer, the layer automatically has a Layer Mask created with it. The default is completely un-masked, so that the adjustment applies to the whole layer, but, if you have an active selection when you create the Adjustment Layer, the layer mask will reflect this, and the adjustment will only apply to that selection. If you click on the Layer Mask icon in the adjustment layer, then you can edit the layer by simply painting on the picture.

Working in the same way as the Quick Mask (see page 265), you can paint on the picture using the Brush tool to mask out certain areas, and the adjustment won't affect those bits. If you use the Eraser, you will delete parts of the mask allowing those bits to be affected by the adjustment. Black areas will mask the layer; white areas will let the layer show through. Setting the opacity of either tool will affect the opacity of the Layer Mask as you paint or erase it. To actually see the mask as you are editing, use Alt-backslash to toggle the mask view on and off. To toggle the Layer Mask on and off, Shift-Click on it. Elements works in a similar way, but to see the mask you have to Alt-Shift-Click on it.

Layers and file size

Be aware that as you create new layers, you will increase the file size of your document. To retain all of the layer information, you can save your picture as a **TIFF** or a Photoshop file (.psd), which is better at compressing layers, giving a smaller file. When you have finished with your picture you can save a copy as a JPEG, which will automatically flatten all of the layers into one layer reducing the file size. Alternatively, you can flatten the image yourself using the Flatten Image command on the Layers palette sub-menu. If you only want to merge certain layers, then make sure that those are the only ones visible, before using the Merge Visible command.

This is a very simple look at layers. They offer many more complex functions and a sophisticated degree of control.

Reducing depth of field

On occasion you might not be able to achieve a shallow enough depth of field to completely throw the background of your image out of focus. This is especially a problem if you are shooting with a wide-angle lens or if you are using a digital camera with a small sensor. If you are photographing with a compact camera, it can be almost impossible to achieve a completely blurred background.

Luckily, by combining the skilled use of selections and layers, it is possible artificially to blur a background. This is a fairly simple technique, but it works best when there is a subject on a separate plane to the background. To progressively blur something as it stretches off into the distance is a much more difficult thing to achieve.

Earlier versions of Adobe **Elements** didn't allow you to create Layer Masks on Layers, or to use graduated fills, so reducing the **depth of field** was a much more complicated process. The latest versions have added this functionality, but make sure that you are in the Expert Mode.

- Open your image and make sure that the Layers palette is open.
- If there is just one layer to your document, it will appear in the palette as a default background. Select Duplicate Layer… from the pop-up menu at the top of the Layers palette . A new layer called 'Background copy' will be created above the background layer. You can rename this to 'Blurred layer' if you wish.

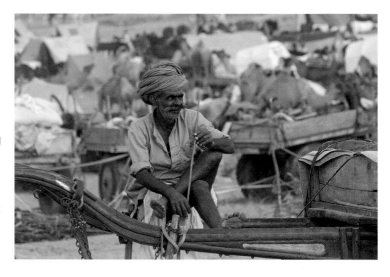

Camel drover, Pushkar Mela, India ⌃

In this shot of the camel drover, shooting on a camera with a crop sensor has effectively given too much depth of field, even though the aperture was f4. I find it slightly distracting, especially at lower reproduction sizes. Luckily it is a fairly simple process to reduce the depth of field in the background of a shot.

Creating a blurred background ◄►

In the *Layers* palette create a duplicate layer and blur it using the *Gaussian Blur* tool (left). You can also use the *Lens Blur* tool (right) for this if it is present on your version of Photoshop, as it offers more sophisticated control.

- With the newly created layer selected, apply a blur using the Lens Blur filter [Filter > Blur > Lens Blur…] This opens up a dialog box with a lot of complicated options. It is worth experimenting with this filter but, for the time being, control the degree of blur using the Radius slider in the Iris section. If you are using a different program or an older version of **Photoshop** without the Lens Blur filter, then use the Gaussian Blur filter [Filter > Blur > Gaussian Blur…] instead, then use the Radius slider to control the degree of blur.
- Make a rough selection around the area that you want to be blurred; click on the new layer and then click on the 'Add a mask' button at the bottom of the palette in Photoshop or at the top of the panel in Elements. This creates a mask

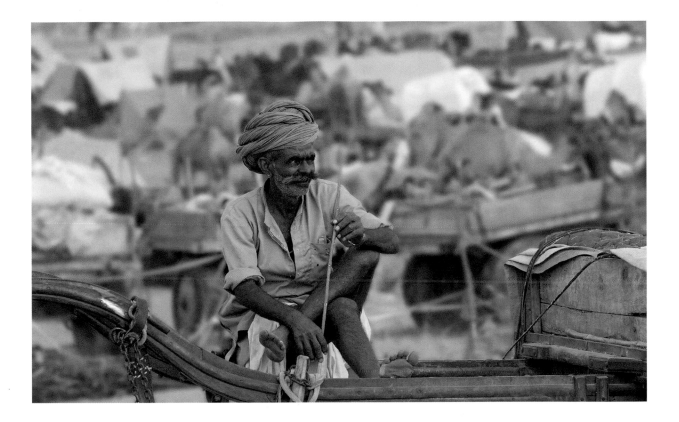

**Camel drover,
Pushkar Mela, India** ∧

In the finished picture, the man stands out from the background more, but the background is still recognizable, so the mise en scène of the image still works and you can see that this man is at some sort of mass gathering of camels!

Creating a Layer Mask ❯

A rough selection has already been made with the *Lasso Tool*. Now, create a *Layer Mask* on the top layer by clicking the *Create Mask* icon. The mask, which masks the top, blurred layer of the image allowing the underlying sharp portions to show through, is edited in the same way as the *Quick Mask*.

attached to the layer covering those bits of that layer that were not selected: the bits you don't want to be blurred. It also changes the colour palette at the foot of the Toolbox to black and white. The Layer Mask behaves in exactly the same way as the Quick Mask (see page 265). White areas of the mask allow the layer to remain visible, while

any black parts are masked out, letting the sharp underlying image show through.

- I find it easier to work with the layer mask overlay showing, rather than just seeing the effect of any changes. To see the mask as a red overlay, click on the Layer Mask to select it, then use Alt-backslash to toggle the visible mask on and off.
- Add to the mask by drawing on it in black with the brush; subtract from the mask using the eraser, or using the brush and drawing in white. Areas where the mask is clear allow the blurred layer to show through. The blurred layer doesn't show in the masked areas, which use the underlying sharp layer, so these will be shown as sharp on your picture.
- If you change the painting colour to a 50% tint of black, say, then it will only mask the image by 50%, allowing 50% of the blurred layer to show through.
- If you want to have a graduated blur, which will look more natural if you want to blur something that stretches off into the distance, then draw on the Layer Mask using the Gradient tool. Draw this from dark to light, starting from the area that you want to mask the most – in this case, the least blurred.

Digital graduated filters

In the days of film, the only way to balance a picture with too much contrast was to use a graduated Neutral Density (ND) filter (known by photographers as grads). These faded from dark to clear, usually with a soft gradation and could be fitted over the camera lens and adjusted in order to, for example, darken a light sky so its exposure balanced with a dark foreground. They usually come in strengths of 1, 2 and 3 stops, each with a hard and soft gradation so a comprehensive kit comprised of six rather expensive filters, which seemed to have a propensity to attract dust and scratches.

As with so many aspects of photography, the advent of digital technology has made using graduated filters so much easier. Now you don't have to carry expensive and fragile resin filters, you can recreate the whole effect digitally.

Both Adobe **Lightroom** and Adobe **Camera Raw** (ACR) have a comprehensive graduated filter tool built

Graduated filter in Lightroom ⌄

This shows the affect of a single graduated filter drawn on a white document. The filter was drawn from the bottom left to the top right. It has had the exposure reduced by four stops, the contrast increased and a cold cast added.

in, that you can use whilst processing your **RAW** files. The advantage of making these corrections at the RAW-processing stage is that you are able to apply the filter to the RAW data. Most RAW files record in at least 12-bit, which records far more information and tonal gradations than an 8-bit **TIFF** or **JPEG** (see page 15). The extra tones in the RAW file give far more scope to lighten and darken parts of the picture, with minimal loss of quality.

Grads to lighten and darken

The most common use for the digital graduated filters is to balance areas of lightness and darkness in a picture. Sometimes all that is needed is a subtle change. When photographing reflections in water, the water tends to absorb between one and two stops of light, so the reflection is always darker than the non-reflected parts of the picture. When I was photographing the reflection of the Tokyo tea-shop, which is reproduced on page 232-233, I needed to use a resin graduated filter to balance the rest of the picture with the reflected parts.

With a digital graduated filter, you don't just have to darken parts of the picture. By dragging the exposure slider to the right, you can lighten parts of the picture too. There are other more subtle changes that you can make: using the highlights or shadows slider on the graduated filter you can alter the tone of specific areas.

To actually apply a graduated filter, click on the Graduated Filter tool, and then click and drag over the area you want to affect. The filter is darkest at the point that you start drawing the filter, and the transition is about halfway down. By the end of the

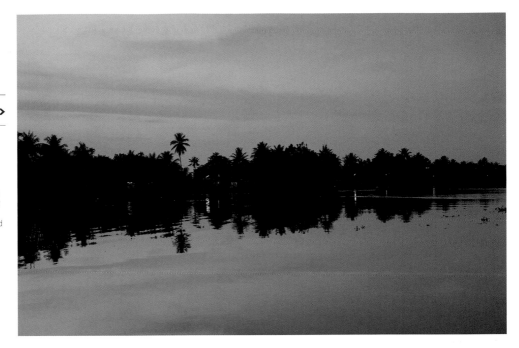

Sunset in the backwaters of Kerala, India ◇▷

The water is absorbing a lot of the light in this sunset, so I balanced out the reflection with three subtle filters. One darkened the top left; one lightened the bottom right, and a third lightened from the right of the picture. The colour balance of the image stayed fairly constant throughout, and so none of the filters changed this at all. The final image looks more balanced and symmetrical.

drawn filter it has no effect at all. You get a line at the start of the filter, one in the middle and a final one at the end of the filter. The effect of a filter on a white document can be seen in the example to the left. You are able to draw any number of filters to build the effect you want. To edit a filter, click on the circle on the mid-line to select it.

If a combination of graduated filters doesn't give you enough control, Lightroom 5 also has a Radial Filter which enables you to affect the image in an circular or elliptical fashion.

Grads for colour and sharpness

With digital graduated filters, you are not simply limited to lightening or darkening areas of the picture. There are sliders that affect the **white balance** and others that will edit the **saturation** and even the **sharpening**. The white balance slider is particularly useful as it allows you to compensate for pictures where there are more than one light source, leading to parts of the picture having a different **colour cast**.

Each graduated filter can have more than one attribute applied to it. You might have a slider that lightens an area of the picture that is in shadow, as well as warming up the white balance slightly. This might be countered with another filter working on the lighter areas of the picture; darkening them to balance the shadows and cooling down the white

Kalash brother and sister, Chitral, Pakistan ▷

These two people from the Kalash tribe in Pakistan were standing on a verandah, which meant that their heads were in deep shadow. The white balance was further complicated by a bizarre green cast to the shadow areas. I used three graduated filters: to lighten the shadow area and take out the colour cast; to darken the foreground and warm it up slightly, and a third to lighten the right-hand side of the picture at an angle from the bottom.

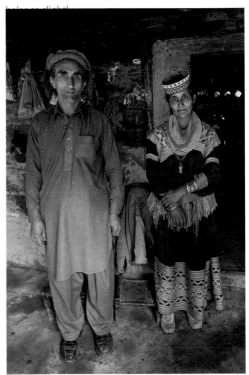

Combining multiple files for dynamic range

There are times when the dynamic range of your subject will be so great that you won't be able to bring all of the tones into range by simply using the Highlight/Shadow or Curves tools, Graduated filters or selective corrections. In these instances, there is still a solution. You can use the selection techniques to combine pictures with different tones in order to bring out different elements of the same subject.

On page 147 of the Execution section, I looked at taking a range of shots of the same subject at different exposures. By using a tripod, you can ensure that all of the images will be easy to line up in **Photoshop**. Using this technique you can photograph a scene with much greater **dynamic range** than your camera can resolve in a single shot.

There is an automatic function on Photoshop called Merge To HDR that attempts to combine various different pictures to increase the dynamic range, but I have found that you get a better, more controlled result by manually assembling the files.

The first stage is to process the constituent images, making sure that each of the problem tonal areas has a 'good' version. If you have only shot one RAW file, then you can process this in as many ways as you need in order to achieve the same result. This is easier than trying to process all of the tones into one image using the Tone Curve tool, but you won't be able to span as wide a dynamic range as you could with a series of differently exposed shots. Once you have all your images ready, follow these steps, using either Photoshop or **Elements**:

- Select the image that is closest to being correct, with as small an area as possible that needs altering. For instance, on the image of Mount Batur in Bali, the best starting shot is the averagely exposed version (above).
- Select an area on the image that you need to lighten or darken using the selection techniques on pages 264-267. If the selection is along a hard line, such as an illuminated sign, then you might only feather by one or two **pixels** so as to avoid a completely hard edge. If it is a large area in a landscape and you are trying to blend it in to similar tones, then you would apply a fairly large feathering of around 20 pixels or more, depending on the size of the area that you are working on.
- Find the image with the correct tonal range for

the selected part of the picture. Select the entire picture area in that document [Select > All] and then copy it [Edit > Copy].
- Return to the original document and paste the copied layer into the previously selected area. [*Photoshop*: Edit > Paste Into] [*Elements*: Edit > Paste Into Selection]. A new layer will be created, with the pasted element confined by an automatic Layer Mask, which is created from your feathered selection. As you are pasting something that is exactly the same size as the original and identical in everything but tone and colour, then it will line up exactly with the background image.
- You can edit the layer mask, as shown on pages 272-273, to alter the pasted selection.
- Repeat these steps as necessary with other required elements of the image.

You can change the order of the newly created layers by clicking and dragging, and toggling them on and off to assess their effect using the eye icon (for more information on layers, see page 270-271). You can also change the tone of the various sections using the tools outlined on pages 259-263. These will only affect the selected layer.

If you are making a large change, then the effect will often look more realistic if you achieve this in more than one step. Adding an intermediate layer can reduce the transition. It is quite simple to stack these changes as layers and then alter their positioning by dragging in the Layers palette until they are in the correct order, so that any intermediate layers don't cover any required parts of the picture.

When you are making a selection, the result will look a lot more natural if your selection follows any

Gunung Batur volcano, Bali ◀

This image of the Gunung Batur volcano on Bali is heavily backlit. For there to be any detail in the trees in the foreground, the sky would totally bleach out. There is also some chromatic aberration (coloured fringing) on the edge of the mountain on the right. From the same RAW file, I created four versions of this image. A base image with the correct settings to bring out the trees in the foreground, two progressively darker, more flat exposures for the sky and an image with Chromatic Aberration correction. I also processed a separate image from another almost identical shot that wasn't quite so sharp but had an eagle circling in the mist.

natural lines in the picture, such as the line of a hill or the outlines of people. The harder the line that you are following, the less feathering that you should add to the selection. If one part of the selection requires feathering and a different part doesn't, then convert the selection to a Quick Mask (see page 265) and use a feathered brush for one part and a relatively hard-edged brush for the other. When you convert back to the selection, part of it will be feathered and part hard-edged.

Combining multiple files for other corrections

You can use this technique to correct an image that has been shot under two different light sources, such as an interior shot under incandescent light and a exterior shot at dusk. The camera's **white balance** facility will only be able to allow for one of these **colour temperatures**, but you can process two copies of the **RAW** file at different colour temperature settings and then combine the two corrected files. You will be able to produce a single image that doesn't show the **colour casts**.

Assembling the parts ＜

To assemble the various constituent parts, make a selection using the Lasso tool, then feather it and select [Edit > Paste Inside] to paste it into the selection. As you are pasting from a copy of the original image, it will line up perfectly. The original selection is converted into a Mask. If you make your selection along the natural lines between tones in your image, then the different layers will be harder to spot in the final image.

This is also the same technique that you could employ if you were attempting to paste different elements from various pictures together. For instance, if you wanted to have a picture with a more striking sky, you could use this technique to paste in a sky from another picture. The problem with doing this, though, is that it is very difficult to make the picture look realistic. The light on different parts of the composite image may not be right: too intense in one area, or striking the scene from different directions.

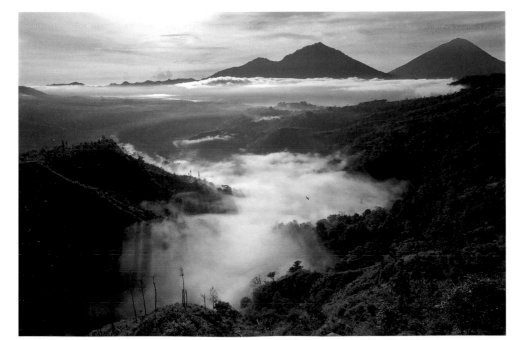

The finished image ＜

The finished image is a composite of four separate versions of the same original RAW file, and an eagle lifted from an almost identical, but slightly softer frame. The result is far more like the scene as I perceived it when I took the picture, but not affected by the inherent weaknesses of the photographic process and how it handles contrasty subjects.

History

We are all used to the Undo function on computers, which allows you to reverse the last command. However, when correcting images you sometimes have to carry out a number of tasks before you can see the real effect of your changes and, in these instances, the Undo function is of little use. Fortunately, Photoshop, Elements and Lightroom have a History palette that enables you instantly to go back multiple steps if you don't like what you have done.

As you carry out alterations to your image, each step is added to the History palette. By simply clicking on any previous step you can instantly restore the image to that point in the editing. The subsequent steps remain present but greyed out and you can click on any of them to see which state you want to revert to. Subsequent steps are only deleted when you start to work on the image again.

For example, you might carry out ten corrections and then decide to go back a few steps. Simply click on step 6, say, to see whether to revert to this point. You can also click back on step 10 to check your decision. If you decide on step 6 and then start to work on the image again, everything from step 7 onwards will be forgotten and the next thing that you do will become the new step 7. If you want to take the image back to the very beginning, to the point at which you first opened it, simply click on the image at the top of the palette.

You can access the History palette in **Photoshop** by selecting [Windows > History]. In **Lightroom** it is visible in the left-hand panel of the Develop module. By default, Photoshop only remembers 20 history steps, but this can be increased if you have adequate disk space. **Elements** has a virtually identical History tool [Window > Undo History] that allows you to undo up to 50 steps (expandable to 1000), but it doesn't have the ability to create snapshots.

Make a snapshot

When you are happy with a series of changes, create a snapshot of the image by clicking the small camera icon at the bottom of the History palette. This creates an instant copy of the file that you can revert back to. You can create any number of snapshots and toggle between them to see which is best. To resume editing, simply click on the chosen snapshot and start to make your changes from that point. In Lightroom, simply click on the plus icon in the Snapshot panels above the History panel to create a snapshot. You will then be prompted to name the snapshot.

Remember, though, that none of the snapshots or history steps are actually saved when you save the document in Photoshop. If you quit the program or your computer crashes, you will lose everything up to the last save. Both History steps and Snapshots are remembered in Lightroom.

Photoshop History palette ∧

The History palette allows you to record and subsequently reverse a number of steps in your image. This allows you to experiment with different edits without having to save multiple versions. Remember, though, that if you close the image, only the last state of the image is saved and all of the history steps are lost. The various steps you take are automatically recorded. The icons on the bottom of the palette are, from left to right: New document (creates a new document from the current state of the image; Snapshot (creates a snapshot of the current state of the image) and Delete (removes the current state of the image). To return to the unedited, opened image, click on the image at the top of the palette.

Lightroom History palette ‹

The Lightroom History palette is in the left hand section of the Develop module. History steps are remembered if you select a different picture or quit the program, and snapshots can be created in the Snapshots panel which is above the History panel.

Focus on

Korzok Gustor festival, Lake Tsomoriri, Ladakh

The Korzok Gustor is a Buddhist monastery festival which happens at a small village on the shore of the remote, high-altitude lake Tsomoriri in Ladakh, India. Attracting many of the Chang-pa nomads who graze their Yaks and Pashmina goats on the grasslands above the lake, the festival features masked Cham dancing by the monks. They act out religious morality plays including the famous Black Hat dance.

Many of the nomad women wear ornate headdresses made from turquoise. I wanted to take a shot that showed in some sort of context. I found a position behind a woman wearing a headdress and composed the picture to show the monastery courtyard in the background, then waited for one of the dancers to be in a good pose. The result is a picture with depth, having a foreground, midground and a background.

The festival happens in the middle of the day, so the light was contrasty and the shadows very dark. I had to use the Shadows slider in Lightroom to lighten them, and then somewhat counter-intuitively decrease the black slider to ensure there was a good black point.

 Find out more >

Nikon D3x, ISO 100, RAW.
24 mm. 1/800 second, f6.3

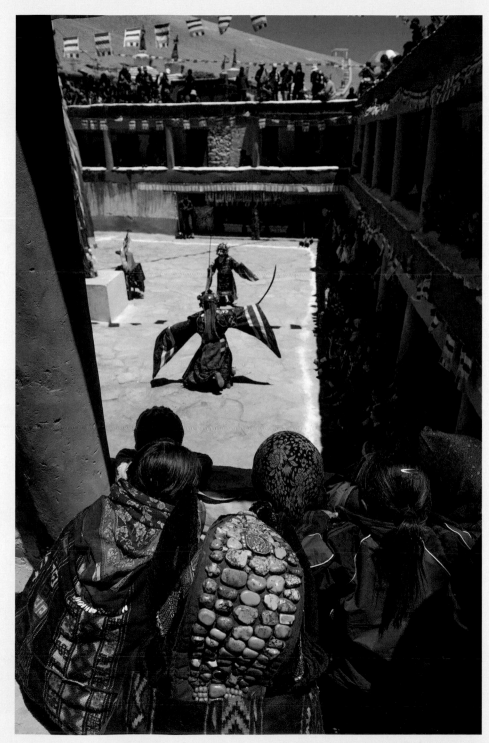

Retouching

Whether you are shooting digitally or scanning film, there will be times when you need to retouch your images. Sensors are prone to collect dust, which is magnified in the image and needs to be painstakingly touched out, and scanned film can suffer from dirt and scratches. All of these appear as black lines or dots on your pictures and are particularly noticeable in areas of continuous tone, such as skies. Luckily, there are a couple of tools in Photoshop and Elements that are designed to retouch these faults, although they might not all be available in earlier versions of the software.

Retouching tools

To select the different retouching tools, click and hold on the Retouching tools icon in the **Photoshop** Toolbox. This will call up a sub-menu that allows you to select the Spot Healing Brush tool, the Healing Brush tool or the Patch tool. In **Elements** you can choose between the Spot Healing Brush tool and Healing Brush tool [Alt-click to toggle between them on the Tools palette]. With all of these tools you can select the size and hardness of the brush that will be used for retouching (see page 267). The smaller the brush, the more precise the retouching, and the softer the edges, the more the correction will blend in to the surrounding image.

Both Healing Brush tools work in a similar way but the Spot Healing Brush retouches by sampling the areas around the area being retouched, whereas the Healing Brush allows you to Option-click anywhere and the brush will use that as the source. As with most automatic functions, the Healing Brush tools can be rather heavy-handed. They work best on continuous areas of tone; if there is any detail in the sampled area, or if two areas of different colour meet, then they can be fooled.

In Photoshop, the Patch Tool allows you to select an area that needs retouching, such as a part of the sky. The most useful function is accessed by selecting

Spot Healing Brush tool ▶

Dust and scratches can be retouched using either the Spot Healing Brush tool via the pop-up list or the Clone Stamp tool. This example shows the Spot Healing Brush tool: choose a brush style then paint over the affected area. This is shown by the black wedge. When you release the brush, the program will automatically retouch the area. This works well on areas of continuous tone, but can become confused if there are transitions or areas of detail.

Elephant at Etosha National Park, Namibia ▶

This tight crop of the elephant accentuates its size and power, but the oryx in the background are distracting. Luckily, they are easy to remove.

Healing tools sub-menu ◀

In Photoshop, if you click and hold the Healing Tool, you will see this sub-menu that allows you to select the various options. You can select further options for each of these

the Content Aware option and double clicking on the selected area. Photoshop will then intelligently retouch the area by sampling the selected area.

You can change the options of all of these tools in the Tool Options bar at the top of the image window in Photoshop, and at the bottom in Elements.

If these tools don't produce a good result, then you can use the Clone Stamp tool to retouch the picture manually.

Clone Stamp tool

The Clone Stamp tool is available in the Toolbox of both Photoshop and Elements. It redraws a selected part of the picture over another part of the picture, based upon a defined source point. Like the Healing Brush tools, the characteristics of the Clone Stamp are affected by the size and hardness of the brush you select. Option-click to set the source point, and then start painting over the area that you want to retouch. If you select 'Aligned', then the source will always be the same distance away from the brush when you start painting from a new point. If 'Aligned' isn't selected, then the source point will start at the exact spot where it was set. You will usually get the best results if you repeatedly set a source point and use smaller, soft-edged brushes, rather than painting large areas with a large brush.

It is not just dust spots and scratches that you might want to retouch. Digital imaging allows you to take pictures on occasions when, previously, you never would have bothered. There might be an unsuitably bright car or loudly dressed person in a picture, or aeroplane vapour trails marring an otherwise perfect sky. The direction of the sun may mean that your own shadow is unavoidable in the picture or that you need to shield the lens with your own hand to prevent flare. All of these elements can be removed with digital retouching. You can even remove specular reflections from shiny objects and blemishes from peoples faces, if you think that it will make your pictures look better.

Some subjects are easier to work on than others – skies, water, foliage, sand, grass and tarmac can be seamlessly retouched very quickly. Areas of detail or with hard and regular lines will take a lot more time and skill, which is why it is worth thinking about the retouching that you might have to do when you are taking the picture. You can see more about taking pictures with a view to eventual retouching in the Execution section on page 146.

Clone Stamp tool in action ❯

With the image zoomed to 100%, use the *Clone Stamp* tool to sample parts of the image and use them to draw over the bits of the image that you want to replace. Repeatedly resampling and working in small areas with a soft brush will disguise the alteration. The cross hair shows where the sample point is, and the circle shows the size of the brush.

Finished example ❯

Without the oryx in the background, the finished shot has fewer distractions and all of the attention is focused on the elephant. The fact that the background was both plain and out of focus made it easy to retouch. Also the transition between the elephant and the background made creating a join much more natural. It is better to work on as high a resolution shot as possible and zoom to 100%. Generally, any errors are tiny and less easy to spot, especially in moderate or small reproductions.

Panoramas

Once you have photographed a series of images to make into a panorama, you have already have done the most difficult part of the process, since it is relatively easy to stitch the images together. There are a number of programs that you can use, including a function buried away in Photoshop and Elements called Photomerge.

The first step is to place all of the images that will make the panorama into a folder on your computer. If you are processing them from RAW files, you should use the same settings in order that the images look as similar as possible; this will make the blending much easier.

The subsequent steps depend on how accurately you have photographed the constituent images. If the tripod was perfectly level, you have photographed the images with a wide overlap and cropped loosely, then Photomerge can finish the panorama virtually on its own.

For Photoshop version CS6 and CC or Elements version 11 or later

- Open the Photomerge function [*Photoshop*: Automate > Photomerge...] [*Elements*: Enhance > Photomerge®... > Photomerge® Panorama...]
- Select Folder from the Use pop-up menu and navigate to your folder of images.
- From the series of Layout Options, try the Auto function. Often this will do a perfect job completely automatically. If you leave 'Blend images together'

Photomerge selection window ◄

When you open the *Photomerge* tool you are given a range of options. If Auto doesn't produce a good result, try again with the *Reposition/Interactive Layout* option. Locate your selection of prepared images and click OK.

Photomerge window ▼

If you try a fully automatic *Photomerge* then eventually the image will appear in Photoshop as a finished image. If you choose the *Reposition/Interactive Layout* you will get this interactive window where you can adjust how the images are assembled, if necessary.

unselected, then each of the images will be in a separate layer in Photoshop. If you select this option, they will be blended together into one layer, often achieving a far better and, certainly quicker, result than you might manage on your own.

- If you are not happy with the Auto result, try again, selecting Reposition/Interactive Layout. Photomerge will open all of the images and stitch them together.
- If any of the elements do not line up exactly, then click and drag them into place. Select Show Transform Controls to be able to rotate or scale the individual components.

For earlier versions of Photoshop
- Open the Photomerge function [Automate > Photomerge…].
- Select Folder from the Use pop-up menu and navigate to your folder of images. Make sure that the 'Attempt to Automatically Arrange Source Images' box is checked and click OK.
- Photomerge will open all of the images and stitch them together automatically. Often all of the images will fit together pretty well, but any images that can't be fitted will be placed in a scrollable bar at the top of the Photomerge Window.
- Click and drag on any of the images that haven't been included in the panorama and drag them into place in the panorama layup.

- If any of the elements do not line up exactly, then click and drag them into place. If you have an image selected, you can click on the Photomerge Rotate tool and rotate any individual image so that it fits better.
- Once you are happy with the panorama, you have a number of options. You can save the Photomerge document ready to work on again later, using the 'Save Composition As…' button. To have Photomerge perform the blending for you, click the 'Advanced Blending' checkbox and click the OK button to open the blended image in Photoshop. Alternatively, to open each of the assembled elements as separate layers, so that you can edit them yourself, click the 'Keep as Layers' checkbox, then click OK.

For Lightroom 5
- If you have Photoshop installed on your system, you can open a series of shots that make up a panorama directly into Photomerge by selecting them and then selecting [Photo > Edit in > Merge to Panorama in Photoshop…]

You might have to do some retouching to the joins in the panorama, using the techniques on page 280, and, once the panorama is finished, you might have to rotate and crop it to remove blank areas in the picture (see page 252).

Panorama of the Diavolezza Alps, Switzerland ⌄

This panorama shows some of the true scale and majesty of this part of the Swiss Alps. It takes in about 180° and, as the sun was over to the left, there are shadows but not a great disparity of exposures. This made the image very easy to assemble. This whole panorama only took a few minutes to shoot and a similar time to create.

Black-and-white conversions

Although many cameras have a greyscale mode, which allows you to shoot black-and-white pictures, you can get better results shooting in colour and converting the images to greyscale afterwards.

A simple greyscale conversion in **Photoshop** [Image > Mode > Grayscale], in **Lightroom** or in simple **RAW** processors doesn't produce particularly good black-and-white images. The problem is that many wildly different colours reproduce as similar tones, giving a very flat, grey result. Instead, one of the best ways to produce vibrant black-and-white images is to shoot with your camera set to save colour files, and then to work on the conversion in post-processing. There are a couple of ways to do this, depending on the software that you use.

Bear in mind that, with all these methods, you can also apply the tools in the Basic and Tone Curve panels to alter the levels, **contrast** and **tone curve** of your whole image, in the same way that you would if the image was in colour. By setting the **exposure**, blacks and contrast you can give the image more punch.

Using Adobe Lightroom or ACR with Photoshop
If you are using Adobe Lightroom or **Camera Raw** with Photoshop, then there is a comprehensive greyscale manipulation feature tucked away in the program that gives you a far greater degree of control over the relative tones in your image.

In the HSL/Color/Grayscale panel, simply click on Grayscale. The image will automatically be desaturated and you will have a Grayscale Mix, comprising a series of colour sliders that will let you alter various colours in the original image. This will also have the effect of changing the way that the tones in the black-and-white image are reproduced.

The way that the sliders work is pretty straightforward. If you want the green areas to reproduce as a darker tone, then move the green slider to the left, towards the negative numbers. If you want them to be lighter, move the green slider to the right, towards the positive numbers. The sliders range from -100 to +100. They won't necessarily start at zero, though; that depends on the original image and on the automatic conversion that Lightroom applies when you select B&W.

There is another way to use the Grayscale tool in Lightroom. If you click on the double circle Targeted Adjustment tool in the top left of the panel, you can select the colour areas that you want to affect. This is useful if you can't remember exactly the original colour of an area of tone in your picture or, for that matter, if the colour in question is a mix of two of the colours in the Grayscale Mix palette. Once you have selected the Targeted Adjustment tool you can click in the part of the image that you want to change. You can either use the up and down arrow keys progressively to lighten or darken that colour in the image or else click and drag upwards to lighten, or downwards to darken.

Moai on Rapa Nui (Easter Island), Chile ‹ ∧

The straight conversion (middle) from the colour RAW file (bottom) gave a very flat result. However, by using the Grayscale Mix tool in Adobe Lightroom, I was able to lighten the stonework and darken the sky significantly (top image). The resultant values for this image can be seen in the B&W panel screen shot above. There are also a range of preset values, including sepia and selenium-toned images.

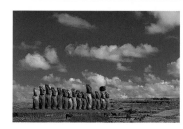

ⓘ For further
information on
shooting in
black-and-white,
see page 138.

Using Photoshop

Photoshop has a custom tool for adjusting black-and-white images [Image > Adjustments > Black & White…]. This allows you to enhance and alter the tones on any colour image. This tool is especially useful if you have a camera that can only shoot **JPEGs**. It automatically desaturates the image, effectively making it a greyscale, and then allows you to adjust the reds, yellows, greens, cyans, blues and magentas of the original image, similar to the Grayscale panel in Lightroom.

The sliders behave in a similar way. So, if you want to darken the blues in the image, slide the blue slider to the left; to lighten them, slide it to the right. The sliders run from +300% to -200% and, like the equivalent tool in Lightroom, don't necessarily start at zero.

Photoshop also has a series of presets, available though a pop-up menu that emulate certain coloured filters used in traditional black-and-white photography, including:

Blue lightens blue skies that are reproduced too dark.
Green lightens foliage and improves lighter skin tones.
Red radically darkens blue skies.
Yellow slightly darkens blue skies and lighten reds, including skin tones.

Using Elements

Elements has a more simplified tool which gives you a degree of control over the conversion to greyscale. The Convert to Black and White tool (Enhance > Convert to Black and White…] allows you to adjust the contrast and how the reds, greens and blues are reproduced.

Woman in Irkutsk, Siberia, Russia ❯⌄

This woman was very proud of her cat with different coloured eyes. A straight grayscale conversion produces quite a flat result (right) but using the Photoshop Black & White Tool allows a more punchy result to be created (shown in tool preview below). This image also shows the preset filters available in the tool. This image was shot in film and scanned.

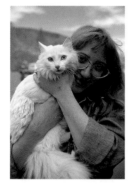

Applying tints in Photoshop

Although you are editing the image as a greyscale, it is still an RGB (colour) image in Photoshop. This means that you can apply a slight tint, which can be far more visually pleasing than pure grey tones. This is a throwback to the days when black-and-white pictures were printed on photographic paper, which often had a slightly warm or cool tone. In some cases this was even accentuated with a colour wash in the photographic process.

Using the Black & White tool in Photoshop, simply select the Tint checkbox and then adjust first the Hue to get the colour you want and then the Saturation to set the colour intensity. We are all familiar with so-called sepia-toned images but these are generally very unrealistic, producing quite a camp effect. My suggestion is to keep any colour tints subtle.

Another way to apply a tint to an image in any version of Photoshop is to use the Duotone function. First, convert the image from a colour (RGB) image [Image > Mode > Grayscale] and then select Duotone [Image > Mode > Duotone…]. This calls up a dialog where you can mix a colour with the black of a greyscale image. This is a complicated tool, so my recommendation is just to click on 'Load…' and apply the presets until you find the effect that you are looking for.

Sharpening

Every digital image will need some degree of sharpening, not because it is out of focus but due to inherent issues with the digital process. Many digital cameras have an anti-aliasing filter in front of the sensor to prevent an effect known as moire patterns, where fine detail shows visual interference. A side effect of this filter is to slightly soften the image. It is possible to apply sharpening routines to your image in the camera and also in post-processing to combat this.

Sharpening is one of those contentious areas that digital photographers tend to disagree about; there seems to be a range of opinions about when, how and how much to sharpen. What I have tried to outline here is a simple, yet effective workflow that will make sure that your pictures are sharpened enough but not over-sharpened.

Over-sharpening can ruin a picture, especially in areas of fine detail. It can cause a halo effect, where detail appears to have an outline, and make the picture as a whole look too contrasty, as illustrated by the third image, right.

Unfortunately, the default settings for sharpening are often too high in many cameras. If you are shooting JPEGs, then you need to reset the level of sharpening to get it right. Some people advocate that you should only sharpen JPEG images on a computer in post-processing but, generally speaking, it is worth applying a low sharpening in-camera, before the image is compressed and artifacts and errors are introduced by the compression. Make sure that the camera is set for the lowest sharpening, unless you find that this doesn't sharpen enough, then use the medium or normal setting. This is usually done through settings menus.

If you are shooting RAW, then in-camera sharpening is one of the settings that can be over-ridden by your RAW-processing software. However, it is still worth setting the level in-camera, so that, if you switch from RAW to JPEG, the settings will be correct. What's more, the camera will use this setting for creating the JPEG preview that is viewed on the LCD preview screen. Having this slightly sharpened can make judging focus much more accurate.

A good sharpening workflow can be broken down into three stages, but it is worth remembering at each stage that you should be very conservative – it is better to under- rather than over-sharpen.

Capture sharpening

Capture sharpening is intended to combat the inherent softness caused by the process of digital capture, not to correct out-of-focus parts of the image or to give an overall boost in sharpness prior to printing. It is carried out in camera, if you are shooting JPEG, and during RAW processing, if you are shooting RAW.

The sharpening tools built in to **Camera Raw** and **Lightroom** are very sophisticated: they actually read the camera make and model from the metadata of the image and vary the actual sharpening applied for a given setting depending on the camera.

There are four different sharpening controls:
Amount Default 25. Setting the amount to zero turns off the sharpening; a setting of 150 is maximum sharpening.
Radius Default 1.0. This affects the size of the detail that is sharpened; use a low setting for finer detail.
Detail Default 25. This slider affects how much the edges of detail are sharpened. Lower numbers mainly sharpen the edges of details.
Masking Default 0. Masking can reduce the effect on edges. Zero sharpens everything equally, whereas a setting of 100 masks all but the strongest edges.

The default settings should be a good start for most pictures. If you do decide to increase the sharpening, zoom to 100% to see the effect and only make subtle

No sharpening

The Sharpening panel in Lightroom allows you to use capture sharpening to compensate for the inherent lack of sharpness in digital images. This example shows a completely unsharpened image, straight from the camera with sharpening switched off in camera and in Lightroom. This image is a crop of the portrait on page 75, zoomed to 100% on screen, which shows the amazing quality of modern digital cameras.

changes. Adjust the Amount slider, then use the Radius and Masking to protect finer detail.

Creative sharpening

Creative sharpening is carried out in your post-production software, such as Adobe **Photoshop** or **Elements**. It is used to sharpen localized bits of the image for creative effect or to try to correct slight errors in focus, by increasing the contrast of edges to give the effect of sharpness. If you get the focus right, then you shouldn't need to perform any creative sharpening at all.

This sharpening can be carried out with the Unsharp Mask filter [*Photoshop*: Filter > Sharpen > Unsharp Mask…] [*Elements*: Enhance > Unsharp Mask…].

The filter has three controls:

Amount The strength of the sharpening.

Radius The size of the sharpening: a low setting of one or two **pixels** will only affect edge details but a higher setting affects a wider band and can cause fringing.

Default sharpening ∧

The same image with the default levels for sharpening applied in Lightroom. This is an amount of 25 which is applied depending on a built-in camera profile. The texture of the skin is far more defined but the magnified window above the settings (which shows a part of the picture at 100% whatever the overall magnification) shows that the fine detail of the beard is not over-sharpened. The area shown by this window can be manually selected.

Over-sharpened image ＞

This image has been deliberately over-sharpened to a value of 150 to show the effect. The texture on the skin is over-defined and looks far too contrasty. In the magnified window, the hair on the beard has been greatly over-sharpened and is heavily fringed.

Threshold This is a measure of how different a **pixel** has to be from its neighbours before it is considered an edge and is sharpened. A threshold of zero sharpens everything, but if you set the threshold at two or more, the filter will avoid **sharpening** subtle changes in tone, such as detail in skin.

Unless you want to be a sharpening expert, setting the degree of sharpening with the Amount slider, then protecting subtle tones using the Threshold is probably as far as you need to go.

You can also sharpen images using the Smart Sharpen filter [*Photoshop*: Filter > Sharpen > Smart Sharpen…] [*Elements*: Enhance > Adjust Sharpness…]

Output sharpening

Output sharpening should be the last step in your workflow and compensates for the loss of sharpness introduced by resizing the image, printing and by viewing the image over the internet. The level of output sharpening will depend on what you are doing with your image. For instance, if you resize the image and print using an inkjet printer this will need a different level of sharpening to an image that is reduced and saved as a **JPEG** to go online.

Adobe **Lightroom** has a print module where you can select the degree of output sharpening. If you are printing or resizing and saving the image in an imaging process such as **Photoshop** or **Elements**, you will need to apply sharpening using the Unsharp Mask after any resizing and just before printing or saving for web.

These settings should be found by trial and error and should be fairly constant for a given output. Once you have worked out these settings, you can apply them automatically, although you might have to reduce the amount of sharpening if there is fine detail in the image that ends up looking over-sharpened.

Finally, a few rules to remember when sharpening your images:

- Always assess the effect by viewing the image at 100%.
- Always save a full-resolution copy of your image after capture and creative sharpening.
- Don't spend ages sharpening each image; in truth, slight variations will have little effect on the image.
- If you sharpen conservatively, you are less likely to over-sharpen the image.

ⓘ Resizing

There are many times when you will need to resize your image. It might be that you are going to email it to someone, post it on a website or even print it. In all of these cases, there is no point using the full-sized image, especially if you have a high-resolution camera, where the file size can be huge, or if you have made a high-resolution scan of a transparency.

However, you should always keep a saved copy of the high-resolution file. If you resize an image and then save and close the image, the high-resolution version will be lost. I always lock all of the high-resolution processed TIFFs at the file level, so there is no way that they can be overwritten if I absent-mindedly resize them and hit Save. I also only save the resized files as JPEGs, so that there can be no confusion over which version is which: the TIFFs are always the high-resolution versions.

Resizing in Photoshop or Elements

To resize your image, open the Image Size dialog [*Photoshop*: Image > Image Size…] [*Elements*: Image > Resize > Image Size…]. You can either change the Pixel Dimensions or alter the Document Size and Resolution (pixel density). If you want the file size to change, then make sure that the Resample Image checkbox is ticked. Any extraneous data will be jettisoned, making the document smaller and easier to print or email. If you just want to change the resolution (pixel density) without changing the file size, make sure this box remains unchecked. If you lower the resolution from 300 pixels per inch (dpi) to 72 dpi then the width and height will get commensurately larger. Typical values that you should consider resampling the image to are 72 dpi for web use and 300 dpi whenever high-resolution is required.

There are a number of options for the type of resampling that Photoshop will use to make the image either larger or smaller. Bicubic Smoother is best if you are enlarging the image, whereas Bicubic Sharper is best if you are reducing the image size. It is possible to resample your image and make it bigger but it is better to make sure that the file size is large enough to start off with, as you cannot actually introduce detail. However, there are some circumstances – such as when you are printing a large print – where interpolating your image to a larger size will give you a better quality result.

Printing

Even if you are shooting digitally and viewing your pictures on a computer, you are likely to want to print your pictures at some point. This might be a series of prints to show to family or friends or a large image to frame and put on the wall.

You have a few options for getting prints. You can copy the images on to a memory card and have them printed at a high-street shop; you can order prints over the internet via a website, or you can print them yourself using an inkjet printer.

I have found that however you choose to print your pictures, you get better quality results more quickly if you resize them first. Most printer drivers aren't that good, certainly not compared to a complex program like Photoshop. The quality of your print will be far better if you let Photoshop do the resizing and the colour management, rather than the printer driver.

Another advantage of resizing the image yourself is that you can apply any sharpening to the image at the correct size and this information is preserved by Photoshop during the printing. If you allow the printer driver to resize the picture as it is printed, then much of this sharpening can be lost.

Most inkjet printers will have a 'native resolution'. This is the optimum **resolution** for pictures to be sent to it. Although printers have settings up to 720 dpi and higher, the native resolution is generally lower. For the optimum setting for your printer, look in the manual or search online. Typically, the native resolution of many printers, including popular Epson models, is 360 dpi, so you will get the best results if you resize your picture to 360 dpi, add the necessary sharpening and print.

If you are making a large print, then you could drop this resolution down to 240 dpi, or even as low as 180 dpi and still get good results, though you should use the highest of these resolutions possible.

Most printer software is not as good at colour management as Photoshop, so you should switch off all colour management in your printer software, and colour manage with Photoshop instead. When you install the printer software, it should give you a profile for the printer, which can then be used by Photoshop:

Printing with Photoshop or Elements
- Open the Print window [File > Print…] or [File > Print with Preview…] if you're using Photoshop CS2 and earlier.
- Select Color Management, as opposed to Output, from the pop-up menu.
- Under Color Handling, select Photoshop Manages Colors.
- Under Printer Profile, select your printer's profile.
- Switch off colour management in the printer dialog.
- Photoshop will now be doing all of the colour management, based upon the profile of your printer.

To get the best quality prints, to hang on the wall or put in a portfolio, use good quality inks and paper. Cheap generic inks and paper are only really good enough for office not photographic printing.

> ⓘ **Pro tip**
>
> Most cheaper inks and photographic papers are not archival. That is to say that they will degrade over time, especially if they are framed and put on the wall, when they will be continually exposed to daylight. The way to avoid this is to use archival inks and paper. These are designed to be longer lasting. It is also possible to buy cotton-based papers for fine art prints that have a much nicer texture than glossy coated papers; not only do they last longer, they look nicer too! If you are selling prints, then you will have to use archival inks and papers, otherwise in a year or two, you might have a lot of very unhappy customers.
>
> Good quality archival inks are more expensive, so many photographers have a good quality printer for archival work and a cheaper printer for day-to-day work. The amount saved per print will more than pay for the cheap inkjet printer.
>
> In order to cut down on wasted ink and paper, it is possible to calibrate your printer. There are a number of businesses that will do this for you. Simply download a sample image from the internet, print it without any colour management and send it off in the post (with a payment, of course). It will be analyzed and a custom printer profile emailed to you. Some services will even allow you to send a second print, made using this profile, for confirmation. The profile is only valid for a single ink/paper combination. It is not cheap to make a profile but the savings in paper and ink, let alone time, will soon make up for it. For more information about printer profiling, see our website: footprinttravelphotography.info

Web presence

Once you have worked your way through this book, a good way of showing all of your pictures to friends and family is to upload them on to the internet. There are a number of options that you can explore: you can upload them to a private website, to a private section on a social networking site or on to a public image-sharing site.

Be aware of privacy issues – especially if there are recognizable people in your pictures – and copyright. Ideally, you should be able to manage privacy so that you can control who gets to see your pictures if you put them on a public photo-sharing site. Even if you subsequently decide to let anyone look at them, this should be a decision not an omission!

There is a risk of people stealing pictures from public photo-sharing sites and sometimes using them on their own websites and even in print. Although you might not be intending to sell your pictures yourself, it is unlikely that you would be happy for someone else to use them without your permission. To minimize the chance of this happening, reduce the size and quality of the images, so that they can't be used so widely and even consider adding a watermark to them, so that they will have your email or copyright notice written on them.

Uploading images
Images on the internet look better if they are resized to the correct dimensions and saved at a resolution of 72 dpi. You should also convert the profile to sRGB, the best colour profile for pictures on the internet [*Photoshop*: Edit > Convert to Profile > sRGB] [*Elements*: Image > Convert Color Profile > Apply sRGB Profile].

To ensure that your images load as quickly as possible, save them in a format that is designed especially for the web using the Save For Web tool [File > Save for Web…]. This allows you to view the effect of any compression and to save images without any previews, which will make the file size as small as possible.

Creating a web gallery
If you have your own web space, you can create your own web galleries using **Photoshop** or **Lightroom**. These programs can even upload the galleries for you and can automatically add a copyright notice to your pictures as they create the gallery.

Creating a gallery in Photoshop CC
In recent versions of Photoshop, web galleries are created in Adobe *Bridge*, the free image browser that comes bundled with Photoshop.

The interface in Bridge is somewhat similar to the Lightroom Web module, but without the live preview. If you want to preview your selection in Bridge, you have to open a browser. Bridge can upload galleries to your webspace for you.

Creating a gallery in older versions of Photoshop
- Open the Web Photo Gallery module [*Photoshop*: File > Automate > Web Photo Gallery…]
- Select a pre-set gallery style from the Styles pop-up menu.
- Work through each of the settings on the Options pop-up menu. This will let you set the colours, size of the thumbnails and images and any text options.
- Choose a source folder for the images and a destination folder.
- The result will be much better if you prepare the source images so that they are the correct size and resolution for the web (see above). Deselect the Resize Images checkbox on the Large Images option panel, so that Photoshop uses your carefully prepared images and doesn't create new ones.
- Manually upload your gallery to your web space using an FTP program.

Web module in Lightroom ▾

The Web module in Lightroom allows you to make a selection of images using a folder or a collection and create a web gallery in a number of styles. Some are built in; other versions can be downloaded from the internet. If you are uploading pictures for family and friends, then you can use some of the more light-hearted templates, such as this flash gallery that emulates a pile of Polaroid prints.

Creating a gallery in Lightroom

- Create a collection of the images you want to use.
- Click on Web to enter the web module.
- Click on a Flash or html gallery preset. You can download more galleries styles from the internet.
- Change the options in the Site Info, Color palette, Appearance, Image Info, Output and Upload Settings panels. Your changes will be reflected in the preview.
- Click either on Export to produce a copy of your website on your computer, or on Upload to upload it directly to your web space.

You can download web gallery templates from the internet. Amongst the best are those from *The Turning Gate*. Some can handle multiple galleries, allowing you to create a whole photo website.

Uploading to Photo-sharing sites

One of the best ways to share your pictures online is simply to upload your pictures to a picture-sharing

Web gallery creation >

Older versions of Adobe Photoshop had a comprehensive web gallery creation tool. Select the style of gallery from the Styles pop-up menu and then set the various options using the Options pop-up menu. More recent versions of Photoshop create galleries through the free Bridge image management application.

Flickr gallery ⌄

There are a number of online photo gallery sites where you can upload your images. Some are free; for others, there is a small charge. The recently re-designed Flickr gives you a vast 1TB of storage for free. Make sure that you protect your work using watermarks and privacy settings: many people use online sites as a place from which to steal images!

site, or even a social media site. The most well known of the image-sharing sites is *Flickr*, but many other sites are available. At the time of writing, Flickr offered a free (advertising-based) one Terabyte of storage space, making it a great option for back-up too. Flickr has recently had a design upgrade and resisted the temptation of making all of the thumbnail images square: something that both *Facebook* and *Instagram* could learn from. The best social networking site for sharing pictures is arguably *Google+*, as it preserves the shape of your images, allows you to create albums and allows you unlimited uploads.

Publish and be damned

Lightroom has a comprehensive 'Publish' facility, which allows pictures to be published to popular photography-sharing sites, rather than simply uploaded to them. This means that any changes to the image or any of the metadata (captions and keywords) can be semi-automatically updated. This means that you can upload pictures so that your friends can see them, and then upload the changed versions after you have finished post-processing them. It also means that any changes to captions can also be uploaded, allowing you to make refinements without having to re-upload your pictures. There are publish plug-ins for all of the popular image sharing sites, including *Zenfolio*, *500px* and *Smugmug*.

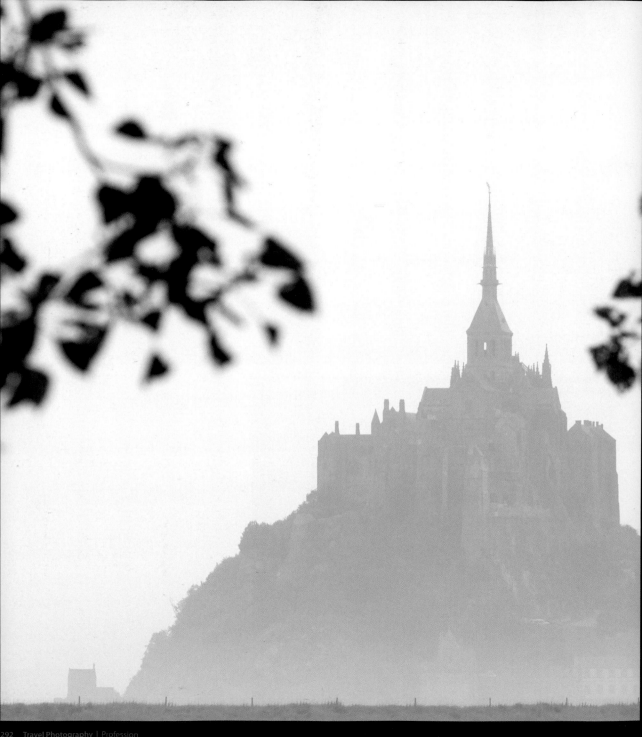

Profession

There are a number of ways to make money out of your pictures without having to enter the fiercely competitive world of magazine and commercial commissions. Photolibraries, art sales and competitions can all give your photos a bit more public exposure and earn you some cash for further travel or photographic equipment. To succeed as a professional, however, you will need more than just good pictures: quality, consistency, originality and a marketing strategy are just as important. This section provides some hints on how to get started.

Mont St Michel, Haut, Normandy, France

Nikon D2x, ISO 200, RAW. 145 mm lens (217 mm equivalent). 1/25 second, f4. Tripod

Photographing a misty Mont St Michel in the morning, I opted to compose the picture so that the monument was framed by this out of focus arch of leaves. This creates depth to the picture and also fills an otherwise featureless area.

Working professionally

Working professionally is about more that getting paid for your photographs. Professionalism is a way of working, an ethos that should ensure that your pictures are of the highest quality. If you are trying to make it in this competitive world, then you need as much working in your favour as possible, and superlative quality images are a good place to start.

Quality encompasses all aspects of your photography. Your images will have to be imaginative and fresh, the subject matter and the execution will need to be original and to stand out to editors and designers as well as the public who might buy a book or magazine or pick up a travel brochure. The pictures will have to be technically perfect and shot on the best quality equipment. What's more, you will have to take good pictures day after day, even when you are ill, tired or just fed up. You will need to come back with the goods whether or not the weather is bad, a city is covered in scaffolding or there's a general strike.

Professional travel photography is a massively oversubscribed field. Countless travellers with cameras think that taking a few pictures on their trip could be a passport to some Peter Pan existence where they never need to grow up or finish travelling. In truth, professional travel photography is a world away from the languid existence that first lured many of us into the field. Simple economics means that you have to produce a large body of work from the shortest possible trip. Spending a few months mooching round Southeast Asia to come away with a few good shots simply isn't commercially viable. The stock image market, where photographs are marketed by libraries and agencies, is already flooded with pictures, and rates for individual images are dropping.

To get lucrative commissions for work, you will need to show reliability. Trips often need to be planned like a military operation, involving internal flights, synchronized timetables and pre-booked hotels. On an average day, you might need to be a porter, negotiator, security guard, map reader, planner, driver, diplomat and, finally, if all goes well, a creative photographer. You will need to get on with all sorts of people and treat each person you meet and each photograph you take as if they are the most important of your life. You will need to find fresh **angles** on tired old places and be enthusiastic about them, even when you would rather just slink back to the hotel and go to bed.

But, for all of this, being a professional photographer can give you unprecedented access to places and people. Having a press pass allowed me to move relatively freely at various Indian festivals and even to photograph the Dalai Lama. I have stayed in places I would never have been able to afford on my own and to visit locations that are out of bounds to ordinary travellers. A typical day at the 'office' might include trekking to Machu Picchu,

BBC books

My two books for the BBC, *Unforgettable Places to See Before You Die* and *Unforgettable Islands to Escape to Before You Die*, have been translated and sold all over the world. At the last count we had 40 co-editions in a bewildering array of languages, and even a few compilations and special editions for Marks and Spencer.

Press and photo passes

These are some of the press and photo-passes I have been issued with over the years, including a Cuban press pass, a number of accreditations for Indian festivals, including the Maha Kumbh Mela, and a pass to photograph the Pamplona bull run from the crowd barrier. It is also an indicator of the ageing effects of being a professional travel photographer!

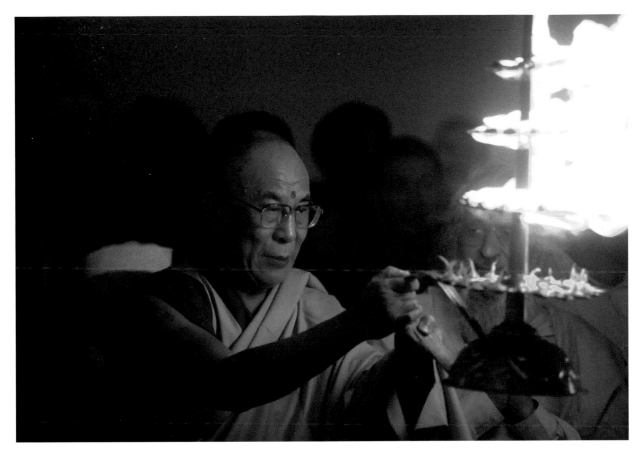

photographing polar bears or joining in a Spanish fiesta. It is an exhausting and competitive existence, but I wouldn't do anything else.

If you're determined to give it a go, you will need creativity, professionalism, originality and a little lateral thinking; you will also have to work very, very hard.

Finding a niche

It is important to establish your own niche – something that will make you stand out as a photographer. You are unlikely to make a living by taking general pictures of the familiar travel icons: they have all been seen before, and the photolibraries are full of them. If you specialize, then you can work at developing a reputation for a given subject or approach, which will give you something to market to magazine and book publishers. You will even be able to approach commercial companies if you specialize in aerial or underwater photography.

Choose a field in which you already have interest and knowledge – such as textiles, food, birds or surfing – and exploit any specialist skills that you may have. For instance, if you are a proficient climber, then forge a niche shooting from high angles and vantage points that are out of the reach of general photographers. You could specialize in a geographical region where you know or are prepared to learn the language. By developing expert knowledge of a country you automatically put yourself ahead of photographers who are just passing through.

My primary niche is that I write as well as take pictures. This means, in essence, that I can create a market for my photographs myself: if I sell a feature, there is a good chance that the publication will also want to buy my pictures. Often the ability to both write and takes pictures is a unique selling point that helps secure a commission in the first place. What's more, because I do both myself, I don't have to split any fees with a writer or indeed factor in their travel and living costs. An ability to write as well as photograph was also one of the reasons I was commissioned to write the book you are reading now.

The Dalai Lama at the Maha Kumbh Mela, 2001 ∧

Nikon F5, Provia 100 ASA film. 80-200 mm lens. Exposure not noted

The Dalai Lama attended the Maha Kumbh Mela and I had an official press pass, so was allowed to photograph him. I stood in the sacred River Ganges, with a few Indian press photographers who were jostling somewhat, so I stood a little further back and shot over their heads with an 80-200 mm lens. I didn't want to use flash and so used the available light from the burning lamp. I took a spot reading from the Dalai Lama's face to work out the exposure. Hand holding the camera was difficult as I needed to use a slow exposure but I managed to get a number of shots without camera shake.

Bathing pilgrims at the Maha Kumbh Mela
Allahabad, Uttar Pradesh, India

Shooting the Kumbh Mela festival at Allahabad in 2001 for *Geographical Magazine* was one of the highlights of my career. This was considered the most auspicious time for the festival for 144 years and it attracted unprecedented numbers of people. The crowds were staggering and the conditions were phenomenally challenging. I spent almost two weeks living in a tent in an ashram on a dry river bed, eating vegetarian pilgrim food, meeting and photographing holy men, pilgrims and many of the organizers and support people. My journalist colleague and I got up before sunrise every day and walked around taking pictures and interviewing people until after dark.

The Mela authorities threw up a vast tented city on the dry banks of the river Ganges, where it meets the Yamuna and the mythical Saraswati. The whole city was constructed in a matter of months and had electricity, a telephone network, hospitals, police stations and post offices. On the main bathing day there were so many pilgrims on the site that it became one of the largest cities in the world by population. We decided to focus on this aspect of the festival in our coverage for the magazine.

This photograph illustrates a number of issues about photographing festivals. First, I had to get up onto a massive road bridge that spans the river Ganges and walk for some considerable time to reach the river. This gave me the high viewpoint. Using a telephoto lens to isolate a part of the great crowd of pilgrims actually conveys their number better than a wide-angle shot. The lens has compressed the perspective, reducing the gaps between the people and making them appear even closer together. Although the light was ostensibly coming from the wrong direction, the photograph still conveys the colours, scale and chaos of the event.

The festival lasted for over six weeks and, although *Geographical* is a monthly magazine, we managed to photograph the main bathing days and still get the feature published in the magazine before the festival had actually ended – no mean feat in the days of film, with over a hundred rolls to edit and caption.

⊕ **Find out more** ❯

Nikon F5, Provia 100 ASA film.
80- 200 mm lens.
Exposure not noted.

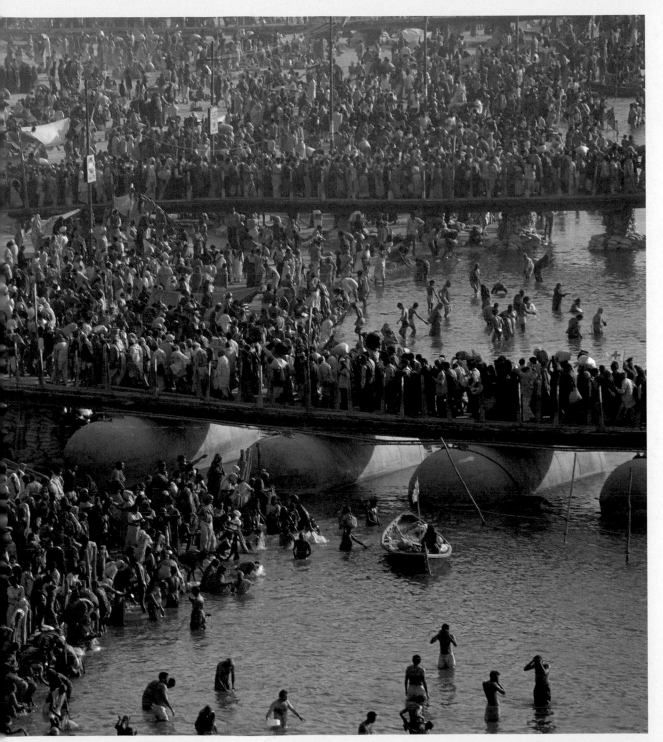

Equipment

Although you can take good and creative pictures with any camera, to get images of the highest technical quality you will need to use the best quality equipment. Unfortunately, quality costs. Buying professional camera bodies and a range of lenses from wide to super-telephoto is a considerable investment but, then, if you are trying to make it as a working professional these are the tools of your trade.

Professional cameras tend to be tougher and more resilient than amateur cameras. They are generally better sealed against dust and light amounts of rain. Their components are designed to last for longer and to shoot more exposures. It would be tempting fate to say that they are less likely to break down but they should be better suited to a life on the road. There are often extra features that will only really be of use to professional photographers: higher speed **motor drives**, the ability to control cameras over a wireless network and even voice memo facilities to caption every shot. Professional cameras often entitle you to faster handling at service centres and some manufacturers will lend you equipment while yours is being fixed.

Lens quality is of paramount importance to the professional photographer. Professional lenses tend to give more even coverage than amateur lenses, especially at the edges of the frame. They have a wider maximum **aperture**, allowing you to take pictures in lower light levels. Most importantly, they have a higher **resolution** and less inherent defects. If you put a cheap lens on a camera with a **high-resolution sensor**, the sensor will show up the defects of the lens. You might not notice this at lower reproduction sizes but, if you are hoping to sell work for lucrative full page, double page and front cover positions then you should aim for the best. Not every person buying pictures will care or even know what to look for, but those that do will generally be working for the better publications. And, getting your work in the better publications is how you advance both your career and your bank balance.

In the days of film, professional photographers spent more money on lenses than on the camera body itself but with digital photography the camera or, more specifically, the **sensor** is of equal importance. People tend to regard the resolution of the sensor as the only thing that matters but there

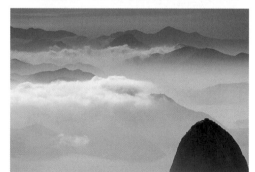

Tomatina festival, Buñol, Spain ‹

Nikon F5, Velvia 50 ASA film.
17-35 mm lens.
Exposure not noted.
Underwater camera housing

You don't just need a range of lenses; other equipment can be vital for taking pictures in different scenarios. This image was shot with an underwater housing to protect my camera from the flying tomatoes and firehoses that are turned on the crowd to keep people cool. Without this I wouldn't have been able to photograph from so close to the action.

Murphy's Bar Montserrat ›

Nikon D3x, ISO 1250, RAW.
28 mm. 1/15 second, f9.

Although there were low light levels, I wanted to use a fairly small aperture to have the entire interior of this Caribbean Rum Bar in focus. This meant that I had to handhold the camera at 1/15 second, which is possible, but takes some practice. This was part of a brief shoot for a glossy UK travel magazine.

Sugar Loaf Mountain, Rio de Janeiro, Brazil ‹

Nikon F5 Provia 100 ASA film.
400 mm lens. Exposure not noted. Tripod

Different focal length lenses will give you more creative and practical choices, especially in the telephoto and super-wide ranges. This image of the bay at Rio was the basis for the cover of my first book. It needed special access to Corcovado at sunrise, before it officially opened, and a sturdy tripod to prevent camera shake.

are other characteristics, such as **pixel capacity** (which affects **dynamic range**) and high **ISO noise** levels, that are equally important. Even if the resolutions are similar, a current professional **DSLR** will tend to have a much better performing sensor than an amateur camera by the same manufacturer.

It is not just the camera and lenses that will affect the quality of your images. You should ensure that the filters you use are of the highest optical quality, as these will have a great effect on the picture. The **polarizing** filters that I use cost more than some amateur lenses but give me the best possible results.

Quality is about more than just having expensive equipment; it is about knowing how to use it. Although you can salvage poor **exposures** in post-production, it is always better to get things correct

in the first place. For instance, using **graduated neutral density filters** can bring parts of the sky, especially white clouds, into the dynamic range and stop highlights blowing out.

Quality is also about reliability. If you are commissioned by anyone to take pictures, then they will expect you to have at least a back-up camera and back-up lenses in case of equipment loss or failure. Winning your first commission, then coming home with no pictures because your only camera broke or your single copy of the images corrupted won't enhance your chances of getting future work or of getting paid. Carry spare equipment and make sure it is all regularly serviced. I budget some 10% of the total equipment cost annually for servicing to try to avoid equipment failures.

Soufrière Hills volcano, Montserrat ⌄

Nikon D3x, ISO 160, RAW. 85 mm. 1/640 second, f5.6.

Shooting from a bobbing boat is always tricky, but the old capital of Plymouth is in an exclusion zone, following its destruction by the Soufrière Hills volcano in 1995. I was shooting in Montserrat for a UK travel magazine, who had expectations of beach resorts and bikinis! Unfortunately, Montserrat isn't that sort of destination; nevertheless the pictures won the Caribbean Tourism Organization, *Best Photojournalism Award* in 2011.

Taking pictures for sale

The shelf life and continued saleability of your pictures can be influenced by your choice of subject matter. A skyline of a rapidly changing city like Shanghai will only really be current for a few months but you could sell a good portrait for 20 years or more. Some of the decisions that you make now could affect whether or not you can make money from your photographs for years to come.

Originality is important if you are taking pictures to impress your friends; it becomes vital if you are trying to make a living through travel photography. Stylistically, your work has to be original to stand out. Look for new **angles**, approaches and treatments to bring a unique view to your images.

Your pictures will be more saleable if you photograph with looser crops and keep key objects away from the edge of the frame. Pictures in magazines and books are often cropped for space and design purposes, and a slightly looser crop will give the in-house designer more flexibility. Pictures may also be bled off the edge of the page, in which case the designer will allow up to 5 mm of overlap in case of inaccuracies during manufacture. If a vital detail in your picture runs right to the edge of the frame then the designer might either have to change the design or, more likely, change the picture!

Publications tend to use a lot of vertical images, so shoot these as well as horizontals. And try to consider potential cover images, too. Look at a range of magazine covers to see the styles of shot that are used. Leave space at the top of a potential cover shot for the masthead and keep the image simple to allow the necessary text lines to be overlaid. Horizontal images with areas of continuous colour, such as blue skies or even deep shadows, which designers can run text over can be sold for lucrative double-page spreads to open features.

Plan the content, style and format of the shots you will need. Shoot around the subject, taking a range of pictures, including details. These are often reproduced in small sizes but you will still be paid for them. Make sure to shoot a couple of establishing shots that could be used as an opening double page spread and remember to photograph other travellers in action. If you get signed **model releases** then your pictures can be worth even more. For more about the range of shots to take, see Photostories, page 224.

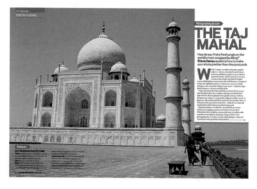

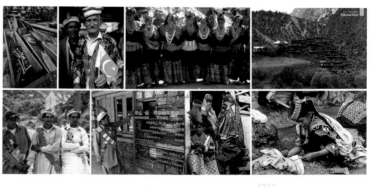

Maxim Magazine,
Czech Republic ◄

One of the advantages of having agencies all over the world is that they can place stories in territories that you would never think of working in. This story on the land-divers of Vanuatu was picked up by *Maxim* in the Czech Republic, as well as magazines in Spain, Germany and the national press in the UK.

Take Better Travel Photos ◄

As well as writing and photographing stories, I write a lot of stories about taking pictures: in this instance on how to photograph the Taj Mahal. I am officially the Consultant Editor for this magazine, published by *Wanderlust Magazine.*

Geographical Magazine ▼

I wrote and photographed a story about the Kalash people of northern Pakistan, and their vibrant Joshi Spring festival.

Organization and workflow

A professional needs to establish a detailed workflow and to follow it religiously to avoid mistakes and lost images. My workflow has developed over the years and was modified when I made the switch to digital. Adapt these basic principles to suit your own needs and be aware that your workflow will evolve.

If you are shooting with two or more cameras, synchronize the time and date settings. Use a different file-naming prefix for each camera and set the file numbering to continual, so the numbers won't restart every time you change the memory card. You can then put all your pictures in a folder and sort by date, ready for editing; as each file will have a unique name, the images won't copy over each other.

Edit these pictures comprehensively. Check the focus at 100% magnification and assess the **exposure**. If a shot is out of focus or the exposure isn't correct (or at least salvageable in post-production), then throw it away. Picture editors will judge you by any poor quality images you send rather than by the good ones. It is not a picture editor's job to whittle out your seconds, and they will resent you submitting them.

When you have edited your pictures, then renumber them. I do this chronologically, sorting the images by date. Work out a numbering system that fits your work. Don't make it too complicated, but leave capacity for your system to expand for the future.

I now run my entire workflow with Adobe **Lightroom**. **RAW** files are imported and a *ColorChecker Passport* calibration applied (see illustration, right). I then create full-sized previews to improve performance and edit all of the images, deleting those that don't make the grade. After re-numbering, shortlisted RAWs are processed and exported to be checked and, if necessary, retouched in Adobe **Photoshop**. Finished images are saved as **TIFFs** and re-imported into Lightroom as my finished master collection. These images can then be distributed through Lightroom. It is not strictly necessary to have the TIFF stage, as all distribution and exporting can be done from RAW files, but as I have some images that will have needed retouching and some TIFF scans from transparencies, I like the standardization of knowing only TIFFs are finished master images.

Lightroom allows you to publish images to a variety of social media sites, professional online storage sites such as *Photoshelter* and directly to some photolibraries. This means that I never have to create **JPEGs**: these are automatically created on the fly and then disposed of by Lightroom, which avoids cluttering my system.

My entire archive is backed up twice, with one complete set kept in a fire safe. All finished images are archived to Photoshelter, where they can then be added to image galleries that can be embedded into websites as slideshow, or delivered to clients.

Captions and keywords

Lightroom allows you to add captions and keywords to images and to apply copyright information. This information is added to the metadata files that are created during RAW processing. Accurate captioning and keywording is a vital part of professional photography. Include the names of places and people and any relevant dates; this information is often used by magazines and publications.

Keywording allows clients to search online libraries for work that you have submitted and is the basis for anyone commercially to locate your images. You should imagine all of the words that people might use to find your pictures. This might be descriptive nouns like mountain or sunset; emotional words, such as lonely or happy; colour-based words (red or cold); photographic words (blur or vertical) and concepts, such as bravado or domination.

I currently outsource all of my keywording to a company in India. All I have to do is supply the comprehensive image captions. All of the keywords and captions are imported into Lightroom, which can then update this information at any of the places they have been published by the program, including at Photoshelter which will automatically update any embedded galleries and slideshows.

Xrite ColorChecker Passport ◄

Different cameras record colours in slightly different ways. If you shoot a calibration chart you can create an individual profile for your camera in Adobe Lightroom. This doesn't just make your RAW processing easier and quicker but can give you more accurate results. Some people create a profile for every lighting set-up; I am happy just shooting one calibration per camera, per trip, unless this spans significantly different locations.

Pitching an idea

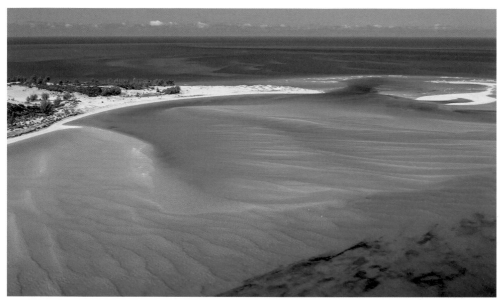

The first question you have to ask when trying to sell your travel photographs is why a client should buy your pictures rather than go to someone more established. If you can't think of a reason, then it's unlikely that the client will be able to either.

If you are trying to sell your work to magazines or other publications, then not only will your images have to be stylistically original, the idea behind them will have to be original as well. Newcomers are seldom approached by magazines; instead it is up to you to pitch an idea that will grab their attention. Magazines are always trying to come up with new features. Newspaper travel sections may be looking for hundreds of novel themes a year and trying not to repeat things covered by their competitors. If you can hit them with an idea they haven't seen before, then you will have opened the door to a possible commission. That doesn't mean it won't slam in your face at a later stage but at least you will have made the first step. Ideas should ideally stand as one liners. Two of my most instantly intriguing pitches have been "Hiring a plane and flying around southern Africa is cheaper than you might think" and "For the Kumbh Mela festival, the Indian authorities will build one of

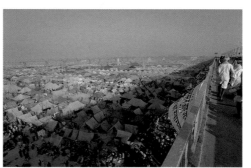

Cleaning the Shard, London ◄

Nikon D3x, ISO 200, RAW.
14 mm. 1/160 second, f5.6

Shooting local stories and pitching them to overseas magazines is a great way to break into the industry and to practise travel images in your home town. You can count on enhanced research and better access than shooting on the road. This was taken at the newly opened viewing platform at the tallest tower in London.

the largest cities in the world on a dry river bed in just six months" (see page 296). Just hearing these ideas makes people want to know more. Recently, I successfully pitched an idea about the Kalash people in Pakistan. A small non-Muslim tribe, they trace their lineage back to Alexander the Great and receive aid from Greece. Although all I wanted to do was photograph their vibrant spring festival, my idea tied this remote people to the Greek financial crash and was picked up by a serious magazine.

Make sure that your online portfolio is ready and appropriate before contacting likely clients. Many publications and commercial companies commission travel-style photographs, but you need to make sure that your work is applicable to them. A publication would only commission you to illustrate a feature, so include a few good photostories in your portfolio. Commercial companies will usually be looking either for lifestyle shots of people travelling to use in travel brochures or for specific images, such as food. It is not worth showing them a general travel portfolio as they will go to libraries for those images. Most photographers I know don't have printed portfolios: if you are heading to a meeting then you can take a portfolio of images on a laptop or tablet. This should also include examples of any work that you have had published. Also make sure that you have good-quality business cards. People will judge your professionalism right from the first contact.

There is always a risk when pitching a story that the publication will steal the idea. This is less likely to happen if you are an established photographer and the client feels they can trust you to deliver the goods. When you are first starting out, it is often better to approach the client with a finished feature,

complete with photographs and text, so that they know exactly what they are buying. This mean that you will either have to write a story yourself or link up with a journalist. There are a number of online forums where you can look for writers with whom to collaborate. If you're lucky, the writer will already have links with a publication and so can pitch your pictures with their words. This is a good way to start making contacts in the industry but make sure you have agreed in advance how you will split any payments. Alternatively, approach magazines that publish photostories so that you don't have to think about words. In most cases, pitch ideas to the travel or general editor, not just the picture editor.

If you are shooting on spec (speculatively, without a commission), then try shooting ideas close to home. You could even shoot in your local area and pitching the story to an overseas publication. This will allow you to build your coverage and shoot around an idea and not have to underwrite large expenses. Many travel magazines carry domestic stories and some will only cover local and domestic locations.

Don't limit your target market to specialist travel magazines. A lot of non-travel magazines will carry general interest stories, which could be shot whilst travelling. The cleaning of the Taj Mahal, for example, would make a great general interest feature, especially if you managed to get special access to shoot up on the scaffolding with the cleaners. There are also a raft of special-interest magazines, covering subjects from food to sailing, that could be a good market for your pictures. Print is not the only medium to consider; a number of online publications publish photographic work, although the rates are lower.

Buddha statues,
Bangkok, Thailand ∨ >

Nikon F5, Velvia 50 ASA film.
Various lenses and exposures

Sometimes you can create a whole story by shooting a series of images with a theme. On a number of visits to Thailand I have photographed the making, sale and transportation of Buddha images in the city. I like the incongruity of the sacred and the profane.

Copyright and legal issues

As well as the usual legalities of running your own business, there are a few issues that apply particularly to working as a photographer.

Copyright

The biggest issue you need to address when trying to sell your photographs is copyright. As the photographer, you automatically own the copyright to your pictures, which in the UK gives you the following copyright and moral rights:

- to say who can and can't use your pictures
- to be paid each time they are used
- to be credited as the photographer each time your photos are used
- to ensure that your pictures are only used in a way that you morally agree with.

In the USA you have to register copyright for it to be valid. This is a fairly simple process, which guarantees automatic penalties for infringement. In most other parts of the world these rights are automatically yours and you have to sign something to give them away. Many book and magazine publishers, commercial companies and even competition organizers will try to get you to do just that! Some will make it a condition of accepting work or entering a competition.

Keeping hold of your copyright is always a good idea. Your photographs are a commercial asset and it pays to keep control over their usage, as a recent instance from my own work illustrates: I was commissioned by a magazine to take pictures for a feature. The magazine initially wanted copyright on all the images I shot, which I turned down, so they agreed to 56 days' exclusivity from publication – basically two issues of the magazine. The pictures were a great success, and I was subsequently able to sell rights to them to other users for considerably more than the initial fee. If I had given away my copyright in the first instance, I would never have been able to do this.

So-called 'rights grabbing' contracts are seldom straightforward and can be bewildering to the uninitiated. Phrases to look out for are "assigning rights in perpetuity" or "granting rights". Some contracts will state that copyright remains with the photographer and then get you to grant them the right to use and even sell your pictures for ever for no fee! You might still have the copyright but they have taken much of its worth from you. In all cases be very careful of

Uluru, Australia ◄

Nikon F5, Provia 100 ASA film. Lens and exposure not noted.

Some places, including Uluru, have special restrictions on professional photography. You have to get a permit, undergo a briefing about what you can, and can't photograph and are heavily restricted in your movements. If you are caught taking pictures professionally without a permit then you can be fined. Any professional photography of the whole of the 'sunrise' side of Uluru and anything to do with the climb are forbidden. Pictures also have to be vetted so that they don't include any sacred sites that will offend the traditional owners.

Changing of the guard at Buckingham Palace, London, England ◄

Nikon F5, Provia 100 ASA film. 17-35 mm lens. Exposure not noted. ND8 Neutral density filter

One way to avoid the need of a model release is to render anyone in the picture completely unrecognizable. In this instance, partly to liven up a relatively dull image, I selected a very slow shutter speed of around a second and intentionally introduced some blur into the shot by moving the camera during the exposure. This also conceals the harshness of the light: the ceremony happens every day at 1100.

contracts that seek rights to your work, other than single publication rights. Negotiate to ensure that a publication doesn't claim the right to distribute, publish or sell your work without your permission.

Before you sign anything or even enter a competition, read the terms and conditions carefully.

If you are still concerned, then seek independent advice. There are a number of copyright resources and photographers' forums on the internet that will help.

Remember, copyright is a valuable resource; handing it over for nothing or allowing people to use pictures in perpetuity for little or no fee is just like handing them cash. It is usually possible to negotiate fairer usage terms, but if a contract is irredeemably unfair, sometimes the only professional thing to do is to walk away.

Model and property releases

Releases are signed permissions granted by people in your pictures to say that they are happy for you to publish images of them or their property. They are required for the more lucrative, commercial uses of your pictures, such as advertising, and are intended to prevent anyone who publishes an image being sued by the subject of the photo for reproducing their image without permission. Generally, you do not need a model release for the editorial use of photos (in magazines, books and, even, travel brochures), although certain countries, such as France and Spain, have privacy laws that mean you can be sued for publishing pictures of people taken without their permission even in a public place. If you are taking any lifestyle shots with models, even if they are friends or people you meet on your travels, then you should always get model releases for any recognizable people, as it will make your pictures more saleable.

I am wary of model releases for travel pictures for both moral and legal reasons. Most countries – including the UK – have legal rulings that state that a contract has to be fair to be legal. Getting someone from a developing country, who might be illiterate in their own language, to sign a contract written in a language they don't understand doesn't seem to pass this test. If you can get a valid model release for the recognizable people in your pictures, make sure it is translated into their language and that they understand what they are signing. Try to get the form explained and witnessed by a local guide. This often means that you will have to pay them but, if you are intending to sell the pictures, then this is only right and proper. There are various apps to create digital releases available for mobile phones and tablets.

From a legal perspective, an invalid model release places liability for any legal action with the

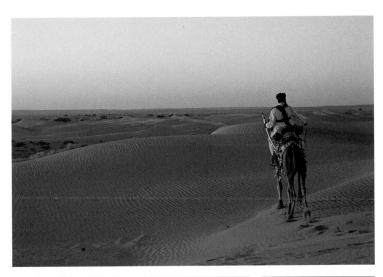

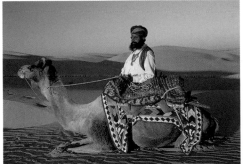

Mr Desert, Jaisalmer, Rajasthan, India ◄ᴧ

Nikon F4, Provia 100 ASA film. Lens and exposures not noted

When you find someone who is willing to be photographed (and who understands model releases) then it is worth making the most of it! I have known Mr Desert, who ran camel safaris in Jaisalmer, for many years and over a number of visits to India. He used to ring me up some years to wish me a Happy Christmas! He was given the title of Mr Desert for life, after winning the Rajasthan Tourism department Mr Desert competition five years in a row. I went out to the desert with him and shot a range of images – covered by a model release, of course. Sadly Mr Desert died recently, but I will never forget the mischievous twinkle in his eyes as he galloped around the dunes!

photographer. Without a model release, the liability is usually with the person or business who publishes the picture, not with the person who took it. Be sure to disclose the fact that there is no release when you sell the images, and avoid any contracts that say that you will provide indemnity for any losses a client might incur.

There are links to some sample model and property releases on our website. Some people now create electronic model and property releases using software such as *Easy Release*.

Ⓦ The URLs of all the sites and products mentioned in this chapter are given on the website: footprinttravelphotography.info

Libraries, competitions and art sales

You don't have to deal directly with magazines, publishers and commercial companies to make some money out of your travel photography. Neither do you have to spend months on the road, wading through crocodile-infested streams, trekking up mountains or struggling across deserts on a pushbike. Some of the most saleable images could just be of your family enjoying a quiet holiday.

Library sales

A photolibrary basically sells the rights for third parties to use pictures. These might be commercial companies, publishers or individuals. The library provides the marketing and an online search platform, sells the images and collects the money on your behalf. Libraries take a percentage for their troubles – typically between 30% and 70% depending on the library and the rights sold. Selling through a library takes away the hassle of dealing with clients, allowing you to concentrate on taking pictures. They will also market your work all round the world. Some expect images to be keyworded; others will do this for you.

There are different rights that you can offer with your pictures, which will affect which library you choose for your work. The three categories are licensed collections, royalty-free images and, increasingly, microstock.

For licensed, or rights managed (RM) images the client pays for the rights to use an image. The price depends on the usage, the size of reproduction, the number of times it is used and the territories it is used in. Clients pay more for exclusivity – a guarantee that no-one else will be able to buy an image for a similar use – and for commercial usage, such as advertizing, for which they would usually expect a valid property and/or **model release**.

For royalty free images, the client will buy a digital copy of an image and be free to use it whenever and however they want. Royalty free (RF) images usually need a model and property release, where applicable.

Microstock sells images for next to nothing but aims to sell them so many times that the usage fees builds up – at least in theory. Microstock tends to make more money for the agencies rather than the photographer, so my advice is to respect your work and not allow it to be licensed in this way.

It is worth remembering that most of the travel libraries have all of the travel pictures that they want. Unless you join one of the unmoderated collections, your work will have to be of exceptional quality and originality to be accepted. The problem with the

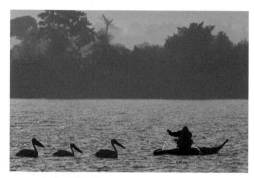

Man fishing from papyrus boat, Lake Tana, Ethiopia ◄

Nikon D2x, ISO 100, RAW. 400 mm (600 mm equivalent). 1/400 second, f7.1

Lake Tana in Ethiopia is noted for its ancient painted monasteries. It is also noted for the papyrus boats – almost identical to those used in Egypt at the time of the Pharaohs. Researching and subsequently photographing details like this can give you shots that will sell well in photolibraries. Having a shot with pleasant colours and a level of humour can also make your image stand out. Lastly, including large amounts of space so a designer can run text over it, means your picture can be used for a prestigious and lucrative opening spread.

Man in Yakel kastem village, Vanuatu ◄

Nikon D2x, ISO 320, RAW. 75 mm (113 mm equivalent). 1/60 second, f2.8

Good portraits with eye contact and a feeling of engagement are always saleable, mainly because many people struggle to take them. This image has been sold as the cover of a travel magazine. A portrait will be more saleable for advertising and commercial uses if you have a model release (see page 305). It was shot in very low light, so increasing the sensitivity to 320 ISO helped avoid camera shake.

unmoderated collections (where pictures have to pass a basic quality control but are not edited in any other way) is that they are absolutely vast, so your pictures may have to compete with tens of thousands of other shots of a similar subject.

As always, the key is originality. There is no point trying to submit a picture to a library which already has hundreds of almost identical shots and expect yours to sell. Prices are dropping in the industry, yet there is always a market for good, model-released images, especially those of travellers on the road: pictures of older travellers are especially desirable to advertizers, reflecting their lucrative share of the travel market. You will probably make much more money from a picture of an active, good-looking retired (model-released) couple on an African safari than from any number of artistic shots of wildlife.

All of the good libraries have an online presence. A good way to find them is to do a search or to look through travel publications that publish work similar to yours and see which agencies and libraries are credited. Different libraries will have their own submission guidelines, which are usually on their websites. Some popular libraries are listed on our website.

Competitions

There are a number of fantastic photographic competitions in which, as well as prestige and recognition, you can win photographic equipment, holidays and even large cash prizes. Although you might think that you have no chance of winning, a surprisingly large number of people submit images that don't fit the criteria of the competition, or they send in badly printed or creased pictures, or they don't follow the rules. Only enter good quality, original and appropriate pictures.

Be careful which competitions you enter, however, as some are set up to enable commercial companies to get hold of images without paying for them. The worst case that I have come across was a competition that took the copyright on all images submitted, allowing them to be used and sold without any benefit to the photographer. What's more, the small print said that the photographer had to have a model release and indemnified the competition organizers for any losses they made by selling the images, if the model release didn't stand up!

Always remember that your images have a value and you should, therefore, be suitably remunerated for their use. Entering a competition shouldn't mean giving away the rights to your pictures. (See Copyright and legalities, page 304.) There is a link to a campaign which carries a listing of both good photography competitions, and those rights-grabbing ones to avoid on our website.

Art sales and exhibitions

You are unlikely to make a fortune out of art sales but, if you have some beautiful images and want to let people see them, then why not organize an exhibition? An increasing number of bars and cafés, as well as independent galleries, hold exhibitions of photography. An Italian restaurant might love to display some pictures of Rome, or an Ethiopian restaurant might jump at the chance to exhibit images from Ethiopia.

Hosting an exhibition gives you the opportunity to sell prints. You should make sure that they are of a good quality and that they are 'archival' – printed with inks that will not fade for a considerable time on good quality paper. If you are serious about this method of selling your work, you could also set up a website to sell your prints direct to the public, although you will have to market the website to get enough hits, and also deal with shipping and transportation.

Fira, Santorini, Greece ⌄

Nikon F5, Provia 100 ASA film. 17 mm lens with tripod and graduated .6 ND filter. Exposure not noted

An interesting and unique shot of a familiar place where people go on holiday is far more saleable than a shot of some exotic, yet dusty location that only a few people visit. This image could be sold for a variety of uses including travel brochures or holiday advertizements. A graduated ND filter was used to stop the brighter, left side of the image from being too light.

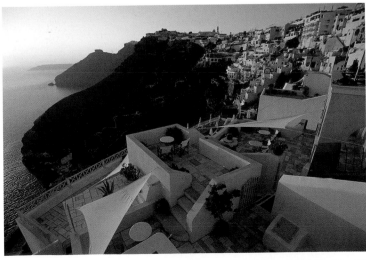

Online marketing

Marketing yourself as a travel photographer is a difficult task that hinges on actually having something to offer to prospective clients. If your work isn't that impressive, or you only have a few good general images, then it's not worth marketing yourself. Instead, put your good pictures in a photolibrary and continue to enjoy travelling, taking pictures and improving your skills.

If you do have enough original work and a marketable niche, then the first thing to do is to create a good website. A web presence is vital as it is the easiest way for prospective clients to easily check out your work. It doesn't have to be a full searchable archive with sales capability, but somewhere to show galleries of your best images and a portfolio of published work.

There are a number of commercial sites that will achieve most of this for you and will even sell work on your behalf. It is better to use a more functional professional site than any of the free sites, as, apart from making you appear more professional, they are likely to provide better searches, more professional captioning, syndication facilities and efficient marketing. Some sites will even let you portal a search engine of your own images within your own website. A third party site also acts as a back-up for your best images.

I currently use *Photoshelter*, which allows me to distribute **high-resolution** pictures to clients but also embed live galleries and slideshows on my various websites. As these are edited on the Photoshelter site, changes are instantly reflected on any sites where they are embedded. With the right plug-in you can even edit Photoshelter galleries using **Lightroom**. I have a folder in Lightroom on my laptop that is linked to a 'Current Work' gallery on my professional website. Adding images to that folder whilst I am on the road, instantly adds them to my current work gallery, if connected to the internet. Similar sites include *Smugmug* and *Zenfolio*.

If you're creating your own website, you need to decide between two basic types of web programming – HTML and Flash. HTML is simpler and more compatible with search engines, while Flash allows animations and more complex functionality. Simple flash galleries can look stylish and functional, but a lot of photographers go overboard and have websites that are too

complicated. Flash is also not supported on Apple IOS devices, like the iPad. Apple is leading a move to universally adopt HTML5, which supposedly enjoys the benefits of both formats. Remember, if you are a photographer, the most important function of your site is to display your pictures. People should be able to find out about you and see your pictures with as little trouble as possible.

Adobe Lightroom and **Photoshop** offer the ability to create web image galleries in Flash and HTML. Lightroom will even upload these to your own webspace for you. There are a number of custom galleries available and these can be uploaded and incorporated into your existing website. Some are simple and stylish; others completely crass!

If you are trying to market yourself as a serious photographer, then you should definitely avoid the sort of designs that make your work look amateurish, such as those with too much animation and graphics. If you are proud of your work then you should make sure that it is at the forefront of your website rather than some crass animation. I am also personally

Planning a website

My professional website has been created in HTML and uses embedded galleries that are hosted on Photoshelter. I can edit these and add images using the *Photoshelter Archive* plug-in in Lightroom. I have created a folder on the version of Lightroom on my laptop, which is linked to a folder on Photoshelter, which instantly publishes a *current work* gallery on my website. I can easily update this folder with my latest work when I am on the road, and the changes are instantly reflected on my website. Another way to achieve this is to create a page on your website that references a gallery of images; which can then be created and edited using the web module of Lightroom; or any other program which is able to create and upload web galleries.

against self-indulgent mission statements on photography websites too: let your work speak for itself.

If you commission someone to make you a complicated site, it could be months before you can afford to pay them to update it. Learning simple HTML yourself or using a proprietary site like Photoshelter means that you can update your site quickly and cheaply, adding new sections and galleries as your work develops. A website should be dynamic and evolve with you. You should be able to upload galleries to illustrate features or as custom searches whenever you need to. If you are pitching ideas for a magazine, email the pitch, include links to your website and put up specific galleries to support the ideas you are pitching.

Probably the most important thing about your website is the domain name that you choose. Travel photography is such an oversubscribed field that, on the rare occasions travel or picture editors search the internet for photographers, there will be thousands of websites for them to choose from. They are more likely to look at your website if you have contacted them and sent them the URL or if they have seen your work published with a picture credit that links to your website. My website URL is stevedavey.com; I try to use this as a picture credit wherever possible, letting anyone who is interested know my name and web address in one hit.

Ⓦ The URLs of all the sites and products mentioned in this chapter are given on the website: footprinttravelphotography.info

Professional hosting sites ❯ ⌃

Although there are a number of free web gallery sites online, if you are trying to establish yourself as a professional then it is worth subscribing to a professional site. I use Photoshelter, which allows me to upload images and distribute them to various clients all over the world. I can create and syndicate galleries and can even use Photoshelter to provide a search engine on my own site. Photoshelter allows you to embed galleries and slideshows into your own website, which are linked to the Photoshelter gallery. Most professional sites will allow you to create a whole portfolio website with their tools, including contact and text pages as well as image galleries.

Glossary

Angle Direction that the photographer chooses to view and photograph the subject.

Angle of view The amount of a scene, in degrees, that a lens can capture; determined by the focal length.

Aperture A measure of the hole that lets the light into the lens. The larger the number, the smaller the hole. Aperture controls depth of field.

Aperture priority mode Automatic exposure mode in which the photographer sets the aperture and the camera sets the shutter speed.

Artefact Image degradation caused by digital compression, often seen in low-quality JPEGs.

ASA American Standards Association. A measure of sensitivity. The same as ISO but usually applies to film.

Aspect ratio Ratio of width to height. 4/3 format has a ratio of 4:3 and is squarer than the 3:2 ratio of 35 mm film and most DSLRs.

Auto ISO Setting whereby the camera sets a higher sensitivity, if it thinks it needs one.

Auto white balance Setting whereby the camera attempts to neutralize colour casts, even if they are intended, such as the warmth of sunset.

Backlighting Light that comes from behind the subject.

Bit depth Amount of information used to record each pixel. An 8-bit image (such as a JPEG) can show 256 shades in each of the red, green and blue channels that make up the image. A 12-bit RAW file can show 4096 shades and a 16-bit TIFF or Photoshop document can show 65,536 shades in each channel.

Blown highlights Highlights that are overexposed, showing no detail.

Bracketing Taking two or more images with different exposures in the hope that one is correct.

Bridge camera A camera that is part way between a compact and a DSLR. It has a large fixed zoom lens. The image is viewed through the lens using a screen rather than an optical viewfinder.

Cable release Device used to take a picture without moving the camera. Used for long exposures. Can be a physical, infra-red or wireless connection. The best have a 'B' or bulb setting.

Calibrate Adjusting an imaging device (camera, scanner, screen) so that the colours match an international standard.

Calibration chart Chart which can be photographed to calibrate your camera.

Camera Raw (ACR) Adobe's RAW-processing utility, used with Photoshop and Elements.

Camera shake Inadvertent movement of the camera during the exposure, which causes a blur or double exposure in the image.

Centre-weighted meter Light meter which measures the whole frame but biases the centre. A legacy from film SLR days.

Chimping Obsessive reviewing of images on the LCD preview screen.

Chroma noise Also called colour noise. Random coloured pixels which occur at high sensitivities.

Clipped highlights Same as blown highlights but refers to the point on the histogram at 255 where no detail is recorded. Anything brighter than this is 'clipped' off

the graph. Anything at 0 or darker on the histogram is referred to as a clipped shadow and will be black with no detail.

Cloud Remote storage for computers and smartphones, accessed over the internet.

Colour cast Overall colour of an image, usually caused by photographing in different colour temperatures.

Colour temperature A measure of the colour of light which the human eye perceives as 'white'. Light from thermal sources (anything from a match through to the sun) gives off light on a scale from red to blue. Fluorescent light is predominantly green. Colour temperature can be controlled with the white balance facility.

Compact camera Small camera with fixed lens. Usually has a zoom lens and a fairly small sensor.

Continuous focus Autofocus mode in which the camera continually refocuses while the shutter-release button is held down.

Contrast Difference between highlights and shadows.

Converging parallels Distortion that causes the top of a building to appear to narrow at the top.

Crop factor Amount by which a crop sensor increases the magnification and decreases the angle of view. Sometimes incorrectly referred to as the focal length multiplier.

Crop sensor A sensor smaller than the 36 mm x 24 mm of the 35 mm frame. Has the effect of increasing the magnification, and decreasing the field of view by a given amount, known as the crop factor.

D/SLR Convention for referring to both DSLRs and SLRs.

Depth of field Amount of a scene in front of and behind the point of focus that is 'acceptably sharp'. A shallow (or narrow) depth of field means this zone of focus is small. A greater or large (also called wide) depth of field means this zone is large and much, if not all, of the picture is in focus.

Diffuser A slightly opaque cover for a flash that softens and distributes the light.

Digital noise Speckling and random coloured pixels caused by the magnification of the sensor signal at higher sensitivities. Noise is greater in shadow areas for the same reason. Noise can also be caused by very long exposures.

DNG Digital Negative. An open source RAW format created by Adobe. You can convert other files to the DNG RAW format.

DSLR Digital Single Lens Reflex camera. You view the image through the lens that is used to take the picture. Takes interchangeable lenses.

Dynamic range The number of stops of brightness that a camera can capture between black and white.

Elements A cutdown (and considerably cheaper) task-based sibling of Photoshop, also from Adobe.

Evaluative meter Meter with a number of different zones that seeks to interpret the scene. Also called multi-zone or matrix meter.

Exposure The amount of light which reaches the sensor or film. Controlled by the sensitivity, the aperture and shutter speed. Sometimes also taken to mean the actual act of light entering the camera.

Exposure compensation Setting by which the suggested exposure can be over-ridden by a given amount to achieve the desired exposure.

Exposure lock Button to hold the light reading and calculated exposure, even if the camera is subsequently pointed at something else.

Exposure mode Modes which set different combinations of shutter speed and aperture. Automatic modes are aperture priority, shutter-speed priority or program. There is also a manual mode.

Exposure value (EV) Combination of a series of shutter speeds and apertures that will result in the same exposure at a given sensitivity.

f-stop Increment of the aperture. Each complete f-stop lets in half or double the amount of light. See also stop.

Field of view Amount of a subject that can be seen by a lens. It is a linear distance and is the product of the subject distance and the angle of view.

Fill-in flash Using a flash to lighten shadow areas and balance the dynamic range.

Fish-eye lens Very wide-angle lens that gives a circular distortion effect.

Flare Either overall lightness and loss of contrast or light spots caused by stray light entering the lens obliquely during exposure.

Flash Electronic lighting device that produces a short, intense burst of light. Some cameras have small flashes built in but these are much weaker than a separate flash that sits on the top of the camera.

Flash synch speed The fastest speed that a camera can take a picture using a flash.

Focal length The distance away from a lens that the lens will focus a picture of an object at infinity. In truth, you will never need to know this definition.

Focal length multiplier Slightly erroneous term for the crop factor. Strictly speaking, the focal length is unchanged by using a camera with a crop sensor; it is the angle of view that is changed. However, the resulting magnification is the same as if the focal length had been multiplied.

Focus distance The distance from the camera at which the lens is focused.

Focus lock Holds the focus setting when shooting in autofocus mode, allowing you to recompose the scene but use the same focus setting.

Focus modes Modes that are designed to handle different picture-taking scenarios, including moving subjects.

Focus point Marked point in the viewfinder which is used for autofocus and, sometimes, also as the source for a spot meter. These points can be moved, more or less easily to aid composition.

Focus tracking Autofocus mode in which the camera locks on to and, in some cases, predicts movement.

Front lighting Light coming from the front. Can sometimes be too flat.

Full-frame Term for a sensor that is the same size as 35 mm film (36 mm x 24 mm). Nikon term this Fx format.

Golden hours The hour just after sunrise and just before sunset when the colour temperature of the light is very warm and golden.

Graduated neutral density filter Rectangular filter that has a neutral density filter at one end, fading to clear at the other. Can be used selectively to darken skies or other parts of the picture.

Grey card Card designed to be a photographic midtone and used as an aid to metering.

High-key An image with a lot of highlights and intentional overexposure. Usually exposed so that the shadows reproduce as midtones, causing highlights to burn out.

High-resolution An image with a larger number of pixels to allow high-quality reproduction.

Histogram Chart of the tones of an 8-bit image. Ranges from 0 to 255, with 0 being black and 255 being white. Available on cameras and in imaging software.

Hotshoe The connector on the top of a camera for mounting and communicating with a separate flash.

Hyperfocal distance Point at which, for a given lens and focal length, everything from half the hyperfocal distance through to infinity will be acceptably in focus. Hyperfocal distance is a way of maximizing depth of field without using a very small aperture.

Image stabilization Combats camera shake using a gyroscope in the lens. Can allow you to handhold the camera at speeds two to three stops slower than normal.

Infrared focus illumination Some flashes have the ability to fire out a beam of infrared light to help the camera to focus in low light.

ISO A measure of digital camera sensitivity set by the International Standards Organisation. Identical to ASA.

JPEG This is a compressed and lossy 8-bit file format used by many digital cameras. The file sizes are small but, every time you edit and save a JPEG, you lose quality.

Light meter Measures the intensity of light reflected from a scene.

Lightroom RAW-processing and image-management programme from Adobe.

Long exposure noise Digital noise caused by the sensor heating up during very long exposures.

Lossless A digital process that doesn't result in a loss of quality.

Lossy A digital process that results in a loss of quality.

Low-key An image with intentional underexposure. Usually exposed so that the midtones are reproduced as shadows, giving an overall dark feeling.

Low-resolution An image with a smaller number of pixels. It can't be reproduced at large sizes and won't show much detail but is suitably small for sending over email.

Luminance noise Digital noise which shows up as a random speckling effect in the image. Visible in underexposed shadows and at higher sensitivities.

Macro lens Lens designed to take close-up pictures at a magnification ratio of 1:1 (lifesize) or greater.

Macro photography Close-up photography using a macro lens.

Manual exposure Exposure mode in which the photographer, not the camera, interprets the meter reading and sets the aperture and the shutter speed.

Maximum aperture The widest possible aperture of a lens.

Medium format A camera that takes film that is larger than the standard 35-mm roll film (36 x 24 mm). It is also now taken to mean a digital camera with a sensor that is larger than the 35-mm format.

Metering mode Different light meters, used for different lighting conditions and exposure modes. See also spot meter, centre weighted meter and evaluative or multi-zone meter.

Mirrorless (compact system) camera A compact camera system that has interchangeable lenses, but utilizes an electronic viewfinder. Occupies the middle ground between a DSLR and a compact.

Mirror lock-up Allows the mirror of an SLR or DSLR to be moved out of the way prior to a long exposure to avoid camera shake.

Mise en scène Literally 'place in the scene'. A film and theatre term for the things which are included in the scene. Very useful concept for photographers.

Model release A legal document signed by the subject of a picture that gives you the right to sell their image commercially.

Motion blur A blurring effect caused when the subject moves during an exposure and that movement is recorded by a relatively long shutter speed.

Motor drive A mode whereby a number of pictures can be taken in a short period of time.

Multi-zone meter Meter with a number of different zones that seeks to interpret the scene. Also called evaluative or matrix meter.

Neutral density filter A filter that reduces the amount of light entering the camera, but without changing the colour of the picture.

Noise Random speckling on the picture caused by using a high ISO.

Off-camera flash lead Allows a flash to be used without it having to be on the hotshoe. Gives a better quality of light and helps to avoid red eye.

Optical viewfinder A viewfinder which allows you to look at the subject itself, not at an LCD screen.

Overexposure When a picture gets too much exposure and is too light.

Panning A technique where the camera is moved during the exposure to keep a moving subject sharp and to blur the background.

Photoshop The pre-eminent image manipulation and editing program, from Adobe.

Picture scene mode A mode whereby the photographer sets the picture type (such as sunset, fireworks, sport or portrait) and the camera biases the exposure, white balance and other settings accordingly.

Pixel A light-sensitive receptor on a camera sensor, which corresponds to a coloured point in a digital image.

Pixel density The number of pixels fitted on to a sensor which indicates quality, in terms of capacity, dynamic range and noise characteristics.

Polarizing filter A filter which can be used to cut down reflections in the image.

Prime lens A lens with a single focal length (as opposed to a zoom lens).

Program exposure mode An exposure mode whereby the camera sets both the shutter speed and the aperture.

RAW A high-quality camera format that records exactly what the camera sensor sees, before any camera settings (white balance, saturation and sharpening) are applied. Needs post-processing on a computer but gives a higher quality result than a JPEG.

Rear synching Firing a flash at the end, not the beginning of a long exposure so that the flash exposure is superimposed on top.

Reciprocity failure Where film needs progressively more exposure for longer shutter speeds.

Red eye Where direct flash is reflected back from the retina producing a demonic red glow in the eyes.

Resolution For digital cameras, this is the number of pixels in an image. Sometimes this is also used to refer to the pixel density, or numbers of pixels in an inch (dpi).

Ring flash A circular flash that fits over the lens and gives a flat, shadowless light.

Ringflash adapter An adapter that uses fibre optics to take light from a conventional flash and fire it through a tube that fits around the lens to emulate a ring flash.

Rule of thirds Compositional rule that says a picture will look more balanced if the subject lies on a horizontal third, rather than in the centre.

Saturation The intensity of the colours of an image.

Sensitivity A measure of the amount of light the sensor (or the film) needs to make an exposure.

Sensor The light-sensitive receptor in a digital camera that replaces film. Sometimes referred to as a 'chip'.

Sharpening Slightly increasing the contrast of an image to improve its sharpness and clarity.

Shift lens Lens with a front element which can be raised to get the top of a building into the frame without tilting the camera and causing converging parallels.

Shutter speed The amount of time that the shutter is open. Controls the exposure and how the camera sees movement. Sometimes referred to as exposure time.

Shutter speed priority Automatic exposure mode where the photographer sets the shutter speed and the camera sets the corresponding aperture.

Side lighting Lighting coming from the side of a subject, accentuating light and shadow.

Single focus Autofocus mode whereby the lens will focus once every time the shutter release button is pressed, then keep that focus until the button is released.

Slow-synch flash Mode whereby the flash is set to fire during a long exposure balancing the ambient light.

SLR camera Single Lens Reflex. You look through the lens to compose your picture using a mirror and a prism. Takes interchangeable lenses.

Specular highlights Highlights caused by reflections on water or shiny surfaces that are well outside the camera's dynamic range.

Spot/partial meter A light meter which measures a small amount of the frame. Useful for accurate manual metering. A spot meter can measure as little as 2°. A partial meter measures a much wider area.

Standard lens Lens which gives a similar magnification to the human eye. For 35 mm film, this is about 40-60 mm focal length.

Stop Increment of exposure, correlating to the f-stop of aperture. Each stop is a doubling or halving of the amount of light entering the camera.

Teleconverter A lens extender that sits between the camera and a telephoto lens and increases the focal length. A 2x converter will double the focal length.

Telephoto lens A lens with a greater focal length than a standard lens. This gives a greater magnification and a narrower angle of view.

TIFF Tagged Image File Format. A high-quality, lossless image format. More useful as a computer rather than a camera format. Can be both 8 and 16 bit.

Tone curve A graph showing how tones are reproduced in an image. Altering the tone curve can locally change the contrast of various tonal groups.

Tripod quick-release plate Mount screwed to the base of the camera to allow it to be easily attached and removed from a tripod.

TTL mode Through The Lens. A mode whereby flash exposure is calculated 'live', based upon the light entering the camera.

Underexposure Where a picture gets too little exposure and is too dark.

UV filter Filter to screw into the front of the lens for protection and to cut down on UV light, which can cause haze in your pictures.

Vibration reduction Combats camera shake using a gyroscope in the lens.

Viewpoint Height that the photographer chooses to view and photograph the subject.

White balance The way that a camera controls colour temperature. Often taken to mean neutralizing colour casts.

Wide-angle lens A lens with a greater angle of view and smaller magnification than a standard lens.

Zoom lens A lens with variable focal lengths.

Index

Join us online...

Follow us @FootprintBooks on Twitter, like Footprint Books on Facebook and talk travel with us! Ask us questions, speak to our authors, swap stories and be kept up-to-date with travel news, exclusive discounts and fantastic competitions.

Upload your travel pics to our Flickr site and inspire others on where to go next.

And don't forget to visit us at footprinttravelguides.com

Credits

Footprint credits

Text editor: Sophie Blacksell
Layout and production: Angus Dawson
Additional proof reading: Lucy Sherley-Dale

Publisher: Patrick Dawson
Managing Editor: Felicity Laughton
Advertising: Elizabeth Taylor
Sales and marketing: Kirsty Holmes

Photography
All images © Steve Davey/stevedavey.com
unless otherwise indicated

Print
Manufactured in Spain by GraphyCems
Pulp from sustainable forests

Footprint feedback
We try as hard as we can to make each Footprint
guide as up to date as possible but, of course, things
always change. If you want to let us know about your
experiences – good, bad or ugly – then don't delay,
go to www.footprinttravelguides.com and send in
your comments.

Every effort has been made to ensure that the facts
in this book are accurate. The authors and publishers
cannot accept responsibility for any loss, injury or
inconvenience however caused.

Publishing information
Footprint Travel Photography 2nd edition
© Footprint Handbooks Ltd October 2013

ISBN 978-1-907263-84-2
CIP DATA: A catalogue record for this book is available
from the British Library

® Footprint Handbooks and the Footprint mark are a
registered trademark of Footprint Handbooks Ltd

Published by Footprint
6 Riverside Court, Lower Bristol Road,
Bath BA2 3DZ, UK
T +44 (0)1225 469141
F +44 (0)1225 469461
www.footprinttravelguides.com

Distributed in the USA by
Globe Pequot Press, Guilford, Connecticut